DUBLIN

Donated to

**Visual Art Degree
Sherkin Island**

GERMAN SCULPTURE OF THE LATER RENAISSANCE

JEFFREY CHIPPS SMITH

German Sculpture of the Later Renaissance c. 1520–1580

Art in an Age of Uncertainty

PRINCETON UNIVERSITY PRESS

PRINCETON · NEW JERSEY

Copyright © 1994 by Princeton University Press
Published by Princeton University Press, 41 William Street,
Princeton, New Jersey 08540
In the United Kingdom: Princeton University Press, Chichester, West Sussex

LIBRARY OF CONGRESS CATALOGING-IN-PUBLICATION DATA
Smith, Jeffrey Chipps, 1951–
German sculpture of the later Renaissance, c. 1520–1580 : art in an age of
uncertainty / Jeffrey Chipps Smith.
p. cm.
Includes bibliographical references and index.
ISBN 0-691-03237-8
1. Sculpture, German. 2. Sculpture, Renaissance—Germany.
3. Reformation and art—Germany. I. Title.
NB565.S65 1994
730'.943'09031—dc20 93-25455

This book has been composed in Garamond #3
by The Composing Room of Michigan, Inc.

Princeton University Press books are printed on acid-free paper
and meet the guidelines for permanence and durability of
the Committee on Production Guidelines for Book Longevity of
the Council on Library Resources

Printed in the United States of America

10 9 8 7 6 5 4 3 2 1

Published with the assistance of the Getty Grant Program

DESIGNER Laury A. Egan
PRODUCTION COORDINATOR Anju Makhijani
EDITOR Timothy Wardell

To Sandy
and our Children,
Spencer, Abigail, and Harlan

CONTENTS

LIST OF ILLUSTRATIONS

PREFACE

A PROJECT as complex as this would never have been possible without the considerable assistance of many individuals and institutions. My greatest debt is to Sandy, my wife, and to my children, Spencer, Abigail, and Harlan who have helped in innumerable ways. Not only have I dragged them from Austin to Munich on two occasions, but I have subjected them to more museums, churches, and castles than any normal person should be forced to endure. My daughter's plea for "No more churches today" stills rings in my mind. As a result, my children now know their saints far better than most of my fellow art historians. I also appreciate the good natured support from my parents, Paul and Chipps Smith, my brother, Douglas Smith, and my in-laws, Robert and Ruth Ambrose. I am particularly indebted to the Alexander von Humboldt-Stiftung in Bonn. Through their largess, I have been able to enjoy three long and quite stimulating periods of sustained research in Germany. Thanks go to Lucie Pohlmann, my current Humboldt advisor. At an early stage of this endeavor I received a grant-in-aid from the American Council of Learned Societies. The College of Fine Arts and the University Research Institute of the University of Texas at Austin have awarded me several grants including two research leaves. I am very grateful to David Deming, my chair, and Jon Whitmore, my dean, for their on-going help. During my stays in Munich I have been affiliated with the Zentralinstitut für Kunstgeschichte. Jörg Rasmussen, Willibald Sauerländer, and Wolf Tegethoff have been wonderfully supportive hosts.

Over the years I have benefited from the ideas, advice, and positive criticism of many colleagues. I wish to thank John Clarke, Charles Edwards, Terence Grieder, Linda Henderson, Joan Holladay, Sigrid Knudsen, and Brenda Preyer at the University of Texas. Susan Lindfors patiently typed photo permission letters. Jana C. Wilson skillfully produced the map of Germany and three plans used in this book. At one stage, Lois Rankin ably served as my research assistant. Among my students, Lamar Lentz, Katie Luber, Tania String, and Susan Webster have patiently tolerated my fascination with German art. Their good humor and friendship have meant a lot. Jane Hutchison and Larry Silver have kindly read much of my manuscript and pointed out passages needing improvement. Thomas DaCosta Kaufmann, Cynthia Lawrence, Corine Schleif, Alison Stewart, and Charles Talbot have all helped in different ways. Tom and Heidi Kaufmann proved to be insightful travel companions during numerous weekend trips through Bavaria. Tom encouraged my new found appreciation for rococo churches and all of those angels. I also wish to acknowledge the help of Christian Theuerkauff (Berlin); Wolfgang Frhr. von Stromer (Burg Grünsberg); Elke Kilian and Heinrich Magirius (Dresden); Bernhard Heitmann (Hamburg); Ingrid Allmendinger, Peter and Dorothea Diemer, H. W. Lübbeke, Alfred Schädler, Ingrid Szeiklies-Weber, Peter Vignau-Wilberg, Peter Volk, and the staff of the Zentralinstitut für Kunstgeschichte (Munich); Hermann Maué, Matthias Mende, Klaus Pechstein (Nuremberg); Peter Reindl (Oldenburg); Heinrich Geissler and Claus Zoege von Manteuffel (Stuttgart); Wolfgang Schmid (Trier); Tillman Kossatz (Würzburg); and the dozens of other curators, scholars, and archive professionals who have provided me with photographs and other necessary material. Over the years, Christian Theuerkauff and my colleagues in Nuremberg have been remarkably tolerant of my repeated research requests. After the completion of my text, I received Wolfgang Schmid's new book, *Kölner Renaissancekultur: Im Spiegel der aufzeichnungen des Hermann Weinsberg (1518–1597)* (Cologne, 1991). This superbly edited account of one Cologne citizen's comments on this period and, occasionally, its art is highly recommended. Finally, I wish to thank Elizabeth Powers, Timothy Wardell, and the other editors at Princeton University Press for their faith in this rather large endeavor.

St. Ambrose Day, 1992
Baldham (Kreis Ebersberg)

GERMAN SCULPTURE OF THE LATER RENAISSANCE

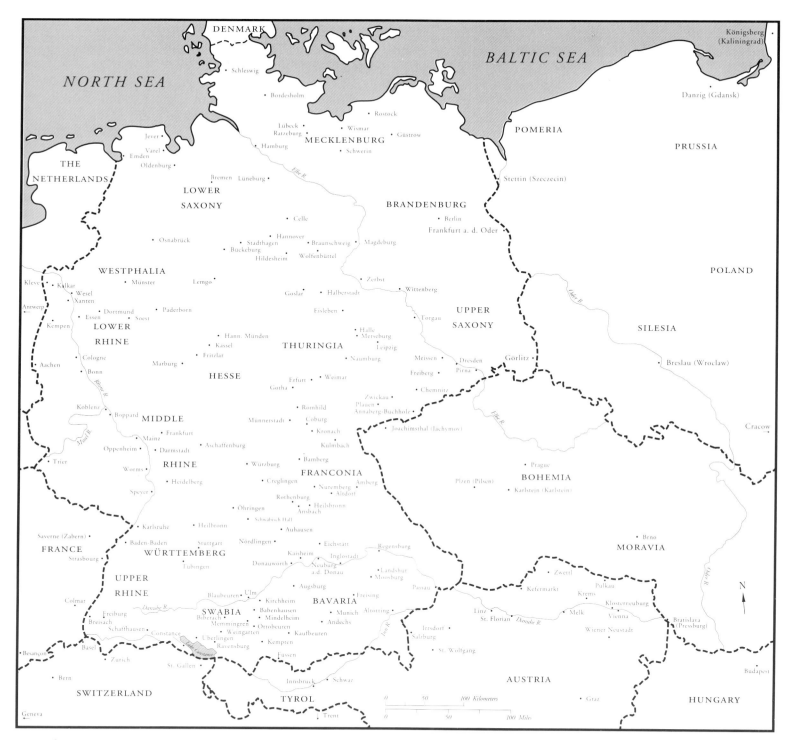

Map of the Major Artistic Centers in Germany and Parts of Central Europe in the Sixteenth Century

INTRODUCTION

I have been trained in (the art of) sculpture.
In earlier times I was highly esteemed
When I made idols
To which one prayed and brought offerings.
I made them of wood and stone
Also of pure clean crystal
Harmoniously measured and fully formed
For which I was highly paid with money.

The Sculptor

IN 1568 famed Nuremberg meistersinger and shoemaker Hans Sachs published this description of the sculptor in his *Book of Trades*.[1] (fig. 1) Taken together with its accompanying woodcut by Jost Amman, this brief poem provides an astute assessment of the status of sculpture in the German-speaking lands during the mid-sixteenth century. The sculptor-narrator laments that life was better in the past when he was well paid for carving religious statues. He implies that his trade is no longer so highly esteemed. What has prompted this "decline"? Our artist alludes to the time when he made idols. Such religious statues provided the economic foundation of German sculpture before Protestants from Wittenberg to Basel challenged the traditional role of church art and the spiritual abuses that art perpetuated. Sachs's choice of the term "idols" or literally "heathen gods" deliberately underscores the sculptor's dilemma. Materialistically he was better off before the Reformation; however, spiritually he acknowledges that his earlier statues may have injured true religious devotion when worshippers mistook the physical object as the actual manifestation of the Virgin or a saint. Some prayed to and left offerings for these wooden or stone sculptures without understanding them as mimetic signs, visual reminders of things unseen.

While Sachs's text is about the past, Amman's woodcut illustrates the present. Our sculptor is far from destitute. He is still working. Indeed, he carefully chisels part of the miter of a recumbent effigy of a bishop. This is a lucrative and prestigious commission destined for a prominent episcopal setting. Many artists capitalized upon the constant demand for elaborate tombs and epitaphs in the aftermath of the Reformation. Behind our master rests a statue of a common woman, likely the personification of Prudentia (Prudence), whose pose reveals the sculptor's knowledge of the Venus pudica tradition. Is she not also just as "harmoniously measured and fully formed" as any of the sculptor's earlier Madonnas? At the rear of the studio on the shelf are plaster casts, an uncut block of stone for a future project, and a seemingly completed architectural sculpture perhaps for a mantlepiece or window frame. One of the interesting outcomes of the Reformation was the expanding market for secular sculpture, including classicizing statues and architectural decorations. In sum, our well-dressed sculptor may long for the old days but he seems to be surviving nicely. Amman often included cracked window panes in many of his workshop scenes so poverty is not being suggested here.

This woodcut and text, with their tension between present and past, signal a recognition that Sachs, Amman, and our hypothetical sculptor acknowledged living in a new age that, for better or worse, emerged with the Reformation. My book is about this new historical era and its art. I have subtitled my study "Art in an Age of Uncertainty" because this was indeed a tumultuous time. The Roman Catholic Church, its doctrine, and its practices, which included the use of art, were challenged as never before. The confessional debate between Catholics and the ever growing palette of Protestant sects touched all aspects of life and even death in the German-speaking lands. Add to this mix a rich array of political particularism and social

3

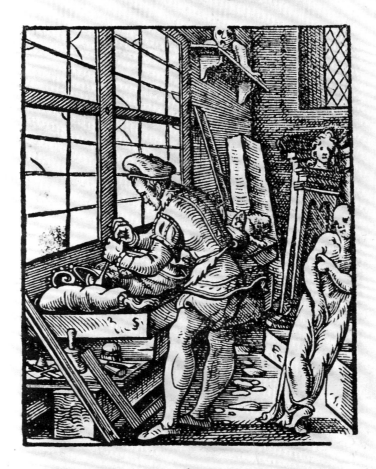

Der Bildhauwer.

Bildschnitzen so hab ich gelehrt/
Vor jaren war ich hoch geehrt/
Da ich der Heyden Götzen macht/
Die man anbett vnd Opffer bracht/
Die ich machet von Holtz vnd Stein/
Auch von Cristallen sauber rein/
Gliedmasirt vnd wolgestalt/
Die mit Gelt wurden hoch bezalt.

Der

1. Jost Amman, *The Sculptor*, woodcut illustration in Hans Sachs, *Eygentliche Beschreibung Aller Stände auff Erden* (Frankfurt: Sigmund Feyerabend, 1568), p. H iv; Wolfenbüttel, Herzog August Bibliothek

turmoil, such as the Peasants' War, and one finds conditions that were not always conducive to the production of art.

This explains why historians of German art have long shied away from art that post-dates the careers of Albrecht Dürer, Veit Stoss, and their peers. In a now memorable essay entitled "The Crisis in German Art in the Sixteenth Century" (1914), Georg Dehio lamented the demise of a national artistic patrimony after about 1530.[2] Dürer died in 1528; Matthias Grünewald, Peter Vischer the Elder, Tilmann Riemenschneider, and Hans Burgkmair followed him to the grave soon after. Hans Holbein the Younger moved to England, and Lucas Cranach the Elder and Hans Baldung Grien had reached their peaks. The best of the next generation, such as Vischer's sons, died prematurely or saw their careers stunted by the Reformation. Dehio ultimately blames the Reformation, though he cites the polluting influence of the Italian Renaissance for diluting the true national character of German art. He notes that in a single decade between 1500 and 1510 more superior quality wooden sculpture was produced than during the entire second half of the century. This attitude, however right or wrong, however dictated by national chauvinism and prevailing ideas about the evolutionary nature of artistic development, has influenced generations of scholars. For many, German art somehow lost its directional bearing, its path to greatness, indeed its "Germanness" with the advent of the Reformation and the Renaissance. Even in the mid-1980s, one emeritus German museum curator chided me for focusing upon the wrong period of German sculpture. I was advised to study the peaks not the valleys of art. Badly belaboring the analogy, I responded that the valleys are truly more fertile and it is there that the paths to the peaks always begin. Furthermore, to dismiss a period because it does not produce a Dürer or a Teutonic Michelangelo is myopic. Nevertheless, what I find important underlying the comments of Dehio, his successors, and Hans Sachs is the fundamental realization that, for better or worse, something changed in German culture beginning around 1520.

This book is a study of German art, and specifically sculpture, between about 1520 and 1580. Research over a decade ago on the heritage of the city of Nuremberg convinced me of the folly of dismissing mid-century German art. The personality of the painted portraits of Georg Pencz, the astounding virtuosity of the goldsmith work of Wenzel Jamnitzer, and the sophistication of the terracottas and brasses of Johann Gregor van der Schardt rival their predecessors and readily disprove the sweeping claims about the qualitative superiority of pre-Reformation art. Here, as in any era, talented sculptors worthy of study can be identified. Pitting one period against another, à la Dehio, is rarely constructive. My task is not to champion my chosen era, defending it against the dismissive barbs of past scholars. Rather I wish to tell a rather long story that introduces the reader to the artistic and cultural richness of this dynamic time. What happens when art and revolution collide? In the ten chapters that follow, I offer a contextual approach to the material. How can the artistic transformations of the era be understood as manifestations of the concurrent cultural changes? Put succinctly, why were certain types of sculpture commissioned and what factors helped to determine their functions and forms? In each chapter, I offer a series of paradigmatic case studies that hopefully explain the issues at hand. Although I cast my net widely, the breadth of the topic prohibits any claims to inclusiveness. For overall unity, I have designed the chapters to build successively upon each other. That is, Chapter Two ("Art or Idol?") assumes the reader's familiarity with the contents of Chapter One ("For Our Salvation: The Role of Religious Art in Pre-Reformation Germany"). Chapters Three through Ten, each following a loose chronological construct, address different categories of sculpture. This means that an artist, such as Peter Vischer the Younger, might be discussed piecemeal in several different chapters. To balance these ten essays, the book concludes with a biographical catalogue, a reference section offering succinct vitae of forty-four masters.

Throughout the book I employ the terms "German" and "Germany" in a more linguistic than political sense. I am concerned with the sculpture produced in or for the German-speaking lands of Central Europe. (See map on page 2.) Modern territorial borders often have little to do with the reality of the sixteenth century as the shifting national associations of towns such as Strasbourg (Strassburg), Gdansk (Danzig), and Kaliningrad (Königs-

berg) demonstrate. Language provided the common thread. When the archhumanist Conrad Celtis praised the virtues of "Germania" and urged the German people to seize their destined greatness, he was hardly advocating a single political state.[3] He was speaking of a cultural identity as fundamental yet as diffuse as that of contemporary Italy. Both Germany and Italy as states are nineteenth-century creations. Individual allegiances tended to be rather more local. Dürer might grandly sign himself "Albertus Dürer Germanus" when the occasion called for signifying his origin, as in the *Madonna of the Rose Garland* done originally for the German merchants' chapel in Venice, or, use the vernacular, in the *Martyrdom of the Ten Thousand Christians* in which the artist stands next to the deceased Celtis. Yet he remained "Albertus Durerus Noricus" or Albrecht Dürer of Nuremberg as he proudly notes in his *Self-Portrait* of 1500.[4] Similarly, Michelangelo thought of himself as a Florentine first and an Italian second. On one of the walls of the Johanniskirche in Schwäbisch Hall is the inscription "SEM SCHLÖR V. LAUTENBACH BILDHAWER 1558." Schlör proudly recorded his name and that of his native town. Like most other artists, his sense of place was local or, at best, regional in definition. He was German but not part of a German political nation.

During the sixteenth century, the German lands constituted a topographic mosaic, a sometimes bewildering array of hundreds of confederations, princely and ecclesiastical territories or states, and free cities and towns. There was no "German" capital. There was no true center though the great mercantile or princely cities, such as Augsburg, Cologne, Lübeck, and Nuremberg, or, later, Dresden, might exert their influence broadly. The sole approximation of a political union was the Holy Roman Empire, whose origins extend back, loosely at least, to Emperor Charlemagne's revival of the Roman empire in the early ninth century.[5] Around 1520 the realm embraced far more than just the current Germany, as parts of modern Italy, France, Switzerland, The Netherlands, Belgium, Poland, Bohemia, and Austria were included. The core, however, was this German-speaking territorial mosaic. Indeed already by 1486 the expanded title of the Holy Roman Empire of the German Nation was beginning to be used. In reality, the empire under

the direction of the emperor, who was selected by seven electors, was stronger as a unifying ideal than a practical political force. Periodic imperial diets or meetings did provide occasions for discussing and sometimes solving common problems, such as the defense of the realm against the Ottoman Turks or, critically, for negotiating peace between the Catholics and Lutherans. For the purposes of this book, I have opted for the term "German" since it designates more precisely my geographic and conceptual perimeters. Some regions, notably eastern Austria, Switzerland, and much of northwestern Germany, receive far less attention than Bavaria or Saxony due to my choice of artists and paradigms.

In my title I have given the dates c. 1520–1580 and the descriptive term "later Renaissance." Both require a brief explanation. On 31 October 1517 Martin Luther posted his 95 Theses on the Schlosskirche in Wittenberg. Rightly or wrongly, this event is normally cited as the moment the Reformation was born.[6] For us, the day, month, and year matter less than the emergence of a force that would forever change the direction of German and European history. The nascent evangelical movement would quickly affect art. As will be discussed in Chapter Two, claims of idolatry, acts of iconoclasm, and a widespread gnawing sense of uncertainty characterize the 1520s. The decade's dynamics vividly contrast with those of the 1500s or 1510s. Obviously no date presents a wholly clean break with the past. For me, the 1520s offer a transition, a time of change that universally affected individuals and regions though at different moments and in different ways.

Meanwhile, the second specter feared by Dehio—the Renaissance—is inextricably weaving its way into the fabric of German art by the 1520s. At the crossroads of Europe, Germany had long embraced outside artistic influences whether the French Gothic in the thirteenth century or Netherlandish naturalism two hundred years later. Each new wave was adopted, adapted, and assimilated. It mattered little that the inventive local offshoots lacked the "purity" of their sources. Italian Renaissance art with its humanistic themes, classical architectural and decorative vocabulary, and codifications of space and human proportions actually entered German art later than it did in Hungary and Poland. Initially, its impact was limited to the design of a

frame or the choice of a theme.[7] Only with Dürer, Burgkmair, and Altdorfer, among others, were the goals of the Italian Renaissance truly embraced and interpretatively disseminated, notably through prints, for the edification of artists and patrons alike. Like other lands, Germany had its share of ambitious humanist scholars who encouraged artists with their knowledge and their commissions. For me, Dürer's *Self-Portrait* of 1500 in Munich (Alte Pinakothek), with its co-mingling of spiritual and intellectual ideas, its antique script and proud inscription, and its artistic self-awareness, signal the Renaissance's firm foothold in Germany. As Strieder has observed, Dürer may have been the first to use the word "Kunst" or "art" in the modern sense as a synonym for "können," meaning to know or to understand.[8] Art was thus craft plus knowledge. The desire to know and then to teach others defines Dürer's career, especially in the last three decades when he grappled with his theoretical treatises and a growing number of talented students.[9] Dürer and his peers epitomize the early stages of the Renaissance in Germany.

Nevertheless, most of German art lagged a decade or more behind. Sculpture in particular was slow to embrace the Renaissance. This was a dynamic yet conservative medium that, because of high material costs and the religious nature of most carvings, responded very slowly to change. There were exceptions, of course, such as the Vischer family in Nuremberg. While recognizing the inherent semantic problems and contradictions of labelling two contemporary artists working in essentially the same environment as "Gothic" in one case and "Renaissance" in the other, I think that this applies often during the early sixteenth century. Virtuoso sculptors like Tilmann Riemenschneider, Veit Stoss, and Hans Leinberger share much in common with Dürer or Burgkmair, but they represent the end of a tradition or a period not the beginning.[10] Their art has a different direction than the brasses of Peter Vischer the Younger, the portrait medals of Hans Schwarz, or the plaquettes of Peter Flötner. Around 1520 a distinctive shift occurs in German sculpture. Patrons are increasingly aware of a growing polarity or, put another way, range of available stylistic possibilities. As will be discussed in Chapter Seven, in 1531 Cardinal Bernardo Cles wrote to Dr. Christoph Scheurl, the legal advisor to the Nurem-

berg city council, to commission a new fountain for his residence in Trent. He carefully specified that it had to be "auf ain New lustige manir" by which he means in the "modern" or Renaissance style. He cites Flötner's *Apollo Fountain* (fig. 195) to indicate what he considers this style to be. Others, including Flötner himself, use the term "Welsch" (Italian) to describe what they meant.[11] Once again change was happening, a change that contemporary observers duly noted. Patrons and artists alike had choices even if increasingly an amalgam of the two trends was the most common result. The years around 1520 witnessed the spread of the Renaissance into sculpture. Yet this was a maturer Renaissance thanks to the assimilation and vernacular translation of ideas by Dürer and others over the preceeding two or three decades. To distinguish it, I use the term Later Renaissance. This more accurately describes the art than does either the broader term "Renaissance" or the popular German expression "between the Renaissance and the Baroque". The latter negatively implies once again a void or emptiness, traits that hardly apply to this spirited age. Looking further afield, one cannot simply adopt the standard labels for Italian art of the Early Renaissance, High Renaissance, and Mannerism since these fail to match or adequately explain the developmental course of sixteenth-century German art. For instance, a good case can be made that Germany never really experienced a High Renaissance.[12]

The terminus for this book is 1580. This marks another critical moment of transition: the advent of the Counter-Reformation. The Peace of Augsburg (1555), as will be discussed in Chapter Four, brought official political and territorial recognition to the Lutherans, though not to other Protestant sects. The beleaguered German Catholic Church, reeling still from the tumult and defections of the previous decades, gained peace and a temporary halt to further territorial losses. The Catholics used the next quarter century to rebuild the German church. Institutional changes were made. The Jesuits spearheaded educational reform. The edicts of the Council of Trent, which concluded in 1563, clarified doctrine so that the faithful could know exactly what it meant to be Catholic. Many edicts directly responded to such Protestant criticisms as the intercessory power of saints, indulgences, and multiple cleric benefices. By about 1580 one finds a

renewed sense of Catholic identity and a growing militancy, especially among the leaders of the Congregatio Germanica. The Counter-Reformation had begun in earnest. In Catholic and Protestant lands, art was enlisted in the confessional battle for the hearts and souls of the populace. The seeds for this remarkable resurgence of religious and, it turns out, secular art were planted by mid-century yet would not truly blossom until the 1580s when churches like St. Michael's, the Jesuit bastion in Munich, announced a new art historical chapter in the German-speaking lands. This will be the subject of my next book.

TO DATE there exists no thorough study of German sculpture of the period c. 1520–1580 in any language. The situation contrasts vividly with the vast bibliography on late Gothic sculpture. New writings on artists like Tilmann Riemenschneider or Veit Stoss appear annually. The richness of this earlier material certainly invites continued research. Nevertheless, this feast and then famine pattern is surprising. Two explanations come to mind. First, there was quite simply far more sculpture produced in pre-Reformation Germany than in the decades after 1520–30. Every church in every town needed artistic embellishments. With the advent of the Reformation, commissions for major religious projects largely ceased, victims of changing attitudes about art. Church programs were not updated continuously as in the past. Elsewhere iconoclasm took its material and spiritual toll. Churches that ultimately did redecorate often did so after 1580, as in the case of St. Ulrich and Afra in Augsburg. And second, the worry, as voiced above by Dehio, that the new art from the 1520s was somehow not as "German" as before due to the corrupting influences of the Reformation and the Italian Renaissance has affected scholarship whether consciously or unconsciously. Consider Adolf Feulner's *Die deutsche Plastik des sechzehnten Jahrhunderts* (Florence, 1926), who, not withstanding his book's broad title, announces on page 1 that nothing after 1530 is worth his attention. His last illustration is a work by Johann Brabender of 1542 done in a consciously pre-Reformation style. Wilhelm Pinder's otherwise excellent *Die deutsche Plastik vom ausgehenden Mittelalter bis zum Ende der Renaissance* (2 vols., Wildpark-Potsdam, 1929) devotes only 14

of its 500 pages to artists active after 1520. In more recent times, editor Georg Kaufmann's *Die Kunst des 16. Jahrhunderts* (Berlin, 1970), volume 8 in the imposing *Propyläen Kunstgeschichte* series, includes but five works from our nearly forgotten decades. More focused studies of German art by von der Osten and Vey (1969), Liebmann (1982), and Ullmann (1984) suddenly become very brief and general once they cast loose from the "age of Dürer." The boundary of the familiar, the comfort of the well-known, seemingly inhibits later exploration. Of all of the survey texts, only Feulner and Müller (1953) and Müller (1963) offer true insight into the dynamics of post-1520 sculpture yet in both cases the comments are brief.

As a glance at the chapter notes and bibliography indicate, I cannot complain about the lack of specialized literature, which is often of outstanding quality. I have benefited enormously from the research of others. In the past two decades or so there has been a tremendous surge of interest in German art and culture between 1520 and 1580. Art historians are following the path, now expanded to a broad highway, blazed earlier by historians and linguists. For instance, excellent artist monographs by Dressler on Alexander Colin and by Reindl on Loy Hering, among others, have appeared. Ambitious exhibitions focusing on cities, such as Augsburg, Nuremberg, and Prague; on regions, like southwestern Germany or the Danube and Weser river areas; on daily life, such as Gagel (1977); and on historical developments, including the major shows in Berlin, Hamburg, and Nuremberg about Luther and the Reformation organized in 1983, have enriched the dialogue. Much of the literature on this period, however, remains directed to its specific concern whether an artist, a church, a town, a region, or a medium. Although this is often necessary, parallel stylistic developments or interconnecting manifestations of fundamental ideas are occasionally overlooked when the scholarship is too tightly focused. Some literature on the pre-Reformation period, notably Baxandall's examination of the "period eye" or Schleif's investigation of a specific church in order to understand broader issues of patronage, offer instructive models for exploring the deeper messages of the artistic material.[13] Until recently, the political divisions of the modern German state, exacerbated by World War

II and the subsequent Cold War, spawned intellectual barriers that discouraged exploration beyond one's immediate borders. Even for most American scholars, Germany really meant West Germany plus Lucas Cranach the Elder until just a few years ago. From this wealth of scholarly contributions, both old and new, and my own research, I endeavor to present a broader assessment of German sculpture than has been attempted before. Hopefully this book will stimulate debate and provide a stepping stone for future studies.

In the following chapters and biographical catalogue, I have included much but I have also omitted considerably more. Where useful I have commented on workshop practices, guild policies, and technical issues; however, since the method by which one made art and the artist's general association with his or her guild changed little between the early and mid-sixteenth century, my remarks are brief.[14] I tackle the issue of the relative status of the sculptor only in my conclusion. Taken collectively, these artists were not theoretically inclined. Unlike their Italian counterparts, they authored no treatises or literary musings on their medium.[15] These masters have left few personal comments about their own sculptures. The paragone or comparative debate over the relative superiority of sculpture or painting was hotly contested in Italy and ignored in Germany.[16] Only the threat of economic infringement might induce guild squabbles about the merits of their respective arts. And while Hans Peisser once was dubbed the Phidias of Nuremberg ("Phidiae Norici"), such conceits were never cultivated. As we shall see, the "Kunst" exists in German sculpture created between about 1520 and 1580 but it generally lacks the self-consciousness that characterize Dürer's career and the artists active at the courts of Munich, Prague, or Dresden at the end of the sixteenth century.

For Our Salvation:
The Role of Religious Art in
Pre-Reformation Germany

ᗧ

RELIGIOUS IMAGES were ubiquitous in late fifteenth- and early sixteenth-century Germany. This was an image culture. The stories of Christ, the Virgin Mary, and the saints were brought to life in pictorial form for the spiritual edification of all. The famous Strasbourg preacher Johann Geiler von Kaisersberg (1445–1510) urged his flock to

> take a picture of paper where Mary and Elizabeth are depicted as they meet each other, you buy it for a penny. Look at it and think how happy they had been and of good things. . . . Thereafter show yourself to them in an outer reveration, kiss the image on the paper, bow in front of the image, kneel before it.[1]

Such recommendations were commonplace in an era in which inexpensive religious prints were readily available and in which churches were filled as never before with a dazzling multitude of altars, sculptures, and reliquaries. Statues of the Virgin and of popular saints adorned many houses, while scenes of Christ's passion were commonplace at cemeteries.[2] Although scholars can argue about whether this period was intensely pious or rather indifferent to the church, its universal desire to translate the infinite into a visual form cannot be denied.[3] The mysteries of Christ's sacrifice or the miracle of transubstantiation are less abstract and more accessible to the mind when rendered pictorially. Popular religious treatises, such as the *Hor-*

tulus Animae or *Garden of the Spirit*, which was published in at least 103 editions between 1498 and 1523, mixed biblical and hagiographic texts with prayers; however, it was the inclusion of innumerable illustrations that assured their success with a broad lay audience.[4]

The power of images is difficult for the modern observer to comprehend fully.[5] For many, an image was more than a simple depiction of a holy story or figure. It provided an accepted means for initiating an intimate dialogue between the individual and the Virgin Mary or a particular saint. These late fifteenth- and early sixteenth-century carvings, paintings, or prints reduced the distance between heaven and earth. By stressing the humanity of a saint or the physical sufferings of Christ, the artistic image rendered them more approachable. It translated their lives into a language of forms drawn from common experiences. Mary may be the queen of heaven but she is also the universal mother grieving over her son's death. The viewer is drawn into the conversation of the Man of Sorrows and the Mater Dolorosa in Wolf Traut's woodcut of 1512.[6] (fig. 2) "Behold [you] who pass by because you [are] the cause of my sorrow" reads the inscription beneath the holy figures. What could be more personal, more humbling than Christ directing his comments at the viewer? Here text and image, with its red highlighting of Christ's wounds, encourage an empathetic response on the viewer's part. An indulgence reward of almost four years,

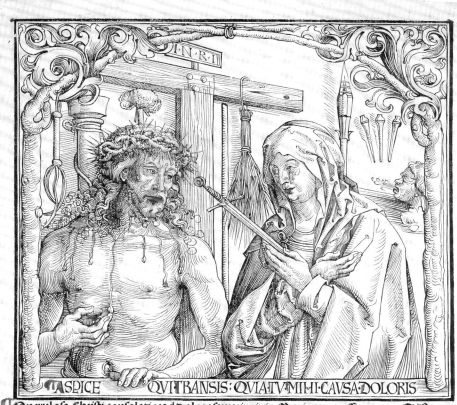

2. Wolf Traut, *Man of Sorrows-Mater Dolorosa*, 1512, woodcut, Washington, National Gallery of Art

listed at the bottom of the print, codifies two further points: the Catholic church's acceptance of images as an essential devotional tool and the individual's willingness to use images if it would enhance his or her chances of obtaining eternal salvation, the Christian's ultimate goal.

If German society embraced art as a "visual externalization of faith," it also accepted the idea that art could have, through divine assistance, near magical powers.[7] Stories of miraculous cures or of saintly apparitions affected through a painted or carved image are commonplace. Michael Ostendorfer's woodcut of the pilgrimage to the beautiful Virgin in Regensburg illustrates the most famous contemporary shrine.[8] (fig. 3) Following the razing of the Jewish synagogue in Regensburg in late February 1519, the citizens erected a temporary wooden chapel dedicated to the Virgin on its site. A thirteenth-century Byzantine icon of the Virgin and Child that was thought to have been painted by St. Luke was placed within the chapel. The first masses were given on 25 March. Miracles credited to the Virgin were recorded almost immediately. Seventy-four are documented before the end of the year; 731 miracles are recorded for 1522. Thousands of pilgrims flocked to Regensburg seeking the Virgin's intercession. Ostendorfer shows the crowds praying before the painting within the chapel; others process outside. A small group prostrate themselves before Erhard Heydenreich's statue of the Virgin and Child seeking help. In all cases, it was the image, whether in painted, carved, or printed form, that was held to be responsible for the miracles. In 1519 over 10,172 lead and 2,430 silver pilgrimage tokens were sold; the following year the number soared to almost 110,000 lead and 9,763 silver tokens. These tokens and the vast but unknown number of woodcuts of the Beautiful Virgin by Albrecht Altdorfer were more than simple souvenirs. The miraculous power of the Virgin Mary as manifest through the Regensburg icon could be duplicated endlessly and transported back to the pilgrims' own locales. In fact, it was the image that was all important. Replicas, such as the wooden votive relief carved by a follower of Veit Stoss in Nuremberg in 1520, could be created in other towns and still carry the same salvific potential.[9]

This dialogue between the individual on one hand and Christ, Mary, or the saints on the other represents one of the critical developments in late medieval piety.[10] As the spiritual burden was placed ever more on the individual and less on the institution of the church, the devotional role of art increased significantly. Between 1490 and 1492 Adam Kraft carved the monumental (2.5 x 6 m) stone epitaph of Sebald Schreyer and Mattheus Landauer on the eastern exterior wall of the choir of St. Sebaldus in Nuremberg.[11] (fig. 4) The three-sided relief illustrates Christ carrying the cross, the entombment, and the resurrection. Directly beneath the empty cross are two men in contemporary dress. Holding pillars and a hammer is Kraft, the sculptor whose likeness is known from his tabernacle portrait in St. Lorenz in Nuremberg. Schreyer stands next to him bearing the crown of thorns and the three nails. Both men are the same scale as the other participants. Schreyer stares directly across the panel at Christ whose head is on the same level. Kraft and Schreyer, artist and church superintendent, are rendered as physically and spiritually present at Christ's entombment. In his *Imitatio Christi*, one of the most influential fifteenth-century texts, Thomas à Kempis urged his readers to

> take up the Cross, therefore, and follow Jesus, and go forward into eternal life. . . . He died for you on the cross, that you also may bear your cross, and desire to die on the cross with Him. For if you die with Him, you will also live with Him. And if you share His sufferings, you will also share His glory.[12]

Kraft and Schreyer, or for that matter any empathetic onlooker, are co-sufferers who aspire to share in Christ's salvation. The image is once again invested with an active spiritual role. The carving serves both as a tangible, indeed eternal, record of their piety and as devotional aid with the potential to edify other Christians passing the epitaph, which is situated directly opposite the Rathaus on one of Nuremberg's busiest streets.

During the late fifteenth- and early sixteenth-century the veneration of saints increased dramatically in Germany. The new brotherhoods dedicated to the Virgin, St. Anne, or other holy figures appeared in almost every town.[13] The Brotherhood of the Rosary in Ulm that Felix Faber started in 1483 soon had 4,000 members.[14] Most of the 99 brotherhoods in pre-Reformation Hamburg were

3. Michael Ostendorfer, *Pilgrimage to the Church of the Beautiful Virgin in Regensburg*, c. 1520, woodcut, Veste Coburg

4. Adam Kraft, *Schreyer-Landauer Epitaph*, 1490–92, Nuremberg, St. Sebaldus

founded after 1450.[15] The codification of inter-
cessory tasks a particular saint might accomplish
became ever more rigid. One prayed to St. Marga-
ret for childbirth; St. Apollonia for toothaches; or
St. Valentine for cure of epilepsy.[16] An ever-more
personal dialogue between the individual and the
community of saints emerged. Booklets for pas-
toral clergy, such as the *Summa Rudium*, stressed
that venerating the saints was the same as adoring
God and that saints were powerful intercessors.[17]
Their holy lives were recorded in the sculptures and
paintings of every church. For instance, St. Chris-
topher, to whom one prayed for a safe day or jour-
ney, was normally difficult to miss upon entering or
exiting a church. The fresco of St. Christopher in
Augsburg Cathedral or the stone statue of the saint
formerly in Strasbourg Cathedral measured respec-
tively 14 and 11 meters.[18]

Holy relics were essential features of every reli-
gious establishment.[19] The sanctity of a particular
church was often measured in terms of the impor-
tance and number of its relics. The churches of
Cologne could claim the shrine of the Three Kings
and the remains of St. Ursula and many of her
11,000 virgin companions, among others. In
1496, 142,000 pilgrims travelled to Aachen to see
displayed in the cathedral the relics of Christ's
swaddling clothes and the loincloth worn on the
cross.[20] Spectacular relics continued to be redis-
covered. For instance, on 14 April 1512, amid the
splendor of the imperial diet at Trier, the cathe-
dral's high altar was opened.[21] To the joy of Em-
peror Maximilian I (r. 1493–1519) and the other
noble spectators, the clerics found the previously
unknown Holy Dress of the Virgin Mary amid the
jumble of relics. This pious object quickly became

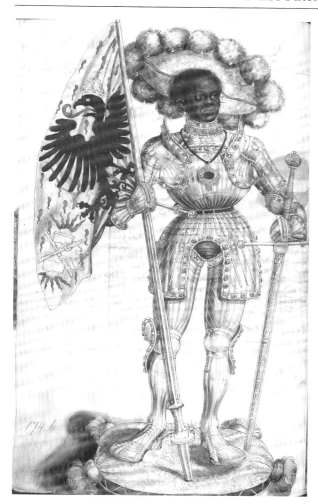

5. *St. Moritz*, Hallesches Heiltumsbuch, 1526–27, Aschaffenburg, Hofbibliothek, ms. 14, fol. 227v

these physical fragments that tie earth and heaven together.

So powerful was the belief in relics that individuals and occasionally even civic groups amassed impressive collections during the fifteenth- and early sixteenth centuries. By 1525 Cardinal Albrecht von Brandenburg, archbishop of Mainz, possessed at least 353 reliquaries containing 21,484 bones and other holy items that were kept in the Neue Stift at Halle, his preferred city of residence. This collection, known as the Hallesches Heiltum, was carefully catalogued and meticulously reproduced in watercolor sketches in a manuscript now in Aschaffenburg.[22] (figs. 5 and 6) For each of the relics not appropriately housed, the cardinal com-

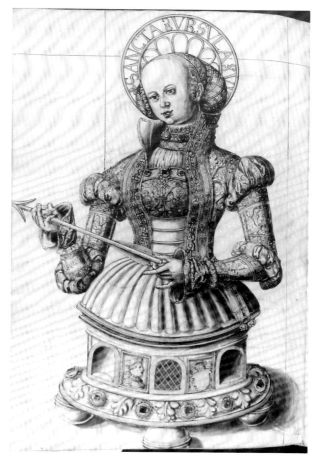

6. *St. Ursula*, Hallesches Heiltumsbuch, 1526–27, Aschaffenburg, Hofbibliothek, ms. 14, fol. 353v

the primary focus of pilgrimages to Trier, local processions, indulgences, and inexpensive prints. Nevertheless, whether the devout journeyed to a church or stood by the roadside to view the procession of relics on a feast day, it was the image, the artistic encasement of the relic, that was really seen. The bones and other holy paraphernalia are enshrined within sumptuous reliquaries or set into altars of varying magnitudes. Often the lives of the saints are beautifully recounted in painted or carved form. The splendor of the church, the fundamental faith in saintly intercession, and, indeed, the individual's hope for salvation are inextricably bound up in the ritualization and the pictorial imaging of

missioned expensive silver reliquaries from leading German goldsmiths, including Paulus Müllner, the Krug family, and Melchior Baier of Nuremberg, as well as others from Augsburg and the Rhineland. Once again, it was the image, the outward artistic appearance, that defined the identity of the contents for the viewer. Some were overwhelming both for their material expense and their physical scale. The reliquary statue of St. Moritz, clad in silver armor, was over life-size.[23] This particular statue, which contained seven particles of the Theban military saint who was one of the church's co-patrons, stood beneath a special baldachin placed prominently before the high altar in the choir. Other reliquaries were set on the altars of their respective saints during feast days. For instance, the cardinal commissioned the silver reliquary bust of St. Ursula, containing 28 holy particles.[24] On the 21st of October the bust was carried in procession to the St. Barbara Altar in the south aisle of the Neue Stift. Services were then performed there to honor Ursula to whom the altar was secondarily dedicated.

The motives of Albrecht von Brandenburg, whose relief portrait adorns the base of the St. Ursula reliquary, were primarily pious though religion and politics were inseparable during these early years of the Reformation. Like most other Christians of the period, the cardinal was exceedingly concerned with his personal salvation. The Catholic doctrine of good deeds held that salvation depended largely upon the works performed during one's lifetime. The more charitable gifts given to the church, including the establishment of masses or the endowing of an altar, the more likely would be the individual's chances of celestial bliss. This exchange of temporal for heavenly goods was a fully accepted practice prior to the Reformation and ultimately accounted for a high percentage of the artistic gifts made to churches.[25] Furthermore, one could shorten the time spent in purgatory by amassing church-sanctioned indulgences, such as the roughly four years awarded for reciting the prayer associated with Wolf Traut's *Man of Sorrows-Mater Dolorosa* woodcut. (fig. 2) Through his donations, his veneration of the saints whose relics were in his collection, and his other deeds, Albrecht von Brandenburg claimed an indulgence equaling 39,245,120 years of penance.[26]

In 1509 Lucas Cranach the Elder published the *Wittenberger Heiltumsbuch*, a booklet with 123 woodcut illustrations of the relics of Friedrich the Wise, elector of Saxony, that were housed in the Schlosskirche in Wittenberg.[27] This compendium served as a pictorial inventory of the collection and as a documentary record for a larger public audience. The illustrations include portraits of the donor and his brother, Johann the Steadfast, a schematic view of the Schlosskirche, and the individual reliquaries. The contents of each reliquary is provided. For instance, housed within a gilt-silver statuette of St. Catherine are 36 holy fragments of her body, her tomb, and even three of Mount Sinai.[28] This quantifying presumably advertises the potency of the specific reliquary. Yet it is the artist who magically has coalesced these disparate fragments into an aesthetically pleasing statuette of the virgin saint capable of sustaining the viewer's attention. The opening text provides a bit of history and a survey of the highlights of the 5,005 relic collection.[29] It also exhorts "all pious christian people" to study the illustrations "in order to better their lives and increase their happiness."[30] A clear listing of the indulgences that total 1,443 years is provided as inducement for visiting the Schlosskirche when the relics were displayed.[31]

The collection of relics was not limited to the great ecclesiastical and secular princes. For instance, in Nuremberg individuals including Nikolaus Muffel, the highest civic official and superintendent of the Klara-Kloster, used 2,000 florins of city money in 1469 to acquire relics for the citizens' spiritual benefit.[32] Nuremberg was also the guardian of the imperial collection of holy relics and regalia, which were shown in the Hauptmarkt annually on the feast of the Holy Lance, the second Friday after Easter.[33]

A woodcut of the Heiltumsstuhl or display tower shows the devout pressing forward to get close to the relics. (fig. 7) Heavily armed soldiers stand ready to protect the relics if the crowd gets unruly because of its fervor. Above, the city councillors hold long candles while church dignitaries hold the relics for all to see. The cleric at the left reads a description of each relic to the faithful while using his staff to point out, from left to right, the splinter from the manger, the arm bone of St. Anne, the tooth of John the Baptist, a piece of John

7. *Display Tower of the Holy Relics*, 1487, woodcut, published in Nuremberg by Peter Vischer, Nuremberg, Bayerisches Staatsarchiv, Reichsstadt Nürnberg Handschriften, nr. 399a

the Evangelist's garment, and links of the chains that once bound Sts. Peter, Paul, and John the Evangelist. Each of the onlookers gathered below who recited the appropriate prayers was granted an indulgence of 37 years and 275 days.

RELIGIOUS PIETY and civic or episcopal pride were bound inextricably together. I wish to consider four contemporary sculptural projects, in Augsburg, Bamberg, Nuremberg, and Eichstätt.[34] Each celebrates a patron saint who was being newly honored by the erection of an elaborate shrine. As a group these exemplify the strong rivalries that existed between neighboring towns. In 1491 the bones of St. Simpertus (d. c. 807; canonized 1468) were rediscovered in Augsburg.[35] Amid a lavish ceremony, attended by the future emperor Maximilian I (r. 1493–1519), the dukes of Bavaria, the count of Württemberg, and numerous other lay and clerical officials, the holy relics were translated

into the church of St. Ulrich and Afra. For Simpertus, the first bishop of Augsburg and a nephew of Charlemagne, a chapel with an elaborate protruding baldachin on the south side of this Benedictine abbey was erected.[36] Between 1492 and 1495 Michel Erhart carved a new tomb for the saint.[37] Only his recumbent effigy of Simpertus, now in Munich (Bayerisches Nationalmuseum) survived the iconoclastic sacking of the abbey in 1537 (fig. 8). Erhart based his design on the conventional form used for contemporary episcopal epitaphs, a subject that will be discussed in Chapter Five. Simpertus, clad in his bishop's robes and miter, holds a crozier and a book. Erhart modelled the miter, gloves, and other vestments on the forms of those traditionally used by the bishops of Augsburg. The original configuration of the tomb is unclear though it is unlikely that scenes from Simpertus' life ornamented the base since in 1492 Bishop Friedrich von Zollern also commissioned Adolf Daucher, Erhart's son-in-law, to carve an adjacent altarpiece dedicated to the saint.[38] The narrative events of Simpertus' life were most likely represented in the altarpiece. At least three motives can be discerned for the creation of Simpertus's tomb. First, the memory of the newly canonized saint is honored. Second, the tomb celebrates the venerable antiquity of the bishopric of Augsburg since it was founded nearly 700 years earlier. Friedrich von Zollern could proudly point to a long and illustrious lineage. And third, a holy shrine would, and in this case did, attract pilgrims, thereby bringing economic benefits to the city and diocese.[39]

Shortly thereafter, on 19 August 1499, Heinrich III Gross von Trockau, bishop of Bamberg, commissioned Tilmann Riemenschneider to carve a new tomb for Emperor Heinrich II (d. 1024; canonized 1147) and Empress Kunigunde (d. 1033; canonized in 1200).[40] (fig. 9) The bishop and cathedral deacon hoped, quite unrealistically, that the double tomb would be finished by 9 March 1500, in time for the ceremony marking the tercentenary of Kunigunde's canonization. The choice of Riemenschneider of Würzburg indicates the bishop's resolve to hire the finest available sculptor; the city of Bamberg lacked a master of equal talent. In 1499 Riemenschneider was a logical alternative since in this year he had just completed the imposing tomb of Bishop Rudolf von Scherenberg

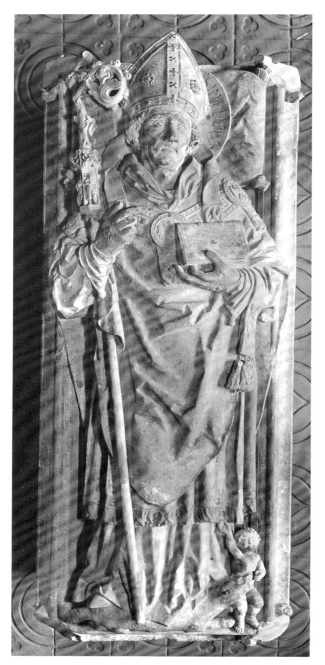

8. Michael Erhart, *Effigy from the Tomb of St. Simpertus*, 1492–95, originally in Augsburg, St. Ulrich and Afra, now Munich, Bayerisches Nationalmuseum

saints. From the worshippers' vantage point the imperial couple, dressed in their regalia, were identifiable but not especially visible since the effigies were set high on a tall base. More legible were the six large reliefs adorning the sides of the base. Here the scenes of their lives and their sanctity were recounted clearly. Stories such as St. Benedict curing Heinrich or the weighing of Heinrich's soul in heaven offer proof of the miracles granted to these two exemplary Christians. Just as the tomb of St. Simpertus in Augsburg alluded to the antiquity of the diocese, Heinrich and Kunigunde's shrine referred directly to Bamberg's episcopal origins, since Heinrich was personally responsible for its founding. At the Synod of Frankfurt in 1007 the emperor knelt before the archbishop of Mainz and successfully pleaded that Bamberg be designated the seat of a new bishopric.[42]

Bamberg's decision to erect a lavish tomb may have been prompted in part by its rivalry with other episcopal cities, such as Augsburg, and with Nuremberg within its own diocese. The latter was a much younger town, yet during the fifteenth century it had surpassed Bamberg as the economic and political center of the region. As early as 1488 Peter Vischer the Elder began designing a monumental brass shrine for St. Sebaldus, who lived in the eighth or ninth century and was canonized in 1425, for Nuremberg's Sebalduskirche.[43] (fig. 10) The

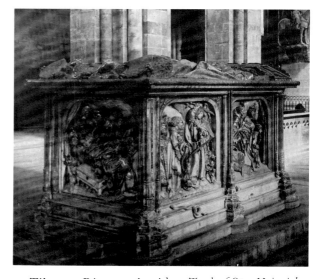

9. Tilmann Riemenschneider, *Tomb of Sts. Heinrich II and Kunigunde*, 1499–1513, Bamberg Cathedral

in Würzburg Cathedral.[41] The Bamberg shrine, made of lime and sandstone, was finally erected on 6 September 1513. It was placed in the center of the nave of the cathedral, a setting accessible to all and one that encouraged the pious veneration of the two

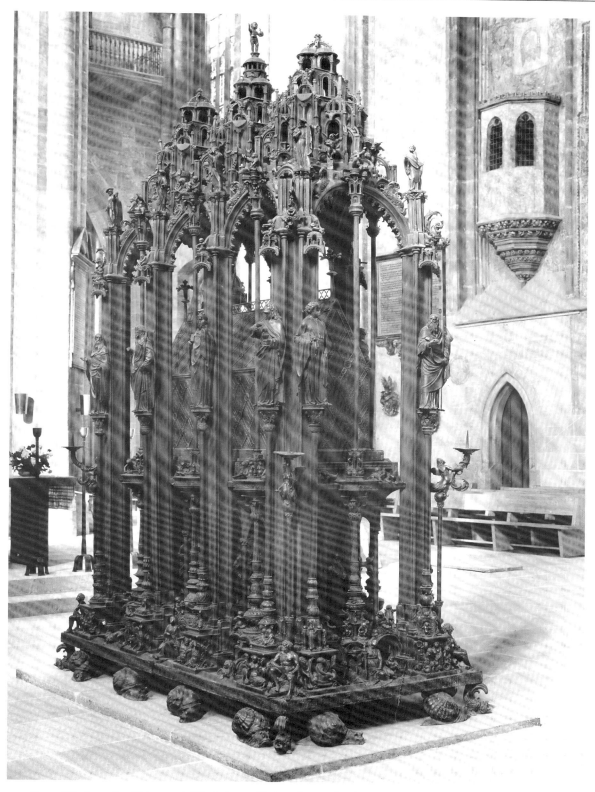

10. Peter Vischer the Elder and Workshop, *Shrine of St. Sebaldus*, c. 1488–1519, Nuremberg, St. Sebaldus

project to honor the city's patron saint faltered several times for lack of funds. Most of the modelling and casting occurred between 1508 and 1519 though there was a hiatus from 1512 until 1514. To complete the project, Anton II Tucher, the first treasurer and leading civic official, called groups of Nuremberg's wealthiest citizens to the Rathaus between the 17th and 19th of March 1519 to raise the money necessary to pay the Vischer workshop. He appealed to their local pride while pointedly reminding them that each donor would receive rich material and spiritual rewards from God and St. Sebaldus for their generosity.[44] The effort was successful and four months later the shrine was dedicated.

The *Sebaldus Shrine* is one of the greatest monuments of German Renaissance art, yet its virtuosity together with the profusion of brass marginalia and classical allusions should not obscure its fundamentally conservative design. Peter Vischer and his sons set the large silver reliquary chest within an elaborate brass canopy. The canopy's sides are open to permit a clear viewing of the chest. Statuettes of the apostles, symbolic of the community of saints of which Sebaldus was a part, and candle holders, providing ready illumination, surround the chest. Below, as at Bamberg which also has a canopy-like character, the base is ornamented with reliefs illustrating Sebaldus' life. The shrine achieves its two basic functions: properly housing the saint's remains and communicating his story to the faithful. Civic pride rather than the antiquity of a diocese was the fundamental motivation for the shrine's commission. The choice of material was hardly accidental. Around 1500 Nuremberg boasted two major stone sculptors, Veit Stoss and Adam Kraft; however, Sebald Schreyer and others initially involved with the project selected Peter Vischer the Elder, the brass founder. The shrine reflects Nuremberg's long held position as Germany's preeminent metalworking center. Any major town could have a stone shrine but only Nuremberg had the expertise for a truly remarkable brass monument. Its myriad of figures and intricate details advertises the skills of Nuremberg's artists. Furthermore, the quality of the Vischer shop was already well-known since under Hermann I and Peter the Elder, the foundry had supplied funerary monuments, baptismal fonts, fountains, and a host

of other objects to patrons throughout Central Europe.

Not to be outdone, Gabriel von Eyb, prince-bishop of Eichstätt, commissioned an Augsburg artist, most likely Loy Hering, in 1512 to sculpt the imposing monument for St. Willibald (d. 787; canonized 1256), the diocese's founding bishop.[45] (fig. 11) The shrine, completed by 1514, consists of an over life-size seated statue of Willibald carved in fine-grained solnhofen limestone that is set within a Renaissance-style shell niche. Early on, but not necessarily originally, a crucifixion group with Mary and John the Evangelist was placed on top of the niche. The monument's form was altered permanently in 1745 during renovations for the bishopric's millennial anniversary. The shrine was set conspicuously between the nave and the entrance to the western (or Willibald) choir in the cathedral. Immediately behind was the *Willibald Altar* with the saint's remains encased in a reliquary.[46] In contrast with the funerary shrines at Augsburg and Bamberg, the seated statue of St. Willibald appears to be involved perpetually in the life of his cathedral. He stares directly over the congregation towards the high altar. His imposing physical scale and highly individualized face make him a beneficient guardian for the diocese. Furthermore, his distinctive rationale or liturgical breastplate with the clearly inscribed words: "IVSTICIA / FIDES. SPES. CARITAS / FORTITVDO" is identical in form with the rationales worn throughout the centuries by his successors.[47] Thus a direct lineal association between the reigning bishop, Gabriel von Eyb, and St. Willibald would have been evident to the worshippers. Willibald's illustrious heritage provides the foundation for his successors spiritual authority.

The artistic commissions at Augsburg, Bamberg, Nuremberg, and Eichstätt all involved providing a visual image to their patron saint. None is a portrait yet each is given a personalized, if somewhat piously dour, countenance. Saintly and human traits are brilliantly merged. In two instances, the saints' exploits are narratively recounted for moral and spiritual edification. Each shrine provides a fitting locus for their respective cults. Each is physically imposing, prominently placed, and visually impressive, characteristics that are appropriate to the dignity of the saints and alluring to the

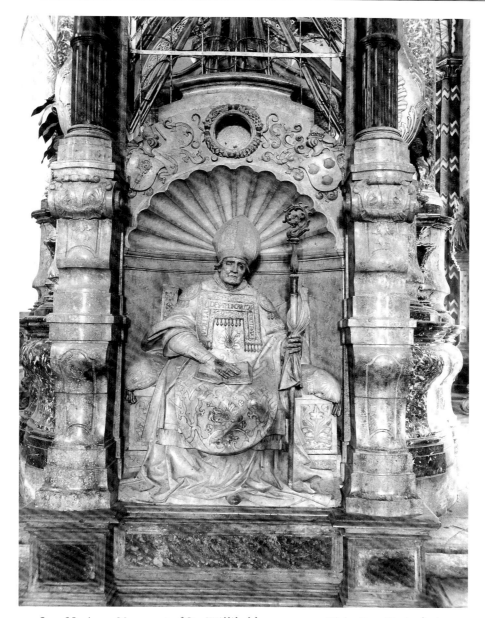

11. Loy Hering, *Monument of St. Willibald*, 1512–14, Eichstätt, Cathedral

devout visitor. In each case, the antiquity and sanctity of the saints were celebrated as if to legitimize the individual church's right to serve the respective congregations. Certainly each town wished to secure the favor of its local saintly intercessor. Yet it was competition that prompted these regional rivals to erect such elaborate shrines within a matter of years of each other. In the neighboring bishopric of Würzburg, cathedral officials, not wishing to be outdone, decided to erect a new high altar instead of a shrine although the fundamental intention was the same. Sculptor Tilmann Riemenschneider, the author of the Bamberg tomb, carved the wooden retable between 1508 and 1510.[48] Prominently displayed in the predella were his life-size busts of Sts. Kilian, Kolonat, and Totnan, the three Franconian apostles.

This pictorialization or tangible imaging of faith

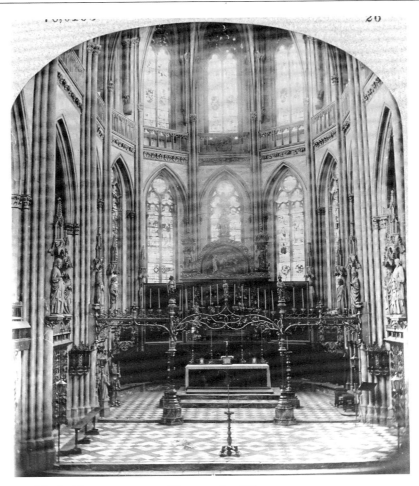

12. High Altar, 1529–34, Xanten, St. Viktor

in saints could be found in varying forms through-out the German lands. In the case of the Stiftskirche St. Viktor (Dom) in Xanten, the relics are deftly integrated into the design of the high altar (1529–34).[49] (fig. 12) It functions as both an altar and a giant reliquary repository. The mid-twelfth-century shrine of St. Victor is placed in the center (or corpus) of the altar. Surrounding it within the Renaissance-style frame are Wilhelm von Roermond of Cologne's twelve sculpted reliquary busts, which include Sts. Victor, Helen, Mary, and John the Evangelist. Until 1795 a great golden retable donated by Archbishop Bruno I of Cologne (d. 965), the brother of Emperor Otto I, stood beneath the shrine. Its place is now occupied by paintings attributed to a follower of Jan Gossaert. The relics of 20 additional saints are displayed in the predella (or

Sarg) though this arrangement may not be original. Statues of Christ, Victor, and Helen in the altar's superstructure (or Auszug) and Barthel Bruyn's painted Crucifixion and wings further detailing the lives of Victor and Helen complete the complex design. Relics and images are once again inextri-cably mixed to form a compelling statement of saintly power, a message that touched every wor-shipper in St. Viktor. Analogous altars were erected in the first quarter of the sixteenth century in the Neue Stift at Halle and Strasbourg cathedral.[50]

FOR THE INDIVIDUAL, donations to the church, whether in the form of alms or the commissioning of religious art, were pious deeds or good works, requisite activities sanctioned by the Catholic church for a Christian seeking salvation. During

the later fifteenth and early sixteenth centuries, princes, clerics, and wealthy burghers alike increasingly favored more tangible gifts. Altarpieces and holy statues, often prominently marked with coats of arms, provided an ideal solution since both God and the local community would know the donor's identity. Indeed, many altarpieces were referred to by the donors' not the saints' names.[51] German churches were enriched as never before. Talented sculptors such as Tilmann Riemenschneider or Veit Stoss prospered from the seemingly never ending number of orders. For instance, Riemenschneider supplied altarpieces to churches throughout the Würzburg diocese. Between 1496 and 1514, Riemenschneider carved at least seven altarpieces just for the nearby free city of Rothenburg.[52] A Nuremberg chronicler recorded that local artisans created 23 altarpieces between 1488 and 1491.[53] Similar statistics can be found for other cities during this period.

This blossoming of religious art occurred in virtually every parish church, cloister, and cathedral throughout the German-speaking lands. Lay attitudes are most clearly seen in the decoration of local churches where patricians, guilds, and brotherhoods alike vied with one another in offering physical manifestations of their religious devotions. Briefly I wish to examine churches in Ulm, Biberach, and Zürich for which fairly thorough information about the artistic decoration exists.

The skyline of the Swabian town of Ulm is dominated by the 161 meter tall tower of the Münster. Although the top of the spire was only completed in the nineteenth century, it is nevertheless a fitting symbol of Ulm's pride and commitment to its principal parish church. Writing in 1488 Felix Faber, a Dominican, described the Münster as "more beautiful than all the others."[54] He singled out the the great size of the church, the splendor of its remarkable stained-glass windows, and the unusual number of altars for special notice. Concerning the latter, Faber wrote

> Third, there are more altars here than in all other parish churches: for it has fifty-one altars, all well provided and fully recognized; and they are fitted out not by princes or nobles or strangers but by the citizens of Ulm themselves, and just as they are the patrons of the church, so they alone maintain all altars. And there are many altars which have five or at least four or three privileges.

Hermann Tuchle's detailed study of the Münster's altars reinforces Faber's claim that it was the citizens of the city that commissioned and maintained its altars.[55] Of the 52 altars identified in the local archival records, at least 43 were donated by merchant families, one by the city council, and the rest, excluding the high altar that, of course, has no specific patron, by clerics, many of whom stemmed from Ulm's patriciate class. Interestingly, none of the city's trade guilds endowed an altar in the Münster. Their altars were to be found in other local churches, such as the Wengenkloster where the St. Luke's guild, which included sculptors and painters, and the smiths had altars dedicated to St. Luke and St. Eligius (Eloy) respectively.[56] Each altar had multiple dedications to saints. The altar that Hans Besserer endowed in 1456 was dedicated to the Virgin, John the Evangelist, and St. Barbara; John the Baptist and St. Catherine were added in 1492.[57] Over 100 different saints were associated with specific altars.[58] Most of the 52 altars were adorned with an altarpiece or, at least, a statuette. Unfortunately, with the iconoclastic cleansing of the Münster in 1531, masterworks by Hans Multscher, Michel Erhart, Jörg Syrlin, and the painter Martin Schaffner, among others, have been lost. Of the many retables in the church only the Hutzaltar that Schaffner and an Ulm sculptor completed in 1521 survives.[59] This altar, originally in a chapel under the west tower and now the church's high altar, exists today only because the family removed it from the Münster before 19 June 1531 when the stripping of the church began. The remarkable number of altars formerly in the Münster, however, represents but a fraction of the total decoration scheme, since dozens of stained-glass windows, wall paintings, and sculptures, including Syrlin's famous choir stalls completed in 1474, adorned the rest of the building.

The artistic situation at Ulm is mirrored but on a smaller scale by that of the nearby imperial city of Biberach an der Riss. With a population of only about 5,000 or 13,000 less than Ulm, Biberach's parish church of St. Martin may have lacked the grandeur and artistic importance of Ulm Münster,

yet the categories and uses of art were almost identical.[60] Following Ulm's lead, the citizens of Biberach also stripped their churches of art at the end of June 1531. Fortunately, two brothers, Joachim I and Heinrich VI von Pflummern, compiled detailed descriptions of the town's artistic patrimony and the religious services in which art was used.[61] Joachim (1480–1554) was a patrician magistrate and a church superintendent while Heinrich (1475–1561) was a priest. In his introduction Joachim wrote that his purpose was to inform "those who would like to remember the Christian faith, good order, and Christian custom . . . and for those young people now and in the future who have no knowledge of it."[62] Joachim von Pflummern was concerned that with the advent of the Reformation into Biberach in 1531 no one in the future would be able to remember the Catholic ceremonies and practices that had formerly been practiced there.

Joachim von Pflummern informs us that church of St. Martin had 18 altars.[63] For each altar he lists information about its dedication, the number of masses, and, in most cases, the type of altarpiece. The St. Ursula Altar, to the north side of the choir, consisted of a carved Madonna and Child and, in the predella, a painted representation of St. Ursula with her virgins in ships.[64] The bakers' guild gave the All Souls Altarpiece.[65] The corpus contained a large sculpted Coronation of the Virgin; the wings, also carved, depicted the Annunciation on one side and the Nativity and Adoration of the Kings on the other; the predella showed the souls in the fires of purgatory. Through the masses and prayers endowed by the guild, the bakers hoped to intercede on behalf of the souls of their deceased bretheren currently in purgatory.[66] Joachim continues his description by innumerating the other sorts of artistic embellishments within the church. For instance, in addition to the altarpiece in the Fligler Chapel, located in the choir, stood a great limewood St. George on horseback and, nearby, another statue of St. Margaret.[67] Page after page of descriptions of painted and carved images of saints and biblical stories yield a picture of a church solidly ornamented from vault to floor, from nave to choir.

Zürich possessed over 100 altars, 27 of which date between 1486 and 1518. While Garside's estimate that religious art in Zürich's churches increased a hundred fold between 1500 and 1518

seems rather exaggerated, the pattern of proliferating altars, liturgical services, and artistic decorations encountered at Ulm and Biberach holds true there.[68] The Grossmünster, before it was stripped by Ulrich (Huldrych) Zwingli's followers, contained at least 17 altars. The high or passion altar included the two elevated reliquaries of Sts. Felix and Regula which during an annual procession would be carried through the city streets. Jeweled silver busts of the two saints would be placed on the altar on feast days. The Chapel of the Twelve Apostles contained another five altars, the sepulchres of Sts. Felix and Regula, Hans Leu the Elder's panels of Christ and the two city patron saints (1497); murals of Christ and the apostles; and the Easter Grave, a large wooden entombment group of 1515. Clothes and paintings donated by pilgrims further enriched the chapel. Extensive painting and sculpture programs throughout the church completed the decoration.

Statistics about other churches corroborate the evidence gathered for Ulm, Biberach, and Zurich. Although the information usually pertains only to the number of altars rather than the more comprehensive information provided by Joachim von Pflummern for Biberach, one may safely assume the altars were ornamented with a rich array of paintings, statuettes, armorial shields, epitaphs and tombs, and liturgical objects. Typical of parish churches, where lay and corporate patronage peaked during the early sixteenth-century, St. Martini in Braunschweig had about 20 altars; the Marienkirche in Zwickau possessed 25 altars; the Liebfrauenkirche in Frankfurt had at least 14 altars; and the Frauenkirche in Munich had 24 altars while nearby St. Peter had at least 20 more.[69] The number of altars in Lübeck's Marienkirche grew from 6 or 7 in 1300 to 26 or 27 in 1400 to 38 private plus at least 4 communal altars staffed by 66 vicars just before the Reformation.[70] Writing in 1512–13, Barthel Stein claimed that Breslau (Wrocław) had a total of 370 altars with 43 in the cathedral and 58 in the parish church of St. Maria Magdalena.[71] Christoph Scheurl reported in his *Oratio* of 1509 that Friedrich the Wise's newly completed Schlosskirche in Wittenberg contained 20 altars.[72] Great monastic churches like St. Gallen, which was secularized in 1529, had at least 33 altars.[73] Yet even a modest pilgrimage church like Andechs, south of

Munich, which only received its first abbot in 1458, had a few decades later at least eight altars and a famous collection of holy relics.[74] Johannes Kessler, a sixteenth-century chronicler, reported that the Protestants destroyed 63 altars formerly in the cathedral at Constance.[75] Among the North German cathedrals, Magdeburg and Meissen possessed at least 48 and 56 altars respectively.[76] Wolfgang Schmid has estimated that at the beginning of the sixteenth-century the archepiscopal seat of Cologne had 26 altars in the cathedral; St. Apostelen about 20; the other collegiate churches of Sts. Georg, Kunibert, Severin and Ursula each had about a dozen; and the parish churches of St. Lupus (in 1488), St. Jacob (in 1562), and Klein St. Martin (in 1506) had 3, 9, and 12 altars.[77] These number of altars alone, when factored for every church throughout the German-speaking lands, is staggering and clearly demonstrates both the pictorialization of faith and its significant economic impact upon the careers of sculptors and painters.

Regional distinctions in donation practices appear to have been relatively unimportant since the "density" of art within churches and the functions for which the art was used varied little from one area to another. There were, however, a somewhat greater and qualitatively superior number of sculptors active in southern Germany and the Rhineland due to the economic vitality of cities like Augsburg, Nuremberg, and Ulm or the power of episcopal seats such as Cologne, Constance, Mainz, or Würzburg. For most of the churches cited above, only fragments of their artistic patrimony have survived the Reformation, subsequent wars, and the aesthetic transformations of succeeding periods. I wish to look briefly at St. Lorenzkirche in Nuremberg, which, in spite of later alterations, still retains a high percentage of its original decorations.

St. Lorenz, the younger of Nuremberg's two major parish churches, served most of the southern half of the city. (fig. 13) On 12 April 1472 its impressive hall choir was dedicated; final construction was finished in 1477. While several of the altars were transferred from the old choir in 1472, the modern, greatly expanded structure allowed ample opportunities for the patricians to erect new altars and other artistic projects.[78] St. Lorenz had 17 altars including two in the adjacent cemetery chapels.[79] The sculptures and paintings for at least

seven of these post-date 1472 and are attributed to Michael Wolgemut, Hans Süss von Kulmbach, and Wolf Traut, among others. With the completion of the chevet, the clear windows were gradually replaced with colored lights recounting Christian stories. These windows were designed and/or executed by Peter Hemmel von Andlau of Strasbourg, Albrecht Dürer, Hans Baldung Grien, Kulmbach, and the Hirsvogel workshop.

Dominating the choir still are two of the miracles of pre-Reformation art: Adam Kraft's sacrament house of 1493 and Veit Stoss's *Angelic Salutation* of 1517–18.[80] (figs. 14 and 15) Kraft's 18.7 meter tall tabernacle stands just to the north of the high altar. Its basic function is to provide a a place for storing the wine and the host before the communion ceremony. The artistic beauty and scale of the sacrament house lure the viewer's eyes, a point of great concern to the donor Hans IV Imhoff.[81] Once attracted, the worshipper is provided with clear didactic lessons about Christ's sacrifice and the institution of the eucharist as Kraft's sandstone figures perpetually re-enact these mysteries. Immediately above the niche where the priest retrieves the wine and bread, Kraft has carved scenes of the Last Supper and Christ's passion. This narrative sequence culminates above with the Crucifixion and angels holding the instruments of his torment.

Although the sacrament house is prominently marked with the arms of donor Hans IV Imhoff the Elder and was subsequently maintained through an endowment administered by his heirs, it was intended as a gift for the entire parish's use and enrichment. Kraft proudly portrayed himself as the most prominent of the three kneeling figures who seem to bear the weight of the sacrament house upon their backs. As in the recently completed Schreyer epitaph on the outer east wall of St. Sebaldus, Kraft represents himself holding his hammer and chisel. (fig. 4) Both monuments celebrate his artistry and his piety. The message implicit in Kraft's design works vertically from heaven to earth, that is from top to bottom. Christ's sacrifice, recounted in the upper carvings and foretold by the accompanying Old Testament prophets, is sacramentally present in the eucharist stored behind the gilt grill. Next, on the balustrade at the viewer's eye level, stand statuettes of Lorenz, Sebaldus, and other saints whose lives offer a spiri-

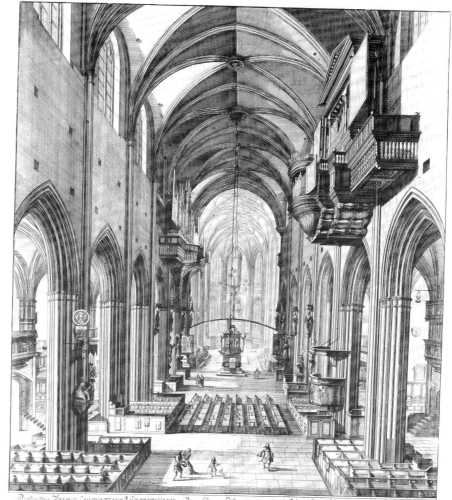

Perspectiva TEMPLI LAURENTIANI NORIBERGENSIS in Patriæ Honorem delineata & excusa à Joh. Andrea Graff Norib. Pictore Francofurti ad Mœnum.
Inwendige Abbildung der schönen alten Pfarr-Kirchen zu St. Laurentzen in Nürnberg, welche seinem Vatterland zu Ehren
abgezeichnet und ins Kupfer verlegt Johann Andreas Graff von Nürnberg, Mahler, Franckfurt am Mayn, im Jahr 1685.

13. Johann Ulrich Kraus (after Johann Andreas Graff), *View of the Interior of St. Lorenz*, 1685, engraving, Nuremberg, Germanisches Nationalmuseum

tual guide to all Christians. Finally come the laity, in the form of Kraft, his two companions, and every worshipper studying the sacrament house, who are the recipients of God's grace, Christ's redemption, and the church's council.

Similarly, Stoss's *Angelic Salutation*, suspended from the vaults immediately before the high altar, provides the same seductive combination of practicality and physical beauty. The over life-size limewood figures of Gabriel and the Virgin Mary re-enact the Annunciation.[82] Stoss has framed them within a giant set of rosary beads ornamented with roundels recounting the joys of the Virgin. The

moment is celebrated by the blessing figure of God at top and adjacent adoring angels. Unfortunately, the ensemble presently lacks the giant golden crown that originally hung above it.[83] Anton II Tucher, then Nuremberg's highest civic official, donated the *Angelic Salutation* and Jakob Pulmann's Marienleuchter, a iron candelabrum designed and placed specifically to illuminate Stoss's sculptures. While the *Angelic Salutation* served no strict liturgical function, Tucher intended it as a devotional aid for the congregation. It offers pictorial inspiration to anyone reciting the rosary prayers of Our Father and Hail Mary.[84] Hovering above the high altar

26

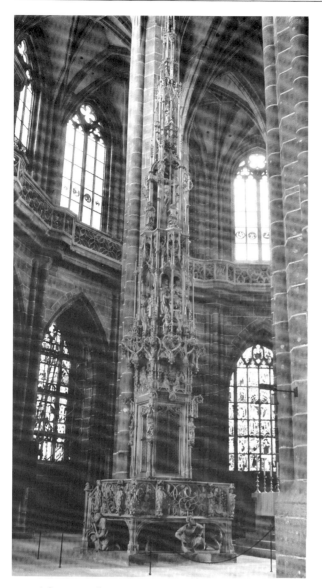

14. Adam Kraft, Sacrament House, 1493, Nuremberg, St. Lorenz

15. Veit Stoss, *Angelic Salutation*, 1517–18, Nuremberg, St. Lorenz

with light reflecting off her deeply cut drapery with its rich blue, red, and gold polychromy, Stoss's Virgin Mary, experientially, is pure magic. The material and the spiritual are melded into a radiant vision of the mother of God. Mary, queen of heaven, floats through the upper reaches of the church, yet her lifelike features, perfect yet humble, create an intimate bond with each and every worshipper below. More than almost any other sculpture of this period, Stoss's *Angelic Salutation*

anticipates the poignant theatricality of German Baroque art.

Although St. Lorenz's artistic richness as seen in Johann Andreas Graff's view of the interior in 1685 or by the modern visitor pales in comparison with what one would have seen in the early 1520s, it is still impressive. (fig. 13) The wealth of religious imagery offers great visual delight and spiritual guidance. Sandstone statues of apostles, dating to the 1380s or early 1390s, line the nave and first bays of the choir. The entrance to the choir is marked by a great arch with an over life-size Christ crucified on the tree of life. Secondary statues and paintings as well as family armorial crests fill the nave and aisles. Several epitaphs, most notably Peter Vischer the Younger's brass epitaph of Dr. Anton Kress of 1513 in the choir and the great marble epitaph of Kunz Horn kneeling before the

enthroned Christ, attributed to Hans Valkenauer and dating 1505–10, on the exterior of the sacristy, offer personal statements of piety and salvific aspirations.[85] (figs. 87 and 88) It is important to remember, however, that artistic displays such as that in St. Lorenz were repeated on varying scales in every town in the German-speaking realm. This was a culture that relied upon and responded to visual images as a fundamental component of its religious life.

These altarpieces and statues were also essential elements in the daily and liturgical rituals of the Catholic church. In Nuremberg, the city council regulated the number of masses that were to be given in each church. For example, in addition to the numerous privately endowed masses, the parishioner could attend three sung and another nine spoken masses performed before different altars daily in St. Lorenz.[86] These were supplemented frequently by the special masses offered on saintly feast days. Reliquaries and statues were carried in processions both within the church and through the town.[87] In 1502 weekly processions were organized in Breisach to honor St. Stephen.[88] In every instance the images were the visual conduits between heaven and earth. During the Lenten season cloths covered all altars and statues excepting a single crucifix. This meant literally giving up the stimulation and usage of images for Lent. On Easter day amid great celebration the cloths were removed and the treasures of the church were displayed on every altar.[89] Thus Easter brought with it a dramatic re-affirmation of the power of images.

The ebb and flow of the calendar was punctuated with public ceremonies using images and, in particular, sculptures. In the cities of Ulm, Biberach, and Zürich, discussed earlier, the events surrounding Easter week were virtually identical. On Palm Sunday in Biberach there was a procession re-enacting Christ's entry into Jerusalem.[90] After Vespers it began at the church of St. Leonhard led by the guilds, singing children, one of whom held a cross, and then the priest. Next and most important came the Palmesel, a statue of Christ dressed in a blue choir robe riding on a donkey that could be rolled along on wheels. It was pulled and accompanied by members of the butchers' guild who had originally commissioned the statue. The Burgermeisters and the remaining citizens, beginning

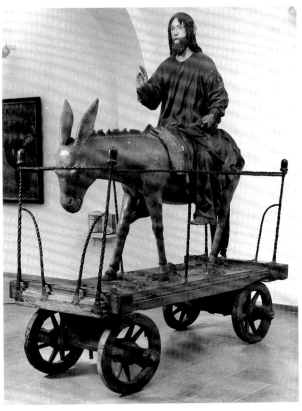

16. Circle of Hans Multscher, *Christ on the Donkey*, 1464, Ulm, Museum

with the men and then the women, followed the statue. A great pealing of the bells of St. Leonhard and St. Niklaus occurred. In Zürich the celebration was performed in the nave of the Grossmünster.[91] While neither of these statues of Christ survive, numerous late medieval examples exist including two from the circle of Ulm sculptor Hans Multscher.[92] One dated 1456 was used in St. Ulrich and Afra in Augsburg and another of 1464, shown here, was wheeled through the Münster and streets of Ulm. (fig. 16)

On Good Friday, shortly after midnight, the priest of St. Martin in Biberach led a group from the choir to the Ölberg or Christ in the Garden sculptural group by the main or western door.[93] Here they knelt and prayed before the image. Torches and candles were placed around the ensemble. Joachim von Pflummern later described the Ölberg as being attractively carved and painted.[94]

17. Mattäus Böblinger, *Mount of Olives*, formerly in Ulm, 1474, drawing, Ulm, Museum

It consisted of statues of Christ, three of the apostles, and an angel with a cross. Judas and the Jews were painted on the wall behind. These Ölbergs were often quite elaborate. Among the most impressive was that erected in the market square before Ulm Münster at the phenomenal cost of about 7,000 gulden.[95] (fig. 17) Designed originally by Matthäus Böblinger in 1474 and erected around 1514, the program consisted of 13 stone figures: Christ, an angel, two Jews, and three apostles plus six prophets on the columns of the monumental tabernacle that towered above. Beyond its involvement in the ritual of Easter week, the Ulm *Mount of Olives* offered a daily reminder of Christ's agony to anyone passing through this bustling square. The Ölbergs at the Grossmünster in Zürich and, still extant, at St. Lorenz in Nuremberg were set outside the churches against the northern walls.[96]

Adjacent to the Biberach Ölberg stood a Holy Grave that was also incorporated into the Good Friday ceremonies.[97] A cross was laid on the main altar of St. Martin whereupon the five wounds on the statue of Christ were kissed by the pastor and other priests. The crucifix was picked up and set down several times to symbolize Christ's carrying of the cross. Next, the statue of Christ, covered by a thin shroud, was placed in the Holy Grave. This consisted of a carved and polychromed entombment group. The back wall may have included a painted view of Jerusalem, much as one can still find in the Holzschuher Chapel at the Johannis cemetery in Nuremberg.[98] Citizens and the guilds supplied the candles that burned day and night until Easter. On Easter, shortly after midnight, the priest announced that "our lord God has risen," a refrain echoed by others throughout the church and the town. A group of children by the tomb also declared that Christ has risen. Indeed the statue of Christ had been removed so only the empty tomb with the shroud remained. On Ascension day, 40 days after the Resurrection, the statue of Christ was literally hoisted up, using ropes, through to the vaults of the church.[99] The resurrected Christ enthroned upon a rainbow was now ready to judge mankind. At each stage of the passion drama, sculpture was crucial to the ritual re-enactment. Statues, such as the Palmesel, achieved their full expressive potential only once a year when they were wheeled through the streets or churches on

Palm Sunday. Other normally static carvings assumed a temporary kinesthetic character within the context of these celebrations. In every instance, the sculptures were active agents. These works were not merely seen but they interacted directly with their audiences. It is little wonder that many of the viewers failed to distinguish between the work of art and what it represented. Statues in particular were invested with a life that inspired some and terrified others, a point that we shall return to in the next chapter.

This intimate interaction of the individual and image characterizes religious practice on the eve of the Reformation. The physical experience of seeing Christ hoisted heavenwards or of meditating on the mysteries of the Virgin while praying before Stoss's *Angelic Salutation* permeated all facets of lay spirituality. And as the accounts such as that of Heinrich von Pflummern of Biberach demonstrate, images also had a powerful and positive effect upon many in the clergy. These objects, far from being mere pieces of stone, wood, or paper, were invested with a power that transcended the material. These were the figurative embodiments of heaven, a means to the spiritual salvation that potentially awaited all devout Christians. By about 1520 a saturation point had been reached in many areas of Germany. The stage was set for Martin Luther, Andreas von Karlstadt, Ulrich Zwingli, and, later, Jean Calvin, among many others, who began questioning the Catholic church, its customs, and especially the traditional functions of religious art. Not surprisingly, the intense personal dialogue with Christ and his saints through these intermediary physical images was challenged and by many violently rejected. Nevertheless, the underlying role of art in the service of the church never totally disappeared. Many of the practices sketched above survived or were actively revived later in the sixteenth-century.

CHAPTER TWO

Art or Idol?

My heart since childhood has been brought up in the veneration of images, and a harmful fear has entered me which I gladly would rid myself of, and cannot. . . . When one pulls someone by the hair, then one notices how firmly his hair is rooted. If I had not heard the spirit of God crying out against the idols, and not read His Word, I would have thought thus: "I do not love images." "I do not fear images." But now I know how I stand in this matter in relation to God and the images, and how firmly and deeply images are seated in my heart.

ANDREAS BODENSTEIN VON KARLSTADT wrote these words about the power of images in his pamphlet *Von abtuhung der Bylder Vnd das Keyn Betdler vnther den Christen seyn sollen* (*About the Abolishing of Images and How Christians Should Not Be Begging*) published in Wittenberg on 27 January 1522.[1] Karlstadt's treatise proved to be one of the opening salvos in what would soon be a raging battle over the correct role of religious art. In the course of the next two decades the unity of the Christian church was rent apart as Lutheranism and then various other Protestant denominations emerged to challenge the authority of Rome. The Catholic church, its clergy, and its practices were subjected to often violent debate. While the individual reformers differed in their personal responses to the traditional use of art in the service of the church, their collective criticisms of idolatry and image abuse forever transformed the history of art in German-speaking lands. For many artists dependent upon religious commissions, the Reformation meant financial and professional ruin. For others it provided the impetus to develop new secular forms of art. The iconoclasm in many towns, especially those in southwestern Germany and Switzerland, resulted in the nearly complete loss of medieval art and, more critically, the artistic models for training future generations of painters and sculptors. In this section, I wish to examine the general character of Protestant criticisms of art, the basic distinctions

between the leading reformers, and the actual incidents of iconoclasm in selected cities.[2] It must be noted at the outset that the local dynamics of the Reformation and the confessional loyalties varied greatly from region to region and from town to town. Catholicism often prevailed and with it came a reaffirmation in the traditional faith in images.

As discussed in Chapter One, artistic representations of holy figures were inextricably woven into the fabric of daily life. Johann Geiler von Kaisersberg told his audience that when passing by a picture or statue of the Virgin one should pray for her intercession with God or at least bow before the image.[3] The Augustinian monk Gottschalk Hollen provided the standard Catholic justifications in his *Summa Praeceptorium*, first published in Cologne in 1481.[4] He stressed that images are essential to religious life in order that we may embrace a knowledge of things unknown; that we may be animated toward doing the same thing; that through the image we may remember; and that we may venerate him whose image it is. Sts. Gregory the Great, Bernard of Clairvaux, and Bonaventura, whose writings had helped form the basis for Catholic doctrine on religious art in service of the church, each recognized the pedagogical usefulness of images.[5] The usefulness of images for reaching a broader audience was succinctly stated in a fifteenth-century Augsburg religious manual. Its author writes, "In order that matter should be

fruitful to all, it is exposed to the eyes of all, as much through letters serving the educated only, as through images, serving the educated and uneducated simultaneously."[6]

The inherent power of these religious statues and paintings is also tied to late medieval theories of vision.[7] Until the early seventeenth-century when Johann Kepler explained the physics of sight as being based upon light, it was believed that the eye was a passive receiver and that the image was the active agent of sight. A sculpture was more than a mere record of a saint; it reflected his or her invisible or unseen holy essence. Although the statue was but a single object, it cast out "species" or rays capable of generating "infinite images of itself" towards its viewers. Having examined the statue, each worshipper then carries away a memory or mental image of it that can be recalled at any later time or place. Thus a statue has the power to replicate itself infinitely and to be the conduit between the divine and the individual. This theory of vision begins to explain the powerful hold that religious representations, and sculpture in particular, had over the devout. The desire to rid one's heart of such images, as expressed earlier by Karlstadt, would result eventually in the vehement iconoclastic catharsis of the Reformation.

The debate over images was not simply between Catholics and Protestants. Some Catholics argued that Christians should eschew crutches such as statues and paintings. These were identified as material impediments hindering a more spiritual dialogue between the individual and God. Thomas à Kempis, in his *Imitatio Christi*, advised his readers "to wean your heart from the love of visible things, and attend rather to things invisible."[8] This reliance upon the intellect rather than the eye to comprehend the word of God was a common refrain among Catholic and Protestant critics.

Erasmus, among other forceful Catholic voices of the period, worried that too many Christians misunderstood the fine line between the appropriate use of images and idolatry.[9] This occurs when a statue or a painting becomes the object of worship rather than simply a representation of an idea or a physical reminder of the holiness of a particular saint. In his *In Praise of Folly*, Erasmus has Folly denouncing images since it would distract the worship of her:

I am not so foolish as to ask stone images, painted up in colors; they would but hinder the worship of me, since by the stupid and dull those figures are worshiped instead of the saints themselves. And it would come about with me exactly as it does with the saints— they are thrown out of doors by their substitutes.[10]

In 1515 Hans Holbein the Younger penned two illustrations in Oswald Myconius's copy of the *In Praise of Folly* showing a fool praying before a painting of St. Christopher and women kneeling before a statue of the Virgin and Child.[11] Holbein, like Erasmus, chided those Christians who held fast to their superstitious belief in images. Erasmus, however, still retained a deep appreciation for the power of art to evoke spiritual thoughts. In his *De sarciendia ecclesiae concordia* of 1533, he described sculpture and painting within the church as "a kind of silent poetry" that often approximates the emotional state of man far better than words.[12]

In contrast to Erasmus's ambivalence towards images, Karlstadt, a professor at the University of Wittenberg, admitted to their influence but condemned these objects as symptomatic of the corruption of faith by the Catholic church. His *Von abtuhung der Bylder* of 1522 was the first comprehensive discussion of the issue of image abuse.[13] The treatise's publication also followed only three days after the Wittenberg city council's decree calling for the removal of unnecessary altar and images from the local parish church. The ruling of 24 January 1522 allowed only three unadorned altars to remain.[14] Karlstadt's argument was based upon three fundamental theses: 1. "That we have images in churches and houses of God is wrong and contrary to the first commandment: 'Thou shalt not have strange gods'"; 2. "That carved and painted idols are standing on the altars is even more pernicious and devilish"; and 3. "Therefore, it is good, necessary, praiseworthy, and godly that we abolish them, and give to the Scripture its proper right and judgment."[15] Karlstadt and most other Protestant reformers anchored their complaints about images on God's commandment to Moses: "Thou shalt have no other gods before me. Thou shalt not make unto thee any graven image, or any likeness of anything that is in heaven above, or that is in the earth

beneath, or that is in the water under the earth. Thou shalt not bow down thyself to them, nor serve them: for I the Lord thy God am a jealous God. . . . Ye shall not make with me gods of silver, neither shall ye make unto you gods of gold" (Exodus 20:3–5, 23). Using this and other scriptural justifications, Karlstadt condemned the Catholic church's reliance upon images as idolatry, a corruption of God's interdiction, and a physical obstacle to the Christian's true understanding of God through the word alone. To restore the word of God all churches must be purified. During the first week of February, an impatient crowd tore down and burned most of the sculptures and paintings in the Wittenberg parish church.[16]

Martin Luther's attitudes about art were more complex and underwent significant evolution during the course of his career. When he returned to Wittenberg in March 1522 following his enforced stay at Wartburg Castle, he condemned mob violence and began to articulate his own positions on the use of religious art. In his *Church Postils* of 1522 he wrote

> See, that is the proper worship, for which a person needs no bells, no churches, no vessels or ornaments, no lights or candles, no organs or singing, no paintings or images, no panels or altars. . . .For these are all human inventions and ornaments, which God does not heed, and which obscure the correct worship, with their glitter.[17]

Luther continued to criticize the misuse of images but he more strenuously denounced Karlstadt as a false prophet in such treatises as *Against the Heavenly Prophets in the Matter of Images and Sacraments* (1525).[18] Likewise, he berated the concept of good deeds by which donations of art were made for spiritual gain.[19] Possibly through his extensive contact with the painter Lucas Cranach the Elder, Luther gradually softened his attack on art and came to appreciate the positive didactic role that art could play. He wrote

> Of this I am certain, that God desires to have his works heard and read, especially the passion of our Lord. But it is impossible for me to hear and bear it in mind without forming mental images of it in my heart. For whether I

will or not, when I hear of Christ, an image of a man hanging on a cross takes form in my heart, just as the reflection of my face naturally appears in the water when I look into it. If it is not a sin but good to have the image of Christ in my heart, why should it be a sin to have it in my eyes? This is especially true since the heart is more important than the eyes.[20]

Nevertheless, Luther tolerated only paintings and, to a considerably lesser degree, sculptures that illustrated appropriate themes based upon the Bible, specifically the life of Christ, the sacraments of communion and baptism, the word of God, and the acts of the apostles.[21] Undue veneration of the Virgin Mary and the saints at the expense of Christ was forbidden.[22] In conjunction with the Cranach workshop in Wittenberg, new Lutheran imagery gradually took form, as will be discussed below. Yet the variety of evangelical themes and the quantity of their art were always severely restricted by pre-Reformation standards.

By contrast with the ultimately moderate Lutheran response to religious art, Ulrich Zwingli and other Swiss-Rhinish preachers, including Leo Jud, Heinrich Bullinger, and Martin Bucer, demanded its total abolition.[23] As the debate over images in the city of Zürich intensified in 1523, the council organized a disputation on the topic on the 26th of October.[24] Invitations were sent to all of the prominent Catholic officials, including the bishops of Basel, Chur, and Constance, as well as the faculty of the university of Basel and to the reformers. Although the Catholics largely boycotted the debate, Zwingli, Jud, and other reformers were afforded the formal opportunity to present their views. Zwingli, as others had before him, stressed God's commandment against idols, though he carried it further by saying that all images both the visible and the invisible ones carried in our thoughts must be banished.[25] Furthermore, images and especially those of saints distract the Christian from Christ himself. "Christ alone was given us as a model for living, and not the saints; for the head must lead us, and not the members."[26] The saints themselves needed only Christ not idols. Concerning claims that an image of St. Martin helping the begger would encourage charitable acts by the viewer, Zwingli retorted

We cannot learn it from walls (i.e.—art), but must learn it only from the merciful direction of God, from his own Word. We find here that images lead us only to outward stupidity and cannot make the heart believing. Thus we see indeed outwardly what the saints have done; but the belief from which all things must happen cannot be conveyed to us by images.[27]

In 1525 in his *Answer to Valentin Compar*, Zwingli made an important distinction about when a work of art is an idol. He noted that the Grossmünster in Zürich formerly had two images of Charlemagne, the church's legendary founder. The painting of Charlemagne kneeling with a model of the building was removed because it was in the church and could thus be idolized. The statue of Charlemagne, on the other hand, was left untouched since its placement high on the Charles tower precluded its misuse.[28] He warned, however, that "as soon as anyone goes astray also with idolatry, then that, too, will be taken away." Furthermore, the tower statue had no "appetite"; that is, it consumed no daily diet of candles, incense, and money to support the benefice of an officiating priest.[29] The cost of maintaining altars and their decorations, expressed in terms of consumption, alarmed many critics. Zwingli had little patience with critics who urged that images be kept for those who were weak in spirit. He advocated action.[30] The Zürich city council soon initiated policies that it hoped would resolve the dilemma though local opposition was stiff.[31]

Underlying all of the rhetoric on images was the fundamental tenet that these objects were impediments to a true understanding of God and thus were obstacles to salvation. By purifying the churches the reformers believed Christians would refocus their attention on the word of God rather than on supposed miracles or on human deeds or works. For Karlstadt and Zwingli, among others, the ridding of religious art was almost a sacred duty. Iconoclasm as a testimony of faith was ridiculed by the more moderate Luther.[32]

The debate over religious art would rage throughout the sixteenth-century. More scholarly arguments were expressed by Jean Calvin, a young French theologian based in Geneva, who explored the moral and psychological reasons for man's cre-

ation of idols. Calvin's writings had a tremendous impact upon the reform movements in France, Switzerland, England, and the Low Countries.[33] Later, Calvinism became firmly rooted in parts of Germany, notably in the Palatinate and, from 1613, in Brandenburg. Calvin blamed idolatry on man's inherent corruption caused by the fall of Adam and Eve. "Every one of us is, even from his mother's womb, a master craftsman of idols."[34] Human nature is such that we desire to create images of the immaterial (God), and once the image is formed humans cannot resist idolizing it.[35]

Calvin blamed the early Catholic church for the Christian reliance on images. He wrote in the *Inventory of Relics* (1543)

But the first vice, and as it were, beginning of the evil, was, that when Christ ought to have been sought in his Word, sacraments, and spiritual graces, the world, after its custom, delighted in his garments, vests, and swaddling-clothes; and thus overlooking the principal matter, followed only its accessory.[36]

Furthermore, he denied the validity of the miracles that the Catholic church claimed were performed by its holy relics. He acknowledged that God performed miracles through Christ and the apostles, but these were temporary gifts of healing from God in order to spread Christianity.[37] Yet bones and other relics were useless and often of questionable origins.[38] In the *Inventory of Relics*, Calvin offers his readers an amusing critique of the wonderous multiplication of saintly remains. How, he asks, could churches claim to possess relics of the Archangel Michael? Typical is his section on St. Sebastian. Calvin writes

This saint, from the wonderful power his remains possessed of curing the plague, was put into requisition and more sought after than many of his brother saints, and no doubt this popularity was the cause of his body being quadrupled. One body is in the church of St. Lawrence at Rome; a second is at Soissons; the third at Piligny, near Nantes, and the fourth at his birth-place near Narbonne. Besides these, he has two heads at St. Peter's at Rome, and at the Dominican church at Toulouse. The heads are, however, empty, if we are to

believe the Franciscan monks of Angers, as they pretend to possess the saint's brains. The Dominicans of Angers possess one of his arms, another is at St. Sernin, at Toulouse, a third at Case Dieu in Auvergne, and a fourth at Montbrisson. We will pass over the small fragments of his body, which may be seen in so many churches. They did not rest satisfied with this multiplication of his body and separate limbs, but they converted into relics the arrows with which he was killed.[39]

Indeed Calvin argues that the Catholic church's foundation upon saints and their intercession was false. He reminds us that the devil was also capable of creating bogus miracles to deceive mankind. Calvin demanded the removal of church art, relics, and all unnecessary paraphernalia. The Calvinist inspired iconoclasm in the Low Countries in 1566 and 1567 proved to be chillingly thorough.[40]

Iconoclasm

Reform rhetoric begat iconoclasm.[41] The theological debates in Wittenberg, Zürich, and a host of other towns were soon translated by the reformers into direct actions against church art. For nearly a quarter century, beginning in 1522 with the destruction of sculptures and paintings in the Augustinian cloister church in Wittenberg, virtually every German-speaking town faced a decision about the continued use or the removal of religious art. Their responses were varied. Often political tensions or deep-seated resentments over clerical power fueled violent actions. In others, firm governmental control prevented radical elements from prevailing. Zürich suffered almost total destruction of its religious art, while Cologne's patrimony survived intact.

Karlstadt's expressed fear of images was widely shared.[42] Religious images were so engrained in the lives and rituals of pre-Reformation society, so linked with one's relationship with the Catholic church, that for many iconoclasm meant liberation. It represented a purging of the church's power over life and spirit. The fervor formerly spent adoring a saint was now used for exorcising this fear of images. Throughout Germany statues were hacked

apart or burned. Some were placed into stocks, hung, tortured, and mutilated like common criminals; decapitation, blinding, and the severing of limbs were frequent occurrences.[43] Other sculptures were mocked by taking them to bathhouses and taverns. If a statue impolitely refused to drink, a dousing with beer followed. Instances of defecation into the mouth of Christ or urination on a saintly carving were not infrequent. Attackers were further emboldened when the holy images did not fight back or defend themselves. In a letter describing the iconoclasm in Basel in February 1529, Erasmus observed, "I am greatly surprised that the images performed no miracle to save themselves; formerly the saints worked frequent prodigies for much smaller offenses."[44] A crowd in Basel carried the great crucifix from the cathedral to the market in a mock procession. Someone then addressed the statue, "If you are God, help yourself; if you are man, then bleed."[45]

This verbal and physical abuse of art prompted Nuremberg artist Erhard Schön and poet Hans Sachs to create an illustrated broadsheet entitled *Complaint of the Poor Persecuted Gods and Church Images* in about 1530.[46] (fig. 18) The text is written from the point of view of the statues and paintings that are being destroyed. Besides complaining about their present sorry state, the images blame men, who now deride them, for being their creators.[47] Schön's woodcut illustrates a group of men calmly stripping a church of its decoration. On the left a man holds a statue of the Virgin and Child; opposite St. Peter faces his demise. The statues are then carried outside the church to the awaiting bonfire. Meanwhile, at the upper right the rich man points out the splinter in his brother's eye while being blind to the beam in his own. Schön and Sachs have used this biblical parable (Luke 6:41–2 and Matthew 7:3) to lambast man's inherent hypocrisy, specifically his refusal to see where the true fault for idolatry lies.

In Wittenberg the destruction of art in the Augustinian cloister chapel and the repeated sermons against idols delivered by Karlstadt and Gabriel Zwilling prompted the city council on 24 January 1522 to decree that all images should be removed from the parish church, that all new fundraising campaigns for church building should cease, and that an inventory of liturgical vessels be made.[48]

18. Erhard Schön, *Complaint of the Poor Persecuted Gods and Church Images*, c. 1530, woodcut, Nuremberg, Germanisches Nationalmuseum

Unfortunately, the council set no firm date by which these actions must be carried out. A couple of weeks later an impatient crowd took control of the parish church and systematically removed and destroyed the sculptures and paintings.

Although Luther returned to Wittenberg soon afterwards and immediately began to preach and write against the unlawful destruction of art, incidents continued to persist. Later in 1522 he travelled through parts of Saxony and Thuringia speaking against Karlstadt. When he climbed the pulpit in Kahla he found scattered about it the remains of a smashed crucifix, a signal of local opposition to his more moderate views.[49] With a few exceptions, further destruction was minimized in electoral or Ernestine Saxony by Friedrich the Wise, the Catholic protector of Luther, and his brother Johann the Steadfast, a Protestant, who viewed such unruliness as a threat to political order. Zwickau, the second largest town in Ernestine Saxony, experienced relatively little artistic damage to the Marienkirche, its great parish church, due to pressure from the electors and the council's desire to maintain tight civic control.[50] During the last years of his reign, Friedrich the Wise, however, was not always successful. For instance, an interesting contrast in responses occurred in nearby Buchholz and Annaberg. Though separated by only a few kilometers and today forming a single city, Buchholz was part of Ernestine Saxony and Annaberg belonged to Al-

bertine Saxony. St. Katharinen in Buchholz was "purified" in 1523, while Duke Georg of Saxony, an ardent Catholic, was able to suppress the iconoclastic sentiments in Annaberg.[51] Nonetheless, the debate between Catholics, Lutherans, and followers of Karlstadt continued throughout Saxony and the adjacent territories. Sometimes a minor incident was enough to unleash terrible destruction. On 15 August 1524, the feast day of the Assumption of the Virgin, the Franciscan monks in Magdeburg were celebrating midday service when a group of hecklers pelted them with stones and eggs. When the monks returned the volley, the angry crowd responded by sacking their church before moving on to St. Nikolaus, the Pauliner church, and the cathedral.[52]

Zürich provided the model for many other Protestant cities which subsequently cleansed their churches.[53] Having disputed the issue in 1523 and 1524, the council finally ruled that the religious statues, paintings, and other liturgical objects must be removed. Between 20 June and 2 July 1524 a group of officials that included Zwingli, guild representatives, and several craftsmen systematically stripped the churches. The doors were locked to prevent disruptions. Liturgical vessels and lamps were melted down. Mural paintings were chipped off and the walls were then whitewashed. The choir stalls, like the wooden statues and paintings, were burned. Their thoroughness

was complete. For 13 days this group progressed in an orderly fashion from church to church. Zwingli announced "In Zürich we have churches which are positively luminous; the walls are beautiful white!"[54]

Zwingli's more radical advocacy of iconoclasm gained a strong following in other Swiss and south-western German towns. Periodic incidents of image destruction or abuse are recorded throughout the later 1520s. Shortly after the Bern disputation of 1528, the council ordered the removal of church art; however, on 27 and 28 January unruly mobs sacked the cathedral.[55] On the second day of the rioting Zwingli preached in the church and said

> There you have the altars and idols of the temple! . . . Now there is no more debating whether we should have these idols or not. Let us clear out this filth and rubbish! Henceforth, let us devote to other men, the living images of God, all the unimaginable wealth which was once spent on these foolish idols. There are still many weak and quarrelsome people who complain about the removal of the idols, even though it is clearly evident that there is nothing holy about them, and that they break and crack like any other piece of wood or stone. Here lies one without its head! Here another without its arms! If this abuse had done any harm to the saints who are near God, and if they had the power which is ascribed to them, do you think you would have been able to behead and cripple them as you did? . . . Now, then, recognize the freedom which Christ has given you, stand fast in it, and, as Paul says in Galatians (5:1), 'be not entangled again with the yoke of bondage.'[56]

Zwinglian-inspired iconoclasm quickly spread.[57] In 1528 St. Gall, Constance, and the abbey at Petershausen succumbed; numerous incidents also occurred in Basel.[58] The following year Basel and Schaffhausen emptied their churches. Erasmus lamented to his friend Willibald Pirckheimer of Nuremberg that neither the financial value nor the artistic merits of an object were sufficient to save it.[59] Strasbourg, which made a political alliance with the Swiss cities on 5 January 1530, ordered its churches stripped of their art though altarpieces had been removed in select churches as early as

1524. Further north, Frankfurt am Main followed suit in 1533.[60]

In Swabia, Ulm and Biberach experienced a relatively thorough purification in 1531.[61] Just one of the 52 altars in the Ulm Münster survived and then only because of its removal by the family that had donated it.[62] Three years later the city council was faced with continued Catholic use of images. On Maundy Thursday, a group of Catholics knelt and placed candles before the Ölberg that still stood in the marketplace before the Münster.[63] (fig. 17) To prevent a recurrence the council quickly ordered the removal of all the figures leaving only the stone tabernacle with its prophet statues.

Three Case Studies

The religious and political situations differed from town to town. Not surprisingly, there were very few incidents of iconoclasm in the great archepiscopal cities of Cologne and Mainz where staunchly Catholic governments prevailed.[64] Yet within their archdioceses many episcopal seats, including Hildesheim and Osnabrück to name just two, and large trading cities either embraced Protestantism or, as in the cases of Erfurt and Augsburg, arrived at a balance of power between the Catholic and Protestant parties.[65] I wish to examine briefly the religious scenarios in three of the most powerful German cities: Nuremberg, Augsburg, and Münster. The first city embraced Protestantism, the second reached an uneasy confessional accord, and the third confronted an Anabaptist kingdom. In every case, however, the cities' sculptors and other artists were adversely affected.

NUREMBERG

In 1525 Nuremberg was the first of the great imperial free cities to adopt Lutheranism.[66] The city council reached its decision after twelve days of heated debate between Catholic and Protestant theologians. Prior to the coming of the Reformation, Nuremberg possessed the two imposing parish churches of St. Sebald and St. Lorenz plus 15 additional religious establishments, including monasteries within its walls for the Augustinian, Benedictine, Carthusian, Dominican, Franciscan,

and Teutonic orders. In spite of this sizeable Catholic community, the patrician city council acted firmly to maintain order once it declared its Protestant faith. The number of anti-clerical incidents and attacks against art works were held to a minimum though Caritas Pirckheimer, the prioress of the Franciscan convent of St. Klara, complained of rowdiness and the damage of several church windows by vandals.[67] Most of the local monasteries, beginning with the Augustinians, sold their property and art objects to the city by the end of 1525. Monasteries were forbidden to accept new members. In fact, most of the monks and nuns left Nuremberg. Since many of the nuns in particular were sisters and daughters of local patricians, convents like St. Klara remained open until the death or transfer of its last members.[68] Liturgical items were sold to Catholic princes, such as Cardinal Albrecht von Brandenburg, or were melted down.

Altars donated to these monasteries were usually returned to their owners. Perhaps the most celebrated instance is Veit Stoss's monumental Mary Altar today in Bamberg Cathedral.[69] (fig. 19) In 1520 Dr. Andreas Stoss, Veit's son and the newly appointed prior of the Carmelite monastery in Nuremberg, commissioned the new unpainted wooden altar glorifying the Virgin Mary for his church.[70] The work was completed within three years as specified in the surviving contract; however, the monastery's dire financial situation prevented final payment to the sculptor. In 1525, Andreas Stoss, as a leader of Nuremberg's Catholics and a vociferous opponent of Protestantism, was forced from the city. Two years later Veit Stoss was still seeking payment. The remaining monks balked claiming that their former prior—not the monastery—had commissioned the altarpiece and, moreover, that they could not pay even if they wished to do so since their property had been seized by the city. Veit Stoss died in 1533 and Andreas Stoss ended his career as the chaplain of the bishop of Bamberg; however, the story of the altarpiece continued beyond both of their lives. In 1543, the city of Nuremberg finally returned the altarpiece to Andreas' heirs. The family soon thereafter sold it to the Obere Pfarrkirche in Bamberg where it remained until 1933 when it was loaned permanently to Bamberg Cathedral. When the altarpiece is compared with Stoss's preparatory drawing, now in Cracow, the changes especially to the superstructure, which no longer exists, and the wings are obvious.[71] Did the damage occur while the altarpiece was still in Nuremberg or perhaps during its transport to Bamberg? These losses could just as easily have happened during the intervening centuries in Bamberg. The former Carmelite altar, nevertheless, is largely intact. Its fate mirrors the period's rapid reassessment of religious art. What was once desired, in this case an altarpiece, fell from favor in Nuremberg. Yet because it was deemed private property, the altarpiece was not destroyed in spite of the suppression of the Carmelite church. Furthermore, what was unwelcome in one Protestant town was still valued in its Catholic neighbor.

The issue of property rights was of great importance in Nuremberg. Since its parish churches had been decorated by the local patrician families, the city council held that these artistic objects belonged solely to the donors and their heirs. Between 1525 and 1542 several altars were removed by the citizens.[72] Fortunately, most of the artistic patrimonies of these churches survive. In the case of Veit Stoss's *Angelic Salutation*, given by the powerful Tucher family, a novel compromise was reached. (fig. 15) The rosary subject matter was deemed objectionable, but rather than removing the sculptural ensemble it was instead covered permanently with its Lenten sheet. The hooded *Angelic Salutation* is visible in Graff's view of the interior of St. Lorenz of 1685. (fig. 13) Similarly, Kraft's huge sacrament house was no longer used in the Protestant communion service, yet the Imhoff family continued to provide for its maintenance for several centuries afterwards.[73] (fig. 14) The shrine of St. Sebald in the Sebalduskirche, which was considered a civic monument, was also left untouched though his feast day was deleted to prevent undue veneration.[74] (fig. 10) Thus property rights and strong civic authority prevailed over anyone who advocated the cleansing of the local churches. Nuremberg's course of actions provided the model for Dinkelsbühl, Rothenburg, Nördlingen, Weissenburg, and the other small free imperial cities in Franconia, as well as Lübeck and a few other Hanseatic towns.[75]

19. Veit Stoss, Mary Altar, Bamberg Cathedral, 1520–23

AUGSBURG

In Augsburg, both an imperial free city and an episcopal seat, the situation was considerably more complex.[76] The populace included Catholics, Lutherans, and Zwinglians, each of whom came to have their own churches. By 1530 the Lutherans occupied St. Anna and the preaching houses—not churches—of St. Georg, St. Ulrich and Afra, and Heilig Kreuz; the Zwinglians had services in the Barfüsserkirche; and the Catholics used the cathedral and the remaining churches. Periodic damage to art prompted the council to issue a decretal on 19 March 1529 forbidding the destruction or disfiguring of objects in churches and cemeteries.[77]

Local religious tensions resulted in several interesting encounters.[78] In 1533 a controversy arose in the Catholic church of St. Moritz between Anton I Fugger, a wealthy parishioner, and Marx Ehem, the Protestant warden of this church. To prevent the

celebration of mass, Ehem ordered the church's sacristy locked. At his own expense Fugger, a Catholic and one of the principal patrons of the church, quickly supplied another set of liturgical objects so the masses could continue. On Good Friday, 11 April, Ehem had the holy sepulchre with its sculptural Entombment group sealed up so the Catholics could not lay the body of Christ, in the form of a carved crucifix, in the tomb. Next, Ehem removed all of the items used for the Ascension day ceremony including the liturgical vessels and the image of Christ seated on a rainbow with its accompanying angels and Holy Spirit. When Fugger secretly had a new, more expensive set of vessels and images made, Ehem secured with timbers and iron the hole in the vault through which Christ rose in the ceremony. Fugger somehow managed to have the hole reopened and the ceremony was progressing as normal before a full audience when Ehem and a group

of supporters, with knives drawn, stormed into the church. After the congregation fled, Ehem lowered the Christ figure and when it was about six meters from the ground he let it go. The statue of Christ and the rest of the ensemble smashed. Ehem had successfully if violently disrupted the Catholics' service. This incident illustrates the passions and strengths of conviction on both sides of the image controversy. It also points out the delicate position of Augsburg's city council that admonished both Ehem and Fugger yet barely punished either for fear of offending the Protestant and Catholic camps.

On 29 July 1534 the city council ruled that Catholic masses were henceforth limited to the cathedral, St. Moritz, St. Ulrich and Afra, and five other churches. This was a significant reduction. Martin Bucer, the Strasbourg preacher, came to Augsburg and spoke against images. As a precaution the cathedral chapter removed many precious works and shipped them to the bishop's residence in Dillingen. Several clerics even transferred their personal stone epitaphs from Augsburg to more secure locales between 1534 and 1537.[79] For instance, in 1537 Konrad Adelmann ordered his epitaph that had been carved in the 1520s by Hans Daucher, Augsburg's leading sculptor, to be moved from the cathedral cloister to Holzheim bei Dillingen.[80]

On 17 January 1537 Augsburg's government abolished Catholicism within the city. The very next day, as the cathedral chapter left for Dillingen, the cathedral and St. Ulrich and Afra were "gereinigt". Similar cleansings of images occurred in Heilig Kreuz on 22 January and, two days later, in St. Moritz and St. Georg. In the case of the cathedral, many of the sculptures and paintings were placed in the crypt rather than being destroyed outright.[81] The stone tombs and epitaphs of former bishops and clerics in the church and the cloister were literally defaced: noses and ears were knocked off or entire heads were smashed though the accompanying coats of arms were rarely damaged. These desecrations were directed against individuals who symbolized the institution of the Catholic church. The Reformers felt that these clerics in death, as in life, should not pray to idols. Interestingly, these Protestant iconoclasts were very selective in the monuments they defaced. Several adjacent epitaphs of private individuals in the cloisters, such as that of

the city doctor Adolph Occo, were left unscathed. Within the church, the Protestants slashed the lower landscape of the giant mural painting of St. Chrisopher while the upper portions, apparently out of their reach, were unharmed. Nearby, the stone Ölberg on the southwall was totally obliterated. Stained-glass windows and the portal statues were left untouched since these were difficult to use for purposes of veneration.

Bishop Christoph von Stadion, writing from Dillingen, complained bitterly about this destruction in a letter to Emperor Charles V.[82] While strongly defending the pious use of images, the bishop lamented the paganism emerging in Augsburg. Specifically, he contrasted the besieged depiction of St. Ulrich that long had appeared on the Perlach tower, next to the Rathaus, with the very recently erected Neptune fountain.[83] (fig. 183) Von Stadion worried about the spiritual health of his flock because under the Protestants pious Christian statues were being replaced by heathen idols. Fortunately, not all of the churches in Augsburg were disturbed. Several powerful patrician families, including the Fuggers and Welsers, protected St. Anna and the Dominikanerkirche.

Protestant domination of Augsburg did not last long. Charles V and his allies defeated the Schmalkaldic League at the battle of Mühlberg in April 1547. The victorious emperor settled in Augsburg and convenied an imperial Reichstag from 2 September 1547 to May 1548. Cardinal Otto Truchsess von Waldburg, the young and militant new bishop of Augsburg, returned in 1547 where he celebrated mass in the cathedral on 5 August.[84] Although the bishop smashed the cathedral pulpit that had be constructed for the use of a Zwinglian preacher, he sought an accomodation with the city by requesting the council's approval to use one "Götzenaltar" with appropriate vessels and art works. On 2 August 1548 a restitution edict between the cardinal-bishop and the city council was signed. Protestant and Catholic services were both to be tolerated. All churches converted to Protestantism between 1534 and 1537 reverted to Catholic use. Furthermore, Truchsess von Waldburg ordered that the redecoration of the cathedral be relatively spare. One crucifix was erected in the choir. The new sacrament house was made of wood rather than of a more costly material. Gradually many of the other

statues and altars that had been placed in the crypt in 1537 were cleaned and reset. Even late in his reign, the cardinal-bishop issued decretals that all objects that could be considered idolatrous should be removed from churches within the diocese.[85] He sought to minimize the potential for conflict.

Thereafter both Protestants and Catholics were permitted to worship in Augsburg. In spite of the occasional Catholic-perpetuated incidents of iconoclasm, the local religious accomodation held.[86] The Peace of Augsburg of 1555 subsequently made a similar recognition of the religious status quo within the rest of the imperial German-speaking lands. As the century progressed and new artistic commissions were given to redecorate the Catholic churches, considerable care was taken to select themes that also would be acceptable to local Protestants, specifically to the Lutherans.[87] Only from the 1570s, in the aftermath of the Council of Trent, were important new artistic projects, including the conscious revival of older sculptural programs, commissioned by Augsburg's Catholics.[88]

MÜNSTER

The religious scenario in Münster was unique.[89] Lutheranism had made strong inroads among the artisans and merchants of the city. In 1533 Bishop Franz von Waldeck was forced to recognize that Münster's parish churches were all Protestant though the cathedral and the cloister churches remained Catholic. Under the direction of preacher Bernhard Rothmann, Münster welcomed Jan Matthys, Jan van Leiden, and other Anabaptists. Within months this group of Anabaptists gained total power, and on 24 February 1534 they declared Münster to be the new Jerusalem, the center of an Old Testament-style theocracy. All non-believers, Catholic and Protestant alike, were banished immediately. Münster's population losses, though severe, were replenished by an influx of other Anabaptists from across northern Europe. At its peak in 1534 Münster had between 7,000 and 8,000 Anabaptists within its walls. On the 24th and 25th of February, mobs sacked the cathedral and the other churches as well as clerical residences. An estimated group of 500 stripped the Mauritzkirche.

Iconoclasm in Münster included the requisite purging of statues and paintings; however, the Anabaptists were somewhat selective in their destruction of art.[90] On 15 March all of the cathedral's books, documents, and seals were burned in the Domplatz in order to obliterate all vestiges of the previous culture.[91] Within the cathedral, the Anabaptists pulled down all altars including the high altar dedicated to the Virgin Mary. All images of Mary, Christ, and the saints, including the monumental late Gothic statue of St. Christopher in the nave, were razed. The great Romanesque silver-plated wooden cross on the choir screen was melted down. The tombs and epitaphs of past bishops and deacons that ringed the choir were broken apart.[92] Since the Anabaptists preceived themselves as the true heirs to the Old Testament prophets and kings, any depictions of John the Baptist or King David were preserved. St. Paul, the patron saint of the cathedral, and St. Peter, symbol of the Catholic church, were singled out for destruction.[93] The large statue of St. Paul on the trumeau of the Paradise portal, the main entrance on the south side of the church, was demolished though the remaining thirteenth-century statues, including those of saints, were largely unharmed.[94] Many of the destroyed stone sculptures were taken from the cathedral and other churches for use in reinforcing the walls of the city, which from March 1534 onwards was under siege by Bishop von Waldeck. In the late nineteenth-century and again in 1979, sculptural fragments have been unearthed in excavations around the old city gates.[95] For the Anabaptists, iconoclasm represented a deliberate break with the immediate past. The debate over idolatry was never as important for the Anabaptists as it had been for the Lutherans or Zwinglians.

Bishop von Waldeck's long siege of Münster, illustrated in Erhard Schön's contemporary woodcut, succeeded when the city fell to his armies on the night of 24 June 1535.[96] (fig. 20) The Anabaptists were annihilated in the ensuing massacre. Catholic control over the city was reinstated though former Catholic and Protestant residents alike gradually returned to their native city. The bishop and the cathedral chapter undertook the renovation of the church but their staggering war debts restricted the pace of the renewal.[97] The first works to be renewed or remade were sculptures that had either a liturgical or a symbolic function. Johann Brabender, Münster's leading post-Anabaptist

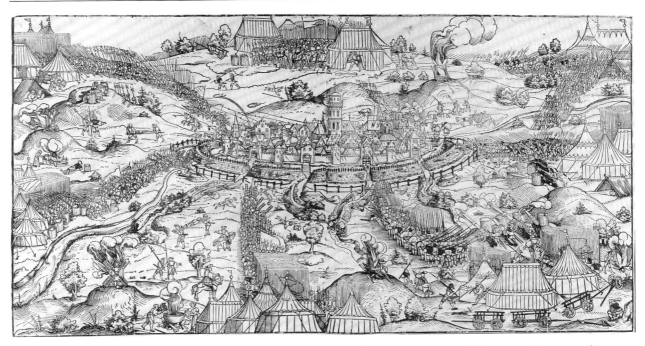

20. Erhard Schön, *Siege of Münster*, c. 1535, woodcut, Ann Arbor, University of Michigan Museum of Art

sculptor, likely carved the sandstone figures on the new 13.3 meter-tall sacrament house of 1536 and, more clearly, the new trumeau statue of St. Paul for the inner Paradise portal.[98] (fig. 21) Both replaced works damaged by the Anabaptists. The energetic and over life-size figure of Paul with his long sword stands proudly. It signals their renewed faith in Paul, the cathedral's patron saint, and their strong reaffirmation of Catholic episcopal power.[99] Wooden choir stalls were in place by 1539. Brabender contributed at least 21 statues of Christ, apostles, and saints that adorned the new choir screen erected between 1542 and 1547/49.[100] Brabender next carved the sandstone Prime Altar with its crucifixion relief that was placed in the crossing in front of the screen.[101] A few years later the cathedral chapter ordered a replica of the silver-plated cross with its wooden corpus figure that originally had been donated by Bishop Friedrich (1152–68) but was destroyed by the Anabaptists.[102] This new carving was placed above the center of the choir screen.

In addition to the numerous church sculptures Johann Brabender also produced several new epitaphs to replace those destroyed in 1534–35. For instance, in about 1540 the heirs of Deacon Theodor von Schade (d. 1521) commissioned the new Renaissance-style epitaph to take the place of its shattered predecessor in the cathedral cloister.[103] (fig. 22) The anonymous author of the Anabaptist ordinance of 1535 singled out this epitaph in his listing of intentionally damaged objects.[104] Von Schade was the only individual mentioned by name in this account which would suggest that he either had angered the emerging reform movement or, more likely, he personified the Catholic hierarchy that the Anabaptists so despised. The deacon, prominently identified by his arms and the inscription tablet, kneels before a baptism scene. Although the subject of the original epitaph is unknown, the inclusion of a baptism that is being sanctioned by God above may be a Catholic commentary on the true meaning of a Christian baptism rather than the Anabaptist's heretical interpretation. Sts. John the Evangelist and Theodore flank the deacon reaffirming the intercessory role of saints.

It took much of the next-century to restore the cathedral to its pre-Anabaptist splendor. The disaster at Münster would subsequently provide oppor-

21. Johann Brabender, *St. Paul*, c. 1536–40, Paradise Portal, Münster Cathedral

tunities for a host of artists, most notably the talented Gröninger family of sculptors, who would later fill the cathedral with lavish altars, holy statues, and epitaphs.[105] A good example of this gradual regenerative process is provided by Johann von Bocholt's St. Christopher.[106] Although the Anabaptists had destroyed the late Gothic statue of this saint, the three meter-tall base had been left largely intact. In 1627 von Bocholt completed his new five meter-high St. Christopher that was then placed on this earlier base; that is, church officials wished it to occupy the exact location of its predecessor. This process of renewal, of re-establishing past ties through the commissioning of works of art

and in particular sculpture, would be repeated in many Catholic cities during the later sixteenth and seventeenth centuries. In Chapter Four we shall examine the Catholic renewal in Augsburg.

INCIDENTS OF ICONOCLASM continued into the seventeenth-century though the Peace of Augsburg of 1555 established the fundamental basis for religious co-existence. Using the principle of "cuius regio, eius religio" ("he who rules a territory determines its religion"), a recognition of Lutheran territorial gains was reached. The settlement, however, was only between the Catholics and the Lutherans. It excluded the Zwinglians, Calvinists

43

22. Johann Brabender, *Epitaph of Theodor von Schade*, c. 1540, Münster
Cathedral

(German Reformed Church), and the Anabaptists.
Problems arose almost immediately. In 1556 Ott-
heinrich became the Palatine Elector and moved
from Neuburg to Heidelberg. In spite of his per-
sonal love of art, Ottheinrich was a staunch Lu-
theran who felt that it was his duty to rid the Palati-
nate, which included the bishoprics of Speyer and
Worms, of its idols.[107] Before his death in 1559,
Ottheinrich ordered the destruction of most of
the religious art in Weinheim and a few other
towns.[108] His precedent emboldened his successor

Friedrich III (r. 1559–76), who, however, was a
Calvinist. His transformation of the Palatinate into
the leading German bastion of Calvinism chal-
lenged the foundations of the Peace of Augsburg.
Furthermore, Friedrich ordered a much more com-
prehensive cleansing of churches and cloisters. The
elector delighted in participating in the destruc-
tion. In 1565 he oversaw the stripping of the nun's
cloister at Liebenau.[109] Upon discovering a paint-
ing of the crucifixion in the private cell of the pri-
oress, Friedrich smashed through it with his fist.

Such incidents continued to occur sporadically into the next century. Dramatic new Protestant- and Catholic-inspired attacks against religious art and churches alike flared up during the Thirty Years War between 1618 and 1648. Against this long backdrop of confessional disputes and political wrangling, it is surprising to discover that religious art continued to be commissioned by Catholic and Protestant patrons alike. It is to this subject that we now turn.

CHAPTER THREE

The Impact of the Reformation on Religious Sculpture, c. 1520–1555

ETWEEN the first iconoclastic riots in Witten-
berg in 1522 and the Peace of Augsburg in
1555, the creation of new religious art dropped
precipitously from the high levels of the pre-
Reformation period. With debate about idolatry
raging in many parts of Germany, relatively few
important non-funerary commissions were given.
Even Catholic patrons who still believed in the effi-
cacy of images hesitated to order new projects in
such a politically charged climate. With episcopal
seats, such as Augsburg or Lübeck, or entire re-
gions, as in the case of Albertine Saxony following
the death of Duke Georg in 1539, embracing Prot-
estantism almost overnight, a similar fate could
befall almost any German town. Few donors were
willing to invest large sums of money in a new
altarpiece or holy statue knowing there existed a
reasonable chance that their gift might fall victim
to iconoclasm if there was a confessional change on
the local or regional level. Religious art would
make a dramatic resurgence though not until late in
the sixteenth century. The interim can be divided
roughly into two periods. The first, extending up
to 1555, was a lull, a time of reassessment and
redirection. The production of religious sculpture
never ceased though the quantity and often the
quality failed to match that of the early sixteenth
century. Yet from this transitional era emerged
ideas for a new Protestant form of sculpture that
would blossom especially in Saxony after 1555, as
will be discussed in Chapter Four. Furthermore, in

the aftermath of the Peace of Augsburg and the
Council of Trent, Catholic patronage slowly re-
bounded as a new confidence and, in some areas,
militancy surfaced.

In this chapter I wish to address the profound
impact that the Reformation had upon religious
sculpture. The confessional polemic with the re-
sulting division of the German lands into Catholic
and Protestant areas affected all artists. The first
section provides a collective assessment of the eco-
nomic and artistic changes during this period.
Next, the careers of four sculptors, each of whom
responded differently to the challenge of the Refor-
mation, are discussed at some length. This is
followed by an examination of the three most sig-
nificant sculptural programs of this era: Cardinal
Albrecht von Brandenburg's glorious yet ill-fated
Neue Stift in Halle, Ottheinrich's transitional pal-
ace chapel at Neuburg an der Donau, and Elector
Johann Friedrich's Schloss Hartenfels at Torgau, the
first true Protestant chapel.

Sculptors in a Difficult Age

The Reformation threatened the livelihoods of
most German artists but sculptors were partic-
ularly susceptible. The majority of their work,
whether commissioned or made on speculation,
treated religious themes. Although some masters,
such as Peter Flötner or Christoph Weiditz, suc-

cessfully developed new secular forms of sculpture, most German sculptors failed to adapt to the changing art market. Many were faced with economic ruin or with the difficult task of trying to work in a related business such as carpentry or masonry. Guild opposition to such cross-overs was intense since the well-being of its own membership was threatened. In 1526 sculptors Martin Hoffmann and Hans Dobel wrote to the Basel city council complaining about the efforts of the joiners and cabinetmakers to prevent them from gaining employment.[1] Hoffman observed that he had "honorably followed his calling in the city for 19 years, but now, however, found that his own skill and training were totally useless." The previous year sculptors and painters as a group appealed to the Strasbourg council for municipal employment.[2] While acknowledging that some religious abuse had existed, they said that they faced ruin and the "beggar's staff" ("verderbens und des bettelstabs warten sint") for lack of work and because their training was now worthless. Such pleas were common throughout the Protestant lands.

In about 1525 Sebald Beham, the Nuremberg printmaker, and poet Hans Sachs addressed one aspect of these religious and financial issues in their broadsheet entitled *Complaint of the Godless against Luther*.[3] (fig. 23) Beham depicts Martin Luther standing with his simple followers on the right side. Holding only the Bible, he tenaciously faces his opponents who include a canon, a priest, a painter, a bell-founder, and a fisherman; the text adds sculptors, goldsmiths, manuscript illuminators, glaziers, organists, and priests' concubines, among others, to this group. Above them sits Christ in judgment. Sachs's text is constructed as a three part dialogue beginning with the "Godless" who make a living by exploiting the faithful. They blame Luther for wielding a sword that now threatens their way of living. Luther chides their unwillingness to debate the issue. He then bases his criticisms of their simony upon scripture. Christ rules in Luther's favor and answers the Godless with his own condemnation of their false beliefs. Like Luther, Christ stresses the gospels clean and pure ("rain und pur") as the essence of the true church rather than its ceremonies and fine baubles.

The correlation between the introduction of Protestantism and the decline in the visual arts was readily apparent to contemporary artists. Hoping to inspire other painters, sculptors, and craftsmen, Heinrich Vogtherr the Elder published his *Kunstbüchlein* in Strasbourg in 1537. In addition to containing woodcut designs, Vogtherr included a preface that reads in part,

> [God has] by a special dispensation of his Holy Word, now in these our days brought about a noticeable decline and arrest of all the subtle and liberal arts, whereby numbers of people had been obliged to withdraw from these arts and to turn to other kinds of handicrafts. It might, therefore, be expected that in a few years there would scarcely be found any persons in German lands working as painters and carvers.[4]

Vogtherr, a Protestant, hoped his illustrations would help revive art; however, in 1550 he sought to improve his own financial situation by accepting a post as court painter in Vienna for the Catholic emperor, Charles V.

A few enterprising artists in Protestant towns continued supplying sculptures for external Catholic patrons. The most celebrated commission was the Silver Altar that King Sigismund I of Poland presented to the Sigismund Chapel in Cracow Cathedral in 1538.[5] (fig. 24) This large altar, which measures 2.48 by 1.75 meters, was the collaborative creation of a team of Nuremberg artists. In 1531 Hans Dürer, Albrecht's brother and the king's court painter, devised the overall design. Georg Herten made the wooden frame and Georg Pencz painted the exterior wings. The corpus of the altar consists of 12 silver reliefs depicting the life of the Virgin. Peter Flötner carved the wooden models that Pankraz Labenwolf then cast in brass. Finally, goldsmith Melchior Baier chased these in silver. Sigismund considered the Silver Altar as the crowning jewel of the royal chapel. His payment of 5,801 guilders and 8 groschen, a remarkable sum that reflects the high cost of materials, was beyond the means of most German nobles. Nevertheless, neither Flötner nor his fellow artists could depend upon the occasional foreign order to support themselves.

In stark contrast with the pre-Reformation period, the wealthy urban population abruptly stopped embellishing its churches. Projects such as

Ein neuwer Spruch/ wie die Geystlicheit vnd etlich Handtwercker yber den Luther clagen.

Der geitzig clagt auß falschem müt/
Seit im abget an Eer vnd Gůt.
Er zürnet/Dobet/vnde Wüt/
Jn dürstet nach des grechten plůt.

Die warheit ist Got vnd sein wort/
Das pleibt ewiglich vnzerstort.
Wie er der Gotloß auch rumort/
Gott bschützt sein diener hie vnd dort.

Der Grecht sagt die Gotlich warheit/
Wie hart man jn veruolgt/verleit.
Hofft er in Gott doch alle zeit/
Pleibt bstendig in der grechtigkeit.

H. B. 26

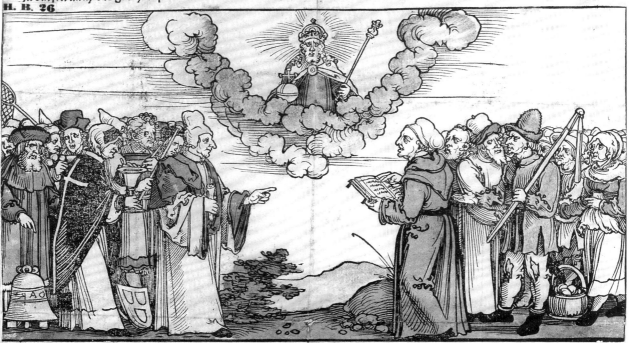

Die clag der Gotlosen.

Hör vnser clag du strenger Richter/
Vnd sey vnser zwitracht ein schlichter.
Eh wir die hend selb legen an/
Martin Luther den schedlich man.
Der hatt geschriben vnd gelert/
Vnd schir das gantz Teütsch land verkert.
Mit schmehen/lestern/nach vnd weit/
Die Erwirdige Gaistlichait.
Von jren Pfrunden/ Rent vnd zinst/
Vnd verwürfft auch jren Gozdinst.
Der Vätter gepot/ vnd auffsetz/
Haysst er vnnütz/ vnd menschen gschwetz
Helt nichts von Aplaß vnd Fegfewr/
Die Meß kum auch kain Sel zu stewr.
All Kirchen Pew/ Zir/ vnd geschmuck/
Veracht er gar/ er ist nie cluck.
Des clagen die Prelaten ser/
Pfaffen/ Münch/ Stationirer.
Glockengiesser vnd Organisten/
Goltschlager vnd Illuministen.
Hädtmaler/ Goltschmit vñ Bildschnitzer
Ratschmit/ Glaßmaler/ seydensitzer.
Stainmetzen/ Zimerleüt Schreiner/
Paternoster/ Kertzen macher.
Die Permenter/ Singer vnd Schreyber/
Fischer/ Zopffium vnd pfaffen Weyber.
Den allen ist Luther ein bschwert/
Von dir wirt ein Vrteil begert.
Sunst werd wir weiter Appelliern/
Vnd dem Luther die Pfend recht schirn/
Můß Prümen/ oder Reuocirn.

Antwort .D. Martini.

Actuum .1.
O da erkenner aller hertzen/
Hör mein antwort des ist kein schertzen.
Die schreyen fast selb thůn mich sten/
Vnd wöllen doch nit Disputirn.
Sonder mich mit worten schrecken/
Jn thut we das ich thu auffdeckn.
Jr grossen geytz vnd Simoney/
Jr falsch Gozdinst vnd Gleissnerey.
Jr Bannen/Auffsetz vnd gepot/
Vor aller welt zu schand vnd spott.
Mit deinem wort/ das ich denn ler/
Nun jn abgeet an gut vnd Eer.
So kunden sy dein wort nit leiden/
Dunt mich schelten/hassen vnd neiden.
Wenn ich hett gschuben vnd geleert/
Das sich jr Reich vmb het genert.
So wer kein besser auff gestandn/
Jn langer zeit in Teutschen Landn.
Dis ist auch die vrsach ich sag/
Das gegen mir auch stent in clag.
Der Handtwercks leüt ein grosse zal/
Den auch abgeet in disem val.
Seyt diß Apgötterey entnimpt/
Also seynd vber mich ergrimt.
3.Regü.18. Von erst des Baals Tempel knecht/
Den jr jarmarck thut nimmer recht.
Actuũ.19. Vnd Demetrius der werckman/
Dem sein handtwerck zu ruck wil gan.
Her durch dein wort das ich thů schreibn/
Jr disen soll mich nitt abtreibn/
Bey deinem vrteil will ich pleiben.

Hans Sachs Schuster.

Das Vrteil Christi.

Joānis.5.
Das mein gericht das ist gerecht/
Nu merck vermaints gaistlichs geschlecht.
Was ich euch selb beuolhen han/
Das jr in die gantz welt solt gan.
Mar. vltĩo. Predigen aller Creatur/
Das Euangeli rain vnd pur.
Dasselbig hant jr gar veracht/
Vnd vil neuwer Gozdinst auff pracht.
Mathei.15. Der ich doch kein geheissen haß/
Vnd verkaufft sie vmb gelt vnd gaß.
Math.23. Mit Vigil/ Jartäg vnd Selmessen/
Den witwen jr die hewser fressen.
Vnd verspert auch das Himelreich/
Jr seyt den Doten grebern gleich.
Vñ schlacht zu dot auch mein Propheten/
Der gleich die Phariseer thetten.
Also veruolgt jr die warhait/
Luce.13. Den euch teglichen wirt geseit.
Vnd so jr euch nit pessern wert/
Jr vnkeuschen. Darumb so kert.
Von euwerm falschen widerstreit/
Dergleichen jr handtwercks leyt.
Die jr mein wort veracht mit drutz/
Von wegen ewerß aygen nütz.
Mathei.6. Vnd hört doch in den worten mein/
Das jr nit solt sorgfeltig sein.
Vmb zeitlich güt/ gleich den Hayden/
Sŏder sucht das Reich gots mit freudn.
Das zeitlich wirt euch wol zufalln/
Sunst wert jr in der hellen qualln/
Das ist mein vrteil zu euch alln.

23. Sebald Beham, *Complaint of the Godless against Luther*, c. 1525, woodcut, Nuremberg, Germanisches Nationalmuseum

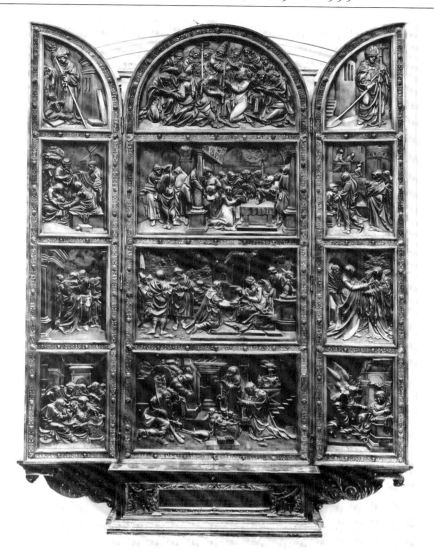

24. Hans Dürer and others, Silver Altar, completed 1538, Cracow Cathedral, Sigismund Chapel

Benedikt Dreyer's St. Anthony Altar (Lübeck, St.-Annen-Museum) completed in 1522 for the chapel of the confraternity of St. Anthony in the Burgkirche in Lübeck became increasingly scarce.[6] (fig. 25) Individuals redirected their spending either towards charitable institutions or, more commonly, towards the enrichment of their own houses. Some purchased small religious reliefs and statuettes, such as the *Arrest of Christ* (London, Victoria and Albert Museum) attributed to Victor Kayser, for personal devotional purposes. (fig. 26) Yet often it is debatable whether a beautifully carved relief like

Master I.P.'s *Adam and Eve* (Vienna, Kunsthistorisches Museum) was ordered for its edifying narrative or for its aesthetic merits.[7] (fig. 27) Therefore, I have chosen to discuss these private religious sculptures with other small collectible objects in Chapter Nine. Absent during this later period are the major lay-sponsored projects comparable to the family chapel that the Fuggers erected between 1509 and 1518 in St. Anne's in Augsburg or the four-tiered red marble altar given in 1518 by patrician Philipp Adler and his wife, Anna Ehem, to the Dominican church in the same city.[8] (fig. 133)

49

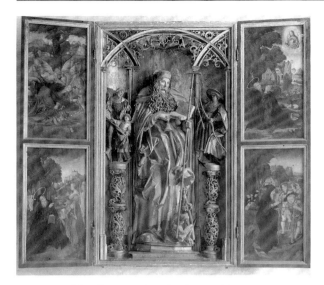

25. Benedikt Dreyer, St. Anthony Altar, completed 1522, Lübeck, St.-Annen-Museum

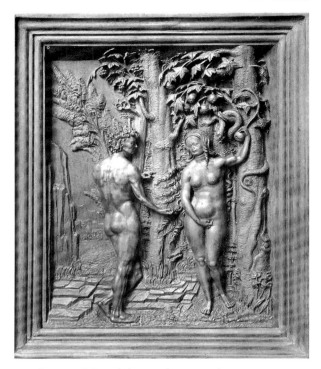

27. Master I.P., *Adam and Eve*, mid-1520s, Vienna, Kunsthistorisches Museum

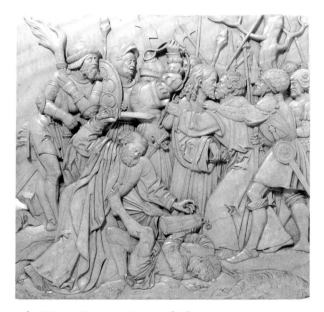

26. Victor Kayser, *Arrest of Christ*, c. 1525–30, London, Victoria and Albert Museum

Daniel Hopfer's etching (B. 21) records the appearance of this altar, which was demolished in 1724.[9] (fig. 28) Its five-tier design begins with the reclining Jesse and the Holy Kinship followed by Christ's Crucifixion and Resurrection. At the apex Sts. Pe-

ter and Paul stand flanking the *vera ikon*. The unknown artist reinforces the grandeur of the program by setting his figures within three stacked triumphal arches whose openings brilliantly permitted light to accent the major figures. Comparably inventive altar designs would not reappear for decades.

The sharp decline in lay patronage was also reflected in the absence of new churches. In contrast with the dozens of buildings that were erected prior to 1520, during the subsequent half century only two notable churches were built in Germany.[10] The Neuepfarrkirche in Regensburg was actually initiated in about 1520 at the height of the cult of the Beautiful Virgin.[11] Intended originally to replace the wooden chapel depicted in Ostendorfer's pilgrimage woodcut, it was completed only around 1540 after a building hiatus and a modification of Hans Hieber's initial plan. (fig. 3) In 1542 the city converted it into a Lutheran parish church. Only the Marktkirche in Halle truly dates to the period under discussion.[12] Construction began in 1529 with the encouragement and financial backing

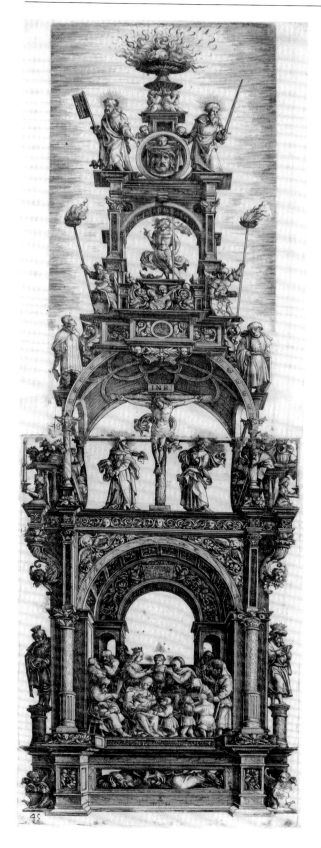

of Cardinal Albrecht von Brandenburg. Yet with Halle's conversion to Lutheranism in 1541 coupled with the Cardinal's forced move to Aschaffenburg, all building ceased. The church, as the center of Protestantism in Halle, was finally finished with local funding in 1554. These two churches, one initiated because of a need to accomodate the influx of pilgrims and the other because a cardinal wished to enrich his preferred city of residence, are the exceptions. The only other substantive religious constructions of this period are the chapels added on to the princely palaces at Celle, Torgau, Dresden, Jülich, Stuttgart, and Augustusburg.

With the absence of new ecclesiastical building campaigns or a steady number of religious commissions, German sculptors lacked the creative opportunities enjoyed by their predecessors. Not surprisingly, there were far fewer significant sculptors active around 1550 than a few decades earlier. The names of these artists are listed in Table 1.

Table 1. Sculptors Active between 1520 and 1555

Hans Ässlinger (act. 1535–67)
Melchior Baier (master 1525–77) [goldsmith]
Claus Berg (1470s–c. 1535)
Johann Brabender (1500/5–62/3)
Peter Breuer (c. 1472–1541)
Hans Brüggemann (c. 1485/90–after 1523)
Hans Daucher (c. 1485–1538)
Peter Dell the Elder (c. 1490–1552)
Peter Dell the Younger (master 1551–1600)
Joachim Deschler (c. 1500–71/2)
Heinrich Douvermann (c. 1480–c. 1530)
Benedikt Dreyer (c. 1485–1555)
Gregor Erhart (c. 1468–1540)
Peter Flötner (c. 1485/90–1546)
Joachim Forster (c. 1500–70)
Matthes Gebel (c. 1500–74)
Friedrich Hagenauer (act. 1520–45)
Loy Hering (c. 1485–1554)
Martin Hering (c. 1515–c. 1560)

28. Daniel Hopfer, *Adler Altar*, c. 1518, etching, Munich, Staatliche Graphische Sammlung

51

Thomas (Doman) Hering (c. 1510–49)
Wolff Hilger (1511–76)
Wenzel Jamnitzer (1508–85) [goldsmith]
Ludwig Juppe (c. 1465–after 1535)
Victor Kayser (c. 1502–52/3)
Hans Kels the Elder (1480–1559)
Hans Kels the Younger (c. 1508/10–65)
Ludwig Krug (1488/90–1532) [goldsmith]
Pankraz Labenwolf (1492–1563) [brass caster]
Hans Leinberger (1480/5–after 1531)
Sebastian Loscher (1482/3–1551)
Leonhart Magt (act. before 1514–1532)
Master H.L. (act. 1510s–20s)
Master I.P. (act. 1520s–30s)
Daniel Mauch (1477–1540)
Conrat Meit (1480s[?]–1550/1)
Jakob Murmann (c. 1467–1547)
Ludwig Neufährer (act. 1530–63)
Hans Peisser (1500/05–after 1571)
Hans Reinhart the Elder (act. 1535–81)
Tilmann Riemenschneider (c. 1460–1531)
Hans Schenck (c. 1500–1566/72)
Dietrich Schro (c. 1510–69/73)
Peter Schro (act. 1510–41/2)
Simon Schröter (act. before 1540–1568)
Hans Schwarz (1492–later 1520s?)
Levin Storch (d. 1546/7)
Veit Stoss (c. 1447–1533)
Arnt van Tricht (act. 1530s–70)
Jörg Unkair (c. 1500–53)
Hans Vischer (c. 1489–1550)
Peter Vischer the Elder (c. 1460–1529)
Peter Vischer the Younger (1487–1528)
Christoph Walther I (act. 1518–46)
Hans Walther II (c. 1526–86)
Christoph Weiditz (c. 1500–1559)

These masters fall into three basic groups: 1. artists whose careers were largely over by about 1530 whether because of age or because of a decline in employment opportunities; 2. artists whose oeuvres consisted primarily of secular art plus the occasional epitaph or tomb; and 3. artists who continued making mainly religious sculptures. Berg, Brüggemann, Breuer, Daucher, Douvermann, Erhart, Leinberger, Loscher, Masters H.L. and I.P., Mauch, Riemenschneider, Stoss, and the elder Vischer belong to the first group. In the case of Daucher, a few later works are known but the

quantity of his production dropped dramatically following the probable expulsion of his wife from Augsburg in 1529 because of her Anabaptist beliefs. Ässlinger, Baier, Deschler, Flötner, Gebel, Hagenauer, Hilger, Jamnitzer, Kels the Elder and Younger, Labenwolf, Magt, Neufährer, Peisser, Reinhart, Schwarz, Storch, Hans Vischer, Peter Vischer the Younger, and Weiditz, most of whom were a generation or so younger than the masters listed immediately above, contributed to the development of secular sculpture in Germany. The Augsburg artists Forster, Kayser, and Murmann should likely be added to this list; however, relatively few secure works by them survive. When the rare opportunity to produce a religious sculpture occurred, they responded inventively. Besides collaborating on the Silver Altar, Peter Flötner occasionally designed altars and altar frames. His drawing of a Transfiguration Altar, now in Erlangen (Universitätsbibliothek), reveals his pictorial talents and his characteristic love of clearly formed architectural decoration.[13] (fig. 29) Yet given the religious climate in Franconia and the early 1530s date of the drawing, its actual execution, whether in stone or metal, was unlikely. The remaining group consists of Brabender, the Dells, Dreyer, the Herings, Juppe, Mauch, and Meit (who both worked outside of Germany), Schenck, the Schros, Schröter, van Tricht, Unkair, and the Walthers.[14]

Only the artists of this latter group succeeded in finding relatively strong patronage for religious projects or, at least, support for one major undertaking. Not surprisingly, many lived in episcopal cities. Brabender was active in post-Anabaptist Münster; the Dells in Würzburg; the Herings in Eichstätt; and the Schros in Mainz and the residential city of Halle. Paradoxically, such bastions of Catholicism as Cologne and Munich produced no major sculptors until much later in the century. In fact, the most imposing sculptural ensemble in Cologne was the great choir screen in St. Maria im Kapitol that a Netherlandish artist, Jan van Roome of Mechelen, made between 1523 and 1525.[15] The dukes of Bavaria employed Loy Hering's son, Thomas, for several mainly secular projects in Munich and Landshut. Van Tricht found a supportive market in Catholic Kalkar and Xanten. Dreyer (Lübeck), Juppe (Marburg), Schenck (Berlin), Schröter (Torgau), Unkair (Minden), and the Walthers

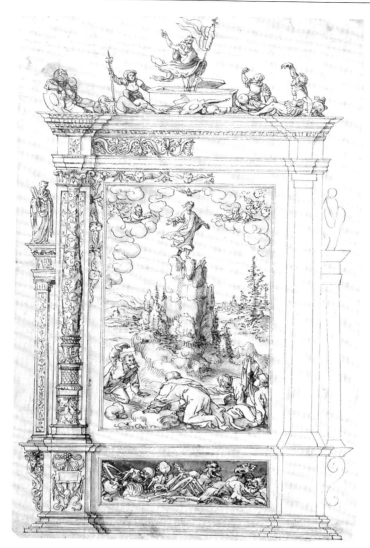

29. Peter Flötner, *Design for a Transfiguration Altar*, 1530–35, drawing, Erlangen, Universitätsbibliothek

(Dresden) worked in cities that either gradually embraced Lutheranism or, like Minden, accomodated both Lutheranism and Catholicism. Not surprisingly, the lands controlled by the Zwinglians and, later, the Calvinists supported very few sculptors and these tended to produce only secular art or funerary monuments.

The character of religious sculpture of the second quarter of the sixteenth century is more subdued than during the pre-Reformation period. The triumphant positivism of the great altarpieces by Leinberger, Master H.L., Riemenschneider, or Stoss, or the empathetic power of their statues, have few post-Reformation counterparts. Neither the bold self-assurance of Berg's *St. Jude* in Güstrow Cathedral nor the melancholic pathos of Leinberger's *Christ in Distress* in Berlin (Skulpturengalerie) can be surpassed by any carvings of the 1530s or 1540s. (figs. 30 and 31) Only Peter Schro's *Christ and Apostles* in the Neue Stift in Halle come close. (figs. 52 and 53) In general, the ever increasing intricacy of detail and the linear exuberance of com-

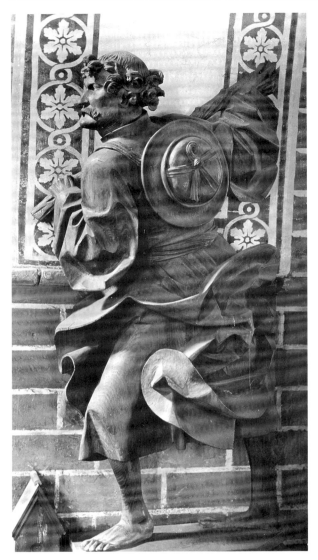

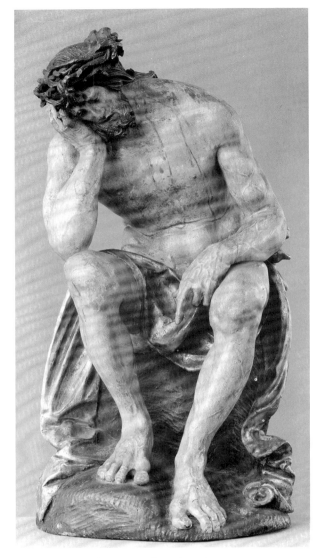

30. Claus Berg, *St. Jude*, c. 1530, Güstrow Cathedral

31. Hans Leinberger, *Christ in Distress*, c. 1525–30, Berlin, SMBPK, Skulpturengalerie

plex, deeply cut drapery folds that typify works such as those by Kraft and Stoss in St. Lorenz in Nuremberg or the *St. John the Baptist* (Nuremberg, Germanisches Nationalmuseum) attributed to Master H.L., yield to a clear, more sober style in the creations of Loy Hering, Johann Brabender, or Simon Schröter.[16] (figs. 14, 15, 32) Protestant criticisms of church art, especially its lavish decoration and expensive character, certainly prompted the rapid simplification that one finds in the late 1520s

and 1530s. This quieter style also reflects the uncertain mood of the period. Protestant challenges to Catholic authority in interpretating and spreading Christian doctrines shook the foundation of the Roman church. Papal dignity was further eroded by the imperial sack of Rome in 1527. The Catholic church was besieged from all sides during the 1520s and 1530s. The optimism of the early sixteenth century was now replaced with a quieter, more introspective spirit. Furthermore, the emerg-

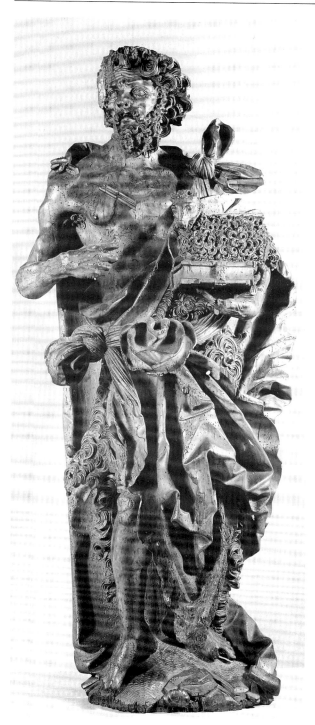

32. Master H.L., *St. John the Baptist*, 1520–30, Nuremberg, Germanisches Nationalmuseum

ing Lutheran sculpture stressed doctrinal clarity over artistic expression. Art was merely the means to an end. Through art the word of God could be spread, and only for this reason was it tolerated. As will be seen below, Peter Dell the Elder's reliefs, covered with biblical texts, are to be read not simply viewed.

This reassessment of one's faith resulted in innumerable epitaphs and funerary monuments but very few major altars or showy ensembles analogous to Stoss's *Angelic Salutation*. It is significant that there was only one noteworthy Catholic project in the 1540s aside from the redecoration of the cathedral in Münster following the reign of the Anabaptists. In 1546 Münster sculptor Johann Brabender carved a new choir screen for the cathedral in Hildesheim.[17] (fig. 33) Its creation was linked to the contemporary religious debate in the city. Under the direction of Lutheran preacher Johann Bugenhagen, Hildesheim embraced Protestantism in 1542 though Catholic services continued in the cathedral for four more years. Arnold Freidag (d. 1546), one of the cathedral's Catholic canons, donated the choir screen. The religious conversion of Hildesheim occurred concurrently with the planning and the execution of the choir screen. At a time when many choir screens were being removed from German churches as physical impediments devoid of liturgical function within the evangelical service, why was Hildesheim's screen completed and subsequently retained? I think the answer can be found in its iconographic program and its unusual design. The screen is prominently inscribed with the text "SOLI DEO GLORIA" ("Honor God Alone"), a point reiterated in Brabender's carvings that focus upon Christ's life and its Old Testament models. Typological comparisons, such as the story of the Brazen Serpent as an anticipation of Christ's Crucifixion or Jonah and the whale as an allusion to the Resurrection, are drawn exclusively from the Bible and offer traditional Catholic analogies that remained popular in Lutheran paintings and prints.[18] Prior to its transfer in 1960 to the Sankt Anthonius-Kapelle adjacent to the cathedral cloister, the choir screen included a pulpit set prominently before its central arch.[19] The pulpit's three simple reliefs are also intended to remind the religiously divided community of its common bonds. In the central scene stands Christ as the Salvator

55

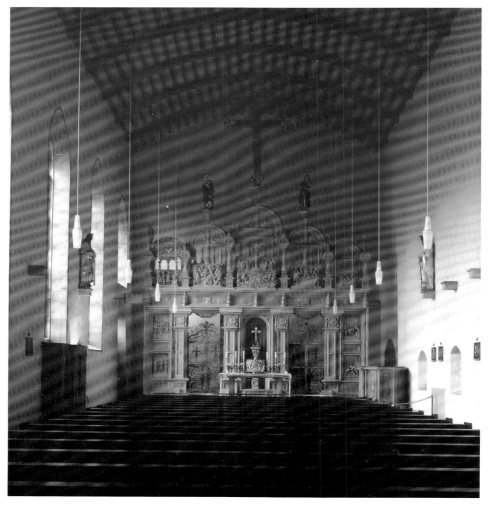

33. Johann Brabender, Choir Screen, 1546, Hildesheim Cathedral, Sankt-
Anthonius-Kapelle

Mundi, the sole judge of mankind's fate. To his right is Mary holding the Christ Child. Mary is both the cathedral's patroness and the worthy virgin whom God picked to be Christ's mother, a point stressed by the carving and the inclusion of Gabriel's greeting—"AVE MARIA GRATIA PLENA" ("Hail Mary full of grace"). The third relief represents St. Bernward (d. 1022) holding an architect's T-square, an allusion to the town's most famous cleric and his role as the builder of the first cathedral. Together they represent three pillars of Hildesheim's Christian faith and history that transcend individual confessional allegiances. The appropriateness of the pictorial images coupled with the central focus of Lutheran services upon the word

of God assured the pulpit's use by generations of first Catholic and soon Protestant ministers.

Questions about the appropriateness of religious art coupled with the period's unsettled mood and a general economic decline combined to restrict the careers of many sculptors. In the cities, non-princely lay patronage of religious sculptures withered. Even in a wealthy and stable town such as Nuremberg, no artistic gifts were presented either to St. Sebaldus or St. Lorenz, the two parish churches, between 1530 and 1555.[20] The nature of patronage also changed since with a few exceptions artists increasingly relied upon nobles or senior clerical officials for their livelihood. Thus often the choice of subject and even style was determined less

by the open marketplace and more by a limited and frequently conservative group of donors. I wish now to turn from the general to the specific by examining the careers of four quite different sculptors active between 1520 and 1555.

The Stories of Four Sculptors

Loy Hering, Benedikt Dreyer, Peter Dell, and Hans Reinhart the Elder, whether working for Catholics or Protestants, each experienced the Reformation's impact. It shaped their careers. Often social and religious forces pushed them in directions different than those they might have chosen in an earlier age. Each adapted to the realities of their situations. What emerges is an interesting picture of a conservative Catholicism, with its adherence to older artistic models, contrasted with an evolving, highly doctrinaire genre of Lutheran art in which the theological program taxes the stylistic creativity of the sculptor.

LOY HERING

Loy Hering was the most prolific and financially successful German sculptor of the period.[21] Between about 1508 and 1553 at least 133 separate projects are attributable either to Hering or to his workshop. Of these only four illustrate secular themes. After his initial training in Augsburg, Hering moved to Eichstätt sometime between 1512 and 1515. Under the strong leadership of Bishops Gabriel von Eyb (r. 1496–1535), Christoph von Pappenheim (r. 1535–39), and Moritz von Hutten (r. 1539–52), Eichstätt remained a Catholic bastion even as many regional towns embraced Protestantism.[22] Thus Hering never fully experienced the professional disruptions wrought by the Reformation that plagued most German artists of the period. From his finest creation, the *Willibald Monument*, to his last, the tombstone for Anna Schenkin zu Geyern of 1553, Hering enjoyed constant employment from clerical and noble patrons. (fig. 11) Most of his sculptures were erected within Eichstätt and its diocese though Hering worked for the bishops of Bamberg and Würzburg and other donors as far away as Boppard and Speyer on the Rhine and Schwaz and Vienna in Austria.

Hering carved exclusively in stone, normally the fine-grain solnhofen limestone quarried near Eichstätt. Like most stone sculptors, Hering's oeuvre consisted primarily of large Crucifixes, the occasional tabernacle or sacrament niche, and, above all, epitaphs and tombs. Surprisingly, Hering produced no independent statues of saints or the Virgin that were the common fare for most pre-Reformation sculptors.[23] Traditionally, German altarpieces were cut from wood rather than stone so even renowned masters such as Adam Kraft in Nuremberg and Hans Backoffen in Mainz were excluded from these lucrative commissions.[24] The altarpieces of Hans Leinberger, Tilmann Riemenschneider, and Veit Stoss, who worked in both ma-

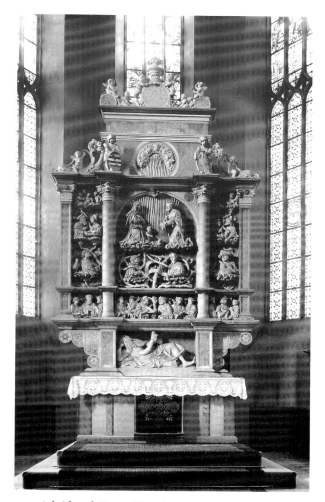

34. Adolf and Hans Daucher, High Altar, 1519–22, Annaberg, St. Annenkirche

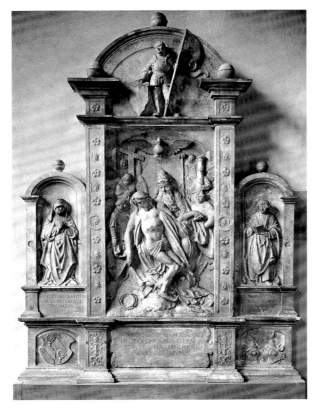

35. Loy Hering, *Moritzbrunneraltar*, 1548, formerly in the parish church of Moritzbrunn bei Eichstätt, now Munich, Bayerisches Nationalmuseum

terials, were done exclusively in wood. Adolf and Hans Daucher's High Altar (1519–22) in St. Annenkirche in Annaberg is one of the few significant exceptions, and in this instance the principal patron, Duke Georg of Saxony, expressly requested the use of costly marble.[25] (fig. 34)

Therefore, it is hardly surprising that Hering completed only four altars in his long career and only one, the *Moritzbrunneraltar* (1548), postdates 1530.[26] (fig. 35) This late altar was commissioned by Bishop Moritz von Hutten for the new parish church of Moritzbrunn bei Eichstätt that he rebuilt after the village was razed by fire in 1540. Seemingly unaccustomed to conceiving altar designs, Hering patterned its triple aedicula formula after one of the popular epitaph types that he had used since the early 1520s.[27] In 1553 when Hering created the *Epitaph for Albert von Hohenrechberg and Moritz von Hutten* in the Willibald choir of Eichstätt

cathedral, its design echoed the Moritzbrunneraltar.[28] The only real difference is the substitution of the two donors in the side niches in place of the Virgin and St. John the Evangelist.

The *Moritzbrunneraltar* exemplifies both Hering's facility as a sculptor and his lack of development. Whether by personal choice, perhaps due to the financial success of his epitaphs, or by limitations in his patronage, Hering never became a great sculptor. His finest creations, such as the *Willibald Monument*, date to the 1510s and early 1520s. When the *Moritzbrunneraltar* is contrasted with his *Wolfstein Altar* of 1519–20 in Eichstätt Cathedral, it seems lifeless and derivative.[29] (fig. 36) Both depend upon prints by Albrecht Dürer as the source for the principal scenes of the *Trinity* and the *Coronation of the Virgin*.[30] Yet the architectural design of the *Wolfstein Altar* provides a greater unity and focus. The projecting columns direct the viewer's gaze towards the central relief while the two twisting wooden putti, which certainly were carved by a shop assistant, are joyous extensions of the angelic host surrounding the coronation. The integration of frame and central scene works effectively as does the thematic associations of the risen Virgin and St. John's vision of the Apocalyptic Woman in the rounded relief in the apex of the altar.[31] The attractive and wonderfully harmonious design of the *Wolfstein Altar* with its strong links to contemporary Augsburg sculpture, such as the Dauchers' St. Anne Altar in Annaberg, reveals Hering's potential. (fig. 34) By contrast, the *Moritzbrunneraltar* lacks this overriding unity. It is the sum of its parts rather than a single, comprehensive design. Although the figures, especially Christ and St. Moritz, are carved in much higher relief, the planarity of the frame seems to flatten the whole altar. Here and in so many other sculptures, Hering appears content to repeat his older artistic ideas rather than striving for new solutions.

Hering's constant success and the steady stream of orders from clerical and regional noble patrons may have restricted his desire to experiment further. Did the Reformation have an influence upon his subsequent career? While there is no clear answer to this question, the Reformation may have been an inhibiting factor. The majority of his commissions before and after the mid-1520s were tombs and epitaphs; however, the sprinkling of re-

quests for altars, sacrament niches, and the like dried up by the 1530s, other than the Moritzbrunneraltar and a couple of others projects made for Bishop Ulrich von Hutten. His donors were concerned exclusively with perpetuating their memories and the salvation of their souls rather than edifying their parishioners. This conservativism, I believe, is a manifestation of the introspective Catholic response to Protestant complaints. Hering's epitaphs, like the mostly localized actions of Eichstätt's bishops, sought to preserve traditional faith rather than forging a new militant response to Protestantism.

36. Loy Hering, *Wolfstein Altar*, 1519–20, Eichstätt Cathedral

BENEDIKT DREYER

Benedikt Dreyer's career offers a sharp contrast to Hering's.[32] Trained in Lüneburg, he was a master in Lübeck by about 1510. Lübeck, a major Hanseatic city with a lucrative Baltic trade, traditionally had supported such talented sculptors as Bernt Notke, Claus Berg, and Henning van der Heide.[33] Dreyer's skills quickly won him major commissions. Between 1516 and 1520 he supplied the wooden statues for the organ and choir screen in the Marienkirche. He completed his St. Anthony Altar for the local brotherhood of St. Anthony in 1522 and the Last Judgment Altar for the parish church of St. Michael in Lendersdorf soon afterwards.[34] (fig. 25) Dreyer was at the height of his success and could anticipate a brilliant future when Lutheranism began gaining in popularity around 1524. The number of new commissions offered to Dreyer dropped dramatically. Under the direction of Johannes Bugenhagen, Luther's disciple who resided there from October 1530 to April 1532, Lübeck officially embraced Lutheranism.[35] Between 1530 and his death in 1555, Dreyer participated in only one, albeit substantive, religious project. Information about his subsequent career is incomplete yet it reveals that Dreyer never received the sorts of creative opportunities, religious or secular, accorded Loy Hering in Eichstätt or the earlier Lübeck masters.

Dreyer's failure to find adequate support is all the more grievous since his one religious project showed great innovation. In 1533 the Protestant parish of the Marienkirche erected a new wooden pulpit. Dreyer contributed the five rectangular reliefs on the face of the pulpit plus the cover with its *Annunciation* and ornamental panels.[36] (Figs. 37–39) The pulpit remained in the Marienkirche until 1699 when it was sold to the church in nearby Zarrentin (Mecklenburg) to make way for a larger stone version.[37] Dreyer's masterpiece is perhaps the earliest extant Protestant pulpit. Bugenhagen devised or, at least, approved its artistic program. The iconography derives in part from Erhart Altdorfer's title page for Luther's first complete translation of the Bible, which was published with Bugenhagen's assistance by Ludwig Dietz in Lübeck in 1533.[38] (fig. 40) Dreyer's first two reliefs depict *Moses with the Ten Commandments* and *John the Baptist*

37. Benedikt Dreyer, *Christ as Good Shepherd*, 1533, relief from the former pulpit in the Marienkirche in Lübeck, now Zarrentin, Parish Church

Preaching with the Lamb of God, subjects included though rendered differently in Altdorfer's woodcut.[39] Both are standard images in Luther's writings and in early Protestant art.[40] Moses with the tablets recalls mankind's failure to follow God's laws, a failure ultimately caused by the fall of Adam and Eve. Dreyer includes a naked, distraught Jew behind Moses. Upon descending from the mountain, Moses discovers the Israelites dancing by the idol of the Golden Calf. Like Adam and Eve before them, the Israelites failed to show sufficient faith in God's law. The accompanying text reminds the viewer that just as Adam brought sin and death into the world, Christ, the second Adam, offers a forgiveness of sin and an opportunity for eternal life.

In the next relief, which derives from a Lucas Cranach woodcut of 1516, John the Baptist prophesizes mankind's redemption through Christ and his word as he exclaims "Behold, the Lamb of God, who takes away the sin of the world" (John 1:29).[41]

The third or central carving represents *Christ as the Good Shepherd*. The tall figure of Christ dominates the relief and would have been readily legible to the Marienkirche audience. His powerful gestures, the raised right hand and the lowered, turned left hand, immediate recall his role as mankind's judge. Christ's sternness is tempered by the lambs who gather at his feet just as they do at the base of the cross behind. Christ, the Good Shepherd, protects mankind while, through his sacrifice, providing its means of salvation.[42] In 1533 Luther deliv-

38. Benedikt Dreyer, *Christ Warning against False Prophets*, 1533, relief of the former pulpit in the Marienkirche in Lübeck, now Zarrentin, Parish Church

39. Benedikt Dreyer, *Annunciation*, 1533, carving for the former pulpit in the Marienkirche in Lübeck, now Lübeck, St. Annen Museum

ered a series of sermons about the Lamb of God and Christ's role as the Good Shepherd that may have inspired the Lübeck pulpit's program.[43]

The fourth and fifth scenes illustrate *Christ Instructing His Apostles to Spread His Teachings Throughout the World* and *Christ Warning against False Prophets*.[44] Reminiscent of his medieval artistic counterparts, Dreyer's Christ towers over his smaller disciples to stress his singular responsibility for man's redemption and for creating the Christian church. The sculptor provides a direct parallel between Christ talking with his disciples and the Lutheran ministers lecturing from this pulpit. The latter are cast as Christ's contemporary disciples preaching the word of God in Lübeck. This association between Christ's disciples and Lutheran ministers was to be the subject of Michael Ostendorfer's painted retable done in 1554–55 for the Neupfarrkirche in Regensburg.[45] In the upper part of the retable Christ speaks with his apostles, and below, the minister, labelled as the servant of the word ("Diener des Wortes"), speaks to his con-

gregation. In Dreyer's last relief, one of the on-lookers sports a turban and another wears a monk's cowl. The sculptor has thus grouped Moslems and Catholic clerics among the false prophets leading Christians astray. A reference to the rising influence of Zwinglians and the Anabaptists may also be implicit.

Dreyer's Lübeck pulpit pulsates with life. Its pedagogical messages, a reflection of Bubenhagen's orthodox Lutheranism, are presented clearly, complete with accompanying texts. The style is as bold and as forceful as any of Dreyer's pre-Reformation works. Crowning the cover above the pulpit, Dreyer included a joyous *Annunciation* relief, a theme that celebrates the maternal role of Mary, the parish church's patron saint. (fig. 39) The light-hearted spirit of the sweet-faced Virgin and the frolicing angels stand in stark contrast with the dour mood of Dreyer's other scenes. The sculptor created a brilliant new conception for a Protestant pulpit, which was after all the primary piece of religious art welcomed back into the Lutheran church.[46] Unfortunately, no record of further pulpits in or near Lübeck can be associated with Dreyer. Few of the many later Saxon pulpits would ever match the beauty and simplicity of the Marienkirche masterpiece.

PETER DELL THE ELDER

The third artist, Peter Dell the Elder, enjoyed the patronage of Protestant and Catholic patrons alike. Unlike Loy Hering, Dell worked comfortably in stone and wood on both large and small scale. This theological and technical flexibility, coupled with his talents as a portrait sculptor and secular artist permitted Dell to succeed in this difficult period. Dell trained with Tilmann Riemenschneider in Würzburg sometime between 1505 and 1510. Stylistic affinities would suggest that he also apprenticed with Hans Leinberger in Landshut in the mid-1510s. Dell's debt to Leinberger is evident when comparing their pearwood *Crucifixion* reliefs now in Berlin (SMBPK, Skulpturengalerie) and Munich (Bayerisches Nationalmuseum).[47] (figs. 41 and 42) Both are fairly small with Leinberger's measuring 21.9 by 15.2 cm and Dell's 26 by 17 cm. Leinberger signed and dated his work "[15]16"; Dell's *Crucifixion* can be assigned to the period 1525–30.

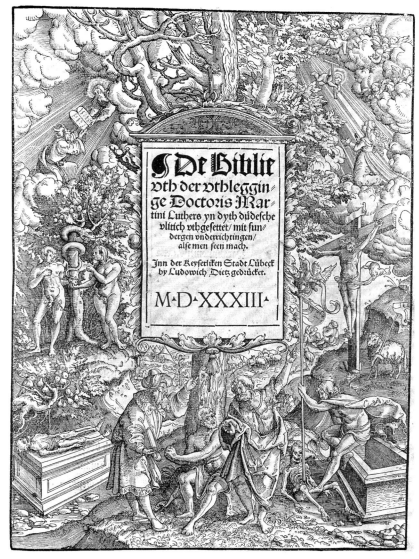

40. Erhart Altdorfer, Title Page, 1533, woodcut, *De Biblie vth der vthlegginge Doctoris Martini Luthers . . .* (Lübeck: Ludwig Dietz), Wolfenbüttel, Herzog August Bibliothek, Sign. Bibel-S, 2° 107

At first glance it is obvious that Dell has borrowed both Leinberger's composition and something of his powerfully emotional style. Yet Dell has transformed Leinberger's rather compressed scene into an elegant house altar mixing free and relief figures. Dell distances Christ both from the commotion below and from the flanking thieves. This permits an undisturbed view of the sacrificial Christ. Without losing his model's narrative animation, as evidenced by the soldier mocking the fainted Virgin, Dell has adeptly elongated his figures. Their ele-

gant costumes, with minute attention to the folds in the case of John the Evangelist, and twisting poses convey a refinement rarely found in Leinberger's art. Like his other small sculptures, the *Crucifixion* was intended for an affluent, sophisticated patron.

Dell's talents gained him a position as the court sculptor to Heinrich the Pious, Duke of Saxony in Freiberg, from about 1528 until late 1533 or early 1534 when he was again recorded in Würzburg.[48] During these years Dell created at least four attrac-

41. Peter Dell the Elder, *Crucifixion*, 1525–30, Berlin, SMBPK, Skulpturengalerie

tive lindenwood reliefs that help document Heinrich's growing Lutheran sympathies. Although Katharina, his wife, embraced Protestantism as early as 1524, Heinrich's conversion was more gradual. In 1528 Dell made the *Crucifixion* now in Dresden (Staatliche Kunstsammlungen, Grünes Gewölbe).[49] The scene is strongly reminiscent of Dell's Berlin *Crucifixion* though the horizontal format of this large (39 x 50.5 cm) relief permits the artist to expand his composition to include more figures, such as the rearing horse or the soldiers gambling for Christ's garments, and more land-

scape details. The righthand soldier holding the hand of the child astride a stick derives directly from Leinberger's Munich relief. In sharp contrast with the Berlin *Crucifixion*, the carving in this and the other Dresden sculptures is very shallow.

If the iconographic program of the *Crucifixion* follows contemporary depictions, that of the *Resurrection*, monogrammed and dated 1529, does not.[50] (fig. 43) In the center, Christ rises triumphantly upwards in a radiant cloud filled with angels as the soldiers guarding his tomb look on helplessly. Christ stands upon the defeated Satan signifying his

42. Hans Leinberger, *Crucifixion*, 1516, Munich, Bayerisches Nationalmuseum

power to overcome death. From his mouth comes the words: "attolite po . . . as principes vestras psal. 23" ("Lift up your heads, O ye gates; and be ye lift up, ye everlasting doors; and the King of glory shall come in, Psalm 24:7").[51] With his right hand he points to the inscription tablet held by an angel. This reads "Cristus expolians principatus et potestates traduxit, fide ter pala triumphans illos in se ipso colo 2" ("And having spoiled principalities and powers, he made a shew of them openly, triumphing over them in it, Colossians 2:15"), Paul's counsel concerning complete union with Christ. His banner bears the text "O HA. IIEGOSURE SVRECCIETVITA" ("I am the resurrection and the life," John 11:25), the word's that Christ spoke to Martha while resurrecting Lazarus.

The *Resurrection* relief includes two further scenes. Within the left-hand grotto stands an angel by the open tomb signifying that Christ has indeed risen. The twin towers of hell appear on the right. Lucifer, crowned and with a scepter in the upper

right-hand window, is powerless to stop Adam, Eve, John the Baptist, and the horde of others who through Christ's resurrection are now freed from limbo. One of Luther's central tenets stressed that the individual's hope for eternal life was based on Christ's own resurrection.[52] Beneath the feet of Adam and Eve is a final tablet inscribed "TV DNE IN SANGUE TESTAMENTVM (DVXISTI) VINCIT D-S DE LACV ZACHA 9" ("As for thee also, by the blood of thy covenant I have sent forth thy prisoners out of the pit wherein is no water, Zechariah 9:11").

Dell's carving reveals Luther's influence in two ways. First, the theme was particularly important to Luther. He placed great significance upon the Descent into Limbo since by this action Christ defeated sin, death, the devil, and hell while liberating from this "Egyptian jail" all believers who could now join God in heaven.[53] And second, Dell incorporated numerous biblical texts into his composition. This reflects Luther's constant emphasis upon scripture, the word of God, as the true guide for Christians. The practice of combining text and image would become one of the defining characteristics of Lutheran art from the 1530s onwards. It was intended to enrich the mind as well as the eyes thus mollifying Protestant critics of religious art who condemned the physical allure of earlier Catholic church art. The power of the visual image thus is joined with the authority of scripture. Although this union of text and image may have been initiated by Lucas Cranach the Elder, Luther's close friend, Dell was among the earliest and most creative practitioners.[54] He was the first true sculptor of Lutheran themes.

The third Dresden relief presents *Law and Gospel*, an allegory of the Old and New Testaments.[55] (fig. 44) This Lutheran subject, alluded to in our discussion of the Lübeck pulpit, was first developed by Cranach in about 1529.[56] Dell probably learned of it through his patron Heinrich the Pious who maintained close contacts with Wittenberg and who in 1528 or 1529 sat for the portrait by Cranach, or a member of his workshop, that is now in Kassel (Staatliche Kunstsammlungen).[57] In the center stands a tree to set up the antithesis between the Old and the New Laws. On the left or barren side of the tree are scenes of the Temptation of Adam and Eve, the Brazen Serpent, and Moses Re-

43. Peter Dell the Elder, *Resurrection*, 1529, Dresden, Staatliche Kunstsammlungen, Grünes Gewölbe

ceiving the Law. Opposite on the living side of the tree are, besides the Crucifixion, the Annunciation to the Virgin on the distant hillside, and the resurrected Christ who stands upon the world thus signifying the defeat of death and the devil. In the lower foreground stand John the Baptist with the Lamb of God and the prophet Isaiah who direct the sinner's attention to Christ. While the Old Law brought no hope for the individual because of man's fall, the New Testament offered redemption to mankind because of Christ's sacrifice. This distinction was important for Luther who wrote in 1532:

This difference between the Law and the Gospel, is the height of knowledge in Christendom. Every person and all persons who assume or glory in the name of Christ should know and be able to state this difference. If this ability is lacking, one cannot tell a Christian from a heathen or a Jew; of such supreme importance is this differentiation.[58]

The texts are now all in German not Latin. For instance, Isaiah's tablet reads "NIM WAR EIN IVN FRAU EMPFET VND GEPIRT ISAI 7"

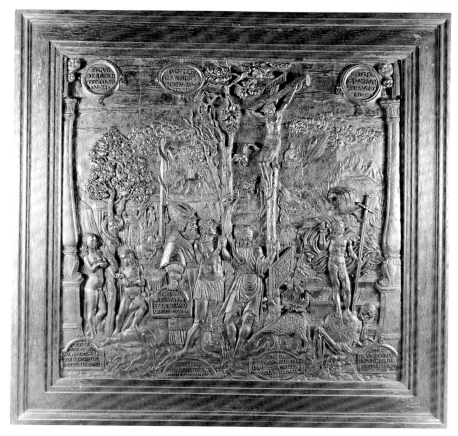

44. Peter Dell the Elder, *Law and Gospel*, c. 1529–30, Dresden, Staatliche Kunstsammlungen, Grünes Gewölbe

("[The Lord himself will give you a sign.] Behold, a young woman shall conceive and bear a son, Isaiah 7:14"). Dell's exact pictorial source is uncertain since the theme quickly gained popularity from 1529. For instance, it is found on several Lutheran Bibles including Erhart Altdorfer's title page to the Lübeck German Bible of 1533.[59] (fig. 40)

Although Dell returned to Würzburg in 1534 and established a successful career carving funerary monuments throughout this Catholic bishopric, he continued producing these wooden doctrinal panels for Protestant patrons.[60] He apparently had little difficulty working for Catholics and Lutherans alike. For instance, in the mid-1540s he completed both the tomb of Bishop Konrad von Bibra in Würzburg Cathedral and the *Allegory of Redemption* relief, formerly in Berlin, with its portrait of Luther administering the sacrament of communion. (fig. 119) In all likelihood, his Catholic benefactors

never knew about his Protestant reliefs since these sculptures were for private use. Their relatively small scale plus their visual and textual complexities precluded their use for a large audience.

In 1534 Dell finished his finest Protestant relief, the monogrammed *Allegory of Faith*, now in Nuremberg (Germanisches Nationalmuseum).[61] (fig. 45) Once again the complexity of the program suggests that the artist collaborated closely with a Lutheran theologian. Yet Dell has transformed dogma into a beautiful work of art characterized by its clear composition, its crisp, clean carving, and its myriad of carefully executed details. Seated in a ship is the female personification of the human soul who is clad in fashionable contemporary attire. The ship's voyage is analogous to the pilgrimage of life.[62] She leaves behind a land in flames in search of heavenly Jerusalem where Christ stands triumphantly upon the world, death, and the devil. The ship is made of

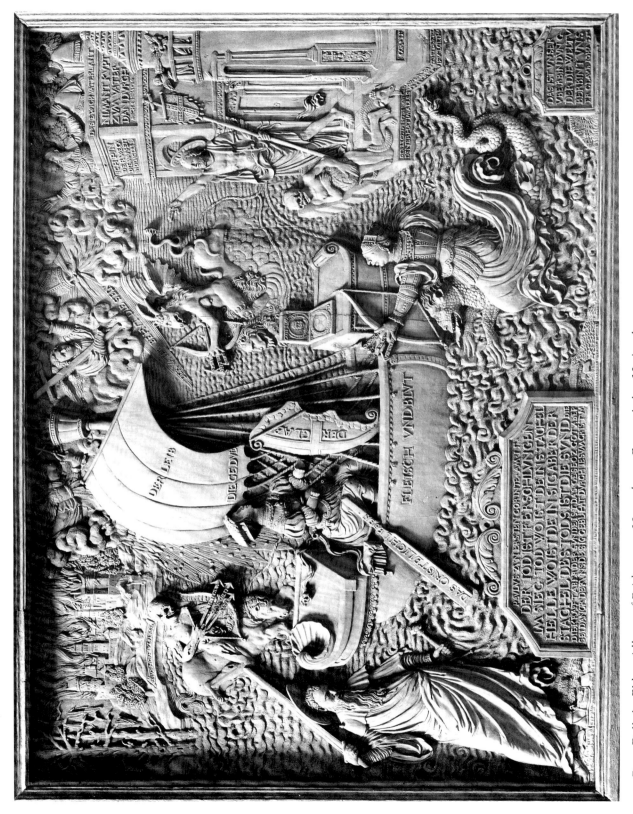

45. Peter Dell the Elder, *Allegory of Faith*, 1534, Nuremberg, Germanisches Nationalmuseum

flesh and blood ("Fleisch vnd Blut"); its sail is love and patience. She is aided by the shield of faith, by the rudder of Christian life, and by the compass that is inscribed "Gottes Wort" or the word of God. Dell's monogram appears on the compass to signify his confessional belief. The voyage is not without its dangers as Frau Welt or the world, death, and the devil are poised to attack the vessel. Each of their arrows is labelled. For instance, those of death represent hunger, sickness, and old age. The Christian soul stares heavenwards to God who vows to protect her. Completing the allegory is the menacing figure of St. Paul at the lower left. His message is contained in the principal inscription tablet, which reads "Death is swallowed up in victory. O death, where is thy sting? O grave, where is thy victory? The sting of death is sin; and the strength of sin is the law. But thanks be to God, which giveth us the victory through our Lord Jesus Christ" (I Corinthians 15:54–7).

Was Dell's allegory carved for a Protestant patron in Nuremberg? With its 1534 date, the relief was likely made after the artist's return to Würzburg. The core of the program derives from the poem *Die christliche Geduld* (*Christian Patience*) that Hans Sachs of Nuremberg published in 1531.[63] The original woodcut illustrating the poem survives only in a c. 1580 copy. This offers a greatly simplified version of the composition that, among other things, lacks St. Paul, Christ on the shore, and many of the lengthier inscriptions. Sachs' prints enjoyed a broad regional circulation though Nuremberg always remained his primary audience. A possible Nuremberg connection is also suggested but not proven by the carving's provenance. Dell's relief can be traced back to 1860 when it hung in the Kaiserkapelle of Nuremberg castle.[64] Since many of the other items in the castle had been civic property for centuries, it is possible that this relief may have been a much earlier gift from a local patrician to the council of this staunchly Protestant town.

Peter Dell flourished during the second quarter of the sixteenth century because of his flexibility and inventiveness. He was able to adapt to the changing religious environments in which he worked whether in Protestant Freiberg or Catholic Würzburg. Following the lead of Lucas Cranach, the foremost creator of new Lutheran pictorial im-

ages, Dell devised the earliest sculptural counterparts. He produced the first Lutheran religious reliefs and demonstrated that such carvings had a legitimate place within the new evangelical community. His achievement is all the more significant when one recalls that between 1528 and 1534 iconoclastic riots broke out in many northern and central German cities. Furthermore, his compositional skills and refined cutting transformed his themes from potentially dry statements of doctrine into visually appealing scenes appropriate for his sophisticated clientele. As we shall see later, Dell applied a similar level of sophistication to his secular reliefs and statuettes.

HANS REINHART

Hans Reinhart provides a fourth response to the challenge of the Reformation.[65] Initially he created portrait medals, such as those of Johann Friedrich, Elector of Saxony, and Cardinal Albrecht von Brandenburg, both dated 1535.[66] (fig. 46) In the following year he pioneered a new artistic form—the religious medal, such as the one depicting the *Fall of Man* on the obverse and the *Crucifixion* on the reverse.[67] (fig. 47) This allegory of fall and redemption, a theme central to Lutheran theology, was commissioned by Johann Friedrich as evidenced by the accompanying explanatory text, his coats of arms, and his motto "Spes Mea in Deo Est" ("My hope is in God"). The *Crucifixion* also includes a secondary scene of the resurrected Christ standing on death and the devil plus another text about Moses and the Brazen Serpent, its Old Testament typological counterpart. The sculptor draws upon the same repertory of evangelical themes utilized earlier by Cranach and Dell.

Reinhart's artistic association with the Lutheran reform movement in Saxony expanded in 1539, the year that he acquired Leipzig citizenship. The political control of the Albertine duchy of Saxony changed on 17 April when Georg the Bearded, the staunch Catholic ruler, died and was succeeded by his brother Heinrich the Pious, Dell's former patron. Determined to convert the duchy, Heinrich convened a meeting of leading evangelical rulers and theologians in Leipzig on 24 and 25 May. Johann Friedrich, Luther, Philipp Melanchthon, Justus Jonas, and Friedrich Myconius were among

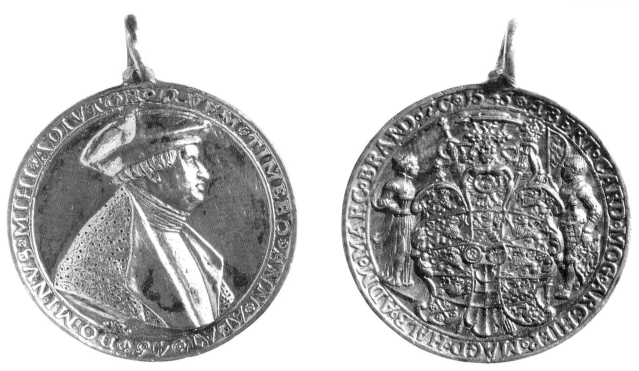

46. Hans Reinhart, *Portrait of Albrecht von Brandenburg*, 1535, Nuremberg, Germanisches Nationalmuseum

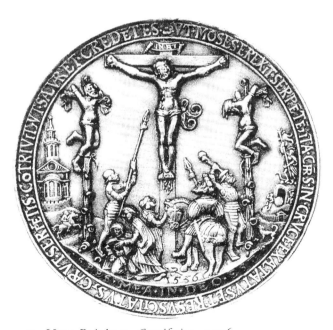

47. Hans Reinhart, *Crucifixion*, 1536

the participants who charted a course of action.[68] In this year Reinhart produced a portrait medal of Myconius, who was one of the two principal implementors of Heinrichs Agende or conversion program, and an Apocalypse medal.[69] (figs. 48 and 49) The obverse depicts St. John's vision of Christ ("the son of Man") standing amid the seven candlesticks (Apocalypse 1: 9–20 and 2:1); the reverse shows God with the Lamb surrounded by the 24 elders (Apocalypse 4: 1–11 and 5: 1–14). While it would be incorrect to say that all images of the Apocalypse are Protestant, Reinhart's audience would have understood the confessional bias of his medal. These two scenes derive from the first two illustrations by Cranach the Elder for *Das Newe Testament Deutzsch* or *September Bible*, Luther's translation that was published by Melchior Lotther the Younger in Wittenberg in 1522.[70] Luther collaborated closely with Cranach, and presumably it was the reformer who decided that only the Book of the Apocalypse would be illustrated.[71] The numerous later versions, including the Lübeck Bible of 1533,

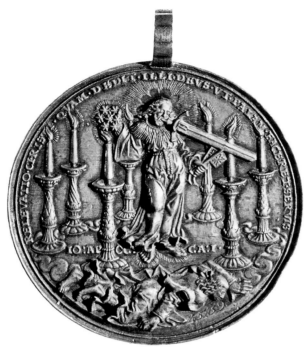

48. Hans Reinhart, *Apocalypse*, obverse, 1539, Munich, Staatliche Münzsammlung

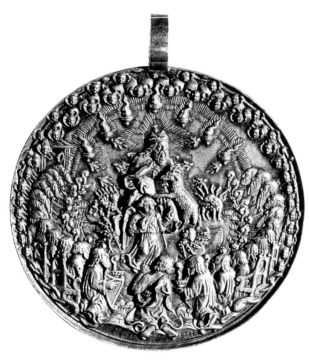

49. Hans Reinhart, *Apocalypse*, reverse, 1539, Munich, Staatliche Münzsammlung

continued to reproduce either Cranach's woodcuts or variants after them. Furthermore, by the late 1530s Lutheran literature and visual propaganda commonly equated the pope with the Antichrist and the Catholic church with the whore of Babylon.[72] In 1540, in the aftermath of the Leipzig convention, Duke Heinrich commissioned Sebald Beham to devise two elaborate Protestant allegories of faith that, in all likelihood, Reinhart was intended to make into the obverse and the reverse of another medal.[73] Unfortunately, Heinrich died in 1541 before the project was completed.

Reinhart's finest medal, the *Trinity*, was created in 1544 for Duke Moritz, Heinrich's son and heir.[74] (fig. 50) It was commonly known as the *Moritzpfennig* or Moritz's penny. Measuring 10.3 cm., this is the largest and most technically complex of Reinhart's medals. In fact, the raised cross had to be cast separately and joined to the medal proper. The *Moritzpfennig* is not strictly a Protestant medal. Rather it reflects Moritz' political posture of the mid-1540s. Upon assuming his office Moritz carried through his father's suppression of the Catholic church within the duchy of Saxony, yet he also adopted a more moderate position that set him between Johann Friedrich and the members of the Schmalkaldic League on one side and Charles V, the Catholic emperor, on the other.[75] Reinhart's medal can be interpreted as a statement of their common Christian faith. Luther addressed the subject of the Trinity on several occasions and his ideas are summarized in the first article of faith in the Augsburg Confession of 1530.[76] Nevertheless, the *Gnadenstuhl* or throne of grace form of Trinity that Reinhart employed can be found commonly in pre-Reformation art and lacks any specific Protestant associations. Surrounding this heavenly apparition of the Trinity is the inscription "PROPTER SCELVS POPVLI MEI PERCVSSI EVM ESAIAE LIII" (". . . for the transgressions of my people was he stricken, Isaiah 53:8"), an allusion to Christ's sacrifice for all mankind. The reverse is dominated by the large inscription tablet held aloft by two angels. The text on the nature of the Trinity derives from the Athanasian Creed.[77] Since the Creed was then accepted by both Catholics and Lutherans, it served as a reminder of their common Christian heritage. Moritz coat of arms, name, title, and that the medal was created by Reinhart in Leipzig in

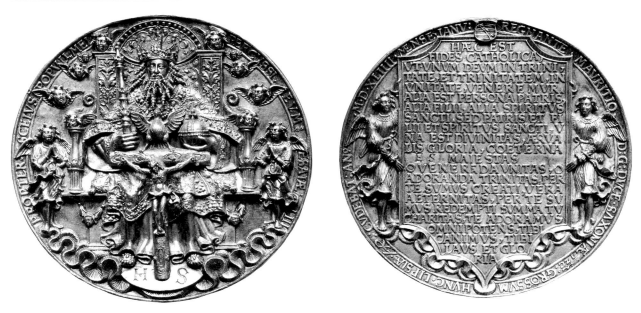

50. Hans Reinhart, *Trinity (Moritzpfennig)*, 1544, Vienna, Kunsthistorisches Museum

January 1544 are contained in the remaining inscription.

These religious medals were cast in multiple copies, though the original edition was certainly never more than a few dozen. Since the majority of Reinhart's religious medals were made of silver, the audience was affluent. Most likely these medals were commissioned by princes such as Johann Friedrich, Heinrich the Pious, and Moritz, and then were given to their lay and clerical political allies.[78] The *Trinity* medallions were too large to wear and were, therefore, kept in chests or cabinets. The Munich example of the *Apocalypse* is fitted with a ring at the top permitting it to hang from a chain or pin. (figs. 48 and 49) When worn, the medal became a statement of the individual's faith and his confessional affiliation in the same way that sporting a portrait medal of Johann Friedrich or Cardinal Albrecht von Brandenburg would have indicated the person's political allegiance.[79] (fig. 46) Religious medals enjoyed tremendous popularity later in the sixteenth and early in the seventeenth centuries especially as the centennials of major Lutheran events were commemorated.[80] Reinhart's works represent the nascency of this phenomenon.

Reinhart remained active until his death in 1581. The majority of his religious medals, excluding reissues, date between 1536 and 1544. A commemorative portrait of Luther was issued in 1547.[81] In spite of his temporary success, Reinhart increasingly turned away from medal production of any kind. In 1540 he began experiencing troubles with Leipzig's goldsmith guild who claimed that he should be subject to their regulations since he worked in silver. Reinhart had to serve a five year apprenticeship under goldsmith Georg Treutler, and it was the city council not the guild that finally approved his three masterpieces in 1547. Given the relative dearth of later medals, Reinhart must have earned his living primarily as a goldsmith and seal cutter.[82]

FROM THIS BRIEF EXAMINATION of these four artists, who were among the most successful of the period, we find that the Reformation and the Catholic reaction to it had a debilitating effect upon the course of German sculpture. Loy Hering enjoyed constant patronage yet the variety of his commissions was remarkably limited. His late oeuvre consisted almost exclusively of epitaphs and tombs. This was an era of few great religious commissions even in staunchy Catholic lands. Though attractive, the *Holy Grave* carved by a middle Rhinish

sculptor in 1531 for the Liebfrauenkirche in Trier or the marble *Altar of Abbess Wandula von Schaumberg* (Regensburg, Cathedral Treasury) of 1535–40 are more noteworthy because of their dates rather than their artistic merits.[83] Faced with changing attitudes about church art and with a sharp drop in the laity's capital support, sculptors were forced to develop new types of carvings. In addition to his funerary monuments, Peter Dell devised small-scale reliefs that were intended for personal devotional purposes. He was the first master who repeatedly translated Lutheran iconographic programs into skillfully cut lindenwood reliefs that were at once spiritually and aesthetically edifying. Dell's refinement appealed to his princely and clerical patrons. Dreyer was not so fortunate since he found fewer opportunities in Lutheran Lübeck. His powerful figures and rather rough cutting technique were ideal for the Lübeck pulpit but less suited to small-scale carvings. For approximately a decade, Hans Reinhart pioneered the religious medal for his Saxon clients; however, he too turned from sculpture in order to support his family. In general, the artistic situation for sculptors of religious art would dramatically improve but not until much later in the sixteenth century.

Complex Church Programs

With the lack of active lay patronage during the period from the mid-1520s until 1555, it fell to the leading ecclesiastical and secular princes to sponsor the few significant sculptural projects. Not surprisingly, the resulting sculptural programs carefully reflected the confessional attitudes of their donors. I wish now to look at Cardinal Albrecht von Brandenburg's foundation of the Neue Stift in Halle and at the palace chapels that Ottheinrich, Count Palatine, and Johann Friedrich, Elector of Saxony, built at Neuburg an der Donau and Torgau. While these churches provide clear models for discussing the distinctions between Catholic and Protestant decorative campaigns, these are also the only major religious cycles of this era. Halle offers a reaffirmation of Catholic beliefs in the power of saints and the efficacy of art; Neuburg and Torgau represent coherent attempts to develop a specifically Lutheran form of church art. Halle would be

the last Catholic campaign until late in the sixteenth century. Neuburg and especially Torgau would provide the foundation for an ever-growing corpus of Lutheran sculptural ensembles. Given the rhetoric about images in the 1520s, it is ironic that the Protestants, not the Catholics, emerged as the primary patrons of religious sculpture from the 1540s until the 1570s.

THE NEUE STIFT AT HALLE

The stories of the Neue Stift and its creator Albrecht von Brandenburg are intimately bound together. Albrecht (1490–1545) was Germany's highest ranking Catholic official and one of the greatest Renaissance art patrons. (fig. 46) As the second son of Johann Cicero, elector of Brandenburg, Albrecht rose rapidly to power. In 1513, at age 23, he was named archbishop of Magdeburg and bishop of Halberstadt. In the following year Albrecht added the titles of archbishop and elector of Mainz plus the attached office of archchancellor of the Holy Roman Empire. Finally in 1518 Pope Leo X elevated him to cardinal.[84] These offices, however, did not come cheaply as Albrecht borrowed heavily from the Fuggers and other Augsburg bankers to finance his appointments. The infamous sale of indulgences that Albrecht sponsored to repay his debts provoked stinging criticism from many Catholics and nascent Protestants alike. In another era or even in a slightly earlier decade Albrecht, the enlightened and humanistically inclined prince, might have been universally admired. Yet as the leading German Catholic cleric during the formative years of the Reformation, Albrecht personified the church and its abuse of power. As such he was the target of considerable vitriolic commentary. Martin Luther derisively dubbed him the "idol of Halle," a reference to his collection of relics and his adherence to Catholic devotional practices.

Albrecht founded the Neue Stift at Halle at this critical moment when the Catholic church was being assailed as never before. In fact, he was the only ecclesiastical prince to commission a significant artistic project during the 1520s and 1530s. While I doubt that the Neue Stift was planned initially as a specific response to the concurrent rise of Protestantism, it came to signify a reaffirmation of the

authority of the Catholic church and its traditional customs. As such the Neue Stift is a fascinating artistic and cultural monument. If its program and its decorations had survived intact, the Neue Stift would be among Europe's most celebrated churches.

Albrecht's ties with Halle began on 21 May 1514 when he made his inaugural entry into the city. Like Ernst von Wettin (Saxony), his predecessor as archbishop of Magdeburg, Albrecht chose Halle as his primary residence. Against the city walls Ernst had erected the Moritzburg, a fortified palace named for the patron saint of Magdeburg. Later in 1514 Albrecht elevated the Magdalenenkapelle in the Moritzburg to a Stiftskirche or collegiate church. This chapel soon proved too small for his burgeoning collection of art and holy relics so shortly after his investiture as cardinal Albrecht began to consider new locations for the Stiftskirche. On 13 April 1519 Pope Leo X approved the transfer to Albrecht of the Dominican cloister near the Moritzburg. In 1520 this church was redesignated as the Neue Stift, dedicated to Sts. Moritz and Mary Magdalene. For Albrecht this new church presented an unparalleled opportunity. Under the Dominicans its decoration had been sparse, and their few altarpieces moved with them across town. The cardinal now commanded a sizeable building, in measuring 69 meters in length, with no artistic program.[85] (Plan of Neue Stift at Halle; fig. 51) Between 1519 and the mid-1530s Albrecht commissioned at least 23 altarpieces, dozens of new reliquaries, and several important sculptural programs. As the project evolved, Albrecht also designated the choir as his future burial site. In order to transform this unadorned church into a Catholic paradigm, Albrecht imported talented craftsmen from throughout his lands, including his master mason and his court sculptor, Bastian Binder and Peter Schro, from Mainz. Binder embellished the exterior of this simple hall church by adding rounded gables to the perimeter of the roof. Schro carved the series of apostle statues in the nave. Matthias Grünewald, the cardinal's court painter from 1516 to about 1526, contributed at least one major altar; other pictures were made by Lucas Cranach, Albrecht Dürer, Hans Baldung Grien, and Simon Franck of Aschaffenburg.

The program of the Neue Stift was complex. Some of the essential sculptural features are indicated on the plan.[86] Sculptures, paintings, reliquaries, tapestries, and other objects filled the entire interior of the church. Collectively these items glorified Christ, the Virgin Mary, and the community of saints. Like St. Peter's in Rome or the Ste. Chapelle in Paris, the Neue Stift housed important holy relics; 21,484 fragments are catalogued. Albrecht perceived the church as a Christian pantheon. Each of the 15 altars lining the south and north aisles had a dual function.[87] First, the paintings, mostly after Cranach's designs, recounted sequentially Christ's passion from the Entry into Jerusalem to the Resurrection and Descent into Limbo. One could proceed from station to station during holy week and re-enact Christ's sacrifice for mankind. Albrecht's personal breviary exclusive to the Neue Stift, dating to 1532 and today in Bamberg (Staatsbibliothek, Msc. Lit. 119), confirms the dedications and prayers for each altar.[88] Second, each altar was dedicated to several different saints. For instance, the St. Augustine altar honored Augustine and the three other Latin church fathers plus Sts. Ignatius of Antioch, Nicolas, Anastasia, Aldegundis, Agathe, Dorothy, Cecile, Ottilie, and Gertrud.[89] On their respective feast days, their relics, housed in sumptuous silver shrines, would be processed through the church to this altar for specific veneration. Although few of the reliquaries survive today, 350 are illustrated in the Hallesches Heiltumsbuch now in Aschaffenburg (Hofbibliothek, ms. 14).[90] These miniatures, completed in 1526, record what was the most celebrated collection of relics in the German lands. In some cases plausible attributions to specific goldsmiths or, at least, to particular cities can be made. The bust of St. Ursula with its profile relief portrait of Albrecht on its base suggests a design by Cranach or one of his followers.[91] (fig. 6) If the Protestants questioned the power of saints especially as intercessors on mankind's behalf, Albrecht's response was a militant reaffirmation of their centrality to Catholic faith.

The choir's program illustrates both Albrecht's regard for Christian saints and his specific role within the church.[92] On the primary east-west axis were three major monuments: the reliquary of St. Moritz, the high altar, and Albrecht's tomb and epitaphs. (fig. 5) Albrecht ordered the reliquary statue of St. Moritz in the early 1520s.[93] Moritz

Halle, Neue Stift (later Cathedral)

A Display Chest with Relics

B–D Albrecht von Brandenburg's Tomb, Epitaphs, and Baldachin

E High Altar with Reliquary Shrines and the Portrait Busts of Albrecht von Brandenburg and Charles V

F Stalls

G Silver Statue of St. Moritz

H Choir Screen

I Pulpit

1	St. Peter	2	Christ
3	St. Andrew	4	St. Paul
5	St. James Major	6	St. John the Evangelist
7	St. James Minor	8	St. Bartholomew
9	St. Philip	10	St. Thomas
11	St. Simon	12	St. Matthias
13	St. Matthew	14	St. Jude
15	St. Mary Magdalene	16	St. Moritz
17	(St. Ursula) ?	18	St. Erasmus

Plan of the Neue Stift (later Cathedral) at Halle during the Reign of Cardinal Albrecht von Brandenburg

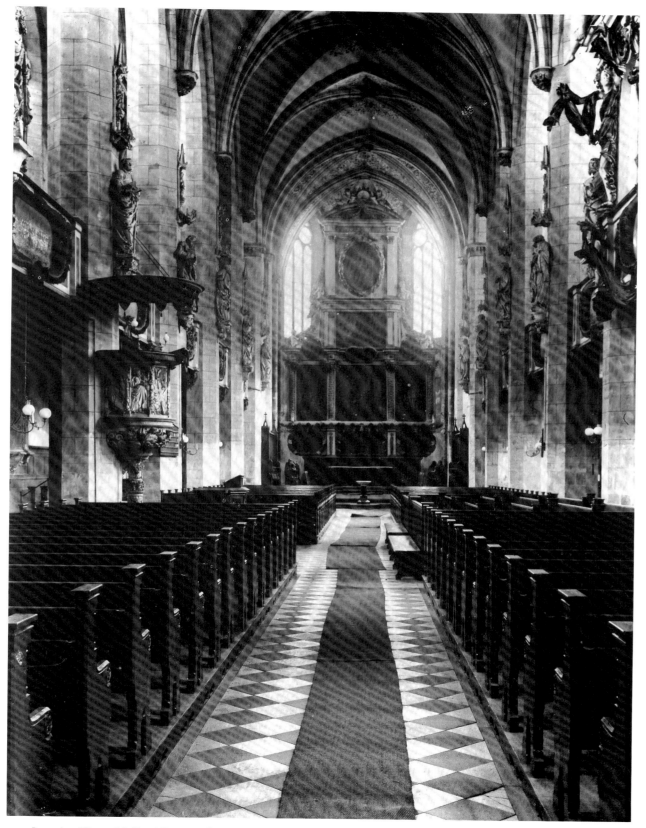

51. Interior View, Halle, Neue Stift (Cathedral)

was the patron of both the Neue Stift and the archbishopric of Magdeburg. The over life-size figure was made of silver with pearls and precious stones ornamenting his armor. Visually it must have been spectacular since it was illuminated by 13 standing lights plus further lamps on a hanging crown. A baldachin or canopy was placed over the statue. Interestingly, the Thebian martyr wears the collar of the chivalric order of the Golden Fleece. Ulrich Steinmann plausibly has suggested that the statue alludes to Charles V, the new Holy Roman emperor whom Albrecht recently helped elect and whom many hoped would, like the military saints before him, defend the Catholic church against its foes.[94]

Located a few meters behind St. Moritz in the upper choir was the high altar, which once again was covered by a canopy. In the center stood a life-size silver statue of Christ as the Man of Sorrows surrounded by numerous angels supporting the instruments of the passion.[95] Set on the altar table were silver portrait busts of Cardinal Albrecht and Emperor Charles V apparently in the guises of Sts. Adalbert and Charlemagne. Albrecht association with Adalbert (c. 956–997), the martyred bishop of Prague, is easy to understand.[96] Trained at Magdeburg, Adalbert experienced great pastoral and political problems within his diocese. Twice he sought Rome's support because of his travails. His life and his ultimate canonization offered a convenient historical model for the beleagured cardinal. In the second bust, Charles as a modern Emperor Charlemagne appeared crowned and held the imperial sword. He also wore the collar of the Golden Fleece, an allusion to his position as the reigning sovereign or chief of this chivalric order. This role adoption could be found frequently in the Neue Stift. For instance, adjacent to the south side of the altar hung a textile portrait of the emperor as St. Eustace. Painted portraits of Albrecht as St. Moritz and St. Martin, among others, were then to be observed in the aisle altars. The two busts of the high altar clearly articulate the pair's respective positions within the Holy Roman Empire. Albrecht is the ecclesiastical lord, the vicar of Christ, and heir to the community of Christian saints. Charles is the emperor, a title that extended unbroken back to St. Charlemagne. Furthermore, like Charlemagne, Moritz, and Eustace, Charles V was held to be a steadfast Christian knight who would defend the Catholic church against all heretics including the

Protestants. From the cardinal's point of view, the emperor and he were the true bulwarks of Christian faith in Germany. In addition to the statues of Christ, Albrecht, and Charles V, the high altar included on each side large shrines displaying the complete skeletons of 17 virgin martyrs who died with St. Ursula. Were these chosen for this spot as a reminder of an earlier German conflict between Christian faith and paganism?

The program of the choir culminated in Albrecht's impressive funerary program in the east end. Between 1522/23 and 1536, Peter Vischer the Younger and Hans, his brother, cast two brass epitaphs and a canopy; Loy Hering carved the now lost tomb stone that was set on axis directly beneath the canopy. (figs. 93–95) The specific features of this ensemble will be discussed in Chapter Five; however, it is necessary to observe here that on top of the canopy sits a cenotaph or chest flanked by angels bearing Albrecht's arms and four candle holders. He intended that his own physical remains be placed in this chest. Although Albrecht wished to use the tomb as a permanent memorial to his foundation of the Neue Stift, the prominent cenotaph would have provoked immediate comparisons with the surrounding saintly reliquaries; one final chest with relics was set in the eastern wall, visible through the canopy, and flanked by the two epitaphs. Given his frequent portrayal as a saint, Albrecht seemingly entertained serious aspirations to be included among this holy community.

This emphasis upon saints and the unbroken lineage of the true Christian community was reiterated in two further sculptural cycles. Wooden choir stalls, completed in 1530, line both sides of the chevet. These are highlighted by half-length busts of Christopher and other saints to inspire the clerics.[97] Second and much more significant are Peter Schro's 18 over life-size (1.95 m) statues of Christ, the apostles, and the patron saints of the Neue Stift that still ornament each pier of the nave and the lower choir.[98] (figs. 51–53) Schro, Mainz' leading stone sculptor succeeded his master(?), Hans Backoffen, as a Diener or court sculptor.[99] Between 1522 and 1526 he received special payments for his service to Albrecht. While the particular projects are not specified, he seems to have worked primarily upon these statues and, less certainly, on two dedication tablets.[100]

These statues dramatically reminded the congre-

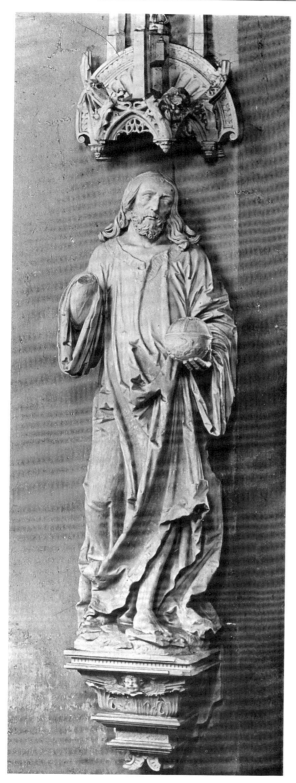

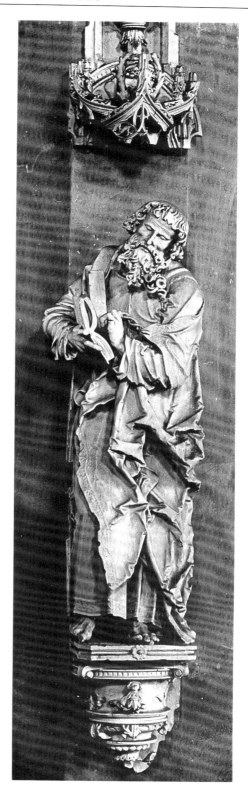

52. Peter Schro, *Salvator Mundi*, 1522–26, Halle, Neue Stift (Cathedral)

53. Peter Schro, *St. James Minor*, 1522–26, Halle, Neue Stift (Cathedral)

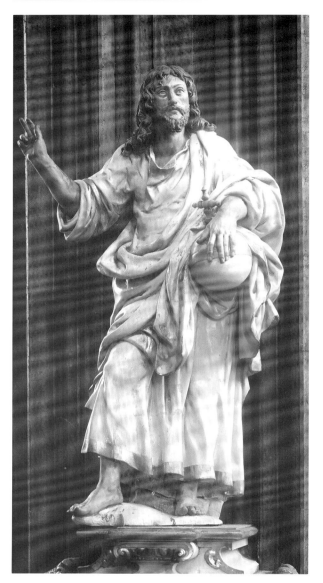

54. Jeremias Geisselbrunn, *Salvator Mundi*, c. 1624–31, Cologne, Maria Himmelfahrt

bunches. This nervous, highly linear style is even more accentuated in *St. James Minor* whose robe ripples with life. The thick strands of hair seem to move with the light. The drapery, the arms, and his gaze focus our attention upon the Bible, the object of his profound meditation. Schro has endowed each statue with a different pose and a varied, though always realistic, facial type. Each figure stands upon an ornamented console. The accompanying tabernacle includes a statuette of an additional saint, such as Dorothy, George, or Christopher.[101]

Was it coincidental that Christ and Peter head this series and that they flank the high altar with its portraits of Albrecht and Charles V? The Catholics traced their authority directly through Peter, who founded the Roman church, to Christ. This cycle reinforces their claim as the sole legitimate church. In fact, Schro underscores St. Peter's role by placing the Virgin Mary, the mother of the Christian church, in the tabernacle above his head. Apostle cycles were not uncommon in the late Middle Ages and early Renaissance.[102] These literally signified that the apostles were the pillars of the Christian church. Beneath the statue of St. Paul is inscribed in Greek: "I am made all things to all men, that I might by all means save some." The text comes from I Corinthians 9:22 and specifically from Erasmus' 1516 edition of St. Paul.[103] Not only does this reveal Albrecht's humanistic inclinations but it also defines the ultimate purpose of the whole decorative program of the Neue Stift. Like Paul, Albrecht hoped to save souls, and the abundance of art was a means to this end. Schro's powerful statues anticipate the exuberant cycles of the early seventeenth century, such as Jeremias Geisselbrunn's series in Maria Himmelfahrt in Cologne.[104] (fig. 54)

Albrecht's personal imprint is further evident in the program of the sandstone pulpit that Ulrich Kreuz completed in 1526.[105] (fig. 55) In the lunettes on each side of the doorway of the pulpit are nearly identical reliefs depicting the Man of Sorrows. That is, the Christian message begins with Christ and his sacrifice. Ornamenting the staircase are four reliefs of the Latin church fathers. The basket of the pulpit is decorated with the figures of Sts. John the Evangelist, James the Major, Paul, and Peter, while busts of Moses and the four evangelists appear immediately below; John has

gation of the living foundation of the Christian church. Christ is a dynamic *Salvator Mundi*. He stares at and is poised to stride towards the congregation. The weight shift of the legs and the slight twist of his torso accentuates his human character as does the seemingly accidental drooping of his robe at his neck. The sculptor has mixed long, deeply cut gatherings of fabric with tight, agitated

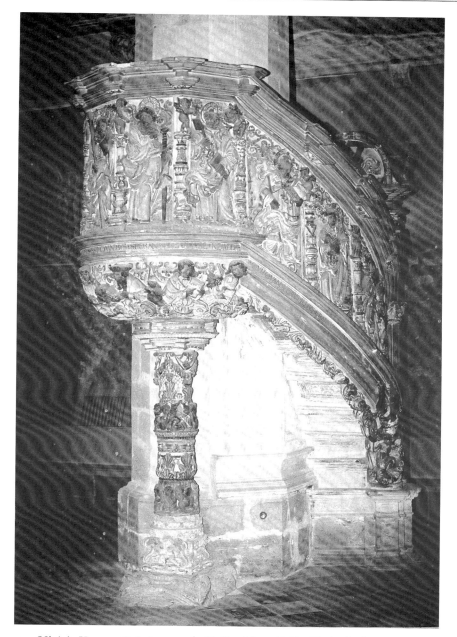

55. Ulrich Kreuz, Pulpit, 1526, Halle, Neue Stift (Cathedral)

the unusual distinction of being represented twice. Like most Christian humanists, Albrecht believed that all of the words of God, from both the Old and New Testament, were important. This point is made prominently in the bold inscription from Proverbs 30:5–6: "Every word of God is pure: he is a shield unto them that put their trust in him. Add not unto his words, lest he reprove thee, and thou be found a liar." In this instance, Albrecht's stress upon God's word is not very different than his Protestant critics. Nevertheless, it is doubtful that Martin Luther would have appreciated the fact that the bearer of this inscription, who appears on the staircase, is the classical messenger Mercury

dressed in a winged helmet and pseudo-antique armor. This unprecedented introduction of Mercury, a union of the sacred and the profane, can only be attributed to the cardinal. Albrecht's interest in the classical world is well-known. For instance, he sponsored scholars Johannes Huttich and Dieter Gresemund whose *Collectanea antiquitatum* of 1520 includes descriptions of Roman tombstones and sarcophagi found in and around Mainz.[106] Here Mercury, messenger of the gods, symbolizes both eloquence, a trait necessary for spreading God's word, and the yielding of the classical to the Christian world.

The whimsical character of Kreuz's stone pulpit stands in sharp contrast with Dreyer's pulpit formerly in Lübeck. (fig. 37) Dreyer's mood is one of serious urgency. The simple, spare design of the latter's plain wooden pulpit emphasizes only Christ and the primacy of his word. Kreuz's rich stone pulpit with its once delicate painting reflects the sumptuous character of the Neue Stift and its patron. Nevertheless, Kreuz's squat figures lack the energy and moral authority of Dreyer's Christ.

Although Schro's apostle cycle and Kreuz's pulpit nicely conform with the Neue Stift's fundamental emphasis on the community of saints, these projects also seem to respond to Albrecht's Protestant critics. In answer to those who questioned the Roman church's legitimacy, the cardinal, through his art, argues that the foundation of the Christian church is based on Christ's apostles and his saints. It is hardly accidental that St. Peter, the rock of the church and the guardian of heaven, is placed directly to Christ's right hand. The pulpit articulates the paramount importance that the Catholic church places upon the word of God. As the vicar of the German Catholic church, Albrecht used these artistic programs to state his fundamental beliefs. Perhaps in 1526 Albrecht still harbored hope that the Protestants could be brought back into the bosom of the mother church by stressing their common bonds. Christian unity, however, was not to be.

For almost two decades Albrecht von Brandenburg single-handedly strove to make the Neue Stift in Halle one of Germany's richest churches. He transformed the bare Dominican cloister into a glorious shrine for his vast collection of holy relics. In distinct contrast with his Protestant and even most of his Catholic contemporaries, Albrecht celebrated the community of saints by commissioning reliquaries, sculptures, and paintings that honored their memory. The quality of this artistic treasure was astounding. Conceivably, Albrecht might initially have been inspired by the contemporary building and decorative programs of St. Peter's in Rome for which he helped to raise funds.[107] The cardinal sought to make the Neue Stift both a monument to his religious piety and a bold symbol of militant Catholicism in Germany.

Unfortunately, Albrecht was more adept as a connoisseur than as an effective politician. In 1535 Hans Reinhart produced an attractive portrait medal of Albrecht. (fig. 46) His arms and the two patron saints of the Neue Stift are proudly displayed on the reverse. The positive image represented there contrasts sharply with the cardinal's growing financial and political problems.[108] Prompted by declining income, Albrecht ordered jewelry and, later, reliquaries from the Neue Stift to be pawned or sold both privately through agents and, more publicly, at the great Leipzig fair. The silver bust of Emperor Charles V, formerly on the high altar, is documented in Leipzig in 1538.[109] The Magdeburg cathedral chapter complained bitterly that Albrecht was disposing of items that they rightfully owned. Concurrently, Lutheranism continued to gain support in Halle. The cardinal responded harshly to the election of an all Protestant town council in 1534. Expulsions and censorship further embittered the local populace. On 27 January 1540, Albrecht, believing himself to be dying, made a new will.[110] The situation in Halle had deteriorated so badly that he declared his intention to be buried in Mainz cathedral; his tomb was later carved there by Dietrich Schro, Peter's son.[111] (figs. 122 and 123) The transfer of the relics and portable artistic treasures from the Neue Stift had already begun. The organ, church bells, and a few reliquaries were sent to Magdeburg. Most of the Halle treasures were divided rather haphazardly between Mainz cathedral and Aschaffenburg, Albrecht's other residential seat. When the final Catholic mass was sung in the Neue Stift on 22 March 1541, the church had been stripped of everything except the stone sculptures and the choir stalls. What had taken years to plan and create was dispersed overnight. Many items continued to be sold. For example, in 1541 a great silver statue of

St. Moritz, most likely the one that formerly stood in the choir at Halle, was melted down in Nuremberg.[112] Much of the art disappeared during later wars, most notably the Margrave's War of 1552–54 and the Thirty Years War (1618–48).[113]

The Neue Stift at Halle, the creation of Albrecht von Brandenburg in the 1520s and early 1530s, was unquestionably one of the greatest artistic accomplishments of the Renaissance. The cardinal boldly reasserted Catholic doctrines through the church's artistic programs. His failure to retain Halle in 1541 and the subsequent dispersal of much of his collection, most notably the reliquaries, following his death in 1545 testify to the beleaguered state of the Catholic church in Germany. Halle embraced Protestantism in 1541, and the Neue Stift would become a Lutheran cathedral in 1688. The demise of the Neue Stift signaled the end of the magnificent age of German church art that had flourished as never before during the fifteenth and early sixteenth centuries. This hiatus would continue until late in the century when once again grand Catholic programs in Munich, Augsburg, and other centers began to emerge.

NEUBURG AN DER DONAU

During these years a much more modest chapel was being erected in Neuburg an der Donau by Ottheinrich (1502–59), count Palatine.[114] The Neuburg Schlosskapelle is a fascinating transitional monument that stands between Halle, the archetypal Catholic program, and Torgau, the first true Protestant chapel. When the chapel was built in 1530, as part of the new western wing of the palace, Ottheinrich was a Catholic. (Plan of Neuburg an der Donau Palace) Yet by the time of its completion in 1543 he had converted to Lutheranism. Little is known about the chapel's original decoration since Ottheinrich probably took most of the portable objects with him in 1544 when, bankrupt, he was exiled to Heidelberg and later Weinheim. Neuburg was also sacked by imperial troops in 1546 because of Ottheinrich's ties with the Protestant Schmalkaldic League. Nevertheless, Hans Vischer's brass relief, Martin Hering's stone Crucifixion Altar, and Hans Bocksberger's painted ceiling provide an idea of the chapel's original beauty and its theological program.

Hans Vischer's *Christ and the Canaanite Woman* offers the key for understanding Ottheinrich's chapel.[115] (fig. 56) The brass plaque, dated 1543, was placed directly over the principal entrance to the Neuburg Schloss chapel. Since this doorway is located along the narrow passageway between the palace portal and the central courtyard, the relief would be seen by all coming into or exiting the palace. The plaque is relatively large (121 x 85 cm) and simple in its composition so even in the darkness of the passageway it is legible. Christ stands conversing with the Canaanite woman who has stopped him to beg his help in curing her possessed daughter (Matthew 15:21–8). Although Christ reminded her that she was not a Jew, he was moved to perform the miracle because of the strength of her faith. "Then Jesus answered and said unto her, O woman, great is thy faith: be it unto thee even as thou wilt. And her daughter was made whole from that very hour" (15:28).

The story perfectly illustrates the Lutheran doctrine of salvation by faith. Martin Luther cited the story of the Canaanite woman on several occasions to stress the importance of persevering in one's faith. In his lectures on Genesis, which were delivered between 11 April and 13 July 1542, he said

This was assuredly a beautiful and illustrious faith and an outstanding example which shows the method and skill of striving with God. For we should not immediately cast aside courage and all hope at the first blow but press on, pray, seek, and knock. Even though He is already thinking of leaving, do not cease but keep on following Him just as the Canaanite woman did.[116]

The story had further relevance since the Canaanite woman was asking not for herself but for her daughter. Was this a reference to Ottheinrich's current situation? In June 1542, following the death of his Catholic wife, Susanna of Bavaria, Ottheinrich brought Andreas Osiander, the Lutheran minister of St. Lorenz in Nuremberg, to Neuburg. Under Osiander's counsel, Ottheinrich issued the Reformation Mandate for Pfalz-Neuburg on 22 June.[117] This short document proclaimed Ottheinrich's decision to convert his lands to Lutheranism. In 1543 Osiander authored the Pfalz-Neuburg Church Ordinance, a detailed explanation of

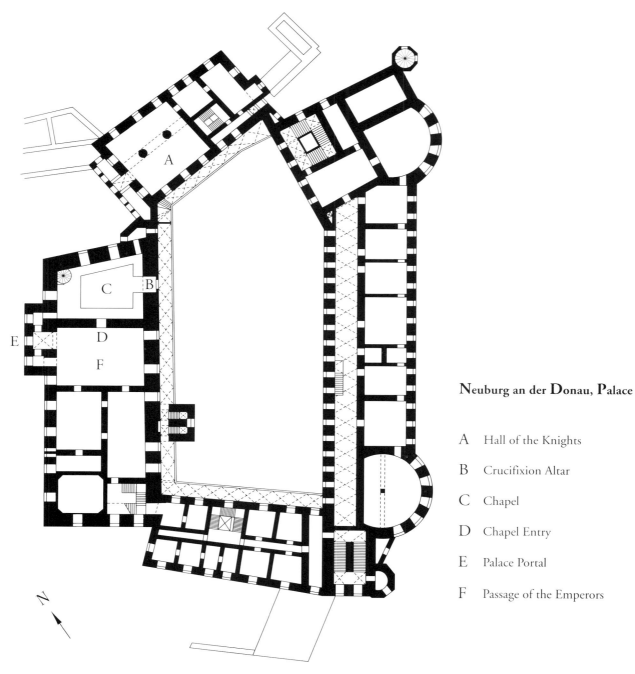

Neuburg an der Donau, Palace

A Hall of the Knights

B Crucifixion Altar

C Chapel

D Chapel Entry

E Palace Portal

F Passage of the Emperors

Plan of the Palace at Neuburg an der Donau

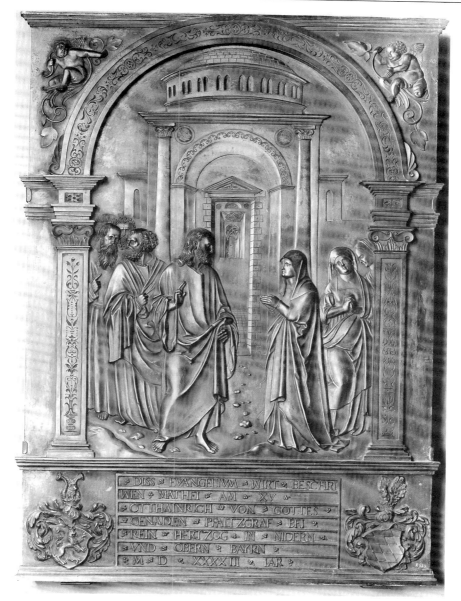

56. Hans Vischer, *Christ and the Canaanite Woman*, 1543, Munich, Bayerisches Nationalmuseum

Lutheran beliefs and church practices that was intended as a guide for the region's clergy and citizens.[118] Ottheinrich, perhaps on Osiander's advice, may have selected the theme for the portal relief because he identified with the Canaanite woman. He sought salvation for his people even though his confessional change would result in grave political difficulties, including conflict with his powerful father-in-law, Albrecht IV, duke of Bavaria and leader of Germany's Catholic princes. His faith, like the Canaanite woman's, was being tested by adversity. As for the choice of artist, Ottheinrich was already familiar with Hans Vischer's work since he reportedly tried to purchase the monumental brass screen that Vischer sold to the Nuremberg city council in 1536.[119] (figs. 228–230) Was the commission given when Ottheinrich visited Nuremberg in late July 1542 and in January 1543 to

83

attend imperial diets? The choice of artist might also have been suggested by Osiander since the sculptor was a member of his parish.[120]

Was there also an implicit criticism of the Catholic church contained in Vischer's relief? Matthew's text reads "And his disciples came and besought him, saying, Send her away; for she crieth after us" (15:23). In this instance, it was the disciples who sought to limit who would benefit from Christ's assistance. Vischer depicts St. Peter standing prominently behind Christ yet turned away towards another apostle who seems to be explaining the incident. Can this negative depiction, specifically of St. Peter, the patron of the Roman Catholic church, refer to failings of Rome to recognize the true worth of Christian faith? While this suggestion is speculative, Ottheinrich's dissatisfaction with Catholicism prompted his confessional change, and his new beliefs would cause him to become one of the Roman church's most ardent foes just a few years later.[121]

In the case of the Neuburg relief, setting and historical context help to define its meaning. Yet there is always the danger of overinterpretation. For instance, there exists a second, earlier version of *Christ and the Canaanite Woman* that adorns the epitaph of Margareta Tucher (d. 1521) originally in Regensburg's Ulrichskirche and now in the cathedral.[122] How can we reconcile the use of the same composition above the chapel doorway at Neuburg and as an epitaph in Regensburg? The story of Christ and the Canaanite woman is fundamentally a universal parable of persevering faith. It was equally appropriate as a theme for an epitaph or, in 1543, for a ruler trying to convert his people. Its use in both instances is related to Luther's doctrine of salvation by faith, a concept that appealed to Protestants and many Catholics in the 1520s. A common belief in Lutheranism links these two reliefs. Margareta's epitaph was commissioned by her husband Martin I Tucher (1460–1528). The couple had fled from Nuremberg to Regensburg in 1521 to escape the plague. Margareta, however, died soon afterwards and was buried there. Martin Tucher was an important member of Nuremberg's government and represented the city on several occasions, such as the diplomatic mission to Zürich that he undertook in 1519 in the company of Willibald Pirckheimer and Dürer.[123] The choice of the epitaph design reflected Martin Tucher's religious

attitudes. Like Dürer, Tucher was listed in 1518 as a member of the Sodalitas Staupitziana, a group of reform-minded patricians and intellectuals who gathered to discuss religious issues.[124] Their name derives from Johann Staupitz who until 1520 was the general vicar of the Augustinian order in Germany and Martin Luther's mentor. This group maintained very close contact with Wittenberg and they eagerly debated Luther's ideas. In 1524 Tucher was appointed Ratsherr, one of the most powerful of town councillors.[125] He was among the officials who approved and oversaw Nuremberg's conversion to Lutheranism in 1525. And it was Tucher, together with Siegmund Fürer, who on 6 October 1526 on behalf of the city, accepted the gift of Dürer's *Four Apostles* (Munich, Alte Pinakothek), the painter's clearest statement of his evangelical faith.[126] Thus whether the epitaph was commissioned in 1521 or around Martin Tucher's own death in 1528, its theme expresses his Lutheran attitudes as well as his aspirations for his wife's salvation through faith.

Either Ottheinrich or Osiander may have viewed a workshop sketch of the composition. The black chalk drawing of *Christ and the Canaanite Woman*, attributed to Hans and now in London (British Museum), represents a reworking of the Regensburg design.[127] (fig. 57) Changes that Hans made in the architecture behind Christ and the addition of playful angels in each spandrel demonstrate that the London drawing was made in preparation for the Neuburg relief. The pilaster decoration in the drawing lacks precision as if its artist had not fully decided on the exact form to be used. This and the summary renderings of drapery folds preclude the possibility that the drawing was made after the completed relief. In all likelihood this was the presentation sketch that Hans would have submitted to Ottheinrich for approval.

Of the once-rich decorations on the ground floor of the Neuburg chapel only Martin Hering's Crucifixion Altar of 1540–42 survives in even fragmentary form.[128] (fig. 58) Just the figures of Mary and John the Evangelist are original. The two thieves and Christ, like the nearby pulpit, were casualties of the sack of the palace in 1546. Hering was Ottheinrich's court sculptor active in Neuberg and nearby Grünau from about 1535 to 1542.[129] (fig. 217) The project was conceived during the last

57. Hans Vischer (attributed), *Christ and the Canaanite Woman*, before 1543, drawing, London, British Museum

years of Ottheinrich's wife's lifetime, which would explain the inclusion of Mary, St. John the Evangelist, and the thieves who rarely appear in Protestant versions of this theme. Ottheinrich's confessional shift, however, is evident. The large marble frame surrounding the Crucifixion is dated 1542 and is boldly inscribed with Ottheinrich's, but not Susanna's, name. Below the cross is the text from John 3:14–15, "And as Moses lifted up the serpent in the wilderness, even so must the Son of man be lifted up: That whosoever believeth in him should not perish, but have eternal life." As has already been discussed, the analogy between the Old Testament story of Moses and the Brazen Serpent and the Crucifixion was among the most popular themes in Lutheran art. (fig. 44) Faith in Christ is once again the fundamental theological message just as it was in Vischer's portal relief. The original pulpit, which was set immediately to the side of the altar, was an intriguing variation of the Lutheran Law and Gospel concept since it contained images of both the four evangelists and the Ten Commandments.[130]

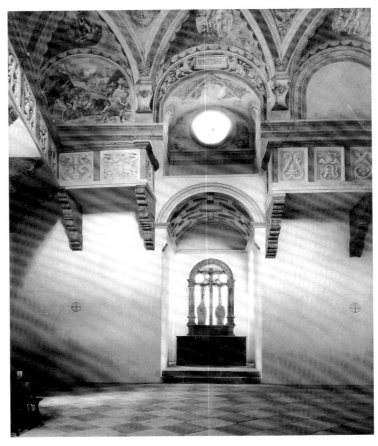

58. Interior View, Palace Chapel, Neuburg an der Donau

Christ's redemption of mankind's sin through the cross and his resurrection tie Martin Hering's sculptures together with Hans Bocksberger the Elder's extensive painted murals that cover the upper walls and the ceiling of the chapel.[131] (fig. 59) Excepting the large central scene of Christ's Ascension, Bocksberger's program depicts Old Testament stories. Each of these, however, offers a typological counterpart either to events from Christ's life or to his teaching. The Sacrifice of Isaac and Moses and the Brazen Serpent, whose text was on Hering's altar frame, are anticipations of Christ's sacrifice on the cross. The Lutheran sacraments of communion and baptism are prominently stressed in such prefiguring scenes as the Paschal Meal and the Gathering of Manna as well as the passage of the Red Sea and the Baptism in Alexandria. Examples of God's punishment for the lack of faith include the Flood and the Egyptian Plague. Osiander, Ott-

heinrich's religious advisor during these critical years, must have planned or, at least, approved the program for Bocksberger's ceiling. The failure of human deeds, due to the fall of Adam and Eve, is fully evident in the Old Testament stories. The fall is portrayed directly above Hering's Crucifixion Altar. The paintings, like Osiander's church ordinance, preach the same message: the individual must have total faith in God and in Christ. And it is Christ rising triumphantly towards heaven who dominates the ceiling. Bocksberger's illusionistic masterpiece reveals Giulio Romano's influence and strongly anticipates the great Bavarian ceiling paintings of the next two centuries.

Ottheinrich's palace chapel at Neuberg was decorated between about 1540 and 1543. During this short period he sponsored the first new Protestant church, a claim of primacy that normally is accorded to Torgau in Saxony. Osiander's active role

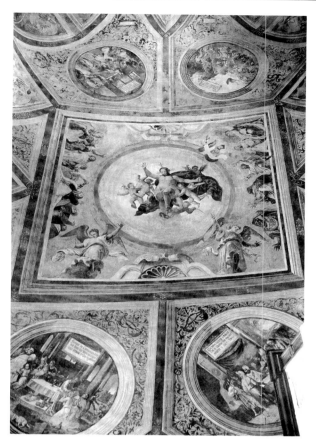

59. Hans Bocksberger, Painted Ceiling, detail, completed 1543, Palace Chapel, Neuburg an der Donau

in facilitating Ottheinrich's conversion may also extend to the unity of the extant sculptural and painted programs, most of which date to 1542–43. Their singular iconographic message, one of faith, is as profound as it is different from the ideas invested in Albrecht von Brandenburg's Neue Stift. With Neuburg and soon Torgau, religious art once again became an essential pedagogical and aesthetic feature of the new Lutheran churches. During these critical years for the fledgling Lutheran church, artists, patrons, and theologians enjoyed a close collaborative relationship just as Dreyer had while carving the Lübeck pulpit.

TORGAU

Ultimately far more influential than Neuburg was the chapel that Johann Friedrich, elector of Saxony,

erected at Schloss Hartenfels in Torgau between 1540 and 1544.[132] (Plan of the Schloss Hartenfels at Torgau) This chapel is particularly important because it provided a model for many later, especially North German, Protestant churches. In contrast with traditional churches with their visual and liturgical emphases on the high altar, architect Nickel Gromann instead stressed the pulpit by setting it in the center of the north wall, clearly visible to all worshippers. (figs. 60 and 61) As Martin Luther stated repeatedly in his inaugural sermon consecrating the chapel on 5 October 1544, the word of God is the true essence of Protestant worship. He said that "the purpose of this new house may be such that nothing else may ever happen in it except that our dear Lord himself may speak to us through his holy Word and we respond to him through prayer and praise."[133] Simon Schröter the Elder's pulpit, ready by the consecration ceremony, provided an elegantly simply podium for Luther and all subsequent preachers. Unlike the complicated form of the Neue Stift pulpit, Schröter, working perhaps after a model by Lucas Cranach the Elder, devised a rounded basket or body supported by three playful angels.[134] Gone are all images of saints.

Each of three sandstone reliefs offers a basic theological message to the worshippers. The largest and central scene illustrates the enthroned Christ speaking with the Jewish priests in the temple (Luke 2:41–2). This event in Christ's youth signifies his first acknowledgment of his life's mission, specifically the preaching of God's word. The minister speaking immediately behind this scene is thus following Christ's precedent. Next is the story of Christ and the Adulterous Woman. For Luther this parable poses a "clear distinction between the Law and the Gospel, or between the kingdom of Christ and that of the world."[135] According to Jewish law, the woman must be condemned and killed. Christianity, by contrast, permits forgiveness of sin. Christ reminds humanity of its inherent sinfulness by challenging the Pharisees with the words "He that is without sin among you, let him first cast a stone at her" (John 8:7). The third relief depicting the Expulsion of the Money Changers (Matthew 21:12–6) draws a direct parallel with Luther's condemnation of Catholic financial abuses, most notably the selling of indulgences. In Cranach's *Passio-*

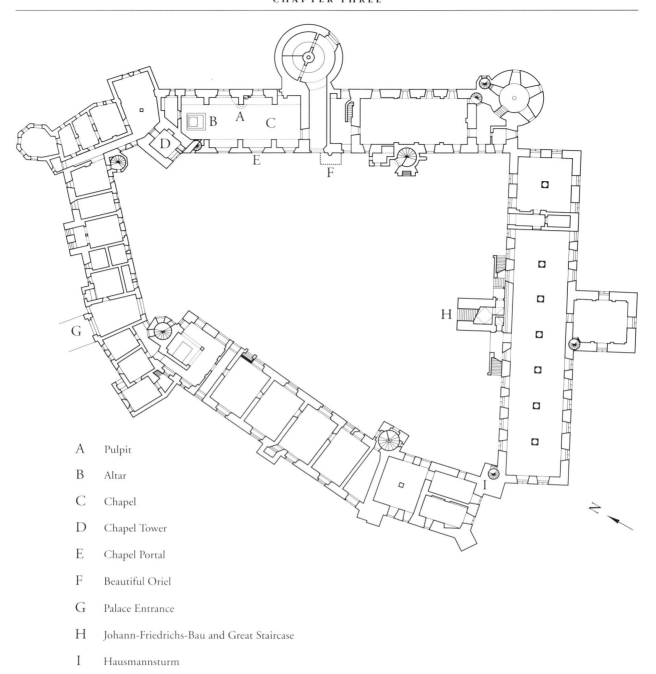

A Pulpit

B Altar

C Chapel

D Chapel Tower

E Chapel Portal

F Beautiful Oriel

G Palace Entrance

H Johann-Friedrichs-Bau and Great Staircase

I Hausmannsturm

Torgau, Schloss Hartenfels

Plan of Schloss Hartenfels at Torgau during the Reign of Elector Johann Friedrich of Saxony

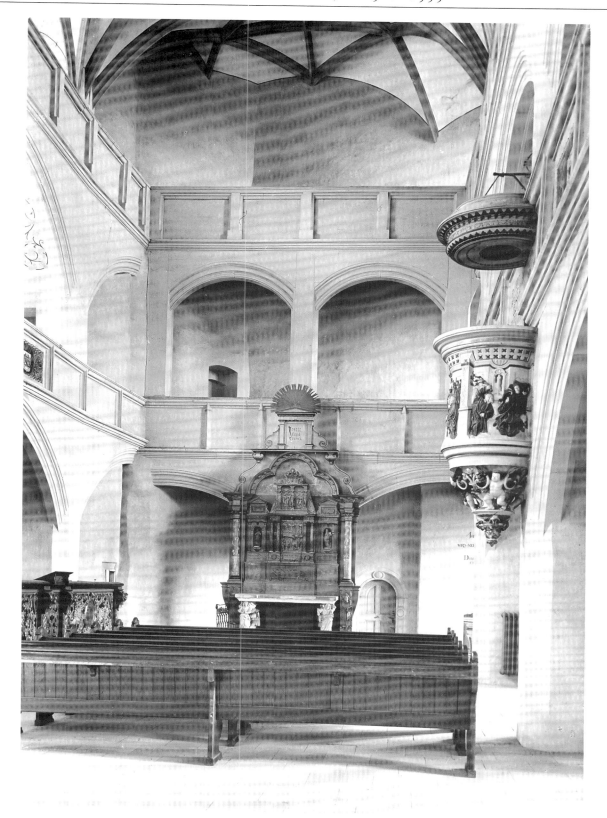

60. Interior View, Chapel, Torgau, Schloss Hartenfels

61. Simon Schröter, Pulpit, 1540–44, Torgau, Schloss Hartenfels

nal Christi und Antichristi (Wittenberg, 1521) the expulsion is contrasted with the pope as Antichrist signing indulgences and other dispensations in exchange for coins.[136]

Schröter's pulpit at once lauds Christ and the word of God while condemning both the Jewish faith and the Roman Catholic church. In the first half of his Torgau consecration sermon, Luther repeatedly distinguished between the true sabbath in which one listens to the word of God and the false Jewish and Catholic observances. He claimed that the Jews are so rigid that they cannot even help someone in need on the sabbath, while the Catholics depend upon their "false trust in the dead saints."[137] The popularity of this message and the appearance of the Torgau pulpit can be gauged by the fact that Schröter and his sons created at least five replicas for other Lutheran churches.[138] The finest example is in the Schlosskirche in Schwerin

that Duke Johann Albrecht I of Mecklenburg ordered in 1560.

Equally precedent setting was the single altar of the Torgau chapel. (fig. 62) The altar stone rests upon four angel statuettes, the rear ones by Schröter and the front pair by Stephan Hermsdorf. These angel caryatids visually sanctify the holy communion that was performed on the simple altar. For Luther a plain stone table that permitted the cleric to face the congregation during the eucharist was all that a Protestant church needed.[139] The Torgau formula for a new Protestant type of church furniture would inspire several later variants, the most significant of which is the altar table with its dynamic angels by Ebert II and Jonas Wulff in the Schlosskapelle in Bückeburg.[140] (fig. 63) For the 1544 consecration there seems not to have been an altarpiece directly behind. The 1610 inventory of the chapel mentions a painted retable illustrating the *Last Supper* in the corpus and *Christ Washing the Disciples' Feet* and *Christ on the Mount of Olives* on the wings.[141] The altarpiece may have been by the Cranach workshop, which supplied several other paintings for the palace chapel.[142] From 1662 until its destruction in 1945, the stone altarpiece originally made for the Dresden Schlosskapelle stood behind the angel altar table.[143]

Located nearby is the large bronze inscription tablet commemorating the chapel's erection that Wolff and Oswalt Hilger of Freiberg cast in 1545.[144] (fig. 64) Its function is similar to the stone consecration panel that Peter Schro(?) carved for the Neue Stift in Halle; however, in place of the patron saints are portrait roundels of Johann Friedrich at the top and, on a smaller scale, the elector's sons, Johann Friedrich II and Johann Wilhelm, and, at the bottom, Martin Luther. The models for the portraits and perhaps the original design for the monument are again by the Cranachs. Other than the addition of a hat, Johann Friedrich's roundel closely recalls Hans Reinhart's portrait medals of the prince from 1535.[145] Even the form of the inscription looks back to these and other medals. These likenesses are set into an attractive Renaissance-style frame filled with playing angels and grotesque ornaments.

The portal of the Torgau palace chapel is surprisingly rich in its carved ornamentation as eight angels hold the passion implements.[146] (fig. 65)

62. Stephan Hermsdorf and Simon Schröter, Altar Table, 1540–44, and Netherlandish Artist, Altar, c. 1554–56, Torgau, Schloss Hartenfels

63. Ebert II and Jonas Wulff, Altar Table, 1603–06, Chapel, Schloss Bückeburg

These energetic figures closely recall Schröter's angels supporting the pulpit. Their attribution to the sculptor is confirmed by the inclusion of his mark chiseled on the left side.[147] Never a great innovator, Schröter followed the models of other. In this instance, the youthful angels with the passion instruments and in their positions derive from the elder Cranach's *Christ Child with Angels* woodcut of about 1513.[148] Schröter has whimsically exaggerated the stances of the upper pair of angels in order to fit them into the restricted horizontal space of the rounded arch. Above the portal is Stephen Hermsdorf's *Lamentation* relief of 1544. Together the carvings offer the visitor a message of suffering and reward. "Blessed are they which are persecuted for righteousness' sake: for their's is the kingdom of heaven" (Matthew 5:10). Christ experienced persecution and was sacrificed ultimately to redeem mankind. The pomegranates in the tendrils behind the angels symbolize Christ's resurrection and the rebirth that his sacrifice offers to all Christians passing by or through the portal.[149] The program's iconography and its physical proximity to the viewer

are reminiscent of pre-Reformation religious art that encouraged the viewer to empathesize with and imitate Christ's sufferings.[150] The portal must have provided some encouragement to Johann Friedrich, who even in 1543–44 was being drawn increasingly into a direct conflict with Emperor Charles V because of his Protestant faith.

The Torgau Schlosskapelle cannot match the artistic brilliance of the Neue Stift in Halle, yet as the essential prototype for later Lutheran churches it must be considered one of the most significant monuments of this era. The chapel was erected by the foremost Protestant prince. Luther not only consecrated the building in 1544, but he certainly was involved in many aspects of its planning. The centralized placement of the pulpit, the simple altar, and the clear evangelical program of the various sculptures all reveal Luther's influence.[151] Most subsequent North German Lutheran churches and chapels owe something to Torgau. In fact when Johann Friedrich moved to Gotha he instructed that his residence, Schloss Grimmenstein, be demolished and rebuilt between 1552 and 1554. He

64. Wolff and Oswalt Hilger, Commemoration Tablet, 1545, Torgau, Schloss Hartenfels

Lutheran areas of Germany, a market, albeit limited, existed for religious sculpture.

THE PERIOD from about 1520 to 1555 witnessed dramatic changes in the traditional conceptions of religious art in general and sculpture in particular. When faced with the angry complaints about idolatry and the inappropriate use of art, the Catholic church in Germany failed to offer a strong rebuttal.[153] The iconoclastic riots sapped the Catholic church's vitality, and from the early 1530s on-

65. Simon Schröter, Portal, Chapel, 1540–44, Torgau, Schloss Hartenfels

brought his Torgau artists to Gotha where sculptor Simon Schröter carved a new pulpit, altar table, and portal. Only portions of the portal survive; however, these fragments of angels reveal the fundamental importance of the Torgau cycle as a model since the deposed elector ordered Schröter to replicate his earlier program.[152] Luther's willingness to reinvolve the pictorial arts in the decoration of the church would inspire Protestant princes and parish congregations alike to enrich their places of worship. For some, only a new pulpit was needed. Yet Torgau was also the seed for the increasingly complex artistic programs in the palace chapels in Dresden, Schwerin, and Celle. Even the showy Protestant churches at Bückeburg and Wolfenbüttel in the early seventeenth century derive their essential features from the Torgau model. At least in the

wards, it experienced a dramatic retrenchment. The ordering of new art continued but at only a fraction of former levels. The Neue Stift may have been one of the century's foremost artistic achievements; however, it spawned no other sculptural projects.[154] Indeed the Neue Stift fell victim to the Reformation in 1541. No other clerical or secular prince rose to articulate a clear reaffirmation of the efficacy of art. Imperial patronage in Germany was negligible. Where Maximilian I, for all his impecunity, had set many of the artistic standards for the first two decades of the century, his successor, Charles V, would always remain deeply uninterested in German art. In this chapter, I have tried to demonstrate that even though Loy Hering and many other sculptors continued to find at least limited employment opportunities, their potential for artistic growth and experimentation was, nevertheless, severely restricted.

Sculptors in Protestant regions hardly fared better. Yet gradually from the ashes of iconoclasm arose a genuinely new Lutheran art. Protestant sculpture offered a positive alternative to traditional religious art. The polemical battles waged in the broadsheets and pamphlets of the 1520s and 1530s were largely absent in sculpture due to its different function and greater expense. Lutheran sculptures, from the reliefs of Peter Dell to the Torgau pulpit, provided clear statements of evangelical doctrine, which is hardly surprising given the close collaboration between artists and theologians. Sculptors adapted the themes developed first by Lucas Cranach the Elder and other Protestant painters. Images were joined with often lengthy texts. Sometimes this union resulted in a dry and unattractive product. This, however, was intentional since the appeal of the sculpture was directed more to the mind than to the eye. Innovation and aesthetic creativity mattered less than the object's ability to communicate. Simon Schröter the Elder was ideal for the Torgau projects, but he is obviously a second-rate sculptor when his works are compared with the brilliant virtuosity of Stoss or Leinberger.

CHAPTER FOUR

Religious Sculpture after the Peace of Augsburg, 1555–1580

THE POLITICAL EVENTS of 1555 altered the future course of German religious sculpture. Between February and September, Lutheran and Catholic delegates to the imperial diet in Augsburg negotiated a religious accord that would tenuously hold into the early seventeenth century. The Peace of Augsburg did not actually end the decades of bitter confessional strife, but the treaty did acknowledge the existence of the Lutheran church. The German-speaking lands were officially classified according to their confessional affiliation. Each prince selected the religious faith for his territory; however, his subjects of the opposite church were permitted to emigrate. The imperial free cities also were empowered to retain their chosen faith, and if both Lutherans and Catholics resided within a town then both churches were to be tolerated. The agreement had innumerable flaws, most notably the omission of rights for Zwinglians, Calvinists, and Anabaptists. Yet given the tumult of the previous decade, the Peace of Augsburg offered the Lutherans political recognition and the Catholics time to reassess their future direction without immediate fear of further territorial losses. For most sculptors there was no immediate economic benefit. Nevertheless, their situation would slowly improve since, with the confessional allegiance of each territory now guaranteed, patrons once again began commissioning significant religious projects.

With the new religious stability came a change in political leadership within the empire. When Emperor Charles V abdicated in 1556, he was succeeded by his brother Ferdinand I (r. 1556–64), archduke of Austria and king of Bohemia and Hungary, who had a far better grasp of German problems. It was Ferdinand, not Charles V, that presided over the Diet of Augsburg in 1555. Ferdinand and his son, Maximilian II (r. 1564–76), favored a more moderate course of accommodation with the Protestants.[1] Both preferred managing the ancestral Habsburg lands in Austria and Bohemia to meddling in the affairs of the rest of Europe. Furthermore, in contrast with Charles V, Ferdinand and Maximilian II frequently engaged German artists to work on their projects in Prague and Vienna.[2] The new Catholic standard bearer was Albrecht V, duke of Bavaria (r. 1550–79), another moderate who supported his faith through peaceful means, including Jesuit educational campaigns and the sponsorship of artistic programs. With Johann Friedrich's fall from power in 1547 and the subsequent death of Moritz of Saxony at the battle of Sievershausen in 1553, Moritz's brother August (r. 1553–86) became elector and new champion of the Lutheran cause.[3] Although August was one of the leaders at Augsburg in 1555, he was also a pragmatist who diligently attended to improving the economy and well-being of Saxony. Furthermore, August maintained cordial imperial relations. In 1542, at age sixteen, the Saxon prince had been sent to reside at Ferdinand I's court for a period of four years. He established a life-long friendship with Maximilian II and, I believe, developed a genuine admiration for the arts based on the splendor of the Habsburgs.

The tranquil tenor of the two decades following the Peace of Augsburg was more propitious to the spiritual and financial investment in religious

sculpture. Initially princely patronage dominated in both Protestant and Catholic areas. Gradually, however, an ever-growing number of towns, especially in Lutheran North Germany, initiated new decorative projects for their churches. As observed in Chapter Three, the initial Protestant debate over idols evolved slowly into grudging acceptance of a limited role for art within Lutheran churches. Much of the impetus for this came from Luther himself and from Johann Friedrich of Saxony, leader of the Protestant princes. Although by 1555 Luther had been dead for nine years and August had succeeded as Elector of Saxony, this trend of reintegrating some art within Lutheran churches would be universally embraced. In this chapter, I wish to address the issues of continuity and change in Lutheran art by discussing the rise of Dresden as Germany's most dynamic sculptural center. Inspired by Dresden's example, Protestant palace chapels, such as Celle, and a wealth of new pulpits in the urban centers of North Germany attractively articulated evangelical beliefs. A similar reaffirmation of religious sculpture may be observed in the Catholic lands. In the second part of this chapter, I shall examine the actions of the Council of Trent and specific programs in Augsburg, Würzburg, Trier, Ingolstadt, and Innsbruck.

August of Saxony and the School of Dresden

The emergence of Dresden as an artistic center is linked with the political upheavals of the decade prior to the Peace of Augsburg. With Johann Friedrich's defeat at the battle of Mühlberg in 1547, the title and most of the lands of the Electorate of Saxony were transferred to his Albertine cousin, Moritz, who resided in Dresden. In 1547 the highly ambitious Moritz inaugurated a major expansion of the Dresden palace to reflect his family and his city's new electoral status.[4] Several North Italian artists were imported to contribute the sgraffito and other paintings while Dresden sculptor Hans Walther carved seven biblical battle reliefs for the frieze of the new gallery in the main courtyard. (fig. 220) By 1549 work began on the renovation of the palace chapel. How far this project had progressed by 1553 when Moritz was killed in bat-

tle is unknown. The initial plans called for limited architectural modifications to the chapel, which had been constructed with elaborate star vaults by Arnold von Westfalen in the 1470s. Moritz's brother, August, assumed the electoral title and the task of enriching the palace chapel. While it might be argued that August merely carried through pre-existing plans, his skillful use of sculpture in the Electoral Succession Monument erected in 1553 or 1554 by Hans Walther on Dresden's new fortifications or in the Moritz Shrine at Freiberg, commissioned in 1559, reveals an appreciation for sculpture that Moritz never displayed.[5] (figs. 140–144) Specifically, August recognized that sculpture was the ideal medium for expressing religious and political doctrines. The permanence and physical presence of the chosen material—stone—endowed these sculptures, which were set in public or semi-public locations, with a lasting authority that painting could not match. Finally, the dating of the chapel portal, which is inscribed 1555, and altar, commissioned in 1554, fall within August's reign.

The Dresden palace chapel portal is imposing both for its scale and its design. (fig. 66) Excluding the upper figures the ensemble measures about 7 meters high and 5.6 meters wide. That the design offers an immediate contrast with its decade old counterpart at Schloss Hartenfels in Torgau is hardly accidental. (fig. 65) Simon Schröter's angels ornament a simple, rounded door frame at Johann Friedrich's palace. Its rudimentary form, coupled with its somber emphasis upon Christ's passion, may have been intended to humble all visitors. By comparison, August's artists have combined Christ's resurrection with a classicizing triumphal arch. The mood of the Dresden portal is victorious. While still offering a staunchly Lutheran iconographic program, the portal signals an aesthetic and, I believe, political shift tied to the new Albertine electoral dynasty.

The design of the portal's architecture is attributed to an Italian stone mason known only as Giovanni Maria ("welsche Steinmetz Johann Maria") who is documented working for August from 1553. Werner Schade has also proposed Francesco Ricchino, a Brescian painter active at the Dresden court from 1549 until 1555, as another possibility.[6] Whomever designed the portal was familiar with Roman triumphal monuments, as well as the

66. Hans Walther, Portal, Chapel, 1555, Dresden, Palace

popular use of the arch form on North Italian buildings and tombs. The architectural massing and placement of the sculpture strongly point to models such as Jacopo Sansovino's Loggetta (1537–45) in Venice.[7]

The portal represents a conscious desire to import current Italian artistic ideas into the Saxon capital. First Moritz and then August welcomed Italian artists to Dresden.[8] Although one might assume that they merely followed the precedent of their uncle, Georg the Bearded, who employed Italian masters in the construction of the Georgenbau of the Dresden palace in the early 1530s, I think issues of magnificence and modernity shaped their decisions. (figs. 218 and 219) By the late 1540s and 1550s the "Welsch" or Italianate style with its thorough adaptation of classical architectural and decorative vocabularies had already exerted a significant impact upon German art. In most cases, however, German borrowings could be found only in the occasional statue, such as those by Peter Flötner, painting, print, or building. The sort of widespread adoption of Italian forms as one encounters in Cracow under King Sigismund I (r. 1506–48) or earlier in Hungary under King Matthias Corvinus (d. 1490) was rare in Germany prior to the late 1530s when Duke Ludwig X of Bavaria began the Stadtresidenz in Landshut. (fig. 213) Inspired by the splendor of the Palazzo del Te in Mantua, Ludwig X hired many of the same craftsmen and built a remarkably beautiful version in his residential town of Landshut. Both Moritz and August had travelled extensively outside Saxony where they saw models that helped shape their vision for Dresden. Moritz served Charles V in Hungary and France, and in 1548 he accompanied Philip II, the emperor's son, on a journey through Italy. The airy palaces from Trent southwards must have presented a vivid contrast with the lingering late Gothic style popular in Saxony and indeed most of Germany. Moritz's response was the Moritzbau or new wing of the Dresden palace with its fashionable, four-story open gallery inspired directly by Italian loggias. (fig. 220) August too must have been impressed with the international character of Ferdinand I's court in Vienna and Prague as he would continuously support Italian artists, most notably Giovanni Maria Nosseni, throughout his long reign. The brothers were drawn to the sophisticated mod-

ernity implicit in the choice of Italian artists and artistic forms. As they strove to transform Dresden into a fitting capital for the new Albertine electorate, they picked a general artistic direction that clearly distinguished them from their Ernestine predecessors. An ambitious new princely house demanded both a new iconography of style and, as shall be seen in this and several other chapters, political content.

Hans Walther, one of the older members of the emerging Dresden family of sculptors, carved the sandstone statues and reliefs of the portal.[9] While his figures do not quite match the grandeur of the arch and the cutting of individual passages such as the drapery folds are rather crudely handled, the overall effect is impressively harmonious. Hans Walther's ensemble stresses Christ's triumph over death. Like earlier Lutheran sculptural programs, it presents a readily legible, succinct iconographic scheme. At the apex stands the resurrected Christ, holding his banner of victory. He is flanked by Faith, Fortitude, and two other now-lost virtues. Below, the prophet Isaiah and St. Paul stand in shallow niches adjacent to the central relief showing Christ's empty sepulchre. The calmness of the angel seated in the center of the tomb contrasts sharply with the distraught soldiers who gesture wildly. In spite of the scale difference, the statue of Christ above seems to hover just beyond the soldiers' grasp. Angels holding palms recline in the spandrels over the doorway. They bring into the space of the viewer on the ground the joyous message of human salvation through Christ's sacrifice and resurrection. Symbolizing the old and new dispensations, statues of John the Baptist, John the Evangelist, Moses, and St. Peter fill the surrounding niches.[10]

The carved oak door, dated 1556, completes the portal. Inscribed at the top are the letters V.D.M.I.E. that stand for "Verbum Domini Manet in Aeternum" ("the word of God will last forever"), the Lutheran rallying cry in the 1520s that was used around 1540 as the personal motto of August's father, Heinrich the Pious.[11] The stress on God's word rather than the institution of the church is once again typically Lutheran.[12] A specific example of the word of God is given immediately below. For the center of the door, Walther carved the *Christ and the Woman Taken in Adultery* relief. As Carl

Christensen has shown, this theme was never exclusively Lutheran in usage; however, it was incorporated into the Torgau pulpit and was painted frequently by the Cranach workshop.[13] (fig. 61) Luther often used this story to contrast the law of the Old Testament, that automatically condemned the sinner, with the grace of the New Testament that offered forgiveness. He wrote

> If you have tasted the Law and sin, and if you know the ache of sin, then look here, and see how sweet, in comparison, the grace of God is, the grace which is offered to us in the Gospel. This is the absolution which the adulteress receives here from the Lord Christ.[14]

The wooden relief, placed at eye level, reminds all who enter the chapel to examine their own sins if they hope to share in Christ's forgiveness. Christ bends to write his words in the dirt as the humbled adultress and the shocked Pharisees look on. If the wooden relief stresses mankind's inherent sinfulness because of the fall, the resurrected Christ at the apex of the portal offers the sinner the possibility of eternal salvation. Completing the doorway are August's coats of arms of the Electorate and Duchy of Saxony. Within the context of the portal's religious program, August is honored as the princely guardian of the evangelical church.

The Dresden palace chapel portal is unprecedented in German churches of this period. It mixes a staunchly Lutheran iconographic program with a classicizing triumphal arch. If the portal at Torgau is still imbued with a strongly Gothic spirit, Dresden marks another example of German patrons and artists embracing Italian High Renaissance forms. The portal, which was constructed by August, also conveys a specific political message to Saxony's allies and adversaries. Moritz was frequently damned as the "Saxon Judas" for his ambitious scheming at the expense of Johann Friedrich and the other Protestant princes. August, the new elector, used events, such as the Peace of Augsburg, and artistic monuments, like the portal and the Electoral Succession Memorial on the palace bastion, to affirm his sincere Lutheran faith and his right to rule the Electorate of Saxony. (fig. 143 and 144) The date 1555, prominently inscribed twice between the flanking columns, may signify no more than the moment of completion; however, I think the year

1555 alludes specifically to the Peace of Augsburg, which August was instrumental in forging, with its formal recognition of the Lutheran church. The portal signals a new era in both art and regional politics.

The interior of the Dresden palace chapel did not match the modernity of the portal, yet this lavishly embellished chapel marks another significant step in the enrichment of Lutheran churches. Unfortunately, nothing of the chapel survives today so we must rely upon the 1629 description of Philipp Hainhofer, an engraved view made in 1676 by David Conrad, and pre-1945 photographs of the altar.[15] (fig. 67) The principal sculptural additions were a new pulpit and a large stone altarpiece. As at Torgau, the Dresden pulpit was situated by the gallery wall in the center of the church. According to Hainhofer and visible in Conrad's engraving, the pulpit's cover was adorned with the Transfiguration, including a free standing figure of Christ at the apex. On the basket or body were stone reliefs of the four evangelists, while the story of Moses and the Brazen Serpent appeared in the relief below. The contrast between law and gospel is thus again reiterated. The sculptor is unknown though the prolific Hans Walther who, together with his workshop, created the portal figures and the battle friezes of the palace courtyard must be considered the prime candidate. Was his shop also responsible for the angels supporting biblical texts that ornament the galleries? This practice of emphasizing the word of God as an artistic motif in Lutheran churches and chapels, already observed in Chapter Three, would continue into the seventeenth century.[16] The biblical paintings hanging on each of the gallery arches and the complex ceiling with its carved and painted Apocalypse scenes are later in date, perhaps part of the restorations of the chapel in 1602 and again in 1662.[17]

Both restoration campaigns affected the chapel's altar.[18] (fig. 62) In 1602 Giovanni Maria Nosseni surrounded the altar with a great stone frame. Then in 1662 the whole altar was transferred from Dresden to Torgau where it remained until its destruction in 1945. The first record of the altar occurs in a letter dated 14 June 1554 in which August instructed Hans von Dehn-Rothfelser, his building supervisor, to order alabaster carvings for the altar in the Netherlands. The choice of alabaster sug-

67. David Conrad, *Interior of the Dresden Palace Chapel*, 1676, engraving, Dresden, Sächsische Landesbibliothek

gests that August wished to have a fancier material for his altar that the Elbe sandstone that was customarily employed in Dresden. One of August's court artists, perhaps Giovanni Maria, Francesco Ricchino, or one of the de Thola brothers, Benedikt and Gabriel, created the sketches that were forwarded to a sculptor probably in Mechelen, the center of the European alabaster trade, or Antwerp.[19] The decorative forms, most significantly the allegorical caryatids, which recall the popular models of Cornelis Floris of Antwerp, support this Netherlandish origin.[20] This altarpiece once again signals August's willingness to look beyond Saxony for art to enrich his capital. By mid-century Brabantine alabaster sculpture enjoyed an increased popularity in the Low Countries and would, gradually, among wealthy patrons throughout northern Europe. Its hard, highly reflective, and often slightly transparent surface richly interacts with light. Typically, alabaster was favored for small devotional altars and intricately cut reliefs.

Regardless of the probable foreign nationalities of the designer and alabaster sculptor, the Dresden chapel altar is historically significant since it was the first major Lutheran stone altarpiece.[21] In the 1530s and 1540s only painted altarpieces were commissioned for Lutheran churches, and this market was dominated by the Cranach workshop in Wittenberg. The Dresden altarpiece demonstrated for the first time that a sculptural alternative was possible. Dresden's artists, led by the Walthers, almost immediately began producing altars carved in sandstone for local and regional churches. From Saxony the taste for sculpted altars gradually spread throughout the Lutheran lands, especially in North Germany in the later sixteenth and early seventeenth centuries.

The program of the Dresden altarpiece is clearly Protestant. Beneath the Trinity in the apex are reliefs of the Fall of Adam and Eve and the Expulsion. Charity and two other Christian virtues support the architectural frame. The central relief contains four

scenes: the Brazen Serpent, the Adoration of the Shepherds, Christ on the Cross, and the Descent of the Holy Spirit. Statuettes of John the Baptist and Moses stand in the flanking niches.

Completing the altar is a Last Supper in the predella. This theme was central to the evolving canon of evangelical art. In 1530 Luther wrote

> Whoever is inclined to put pictures on the altar ought to have the Lord's Supper of Christ painted, with these two verses written around it in golden letters: "The gracious and merciful Lord has instituted a remembrance of His wonderful works." Then they would stand before our eyes for our heart to contemplate them, and even our eyes, in reading, would have to thank and praise God. Since the altar is designated for the administration of the Sacrament, one could not find a better painting for it. Other pictures of God or Christ can be painted somewhere else.[22]

Christoph II Walther of Dresden, Hans' slightly younger cousin, had included the Last Supper in the predella of his large sandstone altar of 1564 in the Stadtkirche in Penig and Hans employed it for the main scene of the imposing altar that he began in 1572 for the Kreuzkirche in Dresden.[23] (fig. 68) The subject also appears on the large painted and carved altar that August commissioned in 1574 for the chapel of Schloss Freudenstein in Freiberg.[24] Here Heinrich Goeding's painting dominates the center while Georg Fleischer the Elder's wooden portrait statues of August and his wife Anna kneel before God in the apex of the frame.

THE STRONG REAFFIRMATION of Lutheran church sculpture in Saxony from the mid-1550s is due primarily to the patronage of Elector August. In 1555, contemporary with the Dresden portal and chapel decorations, August ordered Hans Walther to carve the new sandstone baptismal font for the Jakobikirche in Freiberg.[25] Ornamenting the font are two reliefs depicting the Israelites Crossing the Red Sea and the Drowning of Pharoah's Troops, plus the arms of August and his wife Anna. In the same year August initiated plans for erecting a tomb for his brother Moritz in Freiberg Cathedral.[26] (fig. 140) This huge shrine, completed between 1559 and 1563, would be the grandest fu-

nerary monument in the German lands. These and other projects sponsored or encouraged by August created a stable market for sculptors in Saxony.

These examples, coupled with August's rising stature among evangelical princes, would inspire an ever growing number of elaborate sculptural altars and pulpits both within and beyond the Electorate of Saxony. For example, August's sculptor Hans Walther enjoyed the sort of constant financial support that his counterparts from the 1530s and 1540s lacked. In 1556–57 he produced the new pulpit in the Frauenkirche in Dresden that Hentschel believes is identical with the pulpit in the Gottesackerkirche (now Kreuzkirche) in Bischofswerda, east of Dresden.[27] Of much greater significance is the monumental stone *Last Supper Altar* that Hans created between 1572 and 1579 for the Kreuzkirche in Dresden that in reduced form has been in the Stadtkirche in Schandau since 1927.[28] (fig. 68) Count Anton von Oldenburg and Delmenhorst, a Lutheran ally, endowed the altar as a memorial to his son who died in Dresden in 1570. Elector August acted as the intermediary for this project and, doubtlessly, selected the sculptor.[29] The original appearance of the altar is best seen in the pen and wash sketch attributed to Hans that is now in Leipzig (Museum der bildenden Künste).[30] (fig. 69) The altar's present dimensions of 9 by 6.5 meters are considerably reduced from its initial size since the architectural base with the flanking arches have been removed. A Lutheran altar of this scale whether painted or sculpted was unprecedented. August's Dresden palace chapel altar measured only roughly the size of the corpus or central relief.

The Last Supper Altar, like the Dresden portal, signaled the Albertine willingness to use sculpture to communicate the triumphant Lutheran message. And in this instance, it is articulated with brilliant clarity. Moving upwards from the altar where the actual communion was celebrated, Walther offers the Passover Meal in the predella as the Old Testament counterpart to the central Last Supper. Christ's symbolic sacrifice next becomes a physical one in the Crucifixion. The resurrected Christ crowns the apex of the altar. The unity of the Trinity in death and in eternal life is signified by the Holy Spirit and the half-length figure of God set between the crucified and resurrected Christ. The four evangelists, each holding their gospels, em-

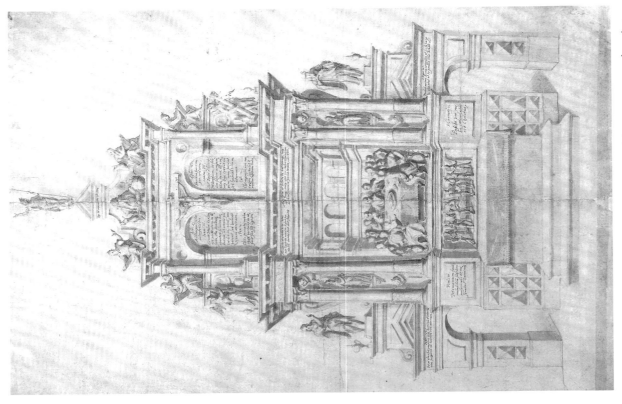

69. Hans Walther, *Design for the Last Supper Altar*, c. 1572, drawing, Leipzig, Museum der bildenden Künste

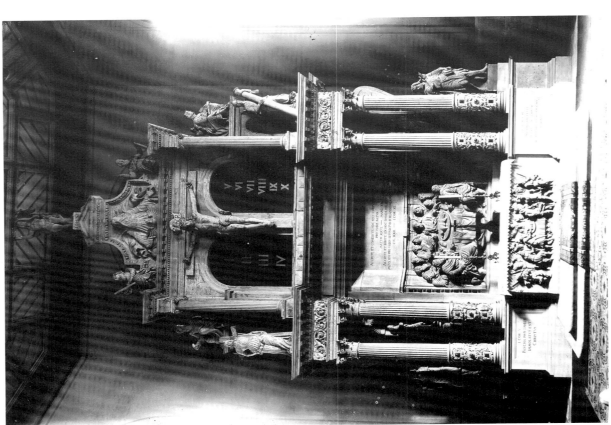

68. Hans Walther, Last Supper Altar, 1572–79, formerly Dresden, Frauenkirche, now Bischofswerda, Kreuzkirche

body the Lutheran emphasis upon the sanctity of the word of God. John the Baptist, the last of the Old Testament prophets, and St. Paul, apostle to the Gentiles and interpretor of the gospels, stand over the arches. Completing the ensemble are the personifications of Faith and Hope on either side of the Last Supper and, above, two angels holding the cross and the column. Inscribed biblical texts are used liberally throughout the altarpiece. The two arches on either side of the Crucifixion are shaped like Moses' tablets but are filled with New Testament citations.[31]

If the iconography is typically evangelical, the formal idiom is increasingly North Italian. While Hans Walther was responsible for the sculpture and, likely, the Leipzig drawing, he must have collaborated on the overall design with one of the elector's many Italian artists. The classicizing architectural frame with the figures set in niches between the Corinthian columns, plus the flanking statues that direct one's gaze upwards towards the resurrected Christ, are more characteristic of Padua, Venice, or Verona than they are of Saxony and Central Europe.[32] The altarpiece builds upon the harmonious union of architecture and sculpture seen earlier in Walther's Dresden portal. Yet in spite of all of the imported Italian features, the Kreuzkirche altar with its prominent placement of texts could scarcely be mistaken for Italian. Walther's figures work better in the drawing than in the actual altar since the carved statues lack either the physical presence or the refinement to compete with the dominating architectural frame.

Hans Walther's Last Supper Altar not only predates the great altars that characterize the militant Catholic art of the end of the century, but it also served as the direct prototype for many subsequent Lutheran altars. Its progeny include Michael Schwenke's altar of 1602 in the Stadtkirche in Lauenstein, the former altar that Giovanni Maria Nosseni and probably Christoph Walther IV made in 1606–8 for the Sophienkirche in Dresden, and Nosseni and Sebastian Walther's altar in the Schlosskirche in Lichtenburg bei Prettin of 1611–12.[33] Nosseni also was involved in the design of the altar that, after several delays, the Freiberg sculptor Bernhard Ditterich began carving in 1623 for the Hauptkirche in Wolfenbüttel.[34] (fig. 70) This work is especially dependent upon the arrangement

70. Bernhard Ditterich, Crucifixion Altar, 1623, Wolfenbüttel, Hauptkirche

of the Last Supper Altar, including the use of flanking arches surmounted with statues. The Hauptkirche was the grandest, most monumental Lutheran church of the early seventeenth century. That the patrons Heinrich Julius, Duke of Braunschweig and Lüneburg (1564–1613), and his son Friedrich Ulrich turned to the Dresden court sculptors for their altar illustrates two things. Although no master could match the role that Lucas Cranach and his workshop played in the formation of Lutheran art during the second quarter of the sixteenth century, the Walther family and their fellow artists in Dresden constitute the first coherent school of Protestant sculptors. Nurtured by Elector

August from the mid-1550s, Hans Walther and
the later Dresden artists enriched churches through-
out Saxony and North German with their altars,
pulpits, fonts, and funerary monuments. Their de-
signs continued to be emulated by other Lutheran
sculptors well into the seventeenth century. Secondly,
the on-going influence of Dresden was inextricably
tied to the continued primacy of the Albertine elec-
tors among Protestant princes, and to their patron-
age of talented artists drawn from Saxony, Italy, and
elsewhere in Europe.

Other Lutheran Sculptural Programs
in North Germany

Although the Dresden school was certainly the
most prominent during this period, examples of
Protestant religious sculpture appeared with in-
creasing frequency throughout North Germany.
Between 1560 and 1563, Johann Albrecht I, duke
of Mecklenburg, erected a new chapel at his palace in
Schwerin that offers an interesting union of sculp-
tors and ideas from both Dresden and Torgau. Hans
Walther fashioned the portal in the shape of a tri-
umphal arch though neither as large nor as grand as
that of the Dresden Schlosskirche.[35] The some-
what damaged relief carvings over the door depict
Christ Carrying the Cross and, above, the Angels
Holding the Passion Instruments. The latter motif
may have been suggested by the portal at Schloss
Hartenfels in Torgau that Johann Albrecht admired
during a visit through Saxony in 1560. The appear-
ance of the chapel at Torgau so impressed the duke
that he hired Simon Schröter, its principal sculptor.
Schröter and his son, Georg, made the Schwerin
pulpit, and Georg carved the altar table supported
by angels, both of which are variations of the
Schloss Hartenfels prototypes. To complete the
chapel's carved decoration Willem van den Broecke
of Antwerp shipped several biblical reliefs that were
placed along the north gallery in 1563.[36]

The most elaborate Protestant project of the
1560s was the Schlosskapelle in Celle.[37] (fig. 71)
In about 1565 Wilhelm the Younger, duke of
Braunschweig-Lüneburg (1559–92), began the
renovation of his chapel, which had been erected in
the 1480s. Whereas most earlier Protestant chapels
were fairly sparsely decorated, Celle is more remi-

niscent of Neuburg an der Donau with its profusion
of carved and painted religious images. The identi-
ties of the chapel's sculptors and painters are un-
known, with the exception of Marten de Vos, the
noted Antwerp painter who signed and dated
(1569) the Crucifixion Altar. The sculptural por-
tions, which seem to predate the paintings, consist
of a sandstone pulpit (1565) contrasting the Fall
of Man with the Crucifixion and Resurrection of
Christ; seventeen half-length relief figures of apos-
tles and evangelists, signifying the dissemination
of Christ's message by his follower, set on the
northern gallery; eight biblical scenes on the west-
ern gallery; and a portrait relief of Duke Wil-
helm.[38] De Vos and his assistants added 76 paint-
ings to the chapel. The significance of Celle lies in
neither the quality of de Vos' paintings nor the
relatively weak carving of the reliefs but in the
visual and iconographic unity of the artistic pro-
grams. The Old Testament typologies, the scenes
from Christ's life, and the depictions of the apostles
reaffirm the centrality of Christ. Absent are any
stories of saints and extraneous events not based
upon scripture, other than a painted scene of a fa-
ther (Duke Wilhelm) reading the bible to a group
of children and an allegory of the Christian church
triumphing over Death, the Devil, and the tempta-
tions of the world. The sumptuous if cluttered en-
semble shows how far Lutheran programs pro-
gressed since the iconoclastic debates of the 1520s.
The pictorial arts have been fully re-embraced. The
Schlosskapelle at Celle would influence several later
north German princely chapels, including those in
Schloss Gottorf (1590–92) at Schleswig and Bücke-
burg (1603–08).[39]

Like August of Saxony, Duke Wilhelm was anx-
ious to hire an artist with an international reputa-
tion who fashionably blended Italian and Nether-
landish art. Although we stressed Italy's influence
earlier, it should be noted that German noble and
civic patrons, especially those in the Hanseatic
towns of the North, had long looked to the Nether-
lands for inspiration. De Vos proved to be an ideal
choice. As a Lutheran who converted to Catholi-
cism only after the Spanish reconquest of Antwerp
in 1585, he was sympathetic to the duke's religious
attitudes. He offered a style strongly influenced by
Michelangelo, whose work he had studied during
his extensive travels in Italy in the 1550s before

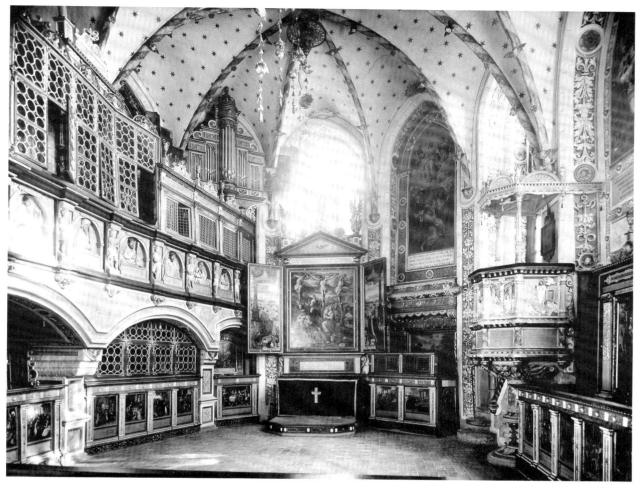

71. Marten de Vos and Others, Chapel, Interior View, 1565–70, Celle, Palace

becoming a master in Antwerp in 1558. The attraction of the Celle project for de Vos is obvious. With Antwerp in the midst of its iconoclastic and political upheavals in the later 1560s, de Vos' artistic prospects were bleak. Celle offered him financial security and the opportunity to paint at least 21 pictures in a coherent cycle.

So far most of the sculptural projects of the third quarter of the sixteenth century that we have examined were initiated by nobles. Protestant burghers continued to balk at displaying too much art in their churches. There proved to be one exception: the pulpit. In evangelical churches, whether Lutheran or Calvinist, the pulpit from which the minister preached the word of God replaced the high altar as the worshippers' focal point. The pulpit's

significance for Luther and in earlier monuments, such as Torgau, was discussed in Chapter Three. During the 1560s and 1570s a growing number especially of North German towns replaced their old pulpits with newer, grander ones of stone or wood. Frequently the artists were local carpenters or stone masons rather than first rate sculptors. Nevertheless, these monuments represent the beginning of what would become a flood of sumptuous Protestant pulpits. Poscharsky, who has written the most comprehensive study of evangelical pulpits, observed that over 200 were made between about 1595 and 1615.[40] The initial impetus may have been the official recognition accorded to Lutherans by the Peace of Augsburg of 1555. After years of military and verbal skirmishing with the

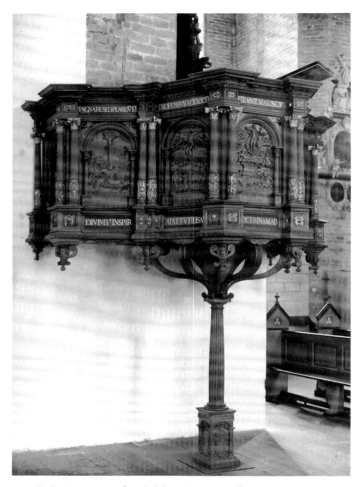

72. Pulpit, 1555–60, Schleswig Cathedral

Catholic church and the emperor, these Lutheran towns could focus instead upon their evolving religious institutions.[41]

In 1555 the Schleswig cathedral chapter, probably under the direction and with the financial support of its preacher Caeso Eminga, initiated plans for a new wooden pulpit.[42] (fig. 72) The large wooden frame rests upon a slender, fluted Corinthian column. The door frame leading to the pulpit's staircase is dated 1560, signifying its completion, and is decorated with Eminga's coat of arms. Text and images once again jointly communicate the central messages about Christ's sacrifice and the word of God. The main inscription running along the lower frame of the pulpit, and thus closest to the parishioners, reads: "All scripture is given by inspiration of God, and is profitable for doctrine,

for reproof, for correction, for instruction in righteousness" (2 Timothy 3:16).[43] The seven multifigured reliefs stress the bringing of the message of God through scenes of Moses presenting the tablets to the Israelites, the Brazen Serpent, the Crucifixion, the Resurrection, the Ascension, the Pentecost, and St. Peter, the cathedral's patron, preaching (Acts of the Apostles 10). Unfortunately, the name of the artist or artists is undocumented though the design of the pulpit suggests a possible Dutch origin.[44]

Schleswig's pulpit was the first of many late Renaissance examples in North Germany and the Baltic cities. In the ensuing decades major pulpits were set up in Güstrow cathedral (1565), Lübeck cathedral (1568–70), Flensburg's Nicolaikirche (1570), Rostock's Marienkirche (1574), Erfurt's Nicolaikir-

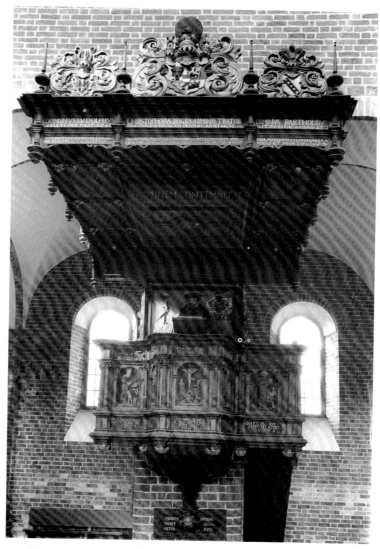

73. Heinrich Matthes, Pulpit, 1576, Ratzeburg Cathedral

che (1570), Ratzeburg cathedral (1576), Flensburg's Marienkirche (1579), Breslau's Maria Magdalenenkirche (1579/80), Rostock's Jakobikirche (1582), and Güstrow's Pfarrkirche (1583), among others.[45] Occasionally, the pulpits were endowed by the church's minister, as in the cases of Schleswig and Lübeck.[46] The wooden pulpit that Lübeck sculptor Heinrich Matthes carved in 1576 for the cathedral at Ratzeburg includes a novel feature.[47] (fig. 73) On the brick wall immediately behind where the preacher would stand is a half-length portrait of Georg Usler, who served as

Ratzeburg's first Lutheran minister from 1566 until 1597. Although the portrait is not physically a part of the pulpit, it is contemporary in date and nicely completes the iconographic message. That is, the story of God's word begins with Moses upon whose head the pulpit literally rests. Wooden reliefs of the Crucifixion-Trinity, the four evangelists, and Sts. Peter and Paul represent the foundation of the Christian church. The minister's life-size portrait signifies the present—the generations of evangelical preachers who, like him, ascend the pulpit armed only with the Bible to share its scrip-

tural lessons with the congregation. The portrait honors Usler but also the critical role he performs as guardian of his flock.

Protestant sculpture, whether in Saxony or Ratzeburg, retains the strongly didactic character that it first assumed in the 1530s and 1540s. The clarity of its message is tantamount. Law and Gospel themes, images of the crucified and resurrected Christ, the evangelists and prophets, and personifications of Christian virtues predominate. The emphasis is upon explicating the word of God and other basic tenets of the evangelical faith. Excluding personal epitaphs and funerary monuments, church sculpture was restricted to a single altar, font, pulpit, or portal. The biblical summa offered at Celle is exceptional. When surveying this period, it is obvious that the skill of the artist and the quality of the carving remain of secondary importance. Only gradually would the artistic level improve due to the activities of the Dresden school. Yet no one will mistake Hans Walther's halting attempts at the *figura serpentinata* or his uncertain handling of flesh with those of his contemporaries Vincenzo Danti or Giambologna. Nevertheless, Hans Walther and his fellow artists must be credited with establishing a solid sculptural foundation for future generations where little had previously existed. The refinement of the creations of Hans' nephew, Sebastian (1576–1645), testifies to the success of these lessons.[48] The prospects for a young sculptor in the Lutheran areas of Germany were certainly far brighter in 1580 than they had been a quarter century earlier when August first ordered the new portal for his palace chapel in Dresden.

Catholic Sculpture and the Council of Trent

By 1555 the Catholic Church in the German lands had reached its nadir. Recognition of Lutheran gains was now acknowledged officially in the Peace of Augsburg. Upwards of eighty percent of the population either claimed affiliation or sympathy with one of the various Protestant sects.[49] Most of North Germany was solidly Protestant. Charles V, who had successfully championed the Catholic cause on the battlefield of Mühlberg in 1547 and at the Augsburg diet of 1548, was to be physically

driven from the German lands only a few years later. Responsibility for defending the faith and dealing with the German nobles passed to his brother, Ferdinand I. The religious situation was hardly propitious to the erection of major new artistic programs. Yet from the ashes of Augsburg in 1555 arose a lively theological dialogue, a renewed sense of Catholic identity, and a rejuvenated faith in the pictorial arts. Indeed art would become a powerful weapon in the Catholic *renovatio*. Between the early 1580s and the 1620s dozens of new Catholic churches were erected or restored. From Münster to Munich, sumptuous sculptural programs were enlisted in the confessional battle. Carved altars and pulpits championed the efficacy of the saints and the correctness of the Catholic faith. Yet before this artistic flowering could occur, changes in the church and a redefinition of its position on art had to take place. In this section, I wish to address these issues and a few of the admittedly scant number of significant religious cycles commissioned between 1555 and 1580.

The creation of religious art never stopped in Catholic lands. Local politics or the advent of a strong cleric occasionally prompted projects even in the most unpromising of times. For example, in 1547 Kaspar Kindelmann became the new abbot of the imperial Benedictine monastery at Ottobeuren.[50] He inherited a church that had been sacked and severely damaged during the Peasant War of 1525 and during the Reformation battles in Swabia. Deciding that a new church was essential if the ancient monastery was to survive, the abbot laid the foundation stone on 25 August 1550. When the church was dedicated eight years later, the decoration included at least ten new altars, choir stalls with reliefs by Hans Kels the Younger, six additional wooden carvings by Kels that were placed above the two doorways leading into the choir, new furniture for the sacristy, and various other enrichments.[51] In Kels, Kindelmann had one of the period's most capable sculptors though a master who was better known for his portrait reliefs, goldsmith models, and stone epitaphs than for his altar designs. Kels was a native of nearby Kaufbeuren but had worked in Augsburg since 1541. None of Kels' altarpieces completed around 1555 survives intact. His sculptures disappeared when Kindelmann's church, a victim of changing

tastes, was destroyed in the eighteenth century to make way for Johann Michael Fischer's famed rococo building. A few wooden reliefs, attributed to Kels based on their stylistic similarities with his small sculptures, are today in the Klostermuseum here. Lieb has suggested that these are fragments from Kels's Apostle Altar that was set originally in the nave as the laity's high altar.[52]

King and later Emperor Ferdinand I commissioned the only other major Catholic building of the 1550s. In his wills of 1532 and 1543, Ferdinand promised to erect a church in Innsbruck for the tomb of Emperor Maximilian I.[53] This was to be a dynastic monument, an impressive symbol of Habsburg grandeur and political authority. Originally, he planned just to add a large chapel on to St. Jakob, then Innsbruck's high parish church. By 1553, this project had been abandoned in favor of a new structure, the Hofkirche, designed by Andrea Crivelli of Trent and set adjacent to the city palace. Construction was completed in 1561; Peter Canisius conducted the inaugural mass on 24 June 1562 on the occasion of the foundation of a new Jesuit school. In the following year Ferdinand and his children formally dedicated the Hofkirche.

The Hofkirche is, of course, best known for the monumental tomb of Maximilian I, which will be discussed in Chapter Six; however, Ferdinand also paid for the decoration of the choir.[54] (fig. 145) Unfortunately, as at Ottobeuren, the original sculpted altar fell victim to later remodelling projects. The 1553 plan called for a high altar featuring a carved Crucifixion group with God and the Holy Spirit above; the wings were to be painted with six scenes of Christ's passion. Twelve apostles adorned the painted predella. Hans von Köln, then painter to Elector Friedrich von der Pfalz in Speyer, received the commission for the wings and predella in 1553. Finding the sculptor proved a harder task.[55] Hans Kels the Younger was asked to do the central carvings. Yet when his estimate, as well as that of the next sculptor, Hans Polsterer (Bolsterer) of Nuremberg, proved too costly, Hans Röpfel of Tölz (Bavaria) was charged to make a trial piece in the form of a relief of St. George. When in 1553 this was judged to be artistically inferior ("nit sogar kunstlich"), the project finally went to Ulm sculptor Kaspar Leschenbrand (Loschenbrand) who, together with the framemaker, Mindelheim carpen-

ter Hans Walch, received payment of 700 gulden in 1556.[56] The only visual record of this altar is contained in Lorenz Strauch's engraving of the interior of the Hofkirche of 1614. (fig. 74) Little can be said about the style of the high altar other than that the painted wings are lacking and that the large sculpted figures of the corpus were set in a two tier, rounded Renaissance-style frame.[57]

As the Hofkirche was being completed, events were happening in nearby Trent that would have a tremendous impact on the future direction of church art. Trent was the site of the great church council originally opened in 1545 to debate Catholic doctrine and to develop strategies for combatting the spread of Protestantism. The third and, for us, most significant meeting occurred between 18 January 1562 and 4 December 1563. In the twenty-fifth and last session, the delegates reaffirmed the church's belief in purgatory and adopted a general policy entitled "On the invocation and veneration of saints, on the relics of saints, and on sacred images."[58] The council strongly claimed that the saints "who reign together with Christ offer up their prayers to God for men." Seeking their intercession does not impugn Christ's role as the "one mediator of God and men"; this is a direct response to Protestant criticism about the Catholics' reliance upon saints.

The council embraced the church's traditional acceptance of religious images as being educationally beneficial. Their text reads in part:

> Moreover, that the images of Christ, of the Virgin Mother of God, and of the other saints are to be placed and retained especially in the churches and that due honor and veneration is to be given them; not, however, that any divinity or virtue is believed to be in them by reason of which they are to be venerated, or that something is to be asked of them, or that trust is to be placed in images, as was done of old by the Gentiles who placed their hope in idols; but because the honor which is shown them is referred to the prototypes which they represent, so that by means of the images which we kiss and before which we uncover the head and prostrate ourselves, we adore Christ and venerate the saints whose likeness they bear. That is what was defined by the

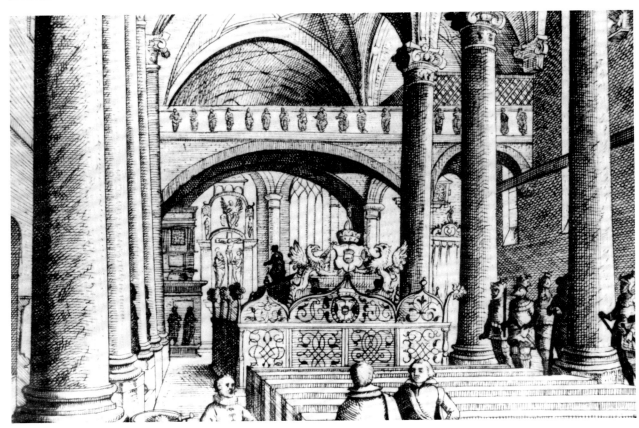

74. Lorenz Strauch, *Interior of the Innsbruck Hofkirche*, detail, 1614, engraving, Innsbruck, Tiroler Landesmuseum Ferdinandeum

decrees of the councils, especially the Second Council of Nicaea, against the opponents of images.

Moreover, let the bishops diligently teach that by means of the stories of the mysteries of our redemption portrayed in paintings and other representations the people are instructed and confirmed in the articles of faith, which ought to be borne in mind and constantly reflected upon; also that great profit is derived from all holy images, not only because the people are thereby reminded of the benefits and gifts bestowed on them by Christ, but also because through the saints the miracles of God and salutary examples are set before the eyes of the faithful, so that they may give God thanks for those things, may fashion their own life and conduct in imitation of the saints and be moved to adore and love God and cultivate piety. . . .And if at

times it happens, when this is beneficial to the illiterate, that the stories and narratives of the Holy Scriptures are portrayed and exhibited, the people should be instructed that not for that reason is the divinity represented in picture as if it can be seen with bodily eyes or expressed in colors or figures. Furthermore, in the invocation of the saints, the veneration of relics, and the sacred use of images, all superstition shall be removed, all filthy quest for gain eliminated, and all lasciviousness avoided, so that images not be painted and adorned with a seductive charm, or the celebration of saints and the visitation of relics be perverted by the people.

The same decree empowered bishops with authority to control any unusual images and to settle any problems of abuse.

The council's text is fascinating both for what it

includes and for what it does not address.[59] In an attempt to write a succinct doctrinal statement, the authors restated the Catholic church's traditional belief in the benefits of images to instruct and to confirm the articles of faith. These images are not idols when used correctly; instead these are exemplars for contemplation and imitation. They argue that paintings and sculptures are simple representations with no inherent power of their own. Nevertheless, to prevent some worshippers from crossing over the boundary into idolatry, the lascivious or "seductive charm" of the object should be minimized. The decree offers only general guidelines. It does not advocate or limit any particular theme or type of art. No new iconographies or styles are proposed. Although various provincial synods, such as that held in Mainz in 1549, had urged image reform and episcopal authority in controlling abuses, the Council of Trent was the first definitive Catholic response to decades of Protestant criticism about art.[60] Pope Pius IV (1559–66) and delegates drawn from across the continent sent a direct message about the theological correctness of religious art to every Catholic diocese and parish.

The Council of Trent's decrees did not result in an immediate flowering of German sculpture and painting. This would happen but not until the 1580s and 1590s. Before lavish artistic commissions could occur, the Catholic church had to solidify its often tenuous authority within the bishoprics still under its jurisdiction. The council's other decrees strengthened the power of bishops while at the same time limited many of the worse abuses.[61] The holding of multiple episcopal titles was prohibited though exceptions, such as Ernst of Bavaria, were accepted if politically expedient.[62] Bishops must reside in their dioceses and undertake annual visitations as a means for better understanding and overseeing their congregations. The council charged the bishops with introducing the Tridentine decrees within their dioceses. The reform of the German Catholic church was directed by the popes through their nuncios.[63] On 23 July 1568 Pius V (1566–72) established the Congregatio Germanica, a standing group of papal representatives and German clerical leaders united in their opposition to the Protestants. By selecting talented bishops and by pushing proper religious education, the Congregatio Germanica often succeeded in reinvigorating the German Catholic church. Especially during the reign of Pope Gregory XIII (1572–85) the German church went on the offensive. Bishoprics that waivered between Protestant and Catholic control, such as Würzburg and Bamberg, were brought back into the Catholic camp.[64] To educate the young and, later, to train new priests, the Jesuit order was introduced into Germany in the 1540s; however, it was not until the 1550s that they became a catalyst in the Catholic *renovatio*. Under the spiritual guidance of Peter Canisius (1521–97), Jesuit schools were established in Cologne, Vienna, Prague, Ingolstadt, Strasbourg, Trier, Freiburg i. B., Zabern (Alsace), Dillingen, Munich, Würzburg, Hall in Tirol, Speyer, Innsbruck, Landshut, Landsberg, Molsheim (Alsace), and Fribourg (Switzerland).[65] Often in the face of strong local opposition from other Catholic groups, the Jesuits advocated militant reform and a return to traditional Christian virtues.[66] New Jesuit churches, however, did not appear until the 1580s.[67]

Five Case Studies

The Catholic revival's impact upon art manifest itself differently in each city, bishopric, and princely territory. To demonstrate this, I wish next to examine five instances in which new religious sculpture did result from a reassertion of strong Catholic authority. The situations in Augsburg, an imperial free city, Trier, an archepiscopal city, Würzburg, a prince-bishopric retaken by the Catholics, Ingolstadt, the university city ruled by the dukes of Bavaria, and Innsbruck, where Ferdinand of Tirol built a private chapel, offer different responses to the religious situation. Yet in each case, the artistic commissions may be linked with a new militant Catholicism that emerged especially in southern Germany. This militancy expressed itself peacefully in the classrooms and parishes rather than on the battle fields as it had in the 1540s.

AUGSBURG

Augsburg, more than any other city, served as the focal point for the skirmishes between the Protestant and Catholic camps. In Chapter Two we witnessed the city's iconoclastic struggles and saw that

significant groups of both confessional faiths continued to reside within its walls. Amid the seeming chaos of the period, Otto Truchsess von Waldburg was elected bishop of Augsburg in 1543.[68] Within a few years, Otto, who became a cardinal in 1544, emerged as Germany's strongest Catholic cleric and an ardent advocate of church reform. The bishop took full advantage of Charles V's victory over the Protestants at Mühlberg and the emperor's presence at diets in Augsburg in 1547–48 and 1550–51 to reassert Catholic authority. He celebrated his inaugural mass in Augsburg cathedral on 5 August 1547. Over the next year Otto demanded civic reimbursement for destroyed church ornaments and restitution of all churches seized by the Protestants between 1534 and 1537.[69] Under his direction a few new artistic commissions were given to replace significant works that had been destroyed in 1537. For instance, in 1554 Christoph Amberger painted a new high altar for the cathedral.[70] Its design and iconography carefully replicate the essential traits of the former high or Mary Altar that Hans Holbein the Elder had painted in 1508–9. Since all traces of the altar had likely disappeared, Holbein's drawing, today in Danzig (Stadtmuseum), must have served as Amberger's model. This selective re-creation of certain paintings and sculptures illustrates a conscious desire to re-establish the Catholic church's bonds with its recent past. As we shall see shortly, Amberger's altarpiece is but one of several examples of this practice. The bishop was, however, sensitive to Protestant complaints about idols so he restricted the amount of decorations permitted in other churches in the diocese.[71]

Bishop Otto championed the Catholic faith while being politically savvy in his dealings with Augsburg's strong Protestant community. During his long reign from 1543 to 1573, he established an accommodation between Augsburg's Catholics and Protestants. Both sides could worship in relative peace and educate their children without interference.[72] Otto strengthened the quality both of priests and public preaching in the diocese. In 1549 he established a Catholic college in Dillingen, site of his official residence; five years later the school was elevated to a university that specialized in training priests. The bishop enlisted Jesuit Peter Canisius, an eloquent moralist and reformer, to be his cathedral's preacher from 1559 to 1567. Bishop

Otto, active at the various sessions of the Council of Trent, published its decrees in 1565 and organized meetings to explain the points to Catholic delegates attending the 1566 imperial diet in Augsburg. Except for his periods of residence in Rome, Bishop Otto provided firm leadership and much needed stability to Augsburg's Catholic community.[73]

Another strong reforming cleric, Abbot Jakob Köplin (1548–1600), restored Augsburg's other major church, the imperial Benedictine monastery of St. Ulrich and Afra. (fig. 75) Decimated during the upheavals of the 1530s, little remained of the church's artistic decorations when it was returned to the Catholics in 1548. For the next twenty years Köplin focused upon his primary task of rebuilding the monastery's clerical community.[74] Only when this was accomplished did the abbot begin plans for the artistic enrichment of his church. Inspired by the Council of Trent's reaffirmation of religious art, Köplin ordered local sculptor Paulus II Mair to carve a monumental new high altar.[75] (fig. 76) When consecrated in 1571, Mair's Mary Altar must have astounded many since at 16.5 meters high it was the largest Catholic altarpiece in Germany since the 1520s, with the sole exception of Hans Mielich's new high altar (1560–72) in Ingolstadt. (figs. 84 and 85) The design of the winged retable with its corpus, predella, and superstructure (Auszug) are intentionally archaic. Mair and his patron consciously looked beyond the prevailing Renaissance style to the altar forms of the later fifteenth and early sixteenth centuries. The standing Virgin and saints in the corpus, the half-length predella figures of Sts. Simpertus, James Major, and Narcissus, and the Gothic-style tracery of the upper sections of the altar recall works such as the *Blaubeuren Altar* (1493–94) by Michael Erhart, Mair's great grandfather, or Jörg Lederer's St. Blasius Altar in Kaufbeuren of 1518.[76]

Rasmussen correctly labelled the Mary Altar as a major example of the Catholic *restauratio*.[77] The appearance of the original high altar of St. Ulrich and Afra is unknown. It is possible that Mair purposefully evoked the memory of this earlier altar much as Amberger's 1554 High Altar for the cathedral paid hommage to Holbein's destroyed master-work. Rasmussen suggests that this reusing of Gothic forms is part of the Counter-Reformation Catholic church's desire to re-establish a tie with

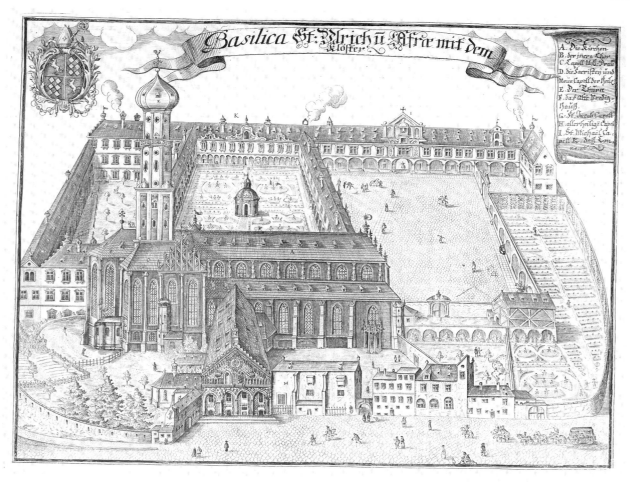

75. Daniel Mannasser, *View of St. Ulrich and Afra in Augsburg*, 1626, engraving, Munich, Staatliche Graphische Sammlung

the historical traditions of the past that had been severed by iconoclasm. That is, historicism provided a means of continuity. In our discussion of Münster following the suppression of the Anabaptists, we observed the same phenomenon as the bishop and cathedral chapter quickly restored and replaced select statues, such as that of Paul, their patron saint. To the Catholic clergy and laity alike, religious sculpture represented a physical embodiment of their beliefs. Works, such as Mair's altar, bridge the intervening dislocation caused by the Reformation back to a time when art piously served a single Christian church. The altars in St. Ulrich and Afra and in the cathedral anticipate the widespread seventeenth-century practice of re-using and incorporating late medieval and early Renaissance sculpture in new altarpieces.[78]

Interestingly, Mair's Mary Altar was replaced only a generation later. Was the change prompted by a shift in aesthetic values or by qualms over the quality of Mair's work? In 1601 Köplin's ambitious successor, Abbot Johann Merk (1600–32), built a new sacristy and, above it, the Marienkapelle (Schneckenkapelle). In the same year he transferred the Mary Altar to this chapel.[79] The church had no high altar until Hans Degler's magnificent St. Narcissus (or Adoration of the Shepherds) Altar was dedicated in 1604.[80] (fig. 77) By 1600 the German Catholic church was much stronger than it had been thirty years earlier. Merk desired a new high

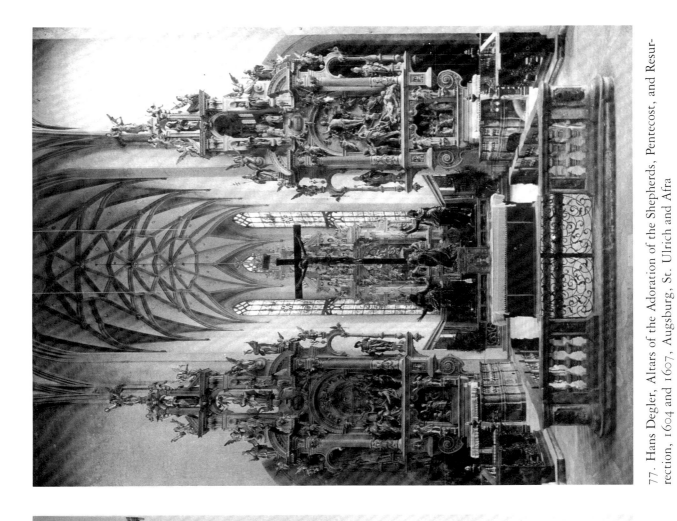

77. Hans Degler, Altars of the Adoration of the Shepherds, Pentecost, and Resurrection, 1604 and 1607, Augsburg, St. Ulrich and Afra

76. Paulus Mair, Mary Altar, 1571, Augsburg, St. Ulrich and Afra

altar that better expressed the church's more confident spirit. When comparing the two altarpieces, Mair's figures seem static and strangely lifeless. Each statue or group of statues dutifully fills its assigned niche; everything is clearly and appropriately arranged. Nevertheless, the Mary Altar is devoid of the fervent spiritualism that characterizes the best pre-Reformation altars. Admittedly, Mair might have been compelled to copy certain features of the original altarpiece destroyed by the iconoclasts. Degler, on the other hand, is a worthy successor to Hans Leinberger or Veit Stoss. He emulated the emotionalism inherent in their finest creations. This is hardly accidental since Degler too studied older altars for both the structure of the frame and his narrative vocabulary. Degler's figures use bold, overstated gestures to animate the telling of the holy story. He offers a brilliant realization of the Counter-Reformation's *theatrum sacrum*, which would come to dominate German sculpture throughout much of the seventeenth and eighteenth centuries. With Degler, one experiences a creative borrowing of the best features of late Gothic and early Renaissance art which are then combined with the zeal of the resurgent German Catholic church.

Although Mair's altar was moved from its original location, it remained tremendously popular with worshippers seeking the Virgin's assistance. Romanus Kistler, writing in 1712 on the occasion of the monastery's 700th anniversary, observed that a large number of votive pictures hung on the walls adjacent to the altar in acknowledgment of the miracles performed by "Maria Trost" (Mary the consoler).[81] The tenor of his text and the implied power of the Virgin as manifest through the altarpiece are strikingly similar to the attitudes discussed in Chapter One.

In addition to Paulus Mair's Mary Altar, Abbot Köplin ordered the restoration of the tomb of St. Simpertus in 1579.[82] (fig. 8) Damage to Michel Erhart's recumbent effigy was repaired and a new stone base, marked with the abbot's coat of arms, was added. Köplin also permitted several members of the Fugger family to assume responsibility for the maintenance and re-decoration of five of the side chapels of the nave.[83] Although most of the resulting artistic commissions postdate 1580, it demonstrates how the wealthy laity were once again eager

to secure the spiritual and social gains associated with church donations.

St. Ulrich and Afra was not the only Augsburg church that gradually added new sculptural decorations. The Dominikanerkirche, which had not been sacked in 1537 due to the strong pressure of the Fuggers and other leading Catholic patricians, received several modest commissions. Antwerp sculptor Willem van den Broecke (Guilielmus Palu-

78. Hubert Gerhard, *Altar of Christoph Fugger*, detail of *Prophet*, 1581–84, formerly in Augsburg, Dominikanerkirche, now London, Victoria and Albert Museum

danus) carved a series of alabaster reliefs for one or, more likely, two projects for the church.[84] Four typological scenes (*Crucifixion-Sacrifice of Abraham, Last Supper-Offering of Melchizedek*), dated 1560, one bearing the arms of the May and Rembold families of Augsburg, hung originally in a red marble frame on the fifth column of the nave. A second, higher quality Crucifixion relief of 1562 also was made for this church. These reliefs are export products. Van den Broecke is documented throughout this period in Antwerp, so trips to Augsburg in 1562 or to Schwerin in 1563, where other carvings were delivered to the Schlosskirche, are unlikely. In January 1581 the heirs of Christoph Fugger (d. 1579) commissioned Paulus Mair, the master of the Mary Altar, to make a frame and several sketches for a new altar destined for the sixth column of the nave.[85] The bronze Resurrection, prophets, and other elements of this once grand altar went, however, to Hubert Gerhard and Carlo Pallago, two young masters only recently arrived in Augsburg who would soon reinvigorate the city's sculptural tradition. (fig. 78) While this particular project was not completed until 1584, it again illustrates the gradual renewal of interest in religious sculpture and the engagement of patricians as well as clerics in the rebeautification of Augsburg's Catholic churches.

TRIER

While Trier had not suffered the violent upheavals of Augsburg, the city and archbishopric also experienced a revival in the aftermath of the Council of Trent. On 7 April 1567 Jakob von Eltz was elected the new archbishop and elector of Trier.[86] In contrast with his three predecessors, von Eltz had been a priest for seventeen years. As a result, he had an unusual interest in correct doctrine and how it could be communicated to his flock. During his formal investiture in January 1569, following a two-year political dispute with the city of Trier, von Eltz publicly embraced the Tridentine decrees. At his first synod on 19 April he sought to institute the reforms of Trent by ordering a visitation of the Trier diocese, which lasted from the summer of 1569 into 1570.

Jakob von Eltz (1567–81) fostered an assertive Catholicism that encouraged the visual arts. In 1569 or 1570, the cathedral chapter, probably with the financial assistance of von Eltz, ordered a glorious new sandstone pulpit.[87] (figs. 79 and 80) The sculptor of this signed and dated (1570 and 1572) monument is Hans Ruprecht Hoffmann, the first of the great sculptors who would enrich German art during the late sixteenth century. Between his arrival in Trier in 1568 and his death in 1616, the prolific Hoffmann would fill the diocese's churches with pulpits, altars, tombs, and epitaphs.

The pulpit's program reflects von Eltz's pastoral concerns. On the basket are five deeply cut reliefs showing the Works of Mercy: visiting the sick, clothing the naked, receiving strangers, giving drink to the thirsty, and providing food to the hungry. A much smaller scene of burying the dead is on the socle below. Two large reliefs adorning the exterior of the staircase represent the Last Judgment and, to the right, the Sermon on the Mount. It was during the sermon (Matthew 5–7) that Christ offered his most complete statement about human relations and man's association with God. The text of the prayer Our Father (Matthew 6:9–13) was first spoken on this occasion. The Trier pulpit links these lessons with Christ's account of the Last Judgment (Matthew 25:31–46), which reads in part:

> When the Son of man shall come in his glory, and all the holy angels with him, then shall he sit upon the throne of his glory: And before him shall be gathered all nations; and he shall separate them one from another, as a shepherd divideth his sheep from the goats: And he shall set the sheep on his right hand, but the goats on the left. Then shall the King say unto them on his right hand, Come, ye blessed of my Father, inherit the kingdom prepared for you from the foundation of the world: For I was an hungred, and ye gave me meat: I was thirsty, and ye gave me drink: I was a stranger, and ye took me in: Naked, and ye clothed me: I was sick, and ye visited me: I was in prison, and ye came unto me (31–36).

Christ next asked whether each soul truly performed these acts of charity. The just would go to heaven while the selfish would find only "everlasting punishment." Through its images and the accompanying biblical inscriptions, Hoffmann's pulpit succinctly explains Christ's teachings to the congregation passing before it.

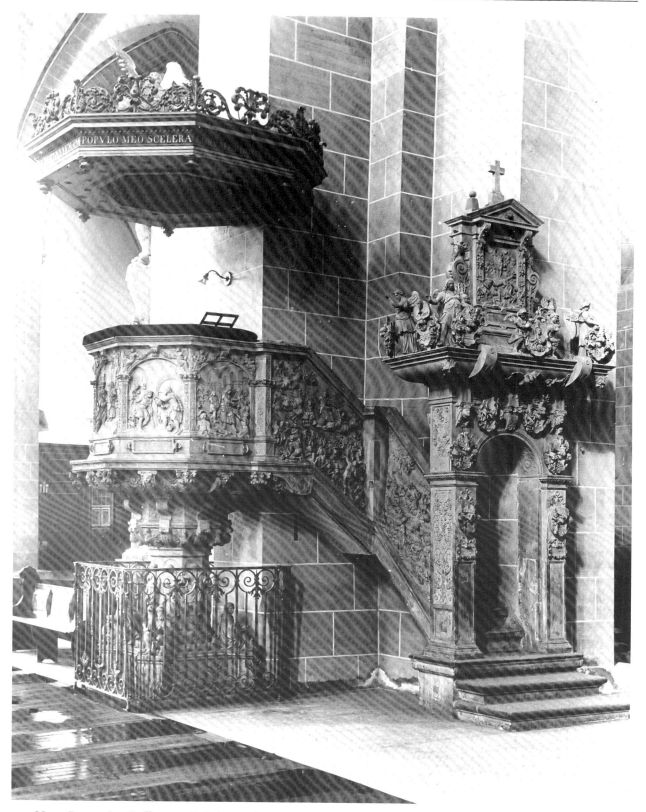

79. Hans Ruprecht Hoffmann, Pulpit, 1569–72, Trier Cathedral

The program continues on the stem and doorway of the pulpit. Adorning the former are seated figures of the four evangelists and standing niche statues of the five senses.[88] Four more reliefs depicting the Annunciation, Nativity, Resurrection, in the large framed scene over the doorway, and the Ascension ornament the portal. These illustrate Christ's life from the moment he entered the world until he returned to heaven. St. Peter, the cathedral's patron, appears in the cartouche held by the two angels in the center of the upper zone of the doorway. The sides of the doorway are inscribed with the names Peter and Paul, the pillars of the Catholic church. Coats of arms, some held by angels and others as reliefs, complete the pulpit. It is uncertain whether Hoffmann originally included a canopy over the pulpit; the current cover dates to about 1830.

Hoffmann, like many contemporary sculptors, drew inspiration from Netherlandish prints. For example, the scenes of Mercy are based closely upon a series engraved by Dirk Volkertsz. Coornhert after Maarten van Heemskerck.[89] A clearer idea of Hoffmann's use of graphic models is seen in his *Last Judgment*, which depends on Cornelis Cort's engraving of 1564 after Heemskerck.[90] (fig. 81) The sculptor is closest to Heemskerck's design in the lower register where the dead rise from the earth and are separated into the saved and the damned. He includes fewer figures and their proportions are squatter though careful attention is given to their musculature. Heemskerck's left-hand figures of the man with the skeletal head and, behind, another man in prayer have been moved to the center of Hoffmann's composition. Their companions likely derive from another print. Hoffmann altered the

80. Hans Ruprecht Hoffmann, Pulpit, detail, 1569–72, Trier Cathedral

Sic ergo erit uidere, sese mutuo
OPVLENTIAM, SVPERBIAM, INVIDIAE luem.
BELLVM INOPIAM TAPINOPHROSYNEN atque opum
VT VNVS OMNIA IN OMNIBVS FIAT DEVS

PACEM parentem uelut in orbem consequi,
Supremus orbi donec ingruet dies:
Cum patre natus de Deo idem homo et Deus.

Feret ultimam aequus arbiter sententiam
Rebusque finem ponet et regnum patri
Restituet, ante a patre creditum sibi,

81. Cornelis Cort (after Maarten van Heemskerck), *Last Judgment*, 1564, engraving, Leiden, Rijksuniversiteit, Kunsthistorisch Instituut, Prentenkabinet

upper zone significantly. Christ is smaller, closer in scale to the foreground figures below. Interestingly, the sculptor excludes the group of saintly intercessors that so prominently flank Heemskerck's Christ. While Hoffmann retains some of the prophets and saints at the rear, he reflects the Council of Trent's stress upon Christ as sole judge. Hoffmann has also incorporated a scene of the blessed passing through the clouds towards God, not Abraham, who holds Christ in his lap. He places this new scene at the highest point of his unusually shaped relief. By contrast, he takes full advantage of the frame by having the damned tumbling downwards towards hell at the lower right. In spite of his dependence upon Heemskerck's print, Hoffmann has produced his own highly

charged composition, one that heightens both the tension and the immediacy of the Last Judgment.

For other architectural and decorative forms Hoffmann referred to prints after Cornelis Floris. In 1557 Hieronymus Cock of Antwerp published Floris's *Veelderleij niewe inventien van antijcksche sepultueren*, which contains designs for funerary monuments.[91] (fig. 110) The motif of the two angels resting in the spandrels over each of the five scenes of Mercy may be found frequently in Floris' compositions, as can the female-headed Ionic console and the fruit and strapwork-bedecked Ionic capital suspended from Hoffmann's basket.[92] The upper half of the Trier doorway recalls another of Floris' designs.[93] Specifically, he borrowed the use of a strong, horizontal bier-like form ornamented with

two prominent straps and a bird (the Holy Spirit at Trier) plus, above, a figural relief set within a rectangular frame topped by a pediment.

Although Hoffmann borrowed ideas from various sources, the result is, in my opinion, the finest of all sixteenth-century German pulpits. The decorative details are exquisitely carved yet subordinated to the carefully balanced form of the whole pulpit. The figural reliefs are especially appealing because of Hoffmann's ability to translate Heemskerck's consciously complex poses and virtuoso nudity into a sculptural idiom. None of the anatomical subtleties are lost. The figures move convincingly through the broad landscapes and elaborate architectural spaces. Furthermore, the overall iconographic program, with its stress on Christian charity and good deeds as the key to salvation through Christ, would have been clear and comprehensible to all. Meyer was correct when she suggested the Trier pulpit was the paradigm for dozens of later Catholic and Protestant examples.[94]

Hoffmann and his growing workshop produced a large corpus of altars and funerary monuments for the cathedral in Trier. In the Dommuseum are ten fragments that survive from an altar he created for the cathedral cloister in about 1570.[95] While none of these projects can be linked directly with the patronage of Jakob von Eltz, the archbishop's strong leadership encouraged others to commission decorations for the cathedral and churches in the diocese. This trend continued under his successor, Archbishop Johann VII von Schonenberg (1581–99), who, among other projects, charged Hoffmann with the erection of the monumental Trinity Altar, a combined tomb and altar honoring Jakob von Eltz completed in 1597.[96]

WÜRZBURG

In contrast with Trier, which had remained predominantly Catholic throughout the Reformation, the religious and hence the artistic situation in Würzburg was considerably more complex.[97] Up until the 1520s Würzburg had been the seat of a wealthy, thriving bishopric. Tilmann Riemenschneider and his workshop finished literally dozens of altarpieces and other religious sculptures for churches in Würzburg and its diocese. Yet between 1525 and the 1570s, virtually no new altarpieces

were placed. While Bishop Konrad II von Thüngen (1519–40) succeeded in crushing the Peasant Revolt of 1525 and driving from office the city council, which included Riemenschneider who was tortured for opposing the bishop, Catholic dominance gradually disappeared.[98] By mid-century, upwards of two-thirds of Würzburg's population was either Protestant or sympathized with evangelical ideas. Lutheran mayors and leading civic officials were common. Many of Würzburg's once thriving monasteries lay empty. Further weakening episcopal authority were the devastations of the Margrave's War of 1552–54 and, in 1558, the murder of Bishop Melchior Zobel von Giebelstadt (1544–58) by agents of Wilhelm von Grumbach, a regional noble.[99] (fig. 120) Grumbach and 1,200 supporters plundered Würzburg and the episcopal lands on 4 October 1563. The situation was so desperate that in 1574, over a decade later, the papal nuncio Kaspar Gropper characterized the Hochstift as still being in ruins.[100]

Against this bleak backdrop, however, Würzburg was blessed with two progressive bishops: Friedrich von Wirsberg (1558–73) and Julius Echter von Mespelbrunn (1573–1617). Von Wirsberg may be credited with stabilizing the situation. In 1561 he opened the Wirsberg Gymnasium, a Catholic school. In the same year and in the face of strong opposition from the cathedral chapter he invited the Jesuits to settle in Würzburg. Peter Canisius, the Jesuit superior for upper Germany whom we have already encountered in Innsbruck and Augsburg, preached here in 1564 and 1566. Recognizing that the Jesuits would be critical to the church's attempt to reassert its authority, von Wirsberg authorized a Jesuit college in 1567 and gave them the abandoned convent of St. Agnes. The following year the bishop ordered a diocese-wide reform based upon the Tridentine decrees. When a 28 year-old Julius Echter succeeded to the throne in 1573 he quickly and successfully strove to improve the economy of the Hochstift. During his long reign, Bishop Echter earned the sobriquet "father of the fatherland."[101] (fig. 310) Würzburg became one of the strongest Catholic bishoprics and, once again, a dynamic artistic center. In the mid-1580s, Echter, as bishop and duke of Franconia, decided to enforce the Peace of Augsburg's law that a region's citizens had to follow the ruler's religious

affiliation. First he excluded Protestants from the city council and all major administrative appointments. In 1587 his actions prompted around 600 Protestants, or approximately one-tenth of the city's population, to emigrate to Kitzingen and Schweinfurt rather than embrace Catholicism.

Echter was a great builder. Already early in his reign he understood that art could be a powerful tool in regaining the spiritual allegiance of his subjects. While one estimate that as many as 300 churches were either built or restored by the bishop may be too high, it does reveal that Echter was a dynamic supporter of the arts.[102] A Frankish poem of 1604 makes the same point.

> There were so many churches built that
> Well it might be wondered at
> How it thus had happened that
> So many churches new had been
> Erected in one Prince's reign,
> So many old ones renovated,
> Enlarged, embellished, decorated.[103]

The majority of his building projects postdate 1580. Included among these are the university of Würzburg, which he refounded in 1582; the Universitätskirche built after Georg Robyn's plans between 1586 and 1591; and the new pilgrimage church at Dettelbach, 14 kilometers east of Würzburg, that was consecrated in 1613 and lavishly decorated with sculpture by Michael Kern.[104]

The bishop's inaugural project, the creation of the Juliusspital and church of St. Kilian, does fall within the dating perimeters of this chapter.[105] He laid the foundation stone for the new hospital on 12 March 1576. The building of both the hospital and its church were completed by 1580. Unfortunately, little has survived the fire of 1699, the two later building campaigns, and the bombings of 1945. Johann Leypold's engraving of 1603 provides the clearest view of its original appearance. (fig. 82) The architect was probably Georg Robyn of Ypres in Flanders, the building master of the archbishop of Mainz. Hans Rodlein of Würzburg carved the large foundation relief (1578) over the principal portal while Peter Osten, Robyn's nephew, worked on the two courtyard fountains and the sculpture for the church.[106] (fig. 83) The pastoral nature of the hospital recounted in the portal relief recalls the emphasis upon charity in the Trier pulpit. The dominant figure is Bishop Echter kneeling in prayer and staring heavenwards towards the Holy Trinity. The banderole held by an angel reads "Tibi derelictus est pauper" (Psalm 10:14–"The poor victim commits himself to thee; {fatherless, he find in thee his helper}"). The hospital's function is illustrated in the rest of the scene. A doctor visits his bedridden patient while the hospital priest sits on the end of another patient's bed. The hospital was intended to serve the poor, the sick, pilgrims, and orphans, six of whom, including two foundlings, are shown in the center.[107] Clarity rather than artistic skill is the chief virtue of Rodlein's relief.

Peter Osten is first mentioned in the hospital building accounts in 1577. Normally a resident of Mainz where he worked for the archbishop, he lived in Würzburg during the erection of the Juliusspital from 1578 until at least 1581. None of his hospital sculptures survive; however, the superb quality of his epitaph of Sebastian Echter, Julius' brother, in the cathedral, reveals his knowledge of Cornelis Floris' tombs and his talent which was significantly superior to any of the local masters.[108] (fig. 113) The two courtyard fountains of Sts. Burkhard, the diocese's first bishop, and Kilian, patron of Franconia, Würzburg, and the hospital, are just visible in Leypold's engraving.[109] Osten's drawing for at least one of the fountains is mentioned on 2 January 1579.[110] For the hospital or Kilianskirche, Osten created the high altar. City counselor Konrad Müller, who was charged with overseeing the hospital construction, wrote on 10 March 1578 that Osten and he had shown sketches for the altar to Bishop Echter.[111] The altar, as completed by August 1579, included statues of St. Kilian and his companion martyrs, Sts. Kolonat and Totnan. Were these three figures, which were probably carved in alabaster, patterned after the prototypical appearance of the saints as established in Riemenschneider's half-length wooden statues for the high altar of Würzburg cathedral in 1508–10?[112] If so, we have another sculptural ensemble of the 1570s that consciously alludes back to a city's earlier spiritual and artistic heritages. Osten also contributed an alabaster(?) relief of the Last Supper for the church's sacrament house or niche.

Few of Peter Osten's sculptures are extant.[113] In addition to the destruction of his carvings for the Spitalkirche, any works that he may have created

82. Johann Leypold, *View of the Juliusspital in Würzburg*, 1603, engraving, Würzburg, Mainfränkisches Museum

83. Hans Rodlein, *Foundation Scene with Prince-Bishop Julius Echter*, c. 1576–77, Würzburg, Juliusspital

for St. Gangolph, the new palace church in Mainz, were lost when the building was broken apart around 1800.[114] This church was constructed by Georg Robyn for Daniel Brendel von Homburg, archbishop of Mainz (1555–82), in 1580. This relative lack of documented works is especially grievous since Osten was a critical disseminator of Netherlandish artistic forms in the Rhine-Main region. He also bridged the gap between older sculptors such as Dieter Schro of Mainz and the Juncker and Kern dynasties that emerged in this area around 1600.[115]

INGOLSTADT AND INNSBRUCK

The final two works that I wish to introduce are very different in terms of their scale, setting, and audience, yet both are striking manifestations of the renewal of Catholicism brought about by the fledgling Counter-Reformation. The first is the monumental high altar that Duke Albrecht V of Bavaria ordered for the Liebfrauenmünster in Ingolstadt; the second is the small altar that Ferdinand, archduke of Tirol, commissioned for his private chapel in the Hofkirche in Innsbruck. (figs. 84–86) One is bombastic; the other demands quiet contemplation. Both are ideally suited for communicating specific religious messages to their respective audiences.

The dukes of Bavaria had long been patrons of the city of Ingolstadt. They initiated the erection of the Liebfrauenmünster in 1425 and established a new university in 1472.[116] With their support, the university and its faculty, most notably Dr. Johann Eck (d. 1542), were among the fiercest critics of Luther and the Protestant movement. When Albrecht V assumed office in 1550 the prominence of the university, like the strength of Bavarian Catholicism, had waned sharply.[117] Having already realized this, his father, Wilhelm IV, in 1549 called Peter Canisius to Ingolstadt first as a professor of theology and later as rector and vice-chancellor of the university. Albrecht V helped Canisius found a Jesuit college here in 1556. Through the efforts of Albrecht V, who had studied here as a boy, and the Jesuits, Ingolstadt once again became a formidible Catholic bastion.

In anticipation of the centennial anniversary of the university in 1572, the duke commissioned a new high altar for the Liebfrauenmünster in 1560.[118] (figs. 84 and 85) This monumental polyptych, which measures about 12 meters high and 4.5 meters wide, is physically imposing and theologically aggressive. It is the first great Counter-Reformation altarpiece in Germany. Hans Mielich, the duke's court artist, designed the altar and spent at least six years producing the 91 different painted scenes. His principal collaborators were sculptor Hans Wörner and carpenter-frame builder Hans Wiesreutter, both of Munich.[119] The altarpiece is a summa of Catholic faith much as the decorations for the palace chapel at Celle were an expression of Lutheran beliefs. (fig. 71) Mary is represented as the mother of Christ and the Catholic church, as well as the patroness of Bavaria, the Liebfrauenmünster, and the university. In general, the program reaffirms the Catholic church as the true institution of the apostles, evangelists, and holy teachers. On the reverse, which is essentially a whole second altarpiece, Mielich painted *St. Catherine Disputing with the Professors*, an obvious allusion to the University of Ingolstadt's essential role in Bavaria's spiritual *renovatio*; several portraits of Ingolstadt professors seem to have been included. Albrecht V and his family are prominently portrayed as donors and defenders of the faith in the central panel of the front of the altar. Large carved and painted armorials remind all viewers of the identity of the patron.

At first glance, Hans Wörner's richly polychromed wooden sculptures seem eclipsed by Mielich's many paintings. The complex frame and the lavish use of gold threaten to overwhelm the sculptural portions. Yet like small gems set within a larger piece of golden jewelry, the carvings are attractive and iconographically essential. In the center of the superstructure is Mielich's large painting of Mary's empty tomb. The assembled apostles look heavenwards, literally out of the painting, towards Wörner's *Coronation of the Virgin* with its angels joyously celebrating Mary's arrival. Mielich, as the designer, has deftly integrated the paintings and sculptures. One section is incomplete without the other. This linkage also occurs on the reverse. At the apex sits Wörner's Christ in judgment accompanied by angels blowing trumpets or holding the passion implements. The kneeling Mary dramatic turns towards her son on our behalf. Reaffirming

85. Hans Mielich, Hans Wörner, and Hans Wiesreutter, High Altar, back, completed 1572, Ingolstadt, Liebfrauenmünster

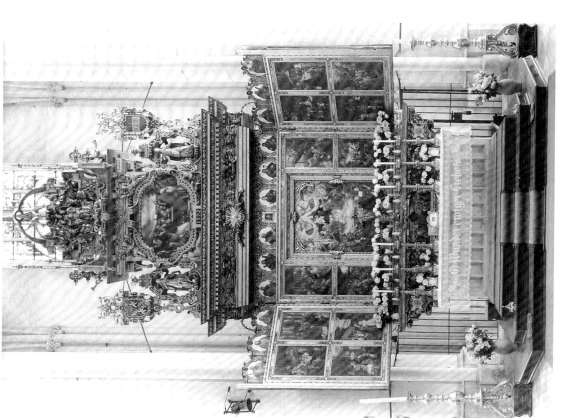

84. Hans Mielich, Hans Wörner, and Hans Wiesreutter, High Altar, front, completed 1572, Ingolstadt, Liebfrauenmünster

the Devil. Peter strides forward holding up his key to the gates of heaven as if to remind the viewer that salvation is possible only through the Catholic church, which he personifies. Wörner shows that he is a superior carver than his Augsburg colleague Paulus Mair. His figures are lively as both the contrapposto of the bodies and the twisting draperies are skillfully rendered. If the quality of his work has been underappreciated, it is only because of its subservience to Mielich's fine paintings.

Mielich's high altar in Ingolstadt is consciously archaic. Like Mair's *Mary Altar* in Augsburg, Mielich looks back to the complicated winged polyptychs mixing painting and sculpture that were popular in the era prior to the advent of the Reformation. In fact, features such as the twelve half-length apostles painted against individual golden backgrounds recalls German painting of the fourteenth and early fifteenth centuries.[120] Mielich's altarpiece thus establishes its continuity with the past much as Albrecht V hoped in this post-Tridentine era to return Bavaria to the state of Catholic orthodoxy that it had enjoyed many decades earlier. Mielich's huge and complex altarpiece functions as a grand pictorial statement of Catholic faith, doctrinal propaganda intended for the edification of the university and civic communities who shared the Liebfrauenmünster, Ingolstadt's largest parish church.

The Silver Chapel that Ferdinand II, archduke of Tirol and son of Emperor Ferdinand, built on to the Hofkirche in Innsbruck in 1577–78 is, by contrast, an intimate setting.[121] Nevertheless, it too is a product of the renewal of Catholic piety that swept through the southern German and Austrian lands in the aftermath of the Council of Trent. Dedicated to the Virgin Mary, the chapel serves as the mausoleum for Ferdinand (d. 1595), his wife Philippine Welser (d. 1580), and their family. Much of the chapel's original decoration survives. The single altarpiece dates to 1577–78 though it was not placed until after the expansion of the chapel in 1587. (fig. 86) In keeping with Ferdinand's fascination with precious natural materials, court goldsmith Anton Ort's reliefs are chased silver and carpenter Konrad Gottlieb's frame is fabricated from ebony wood and three tusks of ivory purchased in Venice. The chapel's name derives from the altar's silvery appearance.

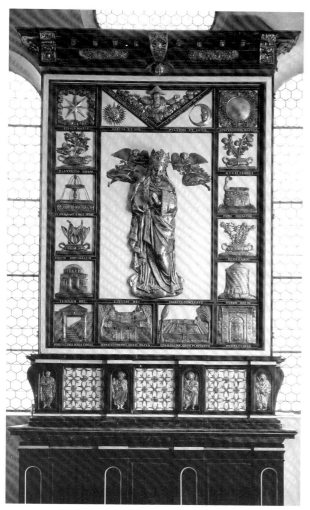

86. Anton Ort and Konrad Gottlieb, Silver Altar, 1577–78, Innsbruck, Hofkirche

the power of saintly intercession, John the Baptist, opposite, directs his gaze outwards towards the viewer. Surrounding Mielich's painting of the archangel Michael, which is set immediately below, are reclining angels holding a palm branch and a scale. Just beneath the frame of this painting are two expressively carved groups of figures rising out of the ground. On the left, the saved souls look piously heavenwards; opposite, the damned theatrically attempt to shield themselves from their impending torment. To the respective sides stand tall statues of St. Peter and Death with the Devil. The majestic and self-assured Peter contrasts vividly with the dark, horrific characters of the Death and

The Innsbruck altar celebrates the earthly and divine natures of the Virgin Mary. It is precisely the type of devotional image that so infuriated Protestant reformers a half century earlier. A large silver relief of the standing Virgin is placed in the center; two angels appear to crown her as the queen of heaven. Egg and others have noted that the statue of the Virgin is either intentionally old-fashion in style or Ort reused another artist's figure that dates to about 1550 or earlier.[122] Arranged on all four sides of Mary are smaller reliefs depicting the Trinity and sixteen allegorical objects, such as the closed garden (*hortus conclusus*), the tower of David, and the mystic rose, to which the Virgin is compared in Catholic prayers. Since the altar was originally a triptych, similar reliefs likely adorned the wings. Did Peter Canisius, the peripatetic Jesuit, suggest the theme to the archduke? The program is based upon the litany of Loreto, a series of devotional prayers that Canisius popularized with his *Letania Loretana*, published in Dillingen in 1558.[123] Between 1571 and 1577, the year the altar was begun, Canisius served as Ferdinand's court preacher in Innsbruck. Completing the design are four apostles in the predella; the reliefs of the remaining eight once decorated the wings. In contrast with the very public nature of the imposing Ingolstadt altarpiece, the Silver Altar is private. Its quiet design invites the single worshipper to honor Christ's mother as he or she slowly recites the 49 titles of the litany. The altar functions as a didactic aid, a visual prompter for the archduke and any other visitors to the chapel.

DURING THE YEARS from 1555 to about 1580 religious sculpture in the German-speaking lands went through dramatic changes. In the aftermath of the Peace of Augsburg, there was a confessional institutionalization, a stability that over the years gradually prompted Lutheran towns from Franconia to the Baltic to welcome art back into their churches. New pulpits and, to a lesser degree, carved altarpieces appear with increasing frequency from the mid-1550s. Under Elector August of Saxony, Dresden replaces Wittenberg and Torgau as the leading Protestant center though an eclectic artistic populism sprouts up further to the north.[124] Catholic patrons never stopped commissioning sculpture for their churches and chapels though prior to about 1570 the number of new works was quite modest.[125] The Council of Trent and, particularly, the regional programs of reform that ensued did have a definite influence upon the future of church sculpture. The emerging Catholic militancy, spurred by the leaders of the Congregatio Germanica and by the Jesuits, replaced decades of malaise and retrenchment. Art, whose benefits were reaffirmed at Trent, emerged as a potent weapon for combating the Protestants and for articulating Catholic doctrine. From Augsburg to Trier to Würzburg to Ingolstadt a few significant sculptural projects were ordered. The archaic appearance of some of these altarpieces intentionally offered worshippers a comforting association with art from the pre-Reformation period. Art provided a critical spiritual and historical link to this earlier era of great piety when the Catholic church reigned unopposed in the German lands. This "new Gothic" influence would persist well into the seventeenth century. Hans Degler's three altars (1604–7) for St. Ulrich and Afra in Augsburg, the Zürn family's sculptures (1611–31) in Überlingen, or Bartholomäus Steinle's High Altar (1609–13) at Stams are, in truth, the heirs of Leinberger, Riemenschneider, and Stoss.

In this and the previous chapter, I have attempted to chart what transpired during the tumultuous years from about 1520 until 1580. German art experienced a catharsis. Damned as idolatrous, religious sculpture only slowly was reembraced as pedagogically useful and, later in the Catholic lands, as a celebratory expression of faith. Many careers were stunted as commissions were never abundant. Other masters specialized instead in the production of funerary monuments or in one of the emerging types of collectible sculpture. By 1580 the atmosphere was again ripe for a resurgence of religious sculpture in both Protestant and Catholic contexts. During the ensuing fifty years, until the devastation of the Thirty Years War chillingly embraced most of the German-speaking lands, sculpture would again flourish and its artists would rival Europe's best.

CHAPTER FIVE

In Memoriam:
Epitaphs and Simple Tombs

❧

Whoever prepares no memorial for himself during his lifetime has none after his death and is forgotten along with the sound of the bell that tolls his passing. Thus the money I spend for the perpetuation of my memory is not lost; in fact, in such a matter to be sparing of money is to suppress my future memory. [1]

THESE WORDS voiced by the Weisskunig (white king), Emperor Maximilian I's allegorical counterpart, express the attitude shared by the majority of his contemporaries. The sixteenth century witnessed a remarkable proliferation of memorial monuments in the German-speaking lands. [2] Where elaborate tombs and epitaphs had largely been limited to the nobility and clergy in the past, now these groups were increasingly joined by the wealthy patrician class that harbored identical aspirations of earthly fame and eternal salvation.

Of all categories of sculpture, memorials—whether epitaphs or tombs—were by far the most prevalent. Many clerics and patricians who never commissioned another work of art would spend freely when ordering their own epitaphs or tombs. This prompted Sebastian Brant, writing in *The Ship of Fools*, to ridicule those who ordered ostentatious tombs,

 'Twas naught but folly, great, untold,
 For men to squander so much gold
 On graves wherein naught else is thrown
 But sacks of ash and rotting bone,
 And waste much money bare of sense
 To build for worms a residence,
 Not thinking where the soul may be
 Which lives for all eternity.
 Souls need no costly cenotaph,

 A marble stone they never have,
 No shield hangs here, no helmet, banner,
 No coat-of-arms in lordly manner
 And no inscription writ on stone. [3]

Even with the advent of the Reformation's withering effect upon religious sculpture, the churches in Protestant towns continued, after a brief hiatus, to be ornamented with often elaborate memorial carvings. A significant number of important tombs, such as that of Elector Ottheinrich formerly in Heidelberg, have been destroyed, yet the majority of monuments survive. If this corpus reveals modest diversity, it also demonstrates how conservative the majority of the patrons and artists were since a few basic designs, such as those in which the individual either stands alone or kneels before the cross, predominate. [4]

A typical, if rather grand, example of this formula is Peter Dell the Elder's *Epitaph of Konrad von Bibra (d. 1544)* in Würzburg cathedral. [5] (fig. 119) The prince-bishop prays at the foot of a small crucifix; a summary landscape defines the setting as Calvary. The emphasis is upon von Bibra with his singular devotion to Christ. Absent are the Virgin, John the Evangelist, and the other protagonists who customarily were included a few decades earlier. Completing the monument are the coats of arms and, below, an inscription plaque. Hundreds

of comparable monuments exist that merely substitute a noble, a cleric, or a wealthy individual in place of von Bibra.

My focus below will be upon highly innovative memorials rather than such workman-like monuments. These sculptures fall, albeit unevenly, into two general categories. In Chapter Five, we shall examine the simple monument: the epitaph or tomb that exists independent of other objects. This encompasses the majority of German memorials. Occasionally, as in the case of Peter Vischer the Younger's epitaphs of Albrecht von Brandernburg or Friedrich the Wise, the setting became more elaborate subsequent to the completion of the work. The second category consists of memorials that were intended from their inception to belong to a series, such as the episcopal cycles in Würzburg or Mainz cathedrals. Here the general form of the memorial or the attire of the individual portrayed often had to match or, at least, refer back to the older monuments in the series. Each new work honored both the specific person and the collective memory of the respective clerical or noble group. These will be discussed in Chapter Six as will several complex tombs, including the shrines of Maximilian I and Moritz of Saxony. These are sepulchres of unusual scale and intricacy that often required a large or specially built architectural setting. The categorical distinctions, made mainly for reasons of clarity, do not apply to the artists. For instance, a master such as Alexander Colin, who completed the mausoleum of Emperor Maximilian I, was equally adept at producing individual epitaphs for Innsbruck's artists and courtiers. Likewise, Loy Hering applied roughly the same epitaph design for single monuments and episcopal series.

There were two basic forms of memorials: epitaphs and tombs. Traditionally, tombs were the most common type of commemorative sculpture; however, as burial laws increasingly required interment in cemeteries outside city walls, epitaphs rapidly gained in popularity.[6] Epitaphs, often known as ex-votos in other countries, are monuments erected at a church as a remembrance of an individual or of a family.[7] It is independent of a tomb and bears no strict funerary function. Occasionally, an epitaph will be set on a wall with the tomb immediately below in the floor. The two forms of memorials are otherwise very similar in conception. The

majority were ordered posthumously by the estate of or by a relative of the deceased; others were prepared during the individual's lifetime. Like most tombs, these epitaphs normally consist of a religious or allegorical scene, a display of the coats of arms, and an inscription tablet, often added years later, with information concerning the death date and a prayer for the deceased's soul. Epitaphs increasingly came to serve as the individual's primary or only memorial since their placement on the walls of a church offered far greater publicity or personal recognition than an often distant tomb. Not surprisingly, epitaphs became ever more elaborate and expensive. Most tombs and epitaphs were carved from local stone though Salzburg marble, Solnhofen limestone, found near Eichstätt, and Mosan alabaster were imported. Rarer were brass or bronze epitaphs and tombplates. The finest of these were cast by the Vischer family workshop in Nuremberg whose clients resided as far away as the Hanseatic towns of the Baltic and distant Poland. In fact, the geographic diversity of their patrons was unprecedented in Renaissance Europe. While Donatello or Michelangelo could boast of their works adorning a handful of Italian towns, neither enjoyed the Vischers' international patronage. The success of the Vischers was unmatched by their German rivals, most of whom ran small local foundries restricted to the production of simple armorial or inscription plaques.

For most stone sculptors, memorials represented their primary source of income. In the case of Loy Hering, certainly the most financially successful sculptor of the 1520s through the 1540s, 109 of the 133 works that Reindl attributes to him are either tombs or epitaphs.[8] This pattern holds true for most other stone sculptors. After several years at the Saxon court of Heinrich the Pious, Peter Dell the Elder returned to Würzburg in 1533 or early 1534. Recognizing that the market for religious sculptures had largely disappeared in the Würzburg diocese, he specialized thereafter almost exclusively in the production of stone memorials, such as the epitaph of Konrad von Bibra.[9] (fig. 119) He could count upon a constant demand for tombs and epitaphs. Dell's son, Peter the Younger, who became a master in Würzburg in 1551 and died there around 1600, followed his father's example. His workshop could offer potential clients four ba-

sic models: a life-size carving of the donor or donors kneeling before either a crucifix or a Holy Trinity; smaller epitaphs in which the kneeling donor(s) is on the same figure scale as the crucified Christ; a life-size standing depiction of the donor; and, finally, an inscription tablet ornamented at top by angels or death genie with a skull and an hour glass.[10] These models must have appealed to contemporary patrons since Peter the Younger's monuments can be found throughout lower Franconia. Although the Dells enjoyed considerable popularity, their tombs and epitaphs were not always particularly innovative.

This is a complaint that can be made about the majority of German sculptors who were satisfied to repeat older conventional models. Their works, however visually appealing, will not be considered here. Instead I wish to address the simple memorials of another group of masters—the Vischer family, Loy Hering, Hans Schenck, Hans Bildhauer, and Cornelis Floris of Antwerp. Whether refining older designs or devising radically new ones, these artists established new creative standards. Most of their ideas were quickly embraced by their fellow sculptors. Others, especially the highly mannered works of Hans Schenck, proved too idiosyncratic to generate a notable following. Yet the success of Schenck's audacious artistic vision should not be judged simply by the limited number of copies that he inspired. He was one of the rare German sculptors who truly valued novelty, the *inventio* so cherished in Italy.

The Vischer Family

In the choir of the Lorenzkirche in Nuremberg hangs the small brass *Epitaph of Dr. Anton Kress*, provost of the church who died at age 35 in 1513.[11] (fig. 87) This work exemplifies the shift occurring in German sculpture in the mid-1510s and 1520s as Gothic forms yield to a new, more humanistic vision. Based upon style and a technical analysis of the material, the artist is identifiable as Peter Vischer the Younger.[12] Here and in other epitaphs, he creatively transformed older memorial formulas. For example, his figural epitaphs display a greater emphasis upon the particular character or features of the patron than is customarily found. Unlike his

father, Peter the Elder, who merely cast the wooden models supplied by other sculptors, Peter the Younger was a designer and a carver. He devised his own compositions and cut his own models, which were then cast by other members of the workshop. Strongly influenced by his stay in North Italy, perhaps in the Paduan workshop of Andrea Riccio, sometime between 1512 and 1514, Peter the Younger delighted in the inventive potential of his art. Although this is manifest most clearly in his small brasses, this attitude also affected his memorial sculpture. (figs. 237–240, 242 and 243)

The innovativeness of the *Epitaph of Dr. Anton Kress* can best be placed in perspective by first looking at a nearly contemporary monument at the Lorenzkirche. In 1504 Kress was appointed provost of this wealthy parish church. Upon returning to his native Nuremberg from Siena, where he received his doctorate in canon and civil law, Kress would have admired the imposing epitaph that cloth merchant Kunz Horn and Barbara Krell, his wife, had erected in 1502 on the exterior western wall of the sacristy.[13] (fig. 88) The epitaph faced the small cemetery that then occupied this site. Between 1511 and 1513, presumably in consultation with Kress, the couple would further enrich the cemetery precinct by building and decorating the Annenkapelle a few meters south of the epitaph. Horn and his wife desired a showy memorial. Its size, measuring 3.3 by 2.4 meters, and color guaranteed that the epitaph would be noticed by other parishioners. Rather than selecting the dull red sandstone quarried around Nuremberg, Horn purchased the highly polished red marble slab in the vicinty of Salzburg. The use of Salzburg stone north of Munich and Landshut is rather unusual because of the shipping expenses, which must have been considerable in this instance because of the dimensions of the slab. The epitaph was likely carved in Salzburg by Hans Valkenauer.[14] Horn's choice of artist and material may be linked to his extensive trading activities in Austria.

Dominating the composition is the powerful figure of Christ, seated and staring directly towards the viewer. He holds the staff, book, and orb, symbolizing his authority over mankind. Christ is surrounded by smaller angels who open the cloth canopy or carry the sword and lily of judgment. Kunz Horn and Barbara Krell are the minute couple

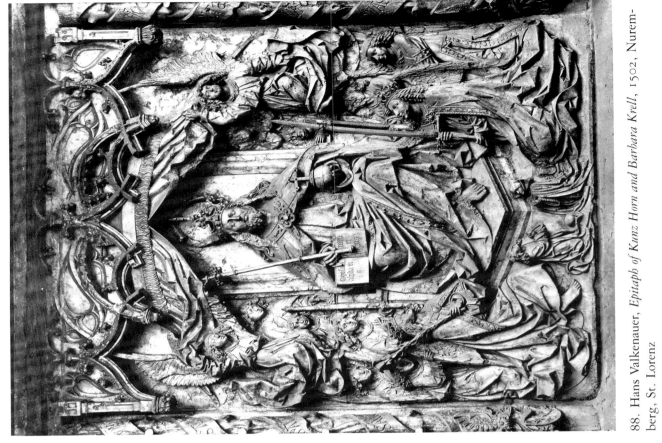

88. Hans Valkenauer, *Epitaph of Kunz Horn and Barbara Krell*, 1502, Nuremberg, St. Lorenz

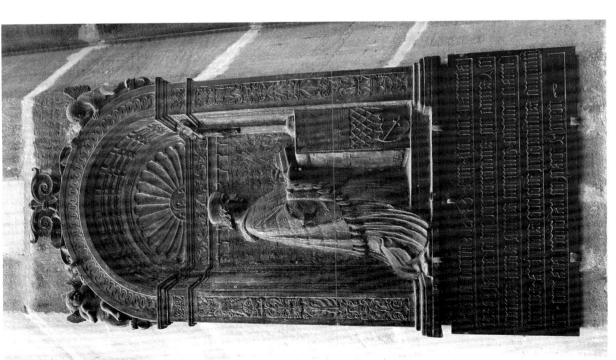

87. Peter Vischer the Younger, *Epitaph of Dr. Anton Kress*, c. 1513, Nuremberg, St. Lorenz

kneeling expectantly before Christ's throne. Their coats of arms and the repeatedly inscribed word "SALVS" or salvation adorn the frame. Eternal reward and, of course, earthly recognition are the couple's goals. Valckenauer's design may well have been prepared by a Nuremberg artist, given its similarity to other local painted epitaphs. The practice of setting the diminutive donors at the bottom of the scene was also quite popular in Nuremberg. In fact, the couple would later appear kneeling beneath much larger saint figures in their Holy Kinship Altar that Wolf Traut painted for the Annenkapelle in 1515.[15] The couple paid for and received an impressive stone epitaph that within their lifetime honored their piety; Horn would not die until 1517 and his wife six years later. In terms of its style and design, the memorial is perfectly characteristic of the period's finest epitaphs.

In spite of their physical and temporal proximities, the Horn-Krell and Kress epitaphs reveal significantly different artistic and intellectual conceptions. Unlike the couple who are dwarfed by the complex grouping of Christ and the angels, Anton Kress is the sole focus of our attention as he kneels before an altar ornamented with a simple crucifix. His eyes gaze intently upon the manuscript in his hands. This is certainly the richly illuminated missal that Kress presented to the Lorenzkirche shortly before his death.[16] The provost is alone, absorbed eternally in his reading. Vischer has created a perfect image for the humanist Kress. He is at once devout and learned. He embodies the well-educated scholar piously dedicated to his office, here signified by his dress, specifically the fur almuce over his shoulders. Vischer has incorporated the Kress family arms into the decoration of the altar. In short, Vischer presents the viewer with a very personal portrait of Kress. In many ways it is the sculptural equivalent to the laudatory biography of the provost that Dr. Christoph Scheurl wrote in 1515.[17]

The location of the epitaph has a very personal character too. As noted in Scheurl's *Vita*, the memorial is situated on a pier adjacent to the high altar and directly beneath the statue of St. Paul. Before his death Kress had commissioned another sculptor, probably Veit Wirsberger, to carve the life-size stone St. Paul for this particular spot.[18] The statue augments the series of Christ and the Twelve Apos-

tles, dating to about 1380, that line the eastern part of the nave and the choir. Scheurl observed that Paul was the provost's favorite saint and, with Peter, was the founder of the Roman Catholic church.[19] Paul, now presented as the thirteenth apostle, is situated directly facing the older statue of Christ. Above Paul is a stone baldachin ornamented with a wooden statuette of Anthony, Kress's name saint. Thus the epitaph completes this three-part artistic ensemble that includes, in descending order, sculptures of St. Anthony, St. Paul, and the provost.

Peter Vischer the Younger's design is an impressive mix of old and new elements. For example, stained-glass representations of Lorenz Tucher, the first provost of the Lorenzkirche from 1477 to 1496, show him dressed in his clerical robes and kneeling in prayer before a bench or, less certainly, an altar ornamented with a book.[20] The rear wall is decorated with a brocade textile suspended from a rod much as one sees in the Kress epitaph. One of the immediate models for the epitaph was Jakob Elsner's donor miniature (folio 3) in the *Kress Missal* in which the provost kneels holding his new manuscript. (fig. 89) He directs his gaze at the vision of the Holy Trinity enthroned in the facing miniature on folio 2 verso. Nevertheless, the sculptor transcends all of these prototypes. For instance, his definition of a coherent space is far superior. Vischer's chapel is set within an Italianate arch with grotesque-filled pilasters. The coffered barrel vault is rendered in a careful one-point perspective scheme; it terminates in a shell niche radiating out from the head of Christ. The shell pattern as well as the repeating ovals on the outside of the rounded arch might have Italian sources though I suspect that Vischer was inspired specifically by the painted *Epitaph of Lorenz Tucher* in the Sebalduskirche that Dürer designed and Hans von Kulmbach executed in 1511–13.[21] The spatial complexity of Vischer's scene is enhanced by careful foreshortening of the altar and crucifix before Kress. The artist's use of space is impressive. He positions Kress back slightly from the altar so that the gap between the two is apparent. Kress holds his prayer book above the altar, which permits the natural light that enters the church from the south or, here, left side to illuminate the text and cast a strong shadow down upon the cloth-covered surface below. Such small

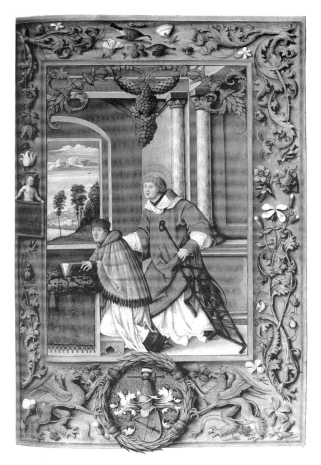

89. Jakob Elsner, *Dr. Anton Kress in Prayer*, *Kress Missal*, 1513, Nuremberg, Germanisches National-museum, Hs. 113264, fol. 3

contemporary contributions to the Sebaldus shrine, Peter the Younger introduced wax casting in which a wax model is made over a clay core. Beyond various technical advantages, wax casting permits a much wider range of textures since it is far easier to mould and to shape than it is to carve wood with its characteristic hard, crisp lines. The softness of Kress' flesh contrasts nicely with his thick strands of hair. Vischer implies the swelling forms and weight of Kress' body beneath the undulating surfaces of the clothing. His feet protrude realistically from the bottom of the alb. Even the brocade and altarcloth ripple, accenting the nature of the material. Furthermore, the transition from high to low relief, as observed in Kress' hands supporting the book, is visually convincing. Peter the Younger, however, limited his use of wax models to small objects, notably reliefs and statuettes. Of his epi-

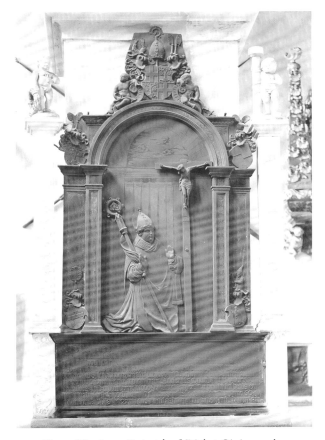

90. Hans Vischer, *Epitaph of Bishop Sigismund von Lindenau*, c. 1544, Merseburg Cathedral

features are important to the overall feeling of the scene since these suggest that ample room surrounds the kneeling figure of the provost. The link between the fictive space of the epitaph and the real space of the church is made by the two angels above the arch. One peers down at Kress while his companion directs his gaze at the nearby high altar.

Although this is an idealized rather than a factual portrait of the provost, Vischer offers arguably the most subtle, the most lifelike representation in German sculpture of the period. Much of this is due to a technical innovation that Vischer adopted from his two trips to Italy in about 1508 and again sometime between 1512 and 1514. In earlier brasses by the Vischer workshop, a wooden model was used for the casting. Beginning with this epitaph and

taphs, only this one, which measures just 130 by 65 centimeters, utilized this technique.

Few later funerary monuments could match the harmony and character of the Kress epitaph. It did inspire several copies, the most slavish of which is the *Epitaph of Provost Hektor Pömer* (d. 1541), attributed to Peter's younger brother Hans, that hangs in the same bay directly opposite the Kress monument.[22] This offers a stripped down replica done in reverse. The figure is stiff, the proportions are awkward, and much of the decorative richness is lost. Hans, who managed the family foundry during the 1530s and 1540s, also recalled certain features of the Kress monument in his brass *Epitaph of Bishop Sigismund von Lindenau* (d. 1544) in Merseburg cathedral.[23] (fig. 90) The bishop kneels before a cross. The space, as defined by the engraved curtain and the coffered ceiling, reads flat; gone are the diverse textures and confidently rendered setting observed in the Kress epitaph. Similarly, the singular focus of Peter's creation is dissipated here as the lavish coats of arms compete with the main composition for the viewer's attention.

Closer in spirit and artistic quality to the Kress memorial, though unconnected with the Vischer shop, is the *Epitaph of Wolfgang Peisser the Elder* in the south aisle of the Franziskanerkirche (Minoritenkirche) in Ingolstadt.[24] (fig. 91) From 1482 until his death in 1526, Peisser served as a professor of medicine at the University of Ingolstadt. He was especially noted for his 1521 writings on the treatment of plague victims. The epitaph's bold inscription tablet held by angels refers to Peisser as a famous doctor to whom the learned Minerva had given an "intelligent head" and who, as "our fatherland's only hope," had earned the right to behold the heavenly choir. The laudatory tone of the text would suggest that the commissioner of the epitaph was Wolfgang the Younger who is shown below on the right kneeling opposite his father.

The artist of this Solnhofen limestone epitaph is unknown. Although previous attributions to both Hans Daucher and Loy Hering can be dismissed on stylistic grounds, this master likely trained or worked in the same city—Augsburg.[25] Schädler observed that the careful handling of the faces and the minute decorative details point to a portraitist accustomed to working on a small scale; however, his tentative suggestion of Friedrich Hagenauer,

91. Augsburg Artist, *Epitaph of Wolfgang Peisser the Elder*, c. 1526, Ingolstadt, Franziskanerkirche (Minoritenkirche)

who was in Munich from 1525 to 1527 and thereafter in Augsburg until 1532, is doubtful. Hagenauer was primarily a medalist who carved small wooden models and the occasional relief. Nothing in his oeuvre would suggest his ability to sculpt such an accomplished stone epitaph. The artist of the Peisser epitaph has created a masterful composition as the three angels stand comfortably within a room rendered in one point perspective. The relaxed dialogue between the flanking angels suggests they are discussing Peisser and his accomplishments. Above, the two figures in the roundels have been tentatively identified as Hippocrates and Galen, the two most celebrated ancient physicians. This flattering analogy with Peisser extends the classical allusions of the inscription and reflects the deceased professor's own love of humanistic literature.

The overall composition, while it may derive

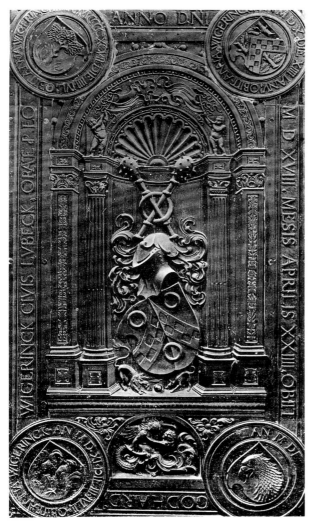

92. Vischer Workshop, *Tombplate of Godart Wige-rinck*, c. 1518, Lübeck, Marienkirche

sons.[27] The Vischers had no direct influence upon the Peisser epitaph; however, their ideas spread broadly and occasionally inspired other artists to adopt their Italianate vocabulary. Ingolstadt, situated midway on the principal trade route between Nuremberg and Augsburg, drew heavily from both artistic centers. Unfortunately, no other works by the master of the Peisser epitaph have been identified.

When examining the production of the Vischer workshop, vexing problems about the attribution of a particular object to a specific family member arise immediately. Even the inclusion of the PV monogram can indicate Peter the Elder, Peter the Younger, or simply the family atelier. In a case such as the unsigned and undocumented *Tombplate of Godart Wigerinck* in the Marienkirche in Lübeck, Peter the Younger certainly collaborated with other shop members.[28] (fig. 92) The monument, which was commissioned after Wigerinck's death in 1518, is a curious compilation of features found in other works.[29] The architecture loosely recalls the Kress epitaph; the angels derive from the *Sebaldus Shrine*; and the battling figures below are reminiscent of the grille made originally for the Fugger Chapel in Augsburg and later placed in the Nuremberg Rathaus. (figs. 228–230) The central coat of arms of Wigerinck and those of his four wives in the roundels complete the composition. One member of the shop, probably Peter the Younger, designed the tombplate. Once this had been approved by Wigerinck's heirs, a model, here of wood, was made. Then another worker, who was primarily if not exclusively a founder, would then cast the brass monument. Throughout the 1510s and 1520s most large-scale commissions typically passed through the hands of many skilled craftsmen within the studio before completion.

In the mid-1520s Peter the Younger received orders for memorials from two of the period's most powerful princes and patrons: Cardinal Albrecht von Brandenburg and Elector Friedrich the Wise. As discussed in Chapter Three, Cardinal Albrecht's plans for the Neue Stift in Halle included a burial site for himself in the choir. (See Plan A of Neue Stift) This aspect of the program continued to evolve up to 1540 when he ordered the relics and artistic embellishments of the church to be transferred to Aschaffenburg in the face of Halle's impending conversion to Lutheranism. The idea for a

partially from Augsburg prints, does recall epitaphs by the Vischer workshop in Nuremberg. The careful placement of figures in space, the coffered barrel vault, and the general architectural vocabulary harken back to the *Epitaph of Dr. Anton Kress*. The setting of the arch within a rectangular frame and the introduction of roundels in each spandrel are very reminiscent of the brass *Epitaph of Margareta Tucher* (d. 1521) in Regensburg cathedral.[26] Although the latter bears the mark of Peter the Elder, scion of the family workshop, its execution was likely by Paulus (d. 1531), another of his

brass epitaph may first have occurred to the cardinal during his extended residence in Nuremberg from the fall of 1522 until the summer of 1523. Albrecht was quite familiar with the Vischer workshop since earlier he had purchased a now lost St. Martin fountain formerly in the Aschaffenburg Schloss.[30] Furthermore, during the fifteenth and early sixteenth centuries, the Vischer family carefully cultivated princely and clerical tastes for brass memorials that ranged from simple slabs to complex, multi-level tombs. Peter the Elder was responsible for the elaborate brass *Tomb of Ernst of Saxony*, Albrecht's predecessor as archbishop, in Magdeburg cathedral.[31] These cast memorials offered better clarity of design, more details, and a potentially greater permanence than a stone counterpart. Such traits, coupled with the aesthetic merits of polished brass, appealed to patrons concerned with erecting lasting monuments to their memory.

In 1523, using Nuremberg patrician Kaspar Nützel as his local agent, Albrecht commissioned the brass epitaph now in the Stiftskirche in Aschaffenburg.[32] (fig. 93) The life-size recumbent image of the cardinal holding his cross and crozier conforms to the same tradition of episcopal representation observed in the earlier *Tomb of Ernst of Saxony*. The difference, however, is in Peter the Younger's naturalistic portrait of Albrecht. His face is characterized by its soft, fleshy appearance and by the cardinal's intense forward gaze. A wooden model was cut after Peter the Younger's design. I suspect that wood was chosen because of the considerable depth of the relief and the epitaph's size, especially in the central piece containing the upper half of the cardinal. Unlike the Kress epitaph, which was cast in one piece, the different portions of this memorial were made separately and then assembled in the Neue Stift at Halle. Initially the epitaph was set immediately behind the high altar in the east wall of the choir, a location that permitted the cardinal's effigy to stare perpetually towards the officiating clerics and worshippers. The artist has taken the unusual step of incorporating the inscription tablet into his central composition rather than setting it above or below the effigy.[33] This permits a full-size portrait without the additional expense of lengthening the brass plate. Vischer's integration of the inscription anticipates the equally novel solution used by the master of the Peisser epitaph.

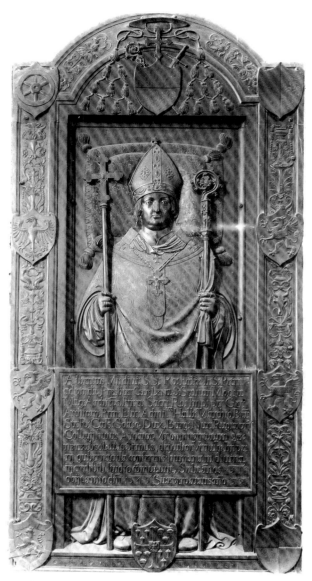

93. Peter Vischer the Younger, *Epitaph of Albrecht von Brandenburg*, 1523, formerly in Halle, Neue Stift, now in Aschaffenburg, Stiftskirche

What began as a simple epitaph rapidly evolved into a more complex ensemble. In about 1528 Albrecht ordered the Vischers to make a second epitaph for the choir wall of the Neue Stift.[34] (fig. 94) He also commissioned a now lost tomb stone for himself from Loy Hering though it is unclear whether this too was intended for the Neue Stift.[35] This second brass epitaph is signed "JOHANNES VISCHER NORIC FACIEBAT MDXXX." Fol-

135

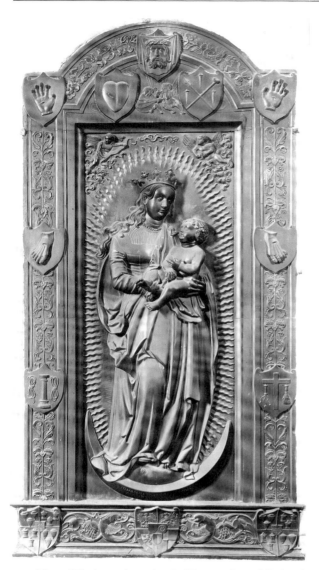

94. Hans Vischer, *Apocalyptic Woman—Second Epitaph of Albrecht von Brandenburg*, 1530, formerly in Halle, Neue Stift, now in Aschaffenburg, Stiftskirche

image of the Virgin and Child flanked by Albrecht, the donor.

By 1536 the basic concept of the Halle memorial ensemble had changed again. In this year Hans executed an elaborate brass baldachin, also today in Aschaffenburg.[36] (fig. 95) On top of the canopy sits a cenotaph or chest flanked by angels bearing Albrecht's coat of arms and, at the edges, four candle holders. Although for many centuries this cenotaph held the relics of St. Margaret, it was originally planned to contain Albrecht's own physical remains. The cardinal intended it to be placed in the choir of the Neue Stift, presumably immediately behind the high altar. What was the relationship of the baldachin to the two epitaphs? The plan, as it had developed in the mid-1530s, called for the baldachin to be located directly over Albrecht's tomb, a carved stone slab such as that Hering had provided around 1528. The effigy or armorial decoration faced upwards towards the engraved relief of Christ's wounds on the underside of the baldachin. The relief's design repeats that of the frame of the *Apocalyptic Woman* though the central scene is now simply an ornamental pattern. The two epitaphs were positioned immediately behind or slightly flanking the baldachin. A reliquary chest may also have been located between the baldachin and the epitaphs, a placement that certainly would have provoked comparisons between Albrecht, founder of the Neue Stift, and the community of saints, whose collective memory was so gloriously celebrated at this church.[37] With the move to Aschaffenburg in 1540 coupled with the cardinal's decision to be buried in Mainz cathedral, the original arrangement and function of the Vischer family's ensemble were forever altered.

Shortly after finishing the epitaph of Cardinal Albrecht, Peter Vischer the Younger commenced work on the even larger funerary monument of Friedrich the Wise (d. 1525) in the Schlosskirche in Wittenberg.[38] (fig. 96) Peter completed and signed the memorial in 1527. Soon afterwards his brother Hans brought the 26 separately cast pieces to Wittenberg and oversaw their assembly on the north wall of the choir facing the high altar. It appears on the right side of Michael Adolph Siebenhaar's drawing of the interior of the church sketched about thirty years before the devasting fire of 1760.[39] (fig. 97) Lucas Cranach the Elder, the

lowing the deaths of Peter the Younger in 1528 and Peter the Elder in 1529, Hans assumed control of the workshop. His design matches the shape and basic form of the earlier epitaph. The Apocalyptic Woman occupies the center while in place of Albrecht's coats of arms are matching shields with Christ's wounds and the instruments of the passion. Originally these brasses hung adjacent to each other, functioning as a diptych with this allegorical

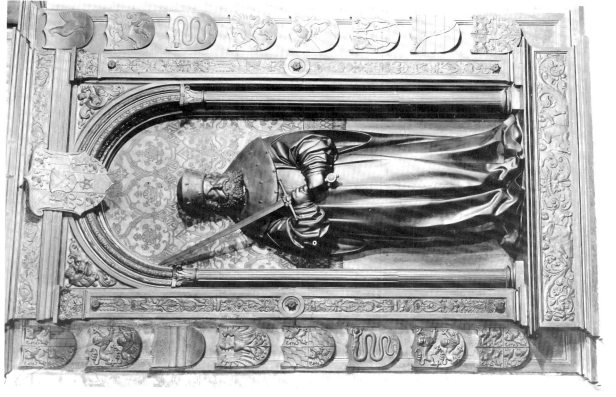

96. Peter Vischer the Younger, *Epitaph of Friedrich the Wise*, 1527, Wittenberg, Schlosskirche

95. Hans Vischer, Baldachin, 1536, formerly in Halle, Neue Stift, now in Aschaffenburg, Stiftskirche

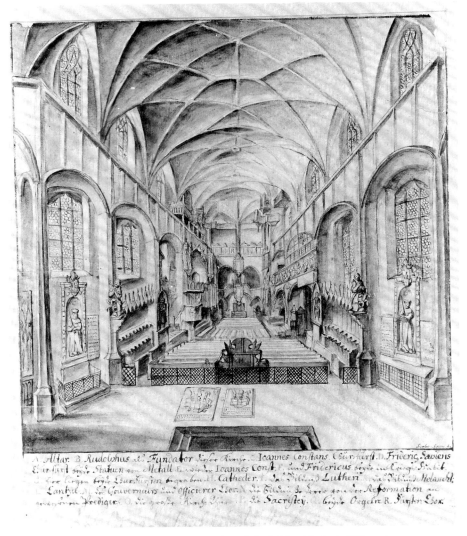

97. Michael Adolph Siebenhaar, *Interior of the Schlosskirche in Wittenberg*, c. 1730, drawing, Wittenberg, Lutherhalle

Saxon court painter, likely provided the sculptor with drawings of the overall design and Friedrich's face.[40] The life-size figure of Friedrich, rendered in very high relief, stands within an impressive triumphal arch that is topped by two angels supporting a laurel wreath-framed plaque inscribed with his motto. The memorial is a formal image of Friedrich as elector of Saxony. Therefore, he grasps the sword and wears the robes and hat of his office. These features repeat a formula used earlier in the funerary monuments of his three immediate electoral predecessors buried in the Fürstenkapelle in Meissen cathedral: Friedrich the Valiant (d. 1428), Friedrich

the Gentle (d. 1464), and Ernst (d. 1486).[41] Both parties were familiar with these monuments since in 1495 Friedrich the Wise paid Peter the Elder to produce Ernst's tombplate.[42] Nevertheless, Friedrich's epitaph is distinguished by its lively physicality. Like the figure of Albrecht von Brandenburg, Friedrich offers a commanding, lifelike presence. He stares protectively into the choir. The shifting of his body beneath the robes and the glistening of light off the highly polished surfaces suggest impending movement. The strong three dimensionality of the relief is further heightened by Friedrich's placement before the damask cloth en-

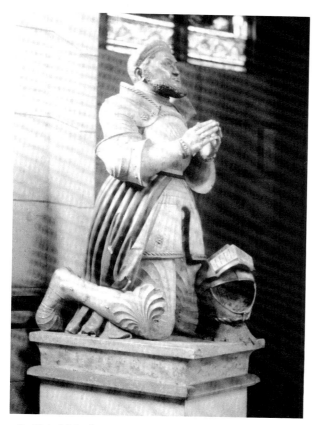

98. *Friedrich the Wise in Prayer*, c. 1519–20, Wittenberg, Schlosskirche

graved on the background. Thus while Peter was bound by an older memorial type, he successfully animates the image of his client.

Although Peter the Younger's *Epitaph of Friedrich the Wise* was intended originally as a single artistic monument, it too belonged to a context in which it functioned in concert with other objects. These may be seen in Siebenhaar's drawing. (fig. 97) On the north wall the epitaph was flanked by a bronze tablet with an inscribed text praising the elector, which was composed by Philipp Melanchthon, and by an older painting representing Friedrich's pilgrimage to the Holy Lands in 1493.[43] A life-size limestone statue of Friedrich was set on a nearby console.[44] (fig. 98) The unknown sculptor in 1519 or 1520 placed this figure of the armor-clad elector kneeling in prayer towards the high altar. Completing the grouping is the engraved tombplate, sometimes attributed to the Vischer workshop,

that lies directly in front of the main altar. It represents Friedrich's electoral coat of arms and lists his titles. While all of these features might have been separate commissions, the resulting ensemble, in place by about 1527, honored Friedrich, his piety, and his accomplishments.

Johann the Steadfast (d. 1532), Friedrich's brother and successor, has a similar monument situated directly opposite on the south wall of the choir.[45] His kneeling stone statue, also made in 1519–20, is a pendant to his brother's. Immediately adjacent hang Hans Vischer's *Epitaph of Elector Johann* and another bronze plaque with a long laudatory text by Melanchthon. And directly before the altar lies Johann's engraved tombplate with his arms and titles. Hans's monogrammed and dated (1534) epitaph is virtually a mirror image of Friedrich's though the figure of the elector turns more to his right and there exist minor distinctions in the architectural decorations. In the course of about fifteen years, from 1519 to 1534, the electors of Saxony and the Vischer workshop transformed two simple epitaphs into a glorious grouping celebrating Wettin power and piety. Even Johann the Steadfast, Luther's staunch supporter, exhibited no qualms about erecting a relatively showy artistic program in this palace and university church.

Brass and, outside of the Vischer shop, bronze epitaphs, tombplates, and tombs continued to be made throughout the sixteenth century. Until the 1580s, however, few artists could match the variety and the aesthetic beauty of the Vischers's creations. Epitaphs such as those for Dr. Anton Kress, Albrecht von Brandenburg, and Friedrich the Wise provided an unreachable standard for other metal casters. Yet even the fame of the Vischer workshop gradually declined following the deaths of Peter the Younger (1528) and Peter the Elder (1529). The dryness and derivative quality of some of Hans Vischer's later works suggest that it was Peter the Younger who contributed the real creative spark to the family atelier.

Loy Hering

Most patrons preferred stone for their tombs and epitaphs. It was more economical than brass or bronze, and throughout Germany there was a ready

supply of sculptors and, occasionally, stone masons to make these monuments. Competent family workshops, such as the Dells in Würzburg, the Rottalers in Landshut or the Brabenders in Münster, emerged and often dominated production within a limited geographic region.[46] By far the most significant of these dynasties is that of Loy Hering of Eichstätt and his sons.[47] From the 1510s until his death probably in 1554, Loy Hering not only enriched the churches of Eichstätt and its diocese but his memorial carvings were made for patrons as far away as Speyer and Vienna.

By the early 1520s Loy Hering had established a basic format for his epitaphs that he would continue to follow with few variations until 1553. As seen in the *Epitaph of Canon Martin Gozmann* of about 1536 in Eichstätt cathedral, this formula consisted of a large central and usually vertically arranged figural relief.[48] (fig. 99) Below is a Latin inscription tablet. The donor's coat of arms is placed within a rounded, here, or a triangular pediment. These features are then joined together by a bold architectural frame mixing whimsy with Italianate forms. In contrast with his Nuremberg contemporary Peter Flötner, Hering rarely worried about the canonical correctness of his architectural features.[49] In this instance, Hering has deftly interwoven the actual frame with the Descent into Limbo by repeating the design of the columns within the relief and by transforming the pediment into a coffered barrel vault. This greatly amplifies the compositional space. The upward extension of Christ's banner and the body of the horn-blowing demon, which is divided by the lintel, successfully link these two spatial zones. Like most of Hering's reliefs, the Descent into Limbo derives from prints, specifically those of Dürer and his circle. In this case, the composition is loosely based on Dürer's woodcut (B. 41) from the *Small Passion*. Into this scene, immediately behind Christ, Hering has introduced the kneeling figure of his patron. The visual appeal of Hering's epitaph then and now is quite obvious. The stylish design is matched by the highly polished whitish-brown surface of the fine-grained Solnhofen limestone and the delicate touches of paint, such as the golden rays of Christ's halo. Hering's carving is painstakingly detailed as he attends to the subtler shading and spatial effects of his print models.

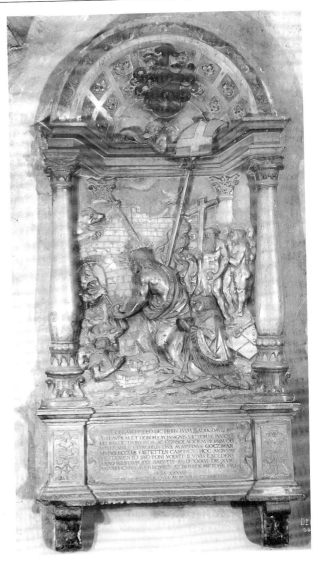

99. Loy Hering, *Epitaph of Martin Gozmann*, c. 1536, Eichstätt Cathedral

An interesting variation of this basic design may be observed in the *Monument of Jobst Truchsess von Wetzhausen* (d. 1541) in St. Elisabeth, the church of the Teutonic Knights in Vienna.[50] (fig. 100) completed in 1524, the monument includes the addition of two side sections featuring Wetzhausen, commander of the Teutonic Knights in Austria, and the facing figure of Death, thus introducing a *memento mori* theme. This triptych or triple arch arrangement was used three years earlier in a family monument erected by Jobst's brother, Georg, ab-

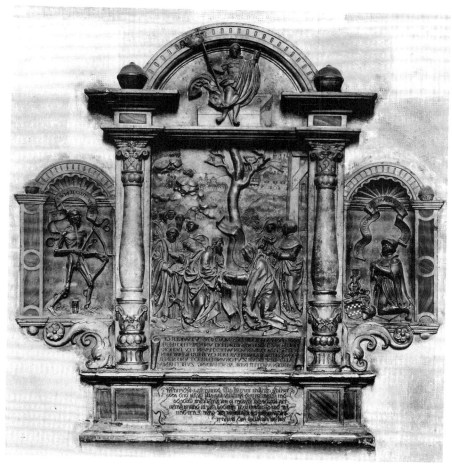

100. Loy Hering, *Epitaph of Jobst Truchsess von Wetzhausen*, 1524, Vienna, St. Elisabeth

bot of the Benedictine Cloister at Auhausen.[51] Hering would retain it in his repertory and continue to employ it for both epitaphs and altars, notably the *Mortizbrunner Altar* of 1548.[52] (fig. 35) Hering uses these four scenes, including the Resurrection above, to draw our eyes horizontally, vertically, and even diagonally across the monument. The work is also thematically unified since the Resurrection, which copies Dürer's engraving (B. 17), and the Christ Appearing to the Virgin, patterned after Wolf Traut's woodcut (Geisberg 1406) of 1516, illustrate Christ's triumph over death, a triumph that can be shared by devout Christians, including the donor. Hering's success at satisfying his patron can be gauged by the fact that in 1532 Jobst presented a second, almost identical version by Hering to the Elisabeth Kapelle or Teutonic Knights chapel in Nuremberg.[53]

Hering also fashioned numerous more conventional though attractive epitaph designs. For Erich I, Duke of Braunschweig-Lüneburg (d. 1540), Hering made an epitaph for the choir of St. Blasius-Kirche in Hann. Münden in about 1528 that features a single figural relief within a simple frame.[54] (fig. 101) Erich and his two wives kneel at the base of the cross. In contrast with the later Gozmann epitaph, the arched portico motif, which defines the space behind Christ, is wholly contained within the relief. As Reindl notes, images with the patron or patrons kneeling beneath the cross suddenly became extremely popular with Hering's clientele from the late 1520s onwards.[55] Catholics, in par-

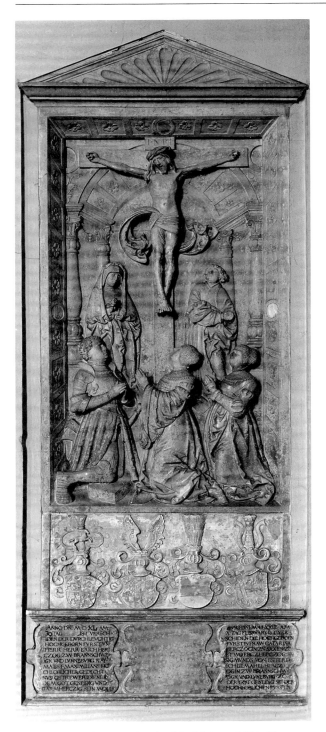

101. Loy Hering, *Epitaph of Erich I and His Two Wives*, c. 1528, Hann. Münden, St. Blasius-Kirche

ticular, may have felt that this was a theme that Protestant critics could not claim was idolatrous.

Hering never lacked commissions. Using Reindl's catalogue as a general source, Hering carved 17 works in the 1510s, 33 in the 1520s, 38 in the 1530s, 38 in the 1540s, and 8 in the 1550s.[56] During the later years he increasingly relied on the collaboration of his large workshop to keep pace with the volume of orders. As a result, the quality of some of the later memorials is uneven depending on the importance of the project. From late 1543 onwards, Hering was assisted by his son, Martin, who had recently worked for Ottheinrich at Neuberg an der Donau. Martin took over the shop in 1553 or 1554 and continued to supply Hering-style monuments for patrons, such as Cardinal Otto Truchsess von Waldburg, bishop of Augsburg, until his own death around 1560.[57] Loy's elder son, Thomas (d. 1549), enjoyed a successful if brief career working at the Bavarian court in Munich and Landshut.[58] His epitaphs, including that of Bishop Philipp (d. 1541) in Freising cathedral, also reveal his father's influence. Loy's memorials provided both a standard of refinement and a corpus of designs that were widely emulated by other sculptors throughout Bavaria and Franconia from the 1520s into the 1570s.

HERING'S USE of elaborate architectural frames for his memorials typifies a growing practice from the mid-1520s. For Hering the quality of his figural carving is immediately evident; however, in the case of many lesser masters, an attractive frame often masks the relative weakness of the sculptor's own style. In the aftermath of the reconquest of Münster Johann Brabender emerged as the city's leading carver. Around 1540 he created a new *Epitaph for Theodor von Schade* (d. 1521) to replace the original one destroyed when the Anabaptists sacked the cathedral.[59] (fig. 22) The frame dominates and orders the sculptures. A second internal frame, in the form of a triumphal arch, draws us to the central Baptism scene. This particular epitaph works well because the frames and the clear design compete with the figures for our attention. Three or four years later Brabender produced the *Epitaph of Johann Bischopink* (d. 1543), Münster's suffragan bishop, in which a simple vine tendril border is used. Here the focus is much more clearly upon the

figures.[60] Brabender's typical short, squatty characters with oversized heads are found in both epitaphs yet they are more obvious in the latter.

Hans Schenck

If Loy Hering's oeuvre epitomizes the harmonious clarity of most German sculpture, then Hans Schenck's memorials represent its most mannered phase. Schenck, who from 1536 was the court sculptor of Joachim II, elector of Brandenburg in Berlin, is best known for his small scale portraits. A few of his epitaphs and tombs survive, if often in a damaged state, in Berlin, Brandenburg, and Halberstadt. The earliest and most conventional of these is the *Tomb of Joachim Zerer* (d. 1543), a court secretary and, from 1537, judge, in the Marienkirche in Berlin.[61] (fig. 102) Zerer is presented in half-length, a format deriving ultimately from Roman stelae that gradually gained popularity with German and Austrian humanists early in the sixteenth century.[62] He stares off to his left while pointing at the skull cradled in his left hand. This *memento mori* theme extends to the marvelous figure of Death reclining in the pediment and to the inscription below that begins with the words: "How quickly passes the time of human life." Death mocks the somber Zerer and his earthly status. The skeleton's cloak extends downwards, casting a chilling shadow on Zerer's head.

What begins as the triumph of death soon becomes a conflict between Christ, Death, and Sin in Schenck's *Epitaph of Gregor Begius* (d. 1549) in the Nicolaskirche in Berlin.[63] (fig. 103) The full-length and slightly under life-size Bagius, a court counsellor, is dressed in the latest fashion. With his foreshortened right hand, he draws the cloak across his chest. In his left hand he grasps a silver painted snake that holds a sheet of paper in its mouth. Although other meanings are possible, the inclusion of this snake as a symbol of Satan links Bagius with Adam and Eve who are shown toiling at the lower right as a result of their sin. This association is further clarified by the position of Adam standing directly on Bagius's left foot. Mankind, since Adam and Eve, has succumbed to the Devil and Death, both of whom are rendered to Bagius's left. Christ sits opposite in a position mimicking Death's. His

victory over the Devil and Death is signified by their chained enslavement below him. Thus Bagius, as a mortal human, will be tempted by sin; however, through his faith in Christ, he will ultimately triumph. "The just shall live by faith" (Romans 1:17) states the text on the outward face of the right-hand strapwork. The remaining inscriptions reiterate this basic message. On the edges of the strapwork is written: EVANGELIVM GRATIA VITA (gospel, grace, life) and, opposite, MORS PECCATVM (death, sin). "O death, where is thy sting? O grave, where is thy victory?" (I Corinthians 15:55) and "Then when lust hath conceived, it bringeth forth sin: and sin, when it is finished, bringeth forth death" (James 1:15) read the texts in the center. This idea is articulated further in Schenck's so-called *Christus Victor Epitaph* in the same church where a full-length Christ stands with his banner upon Death while two devils are firmly locked to the flanking scrolls.[64] (fig. 104)

Schenck was among the first German artists to incorporate Antwerp strapwork designs into art. The projecting frame surrounding Bagius derives from the decorative prints of Cornelis Bos and Cornelis Floris.[65] The introduction of these mannered fantasies coincides with Schenck's new predilection for elongated, twisting figures with small heads.

In 1558 Schenck, using Pincerna, the Latin form of his name, signed and dated his greatest work: the *Tomb of Friedrich III von Brandenburg, archbishop of Magdeburg*, located on the south side of the choir enclosure in Halberstadt cathedral.[66] (figs. 105 and 106) Friedrich, son of Joachim II, elector of Brandenburg, died in 1552 at age 22. Through his father's efforts he was appointed co-adjutor of Magdeburg in 1547, bishop of Halberstadt in 1548, and archbishop of Magdeburg in 1550. Pope Julius III held up the later appointment for a year due to his concern that Friedrich would embrace Protestantism as his father had in 1539.[67] Friedrich died after only 25 weeks in office. Friedrich's tomb, commissioned by Joachim II, is a summation of Schenck's other funerary monuments. The bare-headed archbishop stands before a cloth of honor held by two angels. In his hands he carries a book and a large set of rosary beads as if to signify his acceptance of Catholicism. The youthful face and the carefully trimmed hair recall Schenck's portrait medal of Friedrich done in 1548.[68] He is enframed

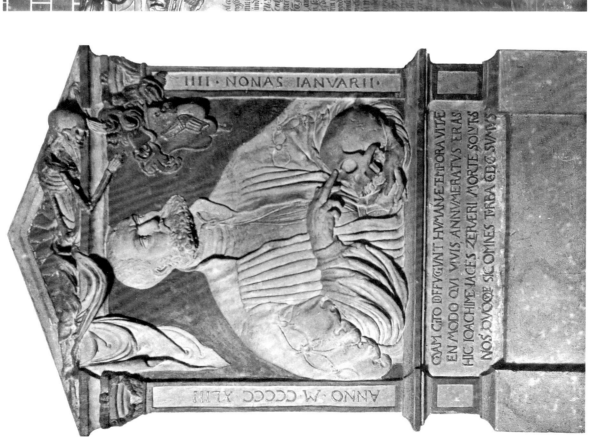

103. Hans Schenck, *Epitaph of Gregor Bagius*, c. 1549, Berlin, Marienkirche, formerly in Nicolaskirche

102. Hans Schenck, *Epitaph of Joachim Zerer*, c. 1543, Berlin, Marienkirche

104. Hans Schenck, *Christus Victor (Epitaph of Paul Schulheiss{?} and His Wife)*,
1556, Berlin, Marienkirche, formerly in Nicolaskirche

by a triumphal arch with wreath-bearing angels in
the spandrels. Other angels holding armorial
shields dance whimsically atop the adjacent capi-
tals. Further coats of arms, some held by female
figures (virtues?), dominate the upper levels of the
tomb. God sits at the apex of the ensemble.

Human mortality and Christ's conquest over
Death and the Devil provide the theme for the sides

and lower portions of the tomb. The crowned figure
of Death, set in the niche to Friedrich's left, gloats
as it stares triumphantly at the first victims: Adam
and Eve, who are bound together to a column by a
human-faced serpent. Schenck next extends this
message into the realm of the viewer by adding
scenes of the triumph of Death over all mankind in
the five-meter-long frieze located below on the en-

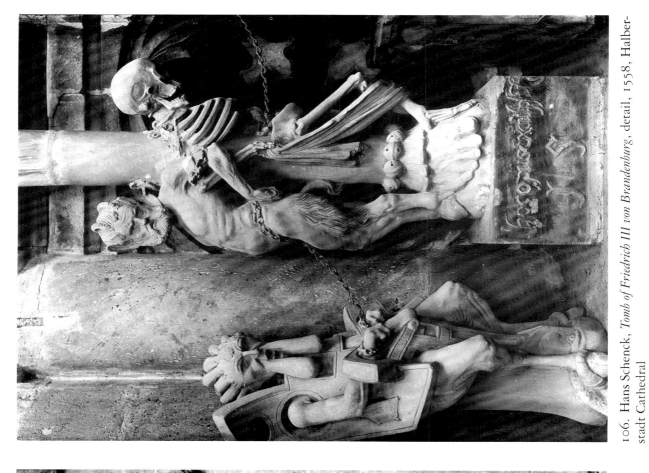

106. Hans Schenck, *Tomb of Friedrich III von Brandenburg*, detail, 1558, Halber-
stadt Cathedral

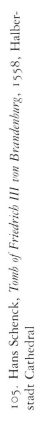

105. Hans Schenck, *Tomb of Friedrich III von Brandenburg*, 1558, Halber-
stadt Cathedral

closure wall at leg height.[69] Death's side of the tomb is associated with the old law by the inclusion above of Moses beneath the cross with the brazen serpent. Schenck repeats the basic program of the Bagius epitaph by representing Christ's triumph opposite. Through his death, indicated by the Crucifixion above, and Resurrection, Christ vanquishes mankind's enemies. His striding position mimics that of Death in the other niche. Christ stares victoriously outwards rather than at his foes. Death and the Devil are bound to the adjacent column while the grotesque figure of Sin sits shackled within the strapwork. Sin's pendulous sacks of fleshy cheek, the hair style, and the strapwork derive once again from prints by both Cornelis Bos and Cornelis Floris.[70]

Friedrich von Brandenburg's tomb offers a wealth of striking contrasts. The archbishop stands alone at the center of the ensemble. His clarity is then juxtaposed to the riotous jumble of the surrounding figures who twist and move in all directions. The careful articulation of the architectural frame threatens to dissolve beneath the wealth of armorial shields and prancing characters. The bizarre figure of Sin with its physiognomic distortions and strapwork restraints is hardly odder than the pair of columns flanking the tomb. Supporting just two angels, these columns expand as they rise. The foot of each column is literally a foot complete with toes and, in between Death and the Devil, fool's bells at the ankle. Fruit and, opposite, bone-laden chains held by animal masks link the tomb with the adjacent columns of the choir. Schenck's inventiveness, hinted at in his earlier funerary monuments, is now given free expression. Few of his contemporaries would follow his lead.[71] Nevertheless, Schenck's ideas anticipate both the developing taste for ever more complicated, more crowded novel designs of later North German sculptors such as Ludwig Münstermann or Christoph Dehne.[72]

Hans Bildhauer

Although Hans Bildhauer of Trier was also interested in death imagery, half-length figures, and Netherlandish decorative forms, his *Epitaph of Johann Segen*, dated 1564, in the Liebfrauenkirche in Trier is wholly different in spirit than Schenck's

107. Hans Bildhauer, *Epitaph of Johann Segen*, 1564, Trier, Liebfrauenkirche

monuments.[73] (figs. 107 and 108) Segen, who commissioned his epitaph at least four years before his death in 1568, is represented in a strikingly naturalistic manner. In contrast with the flattened body and stylized face of Schenck's Joachim Zerer, Segen is carved in very high relief. The bulky body and the waves of fabric of his clerical robes extend beyond the confines of the frame into the viewer's space. Hans Bildhauer carefully developed the aging face with particular attention to the texture of the flesh with its wrinkles and sags. He also highlighted the hands with their veining and minute detailing of joints. Few sixteenth-century

108. Hans Bildhauer, *Epitaph of Johann Segen*, detail, 1564, Trier, Liebfrauen-kirche

sculptors, other than Johann Gregor van der Schardt, ever matched the lifelike quality of this sandstone portrait.

Segen looks up from his well-worn breviary yet seems lost in thought. Will he soon turn to address the viewer? What is hinted at in the physical portrait is completed in the accompanying inscription. It reads

This image here shows to you reader Johannes Segen, on whose body the worms devour, whose spirit heaven nourishes, as a youth he studied eager and chaste, as a man he guided Christian folk through the holy teachings, as a trembling old man now he gave up all of his possessions, earned through his great effort, that a poor student may be supported.

The text alludes to an endowment established by Segen. The allusion to human mortality is reiterated in the skull at the very bottom of the epitaph and by the figure of Death with the hourglass, scythe, and scroll inscribed "Nemini parco" (I spare nobody) above Segen's head.

Hans Bildhauer shared Schenck's fascination with Netherlandish decorative features. The cross-armed herm figures, the grotesque masks, and the scroll and strapwork derive primarily from the prints of Cornelis Floris.[74] Nevertheless, Bildhauer tightly controls these forms. It is the distinctive lines of the architecture and, above all, the bust of Segen that dominate the entire composition. Schenck's epitaphs lack, or consciously avoid, this harmonious clarity.

Comparatively few works by Hans Bildhauer have been identified. According to Trier tax records, he was active between 1556 and 1579. The sculptor reused the basic design of the Segen epitaph for a few other funerary monuments.[75] This half-length format would remain popular in Trier into the seventeenth century. Segen's epitaph is located adjacent to the sacristy and next to the main passage between the Liebfrauenkirche and the cathedral. Directly opposite is the *Tomb of Anton Wiltz* (d. 1628) by Hans Ruprecht Hoffmann, the grandson and namesake of Trier's greatest sculptor.[76] The half-length figure of Wiltz holding a book and a cross turns to his left towards the passageway and towards Segen. In this instance, Wiltz, the cathedral vicar, must have stipulated that his monument should harmonize with Segen's epitaph.

Cornelis Floris of Antwerp

As the sixteenth century progressed many German patrons favored ever grander memorials and funerary monuments rather than more intimate models, such as the Segen epitaph. The prevailing conservative canon of taste, which had gradually embraced classical architectural and decorative features, never adopted the fanciful elements that characterize Schenck's *Tomb of Friedrich von Brandenburg*. Innovations were accepted only cautiously. Even the Dresden school never developed a wholly distinctive repertory of simple memorial designs. Typical is the attractive *Epitaph of Hugo von Schönburg-*

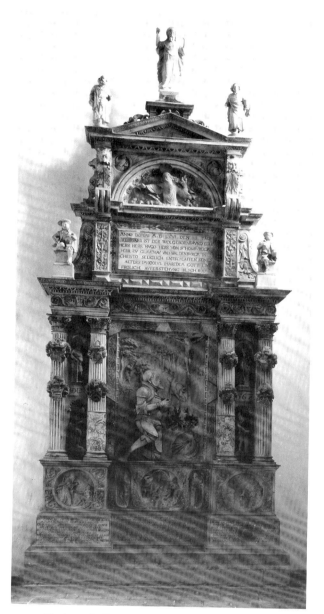

109. Christoph Walther II, *Epitaph of Hugo von Schönburg-Glauchau*, 1567, Waldenburg, Stadtkirche, formerly in the Schlosskapelle

Glauchau that Christoph Walther II completed in 1567 for the Schlosskapelle in Waldenburg (Saxony).[77] (fig. 109) At a height of 6.58 meters and a width of 2.95 meters, the scale of this sandstone monument is imposing. The recently decreased noble kneels before Christ. As in other Protestant monuments, biblical inscriptions are mixed with figurative scenes. The epitaph has a refined appear-

ance. Closer examination of this work, however, reveals that it combines features drawn from several other sculptures by Christoph and by his cousin, Hans II. Much of the architectural frame derives from the portal to the Dresden Schlosskapelle.[78] Other portions, notably the upper section, together with the kneeling patron in deep relief before a landscape can be seen in Hans Walther's *Epitaph of Georg von Schleinitz* (d. 1554) in St. Afra in Meissen.[79] Finally, the placement of the various reliefs and even the particular pose of God in the pediment echoes Christoph's own altar in the Stadtkirche in Penig.[80] For the next couple of decades Christoph recycled and recombined these features in a series of other epitaphs.[81]

Of all of the artists active between the late 1540s and 1580, only Cornelis Floris significantly influenced the development of simple memorial sculpture in North German.[82] While the career of this Netherlandish master falls outside the geographic boundaries of our study, Floris' ideas migrated eastwards by means of his prints, his memorials exported to Cologne and the Baltic, and, lastly, his followers.[83] In 1557 famed Antwerp printer Hieronymus Cock published Floris's *Veelderleij nieuwe inventien van antijcksche sepultueren*.[84] This model book consists of eight plates illustrating ornamental grotesques and seven pages depicting nine different designs for epitaphs and tombs. The latter range from ambitious free-standing tombs supported by allegorical caryatids to flat wall epitaphs with a relief of the deceased and grieving putti. Floris' plate ten, seen here, offers a wall tomb with a central sarcophagus supported by three caryatids. (fig. 110) Two putti resting upon skulls sit on top of the bier. Above is a large relief of the Man of Sorrows with angels set beneath a pediment. Floris often includes appropriate texts. In this case, the inscription is from Luke 12:37: "Blessed are those servants, whom the lord when he cometh shall find watching." As the first printed book of memorial patterns, Floris' ideas were quickly embraced by other sculptors, most of whom borrowed specific details, such as the caryatids, rather than an entire composition. In the next chapter, we shall assess three of Floris' memorials and see how his designs affected the shrines of Moritz of Saxony in Freiberg and Edo Wiemken in Jever.

To exemplify how Floris' ideas were dissemi-

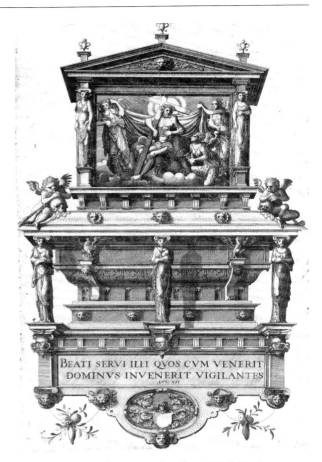

110. Cornelis Floris, *Design for a Wall Tomb*, 1557, engraving, *Veelderleij nieuwe inventien van antijcksche sepultueren . . .* (Antwerp: Hieronymus Cock), pl. 10; Amsterdam, Rijksmuseum

nated in the German-speaking lands, I wish to examined a particular motif: the recumbent effigy resting his raised head upon a hand. This formula is absent from his booklet but it appears in the pendant *Epitaphs of Archbishops Adolf (d. 1556) and Anton von Schauenburg* (d. 1558) that Floris and his workshop made for the choir of Cologne cathedral between about 1556 and 1561.[85] (fig. 111) The epitaphs are alike except for the opposing directions of their bodies and the placement of Anton's miter,, which is beside rather than on his head, since he died prior to his consecration. The monuments consist of two parts: the projecting sarcophagus and the wall decoration. Before this pair of monuments, the inclusion of an effigy in an epitaph was quite rare. Adolf, seen here carved in white marble,

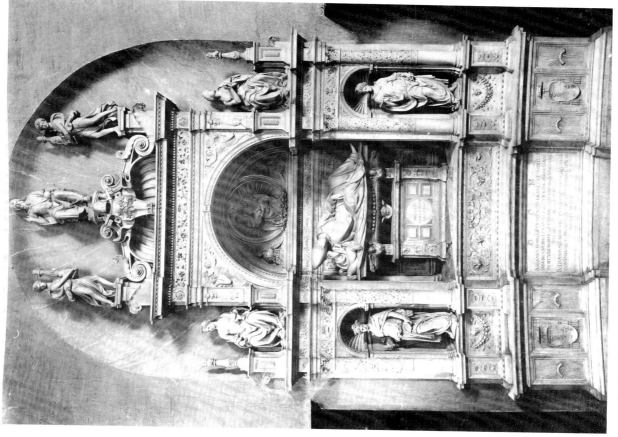

112. Andrea Sansovino, *Tomb of Cardinal Sforza*, 1509, Rome, S. Maria del Popolo

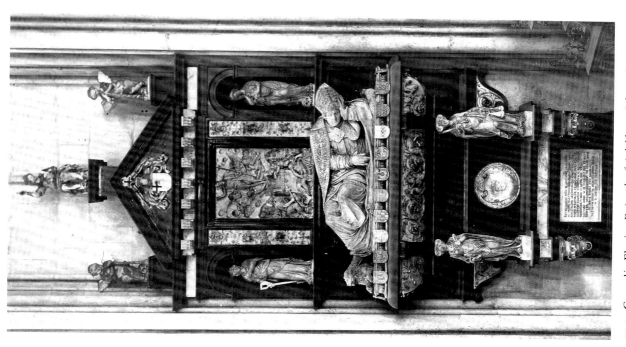

111. Cornelis Floris, *Epitaph of Adolf von Schauenburg*, c. 1556, Cologne Cathedral

lies with his head resting upon his left hand atop a stone casket supported by two caryatid virtues (Wisdom and Justice). His prototypes were Italian. During his stay in Rome in 1538, Floris must have studied the half-reclining figures and the antique caskets that Andrea Sansovino used in his tombs of Cardinals Sforza and Basso, completed by 1509, in S. Maria del Popolo in Rome.[86] (fig. 112) Yet where Sansovino's effigies appear asleep, Floris has Adolf gaze alertly at the activities in the choir. The remainder of the epitaph, with the grieving virtues of Temperance and Strength, angels, and central Resurrection relief, recalls forms first developed in his printed designs.

This motif slowly gained in popularity. It appears in Peter Osten's *Tomb of Sebastian Echter von Mespelbrunn* (d. 1575) in Würzburg cathedral.[87] (figs. 113 and 114) Osten, who resided in Würzburg from 1576 to 1579 while working on the Juliusspital, completed the tomb in 1577. The patron was Prince-Bishop Julius, Sebastian's brother, who had it erected in the south aisle of the church. Normally the interior of the cathedral church was reserved for clerics; important secular personages were buried in the cloister. The effigy, clad in armor, reclines upon two thick books, a reference to Sebastian's training as a doctor of civil and canon law and to his career as a magistrate for the archbishopric of Mainz, which included Würzburg. The seated pose is more casual than that in the Cologne effigies. Here again, however, the deceased is presented as being alive and staring heavenwards. Osten has omitted the casket as Sebastian sits upon a stone lintel. One reason for this is his introduction of Sebastian's corpse carved on a smaller scale at the foot of the tomb. For the remainder of the monument, Osten borrowed liberally from Floris' repertory. For instance, the three virtues (Hope, Charity, and Faith), their classical attire, and their positioning can be found in Floris' prints and sculptures.[88] The architectural frame with the central inscription tablet, the flanking coats of arms on the pilasters, the grotesques in the lintel, and even the design of the circular strapwork frame surrounding the von Mespelbrunn heraldic shield derive from Floris, as do the various trophies, arabesques, masks, and other decorative forms.[89] Nevertheless, their configuration at Würzburg is very much Osten's own plan. He has

adapted the latest, most fashionable northern European funerary forms for his *Tomb of Sebastian Echter*.

The half-reclining or half-seated motif remained popular into and beyond the seventeenth century. Floris' Schaumberg epitaphs directly inspired Cologne sculptor Gerhard Scheben who, in 1599, completed the monumental *Tomb of Duke Wilhelm V the Rich* in St. Lambertus in Düsseldorf.[90] Among the finest variants are the bronze monument of Johann Konrad von Gemmingen of 1612 in the choir of Eichstätt cathedral or the reading figure of Archdeacon Karl von Metternich (d.. 1636) in the Liebfrauenkirche in Trier.[91] (fig. 115) An artist in the circle of Hans Morinck, the Netherlandish sculptor living in Constance, adopted the form for his *Tomb of Hans Caspar von Ulm zu Marpach und Wangen* in St. Pankratius in Wangen am Untersee in 1610.[92]

Changes in Memorial Form and Iconography

With the exclusion of this last group of monuments with their semi-reclining figures, this category of simple tombs and epitaphs is remarkably consistent in terms of its defining features. Most are fairly small, ranging between one and two meters tall. If elaborate armorials and inscription plaques are included the height is slightly greater. These vertically oriented monuments are flat. By this I mean that the actual depth of the carving and even of the surrounding architectural frame is limited in most instances to less than about 30 centimeters. The reliefs are shallow. Free-standing statuettes are rare unless located in side niches or on top of the frame. The sole decorative embellishment that emerges during this period is the frame, which increases both in size and complexity. A classical canon of forms, though often eclectically applied, supersedes traditional Gothic motifs. Antwerp-style strapwork may be observed often from the 1550s onwards.

The range of memorial images in Germany never matched the diversity observed in either Italy or France. Prior to the 1580s, there are no monumental wall tombs such as one finds in Venice or Rome, with the exception of Cornelis Floris' Königsberg memorials, which will be discussed in the next

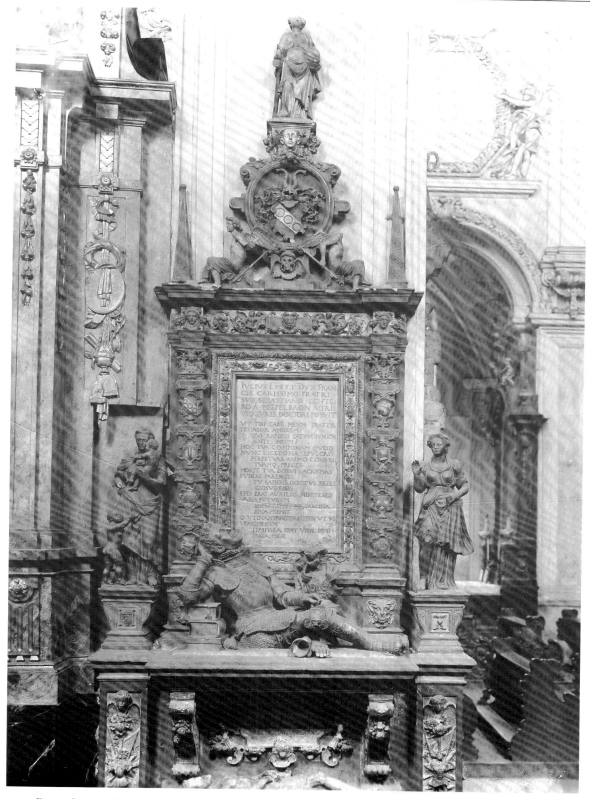

113. Peter Osten, *Tomb of Sebastian Echter von Mespelbrunn*, 1577, Würzburg Cathedral

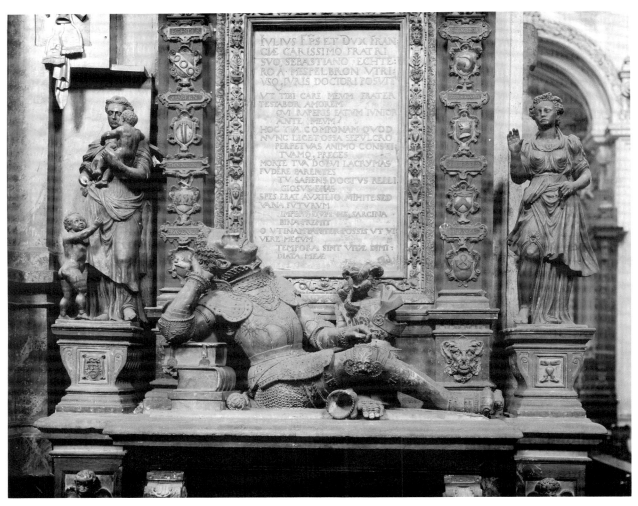

114. Peter Osten, *Tomb of Sebastian Echter von Mespelbrunn*, detail, 1577, Würzburg Cathedral

chapter, and the *Tomb of Philipp, Landgrave of Hesse (d. 1567) and Christine of Saxony (d. 1549)* in Kassel (St. Martin).[93] (figs. 154–156) Absent too are any equestrian memorials or tombs housing portions of a body, such as the heart or viscera of a noble.[94] I hasten to add that neither were these forms common in Germany prior to the Reformation. The *transi* tomb did exist in this part of Europe, but it too largely disappeared with the Reformation.[95] Conrad Meit of Worms' marvelous *Mausoleum for Margaret of Austria* in Brou, which dates to around 1530, embodies a French not German tradition.[96] Peter Osten's *Tomb of Sebastian Echter von Mespelbrunn* represents an isolated revival not the continuity of this form. I have not included a single free-standing

tomb in this chapter since the comparatively few examples offer nothing new to the medieval tradition of the recumbent effigy placed on a stone base. (figs. 8 and 9, 128, 138) The practice of setting a life-size statue of the deceased kneeling in prayer either upon a base or within an architectural frame set against a wall, both found in sixteenth-century Italy and France, would become popular in Germany but not until around 1600.[97] Christoph II Walther's *Epitaph of Hugo von Schönburg-Glauchau* shows how the donor figure is starting to disengage from the background relief but it is not yet a fully independent statue. (fig. 109) While not used in the simple memorials surveyed above, this feature was incorporated in several of the complex tombs to

115. Hans Krumper (attributed), *Tomb of Johann Konrad von Gemmingen*, 1612, Eichstätt Cathedral

be discussed in the next chapter.[98] The majority of epitaphs and tombs depict the deceased, often in prayer, with no accompanying religious scene.

I think that there are two basic reasons for the comparative humbleness of these German examples. First, huge showy tombs had never been popular in the German lands. Most episcopal and secular princes were content with a modest wall memorial or simple free-standing tomb. The large size and iconographic complexity of Nicolas Gerhaerts' *Tomb of Emperor Friedrich III* (d. 1493) in Stephansdom in Vienna, begun in 1469 and completed only in the 1510s, reflect Habsburg pretensions rather than a native artistic tradition.[99] Yet even here the central effigy of the emperor is highly conventional in design. In some of the imperial free cities, such as Nuremberg, sumptuary laws prevented wealthy merchants from erecting tombs adorned with anything other than a simple metal plaque with the name, coat of arms, and profession of the deceased.[100]

The second reason is the Reformation. By the mid-1520s, strident criticism of religious art and the elaborate decoration of churches inhibited memorial sculpture in both Protestant and Catholic territories. A simplification in terms of design

and themes resulted. The intricacy of an early sixteenth-century epitaph, like that of Kunz Horn and Barbara Krell in Nuremberg, yields to the straightforward compositions of Loy Hering or Peter Dell the Elder. Although both of these masters worked primarily for Catholic patrons, the range of subjects that they offered were calculated to be theologically neutral. Neither artists nor patrons wished to invite controversy. Protestant iconoclasts in cities such as Augsburg in 1537 made virtually no distinction between church art and epitaphs. The Augsburg cathedral cloister is lined with memorials in which the heads of both saints and clerics are smashed.[101] Images of the patron kneeling before the cross predate the Reformation and would remain the single most popular theme throughout the sixteenth century. As noted in Chapter One, Thomas à Kempis and other theologians urged the devout to "witness" the events of Christ's life and death. The *Schreyer-Landauer Epitaph* on the outside of St. Sebaldus in Nuremberg depicts Sebald Schreyer holding the crown of thorns and sculptor Adam Kraft with the nails. (fig. 4) The text "desire to die on the cross with Him. For if you die with Him, you will also live with Him" reflects a universal attitude that did not disappear with the advent of the Reformation.[102] For Luther, Christ was the sole means for salvation. In his *Small Catechism* he wrote

> I believed that Jesus Christ, . . . has rendered me, a lost and condemned creature, delivered me and freed me from all sins, from death, and from the power of the devil, not with silver and gold but with his holy and precious blood and with his innocent sufferings and death.[103]

In both Protestant and most Catholic examples, the individual is rendered alone. Gone are all saintly intercessors. Even the inclusion of Mary and John the Evangelist beneath the cross is rare. Frequently too, the confessional affiliation of the patron is not obvious from the pictorial imagery.

Given the character of contemporary religious art, one might expect that sculpted epitaphs and tombs would follow clear confessional distinctions. This, however, is not always the case. Hering's thematic range was quite limited. The Catholic artist's favorite subjects are the Resurrection and subsequent biblical events, such as Christ's Descent

into Limbo or Christ Appearing to Mary. More traditional Catholic themes, like Mary as Protectress or a Pietà with saints, are so unusual as to indicate that Hering must have followed a specific program dictated by the patron.[104] The Dells offer even less diversity of subjects. On the other side, Lucas Cranach the Elder and his son painted numerous altarpieces *and* epitaphs with such characteristically Lutheran themes as Law and Gospel, Christ Blessing the Children, the Baptism of Christ, the Raising of Lazarus, and the Last Judgment.[105] Protestant sculptors slowly implemented most of these themes though epitaphs and tombs displaying anything more than just the patron or the patron beneath the cross are somewhat exceptional.

Hans and Christoph II Walther once again were among the first to translate these favored subjects into carved memorials.[106] Christoph's *Epitaph of Hugo von Schönburg-Glauchau*, completed in 1567, illustrates the complexity of some of the later Saxon designs. (fig. 109) The noble kneels before a landscape with the Crucifixion. Christ's death is typologically paralleled with the adjacent scene of Abraham's Sacrifice of Isaac. Further behind, Christ is baptized. As Christensen has observed, baptism and death were intertwined in Luther's mind.[107] In the *Small Catechism*, Luther cites St. Mark (16:16): "He who believes and is baptized will be saved." Here and in other writings, Luther equates baptism with death and resurrection. Baptism purifies the individual of original sin and, thereby, offers the promise of salvation. Luther wrote that "the sooner we depart this life, the more speedily we fulfill our baptism."[108] In keeping with Lutheran art's inclusion of biblical texts, the sculptor incorporates four inscriptions within the central relief. Under the aegis of God in the lunette, the Old Testament yields to the New Testament in Walther's epitaph; roundels of the Annunciation in the spandrels show the beginning of the New Law. On the base, scenes of the Creation of Adam and Noah's Sacrifice after the Flood bracket the Adoration of the Shepherds, the first moment when the world recognizes

Christ's divinity. Various statuettes of prophets, including Ezekiel and Hosea, and disciples are located in niches or are free-standing along the sides of the monument.

The skeletal apparition of Death with its *memento mori* iconography enjoyed tremendous popularity in the late Gothic period and early Renaissance. It continues to be used on occasion in both Protestant and Catholic memorials. The harrowing form of a skeleton with his sickle peers over Johann Segen's head at Trier. (fig. 107) The viewer of this or of several epitaphs by the Walthers are asked to reflect upon their own mortality.[109] Hans Schenck's memorials shift the focus from the power of Death over humanity to Christ's conquest of Death, Devil, and Sin. (figs. 102–106) Thus his reliefs offer the promise of eternal life through Christ. An interesting mix of these two themes is contained in Christoph II Walther's heavily damaged *Epitaph of Günther von Bünau* (d. 1562) in Dresden (Stadtmuseum).[110] Death with the hour glass stands threateningly behind the patron and his young son while the Devil with an arrow stalks his wife and daughter. Both malevolent figures, however, are chained. In the center of the relief stands a double image of Christ. He is crucified and, immediately above the cross, resurrected. The victorious Christ holds the chains that enslave Death and the Devil.

As with other forms of sculpture, memorials became increasingly elaborate at the turn of the century. Wonderfully complex Protestant epitaphs would enrich the churches in Braunschweig, Erfurt, Magdeburg, and dozens of other North German towns. The same is true in Catholic regions as memorials were used as pictorial weapons in the skirmishes of the Counter-Reformation. From Hans Morinck's epitaphs in Constance to those of the Gröningers in Münster and Paderborn, the power of both the saints and the Catholic church is often aggressively displayed. The intertwining of personal memorial, confessional allegiance, and liturgical needs also spawned the creation of a new hybrid—the epitaph altar—in the seventeenth century.[111]

CHAPTER SIX

Commemorative Series and Complex Tombs

☙

Lᴛʜᴏᴜɢʜ most memorials were intended as independent objects, as we have observed in the previous chapter, others were conceived as parts of a grander whole. Below we shall examine two further categories: funerary series and complex tombs. Series occur in two basic forms. In the first, a new tomb or epitaph is added to a set of monuments, some of which are centuries old. New work's design must often share specific features with other sculptures in the cycle. In the second, a new ensemble is created that collectively honors generations of a particular ruling house. In addition to these series are the complex tombs that are far larger, far more intricate than any other memorials. The scale of these often dictates that a special chapel or section of a church be devoted solely to their display. These personal or family shrines rival or surpass the finest tombs found anywhere in Europe. All memorials glorify the piety and earthly success of their patrons; however, the individuals featured in both series and complex tombs tend to stress their political aspirations to a much greater degree.

Episcopal and Princely Series

In 1627 Hans Ulrich Bueler painted a view of the interior of Würzburg cathedral that shows its appearance following renovations carried out under Bishop Julius Echter von Mespelbrunn (d. 1617).[1] (fig. 116) Foremost among the impressive array of decorations is the series of episcopal tombs lining the nave. A large stone monument adorns each pier. Originally a separate bronze or brass tomb-plate, typically of Nuremberg origin, was set in the floor immediately before the pier. The memorials are independent commissions usually ordered by the deceased bishop's successor. These were intended, however, to be viewed as part of a venerable series—a *via triumphalis* (a triumphal way)—that would stress the antiquity of the diocese and the unbroken continuity of clerical rule. In the face of Protestant challenges to Catholic authority, this and similar series, with their origins firmly rooted in the Middle Ages, offered tangible confirmations of episcopal legitimacy. This was one of the major functions of any ecclesiastical or secular funerary series. A tomb could honor the memory of a particular bishop or prince while simultaneously placing him within the broader context of succession or dynastic rule.

Hans Ulrich Bueler's painting provides a clear idea how a contemporary audience might interact, or, at least, respond, to these episcopal monuments. The memorials are located in the nave with a few others in the transepts. Unlike the choir, which was used exclusively by the clergy, the nave and the transepts represented the public space of the cathedral. The episcopal tombs were constantly before their eyes regardless of whether the worshippers attended mass, listened to sermons preached from the pulpit situated in the nave, or simply wandered about the church as do the men and women in Bueler's painting. Beneath their feet, placed in the floor of the nave, lay many of the older bishops' tombslabs and tombplates. Moving eastwards down the south side of the nave, they would have seen the tombs arranged in reverse chronologi-

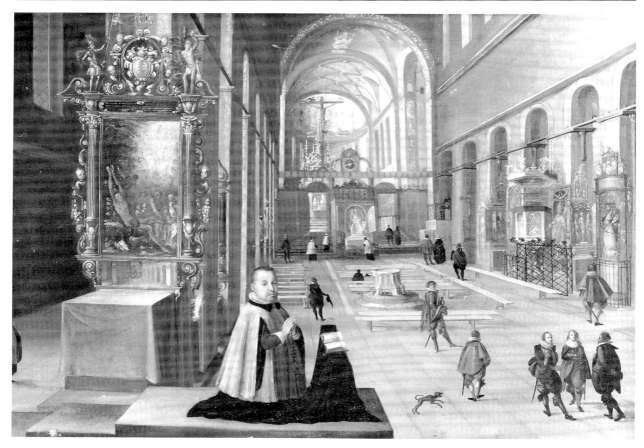

116. Hans Ulrich Bueler, *Interior of Würzburg Cathedral*, 1627, painting, Würzburg, Martin von Wagner-Museum

cal order beginning with that of *Bishop Johann Gott-fried von Aschhausen* (d. 1622) at the right of Bueler's interior view.[2] This is followed by the memorials of *Julius Echter von Mespelbrunn*, *Friedrich von Wirsberg* (d. 1573), *Melchior Zobel von Giebelstadt* (d. 1558), *Lorenz von Bibra* (d. 1519), *Rudolf von Scherenberg* (d. 1495), and so on. Up to this point the only sequential break occurs for *Konrad von Bibra* (d. 1544) and *Konrad von Thüngen* (d. 1540), whose monuments occupy matching spots in the eastern walls of the north and south transepts. This movement down the nave culminates with the *Bust of St. Kilian* set upon the high altar.[3] Kilian (d. 689) was the apostle of Franconia and patron of the cathedral. In recognition of Kilian's proselytizing efforts within the region, St. Burkhard (d. 753), who was appointed the first bishop of the diocese in 741–42, ordered the bones of the saint and his two companions transferred and enshrined in the new cathedral in

752. This direct physical association between St. Kilian and each successive bishop underscores the unbroken authority of the episcopal line.

This association between St. Kilian and the subsequent episcopal rulers is reiterated in the basic design of the majority of the memorials. For example, Tilmann Riemenschneider's *Tomb of Lorenz von Bibra*, completed in 1522, depicts the deceased in his bishop's robes and miter.[4] (fig. 117) He holds a sword in his right hand and a crozier in his left. While the dress and the crozier are common to all episcopal cycles, the inclusion of the sword alludes directly back to the death of St. Kilian and his companions, Kolonat and Totnan. In early depictions of the saint he is represented with the instrument of his martyrdom and the symbols of his episcopal office.[5] From the beginning of the fourteenth century, if not earlier, Würzburg's bishops adopted these features for their memorials.[6] Riemenschnei-

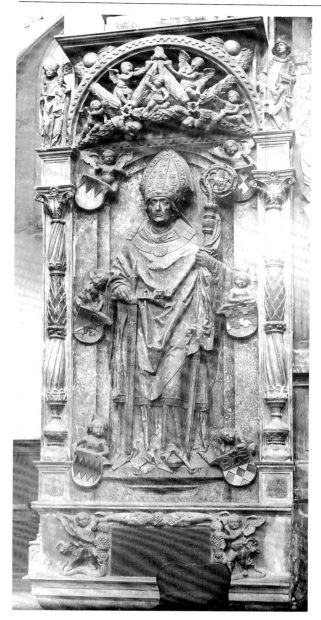

117. Tilmann Riemenschneider, *Tomb of Lorenz von Bibra*, 1522, Würzburg Cathedral

der stressed this connection still further by including a statuette of St. Kilian at the upper left corner of the tomb; opposite is Lawrence, the bishop's name saint. The addition of the sword has a second important purpose. Such swords are more typically observed in memorials of secular lords as a symbol of their territorial authority. The bishop of Würzburg was concurrently the duke of Franconia. Thus here the sword alludes both to the bishop's tempo-

ral authority and to the diocese's founder, St. Kilian.

By their very nature, most of these episcopal memorials are conservative monuments. The effigy of Lorenz von Bibra varies little from Riemenschneider's earlier *Tomb of Bishop Rudolf von Scherenberg* (d. 1495) on the adjacent pier. These two in turn are distinguished from the previous bishops' tombs only by the sculptor's ability to render more natural-looking cloth and more expressive faces. Otherwise, the formula had barely changed during the preceding century. It is the decorative, pseudo-Renaissance frame and the lively angels in the lunette that provide the von Bibra memorial with an individualized character.

Interestingly, this traditional format was abandoned for the next four episcopal monuments before it was readopted by Julius Echter von Mespelbrunn in the seventeenth century. The change occurred when Loy Hering of Eichstätt rather than a Würzburg sculptor received the commission for the *Tomb of Konrad von Thüngen*.[7] (fig. 118) Although Hering had carved rather conventional single-figure monuments for Gabriel von Eyb, bishop of Eichstätt (1496/97–1535), and Georg III Schenk zu Limburg, bishop of Bamberg (1505–22), during the late 1510s, his late funerary monuments centered typically on a large relief panel.[8] The von Thüngen memorial represents the conjunction of these two traditions since the bishop is shown kneeling in a landscape before a Crucifixion whose Christ is very similar to the figure in the *Epitaph of Duke Erich 1 of Braunschweig-Lüneburg*. (fig. 101) In deference to Christ, Bishop von Thüngen has set his miter on the ground before the cross. His sword and crozier are now held by his chaplain and his marshal, signifying his dual offices as prince-bishop. I think that Hering was personally responsible for this change in the episcopal format. By 1540, Hering was the most fashionable of all memorial sculptors in Bavaria and Franconia. His design offered a modern reconfiguration, mixing one of his customary models with the special iconographic needs of his patron. The traditional standing, single-figure formula was retained for von Thüngen's bronze tombplate, now located in the south aisle wall.[9]

Hering's von Thüngen tomb, commissioned in 1543, provided the model for the next three episco-

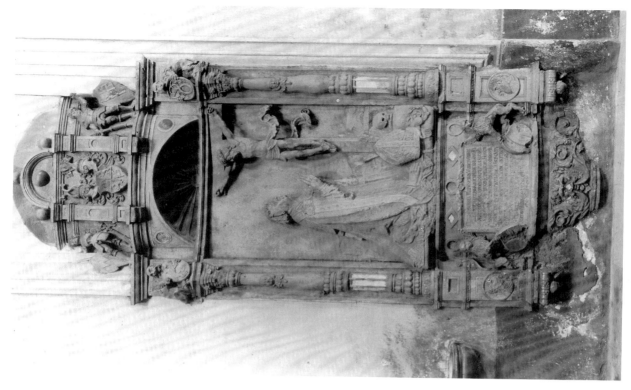

119. Peter Dell the Elder, *Tomb of Konrad von Bibra*, c. 1544, Würzburg Cathedral

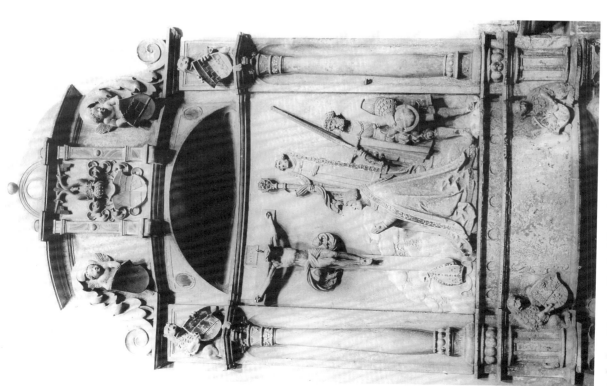

118. Loy Hering, *Tomb of Konrad von Thüngen*, c. 1540, Würzburg Cathedral

pal monuments. Upon Bishop Konrad von Bibra's death in 1544, Peter Dell the Elder must have been instructed to design a matching memorial.[10] (fig. 119) The frame, while slightly thinner, reproduces the essential features found on the von Thüngen tomb. The Würzburg sculptor has even imported Solnhofen limestone for the central relief rather than using local sandstone. Both show the deceased kneeling before the crucified Christ; however, due to the smaller dimensions of his relief, Dell has omitted the retainers and placed the sword and crozier in the foreground. Peter Dell the Younger employed the same general format for the *Tomb of Bishop Melchior Zobel von Giebelstadt*, which was erected in 1561.[11] (fig. 120) The central relief includes the bishop kneeling before the crucifix, but the sculptor has also introduced in the landscape beneath the Marienburg the story of the bishop's brutal murder.[12] This is the only Würzburg episcopal monument that includes specific biographical information other than dates, titles, and coats of arms. The *Tomb of Bishop Friedrich von Wirsberg*, completed in 1574 by Eichstätt sculptor Wilhelm Sarder, derives most of its essential features from the three other monuments, though the quality of its design and especially its crude carving are truly mediocre.[13] Julius Echter von Mespelbrunn returned to the older design for his own tomb, carved probably by Nikolaus Lenkhart shortly after the bishop's death in 1617.[14] (fig. 121) Although the architectural style has been updated, the formula of the single figure standing in a niche, observed in Riemenschneider's *Tomb of Lorenz von Bibra*, has been revived. Bishop Echter, who restored and perhaps partially rearranged the earlier monuments, consciously sought to link his dynamic reign with those of his pre-Reformation predecessors.

The only church that possesses an equally impressive and extensive series of tombs is Mainz cathedral.[15] The Würzburg and Mainz cycles are remarkably similar in terms of their placements and general designs. This is hardly surprising considering Würzburg belongs to the archdiocese of Mainz. Artists moved freely and frequently between the two towns. For instance, Hans Backoffen, Mainz's foremost sculptor until his death in 1519 and author of three archepiscopal tombs, apparently studied with or worked for Riemenschneider in Würzburg.[16] Peter Osten, though based in Mainz,

worked for Bishop Julius Echter von Mespelbrunn in Würzburg. (figs. 113 and 114) The Mainz tombs also are arranged on the piers of the nave. The older ones are set near the eastern choir while Backoffen's later two bracket the entry to the larger St. Martin's or western choir. With only two exceptions, the archbishop-electors of Mainz are represented alone, lying or, since 1396, standing, holding a book and their crozier.[17] Only the designs of the surrounding architectural frames, the placements of the coats of arms, and the dimensions of the monuments vary.

It is within this traditional, conservative framework that Dietrich Schro's tombs of *Albrecht von Brandenburg* (1514–45) and *Sebastian von Heusenstamm* (1545–55) belong.[18] (figs. 122, 123 and 278) As discussed above, Cardinal Albrecht originally planned to be buried in the Neue Stift at Halle. Due to the growing strength of the Reformation there, he transferred his residence and his collections to Aschaffenburg in 1540. He then selected Mainz as the new location for his tomb. Albrecht first commissioned a stone armorial slab that was set immediately adjacent to the steps of the St. Martin's choir.[19] On the northeast side of the adjacent pier the cardinal erected his tomb memorial. The placement, though not in the nave proper, is a prominent one. Albrecht faces the nearby market portal, the church's primary entrance. Directly across the market stood the great fountain that the cardinal had erected in 1526.[20] (fig. 182) Furthermore, anyone wishing to enter the north transept, the sacristy, or the Gothard-Kapelle must pass directly beneath the archbishop's attentive gaze. Albrecht is no longer the young man observed in Peter Vischer the Younger's epitaph in Aschaffenburg. (fig. 93) The corpulent body and sagging face mark the passing of time. Unlike his predecessors, Albrecht holds a crossed staff in addition to the crozier and book. He also wears a double pallium signifying his investiture as archbishop of both Mainz and Magdeburg. Suspended above Albrecht hangs a laurel wreath that casts a shadow on the back of the framing niche. While the antique motif of an angel (or victory) offering a wreath set in the spandrels of triumphal arches passed into medieval and Renaissance tombs, this solution is unprecedented. Perhaps it derives from the wreath reliefs that occasionally adorn Italian tombs.[21] Regardless of its origins, the wreath singles out Albrecht for special

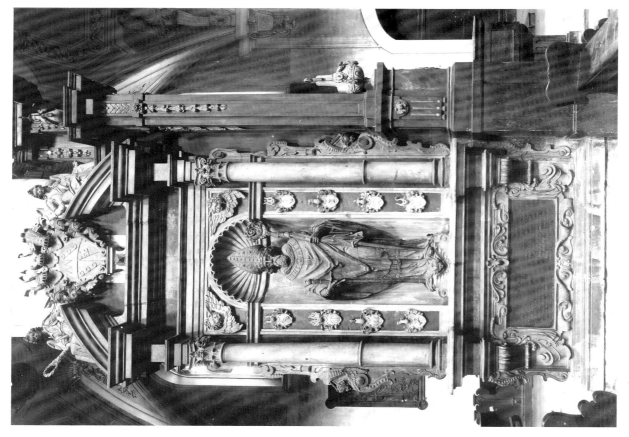

121. Nikolaus Lenkhart, *Tomb of Julius Echter von Mespelbrunn*, c. 1613, Würzburg Cathedral

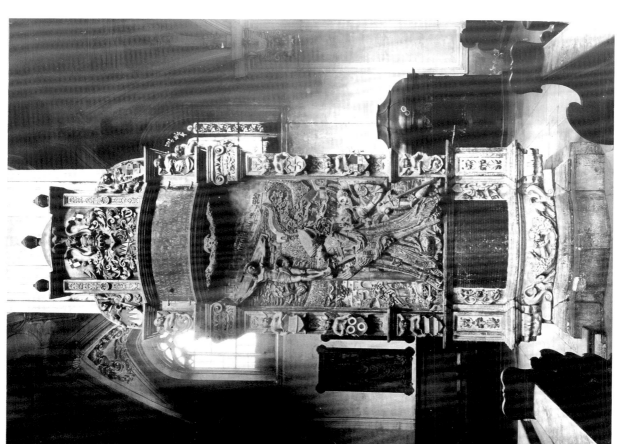

120. Peter Dell the Younger, *Tomb of Melchior Zobel von Giebelstadt*, 1561, Würzburg Cathedral

praise. Is it the resurrected Christ or the marvelously energetic angels above who bestow this honor upon Albrecht, the highest ranking Catholic cleric in the German lands? These two angels impart a joyous mood to the tomb. Standing upon only the back of one foot, each seems destined to leap into the space of the viewer, who cannot readily see the iron bars securely tying the angels to the pier. The tomb's interaction with the viewer extends also to the grinning satyr on the console beneath Albrecht's feet. In a biographical fashion, the satyr, the ram heads, and the cornucopias refer to the archbishop's active interest in humanism and classical studies. Although Dietrich Schro retained the essential features of Mainz's archepiscopal tomb tradition, he personalized this monument by including information about Albrecht's life and aspirations.

Like any sculptor, Schro certainly possessed a working collection of drawings and prints that he could refer to for design ideas. Models developed in one city quickly migrated to others. One of the few extant artist's collections, now in Basel (Kunstmuseum), includes numerous sketches that would have interested a sculptor like Schro.[22] In the *Design for an Altar*, which probably copies an Augsburg prototype of the 1510s, the unknown artist has incorporated motifs such as the angels standing on one foot, the partial or interrupted arches flanking the large central arch, a clear Italianate architectural frame, and scrolling tendrils defining the form of the upper zone. (fig. 124) While Schro never knew this particular sketch, it is representative of the sort of models that sculptors relied upon for inspiration.

Schro's *Tomb of Sebastian von Heusenstamm*, Albrecht's successor, is less successful. (figs. 125 and 126) Whereas the carved figure of Albrecht dominates the earlier work, that of Heusenstamm competes rather unsuccessfully with the architectural frame. The muscular terms with their crossed arms, expressive heads, and rich surface textures command our attention. The new influence of Netherlandish decorative prints, notably those of Cornelis Floris, that appeared in the decade between the two tombs is quite evident.[23] Even the angel on the console is a hostage of the enveloping strapwork. The joyous spirit of Albrecht's tomb contrasts distinctly with the latter's emphasis upon *memento*

mori themes. Despite their individual differences, Schro's two monuments perpetuate Mainz's archepiscopal tomb series that other artists would continue well into the next century.[24]

Few other episcopal churches could match the organization and the comprehensiveness of either the Würzburg or Mainz series. The cathedral at Trier represents a more typical situation. Seventeen tombs of the archbishop-electors of Trier, dating almost continuously from the late tenth century until 1430, adorn the church. Their placement seems almost random, and their designs have few common characteristics. After nearly a century hiatus, during which time the archbishops were buried in Koblenz and other towns, a new group of elaborate tombs were erected in the north aisle of the cathedral. These monuments collectively assert episcopal authority and the ancient heritage of Trier. Between 1525 and 1527, Richard von Greiffenklau (1511–31) commissioned a tall altar-tomb showing himself kneeling beneath the cross.[25] In addition to Mary Magdalene, the archbishop is accompanied by St. Peter, the cathedral patron, and St. Helen. Von Greiffenklau, a militant opponent of Luther's at the Diet of Worms and thereafter, recalls the cathedral's association with Peter, the foundation of the Catholic church's direct authority from Christ. According to legend, the first cathedral of Trier was a converted Roman audience hall that St. Helen, Emperor Constantine's mother and the rediscoverer of the true cross, had donated to the episcopate in the early fourth century.[26] The inclusion of little portrait roundels of Emperors Maximilian I and Charles V stress von Greiffenklau's imperial ties and, more specifically, his role as one of the seven electors.

Grander in design though similar in intent is the nearby wall *Tomb of Johann III von Metzenhausen* (1531–40), dated 1542.[27] (fig. 127) The sculptor is possibly Hieronymus Bildhauer, the father(?) of Hans Bildhauer who carved the *Epitaph of Johann Segen*. (figs. 107 and 108) The standing statue of the archbishop dominates the composition. In contrast with Riemenschneider's *Lorenz von Bibra* or Hering's comparable portrayals of the bishops of Eichstätt and Bamberg, Johann III has greater physical presence and a stronger sense of humanity. His pious and indeed benevolent expression underscores his role as vicar of Christ, shepherd of his

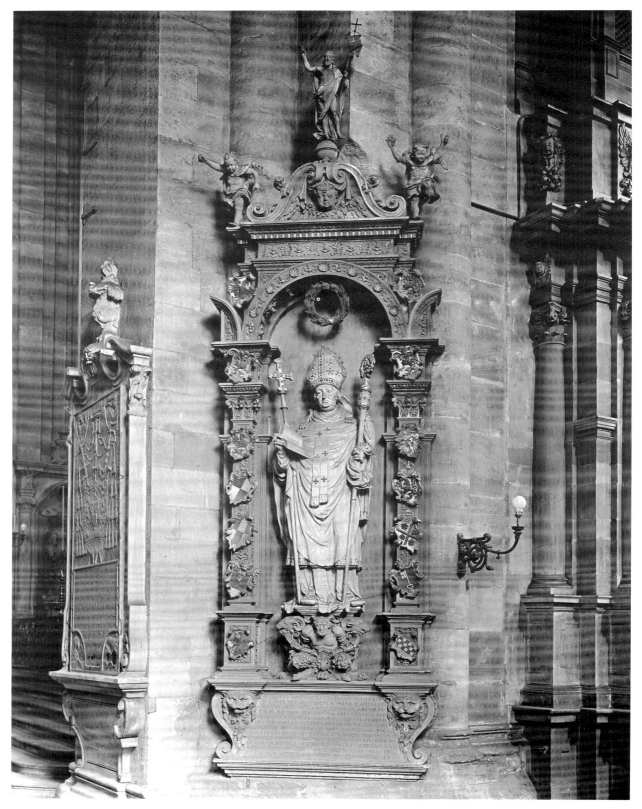

122. Dietrich Schro, *Tomb of Albrecht von Brandenburg*, c. 1545, Mainz Cathedral

123. Dietrich Schro, *Tomb of Albrecht von Brandenburg*, detail, c. 1545, Mainz Cathedral

pastoral flock. During his reign, Johann III staunchly defended Catholic faith and church rights. The carvings on the columns beneath the flanking statues of Sts. Paul and Peter may allude to his battles to maintain church authority. As recounted in the Acts of the Apostles (28:1–6), Paul suffered no harm when he was bitten by a deadly viper that rose from the fire. Because of his Christian faith Paul defeated the serpent just as Catholicism would overcome the serpent of heresy, Lutheranism. According to Irsch, St. Peter, the cathedral's patron saint, triumphs over a shackled burgher in contemporary attire, a reference to Johann III's repeated skirmishes with the city government of Trier over episcopal rights and jurisdictions.[28] As in the von Greiffenklau tomb, medallions of Emperor Charles V and his son Philip II underscore the archbishop's political role within the empire.

On a purely formal level, the Metzenhausen tomb is a particularly fine example of a successful adaptation of Italian decorative motifs. The triple arch design with side figures in shell niches harkens back, at least indirectly, to Andrea Sansovino's *Sforza* and *Basso Monuments* in S. Maria del Popolo in Rome.[29] (fig. 112) The rational use of classical architectural forms, the incorporation of busts and medallion portraits, and the positioning of the statuettes on the capitals in the upper zone of the tomb all derive ultimately from Italian sources. It is doubtful, however, that the sculptor ever traveled south of the Alps since many of these features were available in drawings or prints and had already been incorporated into German art.[30] The sculptor of the Metzenhausen tomb would have studied both the Greiffenklau altar-tomb and the joint *Epitaph of Werner and Georg von der Leyen* of 1534 in Trier

124. Augsburg Artist, *Design for an Altar*, 1510s, drawing, Basel, Öffentliche Kunstmuseum, Kupferstichkabinett

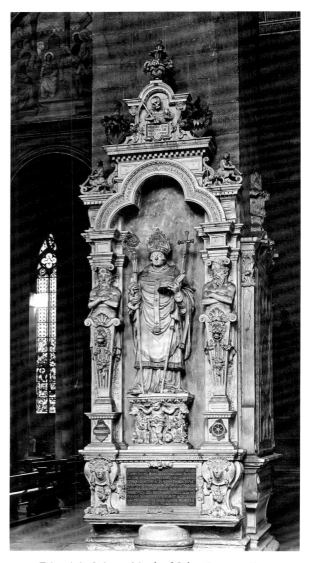

125. Dietrich Schro, *Tomb of Sebastian von Heusenstamm*, c. 1555, Mainz Cathedral

cathedral.[31] Furthermore, Trier's sculptors had long looked for artistic inspiration to nearby Mainz. Many had trained with Hans Backoffen and Peter Schro; others were influenced by the refined art associated with the archepiscopal court of Albrecht von Brandenburg. The master of the Metzenhausen tomb has melded these diverse sources with his own ideas and created a monument of great beauty. Its design and its message are both coherently stated. This same artist probably executed the next memorial in this series: the adjacent *Tomb of Archbishop Johann Ludwig von Hagen* (1540–47) that, unfortunately, was destroyed by the French in 1804.[32]

In addition to these ecclesiastical cycles, continuing secular funerary series can be found throughout the German lands, though none of

these is as extensive or as comprehensive as Würzburg or Trier. No grand imperial mausoleums exist to match St. Denis or Westminster Abbey. The Holy Roman emperors long remained itinerant rulers with no fixed capital. Instead it was the regional counts and dukes who generation after generation chose to be buried beside their predecessors. The south transept of the Elisabethkirche in Marburg houses the tombs of the margraves of Hesse from the mid-thirteenth century until the death of Wilhelm II in 1509.[33] The dukes and electors of Saxony selected Meissen cathedral as their burial

126. Dietrich Schro, *Tomb of Sebastian von Heusen-stamm*, detail, c. 1555, Mainz Cathedral

In the second half of the sixteenth century, the dukes of Württemberg created two different yet related funerary series in Tübingen and Stuttgart.[37] While most dynastic mausoleums honor the initial patron and, with the passing of time, other succeeding family members, the two Württemberg series reveal an unusual historic consciousness. These are family series being created retroactively. Already in 1537 the physical remains of ancestors who had been buried elsewhere started to be transferred to the Stiftskirche in Tübingen. Here new tombs were commissioned and intermixed with those of more recent family members. At the Stiftskirche in Stuttgart a single wall-cycle joins and commemorates the former counts of Württemberg,

site.[34] Older tombs were transferred into the Fürstenkapelle here upon its completion in 1446. The subsequent tombplates, cast in brass and bronze, conform to a standard design of the full-length figure of the deceased in his armor. Even Duke Georg the Bearded (d. 1539) continued this formula when he appended the Georgskapelle, his personal burial chapel, on to the southern side of the Fürstenkapelle.[35] With the death of the childless Georg in 1539 the cycle stopped. His cousins, Friedrich the Wise and Johann the Steadfast, had chosen Wittenberg for their tombs, while his brother Heinrich the Pious, a Lutheran, decided to be buried in Freiberg, his longtime residence, to signify his break with his Catholic predecessors.[36] Heinrich and his heirs approved of the idea of a family funerary cycle but not in Meissen, since Freiberg during the second half of the sixteenth century would become Germany's finest princely mausoleum. Interestingly, at both Wittenberg and Freiberg, the Meissen custom of using metal tombplates was continued, though grander epitaphs were also incorporated. About the time of the demise of the Meissen series, another at Tübingen was being created.

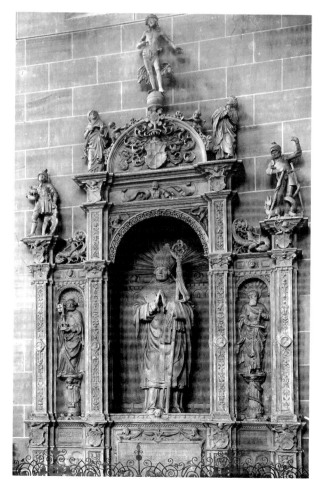

127. Hieronymus Bildhauer, *Tomb of Johann III von Metzenhausen*, 1542, Trier Cathedral

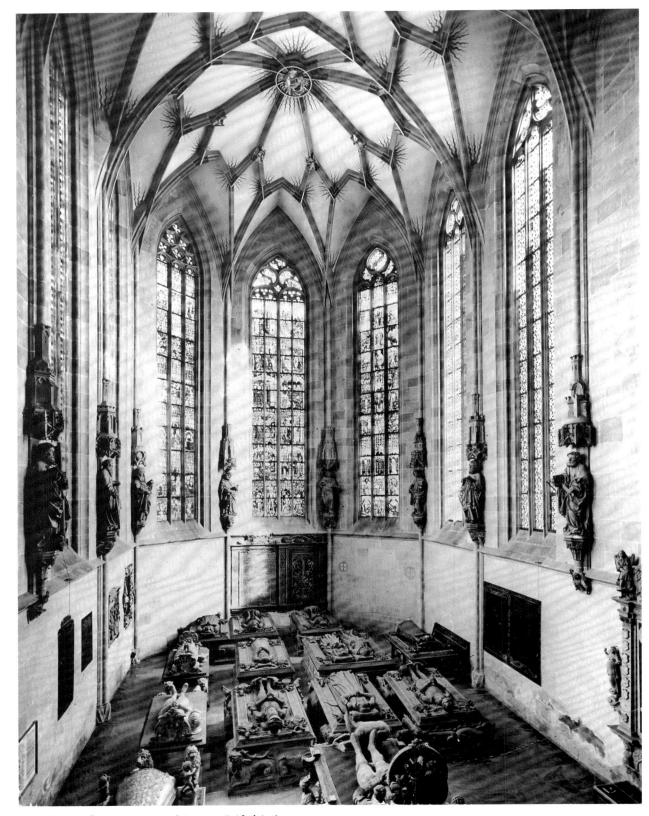

128. View of the Choir, Tübingen, Stiftskirche

from Ulrich the Founder (1234–65) to Heinrich von Mompelgard (d. 1519). The present rulers celebrate the memory of their predecessors while also benefiting from this display of their illustrious ancestry. In order to avoid confusion about titles, it is useful to recall that Württemberg was a county until 1495 when, under Eberhard the Bearded (r. 1459–96), it was elevated to a duchy.

The Tübingen Stiftskirche's transformation into the family burial site was prompted initially by an opportunity resulting from the advent of Protestantism into the duchy in 1534.[38] The choir, which is separated by an elaborate screen from the rest of the church, was suddenly unnecessary due to the liturgical changes. Almost immediately Duke Ulrich (1498–1550) claimed the choir for his family's use. It was his son, Christoph (1550–68), however, who gave the program its definition. (fig. 128) Between 1550 and 1555 Christoph erected the tombs for his father Ulrich, his sister Anna (d. 1530), and his great uncle Eberhard the Bearded. In addition, he transferred the remains and the tomb of Mechthild (d. 1482), Eberhard's mother, from the Carthusian house at Güterstein bei Urach in 1550.[39] Rather than replace Mechthild's particularly fine effigy, carved a century earlier by Ulm sculptor Hans Multscher, Christoph instructed his master, Jakob Woller, to incorporate it within a new double tomb that reunites her with her husband Count Ludwig (1419–50). For the figure of Ludwig, Woller next attempted to match Multscher's sculptural style and to provide him with historically appropriate armor. Each of the Tübingen tombs consists of a recumbent stone effigy, in the respective period dress, set upon a raised rectangular base; each figure faces eastwards. Within a decade Christoph had formed a dynastic funerary ensemble that extended back over a century. With the inclusion of the fourteenth and final tomb, made for Duke Ludwig (1569–93), the series stopped. The choir was virtually full and, more significantly, with the death of the childless Ludwig the ducal title passed to another branch of the family.

In contrast to the multiple tombs in Tübingen, the genealogical series of the counts of Württemberg in the Stiftskirche in Stuttgart was a single monument by one sculptor, Sem Schlör of Schwäbisch Hall.[40] (figs. 129, 131) The Stiftskirche, lo-

cated adjacent to the palace, was the burial site for over 100 family members. As early as 1558 discussions were held concerning the possible restoration of some of the deteriorating funerary monuments. In 1574 Duke Ludwig authorized the re-erection of the fallen stones. He also asked historian Andreas Rüttel the Elder to research their clothes and armor. Plans soon changed. Hans Steiner, the court painter from 1576 to 1610, made drawings for eleven similar monuments for the counts from Ulrich the Founder (1234–65), who first established Württemberg's power, to Heinrich von Mompelgard (d. 1519), Ludwig's great-grandfather who had died without a proper memorial.[41] The series was to be cast, presumably in bronze. Between May and November 1577 Augsburg sculptor Paulus Mair, author of the Mary Altar in St. Ulrich and Afra, worked on the model for Heinrich von Mompelgard.[42] (fig. 130) This trial piece, measuring 3.02 by 1.75 meters, was carved in five sections to faciliatate its casting. Mair selected lindenwood since it permitted the desired high level of detailing. Heinrich stands in a shallow niche with his feet resting upon the Württemberg heraldic lion. The highly ornamental frame is embellished with his arms, grotesques, and the virtues of Faith and Justice. For some reason, most likely the projected high cost of casting, Ludwig decided not to retain Mair even though he admired the model enough to preserve it and later display it in Schloss Urach. Instead the commission went to Sem Schlör, his court stone sculptor.

Between 1578 and 1584 Schlör worked on the monument of the eleven "alten Herren von Württemberg."[43] Rather than carve individual memorials for each ruler, as devised initially by Steiner, Schlör placed his eleven life-size statues within a common architectural frame. Each count stands in a shallow arch separated by flanking herms. In addition to being less expensive, this compositional arrangement marvelously accents the ruling family's lineal continuity. As at Tübingen, a screen originally separated the choir from the rest of the church. With the inclusion of Schlör's cycle, on the north wall, and other ancestral tombs, the choir was transformed into a family mausoleum. Schlör's *Heinrich von Mompelgard*, the westernmost statue, was his first and best. He based his figure on Mair's trial piece, while conforming to Steiner's overall

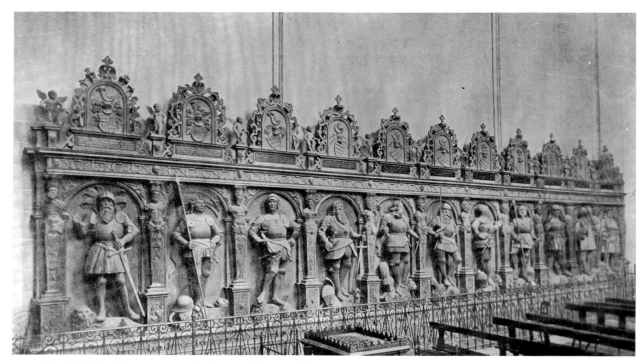

129. Sem Schlör, *Monument to the Counts of Württemberg*, 1578–84, Stuttgart, Stiftskirche

design. The preceding counts become increasingly less individualized though Schlör carefully and, almost comically, varies each pose to avoid repetition. None reveals Schlör's considerable talents as a portrait sculptor that were better used in the decorations of the Stuttgart Lusthaus a few years later.[44]

The only ancestral cycles comparable in complexity with that in Stuttgart are the earlier and never completed imperial shrine that Maximilian I planned for Speyer cathedral, as well as the Wettin monument in the Klosterkirche in Petersberg bei Halle.[45] (fig. 132) In 1565 fire badly damaged the Petersberg church and its collection of late twelfth- and early thirteenth-century tombs of the margraves and margravines of Wettin, the ancestors of the electors of Saxony.[46] Since repair of these monuments seemed impossible, August of Saxony ordered Dresden sculptors Hans and Christoph II Walther to create a new collective tomb. The artists based their ten life-size effigies on whatever remained of the five original bronze tombplates of each couple. Considerable care was taken to match the artistic style and dress with that of the medieval prototypes. Joining the figures is a single frame

whose form suggests a giant bed with an ornamental baseboard. On top of the tall headboard stands an angel holding the coats of arms of August and his wife, Anna of Denmark. The completion date of 1567 is inscribed just below.

August wished to honor his ancestors while calling attention to himself and Anna as the present guardians of their illustrious line. As Keisch has observed, August also desired to articulate a specific political point.[47] The single Wettin line was divided into two branches in the fifteenth century with the Ernestines controlling the electorate of Saxony and the Albertines the duchy. In 1548 Moritz, August's brother, became elector and duke once Elector Johann Friedrich was stripped of his title by Emperor Charles V. Johann Friedrich's repeated demands for reinstatement culminated in 1552 when, among other activities, he transferred the tombstones of eleven Thuringian landgraves to his residence at Gotha. He ordered their restoration to make the point that he, not Moritz, was the legitimate heir to the Saxon and Thuringian lands. With the deaths of Moritz in 1553 and Johann Friedrich in the following year, the issue of Au-

ties as a means of legitimizing and glorifying his own reign.

Complex Tomb Projects

It is fitting that August and Maximilian I initiated the two most significant funerary projects of the sixteenth century. Both understood art's power to shape historical memory. The grandeur of the Moritz shrine in Freiberg cathedral and Maximilian's tomb in the Hofskirche in Innsbruck influences our sense of the respective patrons' reigns. One easily forgets the upheavals of Saxon politics in the 1550s or the impecuniosity of the emperor.

There existed remarkably few precedents for such elaborate monuments in the German lands. Maximilian had completed his father's free-standing tomb, now in St. Stephan's in Vienna. More impressive was the Fugger family chapel in the St.-Anna-Kirche in Augsburg whose original opulence

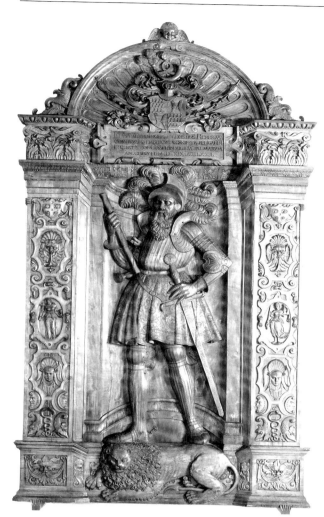

130. Paulus Mair, *Model for Heinrich von Mompelgard*, 1577, Schloss Urach, on loan to the Württembergisches Landesmuseum in Stuttgart

gust's right to succeed to the electoral title was again raised by Johann Friedrich the Middle. Although August received the title, he was not officially invested until 23 April 1566.[48] In the bold shield at the top of the Petersberg monument, which is contemporary with these events, August specifically displayed the double Wettin arms to signify that the family line was again reunited under his aegis. August's concern with such historical justifications reoccurs in other contemporary sculptural projects, most notably the evolving Wettin mausoleum that he was constructing in Freiberg. Like Maximilian I, August appropriated ancestral

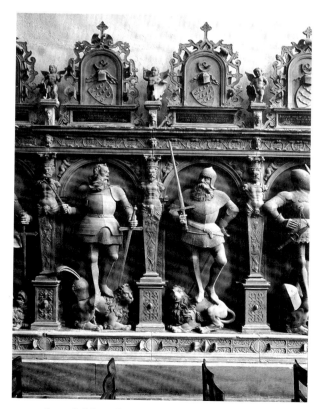

131. Sem Schlör, *Monument to the Counts of Württemberg*, detail, 1578–84, Stuttgart, Stiftskirche

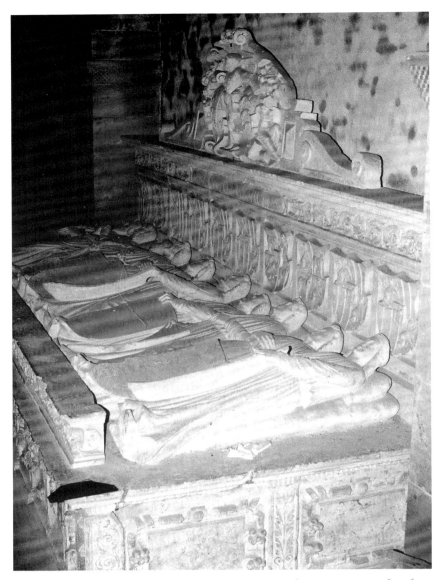

132. Hans and Christoph II Walther, *Wettin Family Monument*, 1565–67, Petersberg bei Halle, Klosterkirche

shaped posterity's image of its patron, Jakob Fugger, the international banker.[49] (figs. 133 and 134) This is the first truly Renaissance-style funerary chapel in Germany. In 1509 Jakob and his brother, Ulrich, signed an agreement with the prior of this Carmelite monastery that permitted them to erect a family chapel by extending the nave of the church westwards by two bays. Initial plans for a chapel may have begun three or four years earlier. By 1513 much of the construction was finished. The consecration occurred there on 17 January 1518, just a few months before the opening of Maximilian's fi-

nal imperial diet. The Lombardian character of the chapel and certain features of the memorials reflects Jakob's Venetian business association and his taste for contemporary Italian art.

The chapel consists of several parts including an altar and choir stalls. For our purposes, I am concerned only with the four marble reliefs, each measuring about 3.5 by 1.7 meters, that ornament the western wall. The identity of the artist or, more likely, artists who carved these reliefs is undocumented and has been the subject of much conjecture. Sebastian Loscher and Hans Daucher are the

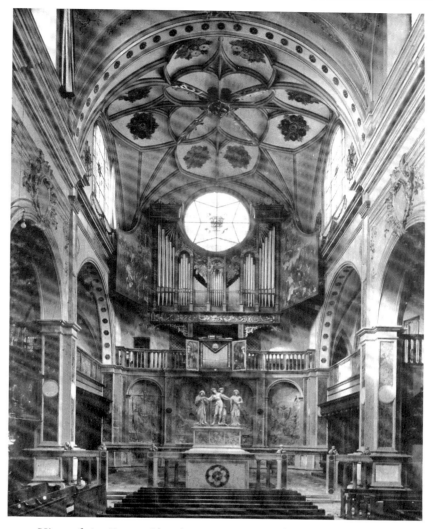

133. View of the *Fugger Chapel*, 1509–18, Augsburg, St.-Anna-Kirche

primary candidates, though during the 1510s the styles of various local sculptors are difficult to disentangle. The central pair of reliefs represent the Resurrection with the shrouded corpse of Ulrich Fugger (d. 1510) below and, to the right, Samson and the Philistines with the effigy of Georg Fugger (d. 1506), the third brother. Both images were designed by Dürer.[50] The author of the outer two armorial reliefs honoring Jakob is unknown though the emphasis upon Italian architectural features, such as the rounded vault linked together with tie-rods or the imitation of the oculus and coffered ceiling of the Pantheon, points to Hans Burgkmair of Augsburg, whose journey to Italy influenced the

architectural features of many of his paintings and prints. In the left one, two warriors, clad in antique armor, guard two bound captives. They also hold a laurel-wreath medallion ornamented with the Fugger symbol—the lily. Grieving putti flank the inscription tablet below. The format of the right-hand relief is roughly the same.

Together the four reliefs offer an impressive tribute to the memory of the three brothers. The unity of design, the large scale of the reliefs, and care given to the detailed carving are unprecedented. These monuments were also admired. Hans Daucher made a small stone relief after the left-hand memorial to Jakob Fugger that in the form of

a plaster copy, owned by Basel goldsmith Jörg Schweiger (d. 1533), entered the Amerbach collection in Basel sometime prior to 1578 and is today in the Historisches Museum.[51] (fig. 135) Other such copies existed. The inventory of Raymund Fugger (1489–1535), Georg's son, lists stone copies of the "Fuggerische Epitaphii," which presumably refer to the St.-Anne-Kirche ensemble.[52] Nobles, clerics, and burghers attending the imperial diet in Augsburg during the summer of 1518 flocked to see the chapel of the empire's wealthiest citizen, Jakob the Rich. Documented among the visitors is Georg, duke of Saxony, who, inspired by its grandeur, subsequently commissioned several important projects by Augsburg's sculptors.[53] Best known of these is the Dauchers' great High Altar for Annaberg. (fig. 34) The Fugger chapel influenced his decision to build his own burial chapel, which was erected between 1521 and 1524, immediately adjacent to the Fürstenkapelle in Meissen cathedral. Although the subsequent bronze tombplate conforms to the traditional Wettin formula, as discussed above, Georg did hire Hans Daucher, one of the Fuggers' sculptors, to make the Lamentation relief over the entry way.[54] (fig. 136) When August, elector of Saxony, resided in Augsburg during the 1555 imperial diet devoted to a confessional accord, he would have had ample opportunity to admire the Fugger chapel since the St.-Anna-Kirche was the focal point of the city's Lutheran community. On Christmas 1525, the first evangelical double communion was performed here, and later a Lutheran school would be established. Nevertheless, it was the idea of a family monument rather than any specific artistic feature that would impress the ambitious young Saxon prince.

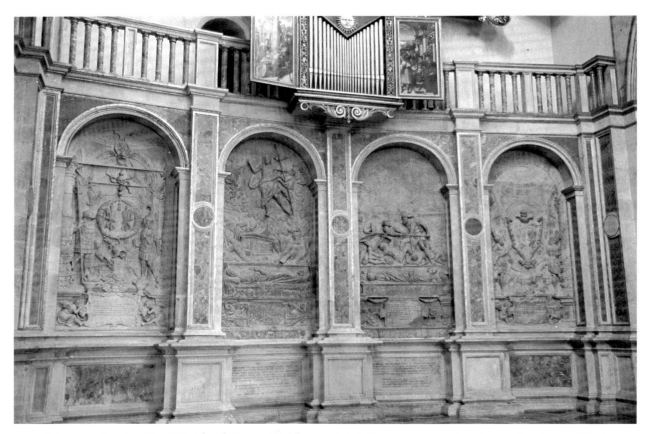

134. Sebastian Loscher(?), *Epitaphs of Georg, Ulrich, and Jakob Fugger*, 1510s, Augsburg, St.-Anna- Kirche, Fugger Chapel

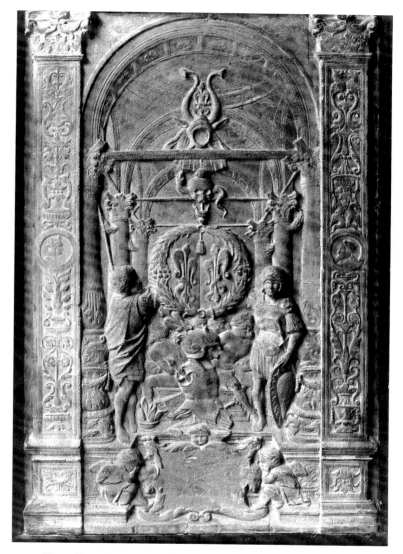

135. Hans Daucher (copy after), *Epitaph of Jakob Fugger*, c. 1520, Basel, Historisches Museum

THE SHRINE OF ELECTOR MORITZ OF SAXONY IN FREIBERG

In the aftermath of his active participation in the famous 1555 diet at Augsburg, August, perhaps inspired by the Fugger chapel, resolved to erect a grand tomb for his brother Moritz. During the next three decades, the Saxon elector would transform the Marienkirche of Freiberg into one of Europe's greatest family mausoleums.[55] (figs. 137 and 140–142) North of the Alps only the French royal tombs

in St. Denis and the slightly later *Tomb of Maximilian I* in Innsbruck are comparable in scale and iconographic complexity. From the outset of his long reign, August utilized sculpture frequently to express his religious and political ideologies. The *Moritz Shrine*, as it is known, combines both. Upon his sudden death at the battle of Sievershausen in 1553, Moritz was buried in Freiberg.[56] Meissen had been the traditional location for the ducal tombs; however, their father, Heinrich the Pious

175

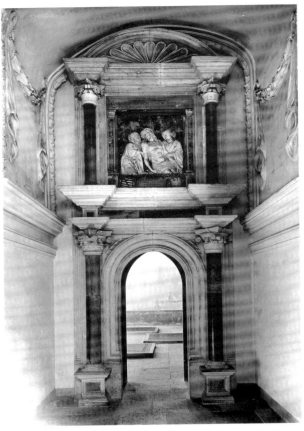

136. Hans Daucher and Workshop, *Lamentation*, c. 1523, Meissen Cathedral, Georgskapelle

(d. 1541), had selected instead Freiberg in order to signal a clear break with his Catholic predecessors. Heinrich's own tomb was a simple slab set immediately behind the new Protestant altar at the entry to the choir. Moritz originally received a comparable marker; however, two years later August instructed his court painters, Gabriel and Benedikt de Thola, and his building superintendent, Hans Dehn, to develop a master plan for a much grander ensemble. Their resulting design called for a large free-standing monument. August obtained the city's permission to use the choir, which had not been employed since the adoption of Lutheranism. His artists removed the choir stalls and the interior wall of the sacristy to make sufficient space. All of the non-Albertine tombs located in the choir were transferred to the nave and aisles. Next Georg Fleischer, the court shriner, presented August with a wooden scale-model in August 1558. After as-

sessing several different cost estimates, which varied depending on the materials used, August commissioned Moritz's tomb in 1559.

Free-standing tombs in Germany are much less common than either wall tombs, floor tombs, or epitaphs. These tend to be used by the upper nobility. In fact, Frederik II, King of Denmark, decreed in 1576 that this type of tomb was reserved only for royalty and princely men.[57] This law, ordered by August's brother-in-law, who frequently employed Germany's best sculptors, likely reflects the common custom to the south. Even wealthy merchants, such as the Fuggers, chose wall memorials. Most free-standing tombs are like those at Tübingen with a simple rectangular base supporting the effigy. (fig. 128) More elaborate is the *Tomb of Hoyer VI, count of Mansfeld*, in the Andreaskirche in Eisleben.[58] (fig. 138) Completed in 1541 by Halle sculptor Hans Schlegel, the rather conventional bier and effigy are flanked by four ornamented columns topped with candle-holding angels. Figural scenes, including the Adoration of the Magi, St. Anne with the Infant Mary, the Crucifixion, and Virtues, plus two male statuettes, enrich the base of each column. The immediate impetus for having a free-standing monument at Freiberg may have been the *Tomb of King Frederik I of Denmark* (d. 1533) that Cornelis Floris erected in Schleswig cathedral between 1551 and 1555.[59] (fig. 139) Many of the features of this work, which was commissioned by Christian III, August's father-in-law, would reappear at Freiberg. Yet none of these works fully anticipate the sheer scale, at six meters long by five meters wide, and complexity of the *Moritz Shrine*. Only Michelangelo's early plans for the *Tomb of Pope Julius II* at the crossing of St. Peter's in Rome would have been larger.[60]

The Freiberg tomb involved an international group of artists. The brothers Benedikt and Gabriel de Thola of Brescia designed it. Antonius van Zerroen, who worked in both Antwerp and Lübeck, was the principal sculptor. He also contributed various architectural and decorative motifs that signal his familiarity with Floris' royal tomb in Schleswig. Most of the tomb was made outside of Saxony. The marble and alabaster came from Dinant and had to be transported via Antwerp, Hamburg, and up the Elbe River to Meissen. Hans Krell, another court painter, sent a portrait of Moritz dressed in armor

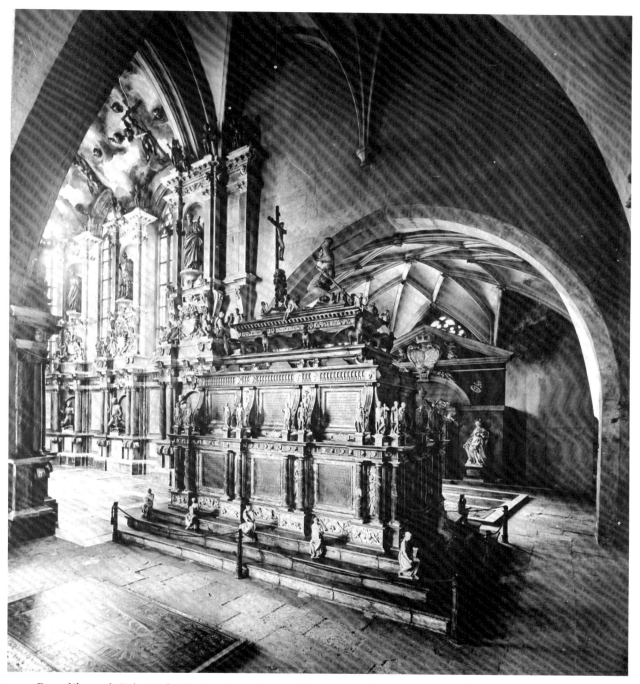

137. Benedikt and Gabriel de Thola, Antonius van Zerroen, and others, *Shrine of Moritz of Saxony*, 1559–63, Freiberg, Marienkirche (Cathedral)

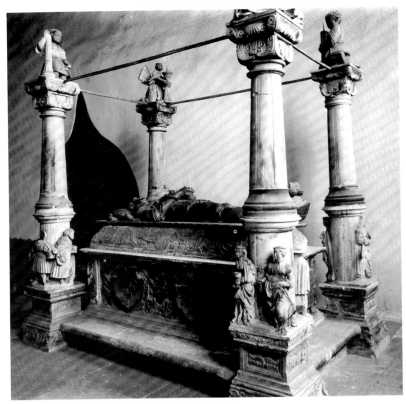

138. Hans Schlegel, *Tomb of Hoyer VI*, 1541, Eisleben, Andreaskirche

to van Zerroen in Antwerp. The brass griffins and cross were cast in Lübeck. Various German and Netherlandish stone masons plus other craftsmen collaborated in the placement and the completion of the shrine.

The alabaster figure of Moritz crowning the monument offers a fascinating and highly personalized variation on traditional funerary types. He is depicted kneeling and looking heavenwards. In the 1590s, with the completion of the second half of the decorative program, Moritz' gaze came to focus on the painted and stuccoed figure of Christ Judging Mankind. Moritz, however, is not represented at a prayer bench or even within a church. Instead the terrain beneath him is rocky. Grasping his electoral sword, he kneels on the battlefield at Sievershausen to thank God for his victory. His helmet, mace, and pistol lay on the ground before him. Further heightening this sense of place and moment is the armor, a precise replica of the set that Moritz

had worn at Sievershausen. Since 1553 his actual suit of battle armor has been displayed prominently on the north wall of the choir just adjacent to the tomb. The de Thola brothers were evidently familiar with other Albertine and Ernestine funerary monuments. The Meissen and Wittenberg memorials show the Saxon princes clad in armor and grasping the electoral sword. (fig. 96) The alabaster statues of Friedrich the Wise and Johann the Steadfast kneeling in prayer with helmets on the floor at their side anticipate the statue of Moritz. (fig. 98)

While this portrait of Moritz may have adopted some of its features from these Saxon prototypes, the expression is totally different. Moritz is presented in rapture, as evidenced in his face and in his splayed left hand. He gazes heavenwards as if in a dialogue with God. The inclusion of the brass cross and stone corpus figure of Christ were afterthoughts added at August's personal request in January 1563, only months before the shrine's comple-

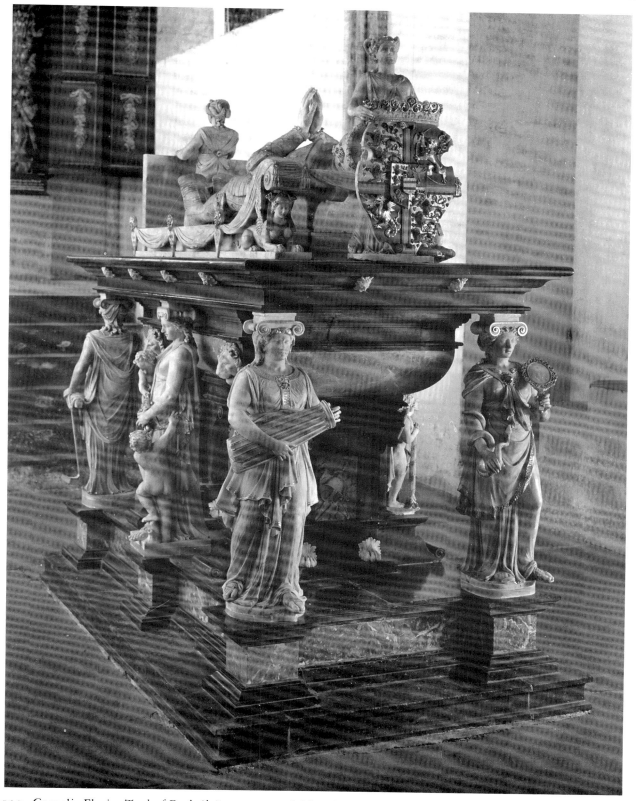

139. Cornelis Floris, *Tomb of Frederik I*, 1551–55, Schleswig Cathedral

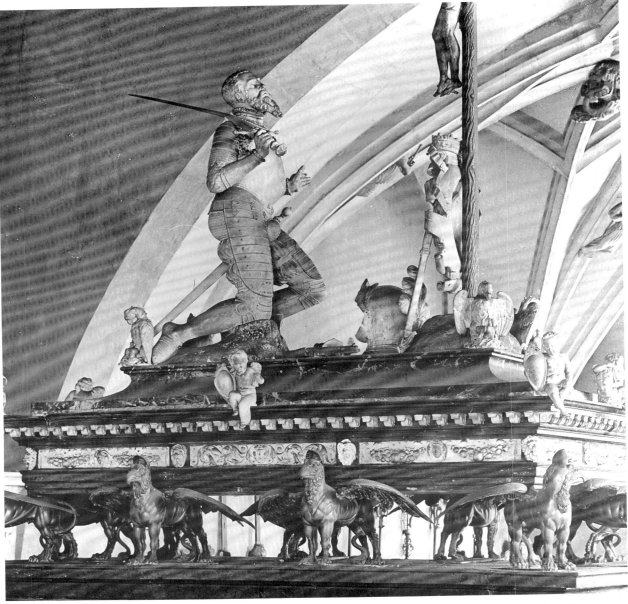

140. Antonius van Zerroen and others, *Shrine of Moritz of Saxony*, detail—*Elector Moritz*, 1559–63, Freiberg, Marienkirche (Cathedral)

tion. With or without the cross, Moritz' features effectively heighten our sense of his religiosity and the rightness of his Christian—that is, Lutheran—beliefs. Moritz is presented to posterity as the true Christian prince. The viewer either knew or could read in the inscriptions below that Moritz died as a result of wounds suffered at the battle of Sievershausen. Moritz, reviled by his enemies as the "Judas of Saxony," is honored here instead as the Alber-

tine martyr who gave his life to protect his lands and his Lutheran faith. The inclusion of the electoral sword reminds one that Moritz brought the electoral title to the Albertine Wettins.

The remaining features of the upper portion of the shrine reinforce this positive image of Moritz. Four statues of pelicans feeding the flesh of their breasts to their young surround him. This is a traditional symbol of Christ's physical sacrifice for

141. Antonius van Zerroen and others, *Shrine of Moritz of Saxony*, detail—*Muse*, 1559–63, Freiberg, Marienkirche (Cathedral)

The two-story base is richly ornamented with additional figures. Alabaster warriors clad in antique armor hold maces and Moritz' various territorial coats of arms. The pilaster reliefs contain allegorical representations of Moritz' interest in warfare, hunting, science, the arts, and, interestingly, garden design, among other subjects. This program stressing Moritz' enlightenment extends to the statuettes of the Nine Muses and the Three Graces seated upon the steps. The motif of the distraught arts robbed of their patron has few German models but can be found more commonly in Italy.[63] Completing the program are twenty Latin inscription tablets describing Moritz' family history, including Heinrich' ascent to the throne and his own succession, his Protestant faith, his humanistic outlook, and his personal triumphs. That Philipp Melanchthon was originally asked to compose these texts testifies to their significance. Melanchthon' son-in-law, Dr. Caspar Peucer, assumed the task, but when his offerings were considered inadequate a team of court scholars and theologians finished the project.[64]

The *Shrine of Moritz, elector of Saxony* is both aesthetically appealing and physically imposing. August commissioned the tomb to be more than a sepulchre honoring his brother. If that was his only intent then a traditional wall tomb or simple freestanding monument would have sufficed. Instead the tomb, as completed in 1563, has no artistic precedents in northern Europe. His international team of artists grafted Saxon funerary traditions and Netherlandish decorative forms to an Italy mausoleum design. In the early years of his reign August worked diligently to rehabilitate his brother's reputation. Moritz is presented here as the devout elector. Moritz' personal flaws are forever masked by the flattering artistic and textual references to his virtuousness.

August's intentions, however, were broader. He conceived of the Freiberg tomb as a symbol of Albertine grandeur and dynastic ambition. Between 1539 and 1555, the family had risen from being the dukes of Saxon-Freiberg to the dukes and then electors-dukes of Saxony. In the aftermath of the Augsburg diet of 1555, August emerged as the pre-eminent Lutheran prince. August's vision transformed Freiberg into a sumptuous mausoleum for the Protestant Albertine Wettins. In addition to

mankind.[61] Can the analogy be extended to allude to Moritz' own death and sacrifice? Eight angels holding hourglasses and other references to mortality are set at the corners and cardinal positions of the bier, which, in turn, is supported by ten brass griffins. Griffins in contemporary Italian tombs signified truth and perseverence, perhaps a reference here to the rightness of Moritz' cause.[62]

142. Giovanni Maria Nosseni, Carlo de Cesare, and others, View into the Choir, 1589–94, Freiberg, Marien-kirche (Cathedral)

143. Hans Walther, *Saxon Electoral Succession Monument*, c. 1553, Dresden, Brühl Terrace

Moritz' shrine, the tomb plates of other family members were set in the floor of the choir and the transept. Eventually Freiberg would be the burial site for the family from Heinrich the Pious (d. 1541) until Elector Johann Georg IV (d. 1694). Before his death in 1586, August initiated plans for the conversion of the rest of the choir. (fig. 142) Between 1589 and 1594, Giovanni Maria Nosseni, the Dresden court artist, Carlo de Cesare, the Florentine bronze sculptor, and a team of over 50 German and Italian sculptors, stone masons, stucco workers, and painters radically transformed the interior of the choir.[65] Six life-size bronzes statues of August, his wife Anna (d. 1585), his parents, his son Christian I (d. 1591) and, later, his grandson Johann Georg I (d. 1656) stand in niches and face the resurrected Christ at the east end. Copious inscriptions identify each person and testify to their staunch Lutheran faith. The visual climax is the ceiling that disappears beneath the painted and stuccoed heaven with Christ seated in judgment. Although this program was completed after August's death, it brilliantly culminates the elector's initial desire to erect an unrivalled family shrine. By comparison, Alexander Colin's joint *Tomb of Emperors Ferdinand I and Maximilian II* in St. Vitus in Prague, an attractive but simple free-standing memorial with recumbent effigies, seems very old-

144. Zacharias Wehme, *Saxon Electoral Succession Monument*, 1591, watercolor, formerly in Dresden, Sächsische Landesbibliothek

fashion.[66] Here as in other projects, August reveals himself to be a more innovative patron than either of the two emperors.

August also conceived of Moritz' tomb as a pictorial means for justifying his own legitimacy as the new elector. As noted earlier, August's succession was bitterly contested by his Ernestine relatives up to and even immediately after his formal investiture in 1566. During the interim 13 years August was wary of these repeated challenges to his authority. The pious portrait of Moritz on the tomb, coupled with the extensive inscribed texts chronicling his legal rise to power, documented the foundation for August's own claim to rightful succession. Moritz' tomb must be viewed as an artistic form of historical validation. Its ideas complement the earlier electoral succession memorial that August ordered built in Dresden.[67] (fig. 143) By October 1553, a scant three months after Moritz' death, Caspar Vogt von Wierandt, the architect of the Dresden fortifications, presented August with a drawing for a new monument honoring Moritz. Working from a design likely devised by the de Thola brothers, Hans Walther and his assistants

rapidly carved the sculptures. Since only the core of the monument survives, a better sense of its original appearance is provided by Zacharias Wehme's watercolor view of 1591.[68] (fig. 144) The over life-size sandstone statues of Moritz and August stand within a baldachin. Above, the Holy Trinity blesses Moritz' transfer of authority as he hands the electoral sword to his brother. Behind Moritz stand Death, with an hourglass, and, around the edge, his widow Agnes. Anna of Denmark appears behind August. The flanking reliefs offer images of good government as Victory crowns Magnanimity and Peace crowns Wisdom. Standing above on the balustrade angels and five ancient warriors hold armorial shields. This is a political epitaph. By word and image, the viewer is reminded that it was Emperor Charles V who invested Moritz with his office, and then, by the grace of god and virtuous rule, the title passed to August. The memorial's setting has always been very public. It originally stood on the Hasenberg bastion, part of the city's new fortifications, and since 1895 it has been located on the Brühl terrace by the Elbe River. First with the Dresden monument and then with the

Freiberg tomb, August adroitly mixed sculpture and politics. These sculptural ensembles strikingly validate August's legitimacy and the rising glory of the Albertine dynasty.

THE CENOTAPH OF EMPEROR MAXIMILIAN I IN INNSBRUCK

In terms of scale and pretense, the *Tomb of Emperor Maximilian I* in the Hofkirche in Innsbruck is the sole peer of the Freiberg monument.[69] (figs. 145–148, 151–152) Of all of the emperor's innumerable artistic projects, this was the grandest. When conceived in 1502, the tomb was intended to be Europe's largest, a fitting tribute to Maximilian who considered himself the ideal ruler and heir to the splendor of both Rome and the Holy Roman Empire. Unfortunately, like some of his other artistic projects, the tomb was far from complete when Maximilian died in 1519; work continued slowly until 1584. Its location and final configuration were determined by Maximilian's grandson, King and later Emperor Ferdinand I, and his great-grandson, Archduke Ferdinand II of Tirol. As observed in Chapter Four, Ferdinand I selected Innsbruck where he built the Hofkirche between 1553 and 1563 to house the tomb. Maximilian's memorial, like Moritz's in Freiberg, simultaneously serves a dual purpose: it honors the deceased and celebrates the glory of the family dynasty.

The tomb consists of five basic parts. First and most striking are the 28 over life-size bronze statues of Maximilian's real and fancied ancestors that stand facing the cenotaph.[70] Originally there were to be 40 statues but in 1518 the number was reduced to 28 since only ten had been completed. Artists from Augsburg, Munich, Nuremberg, and other towns moved to Innsbruck where a foundry was established and the majority of the work was carried out. Painters Gilg Sesselschreiber and Jörg Kölderer designed most figures, though Albrecht Dürer probably contributed those of King Arthur of England and Theodoric, king of the Ostrogoths (d. 526). (fig. 147) Leonhart Magt created the majority of the casting models; others are attributed to

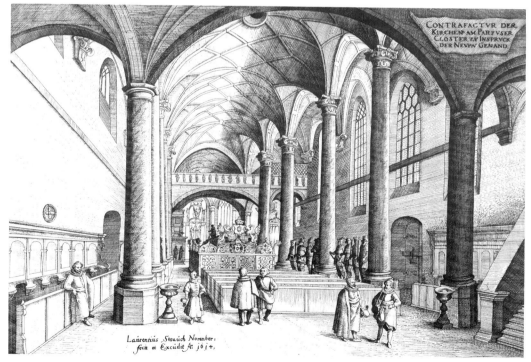

145. Lorenz Strauch, *Interior of the Innsbruck Hofkirche*, 1614, engraving, Innsbruck, Tiroler Landesmuseum Ferdinandeum

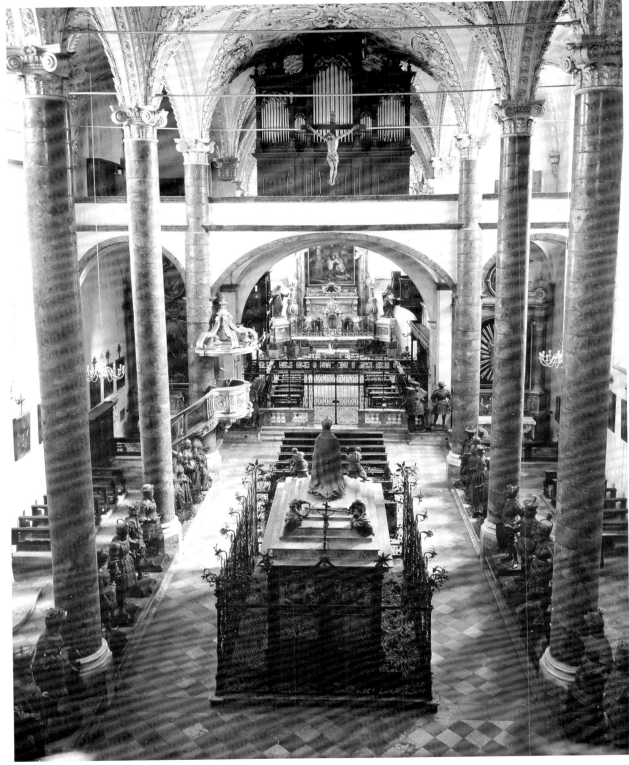

146. Interior View with the *Tomb of Maximilian I*, 1502–84, Innsbruck, Hofkirche

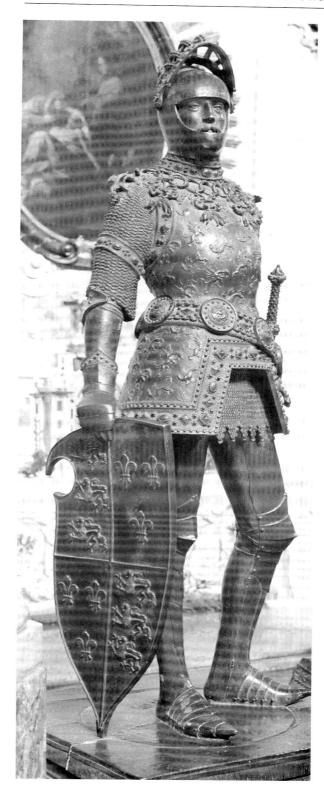

147. Albrecht Dürer (cast by the Vischer Workshop), *Tomb of Maximilian I*, detail–*King Arthur*, 1510s, Innsbruck, Hofkirche

Veit Stoss and Hans Leinberger. Maximilian initially charged Sesselschreiber with the casting of these large figures; however, his slowness and technical inexperience prompted the task to be given after 1518 to Stefan Godl, who was already at work on other portions of the tomb. The series took 41 years to complete from the initial figure of Ferdinand of Portugal (d. 1363), cast in 1509, to that of Clovis (Chlodwig, d. 511), the first Christian king of France, which Gregor Löffler finished in 1550. Among the finest of the group is King Arthur. He has an elegantly regal and relaxed bearing. In contrast with the unnatural massiveness of most of the other statues, Arthur's proportions are thin and slightly elongated. Arthur and Theodoric are distinguished from the other figures by the superior quality of their casting, which was carried out by the Vischer foundry in Nuremberg rather than in the imperial shop in Innsbruck.

This series of ancestors, past, present, and desired, represents the culmination of the Burgundian tomb tradition. During his years in the Low Countries, Maximilian carefully studied Burgundian court culture and its art. In at least three tombs commissioned by Duke Philip the Good (1419–67), statuettes of members of the Burgundian dynasty were used in place of the traditional pleurants or mourner figures.[71] (fig. 148) Mary of Burgundy, Maximilian's first wife, commissioned a similar tomb for her mother, Isabella of Bourbon.[72] This monument, completed in 1476 and originally in St. Michael's in Antwerp, had 24 bronze statuettes of relatives set along the base. Maximilian used this as his basic prototype; however, in place of statuettes that average just over one half meter in height, the Innsbruck figures are well over life-size and are free-standing. Arthur measures 2.12 meters high and Philip the Fair (d. 1506), Maximilian's son, is over 2.72 meters tall. For the viewer then and today, the physical presence of these massive and often elegant bronze statues inspires awe. These silent sentinels also eerily seem alive on certain occasions. All but four, with Dürer's Arthur being one of the exceptions, are designed with an open hand that can be fitted to hold a candle. Torch and candle bearers were a central feature of any princely funeral. Yet in Maximilian's case, these 28 noble worthies pay perpetual hommage to the emperor during specific ceremonies, such as the anniversary of his death. Although a few memorials,

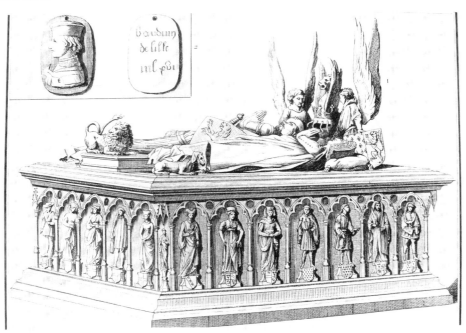

148. Jacques de Gérines, *Tomb of Louis of Mâle*, mid-1450s, engraving in A.-L. Millin, *Antiquités Nationales ou Recueil de Monumens* (V, [Paris, 1790], pl. 4), formerly Lille, St. Pierre, Brussels, Bibliothèque Royale Albert Ier, Cabinet des Estampes)

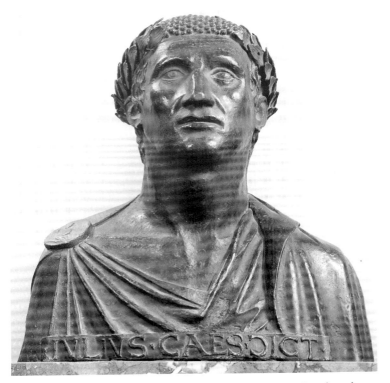

149. Jörg Muscat, *Bust of Julius Caesar*, 1509–17, Innsbruck, Schloss Ambras, formerly in the Hofkirche

such as the baldachin of Albrecht von Brandenburg or the *Shrine of St. Sebaldus*, included candle holders, none matches the inventive audacity of this tomb. (figs. 10 and 95)

The second part of the ensemble is the series of 23 bronze statuettes of Habsburg saints.[73] As in the case of the ancestral statues, the original program was scaled back. Jörg Kölderer and his workshop devised designs for 100 holy figures. Magt prepared the models that Godl cast between 1514 and 1528. Nineteen were completed prior to Maximilian's death; 40 were ultimately finished, though 17 have not survived. The idea of including family saints stems from the tomb of his father, Emperor Friedrich III, originally in Wiener Neustadt and today in St. Stephan's cathedral in Vienna.[74] It was Maximilian who between 1493 and 1513 paid sculptor Michael Tichter for its completion. Just where Maximilian intended these saintly statues to be placed in relation to his own tomb is problematic since no master plan detailing the initial form of the monument exists today. One can only speculate that these were to decorate the base or, perhaps, as in Vienna, the stone balustrade around the monument. In Lorenz Strauch's 1614 interior view of the Hofkirche, the saints stand in a single row on the gallery at the crossing and face the tomb. (fig. 145)

Equally problematic is the intended location of the series of busts of Roman emperors, the third part of the tomb.[75] (fig. 149) In 1534 there were 34 busts documented in Innsbruck; today 20 are located in the *Kunstkammer* at Schloss Ambras above Innsbruck and another is in the Bayerisches Nationalmuseum in Munich. Acutely conscious of his role as successor to the Roman emperors, Maximilian may have been prompted to include them in the overall scheme because of his admiration of the classical coin collection of Dr. Konrad Peutinger of Augsburg. These provided the necessary pictorial models. The first group of at least 12 brass busts, including that of Julius Caesar, the finest were produced under the direction of Jörg Muscat in Augsburg between 1509 and 1517. The rest, which were cast in bronze, postdate 1517. The busts measure between 43 and 51 centimeters in height. Each figure terminates just behind the ears, which indicates that the busts were to be viewed frontally. Their original placement must have been either within a small niche or arranged in a row.

The statues of the ancestors, the family saints, and the Roman emperors were all initiated by Maximilian himself. These figures transform the tomb into a dynastic and imperial pantheon. Maximilian, of course, is at the apex, the heir to Habsburg, Burgundian, and Roman grandeur. This concept conforms closely with the modes of self-glorification that characteristize Maximilian's Triumphal Procession, the Triumphal Arch, and his complicated graphic projects.[76]

Maximilian's master plan for the tomb is unknown. It is entirely possible that a definitive solution was never decided upon, since in 1527, at Ferdinand I's command, Jörg Kölderer travelled to Vienna and Wiener Neustadt to examine possible models; however, no substantive action resulted from this trip.[77] In 1556, coincidental with the erection of the Hofkirche, Hermes Schallautzer, court architect in Vienna, devised a plan calling for the large statues to be placed between the columns of the nave, the saints were to be located higher up on these columns, and the Roman busts were to be set on the two galleries. The cenotaph or tomb proper was to be made of stone, include a kneeling statue of Maximilian, and, along the sides of the base, 24 reliefs illustrating the highlights of the emperor's life. In this year Francesco Terzio, a court painter, made a drawing of the base with the kneeling Maximilian set between two angels.[78] Other than the positioning of the three statues, this design strongly recalled Friedrich III's tomb in Vienna that also has scenes from the emperor's life arranged around the base. Materials for the various parts were selected and ordered. In 1561 Florian Abel, Ferdinand I's painter in Prague, prepared a full-scale (4.74 x 2.095 m) drawing for one side.[79] (fig. 150) The plan calls for eight scenes per long side, a running frieze of trophies, and flanking statues of Virtues. The scenes were based on older prints of Maximilian's life, notably those from the Triumphal Arch. Abel's brothers, Bernhard and Arnold of Cologne, were engaged to carve the reliefs but completed only three prior to their deaths in 1563 and 1564. The sculptor Alexander Colin of Mechelen, who had worked earlier with the Abels at Heidelberg, finished the remaining 21 marble reliefs between 1562 and 1566.[80] Scholars differ in their opinions about which three reliefs are by the Abels, which are by Colin, and which are by journeymen in Colin's workshop. Among the most at-

150. Florian Abel, *Design for the Base of the Tomb of Maximilian I*, 1561, drawing, Vienna, Kunsthistorische Museum (Schloss Ambras)

151. Alexander Colin or Bernhard and Arnold Abel, *Tomb of Maximilian I*, detail—*Maximilian's Marriage to Mary of Burgundy*, 1562–66, Innsbruck, Hofkirche

tractive scenes and the first in the chronological sequence is Maximilian's Marriage to Mary of Burgundy which occurred in the chapel of the Prinsenhof in Ghent on 19 August 1477.[81] (fig. 151) The central group recalls the much simpler illustration of the Weisskunig's marriage.[82] To this Florin Abel added the elaborate architectural setting and the throng of onlookers. Either the Abel brothers or Colin have ably rendered the perspective of the building and the myriad of fine details, though the central figure group is rather overwhelmed by the setting.[83]

Colin was the primary sculptor of the cenotaph. In addition to the reliefs, he carved the models for the bronze frieze (1565), the four Cardinal Virtues (1568–70), and the kneeling figure of Emperor Maximilian (1582–84).[84] Florian Abel's plan for caryatid virtues was abandoned, but not before Innsbruck sculptor Noe Lechner made one of the casting models. Colin himself designed and modeled Fortitude, Temperance, Justice, and Prudence, which are now fully rounded figures seated at the corners of the tomb; these were cast by Hans Len-

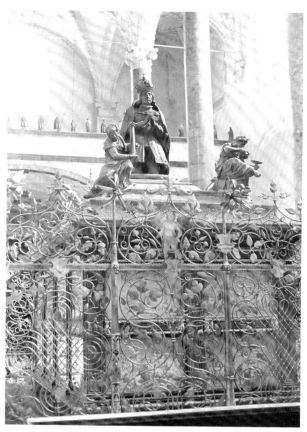

153. Alexander Colin (cast by Ludovico del Duca), *Tomb of Maximilian I*, detail—*Emperor Maximilian I*, 1584, Innsbruck, Hofkirche

152. Alexander Colin (cast by Hans Lendenstreich), *Tomb of Maximilian I*, detail—*Justice*, 1568–70, Innsbruck, Hofkirche

denstreich. (fig. 152) Justice's complex pose and her carefully modelled drapery demonstrate Colin's inventiveness more clearly than do the reliefs. Following the completion of the virtues, Colin devoted most of his attention to other projects, most notably his *Tomb for Ferdinand I, Queen Anna, and Maximilian II* in St. Vitus in Prague. Only in 1582 did he begin work on the final element of the Innsbruck tomb: the statue of Maximilian I. (fig. 153) The emperor kneels in prayer on two cushions as he faces the choir. With drawings by Francesco Terzio and perhaps Florian Abel as designs, Colin created a simple, dignified portrait that Sicilian Ludovico del Duca cast in 1584. Although Italian and French sources may have influenced the definitive form of the tomb, the free-standing Moritz shrine in Freiberg with its massive marble base, relieved by inscription tablets, statues of virtues,

and the kneeling elector offers the most likely prototype.[85]

The *Tomb of Emperor Maximilian* took over eight decades, three patrons (Maximilian I, Ferdinand I, and, from 1564, Archduke Ferdinand II of Tirol), and a constantly shifting team of artists to complete. Due to the sheer scale and cost, the project remains unique.[86] As a collective idea it had no true successors. Perhaps no later noble dared to undertake such a formidible task or, just as plausibly, none could match the scope of Maximilian's romantic dreams of grandeur. It represents a terminus, a monument glorifying the emperor and the Habsburg dynasty, rather than an artistic prototype for future generations. The Innsbruck tomb, which is after all the sculptural equivalent to his great Triumphal Arch, assured Maximilian that his fame would resound long after the waning peals of his funeral bells.

THE PRUSSIAN MEMORIALS
IN KÖNIGSBERG

When examining German funerary monuments after 1550, the influence of Cornelis Floris is encountered repeatedly as observed in Chapter Five. Both the Freiberg and Innsbruck mausoleums were touched by his ideas. Antonius von Zerroen, residing in Antwerp in 1559, adopted numerous decorative features. Similarly, the flanking caryatids seen on Florian Abel's full-scale drawing for Maximilian I's cenotaph provide a direct application of Floris' signature decorative form. (fig. 150) Between about 1548 and his death in 1575, Cornelis Floris worked on several funerary monuments for German and Danish nobles. In addition to the two Cologne epitaphs, the best known are the Danish royal tombs of *King Frederik I* of 1549–53 in Schleswig cathedral and of *King Christian III* of 1569–79 in Roskilde cathedral. (figs. 111 and 139)

The greatest concentration of Floris' funerary works, however, appears in the choir of Königsberg (Kaliningrad) cathedral. In 1525 Königsberg became the capital of the new duchy of Prussia that had been created following the secularization of lands of the Teutonic Knights.[87] Albrecht von Brandenburg-Ansbach (1490–1568), the order's former high master, became Prussia's first duke. Having travelled widely, especially through his na-

tive Franconia and the Rhineland, Albrecht resolved to make his rather spartan capital a center for arts and letters. Scholars and artists were drawn to his court especially following the establishment of the university here in 1544. Converted to Lutheranism by Nuremberg preacher Andreas Osiander in 1522, Albrecht brought Protestantism to Prussia. The choir of the cathedral, now unused, was gradually transformed into the ducal family's burial site by the introduction of Floris epitaphs of Albrecht's wives *Dorothea of Denmark* (d. 1547) and *Anna Maria* (d. 1568) as well as Albrecht's own massive wall tomb dated 1570. (figs. 154–156) The equally large wall *Tomb for Margrave Georg Friedrich and Elizabeth* was erected between 1578 and 1581 by another Netherlander, Willem van den Blocke, who worked primarily in Danzig (Gdansk) and Königsberg. (fig. 157)

Shortly after the death of Dorothea, Duke Albrecht commissioned her epitaph.[88] (fig. 155) Cologne painter and printmaker Jacob Binck, active at both the Prussian and Danish courts, traveled to Antwerp and negotiated with Floris. Binck's role, however, seems limited to that of an agent rather than being involved in the design process. In 1552 the completed epitaph was shipped via Lübeck and set up on the north side of the choir.[89] The epitaph, which was Floris' first memorial, consists of two basic parts: a highly life-like alabaster bust portrait of Dorothea set in a niche and, below, a large inscription tablet. Separating these two zones are small reliefs of David and Abigail and Solomon and the Queen of Sheba. Flanking are caryatids of Hope and Temperance and, below, Faith and Charity. The adjacent *Epitaph of Anna Maria*, that dates about 1570, is virtually identical in design though the proportions are slenderer. The veracity of both faces suggests that Floris either worked from death masks or from detailed portraits supplied to him. Although the epitaph design is Floris' invention, it draws heavily from his trip to Italy where he saw both ancient Roman and more recent tombs that, in various configurations, display a portrait bust above a large inscription plaque.[90]

Dominating the eastern end of the choir is the *Tomb of Duke Albrecht*.[91] (figs. 154–156) Its ambitious scale anticipates the trend towards ever larger wall monuments in Germany during the opening decades of the seventeenth century. Commissioned

192

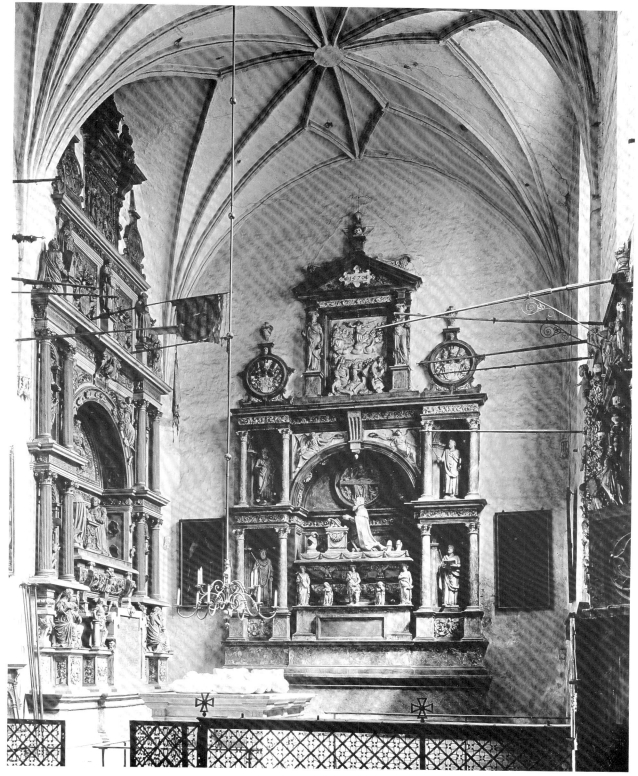

154. View of the Choir, Königsberg Cathedral

155. Cornelis Floris, *Epitaph of Dorothea of Denmark*, 1549–52,
Königsberg Cathedral

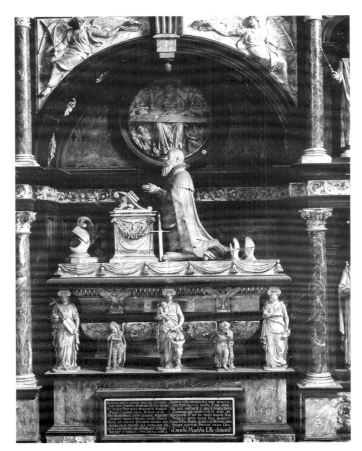

156. Cornelis Floris, *Tomb of Albrecht von Brandenburg-
Ansbach*, 1568–70, Königsberg Cathedral

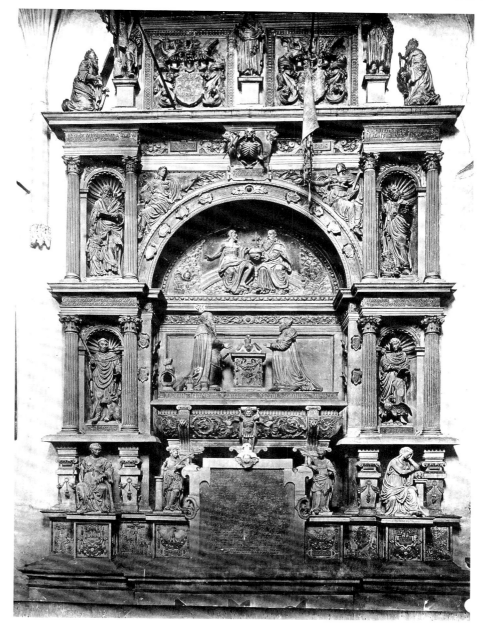

157. Willem van den Blocke, *Tomb of Georg Friedrich von Brandenburg-Ansbach and Elizabeth*, 1578–81, Königsberg Cathedral

in 1568, this was Floris' final and finest wall tomb, a marvelous compendium of his characteristic forms. Like the sculptor's other late works, the Roskilde tomb and the choir screen in Tournai, a strong architectural frame organizes and controls the various alabaster sculptures.[92] Floris set his kneeling figure of Albrecht within a great triumphal arch. The duke kneels at his prayer bench. The floor beneath him is actually the top of his bier that in turn is supported by the caryatids Faith, Charity, and Hope.[93] Angels (or genii) lamenting Albrecht's death stand between these virtues. Directly behind his head is a medallion with a large Pietà separating smaller depictions of the Crucifixion and Resurrection and, beneath Christ, Death and the Devil. In the projecting niches on either

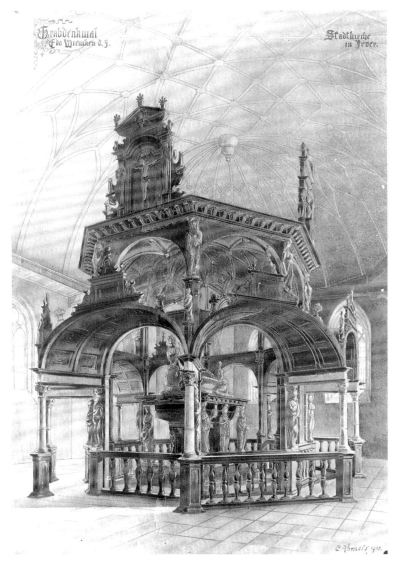

158. Netherlandish Artist(?), *Tomb of Edo Wiemken the Younger*, early 1560s, Jever, Stadtkirche

side of the arch stand Saul, David, Solomon, and Hosea. And above is a crowning relief of the Last Judgment, based upon Frans Floris' altarpiece now in Brussels, and, finally, an hour glass atop a winged skull at the apex.[94] When planning this tomb, Floris drew heavily upon his own repertory of images, since most of the features, from the design of the bier to the caryatid-framed relief above, appear in different combinations in the prints of the *Veelderleij nieuwe inventien van antijcksche sepultueren . . .* (1557) or in his *Tomb of Frederik I* in Schleswig.[95]

(figs. 110 and 139) Nevertheless, Floris weaves these seamlessly together. The elegant harmony of the whole ensemble and the dignified bearing of Duke Albrecht reveal just how far northern European sculpture had progressed in past 50 years.

Certainly attractive but less successful is Willem van den Blocke's adjacent *Tomb of Georg Friedrich and Elizabeth* that was begun in 1578 and set in 1581.[96] (fig. 157) Between 1568 and his death in 1577, Georg Friedrich, margrave of Brandenburg-Ansbach, served as the duchy's administrator dur-

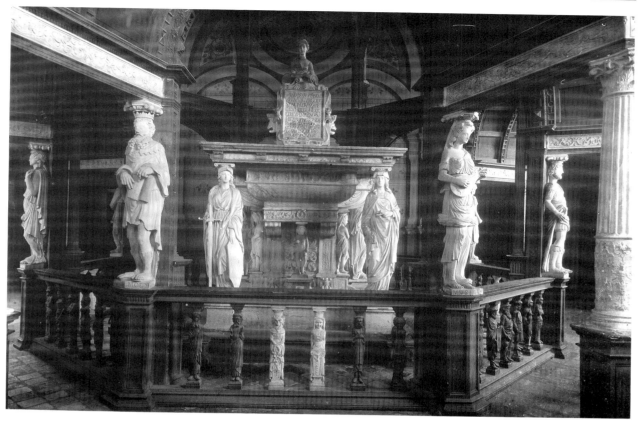

159. Netherlandish Artist(?), *Tomb of Edo Wiemken the Younger*, detail, early 1560s, Jever, Stadtkirche

ing the minority of Albrecht's son, Albrecht Friedrich. While van den Blocke based his design on Floris', it lacks a similar coherence. The kneeling statues of the couple are too small to dominate the composition in the way that of Albrecht does. Furthermore, van den Blocke added a myriad of secondary figures and decorative features that simultaneously compete for the viewer's attention. Up until his death in 1628, van den Blocke continued to draw inspiration from Floris' three Königsberg monuments and his prints.[97] He was one of several masters that spread the Floris style throughout northern Germany and the Baltic.

Floris influenced at least one further complex sepulchre in northern Germany. Another, unfortunately, anonymous Netherlandish sculptor created the *Tomb of Count Edo Wiemken the Younger* (1468–1511) in the Stadtkirche in Jever during the early 1560s.[98] (figs. 158 and 159) This area of East

Friesland lacked a strong sculptural tradition so when Edo's daughter and heir, Maria (r. 1511–75), decided to erect an elaborate sepulchre she sought a master in Floris' circle. The central sarcophagus, especially the arrangement of its recumbent effigy and caryatids, strongly recalls both Floris' Schleswig tomb and his print design for a free-standing tomb for a count of 1557.[99] (figs. 110 and 139) Surrounding this is an intricate octagonal canopy or baldachin ornamented with 16 additional standing caryatids of the Arts and Planets.[100] Jever provides yet another example of the strong appeal of the Floris style. During the third quarter of the sixteenth century, Cornelis Floris either created or strongly influenced most of the complex funerary programs erected in the German-speaking lands. Not since the Vischers has a single master exerted such a powerful impact over such a broad geographic region.

CHAPTER SEVEN

The Renaissance Fountain

ESSENTIAL to the life of any town is an adequate supply of water. Sites for settlements were chosen because of their proximity to a river or spring, a fact often reflected in place names such as Blaubeuren, Donaueschingen, Innsbruck, and Wasserburg. Every village, however humble, would have had a public fountain or well, which often was, along with the church, the focal point of local activities. Medieval literature further glorified and allegorized the fountain, which was at once the source of eternal life, as in the Book of Revelations, of youth, and of love. By the sixteenth century, fountains were ubiquitous.[1] In the larger, more affluent cities, running water was available to the majority of houses. While most domestic fountains issued from a simple spigot or open spout, others were considerably more elaborate and required attractive sculptural decorations. Civic pride was typically intertwined with the erection of great market fountains. The famed *Schöner Brunnen* (*Beautiful Fountain*) of the later fourteenth century in the Hauptmarkt in Nuremberg symbolizes the city's special imperial privileges while the elaborate bronze *Luna (or Diana) Fountain* of the mid-sixteenth century, standing proudly before the city hall in Lüneburg, alludes to the mythical origins of this north German town.[2]

Three general categories of fountains will be discussed in this chapter. The first group is the house fountain, normally small-scale yet surprisingly varied in type, from table fountains to wall decorations in the form of grottos. The second is the civic fountain, which comes in diverse shapes and with sculptural embellishments ranging from simple reliefs to life-size statues of bronze or stone. And the third is the garden fountain, a form that blossomed much later in Germany than in either Italy or France.

Unfortunately, the corpus of high-quality sculptural fountains is relatively small. The rate of loss appears greater here than for any other type of sculpture. Wars, of course, have played an inevitable role in the destruction of Renaissance fountains. For instance, Peter Vischer the Elder cast a St. Martin to ornament a fountain in the residence of Cardinal Albrecht von Brandenburg in Aschaffenburg; it disappeared in 1552 when the troops of Margrave Albrecht Alcibiades von Brandenburg-Kulmbach plundered and then demolished the medieval castle.[3] Metal fountains could be melted for other uses, including weapons and church bells. Other fountains were simply used until deterioration prompted repair and, almost inevitably, replacement. As will be discussed later, many of the single brass and bronze statuettes of this period may once have adorned small fountains. These detachable figures were removed from their original contexts and given new functions, occasionally as a work of older art in a *Kunstkammer*.

Another critical factor underlying the dramatic losses of Renaissance fountain sculptures is the historic transformations in tastes. Fountains, whether in one's house or in the garden, had a functional and aesthetic immediacy. Few affluent patricians of the later seventeenth and eighteenth centuries would have used a Renaissance table fountain for their banquets or accepted one of Alexander Colin's fountains in their garden when more modern alternatives were available and even demanded by contemporary fashions. Cities too, if less fickle and more cost conscious than certain individuals, replaced their fountains with some frequency. In 1516 Sebastian Loscher, assisted by Jakob Murmann the Elder, completed a new marble fountain for the Weinmarkt on Maximilianstrasse in Augsburg, his

fifth fountain project in seven years for the city.[4] The talented young sculptor carved Italianate architectural decorations and perhaps some figurative reliefs on the central pillar; it is unclear whether a statuette was also required for this fountain. His project replaced a virtually new fountain cast by Burkhard Engelberg in 1508, which in turn must have replaced a Gothic fountain. Thus three different fountains occupied this single site within a decade. Local officials may have concluded that the modern or "Welsch" (Italianate) style characteristic of Loscher's works was more appropriate for the city than Engelberg's version. Within a century, a fourth and final fountain, Adriaen de Vries's *Hercules Fountain*, installed in 1602, would be located here.[5] The replacement of older fountains occurred elsewhere in Augsburg and in most other cities.

Although these losses are regrettable, it is nevertheless still possible to address the development of the different forms of fountain sculptures. From a methodological standpoint, I cannot assign primacy to a particular fountain. For instance, the *Marktbrunnen* that Albrecht von Brandenburg had erected in Mainz in 1526 is frequently described as the first Renaissance fountain in Germany. (fig. 182) Such claims are meaningless given the limited size of the extant corpus. Supplementing our knowledge of surviving fountain sculpture are documents and contemporary descriptions, design drawings, wooden models often used for casting, old views, and a comparative group of fountains that adorn paintings and graphic works of the period.

House Fountains

Within the context of a residence, fountain sculptures became remarkably diverse. Some adorned strictly functional water conduits such as spigots. Most, however, were lavish embellishments tied to prevailing social or aesthetic standards of taste among the patrician and noble classes. Fountains were placed on banquet tables for the amusement of the guests. Graceful, metal column fountains stood both indoors and in courtyards. By the 1570s grotto fountains even began to appear within houses. In the sixteenth century, the visual allure of a fountain came to complement the age-old audi-

tory pleasure that one derives from the sound of running water. In this section, I wish to address three sub-categories determined by placement: the table fountain, the standing fountain, and the wall fountain.

Amid the treasures of Emperor Maximilian I's *Schatzkammer* or Treasury in Wiener Neustadt that Albrecht Altdorfer illustrated in one of his woodcuts for the Triumphal Arch of about 1515 is a metal table fountain.[6] (fig. 160) Set on the left with the impressive display of silver vessels and plate, the fountain must have measured slightly over a meter high. It is characterized by a circular basin with a single column adorned by at least three statuettes of nude women and, atop the column, a fashionably dressed soldier drawing his sword. Using air pressure and perhaps some type of pump, wine would have issued from these figures for the guests' enjoyment. This is one of the rare images of a table fountain. Although many are documented in inventories or accounts of late medieval feasts, such as those held at the Burgundian court, few survive.[7] Nuremberg mathematician and calligrapher, Johann Neudörfer, writing in 1547, mentioned seeing an elaborate table fountain by Hans Frey and Ludwig Krug in the house of a local patrician.[8] Frey enjoyed a considerable reputation for his fountains. Several drawings of the 1490s, including *Design for a Table Fountain with a Mountain Scene and Morris Dancers* in Erlangen (Universitätsbibliothek), are attributed to Frey.[9] (fig. 161) The base is equiped with handles for lifting the fountain. Miniature figures move through the hillside below; a shallow-relief frieze of cavorting couples decorates the edge of the basin; and Morris dancers surround the central island. The drawing likely offers a full-scale (75.1 by 34.4 cm) design for this particular fountain. Such works were mainly created by goldsmiths; however, the boundry between sculpture and goldsmith work was not always clear, as witnessed by Krug, a goldsmith, by whom we also have signed carvings, drawings, and prints.[10]

Frey's specialty may have prompted his son-in-law, Albrecht Dürer, to formulate his own table fountain designs, such as his intricate drawing, dating around 1500, now in London (British Museum).[11] (fig. 162) In contrast with Frey's mountain, Dürer offers a slender tree-like stem surrounded with twisting vines. Stripped of its artistic

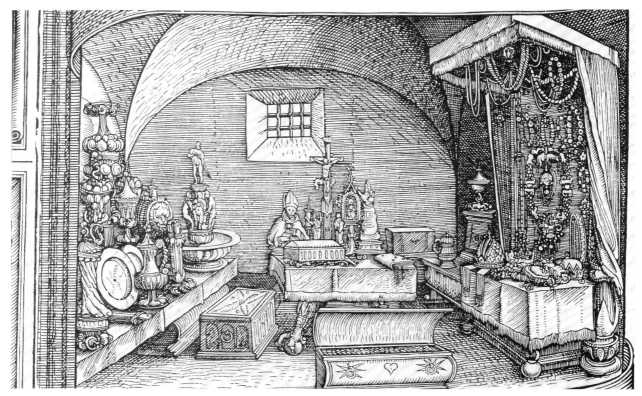

160. Albrecht Altdorfer, *Triumphal Arch of Maximilian I*, detail–*Treasury at Wiener Neustadt*, 1515, woodcut, Berlin, SMBPK, Kupferstichkabinett

decoration, the latter's form, with its base, thick central shaft, raised basin, and slender upper column with a statuette, reflects the basic shape of most German sixteenth-century fountains. An inscription on the reverse, not by Dürer, states that the silver figures, here soldiers and peasants, averaged a height roughly equivalent to about 13.8 centimeters.

Such small statuettes were often the work of sculptors. In his contemporary biography of Peter Flötner, Johann Neudörfer wrote that the sculptor's "delight in his day-to-day work, however, was in carving in white stone, producing nothing but figures to be used for embossing or casting by goldsmiths in the decorations of their works."[12] One of the finest products of Flötner's collaboration with a goldsmith, here Melchior Baier, is the *Holzschuher Cup* of the late 1530s in Nuremberg (Germanisches Nationalmuseum).[13] (fig. 163) With the destruction of most table fountains, related works such as this provide the best idea of their intricate beauty.

Replace the coconut cup with a basin and the Holzschuher cup could be made to function as a fountain. Cast figures of amorous couples and copulating goats set in rocky terrain ornament the base. Flötner's stem winds organically and quite dramatically upwards to support the coconut with its detailed reliefs illustrating the Triumph of Bacchus. At the apex of this 43.5 centimeter tall cup are Bacchus and a satyr, which like the rest of the decorations amusingly explicate the dangers of drink.

The scenographic character of both Frey and Dürer's fountains would continue well into the sixteenth century. Matthias Zündt's etching of a table decoration, made in about 1570, comes complete with a hillside adorned with a castle, houses, city gates, mill, and, encircling the whole, a flowing river.[14] (fig. 164) Liquid. whether water or wine, flowed from the top of the mountain in a cascading stream beneath the various bridges until at several points it entered the river. Zündt also included two working fountains, ornamented with column

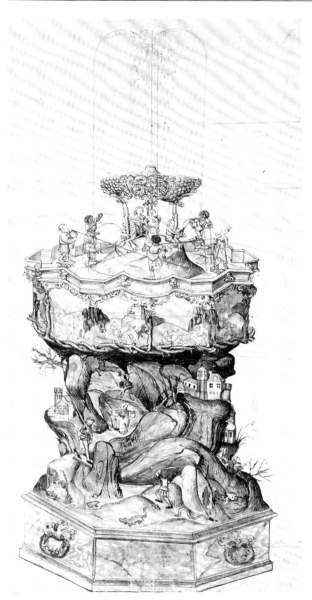

161. Hans Frey (attributed), *Design for a Table Fountain with a Mountain Scene and Morris Dancers*, 1490s, drawing, Erlangen, Universitätsbibliothek

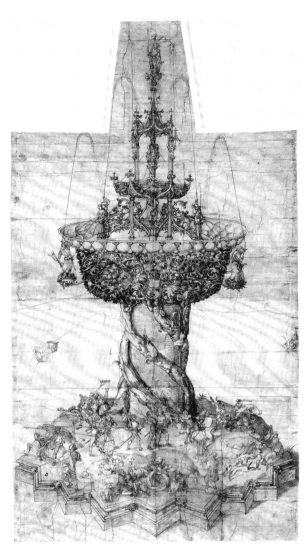

162. Albrecht Dürer, *Design for a Table Fountain*, c. 1500, drawing, London, British Museum

statues, in the market place of his town. In addition to his printmaking activities, Zündt is listed in Nuremberg documents as a goldsmith and a stone cutter. In 1559, Wenzel Jamnitzer, his father-in-law, sent him to Archduke Ferdinand of Tirol's court in Prague to work on a lavish Adam and Eve in Paradise Table Fountain, a project that had to be abandoned two years later because of a lack of silver.[15]

More immediately recognizable as a fountain is the full-scale (151 by 62.1 centimeters) drawing in Veste Coburg firmly attributed to Wenzel Jamnitzer and dating to the mid-1550s.[16] (fig. 165) The base with its grotto landscape complete with insects and reptiles cast from life continues the pictorialism encountered above. The beauty of nature is then immediately contrasted with human artifice in the form of elaborate strapwork, herm figures,

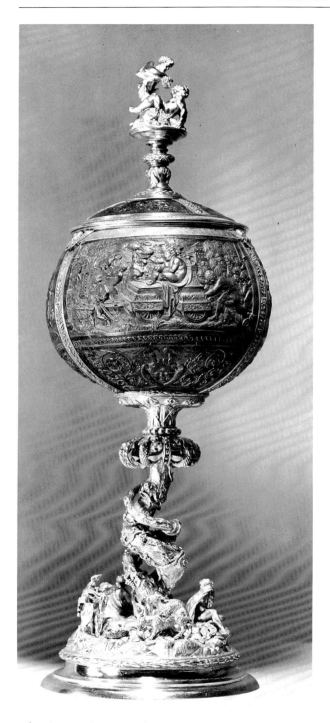

163. Peter Flötner and Melchior Baier, *Holzschuher Cup*, late 1530s, Nuremberg, Germanisches Nationalmuseum

and six metallic cornucopias supporting the first of the fountain's three basins. Jamnitzer develops his design around a single central column ornamented with allegorical(?) female figures and a wealth of decorative motifs. The drawing reflects the extreme sophistication of Jamnitzer's affluent clients who would have appreciated both the fountain's absolute structural clarity and its fascinating mix of natural and man-made elements. Analogous features can be found on many of Jamnitzer's extant works. (fig. 269) While the subsequent fate of this particular project is unknown, such fountains were prized by noble and patrician patrons. In 1562 Jamnitzer sent a similar type of fountain design to Emperor Ferdinand I.[17] We shall return to the issue of Jamnitzer's collaboration with sculptors shortly.

Most of the known table fountains were fabricated in towns such as Augsburg and Nuremberg, which had a strong metalworking industry. The sculptors and bronze casters of Augsburg were particularly active in producing small statuettes for attractive, if somewhat simpler, fountains, such as the *Acteon Fountain* in London (Victoria and Albert Museum).[18] (fig. 166) This rare extant example, dating to the 1550s, stands 80 centimeters high though with the missing basin and pedestal it might have measured over 125 centimeters. Acteon, whom Diana transformed into a stag as a penalty for seeing her and her nymphs bathing, is represented in the middle of his metamorphosis. The artist has set a stag's head with tall antlers upon the classically dressed body of a man. Acteon's frenzied dogs leap up at their master. Below stand three nude nymphs, none of whom is specifically identified as Diana, accompanied by three seated stags. Water would spout through the mouths of all the major figures as well as through Acteon's hunting horn. In the London fountain, the figures dominate its design. The attention to architectural forms and decorative details that characterize some Nuremberg examples are absent here. Forty years earlier Altdorfer depicted a similar-shaped fountain in his view of Maximilian's treasury. (fig. 160) Although Italian prototypes may underlie both works, they show the continued popularity of this particular configuration.[19]

SOME HOUSE FOUNTAINS, too large to be placed on tables, were intended for other interior or

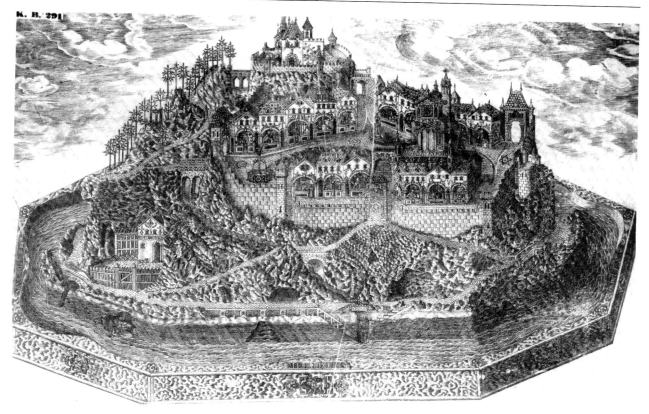

164. Matthias Zündt, *Design for a Table Decoration*, c. 1570, etching, Nuremberg, Germanisches National-museum

courtyard settings. The *Cleopatra Fountain* in Berlin (SMBPK, Skulpturengalerie), resting upon three animal feet, is a rare surviving floor type.[20] (fig. 167) Cast in brass by an unidentified Nuremberg master in the 1540s, it stands 2.02 meters high with a basin diameter of 1.35 meters. Its single column form with a wide basin, a simple candelabrum style, is more commonly found in civic and especially garden fountains, though Wenzel Jamnitzer offered a more complex version in his Coburg drawing. (fig. 165, 185) An even-larger example with two basins is being used by the guests in Erhart Altdorfer's drawing of a *Banquet Scene*, now in Berlin (SMBPK, Kupferstichkabinett).[21] (fig. 168) The design of the column, here decorated with the personifications of Fortitude, Temperence, and Justice, compares closely with Sebald Beham's drawing of a fountain in Erlangen (Universitätsbibliothek) that dates around 1540.[22] (fig. 169) Although Beham had by this time settled in Frankfurt, he maintained contact with several Nurem-

berg artists.[23] Both works feature a primary figure standing at the top of the column who spouts water from her breasts. The capital or support beneath both statuettes is decorated with animal head masks that shoot water into the basin below. In each case, the column tapers upwards before flaring out again. Symmetrically placed acanthus leaves, grotesque faces terminating in an ornamental curl, and, below, three statuettes separated by more grotesques decorate both fountains. The base of each column derives its shape from contemporary goldsmith cups and bowls or prints for these object, such as the engravings by Beham (B. 238–43). Did Beham collaborate with the master of the Cleopatra fountain? It is an attractive, if unprovable, hypothesis; however, at the very least, the sculptor of the fountain borrowed liberally from local designs, including those by Beham.

Another feature that points to a Nuremberg origin for the fountain is the small lizard resting on the edge of the basin. Only one of the original four

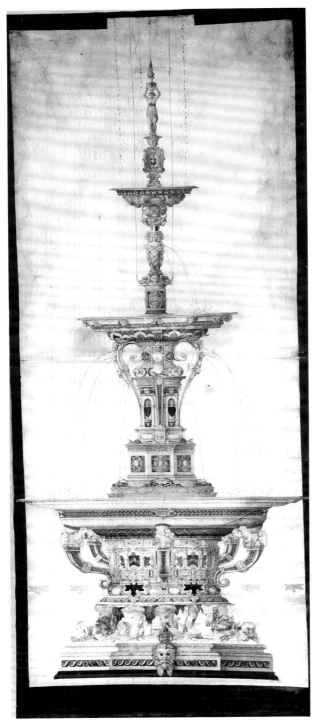

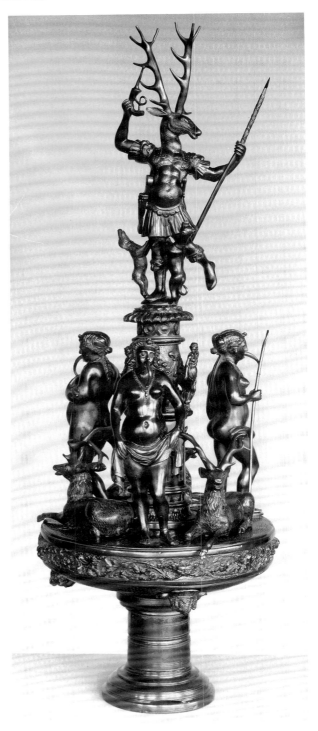

165. Wenzel Jamnitzer, *Design for a Table Fountain*, mid-1550s, drawing, Veste Coburg

166. Augsburg Artist, *Acteon Table Fountain*, 1550s, London, Victoria and Albert Museum

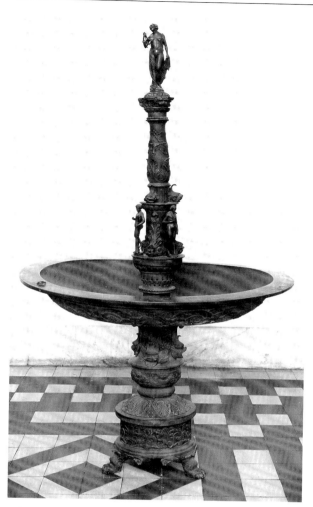

167. Nuremberg Artist, *Cleopatra Fountain*, 1540s, Berlin, SMBPK, Skulpturengalerie

been heard of before and they have presented me with a whole silver snail, cast with all kinds of flowers and grasses around it; and the said flowers and grasses are so delicate and thin that they move when one blows on them.[25]

The lizard on the Berlin fountain may not match the finesse of Jamnitzer's best pieces, yet its striking naturalism surprises and delights the spectator. Only after studying the rest of the fountain do our eyes settle upon the lizard who is curled sleepily on the warmed rim of the basin.

Cleopatra, at the apex of the fountain, is detachable. This 32 centimeter-tall statuette typifies the interchangeable character of many fountain figures. The design of the rest of the fountain, other than the choice of the secondary figures, here three virtues, rarely depends upon the subject of the primary image. The maker of this fountain could easily have substituted a range of other characters in place of Cleopatra. A variety of wooden models or drawings of appropriate themes were doubtlessly available for the patron's scrutiny.

The detachable and interchangeable nature of these statues helps explain why so many were removed from their original contexts at some later date. In Chapter Nine we shall discuss the collecting of small bronzes during this period. In contrast to Italy, with its established appreciation of independent bronze statuette, both Roman and contemporary, Germany initially accepted such figures only when given a decorative function. It is likely that many—if not most—early brass and bronze German statuettes were once part of a fountain.[26] Unlike the Berlin *Cleopatra*, with its breast spouts, many statues did not contain water jets since these were located below within the column or supporting pier. (figs. 183, 185, and 195) The Master of the Budapest Abundance, an Augsburg sculptor of the 1530s, made two versions of the statue from which he derives his current name. The example now in the Cleveland Museum of Art, cast in bronze after a wax model, has a spout projecting from Abundance's right breast, while its Budapest counterpart does not, yet both were intended for fountains.[27] (fig. 170) In the case of the Cleveland statue, a casting flaw in the lower back occurred during it production. Perhaps the commission

lizards (salamanders?) remains. It has been cast after life, a process popularized by Andrea Riccio in Padua that Peter Vischer the Younger likely brought back to Nuremberg. From the 1530s onwards, Pankraz Labenwolf, who cast Peter Flötner's *Apollo Fountain*, and the workshop of Wenzel Jamnitzer specialized in producing insects, lizards, amphibians, and other natural forms using this technique.[24] (figs. 165, 196, and 269) In 1547 Johann Neudörfer praised Wenzel Jamnitzer and his brother, Albrecht, when he wrote

Their skill in making castings of little animals, worms, grasses and snails in silver and decorating silver vessels therewith has never

called for a free-standing fountain, thus making it imperative to create a second, perfect statuette. The damaged Cleveland figure, with or without its spout, would have been more appropriate adorning a wall fountain that prevented a rear view.

A drawing, now in Erlangen (Universitätsbibliothek), offers a design for another floor or courtyard fountain.[28] (fig. 171) The Nuremberg artist, working around 1530, shows an attractive single-basin column fountain. The two statues, a standing naked women pouring wine who mocks the besotted man at her feet, are much larger in relation to the overall dimensions than observed in the *Cleopatra Fountain*. (fig. 167) The figure of Cleopatra is considerably smaller than many extant fountain statues or models. For instance, the *Fortuna* in Berlin (SMBPK, Skulpturengalerie), a lindenwood casting model made around 1520–25 in Augsburg,

stands 55 centimeters high.[29] (fig. 172) Fortuna, with her twisting body and animated drapery, offers an expansive pose closer in spirit to the Erlangen figures. These statues were expected to dominate the fountain rather than merely being a subordinated part of the whole, as in the case of the *Cleopatra Fountain*.

Not all house fountains were as small and as simple as those discussed so far. Four fire-gilt bronze statues of the Seasons, each measuring about 71 centimeters high, in Vienna (Kunsthistorisches Museum) are all that remain of a complex allegorical fountain that Wenzel Jamnitzer and sculptor Johann Gregor van der Schardt made for Emperor Maximilian II.[30] (figs. 173–176) At the moment of its inception in 1568, the fountain was intended to be located in one of the large rooms in his new place, the Neugebäude, outside Vienna; however,

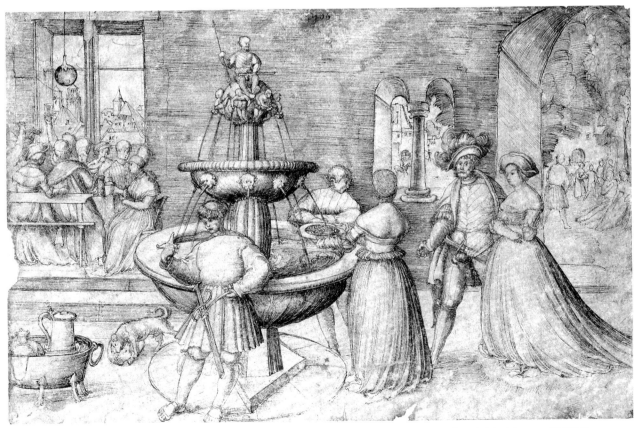

168. Erhart Altdorfer, *Banquet Scene*, c. 1506, drawing, Berlin, SMBPK, Kupferstichkabinett, KdZ 85

206

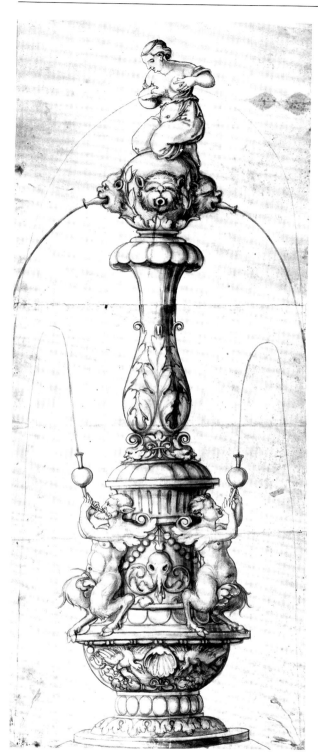

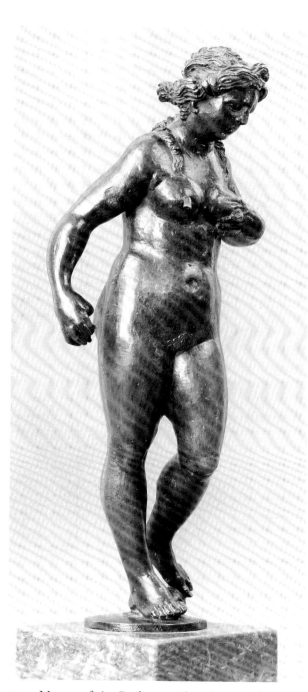

169. Sebald Beham, *Design for a Fountain*, c. 1540, drawing, Erlangen, Universitätsbibliothek

170. Master of the Budapest Abundance, *Abundance*, 1530s, Cleveland Museum of Art, Purchase from the J. H. Wade Fund, 71.104

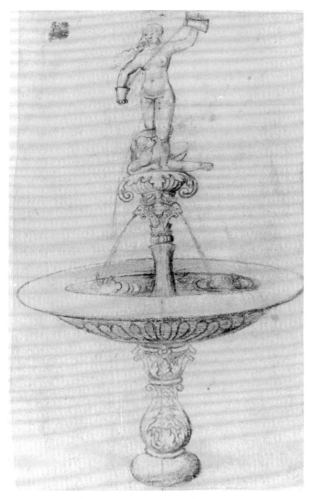

171. Nuremberg Artist, *Design for a Fountain*, c. 1530, drawing, Erlangen, Universitätsbibliothek

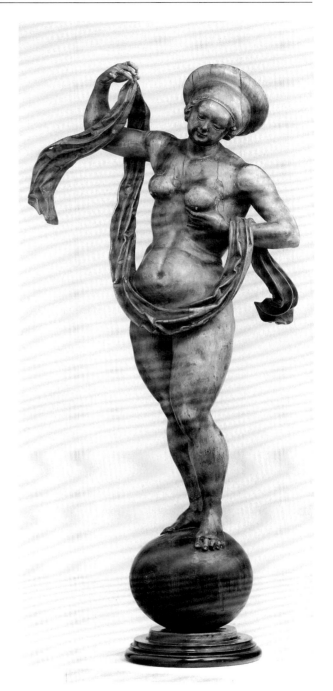

172. Augsburg Artist, *Fortuna*, c. 1520–25, Berlin, SMBPK, Skulpturengalerie

with the emperor's death in 1576, the fountain was delivered two years later to his heir, Rudolf II, in Prague. (fig. 202) The Four Seasons, each in the guise of an ancient god (Flores as spring, Ceres as summer, Bacchus as fall, and Vulcan as winter), formed the supporting base for the fountain, which measured between 3 and 3.5 meters high with a diameter of at least 1.5 meters. Accompanying them was a lion holding a shield with the arms of Austria and Burgundy.

On their heads rested a replica of the imperial crown through which was visible stages representing the four elements.[31] Earth, presided over by a statue of Cybele (Rhea), the ancient terrestrial goddess, was characterized by such features as moun-

tains, which included a forge and a stamping mill, mines, flowers, the seven metals, and the four rivers of Europe (Danube, Rhine, Elbe, and Tiber). The visual impression must have been scene-

173. Wenzel Jamnitzer and Johann Gregor van der Schardt, *Spring (Flores)*, 1570–75, Vienna, Kunsthistorisches Museum

174. Wenzel Jamnitzer and Johann Gregor van der Schardt, *Summer (Ceres)*, 1570–75, Vienna, Kunsthistorisches Museum

ographically akin to the effect observed in the fountain drawings and prints discussed earlier. (figs. 161, 162, 164, 165) The other half of this stage represented water. Neptune standing in his chariot ruled over a domain populated with seamen, mermaids and children, turtles, crabs, and fish. Jamnitzer's expertise at life-casting was exploited fully. Not surprisingly, many of the fountain's spouts were located in this area, though rain fell from Air, the next level. Reigning over this element was Mercury, flying on or under a golden star. He was accompanied by figures of the four

winds, angels, and eagles. Finally, atop the peak of the crown, was fire. Jupiter, holding his thunderbolts, sat enthroned upon his symbol, the eagle, which, in turn, rested on a globe. Below stood much smaller statuettes of the four archangels plus the four rulers of the great civilizations of the past: Ninus (Assyrian), Cyrus (Persian), Alexander the Great (Greek), and Julius Caesar (Maximilian II; Roman), followed by representative figures of the human social hierarchy from the seven imperial electors down to peasants; a rainbow completed the ensemble.[32] The fountain was also a musical auto-

175. Wenzel Jamnitzer and Johann Gregor van der Schardt, *Fall (Bacchus)*, 1570–75, Vienna, Kunsthistorisches Museum

176. Wenzel Jamnitzer and Johann Gregor van der Schardt, *Winter (Vulcan)*, 1570–75, Vienna, Kunsthistorisches Museum

mata as water pressure powered cimbals capable of playing the two dance tunes, *Roland* and *Pickled Herring*.[33]

The fountain offered a marvelous allegory of imperial rule, a microcosm of nature and history. It celebrates Maximilian II as the "dominus mundi," master of the elements, and elected lord of the Holy Roman Empire, the fourth of the world's great realms. As Schürer has noted, the conceit created here parallels those found in the court paintings, such as Giuseppe Arcimboldo's series of seasons and elements that Maximilian II received as a new year's

gift in 1569.[34] In its intended setting in the Neugebäude, the fountain's message would have had special poignancy since this garden residence, with its emphasis upon nature, was constructed intentionally on a site that, according to legend, the Turkish sultan Suleiman the Magnificent had used for his own tent during the unsuccessful Moslem campaign against Vienna in 1529.[35] The repulsion of the Turkish siege was considered a momentous victory for Christianity and the Holy Roman Empire since it thwarted the European expansion of the Ottoman empire and Suleiman's dreams of a world

united under Islam.[36] Furthermore, it was Maximilian's father, then Archduke Ferdinand, who had organized the city's defense. Thus Jamnitzer's fountain, in its projected location in the Neugebäude, poignantly reinforced Habsburg dreams of imperial grandeur.

The program for the fountain was devised in Vienna not Nuremberg. Was it Jacopo Strada, the court antiquarian, whose architectural expertise seems to have been critical to the design of the Neugebäude?[37] The fountain may have been intended to fit within the theme of a particular chamber, the "Schönen Säle." Strada and Jamnitzer were well acquainted since the Italian artist, who was also a goldsmith, moved to Nuremberg in 1546 and became a citizen in 1549. They collaborated, and Strada even attempted to take over the creation of the ill-fated *Adam and Eve in Paradise Table Fountain* that Jamnitzer and Zündt worked on for Ferdinand I.[38] Strada's knowledge of water pumps would have been invaluable both for this project and for the Neugebäude fountain.

In its original form, Jamnitzer's room fountain must have been dazzling. All of the upper portions were cast in silver with portions, such as the natural features, painted with an enamel lacquer. When Ferdinand of Bavaria viewed the fountain in Prague, he was so moved that on 30 September 1578 he wrote to his father, Duke Albrecht V, that he had "never in his life seen anything so artful and beautiful" as "Jamitzer's" fountain.[39] Its subsequent history is not altogether clear. In 1621 it is mentioned as being in a small room in the Prague palace; however, in the inventory of Rudolf II's *Kunstkammer* of 1607–11 the fountain is listed as having been dismantled and stored in 18 chests. Around 1629 it was sent back to Vienna where it remained until 1747–50 when Emperess Maria-Theresa ordered the silver portions melted. Only the Four Seasons, made of bronze, survived.

Although Jamnitzer is credited with producing these four statues, their general design may have been sent to him from Vienna as was the sculptor. Johann Gregor van der Schardt entered Maximilian's service in 1568 or 1569, first in Venice and then in Vienna. In either late 1569 or, more likely, 1570 he arrived in Nuremberg, perhaps accompanying Maximilian II during his inaugural entry on 7 June.[40] When the emperor returned to

Nuremberg on 31 December, he presented van der Schardt with a gift of 50 gulden. While the records do not specify the reason for this payment, it is likely linked to his production of wax models for the Seasons and other fountain figures. This attribution, which I believe to be correct, is based upon stylistic comparisons between the Vienna Seasons and the sculptor's other bronzes, especially his signed *Mercury* in Stockholm (Nationalmuseum) and *Minerva* in Washington (Robert Smith Collection).[41] (fig. 257)

The slender Vienna statues are elegant. Each is rather elongated with an expressive head turning sideways. The sculptor's detailed rendering of hair provokes a rich interplay of light and shadow across the undulating surfaces. This is especially true for *Winter*. Conscious that the statues would be visible from all sides, van der Schardt provided each with a slightly open stance, stable yet suggesting, by means of contrapposto, an impending shift of weight to the forward leg. Their outstretched arms hold the relevant identifying symbols while also animating the surrounding space. Mannerist proportions, most notably in the neck and undersized head, are mixed with great care in the depiction of individual features, such as the strong arms and torso of *Winter* as compared with the softer, more adolescent form of *Fall*. If contrasted with the nudes, such as *Cleopatra* or *Abundance*, observed earlier in this chapter, these sophisticated statues illustrate the decisive stylistic changes entering German art from Italy and, to a lesser degree, France and the Netherlands. We shall return to this issue in Chapter Nine. As for van der Schardt, he is last mentioned in imperial records on 1 July 1571 when he is given permission to travel to Venice. He subsequently returned to Nuremberg where he resided for much of the next decade while creating attractive statues in collaboration with Georg Labenwolf and other local founders.

THE MOST PREVALENT FORM of house fountain was also the simplest. Wall fountains are typically little more than masks or ornamented pipes of scant art-historical significance.[42] Perhaps inspired by north Italian examples, metalworkers in Nuremberg and especially Augsburg fabricated ever more decorative spigots. Representative of these is the voluptuous female nude in Berlin (SMBPK,

177. Augsburg Artist, Female Spigot Decoration, 1550s, Berlin, SMBPK, Skulpturengalerie

Skulpturengalerie), made in Augsburg during the 1550s.[43] (fig. 177) Measuring 33 centimeters in height, this half-length bronze wears a lavish necklace and part of a cloak or robe over her arms. Her hair is carefully pulled back. As a female type she recalls the contemporary nymphs on the *Acteon Fountain* in London, though she is more refined in terms of both the soft modelling of her skin and the quality of the casting. (fig. 166) The designer playfully juxtaposes her sensuality with the grotesque faun mask and spout, images of male sexuality, growing out of her loins.

In addition to these spigots and the various wall fountains sporting small statuettes in a niche or on a column, there existed a related, though more elaborate, category of wall ensembles. Two, albeit very different, design drawings provide an idea how this form evolved during the mid-sixteenth century. (figs. 178 and 179) Peter Flötner's sketch, dating around 1540 and now in Berlin (SMBPK, Kupferstichkabinett), is a presentation design done in pen and black ink with wash.[44] The accompanying inscription warns the patron that the drawing, measuring 37.8 by 30.9 centimeters, is not done to scale, implying the actual wall fountain would be somewhat larger. Reminiscent of the table fountains discussed earlier, Flötner offers a highly pictorial scene with two women and four men bathing in a natural grotto set in the hillside. The spring water issues through two cherub head masks and exits the pool through a faun mask, reminiscent of the Berlin spigot, into a larger trough implied below. Flötner pairs the refreshing character of water with the drinking, music playing, and, potentially, amorous activities of the people, images characteristic of bath-house scenes in contemporary prints.[45] The landscape is wonderfully evocative with its blasted tree in the left foreground, steeply rising slopes, which are better suited for his goats than for the well-fed bathers, and the artistry of Mother Nature, as evident in the cluster of crystals growing at the upper left.

In the neatly penned inscription below, Flötner(?) tells his patron that this is a preliminary design and, significantly, that the materials for making the fountain, including the water pump and the "Berckwerck", could be obtained from "maiser pangratz" who certainly is identical with the sculptor's local collaborator Pankraz Labenwolf.[46] It is possible that fountains like this were common, and that Labenwolf kept a stock of natural forms, precast, available in his shop. Recall that Labenwolf did make life-casts, as in the *Apollo Fountain* in Nuremberg. (figs. 195 and 196) Labenwolf could simply have kept a few basic landscape elements, like the dead tree or a rising slope, to demonstrate his talents to a prospective client.[47] In this instance, the patron must have been local if he or she could stop by "maister pangratz's" studio.

A very different concept for a wall fountain is offered in the drawing, now in Stuttgart (Staatsgalerie) that Friedrich Sustris made in about 1569.[48] (fig. 179) In this instance, the fountain's scale is

178. Peter Flötner, *Design for a Wall Decoration*, c. 1540, drawing, Berlin, SMBPK, Kupferstichkabinett, KdZ 1263

clearly defined by the surrounding architectural setting and the two figures standing in the adjacent chamber. The fountain is set in a large rectangular niche recessed into the wall between the two doorways. A slightly under life-size figure of Nature, wearing a crown of grasses and with nourishing water spouting from her breasts, stands on a raised pedestal above a large stone(?) basin. Accompanied by various animals, including deer, goats, and a unicorn, Nature is placed within a fanciful grotto ornamented with stalactites. The balustrade and the clear architectural frame separate the realm of Nature from the space of the viewer.

Sustris introduces here a fashionable Italianate grotto design. The artist, son of a Dutch painter, grew up in Venice and Padua.[49] Between 1563 and 1567, after a brief period in Rome, Sustris assisted Giorgio Vasari on the decoration of the Palazzo Vecchio in Florence. Like Vasari, Sustris was destined to play a critical role as designer and artistic overseer for many of the great projects of the dukes of Bavaria, for whom he worked from 1573 until his death in 1599 in Munich. While the majority of these artistic projects, including at least two major fountains, post-date our general terminus of 1580, the *Nature Fountain* does not.

Over the fountain is the Fugger coat of arms. Sustris's first German patron was Hans Fugger. Between 1568 and 1573 the artist resided in Augsburg where he renovated portions of the Fugger house on Maximilianstrasse. The Stuttgart drawing may be linked with an elaborate fountain that Hans Fugger ordered for the side of the courtyard of this residence.[50] In 1569 and 1570 Fugger erected a special foundry presumably for the casting of this fountain. Total expenditures exceeded 1,300 gulden, with Netherlandish sculptor-caster Pietro de Neve and goldsmith Cornelius Anthonius Man receiving the highest salaries. These masters seem to have produced the fountain after Sustris' designs, though the Stuttgart drawing may not have been the final concept.[51] Further confirming that this drawing was intended for this palatial city residence is the introduction of Roman-style portrait busts set over the two doorways. One of Sustris' primary tasks was redecorating the library where he incorporated the busts that Fugger had acquired in Venice and Padua with the lavish paintings by Antonio Ponzano, inspired by the Golden House of Nero in Rome, and stuccowork of Carlo Pallago.[52] (fig. 180) These contemporary copies of classical busts were set on pedestals over the doorways, as in the drawing, and in special niches located around

179. Friedrich Sustris, *Design for a Grotto Fountain*, c. 1569, drawing, Stuttgart, Staatsgalerie

180. Friedrich Sustris, Carlo Pallago, and Others, Interior of the Library of the Fugger House, c. 1570, Augsburg

the rooms of the library. Sustris would use a similar formula at Trausnitz castle in Landshut where he worked from 1573 to 1578 after having left Augsburg.[53]

Sustris' knowledge of grottos came from Vasari, who wrote a discourse on the subject in the introduction to his *Lives of the Artists*, published in a greatly expanded edition in 1568.[54] He discusses the appropriate materials and themes. Sustris may have seen Niccolò Tribolo's plans for the grotto of Villa Reale at Castello, a Medici residence, with its use of stalactites and a series of near life-size animals, including a unicorn, gathered around the fountain.[55] Tribolo died in 1550; however, work on this project was completed only in 1567 while Sustris was in Florence. He would have also been familiar with the little grotto erected in the Boboli gardens in 1553–54.[56] Here a clear architectural frame surrounds this wall fountain with its four goats within a shallow, stalactite-covered cave.

None of these examples includes as dominant a central figure as Sustris' Nature. Her placement on a support within the basin adopts a common formula used in Florentine garden fountains. More significantly, Sustris' general model for the figure of Nature seems to have been Ceres from Bartolomeo Ammanati's ill-fated fountain for the Palazzo Vecchio, though Nature's arms are raised and the contrapposto is more accentuated.[57]

Sustris' design for the Fugger house in Augsburg is among the first translations of Italian fountain form north of the Alps, outside of France, which had succumbed to the lure of Italy already in the early sixteenth century.[58] The taste for ever more elaborate fountains, both within the house and in the garden, quickly blossomed in the refined courts in Landshut, Munich, Stuttgart, Innsbruck, and Vienna. We shall return to a few of these in the third part of this chapter.

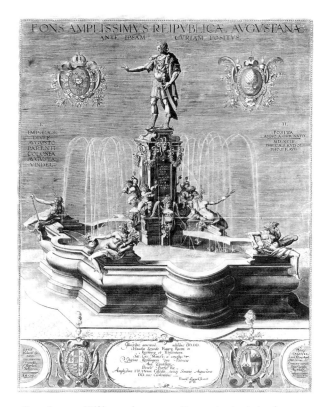

181. Lucas Kilian, *Augustus Fountain* (original arrangement of Hubert Gerhard's Fountain, 1590), 1598, engraving, Augsburg, Städtische Kunstsammlungen

Civic Fountains

In most German towns there was at least one principal fountain located in the main marketplace, often adjacent to the Rathaus. Frequently, these were showpieces, symbols of civic pride, ornamented with the local coat of arms plus a stone or bronze statue. A large, functional basin was, of course, also included. In this section, I wish to examine six fountains of particular artistic merit, which, with one exception, were once again the products of workshops in Augsburg and Nuremberg. Huge public fountains with monumental central statues, such as those adorning Bologna, Florence, Messina, and Palermo, are among the glories of the later Renaissance in Italy; however, comparable monuments do not begin to appear in Germany until the late 1570s.[59] For instance, at the turn of the century Augsburg erected three marvelous new examples: Hubert Gerhard's *Au-*

gustus Fountain plus Adriaen de Vries' *Mercury* and *Hercules* Fountains.[60] (fig. 181) The lessons of the Reformation would influence public artistic patronage throughout the century in both Protestant and Catholic regions. Cautious civic officials preferred smaller fountains with statuettes of nonconfrontational themes. Only Albrecht von Brandenburg's *Market Fountain* of 1526 in Mainz boldly offered a political warning to his subjects. (fig. 182)

Prior to the Reformation, many towns proudly displayed saints on their fountains. St. Christo-

182. Peter Schro, *Market Fountain*, 1526, Mainz

pher adorns the market fountain of 1495–1500 at Urach, while the large trough Fish fountain (1508), located between the Rathaus and St. Michaelskirche in Schwäbisch Hall, has Hans Beyscher's stone statues of St. George and the Dragon, St. Michael and the Devil, and, as a type for the Christian knight, Samson and the Lion.[61] Perhaps the finest extant example is the bronze *Pilgrims' Fountain* with its central statue of St. Wolfgang of 1515–18 that Wolfgang Haberl, abbot of Mondsee, had had made in Passau for St. Wolfgang, home of Michael Pacher's famous altarpiece.[62] Religious themes for civic fountains became much less common during the next half century, until the post-Tridentine resurgence of Catholicism was expressed in such fine works as Hans Ruprecht Hoffmann's *Petersbrunnen* of 1595, honoring Trier's patron saint.[63]

Even prior to the Reformation, many German fountains displayed the figure of a knight dressed in armor. In 1482 Jörg Syrlin the Elder carved three stone warriors for the *Fish Market Fountain* in Ulm, which today are in the local museum along with a preparatory design for the ensemble.[64] These three figures were set in niches around the side of the twisting Gothic pinnacle. Whereas the octagonal fountain formerly in the market place in Munich featured a much larger single knight perched atop a central column.[65] This figure, carved between 1511 and 1512 by Lienhard Zwerchfeld(?), held a banner and shield that were repainted frequently in gold and silver colors by the city's leading artists, including Jan Polack and Hans Mielich. This would continue to be a popular theme, though a soldier in more fashionable attire sometimes replaced the knight, as at Rottweil am Neckar (c. 1550).[66] The idea of a defender can be rendered in the form of a quasi-historical knight, such as Roland at Hildesheim (1546) and Fritzlar (1564); a knight of the Teutonic Order as at Bad Mergentheim (1546–48), the residence of its commander; or in the guise of a ruler, such as the market fountain with Georg, margrave of Brandenburg-Kulmbach, in Ansbach that dates to about 1515, the year Georg and his brother Kasimir divided the family's lands, or the stone statue of Ulrich, duke of Württemberg (d. 1550), in Bietigheim an der Enz of 1549, or the large stone figure of Emperor Maximilian II of 1570 in Reutlingen.[67]

By contrast with these more traditional themes,

one finds a sudden rise in civic—and garden— fountains of mythological and genre subjects. Sometimes the choice is specific to the setting, as in the case of Luna for the Rathaus fountain in Lüneburg or Minerva, goddess of wisdom, for Georg Labenwolf's fountain of 1576 for the Hochschule (former university) in Altdorf near Nuremberg.[68] Mythic figures associated with water were popular, such as the *Siren Fountain* in Bietigheim an der Enz of 1557 and the many Neptune fountains, two of which will be discussed below.[69] (figs. 183 and 210) In a few towns genre images, such as the a bagpipe player and a man carrying geese, both in Nuremberg, or a fool, as in Ettlingen (1549), were erected.[70] (fig. 184) Surprisingly, fountains with civic allegories, such as the *Schöner Brunnen* of about 1390 in Nuremberg, are largely absent in the sixteenth and early seventeenth centuries. Wurzelbauer's *Fountain of the Vir-*

183. Hans Daucher(?), *Neptune Fountain*, 1536–37, Augsburg, Jakobsplatz

tues, dating 1583–89, in Nuremberg and the later *Fountain of Justice* of 1611 before the Rathaus in Frankfurt am Main are the rare exceptions.[71] (figs. 190 and 191)

The most complex of these Renaissance fountains is in Mainz.[72] (fig. 182) Cardinal Albrecht von Brandenburg gave his archepiscopal city a new sandstone market fountain in 1526. Its design is quite distinctive when compared with the examples discussed above. Three large pillars, ornamented with pilaster reliefs, rise up from the circular basin to support the elaborate crown or three-sided superstructure, that at its apex stands over seven meters above the street. The form derives from *Brunnenhäuser*, small buildings covering a fountain or a well. The statues and reliefs have little association with the functional purpose of the fountain or with dispensing water. Instead, Albrecht chose this design to communicate with his subjects. The fountain, replacing an earlier one, is located literally in the shadow of the church, specifically in the market before the main entrance to the cathedral.

The two lintels facing the church bear prominent inscriptions that explicate the meaning of the fountain. In the first, Albrecht is identified as the donor and as the "zealous guardian of the lord" who will repay his subjects' love with his own love. The second text, visible in our illustration, reads

> At the time, when Emperor Charles V, universal ruler ("Mehrer") of the realm, defeated the King of France at Pavia, who was himself imprisoned, and (the year that) the unfortunate peasant conspiracy in Germany was annihilated, had Cardinal Albrecht, Archbishop of Mainz, restored this fountain, which the ages had decayed, for the use of his citizens and their descendants. In the year 1526.[73]

Three messages for his subjects are contained here. First, Albrecht stresses the power of the emperor and the empire to which he serves as the archchancellor. In 1525, imperial forces routed Francis I at Pavia, thus dashing the hopes of any German groups, particularly the fledgling Protestant movement, who had sought an alliance with France against the young emperor. Second, he alludes to the suppression of the peasant revolt, one of the gravest challenges to his political authority.[74] In

1525 organized groups of peasants roamed portions of Germany seeking more freedom, such as the abolition of serfdom, more personal rights, and the power to select their own priests. Many town residents voiced their sympathy. One such public meeting was held in Mainz on 26 April. Alarmed by the advances of the Odenwald-Neckar Valley band, Albrecht's regent, Wilhelm von Honstein, bishop of Strasbourg, tried to rally regional militias. When his call went largely unheeded, he was forced to accede to peasant demands and sign the Treaty of Miltenberg on 7 May 1525. During this period, Albrecht resided in Halle. The revolt's success was short lived and, in the case of Mainz, on 1 July civic officials had to transfer weapons and certain rights, such as the freedom to select the leaders of local brotherhoods and guilds, to episcopal authorities. Albrecht, who returned to Mainz for the imperial council meeting on 14 November 1525, now enjoyed greater powers than he had prior to the rebellion. Mainz was punished but not severely since it had not actively revolted against Albrecht. Thus the inscription on the fountain reminds all, including the peasants from the countryside surrounding the city who sold their wares in the market place, of the archbishop's sovereign authority. And third, the cardinal states that the level of his love is tied directly to the reciprocal affection of his subjects.

These messages are generally reiterated in the carvings, which Lühmann-Schmid has convincingly attributed to Peter Schro, the author of the Halle apostles, and his workshop.[75] The sculptures of the crown of the fountain affirm episcopal authority. The Virgin Mary stands at the apex. Below, set within shallow shell niches are Sts. Martinus (Marinus), the cathedral's first bishop (mid-fourth century) and titular saint, Bonifatius (d. 754), bishop of Mainz and the apostle of Germany, and Ulrich (d. 973), bishop of Augsburg.[76] The first two are specifically tied to the early history of the diocese. Ulrich, whose bishopric later joined Mainz' episcopal see, was revered as a *Quellen* or source protector who insured the purity and the abundance of the fountain's water. Albrecht may also have included Ulrich here because his biography offered an apt parallel to the recent peasant uprising. In the summer of 955 an invading Hungarian army marched through Bavaria and Swabia.[77] Bishop Ulrich ral-

lied the defense of Augsburg, which withstood the Hungarian siege, and helped King Otto I defeat them at the battle of Lechfeld. Otto I rewarded Ulrich by permiting the bishop to mint coins and to establish a market in Augsburg. Was it coincidental that Archbishop Albrecht, who had recently "saved" Mainz from another horde, erected the new fountain in the marketplace immediately before the mint? Directly above the two inscriptions are lavish and beautifully painted displays of Albrecht's full coat of arms and his cardinal's hat perched delicately upon a decorative scroll that leads up to the three saints. The shields are held by fantastic harpy-like creatures; angels or putti hold three other shields at the corners of the crown.

Each of the three piers is adorned on three sides with pilaster reliefs. The formula includes grotesque designs and daily objects in the form of trophies, such as crossed wooden spoons, a hoe with a rake, flails and pitchforks, and an owl and an empty purse. Although these and the bunches of flowers might simply allude to the market place, specifically to the wares and farming tools, a reference to Albrecht's trophies, a victory over the peasants, is also implicit. The cardinal and Peter Schro may have been inspired by Albrecht Dürer's *Peasant Memorial*, published in 1525, with its statue of a brooding seated peasant, with a sword stucking in his back, atop a column composed of farm implements and drinking vessels.[78] A *memento mori* reference appears on another relief. The text "O BEDENCK DAS END" reminds the viewer of the brevity of human life, a point reinforced by the accompanying hourglasses and skull. The overall program stresses Albrecht's authority as earthly vicar for Christ and the Virgin Mary, heir to the *cathedra* of Sts. Martin and Bonifatius, protector of his flock, and victor over his foes. Furthermore, it recalls that the affairs of the market place, as an emblem of life, are transitory. Eternal riches come only through the church. In Mainz, as at Halle, Albrecht carefully enlisted art in his quest for authority and fame.

This bond between politics and a civic fountain was not limited to Mainz. On 26 February 1537 Bishop Christoph von Stadion and the Augsburg cathedral chapter wrote to Emperor Charles V expressing their outrage that the city government had removed the statue of St. Ulrich that had long adorned the Fish Market fountain located before the Perlach tower, and, to make matters worse, had replaced it with the pagan ("Abgott") Neptune.[79] For the embattled bishop this was further proof of Protestant perfidy, just a month after the devastating iconoclastic riots in the city, as we have seen in Chapter Two. The statue of Neptune survives and today stands in the Jakobsplatz next to the Fuggerei.[80] (fig. 183) The 1.75 meter-tall bronze Neptune holds a trident in his right hand and a dolphin rests upon his left. The original configuration of the rest of the fountain is uncertain since it was later transferred to make way for Hubert Gerhard's *Augustus Fountain*. (fig. 181)

Although this figure pales in comparison with the famous Neptune fountains in Italy, such as Giambologna's masterpiece of 1567 in Bologna, its modernity must be viewed instead in the context of contemporary German art. This is the oldest extant, life-size bronze nude. The artist has gamely attempted to instill a feeling of monumentality by means of Neptune's broad proportions and striding posture. The simple elegance of the body, however, contrasts with the fussy detailing of the face, most notably in the beard and hair. It is this that suggests the artist was not wholly comfortable working on such a large scale, which would hardly be surprising given the paucity of opportunities. In spite of being free-standing, Neptune is designed primarily for a frontal view, as little attempt to animate the side or rear views is evident. Was the artist normally a relief sculptor? Both of these characteristics, I think, support an attribution to one of the local sculptors known for his small reliefs. The prime but by no means certain candidate is Hans Daucher, who has been suggested by Fleischhauer.[81] The model for the fountain must have been finished in early 1536, at the latest, since the bronze statue was placed in February 1537. The dates would conform with what we know about Daucher's final years before his death in 1538. Daucher left Augsburg sometime prior to 21 September 1536 when he is documented in Stuttgart as court sculptor to Duke Ulrich von Württemberg. Bishop von Stadion's complaints not withstanding, Neptune was but the first of a group of "pagan" bronze fountain statues that would be erected in Augsburg during the succeeding century. In fact, another statue of a kneeling Neptune

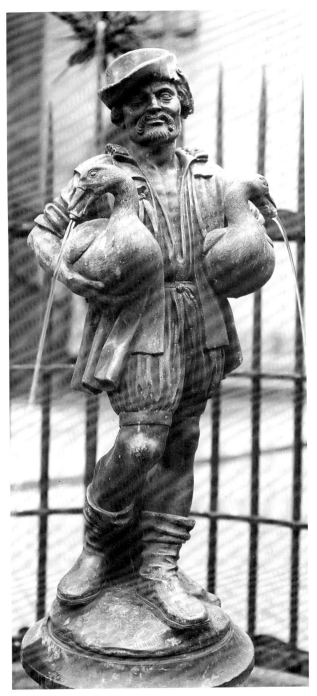

184. Nuremberg Artist (cast by Pankraz Labenwolf), *Geese Bearer Fountain*, c. 1540, Nuremberg, originally in the Obstmarkt

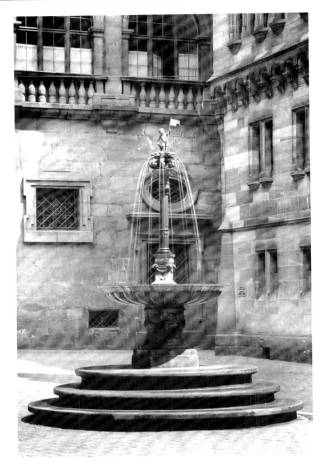

185. Hans Peisser(?) (cast by Pankraz Labenwolf), *Putto Fountain*, 1549–57, Nuremberg, Courtyard of the City Hall

stood, perhaps as early as 1551, before the church of St. Ulrich and Afra.[82] This one offered a compromise between secular and religious themes, since the column included reliefs of the two saints.

Few cities erected fountains with bronze statues as large as the Augsburg *Neptune*. More typical are the *Geese Bearer* and *Putto Fountains* in Nuremberg whose figures measure 69 and 36 centimeters respectively. (figs. 184–186) Like most German founders, Pankraz Labenwolf, who probably cast both of these figures, preferred working on small-scale statuettes. This permitted greater attention to details, such as facial expression, costume, and pose.

The *Geese Bearer Fountain* is currently situated just south of the Rathaus, but originally stood

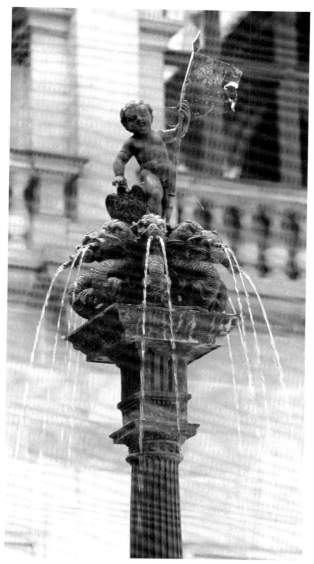

186. Hans Peisser(?) (cast by Pankraz Labenwolf), *Putto Fountain*, detail, 1549–57, Nuremberg, Courtyard of the City Hall

the aftermath of the Peasant Revolt of 1525, a civic fountain celebrating the peasant would be unthinkable, even though Nuremberg had gone to great lengths to mollify its rural peasants by repealing head taxes, the small market tithe, and the *Marktgeld* fee. Rather the Geese Bearer is an icon of the honest, hard-working farmer as signified by his physical strength, rolled up sleeves, and straightforward gaze. He is a prosperous "Ackersmann" or small land owner who has an economic interest in the city's peaceful growth. He has brought two fat geese to market for sale. The quality of his wares may also illustrate his expertise. The Netherlandish folk expression "De Man een vogel, de boer een gans" ("For most people a bird is a bird, but the farmer knows his goose") certainly has a German counterpart.[85] In a city dedicated to mercantile success and to the tight control of its population, including residents in the surrounding countryside, this fountain statuette portrays the city government's ideal image of the farmer who prospers by his labor. The *Geese Bearer Fountain* offers a dignified model or mirror of conduct for those farmers and peasants vending their wares in the market place. And for the urban consumer, who might remember the events of 1525, the statue presents a reassuring, pacific picture. The Geese Bearer embodies too the virtue of concordia, the symbiotic cooperation of rural and civic populations. The farmers depend upon the city for sales and, conversely, the city relies upon its farmers for foodstuffs. In 1552 Hans Lautensack prepared two great etched views of Nuremberg that further developed this theme of mutual benefit through peaceful cooperation.[86]

No documentation exists about the artists of the *Geese Bearer Fountain*. Pankraz Labenwolf, who emerged as Nuremberg's foremost founder in the 1530s following the deaths of the leading members of the Vischer family, likely cast this brass statue. There exists little agreement about the sculptor, whom Bange simply labelled the Master of the Geese Bearer. His lindenwood model survives and today is displayed in the Stadtmuseum Fembohaus in Nuremberg.[87] Pechstein has suggested Hans Peisser; however, none of this master's secure works provides a convincing parallel for the stocky form of this figure and the character of its cutting.[88] The fountain should be dated around 1540 based on the

in the Obstmarkt or fruit market behind the Frauenkirche.[83] The theme is highly appropriate since poultry was also sold at this location. The man holding the geese is finely dressed in short pants, an open shirt with a ruffled collar, a light overcoat, and a fashionable hat. This is not the crude, shabbily attired peasant derided in so many Nuremberg prints.[84] The latter are typically rendered as physiognomic caricatures, often engaged in some form of bodily emission or moral excess. In

style of the farmer. I do not think that it needs to be linked too closely in time with the Rathaus *Putto Fountain* that is inscribed 1557.

If a genre theme was appropriate for Nuremberg's fruit market, something more refined was necessary for the courtyard of the city's Rathaus.[89] (figs. 185 and 186) A graceful putto stands supporting a banner and an armorial shield. Directly beneath his feet are eight coiled dragons with water spouting from their mouths. These figures rest upon a slender fluted brass column and rectangular sockel, which is ornamented on each side by rams heads linked by garlands, plus, below, a large snail rendered in relief. The circular basin with its lobed underside, reminiscent of a goldsmith dish, is supported by a stone base with additional garlands. The delicate balance between the wide basin, the classical architectural elements, and the putto is particularly beautiful.[90]

Pankraz Labenwolf cast this fountain. On the four sides of the sockel is the inscription: "ANNO DOMINI MDLVII PL"; the last year of the date is engraved rather than cast. Labenwolf is also linked with the monument in city documents of 1549 and 1550. Thus the project must have begun by 1549 at the latest and was completed in 1557. Unfortunately, the name or names of the designer and sculptor are not listed. The lindenwood model is still in Nuremberg (Germanisches Nationalmuseum).[91] (fig. 187) The fleshy youth balances on his right foot. The left trails behind accenting the contrapposto of the body. Is the sculptor Hans Peisser? A better, but by no means firm, case can be made for this attribution based on general stylistic similarities between the putto, and the nude children in Peisser's *Caritas* plaquette.[92] Peisser is also documented as the sculptor of the *Singing Fountain* before the Belvedere in Prague, which has some analogies with the Nuremberg putto, though he was working from another artist's design. (fig. 201) Peisser's involvement with fountains is certain even if his association with the Nuremberg fountain is still conjectural.

The artist of the Nuremberg putto seems also to have made the *Fountain of the Planet Deities* now in the courtyard of the Landhaus in Linz an der Donau.[93] (figs. 188 and 189) Technically this might not fall into the category of a public fountain since its original location is unknown, and it was only

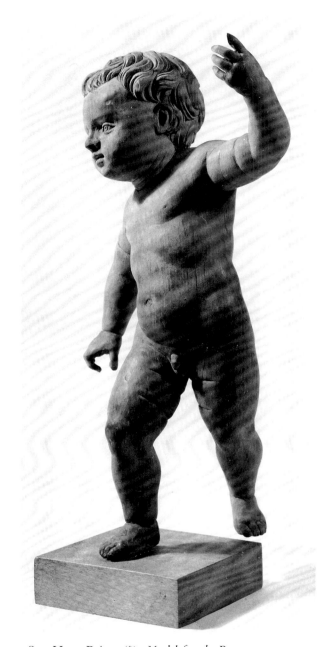

187. Hans Peisser(?), *Model for the Putto*, 1549–50, Nuremberg, Germanisches Nationalmuseum

placed in the Landhaus around 1580. Jupiter, clad as an ancient warrior, stands at the apex of the fountain. Below is a sphere ornamented by three putti riding dolphins and three putti masks. Arranged around the supporting column are six smaller statuettes of Venus, Mercury, Mars, Saturn, Sol, and Luna. The deities strongly recall the en-

1589.[95] (figs. 190 and 191) It stands adjacent to the northwestern corner of St. Lorenz, along the city's major north-south street. Although postdating our terminus of 1580, the fountain stylistically belongs with the art of the 1570s rather than with the more monumental, more Italianate character of contemporary works such as Hubert Gerhard's *Augustus Fountain* in Augsburg. (fig. 181) The iconographic program mirrors the flattering allegories of good government that may also be observed in various editions of the *Reformation*, Nuremberg's published civil legal code, and in the so-called wish medals commissioned by the council.[96] Justice, emblematic of the power of the Nuremberg city council, stands at the top of the column. Six putti bearing the city's coats of arms and trumpets heralding Nuremberg's fame, as well as providing con-

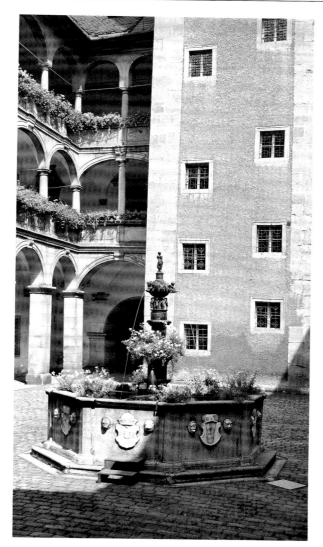

188. Hans Peisser(?), *Fountain of the Planet Deities*, 1530s(?), Linz, Landhaus

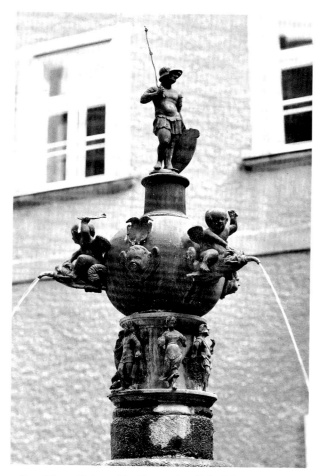

189. Hans Peisser(?), *Fountain of the Planet Deities*, detail, 1530s(?), Linz, Landhaus

graving series of 1528 by the Nuremberg printmaker Master I.B., (B. 11–7) though the Linz figures are much simpler, much less forceful in appearance. The putti, likewise, seem to anticipate the Nuremberg fountain figure. I think that Pechstein is correct in associating the two fountains and in dating the Linz fountain earlier, possibly to the 1530s.[94] The awkwardness of the Linz figures gradually yields to a greater surety of form in the Nuremberg putto.

Nuremberg is also the location of the most complex late Renaissance civic fountain in Germany: the *Fountain of the Virtues* erected between 1583 and

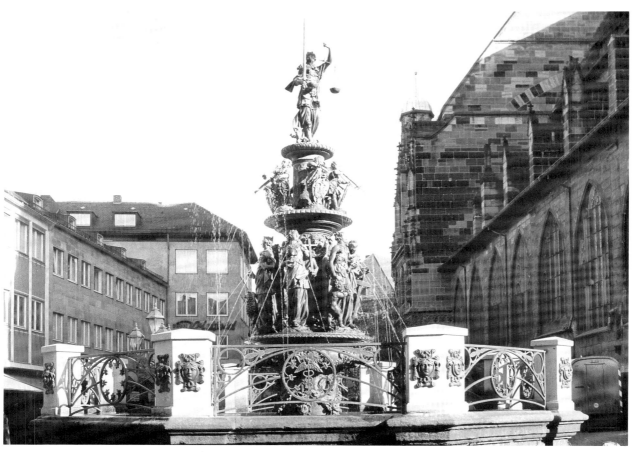

190. Johannes Schünnemann (cast by Benedikt Wurzelbauer), *Fountain of the Virtues*, 1583–89, Nuremberg, adjacent to the Lorenzkirche

duits for the waterspouts, stand around the central column in the second tier. The allegory of good government is completed in the third zone by the statues of the remaining theological and cardinal virtues: Faith, Hope, Charity, Fortitude, Patience (rather than Prudence), and Temperance. The fountain reminds those passing through this busy intersection that Nuremberg's prosperity and safety are the products of the virtuous patrician government. Furthermore, civic or earthly justice, as signified by the fountain, is intentionally juxtaposed with divine justice in the form of the Last Judgment carvings just a few meters south on the west portal of St. Lorenz.

Completing the fountain are garlands, putti heads, shells, and masks that ornament the supporting sockel. Its candelabrum form, highlighted

by a host of secondary figures and the elaborate use of Floris-style masks and strapwork decoration, is highly reminiscent of the intricate designs that Wenzel Jamnitzer made for his fountains and goldsmith works.[97] (fig. 165) Rather than accenting a single figure, as in the *Neptune* and *Augustus* fountains in Augsburg, the author of the Nuremberg monument favors the stacking of interconnecting layers of statues, each enriching the whole while simultaneously competing for the viewer's attention. Other than the distinctions provided by their symbols and varied poses, the lower six virtues are nearly identical. Each has a round face, short curly hair, and a highly mannered costume highlighted by the strapwork corsets enframing their naked breasts through which water flows.

Benedikt Wurzelbauer (1548–1620), grandson

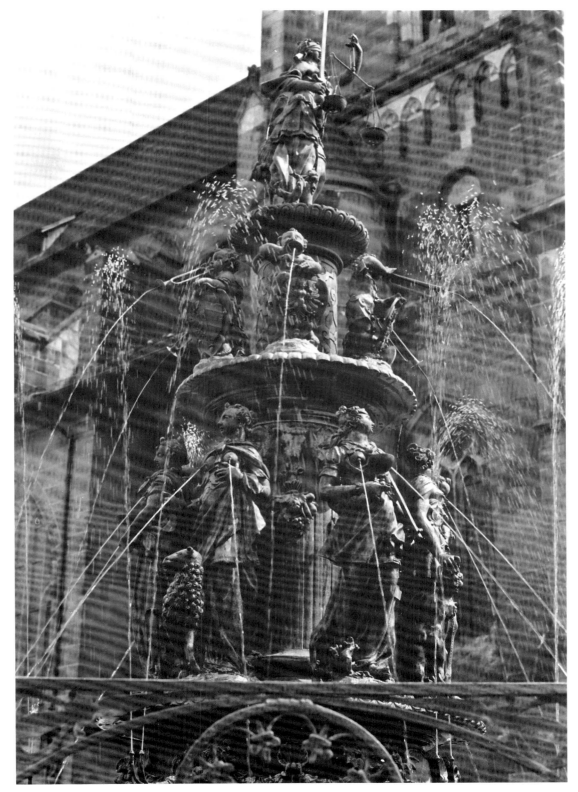

191. Johannes Schünnemann (cast by Benedikt Wurzelbauer), *Fountain of the Virtues*, detail, 1583- 89, Nuremberg, adjacent to the Lorenzkirche

of Pankraz Labenwolf, cast and proudly signed the brass fountain. The designer is unknown though it was probably neither Wurzelbauer nor Johannes Schünnemann, the rather anonymous sculptor of the wooden models who three decades later is documented working in the Dutch town of Bolsward. During his long career, Wurzelbauer would produce numerous fountains, each done in a slightly different style reflecting the fact that he always depended upon models supplied by an ever-changing group of sculptors. The *Fountain of the Virtues* seems to have been his first independent project. Was the fountain originally intended to be cast by Wurzelbauer or Georg Labenwolf, his uncle and teacher? Its inception corresponds with the last years of Labenwolf's life. Upon the latter's death in 1585, Wurzelbauer assumed control of the family workshop. Having proved his talents while assisting his uncle in the production of the *Neptune Fountain*, commissioned by King Frederik II of Denmark between 1576 and 1583 for the courtyard of Kronborg Palace, Wurzelbauer could have secured the Nuremberg either on his own or because of the busy schedule and failing health of his mentor. (figs. 210 and 211)

This Danish project, which will be discussed at the end of this chapter, provided the closest compositional and stylistic model for the Nuremberg fountain. Both consist of a single column enveloped with statues that rise from the center of an octagonal basin. Minerva, one of the three surviving figures from the Kronborg fountain and now in Stockholm (Nationalmuseum), was apparently cast after a wooden model carved by Lienhard Schacht of Nuremberg. In spite of the differences in sculptors, basic similarities link the figures of these two fountains. In particular, the clinging draperies with long, thin folds and gatherings of fabric at the bottom of the surcoat, the stress upon the bared breasts, and the slight striding pose are common to both groups of figures. The distinctive characteristics of the two sculptors are also evident. For instance, Schacht's Minerva is far more substantial; his understanding of anatomy and proportion is better than that evident in the Nuremberg virtues. Nevertheless, I feel that these shared traits, coupled with the similarities of the overall form of the fountains, point to a common designer for both ensembles. Two possibilities include the aging

Wenzel Jamnitzer, whose genius often strayed beyond the strict boundries of goldsmith work, and Johann Gregor van der Schardt, the Nuremberg-based sculptor who collaborated earlier with Jamnitzer and who is documented as working for Frederik II. The latter would be the most likely but, unfortunately, no evidence exists to substantiate his activities as a designer of complex works to be carried out by others. Furthermore, his whereabouts after 1581 are unknown though he may have been working either for Paulus Praun in Bologna or for various Danish patrons.

The concept of an artistically significant civic fountain grew in popularity during the sixteenth century. These symbols of local pride were often invested with special meanings directed to the populace. In Mainz, visitors to the marketplace were reminded both of archepiscopal power and the failure of recent rebellions, while the *Fountain of the Virtues* articulates the ideal of good government as practiced by the Nuremberg city council. This custom became more common in the seventeenth and eighteenth centuries and, to a degree, persists into the present. The *Augustus Fountain*, commemorating the historic origins of Augsburg, Hoffmann's *St. Peter Fountain* in Trier with its counter-Reformation message, or the *Justice Fountain* that Johann Hocheisen erected in 1611 before the Rathaus in Frankfurt am Main exemplify the growing popularity and sophistication of such fountains.[98]

Garden Fountains

One of the most fascinating developments in sixteenth-century German art was the rapid evolution of the garden fountain.[99] After 1550 the impetus increasingly came from princely emulation of Italian pleasure gardens as lavish *Lustgärten* with fountains were constructed in Prague, Innsbruck, Vienna, Munich, Landshut, Stuttgart, and other locales. While garden fountains figure prominently in late medieval and early Renaissance literature, most notably in chivalric romances, extant contemporary examples are virtually non-existent. Our knowledge of fountain forms depends almost exclusively upon secondary representations normally in other media. Albrecht Altdorfer devoted half of his

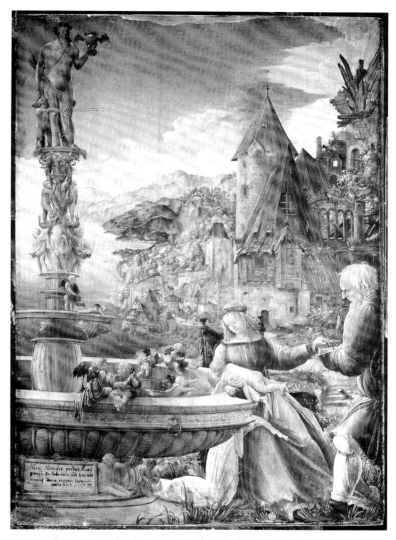

192. Albrecht Altdorfer, *Rest on the Flight into Egypt*, 1510,
painting, Berlin, SMBPK, Gemäldegalerie

Rest on the Flight into Egypt painting of 1510 in
Berlin (SMBPK, Gemäldegalerie) to a huge foun-
tain set in the countryside that provides temporary
comfort to the fleeing Holy Family. [100] (fig. 192)
Here Mary and the Christ child, themselves sym-
bolic of the Well of Living Waters (Song of Songs
4:15) and the Fountain of Life (Psalm 36:9), refresh
themselves by the double-basin fountain with its
pagan gods and putti ornamenting the central col-
umn. Altdorfer, who upon becoming the city ar-
chitect of Regensburg in 1526 may have con-
structed actual fountains, based his design on
Italian prints by Zoan Andrea and the Tarocchi

Master, on contemporary German examples, and
upon his own invention.

Most depictions of garden fountains are asso-
ciated with themes of love and leisure. In Loy Her-
ing's small relief, dating around 1525 and now in
Berlin, a group of naked men and women are set in
a park-like environment highlighted by a broad,
single-basin fountain with a statue of a putto hold-
ing a dolphin. [101] (fig. 193) Venus and Amor stand
on top of the tall, slender column in the middle of
the pool in Lucas Cranach the Elder's *Fountain of
Youth* painting of 1546 in Berlin (SMBPK, Ge-
mäldegalerie), while Erhard Schön's woodcut of the

193. Loy Hering, *Garden of Love*, c. 1525, Berlin, SMBPK, Skulpturengalerie

194. Victor Kayser, *Susanna and the Elders*, c. 1530, Berlin, SMBPK, Skulpturengalerie

same theme shows a fool pissing downwards from the apex of another column fountain with two wide basins.[102] Simpler fountains than the latter can be observed in contemporary scenes of the Judgment of Paris, David watching Bathsheba, the Prodigal Son, and the parable of the rich man and Lazarus.[103] Another popular biblical theme that often includes a fountain is Susanna and the Elders. In Albrecht Altdorfer's painting of 1526 in Munich (Alte Pinakothek), a triple basin, candelabrum type of bronze fountain with a statuette stands on the plaza.[104] In his preparatory drawing (Düsseldorf, Kunstmuseum), the artist originally placed the fountain in the center of the action immediately adjacent to the stoning of the Elders. In Victor Kayser's Berlin relief of the same theme, dating around 1530, the two elders confronting Susanna are oblivious to the explicit warning against their lustful behavior offered by the nearby fountain with its column figure of Moses holding the tablets of the law.[105] (fig. 194) The body of Susanna obscures the lower part of the fountain that likely continues down into the bathing pool. Otherwise, the upper portion is a variation on the shape observed in the *Cleopatra Fountain* in Berlin. (fig. 167)

How many similar metal and stone garden fountains actually existed? An exact number will never be known; however, if the quantity and range of designs illustrated in these and a host of other pictorial images are based upon something other than just the imagination of their artists, then at least a small corpus was on view in patrician and noble gardens. Appreciation for these fountains as an art form grew steadily until by the 1570s they had become a requisite decorative feature for the expanding number of private gardens. In this section, I wish to examine a few of the major examples that prompted this development.

In 1532 Peter Flötner's *Apollo Fountain* was placed in the shooting yard of Herrenschiesshaus am Sand in Nuremberg.[106] (figs. 195 and 196) The imposing archers' company house that Hans Dietmair erected on this site in 1582–83 and at least portions of the practice yard on the north side still stand.[107] The appearance of the original house is

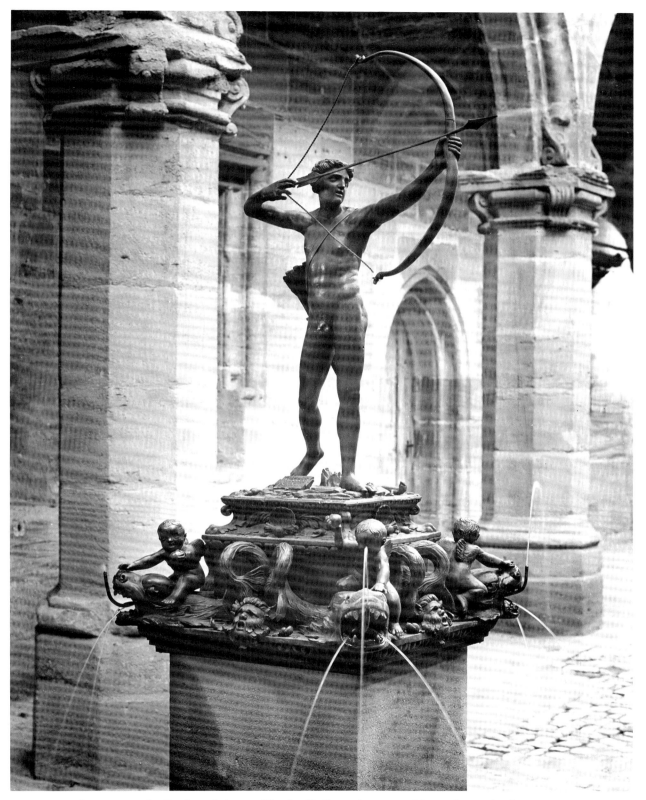

195. Peter Flötner (cast by Pankraz Labenwolf), *Apollo Fountain*, 1532, Nuremberg, Stadtmuseum Fembohaus

196. Peter Flötner (cast by Pankraz Labenwolf), *Apollo Fountain*, detail, 1532, Nuremberg, Stadtmuseum Fembohaus

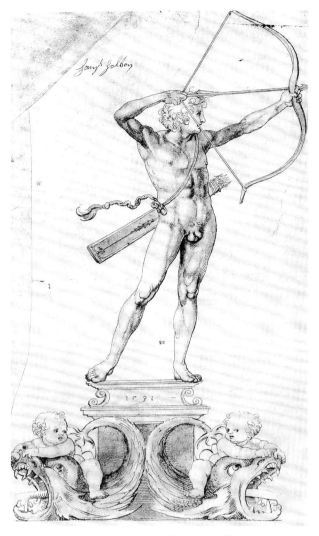

197. Peter Flötner, *Design for the Apollo Fountain*, 1531, drawing, formerly in the Collection of the Grand Duke of Weimar

unknown though the shooting yard was probably not too different. In Hieronymus Braun's monumental drawn plan of Nuremberg, dating 1608, and, more clearly, in a colored miniature in the company's *Schützenbuch* of 1682, Flötner's fountain is shown located in the center of a rectangular pool surrounded by a stone balustrade and, to the north, a small formal garden.[108] With the suppression of the company in 1798, the fountain soon began its migration around the city. Today it is situated in the Stadtmuseum Fembohaus.

The fountain is inscribed MCCCCCXXXII but not signed. In 1547 Johann Neudörfer wrote that it was by Peter Vischer the Elder, who, however, had died in 1529. The correct attribution to Flötner occurs in the correspondence between Cardinal Bernardo Cles, bishop of Trent, and Nuremberg patrician Dr. Christoph Scheurl in 1531–32, a subject that we shall return to shortly. Flötner first prepared a presentation drawing. This was presumably the sketch of 1531 formerly in the collection of the duke of Weimar.[109] (fig. 197) The graceful figure of Apollo drawing his bow stands upon a pedestal ornamented with two matched putti astride sea dragons. The theme was inspired by Dürer's *Apollo and Diana* engraving (B. 68) of about 1502–3 and, more specifically, by Jacopo de' Barbari's engraving of the same subject done in about 1503–4, during the Italian artist's stay in Germany.[110] Copies of this print were certainly available in Nuremberg

where de' Barbari lived in 1500–1 and occasionally during the next several years. Apollo's stance, with the weight placed on his right leg, derives directly from de' Barbari's engraving. Interestingly, Flötner altered his final design. In the statue Apollo has lowered the bow to a more correct shooting position with the string being held by the index and middle finger just behind the right ear, a change certainly requested by Flötner's patrons, the archers' company. Apollo now has the correct sighting line. The arrow sheath, diagonally arranged in the drawing, has been altered to a more static verti-

cal orientation along the body, a solution that derives again from de' Barbari's engraving. The configuration of the base has also been adjusted since Apollo now stands upon a rocky ground with shells and lizards cast from life. Flötner varied the poses of the putti, who hold fruit or balls, and the lines of the sea-dragon tails, which now frame grotesque male masks.

Once Flötner had prepared the wood and wax models, the different sections were cast in brass by Pankraz Labenwolf. The two artists collaborated frequently during these years as already observed in the Silver Altar and the design for a table fountain. (figs. 24 and 178) Labenwolf's interest in casting lizards and other small natural forms from life is first evident in the *Apollo Fountain*. Like most Nuremberg brasses, the entire ensemble is characteristically small in size, as Apollo is 77 cm high and the whole ensemble, minus the pedestal, measures only one meter tall.

Nevertheless, the impression given by the Apollo figure is one of pursuasive naturalism and monumentality. Flötner offers an exquisitely believeable pose in which the entire body tenses under the strain of aiming and drawing the bow. The effect is equally powerful from the back or sides of Apollo, as the artist successfully conceived of a figure physically unified in its action. His careful attention to the lines of the body and the subtle handling of the musculature surpass the nudes of Peter Vischer the Younger and other contemporary German artists. By comparison, the *Neptune Fountain* in Augsburg seems awkward and, despite its greater size, less monumental. (fig. 183) Flötner's Apollo interacts with its immediate environment, most obviously in the foreward direction where the god's gaze and soon his arrow are directed. It activates the surrounding space; Neptune does so only marginally in the frontal position.

Flötner's *Apollo Fountain* also signals the growing sophistication of German patrons, here Nuremberg patricians. The embrace of classical themes and Italianate designs occurred much later in German sculpture than it did in painting or prints. Yet the Vischer family and gradually masters in other towns embraced these new ideas. By the 1530s Flötner capitalized upon this growing acceptance by creating very modern sculptures, by German standards, both here and in a host of other projects,

such as the decoration of the new garden room for Leonhard Hirschvogel's house in Nuremberg. (fig. 212)

The modernity of Flötner's art was also recognized by his contemporaries, including Cardinal Bernardo Cles. On 27 September 1531 the cardinal wrote to Dr. Christoph Scheurl, the legal advisor to the Nuremberg city council, stating that he wished to erect a new fountain at Buonconsiglio, his episcopal residence in Trent.[111] He specified that it should be neither too large nor too costly. It must, however, be an attractive fountain in the new— that is, Italianate—style ("auf ain New lustige manir . . ."). During the next two years extensive correspondence was exchanged between the cardinal and Scheurl, acting as his agent. Two drawings were soon dispatched. On 16 October the cardinal acknowledged their receipt while recording his disappointment. He wished for a design that was even newer in style ("sunders newes"), such as the fountain on the shooting yard in Nuremberg ("so bey Euch zu Nürnberg auf der Schiessstatt oder Schiessgraben stet"). He was, of course, referring to the *Apollo Fountain*. Since this was still being cast, Cles either knew it personally, perhaps from a brief visit to the city, or, more likely, from a description by Scheurl or another acquaintance. On 15 May 1532 the cardinal wrote that he was returning two drawings, one of which was of the *Apollo Fountain*, possibly the very drawing discussed above, and a second of a lavish chair that "Meister Peter Flettner" had made.[112] (See fig. 268) This is one of the rare documented instances of a drawing for one project being sent to another patron for consideration, specifically as a demonstration of style, and then carefully returned. By 28 June a new drawing had been examined by Cles who instructed Scheurl to consult further with Flötner or another sculptor.[113] It is likely, but not definite, that Flötner created the sculptural models that Pankraz Labenwolf then cast. The cardinal sent payment through the Fuggers to Scheurl, and by 9 August 1533 all the accounts were settled.

Cardinal Cles's fountain, intended for the middle of a long doorless wall of the cortile dei Leoni or lion courtyard, does not survive. This garden setting was admired by the poet Mattioli, who in 1539, the year of the cardinal's death, published a laudatory description of the Trent palace.[114] He de-

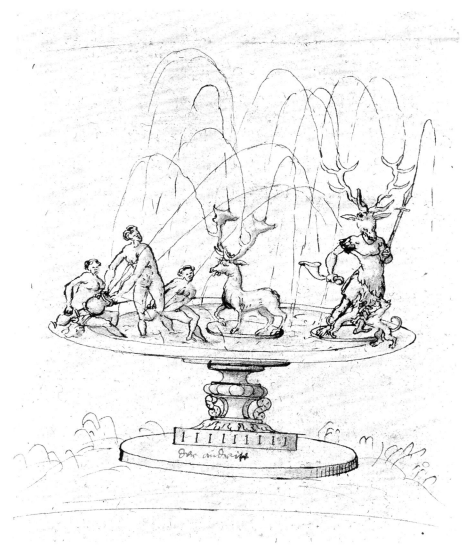

198. *Design for an Acteon Fountain*, 1570s, drawing, Vienna, Kunsthistorisches Museum

scribes the fountain as an attractive work of casting and sculpture. At the top of the column stood Apollo and Daphne. In a letter of 15 May 1532 the cardinal specified that he wanted water to spout from the tree branches, probably a reference to the metamorphosis of Daphne into a laurel tree.[115] Four children on larvae, grouped around the column, spout water into the white marble basin below. In the basin were statuettes of Diana and her nymphs bathing, plus Acteon hunting deer. An unrelated drawing of the 1570s in Vienna provides some idea of what this section of the fountain might

have looked like, though the figures would have been considerably smaller and only a half or three-quarters basin was used since it was mounted into the wall.[116] (fig. 198) This shows Diana throwing water upon Acteon as punishment for his having viewed her bathing. His transformation into a stag, paralleling that of Daphne above, is already attracting the attention of his hunting dogs. The Trent basin rested upon four intertwined marble dolphins. To either side of the fountain stood marble lions with their forepaws upon the rim of the basin as if lapping up water. Today only these two lions,

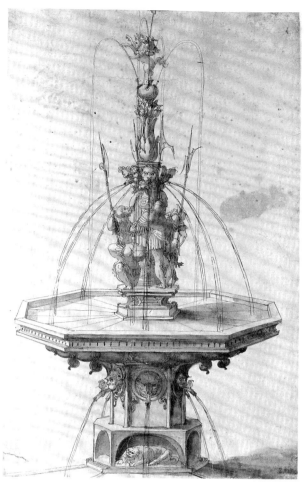

199. *Design for a Fountain*, c. 1550, drawing, Berlin, SMBPK, Kupferstichkabinett, KdZ 5515

at Neuburg an der Donau. Early in this century Habich suggested that an attractive bronze basin then standing in the Marstallplatz behind the Residenz in Munich was the Neuburg fountain.[119] The decorative designs (masks, dolphins, acanthus leaves, etc.) plus the medallions with Roman emperors busts and cavorting centaurs of the frieze of the pedestal are thoroughly consistent with Flötner's art. The sculptor may have provided the overall design or, at least, general patterns for the Neuburg fountain.

A decade or so later, an unknown, probably south German artist produced the design for a fountain, now in Berlin (SMBPK, Kupferstichkabinett).[120] (fig. 199) It beautifully contrasts the basic clarity of the fountain structure, specifically the firm base, octagonal basin, and central column, with the intricate figural arrangement. The rearing horse threatening to throw its rider is considerably smaller than the soldiers below, a reverse of the normal scale relationship in which the upper statues are larger. The imbalance of the horse is continued in the contorted poses of the classically dressed soldiers. Some dramatically bend on one knee; others gape upwards at their comrade on the wild horse; and at least two twist sharply as they attempt to scale the column, perhaps to try their luck at riding the steed. The refinement of the composition and the careful finish of the drawing suggest this was a presentation sketch, analogous to Flötner's *Apollo* of 1531. Unfortunately, nothing further is known about whom it was intended for or whether it was actually constructed.

The patronage of Emperor Ferdinand I and especially his sons, Maximilian II, the later emperor, and Ferdinand II, archduke of Tirol spurred the development of the pleasure garden highlighted by complex fountains. From the 1560s onwards, new fountains were commissioned for their residences in Prague, Innsbruck, and Vienna. Characteristic of their interest is the fascinating but heavily damaged solnhofen stone relief, dated 1560, by Severin Brachmann in Vienna (Kunsthistorisches Museum).[121] (fig. 200) Maximilian II and his wife Maria, daughter of Charles V, face each other within an open garden pavilion. Behind them is a bucolic park populated with deer, goats, and other more exotic animals, including an elephant and a camel. In the center of this fashionable building

not by our Nuremberg artists, are still in Trent. Various attempts to identify existing Acteon figures, such as the fine but later(?) example in Innsbruck (Ferdinandeum), with the Trent fountain are not persuasive.[117] In addition to the *Apollo and Daphne Fountain*, Mattioli reports that another Neptune Fountain stood in the center of the courtyard.[118]

Garden fountains, such as those in Nuremberg and Trent, slowly gained in popularity. Flötner and Labenwolf's further activities in this area are unknown, though the latter continued to cast other types of fountains, including the *Geese Bearer* and the Rathaus *Putto*. (figs. 184–186) In 1535 Labenwolf also collaborated with Sebald Hirder on a fountain for the bath of Ottheinrich's residence

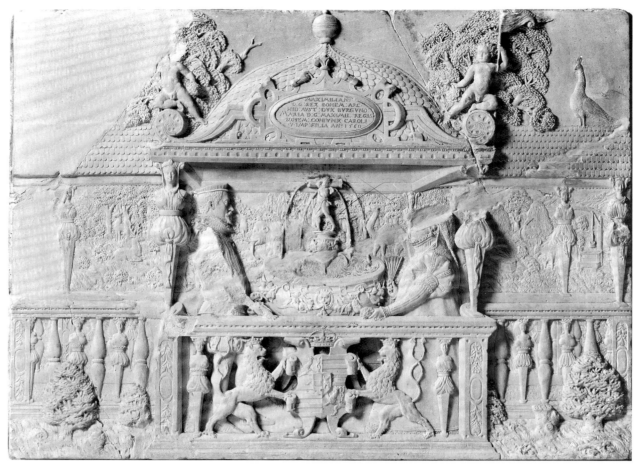

200. Severin Brachmann, *Maximilian II and Maria in a Garden House*, 1560, Vienna, Kunsthistorisches Museum

stands a circular fountain with a statue of Hercules who carries the columns of Gaza. Within this context, the fountain contributes to the lush, Eden-like quality of the scene. Measuring only 23 by 21 centimeters, the relief is a cabinet piece not a plaque intended for a garden setting. Yet with the date of 1560 prominently inscribed above, it might commemorate some event that occurred while the couple was living in Vienna.[122] Maximilian, who had learned to love gardens during his years in Spain, and his wife had at least two retreats.[123] One was erected in about 1556 on Prater Island, formed by a branch of the Danube. Known as Hirschbrunnen, the formal and more natural gardens were laid out adjacent to a lush oak and poplar forest rich with wildlife. The site included a garden house, named the green pleasure house (Grüne Lusthaus), with a dining area and a wall fountain complete with a grotto. The couple also rebuilt Schloss

Ebersdorf, not far from the later Neugebäude, between 1558 and 1561; however, I know of no garden house associated with it. In all likelihood, Brachmann's relief provides a generalized idea of the Grüne Lusthaus at Hirschbrunnen. While the *Hercules Fountain* is obviously not the documented wall fountain, it may replicate an actual fountain or, more broadly, the existence of another small fountain at this location.

In 1563 Archduke Ferdinand II, Maximilian II's brother, commissioned the *Singing Fountain* that still stands in the garden before the Belvedere of the palace in Prague.[124] (fig. 201) The project celebrates the completion of the Belvedere or summer residence that had been initiated by his mother, Anna, in about 1534 and had terminated under his direction in 1563. The fountain was designed by court painter Francesco Terzio.[125] Hans Peisser of Nuremberg carved the wooden models that were

201. Francesco Terzio and Hans Peisser (cast by Thomas Jarosch), *Singing Fountain*, 1563–71, Prague, Belvedere courtyard

cast in bronze by Thomas Jarosch and chased by Antonio Brocco. This international mix of artists was becoming increasing typical of the courts of Central Europe and a significant factor in the rapid dissemination of new artistic ideas. Measuring over four meters high, the fountain was set in 1571. After arriving in Prague in 1561, Peisser served as a court sculptor from 1562 until 1571. With his experience working on fountains, Peisser likely contributed more to the final form of the *Singing Fountain* than just the models. He may have suggested both decorative features and other design elements. At the top of the two-basin, candelabrum-style fountain is a bagpipe-playing putto who stands on a dolphin. Four additional putti, with outstretched arms, ornament the underside of the upper basin. Pan, rendered twice, carries a slain stag while two shepherds stand, arms over their heads, supporting the decorative bulge in the mid-

dle of the column. The use of large figures around the base of the column is reminiscent of the formula observed earlier in the Berlin drawing though now a much more rigid symmetry orders the statues. (fig. 199)

Contemporary with the *Singing Fountain* is the now lost Acteon Fountain that Ferdinand II commissioned for Innsbruck.[126] On 12 November 1564 the archduke sent a colored drawing of the fountain to Innsbruck. Two months later his court sculptor, Alexander Colin, wrote requesting to make changes in the proportions and the poses. Soon afterwards Colin's wax models were cast by Gregor, Elias, and Christoph Löffler of Innsbruck. This was a comparatively simple column fountain with Acteon, half changed into a stag, at the apex with Diana and two standing nude nymphs below; each figure measured less than 30 centimeters. The Acteon drawing, discussed above, was owned by the archduke but its configuration reveals it must have been for another fountain. (fig. 198) Colin's Acteon Fountain was located in the ducal Lustgarten, portions of which still exist adjacent to the Hofburg along the Inn River. The specific placement was in the garden of the ball-game grounds, and views from 1574 onwards record it set within a small fountain house.[127] Parenthetically, Colin created a remarkable number of sculptural decorations for different parts of this garden complex. Between about 1574 and 1578, he made 134 clay statues of gods and animals that Georg Rott polychromed in white for the great pleasure garden. Then from 1579 to 1582 he made 24 great standing images on pillars, seven large clay statues holding bunches of herbs, and 18 small monstrous creatures, all of which were again painted by Georg Rott, for the archduke's private garden.[128]

Colin's activities as a fountain maker were just beginning. On the archduke's recommendation, Emperor Maximilian II ordered seven fountains by Colin for the Neugebäude outside Vienna. Several years after the rebuilding of Schloss Ebersdorf (1558–61), Maximilian had a large pheasant garden constructed nearby. His plans for this site gradually expanded and by 1569 work had begun on the Neugebäude, an elaborate pleasure garden with a small residence, somewhat comparable to an Italian country villa.[129] (fig. 202) This project became an obsession for the emperor. As discussed earlier in this chapter, Wenzel Jamnitzer's allegory of impe-

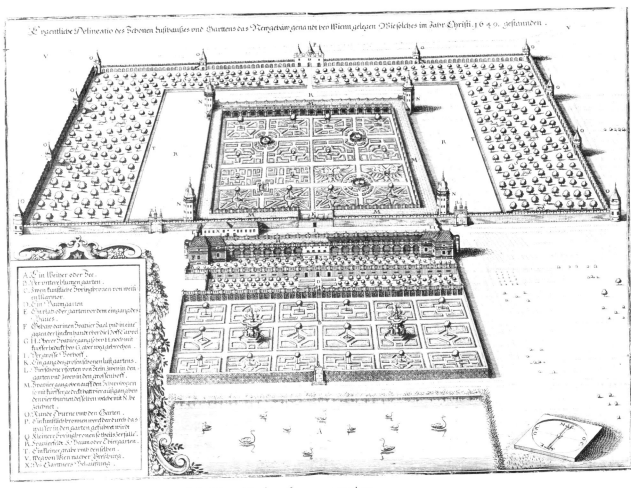

202. Matthäus Merian, *View of the Neugebäude*, 1649, engraving

rial rule was originally intended for the interior of this residence. (figs. 173–176)

In March 1570 Maximilian commissioned the first of Colin's fountains. While the fountain does not survive, a drawing in Innsbruck (Ferdinandeum) by another artist, records its appearance.[130] (fig. 203) The basic form of this white marble fountain recalls that of the *Singing Fountain*. (fig. 201) The lower circular basin is supported by winged nereids while female atlantes with interlaced arms bear the weight of the smaller upper basin. Above, a tall and elegantly graceful statue of a classical-dressed, female water bearer stands holding an urn upon her head. She is accompanied by two putti and, on the rim, two spouting frogs. Colin or whoever supplied the design seems familiar with Italian garden fountains, such as Tribolo's *Fountain of the Labyrinth* at Petraia or its many successors.[131] The

fountain was completed in 1574 at a cost of 1150 talers.

Before Colin had even begun to carve the *Fountain of the Water Bearer*, he received another project for a two-tier fountain with quatrefoil-shaped basins. In this instance a design was sent to Colin who in turn shipped his own sculpted model of the fountain to the emperor at Speyer on 26 August 1570. Colin travelled to Speyer in October to discuss the two fountains with Maximilian. Afterwards he continued on to the Netherlands, likely to his native city of Mechelen, to hire assistants. Marble for both fountains was quarried near Innsbruck. The subject of this second work is unknown. Could it be one of the two quatrefoil fountains illustrated in Matthäus Merian's 1649 view of the Neugebäude? Colin travelled to Vienna in May 1574 to oversee the erection of both fountains.

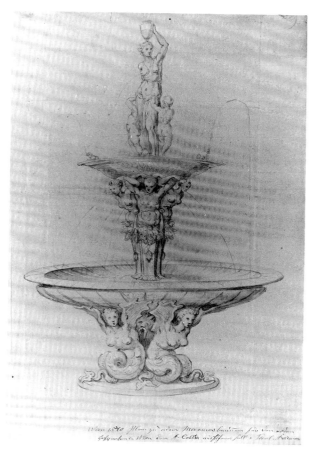

203. *Design for a Fountain with a Water Bearer*,
c. 1570, drawing, Innsbruck, Tiroler Landes-
museum Ferdinandeum

Maximilian was evidently pleased with Colin's efforts since in early 1575 he requested another five marble fountains. With the emperor's death the next year, only the largest of these was ever completed and then only reluctantly by Rudolf II. This fountain consisted of two flat, octagonal basins, the lower of which had a diameter of about two meters, resting on the heads of four reclining lions. The octagonal column is ornamented by four hermae. Fragments of this fountain are today in the Orangerie of Schloss Schönbrunn in Vienna.[132] Unfortunately, nothing is known about the appearance or the subject of the statues above the second basin. Colin's son Abraham brought the completed fountain to Vienna in September 1583.

Just as Cosimo de'Medici's delight in garden fountains spurred their development in Italy from the late 1530s, the patronage of Archduke Ferdi-

nand II and Emperor Maximilian II provided an impetus for their spread in the German lands.[133] Not surprisingly, artists from Augsburg and Nuremberg were involved in many of these fountain projects. Hans Reisinger of Augsburg, who had already cast a bronze fountain with hunters chasing a stag for the court lustgarten in Vienna in 1568, devised a large fountain for the new pleasure garden adjacent to the Residenz in Munich between 1572 and 1575.[134] Although water-circulation problems initially plagued this work, Duke Albrecht V paid Reisinger the amazingly high sum of 12,000 gulden. The casting was done in Innsbruck, where Reisinger was working on the *Tomb of Emperor Maximilian I* in the Hofkirche. The fountain included bronze and, at least, seven stone figures by Caspar Weinhart of Benediktbeuren and perhaps Heinrich Hagart, a pupil of Cornelis Floris, who died during the fountain's erection in Munich. Nothing is known of its appearance since the garden and much of the sculptural decoration of the Residenz would later be changed by Wilhelm V and Elector Maximilian I. Schattenhofer wonders whether the "great metal, life-size female statue" admired by Philipp Hainhofer in 1611 might refer to this fountain since Hubert Gerhard's *Bavaria*, now in the garden, dates to 1615.[135]

Albrecht V's son and heir, Wilhelm V, resided in Landshut between 1568 and 1579 where he hired a group of talented artists including Friedrich Sustris and Carlo Pallago to modernize Trausnitz castle overlooking the city.[136] One task was the construction of a pleasure garden with sculptural decorations. For this Pallago produced at least one stone and bronze-figure fountain in 1575. When artist Joris Hoefnagel visited the castle in 1579, he described this or another fountain being adorned with nymphs or virgins. Geissler has suggested this might be associated with a copy of a Sustris drawing, now in Haarlem (Teyler-Foundation).[137] Here one female sits comfortably in a giant shell as three sea nymphs rest on the basin. Between 1575 and 1578, Pallago might also have supplied the Putto with Dolphin bronzes for another fountain in the garden at Munich.[138]

Interest in fountains was not restricted to southern Germany and the Habsburg courts. Marx Labenwolf of Augsburg delivered a Judgment of Paris Fountain in 1570 or 1571 to Wilhelm IV, count of Hesse, for his pleasure house at Aue near Kassel.[139]

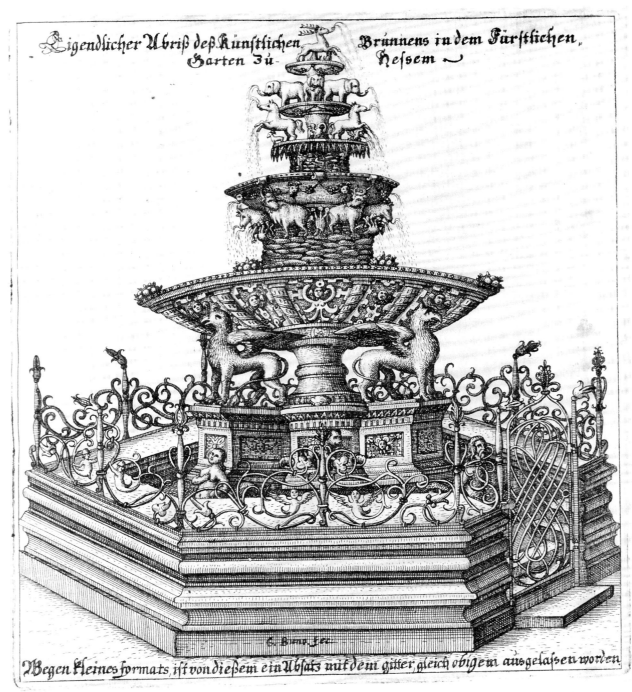

204. *View of the Fountain of the Animals at Schloss Hessen*, 1648, engraving in J. Royer, *Beschreibung des gantzen Fürstlichen Garten zu Hessen* (Halberstadt), Wolfenbüttel, Herzog August Bibliothek

This and the Acteon Fountain, which was erected after 1576, are both lost.[140] Sometime during the 1570s Duke Julius von Braunschweig-Lüneburg (1568–89) commissioned the *Fountain of the Animals* for Schloss Hessen, which is located mid-way between Wolfenbüttel and Halberstadt.[141] An engraved view of this garden fountain was published in 1648 and, luckily, seven of the bronze animals are today in Braunschweig (Herzog Anton Ulrich-Museum) and another, a bull, is in Amsterdam (Rijksmuseum).[142] (figs. 204–206) According to the engraving, the fountain consisted of a hexagonal stone base, apparently with nude male and female figures placed in the pool of water, and a complex candelabrum formula with four basins. Each level is characterized by a different group of animals, beginning with the stag at the top, elephants, rearing horses, bulls, and griffins. The bulls and griffins are placed so that they appear to be supporting their respective basins. Excluding the griffins, the animals are not particularly large, with the horse and bull illustrated here measuring only 32.5 and 21.8 centimeters. If the griffins and the elephants are understandably rather fanciful in appearance, the rest are highly naturalistic with careful attention given to their movements, whether the tension of the horse or the slow yet threatening walk of the bull. The sculptor of these figures is unknown; however, the bronzes were likely cast in the shop of either Marx Labenwolf or Hans Reisinger.

During the 1570s and 1580s Duke Ludwig of Württemberg rebuilt and expanded the pleasure gardens adjacent to the palace in Stuttgart. In addition to erecting the famous *Lusthaus*, seen at the upper right of Matthäus Merian's engraving of 1621, the duke ordered four fountains for the gardens.[143] (fig. 207) The most elaborate was the *Judgment of Paris Fountain*, dating between 1570 and 1575, illustrated in the foreground of Merian's print. This large fountain is characterized by a broad basin and a crowded stacking of bronze figures around the central column, a trait popular with the Labenwolf-Reisinger workshop in Augsburg as observed at Schloss Hessen. In fact, the Stuttgart fountain was likely made by this workshop and might be a replica or recasting of the models used for the *Judgment of Paris* at Aue. Mercury stands at the top of the column. Beneath are a

group of nude nymphs(?) followed by standing female statues who can be identified as Juno, Venus, and Minerva. Not visible but also on this level is Paris seated under a small tree; only this figure, now in Stuttgart (Württembergisches Landesmuseum), is extant.[144] (fig. 208) Below are seated deer, supporting figures, and, on the rim of the basin, frogs.

The Labenwolf-Reisinger workshop's specialization in animals prompted at least one further fountain commission for Stuttgart.[145] In 1573 they completed a bronze fountain with bears dancing in a "vigorous and comical" fashion. The musicians included a monkey playing a three-string fiddle, which is also still in Stuttgart (Württembergisches Landesmuseum). (fig. 209) The configuration of this fountain is uncertain since, in addition to the dance, an "artistically made" hunt with various wild animals plus further frogs, lizards, and snakes amid spraying waters are recorded. This fountain may have been part of a grotto with the statuettes placed within a rustic landscape setting. Dismantled in 1703, some of the figures were transferred to the ducal *Kunstkammer*.

The grandest of all of these princely fountains of the 1570s may have been the *Neptune Fountain* that Georg Labenwolf of Nuremberg created for King Frederik II of Denmark.[146] (figs. 210 and 211) Armed with a design and cost estimates, Labenwolf journeyed to the Danish court probably in the summer of 1576 to discuss the project and to examine the site, the courtyard of Kronborg palace. By fall he had received the formal commission. The production of the *Neptune Fountain* progressed slowly. In 1580 Labenwolf wrote that 70 pieces had been cast. On 17 April 1582, the Nuremberg city council, acting on behalf of Frederik II, issued a stern order to Lienhard Schacht to stay out of the taverns and finish carving the remaining wooden models. Only through this unusual document is the sculptor's name known. The council's edict had the intended result since Labenwolf was able to complete the entire fountain by year's end. In order to test his work and, doubtlessly, to show off his craft, Labenwolf erected the fountain in the Stadtgraben in Nuremberg where it ran for three days much to the delight of the local citizens. On Christmas day Magdalena Paumgartner mentioned this event in a letter to her husband working in Italy. she wrote, "I

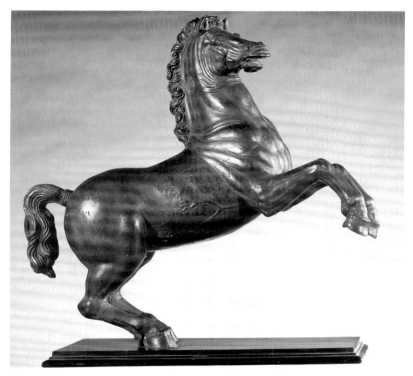

205. Augsburg Artist (cast by the workshop of Marx Labenwolf
the Younger and Hans Reisinger), *Fountain of the Animals*, detail–
Horse, 1570s, Braunschweig, Herzog Anton Ulrich-Museum

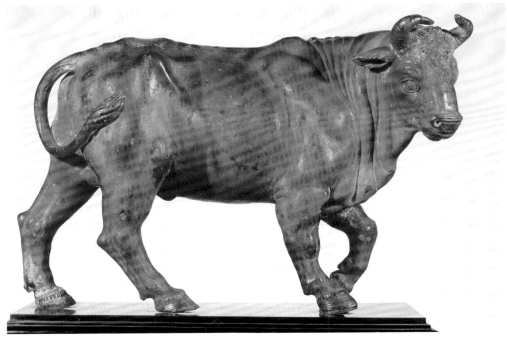

206. Augsburg Artist (cast by the workshop of Marx Labenwolf the Younger and
Hans Reisinger), *Fountain of the Animals*, detail–*Bull*, 1570s, Braunschweig, Herzog
Anton Ulrich-Museum

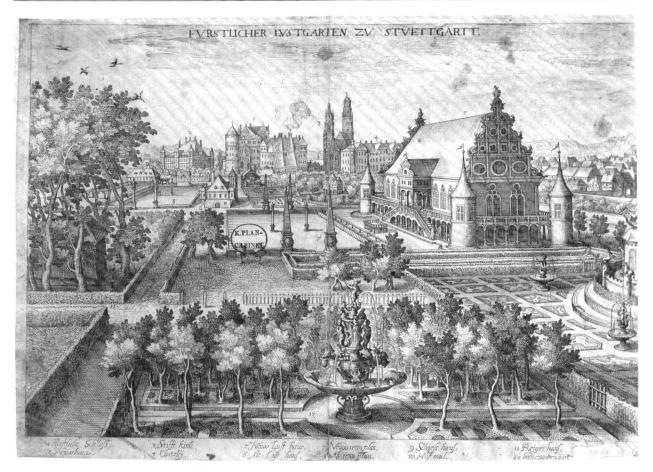

FVRSTLICHER LVSTGARTEN ZV STVETTGARTT.

207. Matthäus Merian, *View of the Lustgarten at Stuttgart*, 1621, engraving, Wolfenbüttel, Herzog August Bibliothek

have also this week gone with your brother and his wife to the Frauen Gate. There, in a canal by the fish stream, a mighty, gushing fountain of pure brass with many waterfalls and spouts has been constructed. We have seen it and you will no doubt have heard about it because it has been built here for the King of Denmark."[147] In March 1583 Georg travelled with the fountain to Kronborg. Interestingly, the city council ordered Georg's nephew and assistant, Benedikt Wurzelbauer, to live in the family foundry until Georg's return. Presumably they wished to guard against the possible theft of trade secrets.

Wolf Jakob Stromer, a young artist who would later become the city's building master, used this occasion to sketch the *Neptune Fountain*.[148] (fig. 210) It consisted of a hexagonal stone basin with a six meter tall column or circular pier culminating

with the figure of Neptune balancing dramatically on just his right leg. Seahorses, putti on dolphins, and sirens adorn the upper portion of the column. Below stand six statues of goddesses including Diana, Minerva, Juno, and Venus, each measuring about 1.5 meters in height. On the concerns of the basin are six hunters or soldiers shooting with guns and bows.[149] Altogether the fountain contained about 36 figures. As noted earlier, the form of this fountain, specifically the placement of figures around a tall, basinless column, was repeated in the *Fountain of the Virtues* cast by the young Wurzelbauer. (fig. 190) A single artist may have been responsible for the designs of both fountains. The *Neptune Fountain* remained at Slot Kronborg less than a century before Swedish troops transported it to Drottningholm palace in 1659. Most of the figures were melted to make church bells. The goddesses Juno,

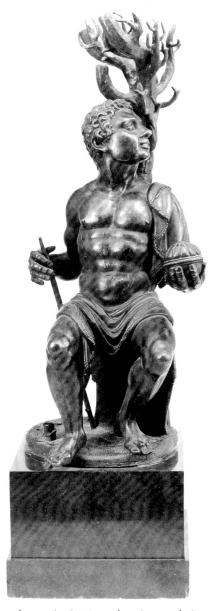

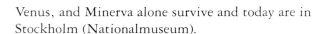

209. Augsburg Artist (cast by the workshop of Marx Labenwolf the Younger and Hans Reisinger), *Fountain of the Dancing Bears*, detail Fiddle Playing Monkey, 1573, Stuttgart, Württembergisches Landesmuseum

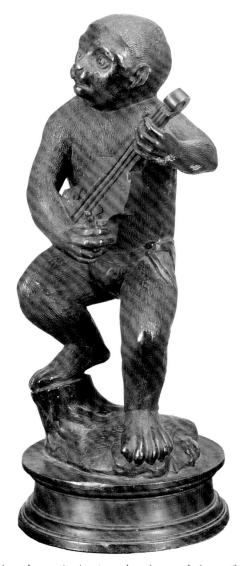

208. Augsburg Artist (cast by the workshop of Marx Labenwolf the Younger and Hans Reisinger), *Judgment of Paris Fountain*, detail—*Paris*, 1570–75, Stuttgart, Württembergisches Landesmuseum

Venus, and Minerva alone survive and today are in Stockholm (Nationalmuseum).

DURING THE COURSE of the sixteenth century, fountains became a significant and often quite expensive art form in the German lands. Their deco-

rative and, in some cases, political potentials were gradually realized. Particularly after 1520, with the mounting battles over religion and religious art, fountains offered renewed opportunities to certain sculptors. Here was a type of art with tremendous flexibility of placement that was ideal for

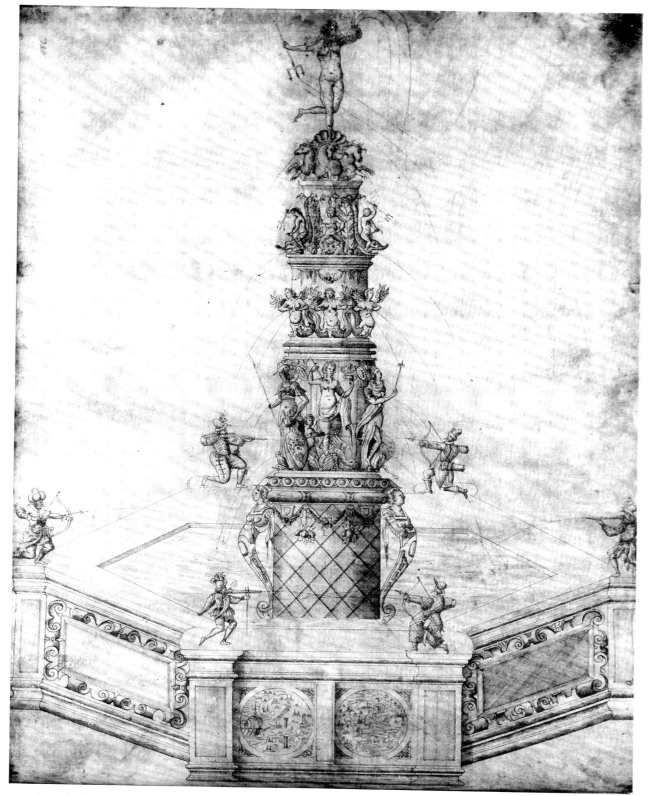

210. Wolf Jakob Stromer, Neptune Fountain, 1582, drawing in Baumeisterbuch I, fol. 186, Burg Grüns-
berg bei Nürnberg, Eigentum der von Stromer'schen Kulturgut-Stiftung

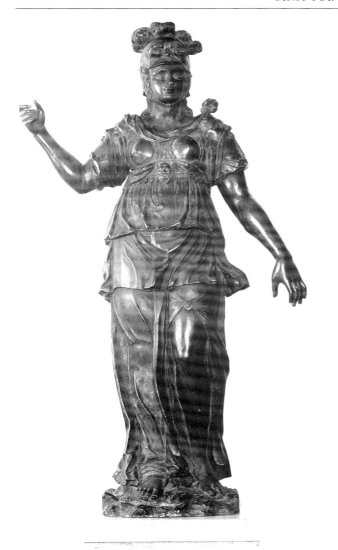

secular settings, whether domestic or civic. The *Cleopatra Fountain* in Berlin or Flötner's *Apollo Fountain* typify the gradual redirection of both private and civic money from traditional religious art to objects capable of embellishing one's home or town. Although age old, the fountain as a category of art was perceived in this century as something altogether new. Innovative solutions were continually being generated by sculptors, especially in Augsburg, Nuremberg, and, to a lesser degree, Innsbruck. Cardinal Cles demanded and received a fountain in the "new lustige manir." Since the form of fountains had never become as rigidly defined as church art had, sculptors were free to adapt non-German models and to develop their own new stylistic ideas. Each new trend could easily be grafted to the growing range of fountain shapes. Certainly an impetus to this development was the acceptance of the Italianate garden fountain. As new pleasure gardens were laid out from Vienna to Stuttgart, fountains were deemed essential to the aesthetic experience. Obviously Maximilian II and his contemporaries were still quite elementary in their expectations for garden fountains when compared with the solutions of Heidelberg and Versailles in the next century. Nevertheless, these patrons in concert with a growing core of talented artists were energetically pushing fountain sculpture in ever new directions.

211. Lienhard Schacht (cast by Georg Labenwolf), *Neptune Fountain*, detail—*Minerva*, 1576–83, Stockholm, Nationalmuseum

CHAPTER EIGHT

Sculpture and Architecture

ONE of the more significant developments in sixteenth-century art was the increasing use of sculpture in conjunction with secular architecture. Reliefs and free-standing statues came to grace many residences and town halls. Traditionally, German patrons favored painting for their decorative projects, which was less expensive though less durable than sculpture.[1] For instance, Jakob Fugger commissioned mural paintings not carvings to adorn the massive facade of his house on Maximilianstrasse in Augsburg, completed in 1515. Albrecht Dürer, Albrecht Altdorfer, Jörg Breu the Elder, and Hans Holbein, among others, all designed elaborate painted cycles for secular structures. Holbein's famed House of the Dance in Basel of about 1521 formerly offered a marvelous mix of fictive sculpture, fanciful architecture, and playful people.[2] Painted facades and council chambers, such as those at Goslar and Lüneburg, typify finer city hall artistic projects.[3] The use of sculpture on civic buildings such as town halls, weighing houses, and armories in the fifteenth and early sixteenth centuries was fairly limited. Often a large relief with the local coat of arms or the statue of a saint was the sole sculptural ornamentation. Erasmus Grasser's comic sequence of lindenwood *Morris Dancers*, made in 1480 for the Dance Hall of the old Rathaus in Munich, offers an exceptional enrichment to this restricted corpus.[4] In another instance, Adam Kraft's sandstone scene of merchants weighing their goods originally defined the function of Nuremberg's Waage of 1497.[5] In this chapter I wish to address the gradual increase in architectural sculpture. I am not concerned with simple house madonnas and minor decorative friezes. Rather I am limiting myself to a few major examples in which sculpture served as an integral facet of the design and meaning of the particular structure. Rooms devoted specifically to the display of statues, such as the Antiquarium constructed in the Residence in Munich, will be examined in Chapter Nine. (fig. 277)

Residential Sculpture

Most of the finest German Renaissance palaces and town houses were built or expanded after 1530. Significant capital investments in residential architecture occurred at precisely the moment when expenditures for new churches and religious art were declining dramatically due to the advent of the Reformation. Nobles and affluent patricians desired grander structures as signs of their wealth, social prestige, or political power. In general these houses are characterized by their airy, more spacious rooms, their familiarity with Italian palazzos, and their adoption of sophisticated sculptural decorations.

Among the earliest and simplest examples is the garden room that Leonhard Hirschvogel (Lienhart Hirsvogel) added on to his home on the Hirschelgasse in Nuremberg in 1534.[6] (fig. 212) In contrast with the older sections of Nuremberg in which the density of existing structures permitted only vertical expansion, Hirschvogel's home was located in a newer district where some larger lots could accomodate wider buildings and walled gardens. Hirschvogel had lived earlier in Venice where his family was one of the principal members of the Fondaco dei Tedeschi, the German merchants' organization. This experience certainly prompted him to commission a room in the new Italian or "Welsch" style. Although the documentation is

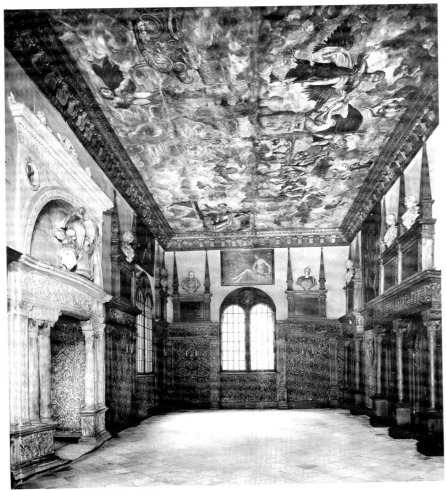

212. Peter Flötner and Georg Pencz, Hirschvogel House, 1534, Nuremberg, Interior View. Photo taken 1934–35

scanty, the project's artistic and, less likely, architectural creator was sculptor Peter Flötner, who since the deaths of Dürer and Peter Vischer the Younger was Nuremberg's leading "modernist." One enters from the garden through an ornate stone doorway with framing pilasters filled with Roman-style graffito and a carving of a two-tailed siren in the tympanum.

The interior is decorated with Georg Pencz's illusionistic *Fall of Phaeton* ceiling painting, measuring 5.6 by 12.2 meters; wooden revêtement with classical architectural motifs after Flötner's designs on all four walls; and a massive fireplace carved with Corinthian pilasters, trophies, garlands, plus triglyphs and bucrania-filled metopes. Playing putti cavort in a series of reliefs at the base of the fireplace while above the lintel stands a large eagle, the family's symbol, with two putti supporting the Hirschvogel coat of arms. The sculpture here is attractive yet hardly profound. Nevertheless, it signals the direction German art would take. Sculptors, such as Flötner, gradually integrated Renaissance motifs, which earlier had been used more commonly in prints and paintings, into the fabric of new residential constructions. Here it is a prominent heraldic display glorifying the status of the Hirschvogel family. Soon far more complex programs would appear at Landshut, Dresden, Torgau, and Heidelberg, among other princely residences.

THE CITY RESIDENCE AT LANDSHUT:
LUDWIG X OF BAVARIA AND THE
DECORATION OF THE ITALIAN HALL

The Stadtresidenz or city residence in Landshut is the oldest German palace in a pure High Renaissance style.[7] Unhappy with the cramped and old-fashion Burg Trausnitz, located above the town, Ludwig X, duke of Bavaria-Landshut and Straubing (r. 1516–45), ordered a new building that would face east onto the Altstadt, Landshut's main street, and west towards the Isar River. The new palace consists of two parts: the German wing (*Deutscher Bau*) and the Italian wings (*Italienischer Bau*). The duke was abroad on a trip through northern Italy when the cornerstone for the German wing was laid on 6 May 1536. He wrote to his older brother, Duke Wilhelm IV of Bavaria-Munich (r. 1508–50), about visiting the "magna palazzo," the Castello del Buonconsiglio that Cardinal Bernardo Cles just had constructed in Trent.[8] Ludwig was even more profoundly impressed with the Palazzo del Te in Mantua that Giulio Romano had recently completed for Federigo II Gonzaga. On Easter Ludwig wrote that "the like, I believe, has never been seen."[9] The Palazzo del Te became the inspiration for the Italian wings of the Landshut Residence. By January 1537 Ludwig had recruited a team of Italian artisans and masons who over the next six years would replicate many of the architectural and pictorial features of the Mantua palace. The courtyard is designed with an impressive loggia while the primary chambers on the first upper floor are provided with such mythological themes as the Hall of the Gods, the Hall of the Stars, and the chambers of Apollo, Diana, and Venus (Ludwig's bedroom). Each of these rooms still retains its complex ceiling paintings by Hans Bocksberger the Elder, Ludwig Refinger, or Herman Posthumus.

In Landshut, as in the Palazzo del Te, painting not sculpture dominates the decorative programs. Little substantive information exists about the original carved Altstadt portal that was destroyed in 1780. Only the Italian Hall (*Italienischer Saal*), the largest room in the palace, includes two sculpture cycles that are central to the room's artistic program, celebrating the glory of human accomplishments and the concept of concord. "CONCORDIA/ PARVA RES CRESCVNT/DISCORDIA/ MAXIMAE DILABVNTVR" reads the inscription around the room. (figs. 213–216) In the center of Bocksberger's elaborate painted ceiling is Fama. She is accompanied by *uomini famosi*, great classical rulers and thinkers, including philosophers, poets, authors, historians, and naturalists. The north lunette displays Apelles, Zeusis, Archimedes, Vitruvius, Praxiteles, and Phidias to represent the arts of painting, architecture, and sculpture. Opposite on the south lunette appear Minerva, Clio (the muse of History), and Philosophy. Although this cycle may have been inspired by Francesco Petrarch's triumphs and, more specifically, by the Dossi brothers' famous ancient authors on the ceiling of the library at Trent, the program's designer, believed to be Ludwig's counsellor Johann Albrecht Widmanstetter, offers a far more comprehensive model of human achievement, a mirror to be emulated by the humanistic Bavarian duke.

The single Italianate fireplace located on the western wall opposite the primary entrance provides the starting point for the room's program. It contains a solnhofen stone relief by Thomas (Doman), the eldest son of Loy Hering of Eichstätt, measuring 85 by 120 centimeters.[10] He joined Ludwig's service in 1540 after being recommended by Munich's guild of painters and sculptors. Cosmic and earthly order are contrasted in the relief. In the center is Ludwig's coat of arms with the date MDXLI. Surrounding the helm are scenes of the planetary deities, beginning with Saturn who holds a sickle, symbolic of his gift of agriculture to mankind; behind a woman distributes bread to the poor. Next come separate representations of Jupiter, Mars, Sol-Apollo, Venus, Mercury, and Luna-Diana. Several allude to the gifts of the gods. For instance, Mercury's eloquence aids the prosperous merchant. By Apollo's feet stands an animal with the heads of a wolf, lion, and dog that signify time past, present, and future. Under Apollo's watchful gaze, the nine Muses dance around a laurel tree. The Apollo relief, the largest of the seven deities, is set immediately above the duke's coat of arms. The analogy extends to Ludwig who is honored as the missing Terra. Under his aegis the gifts of the gods will flourish on earth. Many of Ludwig's contemporaries believed that the planets influenced human activity.[11] For instance, Saturn held dominion over laborers and Mercury over artists and scientists.

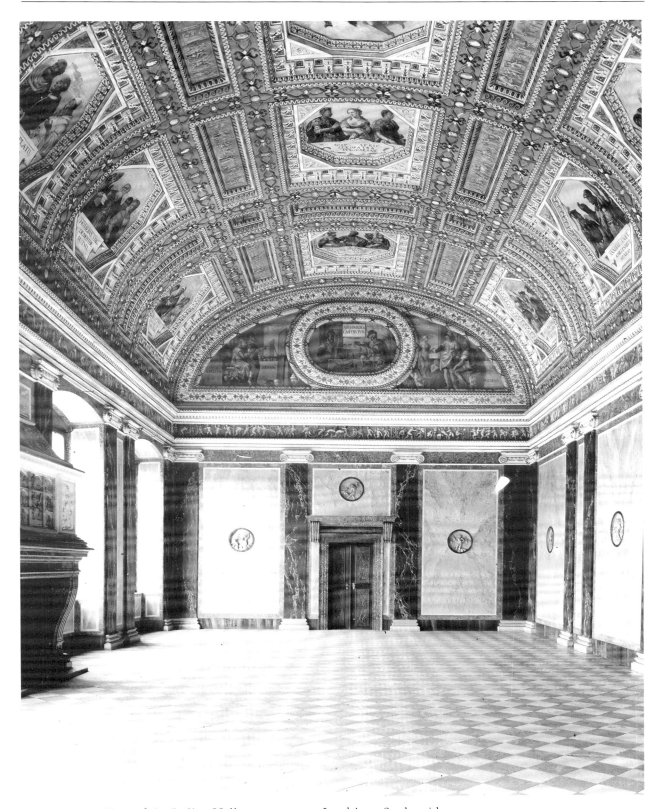

213. Interior View of the Italian Hall, c. 1540–43, Landshut, Stadtresidenz

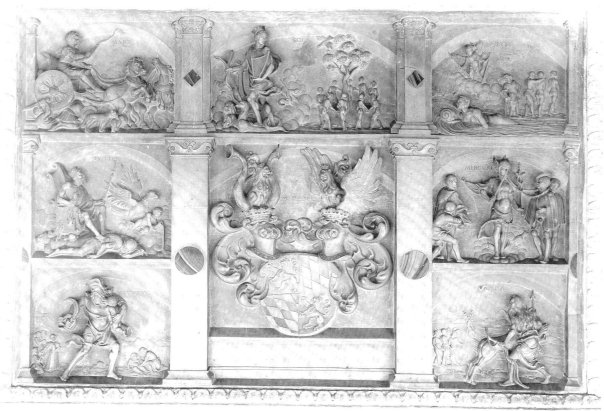

214. Thomas Hering, *Planetary Deities*, 1541, Landshut, Stadtresidenz, Italian Hall

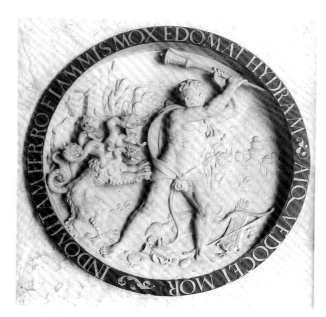

215. Thomas Hering, *Hercules and the Hydra*,
c. 1540–43, Landshut, Stadtresidenz, Italian Hall

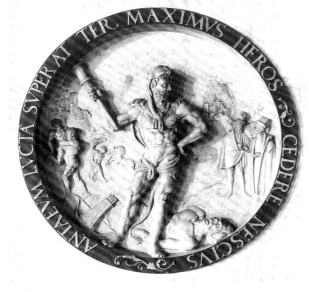

216. Thomas Hering, *Hercules and Antaeus*,
c. 1540–43, Landshut, Stadtresidenz, Italian Hall

Nuremberg Georg Pencz's *Seven Planets* woodcut series of 1531 typifies the mass popularity of the concept of "planetary children."[12]

The link between the gods on the fireplace and the famous men of the ceiling is presented in the Hercules cycle. Hering's twelve roundels each measure about 60 centimeters in diameter. The original placements were altered in the modernization of 1780 and in later renovations. Bulst plausibly has suggested these were set in chronological sequence three per wall between the ionic pilasters beginning in the southeastern corner.[13] Whether the reliefs would have been as prominent as they are now in their isolation against the marble revêtement is unclear. Hering recounts the hero's life from the story of the infant Hercules still in his cradle crushing the serpent, sent by Juno, to his death and apotheosis. Several of the canonical labors of Hercules, such as the fight with the Nemean lion, are mixed with other notable events like his encounter with Atlas.[14] Each roundel is framed by a gilt explanatory inscription in Latin.

The design of Hercules and the Lernean Hydra is typical as Hering adeptly uses both deep relief for Hercules and much shallower cutting for the other features. Hering focuses upon the muscular Hercules, nude except for his lion-skin cloak, as he futilely strikes the creature with his mace. The hissing hydra, a water snake that grew two new heads for each one Hercules severed, attacks. For the moment Hercules ignores the beaked, dog-like creature behind him; this is supposed to be a crab that Juno sent to aid the hydra. Absent is Iolaus who helped Hercules cauterize the heads with the fire that is visible at the upper left. The hydra's swamp or marsh is replaced by a bucolic landscape leading to the walled city (Argos?) and mountains behind.

In the ninth medallion, Hercules appears three times. He stands triumphantly above the dead Antaeus in the foreground. Behind, Hercules crushes Antaeus and, further back, battles with the man-eating horse of King Diomedes of Thrace. At right stand two men discussing Hercules' triumphs. One is dressed as a Turk. In an early sixteenth-century Venetian, Hercules woodcut series, which may have been one of Hering's models, the men stand before a Turkish-controlled town as signified by a large crescent moon.[15] Thrace, now part of Bul-

garia, was then ruled by the Ottoman Turks. This would explain Hering's inclusion of oriental garb but not the presence of the other gentleman who wears the sort of Spanish-influence clothing then popular in South Germany and Austria. Is this Ludwig, Hering's patron, who typically was portrayed with a thin face and full beard? Although somewhat stylized it closely recalls the likeness on Ludwig's tomb that Thomas Hering carved around 1545, just two or three years after the completion of the Hercules cycle, for the Cistercian Cloister of Seligenthal in Landshut.[16]

Whether or not this small figure can be identified as Ludwig is less significant than the fact that the duke himself made a very conscious choice to have Hercules as the main hero of the Italian Hall. When admiring the Palazzo del Te in 1536, he would have noticed the Hercules paintings set immediately above the portraits of Federigo Gonzaga's horses in the Sala dei Cavalli, the palace's grandest room.[17] This chamber might have inspired the idea for a Hercules program in Ludwig's mind but the artistic impact of Romano's frescoes is negligible. For the humanist Ludwig, Hercules offered an ideal prototype for his own reign. According to a Xenophon, the young Hercules encountered Virtue and the vice of Pleasure.[18] Forced to decide the direction of his life, he picked Virtue. This dilemna was popular in scholarly circles and was the subject of Dürer's engraving *Hercules at the Crossroads* (B. 73) of about 1498. Hering's roundels repeatedly represent Hercules as a force for good triumphing over the evil-doers of the world, such as the ravishing hydra or Antaeus who killed all passersby. Only because of his unrelenting virtuousness was Hercules invited to Mount Olympus, an apotheosis recounted in the last of Hering's medallions.[19]

From classical times onwards Hercules served as the *vir sapiens-vir fortis* type, to be emulated by great rulers on their road to eternal fame. In about 1498 Emperor Maximilian I was represented in a broadsheet as the *Hercules Germanicus*, a German variation on the more common *Hercules Gallicus* tradition.[20] Hercules' virtues are carefully listed in the accompanying text. The connection between Ludwig and Hercules was even more specific. Hercules was claimed as an ancestor of the Bavarian dukes.[21] In Johannes Aventinus' *Annales Ducum Boiariae*, completed in 1521, Hercules' son Boius or Baier was

cited as the namesake of Boi or Baiern (Bavaria). Even the lion of the Bavarian coat of arms was linked with the Nemean lion slain and then worn as a cloak by Hercules. Thus Hering's Hercules cycle offered an allegorical model for Ludwig. Through a virtuous life, wise rule, and support for the sorts of human accomplishments chronicled in the painted vault above, the duke might achieve eternal fame both for himself and for Bavaria. The fireplace further enriches the analogy by accenting the cosmic influences on terra, specifically upon the Bavaria governed by Duke Ludwig. So the entire sculpted and painted program of the Italian Hall functions as a glorification of the duke and a model for achieving even further greatness.

The comprehensiveness of iconographic program and the integration of sculpture with other pictorial arts are firmly established in Landshut, a forerunner of the elaborate great halls that were popular in the later sixteenth century, such as those at Schloss Ambras at Innsbruck, Heiligenberg, Kirchheim an der Mindel, Weikersheim, or the Spielhaus at Stuttgart.[22] The ravages of time and changing tastes have decimated many of the original decorative programs of other palaces roughly contemporary with Landshut. For instance, Ottheinrich's residence at Neuburg an der Donau dates to the 1530s and early 1540s.[23] As we noted in our discussion of its chapel in Chapter Three, the troops of Emperor Charles V sacked the palace in October 1546 in retaliation for Ottheinrich's switch to Lutheranism. The western portal, which is shaped like a triumphal arch, has lost its sculpture. Fortunately, the entrance passage with its stuccoed vault still retains its modest roundels depicting Roman emperors. The pattern of the coffering strongly recalls Landshut, which should not be surprising since several artists were recruited by Ottheinrich, including Hans Bocksberger the Elder, the painter of the Italian Hall. The initial appearance of the main rooms at Neuburg is unknown since only a few carved doorways have survived.[24]

A better idea of Ottheinrich's taste can be observed at the hunting lodge that he constructed in the early 1530s at Grünau, five kilometers east of Neuburg. The main hall retains its stag hunting theme.[25] The walls are adorned with painted deer affixed with real antlers. Jörg Breu the Younger painted various scenes, including medallions of

Mars and Venus. Between 1535 and 1540 Martin Hering, Thomas' brother, carved the red marble dedication plaque for this chamber. (fig. 217) It depicts an ideal stag hunt in which the hunters and their dogs drive the beasts from the forest into netted enclosures or into the central stream. By the central tree waits a corpulant noble holding a crossbow. Is this figure to be identified as Ottheinrich since he alone carries a crossbow and an adjacent tree is adorned with his motto "With the times" ("mit der Zeit") written on a banderole? Other nobles deeper in the lush landscape watch the hunt. The setting is generic since the palace behind portrays neither Grünau nor Neuburg. Martin Hering adapted his compositions from the hunting scenes of Lucas Cranach the Elder. The entire lower left section derives from Cranach's woodcut (B. 119) of a Saxon hunt of about 1506. Carved below are Ottheinrich's Palatinate and Bavarian arms plus a lengthy text recounting how he and his wife, Susanna of Bavaria, laid the foundation stone in 1530. Grünau offers an example of a modest painted and sculpted program whose theme is tied to the building's function as a hunting retreat.

FROM DRESDEN TO HEIDELBERG, OR THE TRANSITION FROM ORNAMENT TO ART

From the 1530s sculptural decoration increasingly appeared on the outside of German houses and palaces. In most cases this consists of simple statues, friezes, or portrait medallion reliefs. Made of stone and, in some North German towns, terracotta, these images are attractive yet rarely of high artistic merit. Few major sculptors were involved in such projects. There were, however, several impressive cycles incorporated into the new constructions of the palaces at Dresden and Torgau in Saxony and, slightly later, Heidelberg. These offer three different solutions for integrating sculpture and architecture. Each became a model for other princely edifices.

Between 1530 and 1535 Duke Georg the Bearded built a new wing, the Georgenbau, on the late medieval palace in Dresden. (figs. 218 and 219) The courtyard and street facades were both five storys culminating in a tall gable. A team of sculptors under the direction of Christoph I Walther devised a harmonious design for each facade that

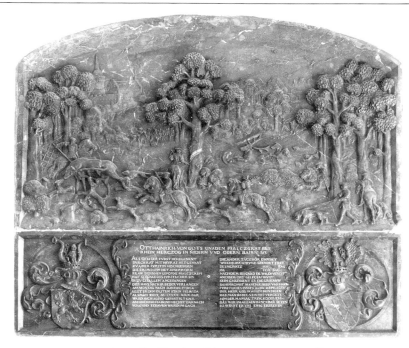

217. Martin Hering, Dedication Plaque, 1535–40, Grünau, Jagdschloss

included free-standing statues and a variety of reliefs.[26] As noted in earlier chapters, Georg was a staunch Catholic and strident foe of Lutheranism. It is hardly surprising that he chose interrelated religious themes for the facades. The court side offered an explanation of human morality and mortality, conditions that resulted from the fall of Adam and Eve. This is balanced on the street facade by images of Christ's role as the redemptor. In both instances the central focus is the entry portal. On the court side, life-size statues of Adam and Eve stand above the doorway. They once flanked the Tree of Knowledge, cut in relief, with its coiled serpent and, below, bust of Death holding a sickle. Their destiny unfolds as the carvings gets closer to the street. In the spandrels of the portal are not the customary victories but Adam toiling and Eve suckling a child. In the relief just above the doorway, Cain slays Abel. The branches of the tree provide a visual link to the foliate frieze, coats of arms, and portrait medallions, presumably of Georg and his family, located between the first and second upper storys. The window mullions extend the vertical movement of the facade upwards to the Dance of Death frieze above. Walther's cycle is

fairly standard, as skeletons claim a cross-section of society from pope and emperor to the market peasant and beggar. Death, the gift of Adam and Eve, is universal.[27]

Georg's nephew Moritz continued this didactic and decorative use of architectural sculpture when he constructed a new west wing at Dresden between about 1545 and 1550.[28] (fig. 220) The flanking spiral staircase towers are profusely ornamented with foliage, portrait medallions, and battle reliefs. More significant, however, are the seven Old Testament battle scenes that Hans Walther added in 1552 to the projecting porch or *altan*. Located immediately above the ground floor arcades, the reliefs each measure about one meter high. Hans Walther utilized this space to provide relatively deep landscapes filled with details such as the walls of Jericho crumbling before Joshua and the Ark. The militant themes, all drawn from the Book of Joshua, may have been chosen as prototypes for Moritz' endless battles against Emperor Charles V and his allies.

The facades of the Georgenbau and the porch of the west wing offer a balanced integration of architecture and sculpture. Both also display an icono-

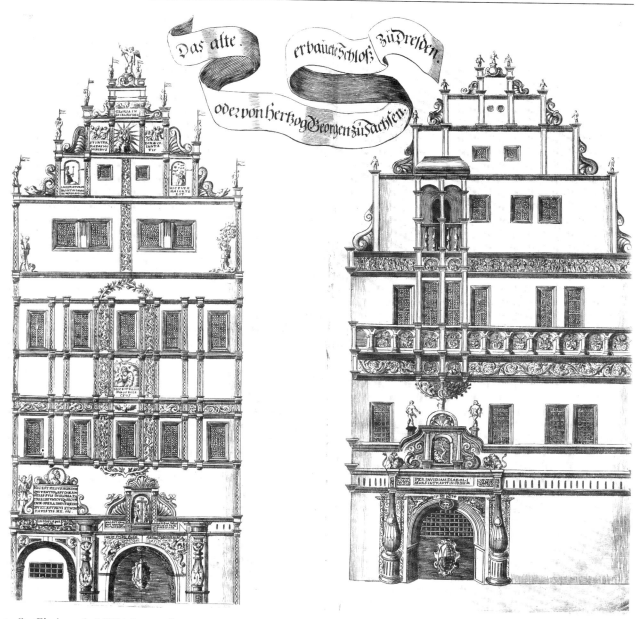

218. Christoph I Walther and assistants, *Street and Court Facades of the Georgenbau*, 1530–35, Dresden, Schloss, engraving, 1680

graphic and compositional coherence that is often lacking in the sculptural programs at Schloss Hartenfels in Torgau or at other roughly contemporary palaces, such as Berlin and Wismar.[29] In the latter group, the sculpture, however attractive, remains ornament grafted on to the architecture. The additive character can be observed at Torgau where Elector Johann Friedrich ordered several major building campaigns in addition to the rather spare chapel

discussed in Chapter Three. The focal point of the courtyard is architect Konrad (Kunz) Krebs' eastern wing (the Johann-Friedrichs-Bau) with its justifiably famous multi-story open staircase erected between 1533 and about 1538.[30] (fig. 221) The bold clear lines of the staircase dominate. Other than the copies of the now heavily damaged statues of the elector and his brother Johann Ernst guarding the two entries to the staircase, the sculpture is at first

253

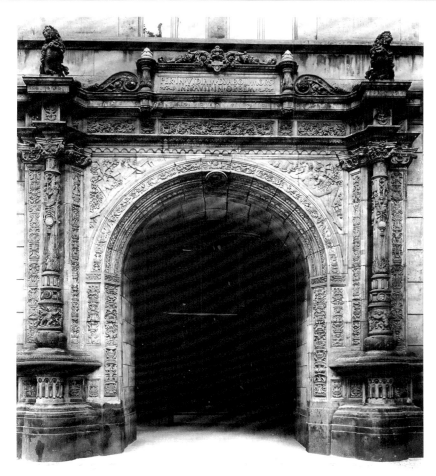

219. Christoph I Walther and assistants, Remains of the Court Facade
Portal of the Georgenbau, 1530–35, Dresden, Schloss

almost invisible. Only upon closer inspection does one realize that the entire surface of the staircase tower is ladened with foliated pilasters, portraits, and the occasional narrative scene all carved in very shallow relief. The coats of arms of Johann Friedrich's maternal and paternal ancestors plus simple images of Samson and the Lion, and David and Goliath adorn the risers and gallery. The window frames on the ground floor contain further relief portraits, fools, and garlands. Johann Friedrich employed Ulrich Kreuz, a fine artist whose talents were better utilized in the 1526 pulpit for the Neue Stift at Halle. (fig. 55) It is doubtful that Kreuz, Michel Mauth, or the other sculptors participated in any aspect of the wing's design. More likely, the sculptural program was devised by the architect Krebs or, less certainly, by the painter Lucas Cra-

nach the Elder who spent considerable time at Torgau in 1535, 1536, and 1537.[31]

Cranach's art did provide the models for the medallions of Lucretia and Judith that Stephan Hermsdorf carved in 1544 for the "Beautiful Oriel" of the north wing.[32] (fig. 222) The oriel strikes a better balance as the sculpture is more critical to the success of the structure's appearance than it had been for the staircase. This type of decorative sculpture enjoyed tremendous popularity on both residential and governmental buildings from the 1530s but, ultimately, remained of secondary artistic significance.[33]

A fundamentally different conception about sculpture shaped the court facade of the Ottheinrichsbau, or east wing, at Heidelberg Castle.[34] (figs. 223–225) Upon becoming the Palatine Elec-

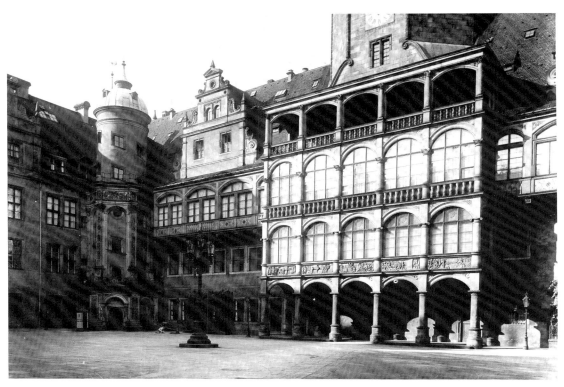

220. Hans Walther, Old Testament Battle Reliefs, 1552, Porch of the Moritzbau, Dresden Schloss

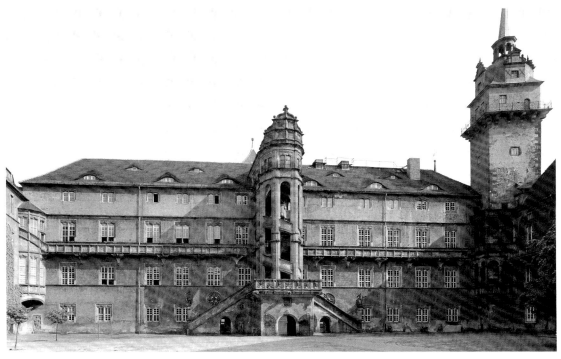

221. Ulrich Kreuz, Michel Mauth, and others, Staircase of the Johann-Friedrichs-Bau, 1533–38, Torgau, Schloss Hartenfels

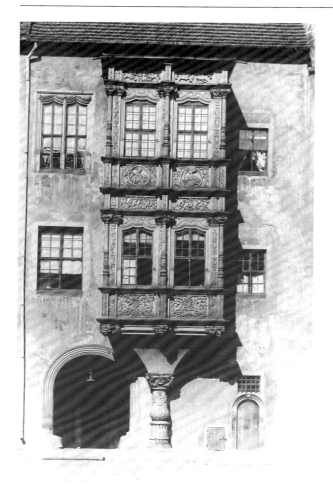

222. Stephan Hermsdorff, "Beautiful Oriel," 1544, Torgau, Schloss Hartenfels

tor in 1556, Ottheinrich embarked on an ambitious rebuilding project at Heidelberg, one which was largely completed before his death in 1559. The three-story court facade, a delightfully eclectic amalgam of classical and Serlian forms, contains a monumental sculpted portal and overlife-size (1.8 m) statues set within scalloped niches between the windows. The statues are carved in a grayish yellow sandstone that vividly contrasts with the red sandstone of the facade. On the first floor, herm figures ornament the mullions while a pair of music-playing putti flank the portrait medallion of a Roman ruler in the pediment above. The sculptures are now fully integrated into the facade's design. While a purist might prefer the calmer, less-crowded facade without the niche statues, Otthein-

rich liked their imposing visual and iconographic richness. As noted in our comments about Neuburg an der Donau and Grünau, Ottheinrich took great personal interest in all of his projects. His fascination with architecture, antiquity, and other topics such as astronomy is manifest in the contents of his famed library.[35]

The sculptural program of the facade glorifies Ottheinrich. It offers a triumphant vindication to his life, which earlier had been troubled by power struggles with the dukes of Bavaria, religious conflicts with Emperor Charles V, and financial bankruptcy in 1544. At the end of his life he was an elector, a position of considerable political significance, and a staunch guardian of Lutheranism. On 7 March 1558 Ottheinrich named Alexander Colin as his master sculptor. Heidelberg proved to be an important stepping stone for Colin's career since he then went on to work for the Habsburgs in Innsbruck, Prague, and Vienna. Little is documented about his earlier activities though he seems to have been trained in his native Mechelen in Brabant and may have worked in Milan. Colin likely worked in Heidelberg before succeeding Anthoni de Vleeschouwer (d. 1558), whose daughter he would marry in 1562. Aided by a team of twelve journeymen, Colin completed the facade sculpture plus numerous interior doorways with figural decoration by 1559. Because of the scale of the project and his many collaborators, Colin worked on parts of many statues but contributed only two or three complete statues.[36] *Caritas* is particularly attractive. (fig. 225) Her thin drapery reveals the lines of her body and animates the surface with its varied diagonal rhythms. The child in her right arm is especially poignant as he tilts back his head to gaze at Caritas' face while gently touching his right fingers to her chin. For this and most of the other statues, Colin devised his own designs though he frequently displays his familiarity with the sculpture of Cornelis Floris and with Italian and Netherlandish prints.

The sixteen statues form three distinct groups of heroes, virtues, and gods. On the first floor flanking the portal are, from left to right, Joshua, Samson, Hercules, and David. The accompanying inscriptions stress their great deeds and, except Hercules, protection of their faith and people. Arranged on the second floor are the virtues Fortitudo,

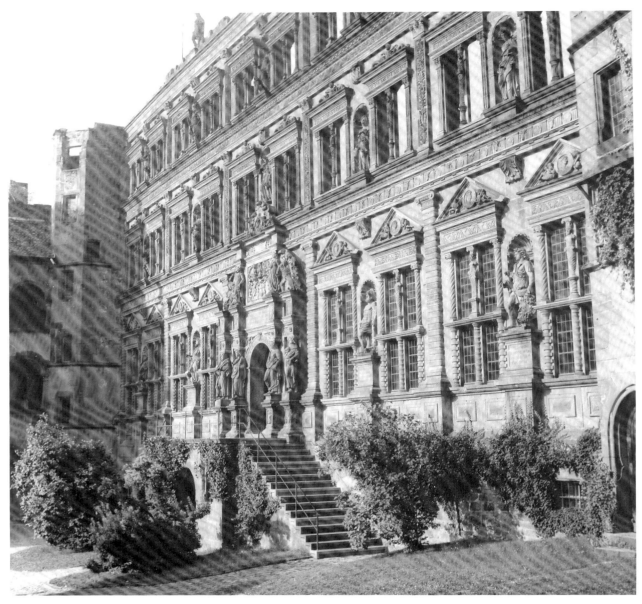

223. Alexander Colin and assistants, *Ottheinrichsbau*, 1558–59, Heidelberg Schloss

Fides, Caritas, Spes, and Justitio. Saturn, Mars, Venus and Amor, Mercury, Luna (Diana) occupy the niches of the third level while Sol and Jupiter stand above in the site of the two now-lost gables. The program is somewhat reminiscent of Landshut in that it includes the planetary deities, who exert an influence over mankind, and earthly heroes, here expanded to three virtuous Old Testament rulers and Hercules. To this mix has been added the three theological virtues (Faith, Hope, and Charity) plus Fortitude and Justice, traits essential for the wise ruler. The "pagan" and biblical worlds have been joined to the present. The vertical integration of the program can also be observed in the center of the facade. Directly above the portal, with its portrait of Ottheinrich, stand Caritas, signifying Christian love, and Venus, physical love. The heavenly and earthly are reconciled under his rule.[37]

225. Alexander Colin, *Caritas*, Ottheinrichsbau, 1558–59, Heidelberg Schloss

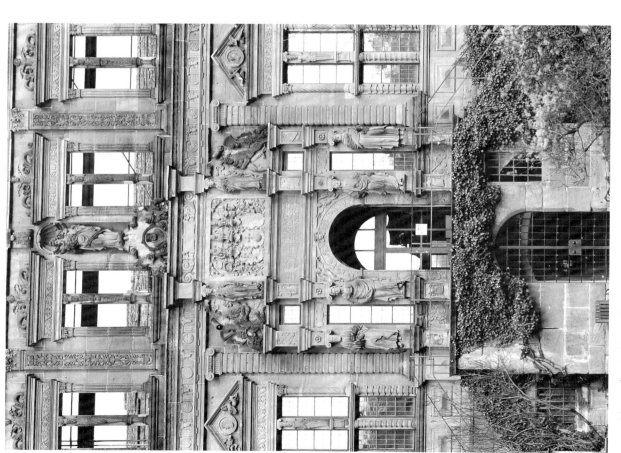

224. Alexander Colin and assistants, Doorway of the Ottheinrichsbau, 1558–59, Heidelberg Schloss

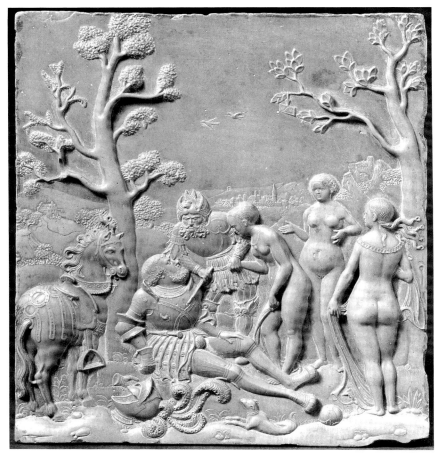

226. Thomas Hering, *Judgment of Paris*, c. 1535, Berlin, SMBPK, Skulp-turengalerie

The program recalls an earlier union of the mythological past and the present in Thomas Hering's *Judgment of Paris* relief of about 1535 in which a younger Ottheinrich assumes the role of Paris selecting Venus, an idealized image of his wife Suzanna.[38] (fig. 226) The relevance of these lessons for a prince is underscored by the inclusion of eight portrait busts of Roman rulers.[39] Some, such as Antonius Pius, were considered wise leaders; others, such as Nero, Brutus, or Marcus Antonius, were flawed. Thus these offer models of varying degrees of success.

The portal is truly a triumphal arch celebrating Ottheinrich. At the apex, immediately beneath the feet of the *Caritas*, is a frontal portrait bust of the elector based on Dietrich Schro's medal of 1556.[40] As in the case of the Roman rulers, he is accom-panied by two music playing putti. In the next level, a relief with Ottheinrich's full coat of arms, including the prominent display of his electoral world orb symbol, is flanked by a pair of caryatids and two scenes of a man fighting a lion. The lion has the advantage in the left-hand relief, while the man is poised to dispatch the beast in the right. Is this struggle emblematic of Ottheinrich's life? The lion reappears in his arms, in a poem honoring the prince, and in Dietrich Schro's minute portrait bust of the elector in which his arms rest upon a pair of reclining lions.[41] (fig. 313) At the very least I think the combat alludes to the choices that every person faces in life rather than specifically to either the exploits of Hercules or Samson. The lower zone consists of a triumphal arch with two winged victo-ries bestowing laurel wreathes, military trophy re-

259

liefs with arms and armor at foot level, further trophies now of musical instruments flanking the inscription tablet above, and four large atlantes figures. Ottheinrich, elector by the grace of God, stresses the spoils of war and harmonies of peace. The facade presents him as the ideal ruler, the embodiment of historical greatness, the balanced nexus of planetary influences and perhaps the temperaments, the enlightened humanist, and the victorious Lutheran leader who has mastered the arts of war and peace. Here at Heidelberg, the iconographic message is beautifully incorporated into the elaborate architectural design of the Ottheinrichsbau. The use of prominent statues in niches was continued in the ruler cycle of 1601–7 on the court facade of the Friedrichsbau at Heidelberg.[42]

Sculpture and Civic Architecture

The inclusion of sculpture on or in public buildings was surprisingly infrequent prior to the 1560s and 1570s. Most elected officials were slow to embrace sculpture as a fundamental feature of significant architectural projects. A lack of opportunity cannot be the sole reason since numerous and often quite imposing city halls were constructed in the aftermath of the Peace of Augsburg in 1555. As we have observed in other chapters, the rise in confidence in the Empire's political stability gradually prompted councils to invest in artistic projects beautifying their towns and contributing to a sense of local identity. In this section I shall examine the few civic sculptural projects. Although exceptional, these examples often offer revealing glimpses of civic aspirations. Their designs and programs also provided models for the boom in civic sculpture that occurred around 1600.

Before turning to the first example, a partial explanation for the scarcity of civic architectural sculpture is necessary. The Reformation with its attendant political and economic upheavals was a significant factor. Statistically far fewer city halls were erected between about 1525 and 1560 than during either the preceding or succeeding two decades. Just as ostentatious religious sculpture largely disappeared throughout Germany, towns also avoided expensive artistic projects. I would also suggest that other artistic and aesthetic factors

are behind the relative dearth of civic sculpture. A telling contrast is provided by two of the period's greatest city halls: Antwerp and Leipzig.[43] Both were completed for ambitious mercantile communities in about 1565. Both either replaced or transformed older medieval structures no longer considered appropriate for the dignity of their communities. Architect Cornelis Floris' facade in Antwerp is dominated by a projecting central bay with a tall gable that incorporates overlife-size religious and allegorical figures. Some occupy niches; others ornament the edges of the gable. Statues such as the Virgin, Brabantia, and the sea centaurs directly allude to the city's patroness, its geographic location, and its dependence on sea trade. At Leipzig, Hieronymus Lotter constructed an imposing horizontal facade with a central tower. Sculpture plays no significant role in defining the building or its meaning for the town. The same situation prevails in Altenburg where Nickel Gromann completed an impressive new Rathaus between 1562 and 1564.[44] Here the sculpture is restricted to minor armorials and medallion portraits on the oriel. Its inclusion at all is due solely to Gromann's familiarity with the sculpture of Schloss Hartenfels at Torgau where he worked in the mid-1540s.

One factor that distinguishes these two buildings is the training of the architect. Cornelis Floris was first and foremost a sculptor.[45] Like many Italian masters, including Michelangelo and Jacopo Sansovino, Floris had a thorough grounding in the pictorial arts before becoming an architect. In a public building such as Sansovino's Loggetta in Venice, niche and relief sculptures are thoroughly woven into the design.[46] Remove these features and the building would appear naked and rather awkwardly proportioned. Personal fame made it easier for a Floris or Sansovino to bridge the proprietary barriers often posed by restrictive guild regulations. Most contemporary German architects began as masons not sculptors. Lotter was actually a merchant who as baumeister was assisted by two trained masons. Not since Peter Parler in the late fourteenth century was there a significant German artist who was active both as a sculptor and an architect. This situation would change again only in the late sixteenth and early seventeenth centuries with painters like Giovanni Maria Nosseni and Friedrich Sustris or sculptor Hans Krumper, each

of whom worked primarily for princely not civic patrons.

In Germany, as in the Low Countries, a distinguished heritage of sculptural embellishment on or in city hall buildings existed. For instance, statues of the Nine Worthies (c. 1360) dominate the Hansasaal and a group of saints (1407–14) enrich the tower of the Cologne Rathaus.[47] (fig. 232) Charlemagne and the Seven Electors by Master Hartmann and Hans Multscher were added to the facade of the city hall in Ulm between 1417 and 1430.[48] Aachen, Wesel, Münster, and Braunschweig, among others, have or once had important programs.[49] German towns, however, rarely adopted the extensive facade ruler cycles that were so popular in the Low Countries in the fifteenth and early sixteenth centuries.[50]

The gradual disappearance of major sculptural programs on German city halls can be linked directly to two other aesthetic developments. First, there was a strong tradition of mural painting. When Basel completed construction of its new town hall in 1513, three statues of the Virgin (now replaced by Justice) and patron saints Heinrich and Kunigunde were added to the facade soon afterwards. Nevertheless, painters received the major decorative commissions. Hans Dig's *Last Judgment* of 1519 fills the entry staircase, while Hans Holbein the Younger's historical precedents of justice and wise government once graced the council chamber following their completion in about 1530.[51] The situation was similar in both Nuremberg and Regensburg. To complement the addition of a new east wing and facades between 1514 and 1522, the Nuremberg counsellors ordered a thorough redecoration of the exterior and great hall.[52] The lavish programs designed by Dürer were exclusively for painting. The use of painting persisted, as evidenced by Melchior Bocksberger's facade paintings of 1573–74 on the Rathaus in Regensburg.[53]

Second, rich architectural embellishments obviated the need for extensive sculptural cycles on many city halls. Civic pride was expressed architecturally instead. Facades ornamented with lavish tracery patterns and, later, complex Netherlandish-inspired gables rising gracefully upwards dominated civic architecture in the sixteenth century. Representative examples may be seen in the city halls at Saalfeld, Plauen, Celle, Rothenburg,

and Schweinfurt, among others.[54] The energetic union of this decorative form of architecture with a program of large statues would occur only later in buildings such as the Rathaus in Bremen that was completed in 1612.[55]

Having sketched out what appears to be an overly bleak picture of civic sculpture, I now wish to examine three significant programs in Nuremberg, Cologne, and Wittenberg. In each instance, however, the sculptures were not part of the original architectural design. Fortune perhaps should be credited for delivering the Vischer family's grille to the great hall of Nuremberg's Rathaus, while at Cologne and Wittenberg new porches were grafted onto the pre-existing buildings.

THE SAGA OF THE NUREMBERG RATHAUS GRILLE

The story of the Nuremberg grille actually begins in Augsburg when in 1512 Hermann Vischer the Younger was commissioned by Jakob Fugger to make an imposing brass screen for his chapel in St. Anna.[56] (fig. 133) It would have been placed at the eastern end to separate the chapel from the public space of the nave. The Nuremberg master began work on the design, the carving of models, and perhaps the actual casting of portions of the grille before his premature death at about age thirty-one in 1517. Production proceeded slowly during the next decade as the Vischer family workshop completed other sections. Apparently not to the satisfaction of Jakob Fugger's heirs, however, who on 2 August 1529 terminated the project ostensibly because it did not follow the original specifications. The Fuggers reached a settlement with Peter the Elder, Hermann's father, by which they relinquished all claims to the finished parts despite their earlier payment of 1,437 gulden. In July 1530 Nuremberg's council, citing their admiration for its artistry, acquired the unfinished grille for 940 gulden. Yet the grille languished in the local armory until May 1536 when the council resolved to complete and place it in the great hall of the Rathaus. Prompted perhaps by rumors that Ottheinrich wanted the grille for his palace chapel at Neuburg an der Donau, the council commissioned its completion by Hans Vischer, Hermann's younger brother and head of the family foundry.

When Hans' progress proved to be too slow, the exasperated council issued an ultimatum that the screen must be finished by Christmas 1539 or the artist would be thrown into the tower prison. The threat worked since by April 1540 the screen was ready for installation. To fit the width of the great hall, the grille was set between a pair of large, decorative stone pillars carved by Sebald Beck.[57] Hans received an additional payment of 1,855 gulden. Unfortunately, the story of the Rathaus grille does not end here. In 1806 Nuremberg, which had lost its status as an imperial free city with its incorporation into Bavaria, sold the grille to pay some of its debts. One of Napoleon's canon makers, Frèrejean of Lyons, melted down all but four of the more artistic sections. (figs. 228–230) Since 1916 these have been in the Musée Léon Marès at Château de Montrottier in Annecy.

The council envisioned the brass grille as a fitting divider separating the western section of the Gothic great hall, which served as the municipal tribunal or law court, from the rest of the massive chamber where imperial diets and patrician dances, among other events, were hosted. Initially the grille was to be viewed in concert with two large, pre-existing mural paintings whose themes distinguished the judicial character of this portion of the room. Michael Wolgemut(?)'s imposing *Last Judgment* covered most of the west wall prior to the alterations of 1619, and Dürer designed the *Calumny of Apelles* (c. 1520) on the north wall just east of the grille.[58] These offered a pictorial warning against falsehood and a graphic reminder that all humans someday would face divine justice.

Any reconstruction of the brass grille must be based on the four extant sections, early descriptions, and the various interior views of the great hall, such as Paul Juvenel's painting of about 1614.[59] (fig. 227) The form was probably not modified too greatly from its initial design for the Fugger Chapel. To convert the grille to its new civic function, however, additional allegorical scenes, coats of arms, and inscriptions were ordered. The grille consisted of eight Corinthian columns supporting a long architrave with horizontal friezes on each side. Two sections of the frieze survive. One is filled with delicate acanthus rinceaux and a pair of battling male nudes; the other contains numerous nudes standing in water.[60] Over the two side doors

were triangular gables, decorated with virtues such as Strength, Justice, and Moderation plus various imaginary beasts, and, above the frieze, lunettes. The two Annecy lunettes, both originally on the eastern side of the grille, display Nuremberg's arms plus more battling creatures. Lost are the reliefs of God the Father and surrounding angels that filled the pediment above the central doorway.

In this instance the grille's significance has less to do with its architectural context than its stylistic inventiveness. We must distinguish between the grille's two primary masters.[61] Hermann was the main artist. While in Italy in 1515 he sketched ancient and contemporary buildings. In one of his drawings of a Roman palazzo, Hermann recorded the harmonious balance between the loggia, the intermediate figural frieze, and the two upper storys.[62] (fig. 231) Features such as these recur in the grille. Based on style, most notably a comparison with his tomb of Elisabeth and Hermann VIII zu Henneberg (1507–12) in the Stadtkirche in Römhild and the Paris drawings, Hermann likely designed the entire grille and cut the models for the two lunettes, and the rinceaux-filled frieze. The variety of poses, the understanding of human and animal anatomy, and the adept foreshortening of Hermann's scenes are particularly impressive. By contrast the figures in the second frieze are awkwardly proportioned and less skillfully cut. These can be attributed to Hans who had access to Hermann's drawings. The rearing horse and figures moving through water recall passages of Hermann's sketch of the Roman palace frieze mentioned above. The same inherent stiffness can be observed in Hans's other sculptures such as his *Christ and the Canaanite Woman* for Neuburg. (fig. 56)

The grille was the period's largest sculptural project made in metal. Only the Shrine of St. Sebaldus, also by the Vischer family and about fifty meters away in the parish church directly west of the Rathaus, rivals it in terms of scale and complexity. (fig. 10) From the figural fragments at Annecy and the secondary views of the grille in situ, Hermann's creation offered one of the most sophisticated German responses to Italian Renaissance art and its evocation of antiquity. The grille's original intended setting in the Fugger Chapel may have spurred Hermann to look to Italy for inspiration. Yet Hermann and his brother Peter the Younger,

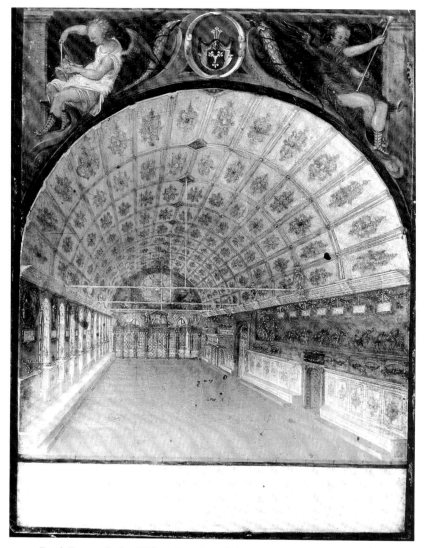

227. Paul Juvenel the Elder, *Interior of the Great Hall of the Nuremberg Rathaus*, c. 1614, painting, Nuremberg, Germanisches National-museum

who will be discussed in the next chapter, were truly the first German sculptors to understand the aesthetic intent of contemporary Italian, especially North Italian, art. In the grille, the Shrine of St. Sebaldus, and a group of small brasses, the brothers offer highly original works that boldly challenged the prevailing direction of German sculpture as represented by artists such as Riemenschneider or Leinberger. With their deaths, brother Hans proved to be unable to sustain their inventiveness. The leadership position, at least in Nuremberg, would be seized by Peter Flötner.

SCULPTURE AND CIVIC ASPIRATIONS: THE RATHAUS PORCHES IN COLOGNE AND WITTENBERG

During the 1560s and 1570s Cologne, Witten-berg, and Lübeck added new porches or galleries to their existing city halls. Each project was intended to modernize an older building. At Lübeck this took the form of a glazed gallery over an open ar-cade.[63] Here the sculpture is mostly decorative, as caryatids alternate with ionic pilasters while above armorial reliefs cover the entablature and three

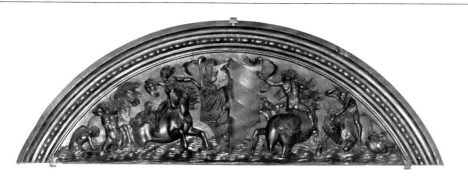

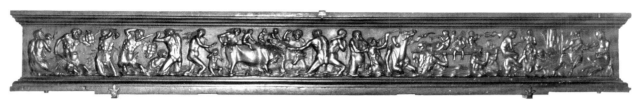

228. Hermann Vischer the Younger and workshop, *Lunette with Nuremberg's Arms*, 1515–17 and 1536–40, and Hans Vischer, *Frieze with Nude Figures*, 1536–40, Annecy, Château de Montrottier, Musée Léon Marès

229. Detail of 228

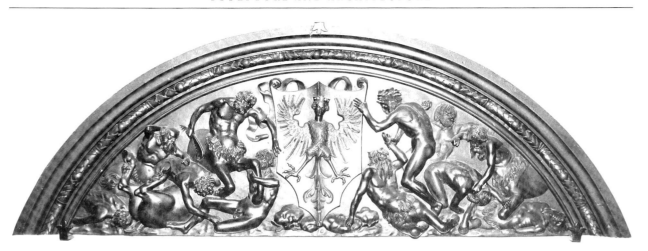

230. Hermann Vischer the Younger and workshop, *Lunette with Nuremberg's Arms*, 1515–17 and 1536–40, Annecy, Château de Montrottier, Musée Léon Marès

231. Hermann Vischer the Younger, *Sketch of a Roman Palace*, c. 1515, drawing, Paris, Musée du Louvre

gables. At Cologne and Wittenberg, however, the sculpture has a more specific iconographic intent linked to governmental aspirations.

In the 1550s Cologne's city council commissioned studies for a large two-story porch opening on to the Rathaus square.[64] Two sketches, one

dated 1557 and signed C.F., have been attributed to Cornelis Floris. A variant design was ultimately employed by Wilhelm Vernukken, who was the building master and less certainly the sculptor from 1569 to 1571.[65] (fig. 232) The lower arcade originally included a stairway offering direct access up to the Hansasaal or great hall. The upper story of the porch was broad enough to accomodate all fifty-one members of the council for ceremonial occasions. The design of the porch recalls a two-tiered triumphal arch. Here the classicizing style transcends mere contemporary fashion as the city fathers consciously mixed architecture and sculpture to evoke thoughts of Cologne's glorious Roman heritage and its current imperial status. Victories fill the spandrels of the upper floor. Some bestow laurel wreaths while others wielding musical instruments trumpet Cologne's fame and civic harmony. Below are busts of twelve Roman emperors with accompanying inscription tablets explaining their relationships to the city. Among the portraits are Julius Caesar, Agrippa, Constantine, and Maximilian II. The choice is hardly fortuitous, as each actually shaped Cologne's destiny. For instance, in about 50 B.C. Caesar's troops besieged the left bank of the Rhine thus allowing his German allies to settle on the west side for the first time. Agrippa stationed two legions of troops somewhere near the site of modern Cologne. The settlement was incorporated around A.D. 50 through the efforts of Agrippina, his granddaughter, who had been born here; it was named Colonia Agrippina, later shortened to Co-

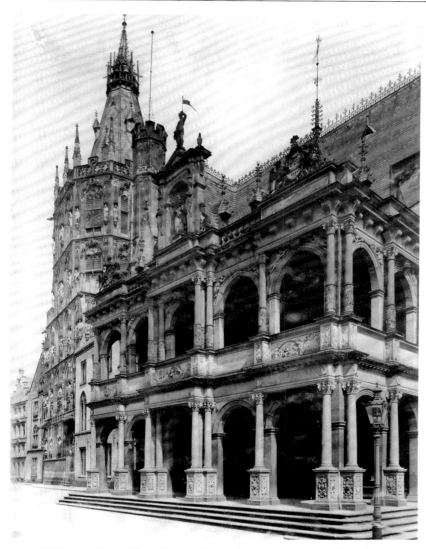

232. Wilhelm Vernukken(?), Porch, 1569–71, Cologne, City Hall

logne, in her honor. Constantine, the first Christian emperor, constructed a permanent bridge across the Rhine here in 310, an event that greatly enhanced the city's economic and political importance. And the inclusion of Maximilian II, the reigning Holy Roman Emperor, illustrated Cologne's ongoing imperial ties.

A second civic theme emerges in the three large reliefs set between the two storys.[66] Each shows a man grappling with a lion. The side scenes recount the stories of Daniel in the lions' den and Samson wrestling the beast, tales that typically signify the power of faith and its triumph over evil. The central relief recounts the misfortunes of Hermann Gryn, a subject that reappears in another sculpture dated 1594 in the Löwenhof or Lion Courtyard of the Rathaus. Through the treachery of two cathedral canons, Gryn, who was then burgermeister, was locked in a dungeon along with a hungry lion. After slaying the creature and escaping his prison, Gryn seized the canons who were then hung from the Pfaffenpforte (Priests' Gate) as a warning against clerical interference in civic affairs. The secular government's long struggle with Cologne's archbishop and clergy is thus presented as a modern battle against evil. Even though the secular populace had

broken the archbishop's control over Cologne in 1288, the issue of civic freedom remained relevant. These three reliefs provide another motive for the inclusion of the portrait busts on the porch. By this means the council stressed not only its Roman past but also its current status as an imperial free city, a title awarded by Friedrich III only in 1475 and maintained under Maximilian II. The councillors, who periodically stood on the porch before their citizens, adroitly exploited architecture and sculpture to articulate Cologne's imperial, not episcopal, allegiance.

In 1570 the Wittenberg council began the renovation of their Rathaus, which was then less than fifty years old. In addition to the elaborate gables of the upper floors, a new two-story, Doric-style porch was constructed over the building's primary entrance.[67] (fig. 233) The tenor of the attractive sculptural program by Torgau artist Georg Schröter contrasts sharply with the historical and polemical messages of Cologne. In a document dated 1573, the council stipulated that Schröter carve statues of Justice and the seven theological virtues.[68] It is the city's wise government and its basis for rule that are being celebrated here. Angels holding Wittenberg's arms occupy the spandrels above the doorway. Flanking the fluted columns of the porch are two female angels labelled RELIGIO and PAX. They carry the shields of Wittenberg's current noble rulers: August, elector of Saxony, and Anna of Denmark, his wife. Justice, wielding her sword and scale, stands proudly atop the central pediment as she is accompanied by the reclining figures of Faith and Prudence. Personifications of Charity and Hope lie on the west pediment while Patience and Fortitude adorn the east side.

While the virtues illustrate the traits necessary for wise rule, the numerous angels, who hold Wittenberg's coat of arms, and the abundant carved biblical inscriptions offer a spiritual justification for civic rule. Painted in gold to ensure legibility, some passages are written in Latin but the majority are in German.[69] These texts stress Wittenberg's abiding faith in God and the populace's need to obey authority. "Except the Lord build the house, they labor in vain that build it" (Psalms 127:1) proclaims the inscription running across the three sides of the architrave of the ground story. "Let every soul be subject unto the higher powers. For there is no

power but of God" (Romans 13:1) read the texts in the east and west pediments. Many of the inscriptions are drawn from Paul's Epistle to the Romans (chapter 13) in which the apostle stresses one's obligations to authority, an appropriate message for the council to direct to its citizens. In the city of Martin Luther where word and image were so closely tied as didactic tools in early Protestant art, the recurring use of biblical texts and allegorical virtues on the Rathaus is hardly surprising. The word of God and Schröter's sculpted virtues, however, are now in the city council's service. Collectively these offer a reassuring ideal of good government to anyone passing through the city's main market located before the Rathaus. The theme and public placement of the porch sculpture also anticipate the allegorical *Fountain of the Virtues* commissioned a decade later by Nuremberg's town council. (figs. 190 and 191)

BY THE 1560s, and especially the 1570s, sculptural decoration on public buildings was again becoming more commonplace. Sculpture could be a simple decorative element or, as at Cologne and Wittenberg, a potent vehicle for articulating civic goals. The range of sculpture was equally varied. Rothenburg's city hall features single statues on the doorway and gable while the life-size herms and wild people of the portal of the Alte Hofhaltung in Bamberg aggressively command one's attention.[70] Certainly the most ambitious use of sculpture occurred at the Rathaus in Lüneburg. Although deprived of the original figured facade, which was altered in the seventeenth century, the building's Ratsstube or council chamber retains its lavish oak decorations carved by Gert Suttmeier and, especially, Albert von Soest between 1564 and 1584.[71] (fig. 234) The chamber, measuring roughly 10.5 by 9.5 meters, contains revêtement, five door frames, and benches all covered with didactic images illustrating virtues, the Nine Worthies, and historical examples of proper moral conduct, such as the Judgment of Solomon or, over the main doorway, the Continence of Scipio Africanus, drawn from the Bible or Roman texts. In 1568 von Soest completed and boldly signed the door frame leading to the burgermeister's room. Floris-inspired herms locked in scrolled braces flank the door while above Sts. Peter and Paul direct us to the detailed Last Judgment relief. Little about the Lüneburg

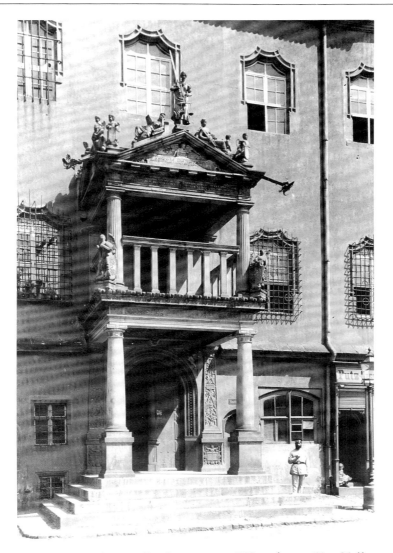

233. Georg Schröter, Porch, c. 1573, Wittenberg, City Hall

program is thematically novel since most of the subjects can be found in older city halls, including elsewhere in this building. Yet the comprehensiveness of the cycle and the fact that sculpture not painting was the chosen medium are significant. By contrast, Lüneburg's earlier great hall, one of Germany's finest, is richly adorned with stained-glass windows (c. 1430) plus morally instructive wall and ceiling paintings (c. 1520–29), but no significant sculptures. A half century later von Soest's reliefs and statues rather than the secondary paintings by Daniel Fuese dominate the Ratsstube. A shift in taste has occurred. Such intricately carved

wooden interiors proved to be especially popular in the late sixteenth and early seventeenth centuries in both private and civic buildings, including the beautiful great hall (1608–12/20) of Bremen's Rathaus.[72]

This gradual revival of sculpture on and in public buildings continued with even greater vigor into the next century. Hans Reichle's monumental bronze *St. Michael Battling the Devil* (1602–07) dominates the facade of the Zeughaus or armory in Augsburg.[73] Jakob Wolff the Younger's new west facade for the Nuremberg city hall includes three portals each with a pair of large reclining statues designed

234. Albert von Soest, Council Chamber Doorway with Last
Judgment Relief, 1568, Lüneburg, City Hall

by Christoph Jamnitzer in 1616.[74] Ninus (Assyria), Cyrus (Persia), Alexander the Great (Greece), and Julius Caesar (Rome) join Prudence and Justice. The statues inform passersby that the glory of the world's four great realms has now been transferred to Nuremberg and the Holy Roman Empire. Similarly in Augsburg, Elias Holl's huge new Rathaus, completed in 1622, liberally incorporates different types of sculpture into the decorative programs of the Golden Hall, the staircase with its imperial busts, and other rooms.[75] In Danzig (Gdansk) the monumental High Tower, the Golden Tower, the Arsenal, the Rathaus, and the patrician Artushof, among other public monuments, were all embellished with noteworthy sculptural programs between 1586 and 1617.[76] In each instance, sculpture and architecture deftly combine to enrich the visual appeal and symbolic message of the respective public structure.

CHAPTER NINE

Small Collectible Sculpture: A Study in the History of Taste

IN THE PRECEDING CHAPTERS, we have chronicled sculpture's use as tangible expressions of piety and, occasionally, pomposity. It was wielded as a didactic tool and as a polemical weapon. Increasingly, however, it also delighted the eye. The harmonious interplay of sculpted surface, reflected light, and dancing water is manifest in the growing number of fountains. Aesthetic concerns, while never wholly absent in any sculpture, became increasingly significant for artists and patrons in the later Renaissance. Prior to the sixteenth century, few sculptures were actually collected. Rather, each work had an assigned function as altar, church statue, tomb, or some other purpose. Sculpture in the home, if it existed at all, was limited to a Madonna and Child or a patron saint. With the Renaissance, a change in conception occured as objects began to be acquired mainly for their artistic merit; utilitarian considerations were often secondary. Small statuettes ornamented desks or shelves above the wainscoting in wealthy burger and noble residences. Reliefs of wood, stone, and metal were stored carefully in cabinets and chests. Like a master print, these objects were meant to be handled and closely inspected. Minute details revealed the artist's virtuosity and mirrored the patron's sophistication. The well-educated clientele was clever enough to understand the subtle recasting of a biblical story or the presentation of allegorical and classical themes. Excluding portrait sculpture, which is discussed in Chapter Ten, the quantity of German *Kleinplastik* or small-scale sculpture was never vast. From the scant documentary records, it appears that later losses, particularly of metallic

objects that were melted down, are quite high. Nevertheless, it is still possible to piece together a general picture of the development of these small sculptures.[1]

Art in the Private Sphere

Two reliefs by Hans Daucher, Augsburg foremost sculptor during the late 1510s and 1520s, illustrate the thematic range and salient characteristics of German *Kleinplastik*. He proudly inscribed the Latinized version of his name, city, and date (1520) on the *Madonna and Child with Angels* in Augsburg (Maximilianmuseum), and, more simply, his monogram and date (1522) on the *Judgment of Paris* in Vienna (Kunsthistorisches Museum).[2] (figs. 235 and 236) Both are carved using Solnhofen limestone whose exceptionally fine grain permits great detail and high polish. The visual appeal of the former is heightened by the red and dark-green marble inlays. The reliefs measure 42 by 31 and 21.1 by 15.5 centimenters respectively. The smaller scale of the *Judgment of Paris* is more typical. Both offer attractive and clearly presented scenes. In the first example, Mary sits holding the Christ Child as a group of angels provide food, music, and entertainment. They are situated within a Renaissance-style building with an elaborate projecting arch whose vault is adorned with Old Testament stories, such as the Sacrifice of Isaac, Moses and the Brazen Serpent, and Jonah and the Whale, that typologically anticipate Christ's future actions. Like many contemporary sculptors, Daucher borrows liberally

235. Hans Daucher, *Madonna and Child with Angels*, 1520, Augsburg, Maximilianmuseum

236. Hans Daucher, *Judgment of Paris*, 1522, Vienna, Kunst-historisches Museum

from other sources. Here his figures derive from Dürer's woodcut (B. 101) of 1518. The architecture, in turn, copies the essential features of the building in Hans Holbein the Elder's *Fountain of Life Altarpiece* completed in 1519 probably for the Dominikanerkirche in Augsburg and now in Lisbon (Museu Nacional de Arte Antiga).[3] Daucher augmented these models by adding numerous details including the vault reliefs and the nude couples ornamenting the column bases. Although these features, most notably the classicizing architectural style and decoration, are hardly new to German art by 1520, such motifs are rarely observed in sculpture. Daucher and his peers were only beginning to bring such innovations to sculpture. As long as sculpture was still tied to the

church and its traditional functions, it remained conservative. Lacking sculpture's inherent expense and investment of time, printmakers were far freer to experiment and, ultimately, to determine the canon of themes and stylistic forms for the rest of German art.

In the case of the *Judgment of Paris*, Daucher's debt to a print is less immediate but no less profound. Cranach the Elder's woodcut (B. 114) of 1508 may have directly inspired only the theme and the general poses of Juno and Minerva on the right,[4] yet it is from prints such as this that Daucher adopted a new treatment of the landscape and the sensuous female nude. German late Gothic relief sculpture is typically very two dimensional with all of the figures packed tightly into the fore-

ground.[5] Pictorial effects are occasionally augmented with separate painted details added behind the carvings, as on the wings of the Erharts' High Altar in Blaubeuren (Klosterkirche). Daucher was among the first sculptors to embrace more detailed space, whether it is the architecture in the *Madonna and Child with Angels* or the landscape in the *Judgment of Paris*. His figures move through their settings rather than overwhelming them. The use of the tall tree on the left to define the composition's perspective and the lushness of the forest behind reflect the influence of the Danube school on Daucher. The sculptor has also drawn the viewer's attention to the three goddesses. Their poses reveal the growing fascination with the erotic in German sculpture, a theme we shall return to later. We are positioned seemingly better than the sleeping Paris to decide the outcome of this beauty contest. Subjects for private contemplation, long exploited by printmakers and painters such as Cranach, only now start to enter German sculpture.

Who were Daucher's patrons? Typically, he worked for nobles and wealthy local patricians. In the aftermath of the imperial diet held in Augsburg in 1518, Daucher received orders from as far away as Dresden and Strasbourg. In the case of these two reliefs, both are associated with the Habsburgs. The coat of arms of King Manuel I of Portugal appear prominently above Mary's head in the *Madonna and Child with Angels*. The sculpture was certainly a wedding gift, since in 1519 the king married Eleonora, Charles V's sister; it remained in the Portuguese royal collection until 1892. Since Charles V was only crowned at Aachen in October 1520 and had yet to visit Augsburg, another family member or, just as plausibly, an Augsburg patrician, such as a Fugger or Welser, with trading ties to Portugal, is more probable as the donor.[6] The *Judgment of Paris* was listed later in the century as in the collection of Archduke Ferdinand II of Tirol at Schloss Ambras above Innsbruck. Did he inherit the relief from his father, and future emperor, Ferdinand I who was named archduke of Austria in 1521? During this decade Daucher carved portraits of both Ferdinand I and Charles V. Three likenesses of the emperor date to 1522, the same year as the *Judgment of Paris*, indicating that he had already established a professional association with the Habsburg court.

Small-scale sculptures, such as those by Daucher, first appeared in Augsburg and then Nuremberg in the 1510s but were not common until the 1520s. Their introduction into German art is the result of the convergence of three different influences: German humanism with its infatuation with Italian and ancient cultures, the success of high-quality printmaking, and the long tradition of possessing a religious object or two for private devotional purposes. Turning first to the subject of humanism, it is significant that many German scholars were educated at Bologna, Padua, and other Italian universities where they were first exposed to the growing discourse about antiquity. Literary texts and, to a much lesser degree, Roman art offered them a window on the past, specifically to the grand human accomplishments of the classical world. Inspired by their Italian experiences, many scholars sought to elevate the level of the arts in Germany upon their return home. For example, medical and legal studies in Padua motivated Hartmann Schedel of Nuremberg to compose his *Liber Antiquitatum*, a catalogue of ancient inscriptions, and his famous world history, the *Liber Chronicarum* or *Nuremberg Chronicle* published in 1493.[7] Schedel also avidly collected the writings of Cicero, Horace, Livy, and Virgil, religious texts, and more contemporary authors. His large library, the location of his own art collection, provided a meeting place for local scholars. Dürer's great friend, Willibald Pirckheimer, also collected antique inscriptions. In addition, he translated the writings of Plutarch and Lucian and composed a history of the Swiss wars in the tradition of Julius Caesar's *Gallic Wars*.[8] German humanists emulated their Italian counterparts. For some, the movement was no less than the intellectual rebirth of their land. Conrad Celtis wrote, "I wish to stimulate and awaken those men among the Germans who excel in learnedness and genius . . . then the Italians, most effusive in self-praise, will be forced to confess that not only the Roman imperium and arms, but also the splendor of letters has migrated to the Germans."[9]

The influence of scholars such as Celtis, Pirckheimer, Johann Stabius, and Konrad Peutinger on early Renaissance artists like Burgkmair, Cranach, and Dürer is well-known. They helped introduce classical themes into German art and occasionally provided the requisite models. When Peutinger

published his *Vitae Imperatorum Augustorum* (Augsburg, 1512), Hans Burgkmair used the author's collection of Roman coins as the basis for his woodcut portraits of the emperors.[10] Yet far more significant was the scholars' gradual stimulation of interest in the classical world. It should be remembered that, unlike Italy, Germany's Roman heritage was still largely unknown. Popular association with the historic and especially pre-Christian past remained rare. Few impressive ruins existed in Germany to inspire the public. Donatello and Brunelleschi could readily find antique sculpture in or near Florence, but this was not true in the vicinity of Augsburg or Nuremberg. A century or more would pass before fledgling collections of antiquities begin to appear in Germany. (fig. 277) Thus even by 1520 the classical world remained a distant myth, a foreign element that touched few lives beyond the rarified circles of Northern humanists, a few cosmopolitan nobles, and some well-travelled merchants. The humanists collectively prepared this elite audience to appreciate the sophistication of their Italian counterparts. Whereas a Donatello or, later, an Antico may have been inspired directly by ancient Roman bronzes, German masters' access to the past was typically indirect. Peter Vischer the Younger looked to Andrea Riccio and other North Italian bronze sculptors much as earlier Dürer used Mantegna as his guide to antiquity. Daucher's *Judgment of Paris* typifies German taste for a thin veneer of classicism packaged in a distinctly un-Roman stylistic idiom. This is characteristic of the fledgling *Welsch* or Italianate style as it was interpreted and developed in the North.

Among German sculptors of the first half of the sixteenth century, Peter Vischer the Younger alone sought a deeper understanding of antiquity. In his brief biography of the artist, written in 1547, Johann Neudörfer observed that Peter loved to read histories and poetry.[11] He frequently collaborated with his friend, the humanist Pankraz Bernhaupt (called Schwenter), in the illustration of poems. For instance, around 1512 Peter contributed 18 pen and wash drawings to Schwenter's *Apologia poetarum* (Berlin, Staatsbibliothek Preussischer Kulturbesitz, ms. lat. fol. 335), a compendium of contemporary poems on classical themes.[12] His *Judgment of Paris* (fol. 74 recto), accompanying Jakob Locher Philomusus's *De iudicio Paridis*, offers a sharp contrast with Daucher's relief. (fig. 237) Peter demon-

strates his understanding of the text. The three goddesses are now identifiable. Juno, who offered Paris political power, wears a crown in the form of a city. Minerva's winged helmet recalls her gift of renown in war. And the totally naked Venus, accompanied by Cupid, reaches out for the victor's golden apple. Her promise of marriage to the fairest woman in the world, plus her own sensuality, have captured the smitten Paris. Juno and Minerva both exhibit jealousy and growing anger as they turn away. Despite the occasional awkwardness of the sculptor's drawing, the figures powerfully evoke the spirit of the story. Peter's muscular Paris is far from the sleeping knight dressed in contemporary German armor in Daucher's relief. The latter's goddesses are much closer to Cranach's courtesan-like women than to any antique source.

Peter may have prepared his *Orpheus Losing Eurydice at the Gates of Hades* brass plaquette, now in Washington (National Gallery of Art), for Schwenter or another humanist friend in Nuremberg.[13] (fig. 238) This black-lacquered relief measures 19.4 by 15 centimeters. The hole drilled at the top indicates that at some date it was either hung on a wall or attached to another object such as a chest or cabinet. Unlike most German brasses and bronzes, this has been cast from a wax, not wooden, model. Peter perfected the lost-wax method of casting during his trip to North Italy sometime between 1512 and 1514. Based upon technical and stylistic evidence, but without any corroborating documentary proof, Peter seems to have been based in Padua, perhaps in the workshop of Andrea Riccio. The subtle, low-relief modelling of the figures and the landscape features lack the hard, linear character that results from wooden models. The plaquette dates to about 1516 or not long after this journey south. Peter has again returned to the classical literary source, here Ovid's *Metamorphoses* (Book 10: lines 1–77), for the story of Orpheus. Shortly after their marriage, the nymph Eurydice was bitten by a serpent and died. The grieving Orpheus followed her to the underworld where he so moved Pluto and Persephone with his music that they granted his wish to return to the surface with Eurydice on the condition that he not look at his wife until they had passed the valleys of Avernus. In 1514 Peter sketched the story more completely in a drawing now in Nuremberg (Germanisches Nationalmuseum).[14] (fig. 239) In the plaquette, the artist

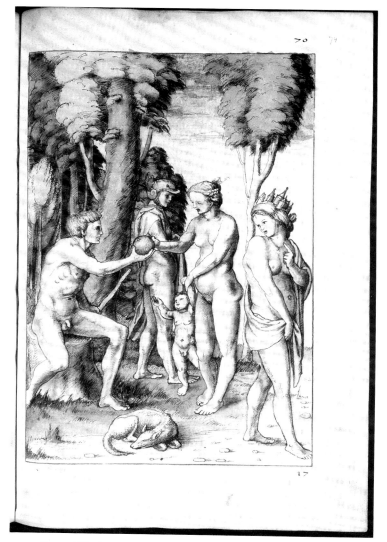

237. Peter Vischer the Younger, *Judgment of Paris*, c. 1512, drawing in Pankraz Bernhaupt (called Schwenter), *Apologia poetarum*, Berlin, Staatsbibliothek Preussischer Kulturbesitz, ms. lat. fol. 335, folio 74 recto)

omitted Cerberus guarding Hades, Pluto and Persephone, the Eumenides, Sisyphus, Titius, and others as he limited the scene to the fateful moment when Orpheus turns to glance at Eurydice. Standing beneath a rocky overhang, clad only in a diaphanous veil, Eurydice gestures goodbye to her husband though she does not reach longingly for him as in the drawing. Orpheus, holding his viol, seems frozen as if simultaneously stunned by the ramifications of his action and captive of his last glimpse of his wife before she slips back into the shadows. As in the *Judgment of Paris*, his protago-

nists stare intently at each other. The physical gulf between Orpheus and Eurydice, reinforced by their respective closed and open landscape settings, poignantly signifies their final separation. By understanding the subtleties of Ovid's text, Peter offers far more than a simple gloss of the story.

Shortly after completing the plaquette, Peter produced a second version of the theme that exists in three copies, the finest of which is in Hamburg (Museum für Kunst und Gewerbe).[15] (fig. 240) Now the setting is reduced to a few flames besides Eurydice and a grassy path beneath Orpheus. The

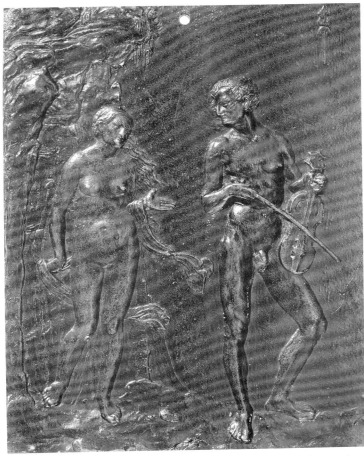

238. Peter Vischer the Younger, *Orpheus Losing Eurydice at the Gates of Hades*, c. 1516, plaquette, Washington, National Gallery of Art, Samuel H. Kress Collection

focus is on the figures not the narrative. Orpheus is physically more fully developed and less angular, and Eve slightly fleshier than in the Washington relief. Both figure poses derive from Dürer's *Adam and Eve* engraving (B. 1) of 1504 as if Peter was intentionally acknowledging Dürer's ultimate, if indirect, reliance upon classical prototypes: the *Apollo Belvedere* and the *Medici Venus*. (fig. 249) As Wuttke has demonstrated, the four-line Latin epigram above the couple was written by Nuremberg humanist and doctor Dietrich Ulsen (Theodoricus Ulsensis) and published originally in 1507 in a volume of texts edited by Conrad Celtis.[16] Thus, once again, Peter demonstrates his ties to Nuremberg's humanists and his profound interest in their dialogue. Dürer was not the only local artist with humanist pretensions and friends.

Well-educated German collectors also gradually developed a taste for small statuettes. In 1549 Georg Pencz painted a well-dressed, 27-year-old man holding a statue group of *Pan Seducing Luna*.[17] (fig. 241) I am less concerned about the identity of the individual, though Jörg Vischer has been suggested, than by the pride with which the sculpture is borne. The statuette is an object of great status. It defines the young man either as an accomplished artist or a cultivated collector with a taste for the classical. German humanists and merchants admired such small statuettes when visiting colleagues in Italy. By the late fifteenth and early sixteenth centuries, artists in Padua and other North Italian towns were producing an ever-growing number of such bronzes.[18] Pier Giacomo Alari-Bonacolsi earned his nickname, Antico, because of

239. Peter Vischer the Younger, *Orpheus Losing Eurydice at the Gates of Hades*, 1514, drawing, Nuremberg, Germanisches Nationalmuseum

his emulation of ancient Roman bronzes. Riccio mixed classical motifs with his own fantastic imagination. Vittore Carpaccio's famous painting of *St. Augustine in His Studio* (Venice, Scuola di S. Giorgio degli Schiavoni) of 1502 shows a room lined with books and small bronzes.[19] If hardly representative, it stands as an ideal for the age in Italy. Far more typical in the North, however, is the situation presented in Cranach's *Cardinal Albrecht von Brandenburg as St. Jerome* paintings in Darmstadt (Hessisches Landesmuseum; 1525) and Sarasota (John and Mable Ringling Museum of Art; 1526) where the passionate collector sits in his study surrounded by books, goldsmith works, and paintings but not a single relief or statuette other than the small wooden Crucifix on his desk.[20]

The introduction of these small statuettes into German art occurred rather late. The first secure examples are Peter Vischer the Younger's two inkpots in Oxford (Ashmolean Museum).[21] (figs. 242 and 243) In the first, made around 1516, an allegorical nude woman stands with one foot resting upon a skull. She points to her eyes with her right hand and clasps the inkwell with her left. Profile busts reminiscent of Roman coins along with the Vischer family mark, two fish impaled on an arrow, ornament the sides of the claw-footed inkwell. These decorative forms, plus the "testa-da-cavallo" design for the shield leaning against the back of the inkwell, are adopted from Paduan models. Similarly, Peter apparently patterned his nude figure after a Fortuna on a medal by Giovanni Maria Pomedelli of Verona. In both the medal and the inkpot, Fortune's ball is replaced with a skull. The

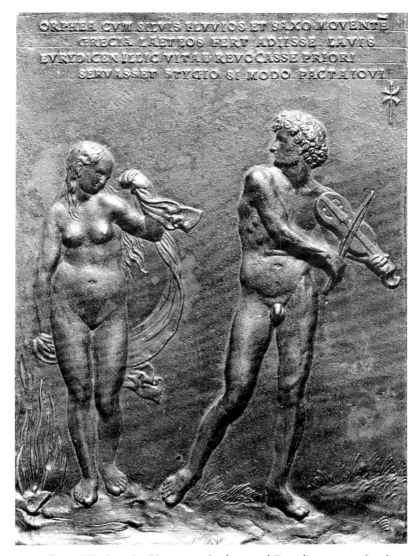

240. Peter Vischer the Younger, *Orpheus and Eurydice*, c. 1516, pla-
quette, Hamburg, Museum für Kuunst und Gewerbe

memento mori theme is further reinforced by the in-
scription "VITAM NON MORTEM RECOGITA"
("Reflect upon life, not death"), a motto that also
appears on the epitaph of Peter the Elder's third
wife. Wuttke and Wixom are correct that here "VI-
TAM" implies eternal life. Thus on one level the
inkpot contrasts the certainty of eternal life with
the shifting fortunes that characterize earthly life.
As a utilitarian object designed for the desk of a
scholar, the inkwell also offers a reminder that the
permanence of the written word far outlives the
transcience of flesh. A similar message is conveyed
by Peter's second inkpot, signed and dated 1525.
The nude woman, no longer so clearly Fortuna,
now touches a vase with her left arm. The artist
varied the appearance of these inkpots through his
choice of surface color. The earlier one has an attrac-
tive natural, brass patina, while the later example
has masked the metal with a black lacquer plus a
few traces of old gilding in the hair and vase. How
many other independent statuettes the artist made
is unknown. Because of the variety of human,
animal, and hybrid forms that the Vischer family
workshop included on the *Shrine of St. Sebaldus* (fig.

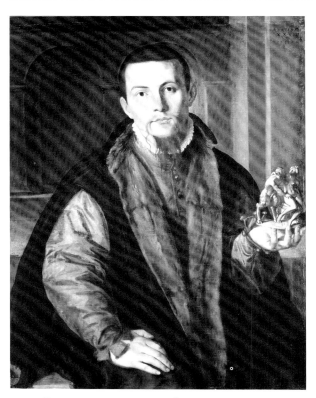

241. Georg Pencz, *Portrait of a 27-Year-Old Man* (*Jörg Vischer?*), 1547, painting, Dublin, National Gallery of Ireland

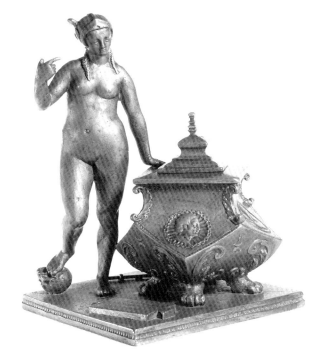

242. Peter Vischer the Younger, Inkpot, c. 1516, Oxford, Ashmolean Museum

10) during the 1510s, virtually every early German brass or bronze figure has at some time been attributed to Peter, his father, or his brothers. Even old attributions in inventories, such as the Small Dog and Cardinal's Head by Peter Vischer listed in the art collection of the patrician Volckamer family of Nuremberg around 1700, may prove to be potentially unreliable.[22]

Comparatively few other artists followed the lead of Peter the Younger. His singular interest in the classical world was not shared by many contemporary German artists. Ultimately far more significant than, though related to, the humanists' fascination with Italy and antiquity was the influence of prints on small sculptures. During the course of the fifteenth century, prints had evolved from crude woodcuts to highly sophisticated objects valued by the pious and equally prized by collectors such as Hartmann Schedel.[23] The high artistic level of works by Martin Schongauer, Master E.S., and the Housebook Master appealed to a growing clientele.

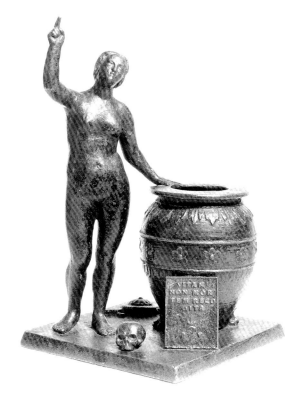

243. Peter Vischer the Younger, Inkpot, 1525, Oxford, Ashmolean Museum

279

Dürer's technical virtuosity and intellectual nimbleness as expressed through his prints gained a European-wide audience. The original edition of some of his prints was quite large if we can judge from the 500 copies that he sent Albrecht von Brandenburg of the *Great Cardinal* engraving (B. 103) in 1523, or the remarkable number of prints that he sold or gave away while in the Netherlands in 1520–21.[24] A few prints were literally precious. Burgkmair and Jost de Negker tinted some impressions of their chiaroscuro woodcut, the *Equestrian Portrait of Emperor Maximilian I* (B. 32), with gold and silver and printed them on parchment not paper.[25] By the early sixteenth century, most of Germany's best printmakers were also its best painters. These artists seized the aesthetic and economic opportunities that printmaking offered. Unlike an altarpiece or a portrait, a woodcut or an engraving was inexpensive to make. Since few prints were commissioned, artists produced their wares for the marketplace. Dürer even hired agents to sell his prints in Italy. The better printmakers made healthy incomes. Recall that during his negotiations with Frankfurt-merchant Jakob Heller, for whom he was painting a large altarpiece, Dürer wrote in frustration "So henceforth I shall stick to my engravings, and had I done so before I should today have been a richer man by 1,000 florins."[26] Despite some censorship connected with the politics of the Reformation, artists were free to select their own subject matter. Religious themes dominated until about 1520 but secular topics steadily gained in popularity. Through prints, art reached an ever broader public. Importantly as well, art entered the private sphere. Whether an individual owned one print or hundreds, this was an art studied mainly in the home rather than in the church. The small scale of most prints dictated viewing as a very personal activity. It demanded close scrutiny much as would a book. This is especially true for the minute engravings popularized by the Beham brothers, Georg Pencz, and Heinrich Aldegrever, the so-called Little Masters from the 1520s on. The ties between painter-printmakers and sculptors are hardly surprising since these artists occasionally collaborated with each other and even resided together, as in the case of Burgkmair and Sebastian Loscher who shared a house in 1510 and co-signed the *St. Alexius* (Ulm, Museum) in 1513.[27]

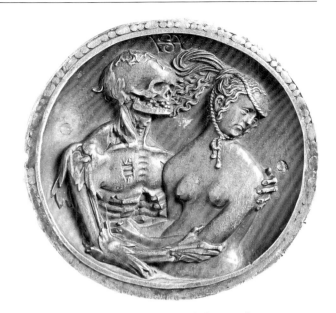

244. Hans Schwarz, *Death and the Maiden*, c. 1520, Berlin, SMBPK, Skulpturengalerie

By the mid-1510s the collecting public had become accustomed to small-scale works of art. The success of prints affected the history of German sculpture. *Kleinplastik* offered sculptors most of the same benefits: small size, lower costs, greater diversity of themes, significant potential for technical and aesthetic virtuosity, and, theoretically, a broader range of patrons. With the advent of the plaquette and the medal, which will be discussed later, artists even had the opportunity to create a form of reproducible sculpture. Many early examples, such as Daucher's *Madonna and Child with Angels* and *Judgment of Paris*, drew compositional and thematic inspiration directly from prints. In about 1520 Hans Schwarz carved several small roundels, including the maplewood *Death and the Maiden* in Berlin (SMBPK, Skulpturengalerie).[28] (fig. 244) Using vivid pictorial antithesis, he offers an allegory of life and death very much in the *memento mori* tradition. The leering figure of Death snatches another victim, a voluptuous young woman. Her soft, curvaceous nude body contrasts with his skeletal form and rotting flesh. Still in the blush of her youth, the woman is dejectedly resigned to her premature demise as her lover turns out to be Death, who respects neither age nor beauty. While not necessarily based on a specific

print, Schwarz recalls the intentionally titillating compositions developed by Hans Baldung Grien and Niklaus Manuel Deutsch in the 1510s.[29] Like Daucher, Schwarz adapted a popular theme to sculpture. Prior to the rise of these small-scale carvings, sculptors had been severely limited to subjects appropriate to church use, to a memorial project, or to the rare civic commission. Painters and printmakers enjoyed a far broader thematic vocabulary. Yet by creating a new form of sculpture that mimicked a print's size and iconography but was rendered not on paper but instead in fine wood and stone or polished brass and bronze, Schwarz, Daucher, Vischer, and their peers brought their art into burgher houses and noble residences.

One additional developmental model deserves mention. The earliest small, domestic sculptures, whether in Italy or Germany, were devotional images. Wooden or metal crucifixes adorned a wall or a tabletop long before the sixteenth century. Statues of Mary and Christ or a patron saint were common features of house chapels. Small, portable ivory diptychs and triptychs were popular throughout the late Middle Ages. Diminutive copies of cult images, such as the many carved representations of the *Beautiful Virgin of Regensburg* that we discussed in Chapter One, were brought home by pilgrims to holy shrines. Thus, affluent German households had a long tradition of embracing a limited number of religious items. These statues and reliefs were utilitarian aids to prayer. Therefore, it is not surprising that the earliest examples of *Kleinplastik* represented traditional religious themes. Before Daucher made the *Judgment of Paris* and Schwarz cut his *Death and the Maiden*, both masters had begun with Christian subjects.[30] For instance, in 1516 Schwarz produced his marvelous pearwood *Entombment* in Berlin (SMBPK, Skulpturengalerie).[31] (fig. 245) Measuring only 28.5 by 20 centimeters, this has the appearance of a monumental altar in miniature. The evocative burial scene with its grieving participants is encased within a bold, Renaissance-style frame that was generally inspired by Burgkmair's designs.[32] Schwarz' patrons, perhaps the couple represented in the medaillons, have an image of the dead Christ upon which to meditate and, with the introduction of the skull, to contrast their own mortality. There is nothing to suggest anything other than a private devotional function for

this relief.[33] In fact, Schwarz utilized a similar design for his *St. Margaret* of 1519 now in Schloss Neuenstein (Hohenlohe-Museum).[34] Here the holy figure stands alone for our quiet contemplation. Nevertheless, the shift from the traditional forms of domestic religious sculpture to *Kleinplastik*, where content and modern stylistic concerns are equally significant, may be observed in these transitional works.

The Exquisite Relief and Statuette

These small-scale sculptures are characterized by the quality of their craftsmanship and materials, plus the growing sophistication of their style. The finest examples date between the mid-1510s and about 1540 with a revival in the 1570s. The economic and political uncertainties of the interim decades depressed the demand for all forms of art as we have already observed. No one artist clearly dominated the market. Comparatively few of the masters worked exclusively on a small scale unless they were also medallists like Schwarz and Christoph Weiditz. The earliest centers were Augsburg and Nuremberg, both traditionally blessed with a large number of talented sculptors and metalcasters. The form soon spread to artists active along the Rhine and Danube rivers, in Saxony, and in princely courts. Given the heavy losses, especially of brasses and bronzes, it is a mistake to be overly concerned with locating the elusive *Urbild* or initial prototype. As in the case of the history of German portrait medals, however, a critical moment in the evolution of the form is easier to pinpoint. Many of the best artists, including Daucher, Schwarz, Sebastian Loscher, Victor Kayser, Joachim Forster, and Jakob Murmann the Elder, were either independent sculptors or apprentices in Augsburg in 1518 when the imperial diet, Maximilian I's last, was held. Loy Hering, active in Eichstätt, also returned briefly to Augsburg, where he had trained, in search of commissions. Most of Germany's leading patrons, from clerics and nobles to patricians and affluent merchants, were also in attendance. A few examples of small sculpture must have been admired by the participants just as many marveled over Schwarz' new portrait medals of Konrad Peutinger, Jakob Fugger, and Hans Burgkmair. It is

245. Hans Schwarz, *Entombment*, 1516, Berlin, SMBPK, Skulpturengalerie

hardly coincidental then that the greatest surge in the production of these reliefs and statuettes, including ones by both Daucher and Schwarz, occurred in the aftermath of the diet of Augsburg.[35]

In searching for an attractive theme that would appeal to their customers, many of the earliest small-scale sculptors represented the story of Adam and Eve. In addition to the obvious narrative potential in retelling the creation, temptation, and expulsion of the first human couple, this was a rare biblical account that permitted artists to experiment with the nude and to explore issues of human sexuality. Among the oldest extant examples of *Kleinplastik* is Hans Wydyz the Elder's *Adam and Eve*, now in Basel (Historisches Museum), that was made sometime between 1505 and 1510 when the Strasbourg master was working in Freiburg i. B.[36] (fig. 246) The figures each measure about 15 cm and are carved from boxwood, a material that had long been popular in the Low Countries for making intricate rosary beads and other minute items.[37] The green-tinted ground plus the tree of knowledge with the serpent are cut separately from lindenwood. Wydyz's initials, H W, appear between the legs of Adam and Eve. The artist has chosen the moment of the fall. Eve stares intently at Adam. The light coloration of their eyes heightens their interaction. Her open, almost aggressive pose con-

246. Hans Wydyz the Elder, *Adam and Eve*, 1505–10, Basel, Historisches Museum

Ludwig Krug, Nuremberg's multi-talented goldsmith, sculptor, and printmaker, created at least six versions of the story of Adam and Eve between about 1514 and 1524. These include woodcuts of the Temptation and Expulsion, as well as a solnhofen stone relief, monogrammed and dated 1514, now in Berlin (SMBPK, Skulpturengalerie).[38] In the latter, Eve reassuringly rests her arms on Adam's shoulder as she urges him to bite the apple. The monkey at their feet, also with an apple, symbolizes the sinful state they are about to enter. In his brass plaquette, made in 1515 and recast in 1518, now in the Cleveland Museum of Art, the artist again accentuates the close interaction between the couple.[39] (fig. 247) Adam casually bends and braces himself against the tree to get a closer view of Eve who is engaged literally in a tête-à-tête with the serpent. Krug depicts a slightly early moment in the narrative when the serpent convinces Eve to try the apple that she holds in her hand. The couple still retain their innate innocence. Here Eve is portrayed as a victim rather than the seductive temptress Krug presented in the Berlin relief. In

trasts with the uncertainty of Adam's. He seeks reassurance or guidance from Eve before biting into the apple that she hands to him. He carries a second apple in his right hand. Adam also suddenly seems aware of Eve's sensuality. Her breasts and overly long abdomen are suggestively thrust forward. Eve's hair is tied back in an appealing if un-Edenesque manner. Although the artist's two figures are anatomically and proportionally awkward, a reflection of Wydyz's inexperience at rendering nudes and his adherence to late Gothic stylistic canons, the ensemble is emotionally poignant and visually alluring. Both figures are carved in the round so they may be admired from all sides. The original owner is unknown but during the sixteenth century the statue group entered the famed *Kunstkammer* of Dr. Basilius Amerbach in Basel, about which more will be said later. From the outset it seems to have been planned as a cabinet piece.

247. Ludwig Krug, *Adam and Eve*, 1515 (recast 1518), plaquette, Cleveland Museum of Art

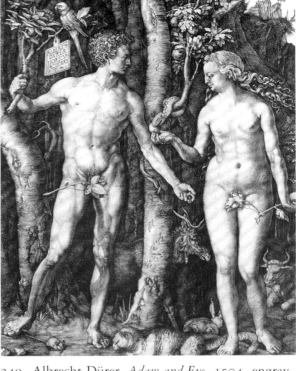

248. Ludwig Krug, *Adam and Eve*, c. 1524, Munich, Bayerisches Nationalmuseum

249. Albrecht Dürer, *Adam and Eve*, 1504, engraving, Nuremberg, Germanisches Nationalmuseum

about 1524 Krug returned to the theme one more time in the red-marble relief in Munich (Bayerisches Nationalmuseum).[40] (fig. 248) Although unsigned, Eve's pose recalls both the Berlin carving and their mutual source, Dürer's engraving (B. 1) of 1504. (fig. 249) Adam crosses his legs and leans against a tree, motifs that the artist borrowed from Marcantonio Raimondi's *Adam and Eve* engraving (B. 1) of about 1512–14.[41] Krug tightly focuses our attention to the center of the composition where he has placed the serpent, the apple, and Adam and Eve, whose eyes and hands are deftly interlocked. The stylized foliage offers a verdant backdrop for the drama unfolding in the foreground. Unlike his early examples, which may have been intended as plaquettes or models for other artists, the Munich *Adam and Eve* is larger, measuring 35 by 27.2 cm, and cut from Salzburg marble, a hard but showy material typically employed for tombs or epitaphs. The size, the color variations, a flecking of red and white stone, and the high polish suggest this relief was expensive

and destined for a prominent placement in a collector's home.

Dürer's engraving also provided the model for Master I.P.'s pearwood *Adam and Eve* in Gotha (Schloss Friedenstein), the finest of the numerous versions of this theme that he carved in the early to mid-1520s.[42] (fig. 250; also see fig. 27) Like Dürer, the sculptor has set the couple before a dense stand of trees in a mountainous location. Master I.P. repeats major features, such as the straight tree between the couple, as well as incidental details including the mountain goat perched precariously on the peak at the upper right. His treatment of the landscape is, however, far lusher as he emphasizes the spatial recession at right and the lush foliage above Adam and Eve's head. Where Krug was content with stylized plants, Master I.P. painstakingly details each leave and piece of fruit. The unusually deep relief and undercutting permit a rich interplay of light and shadow. Active in the Passau-Salzburg region, Master I.P., here and in other reliefs, exhibits the influence of Altdorfer, Wolf Huber, and

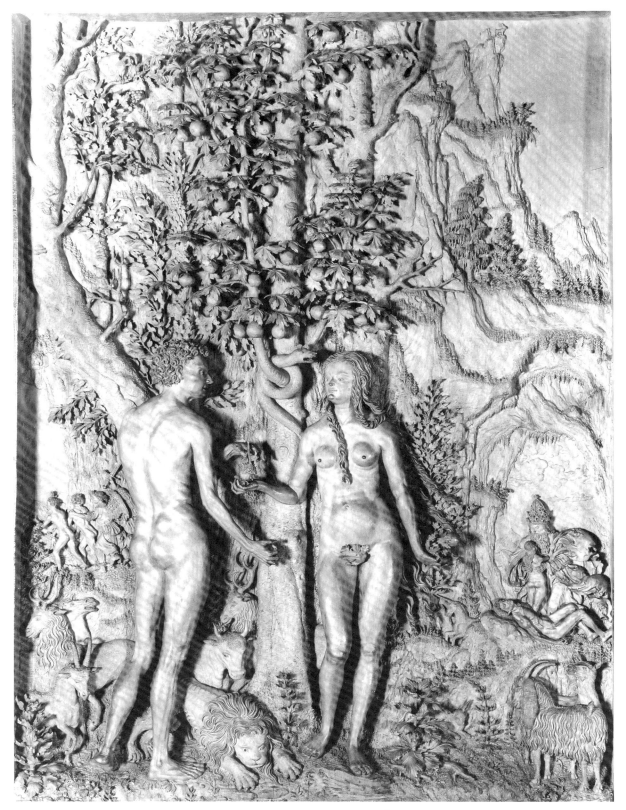

250. Master I.P., *Adam and Eve*, mid 1520s, Gotha, Schloss Friedenstein

the Danube-school artists. Nevertheless, as with his borrowings from Dürer, the master carefully assimilates and alters his sources. Eve's pose derives from Dürer's Eve. Master I.P. switches the leg positions with his figure's right leg now bent to accomodate the slight uphill incline. His Eve, now more full face and with lightly colored eyes, directs her gaze at the apple that she delivers to Adam. Her lithe body is far more elongated than in the print. The strand of hair falling between her breasts clearly accents her sensuality. As for Adam, only his head derives from Dürer's engraving. Master I.P. turns Adam towards Eve in order to receive the apple. As Michael Liebmann has demonstrated, the artist based his figure on the life-size bronze statue of a youth, a Roman copy of a Greek statue, that was unearthed at Helenenberge near Klagenfurt in Austria in 1502.[43] The statue immediately entered the collection of Matthäus Lang von Wellenberg, first at Schloss Strassburg near Gurk, and, in 1519, when the cardinal was appointed archbishop of Salzburg, at Hohensalzburg castle. The Roman bronze would be published with an illustration in Petrus Apianus and Bartholomeus Amantius' *Inscriptiones sacrosantae vetustatis* (Ingolstadt, 1534, p. CCCCXIIII). Master I.P., who may have resided in Salzburg, used both the pose and the slender proportions of this statue for Adam. Only the angle of the arms was significantly changed. The Gotha relief, measuring 62.5 by 46.5 cm, is quite large. The artist began but left incomplete a smaller (25.4 by 31.3 cm) version of the Gotha composition that was in a Munich private collection when Theodor Müller published it in 1951.[44] All of the background elements and some of the animals are largely finished. Adam's body is also mostly cut; however, his head and all of the figure of Eve are only roughly blocked out. The working procedure offers an interesting parallel to Dürer's engraving for which extant trial proofs indicate that Adam and Eve were the final sections of the print to be completed.[45] The original provenance of the Gotha relief is unknown. Could it have been made for Cardinal Lang who owned sculptures by Daucher and Schwarz, as well as prints and drawings by Burgkmair, Dürer, Hieronymus Hopfer, and Hans Weiditz? Bange has suggested that it belonged in the Bavarian ducal and later electoral *Kunstkammer* in Munich before being obtained by Friedrich II

of Saxony-Gotha-Altenburg for his collection in Gotha in the early eighteenth century.[46]

One of Peter Flötner's first known works is the elegant *Adam* in Vienna (Kunsthistorisches Museum) that dates around 1525.[47] (fig. 251) The boxwood figure, with a height of 34.5 cm, probably represents Adam because of his nudity, his leftward turn as if he was facing Eve, and the likelihood that his missing, raised right hand originally held an apple. The lack of requisite identifying features hinders other interpretations. Flötner's *Adam* pays homage to Dürer's engraving especially in the basic pose, yet lacks the latter's conscious classicism. Instead, the Vienna figure is less muscular but far more fluid. Its contrapposto seems natural and effortless. Indeed its graceful harmony was seldom matched in German later Renaissance art except in other works, such as the *Apollo Fountain*, by Flötner himself. (fig. 195) The wooden figure's sensitively cut torso and colored eyes suggest he intended *Adam* as an independent statuette. This does not exclude the possibility that the statue also served as a model to be cast in brass by a founder, such as Pankraz Labenwolf, or in silver by a goldsmith. As observed in Chapter Seven, Flötner frequently collaborated with other Nuremberg masters.

The dramatic stylistic changes that occurred during the first half of the century are evident in the *Adam and Eve* in Vienna (Kunsthistorisches Museum) carved in the 1540s by an Augsburg artist, perhaps in the circle of Christoph Weiditz.[48] (fig. 252) Adam and Eve have a studied elegance. They are gracefully elongated yet fleshier, more physically developed than Flötner's statue or any of the other earlier examples. From the chest downwards, their poses rhythmically mirror each other's. Their hips sway inwards on their weight-bearing legs while their torsos twist outwards in the opposite direction. The artist endowed both with far more expressive facial features and richly detailed hair. Adam and Eve seem fully self-aware. Hans Wydyz' Adam is anxious, uncertain about his course of action. Krug and Flötner stressed Adam's innocence. Now the Augsburg artist depicts Adam as confident, indeed almost analytical, as he listens to Eve. The two figures vaguely recall several of Baldung's depictions of the couple but without the overt sexuality that so fascinated the Strasbourg artist.[49] The Augsburg master has retained something of Bal-

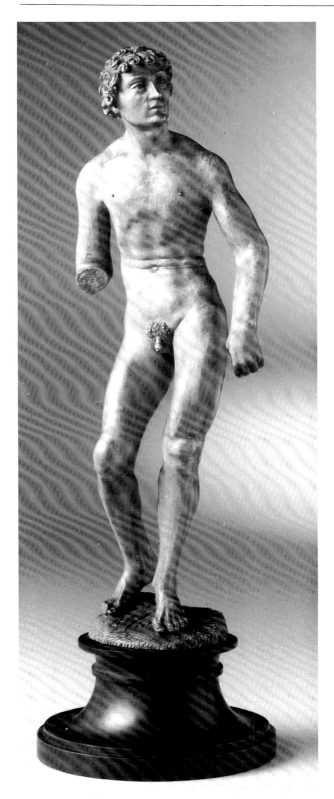

251. Peter Flötner, *Adam*, c. 1525, Vienna, Kunst-historisches Museum

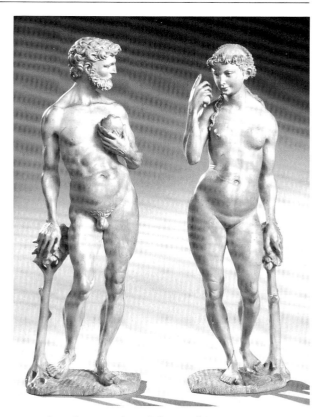

252. Augsburg artist, *Adam and Eve*, 1540s, Vienna, Kunsthistorisches Museum

dung's mature style but controlled it with the sense of balance that characterizes Flötner's art. The statuettes anticipate the refined mannerism found in Augsburg and Nuremberg's goldsmith works in the late 1540s and 1550s, as may be seen for instance in Wenzel Jamnitzer's *Mother Earth* support of the *Merkel Table Decoration* (Amsterdam, Rijksmuseum), completed in 1549. (figs. 269 and 270) The Vienna statuettes were intended from the outset as collector's pieces. They are recorded later in the century in Schloss Ambras. From Eve's upward-pointing gesture, it seems that a tree with the coiled serpent might originally have completed this ensemble.

The theme of Adam and Eve, rendered by numerous other sculptors of the period, was favored by artists and patrons alike since, as a bible story, its use of nudity was expected.[50] Like painters and printmakers before them, sculptors gradually sought other subjects that allowed them to display the human body.[51] Cleopatra bitten by the asp, the

suicide of Lucretia, the judgment of Paris, Susanna and the elders, and innumerable classical goddesses and allegorical personifications were created for discerning patrons. A glance at the total oeuvre of Baldung or Cranach the Elder quickly reveals the remarkable popularity of themes with nude or semi-nude women. It would seem that a Venus or Lucretia by Cranach adorned every castle in Saxony. Just as in our own modern world, German Renaissance artists in all pictorial media recognized that female nudity was a valuable sales tool, especially since their clientele was primarily male.

Some of the earlier attempts at representing the human body by relief sculptors were decidedly awkward. For instance, Loy Hering's *Garden of Love* of about 1525, now in Berlin (SMBPK, Skulpturengalerie), presents an idealized gathering of men and women beside a fountain, perhaps the fountain of youth. (fig. 193) Hering has clearly borrowed several poses from Dürer's engravings. For instance, the standing woman in the center mimics the female in the *Dream of the Doctor* (B. 76) and the reclining woman at right derives from the abducted woman in the *Sea Monster* (B. 71).[52] Yet, unlike Dürer, Hering is uncomfortable rendering nudes. Their bodies are highly stylized with few details. The scene has an additive feeling with little cohesive interaction among the figures. Similar figural problems vexed Victor Kayser. He is a masterful story teller, as observed in his *Susanna and the Elders* made about five years later and today also in Berlin (SMBPK, Skulpturengalerie).[53] (fig. 194) Within the park-like setting just beyond the city walls, the two elders confront the shocked Susanna. The beardless man tugs at his robe to communicate his lust. Their gestures and glances, plus the downcast expression of Susanna, are poignant. Nevertheless, Kayser still displays scant understanding of the female form as her pose and the foreshortening are awkward. Such problems probably mattered little to the owners of these otherwise quite appealing reliefs.

On occasions when the patrons supplied specific prints with well-formed nudes, the sculptors still had minor problems. For instance, in 1550 Hans Ässlinger created two large reliefs for Albrecht V, duke of Bavaria, that reproduce Marcantonio Raimondi's well-known engravings, the *Judgment of Paris* (B. 245) and the *Massacre of the Innocents* (B.

18) after compositions by Raphael.[54] Ässlinger's *Judgment of Paris*, still in Munich (Bayerisches Nationalmuseum), is quite large (30.1 by 44.7 cm) and delicately carved using solnhofen stone. (fig. 253) The Munich court sculptor faithfully replicated his source, though the bodies of several of his figures appear harder and less natural in their movements. Ässlinger copied the forms without fully comprehending how Raphael and Raimondi used each muscle and each limb to construct a fluid form.

Augsburg sculptor Sebastian Loscher took a different approach. He worried less about the particulars of the nude than about the total composition. His *Justice* (*Justicia*) in Berlin (SMBPK, Skulpturengalerie) is not based upon a specific print.[55] (fig. 254) Instead, Loscher's boxwood relief, dated 1536, creatively emulates the apppearance and allegorical language popularized in the prints by the Nuremberg *Kleinmeisters*, the Beham brothers and Georg Pencz.[56] Loscher's Justice is a voluptuous woman scantily clad in an ancient toga. Her pose is artfully awkward. The crossing gesture of her left arm may be necessary to support her twisting body but it also directs the viewer's attention to her breasts. She conforms to the prevailing German interpretation of what a classicizing figure should be. Loscher includes all the requisite symbolic attributes: the sword, balance, and globe held by a putto. He develops the setting so it evokes something of the grandeur of Renaissance architecture and the tranquility of a peaceful landscape. Using a relief such as this, Loscher appealed directly to the same clients who might have bought a Sebald Beham engraving. Measuring only 19.1 by 14.2 cm, the relief demands close attention to its highly polished surfaces and its minutely cut details. The aspirations of this sculptor and a group of contemporary printmaker clearly coincide.

The overall quality of German bronze and brass statuettes, other than several nice fountain figures, declined after the late 1530s. The political and religious struggles connected with the Reformation may have taken its toll. The economic decline coupled with the innumerable military skirmishes waged during the 1540s and 1550s sapped the necessary capital and patronage needed to sustain a high level of private art. What little we know about the career of Jörg Vischer reveals that he was hardly

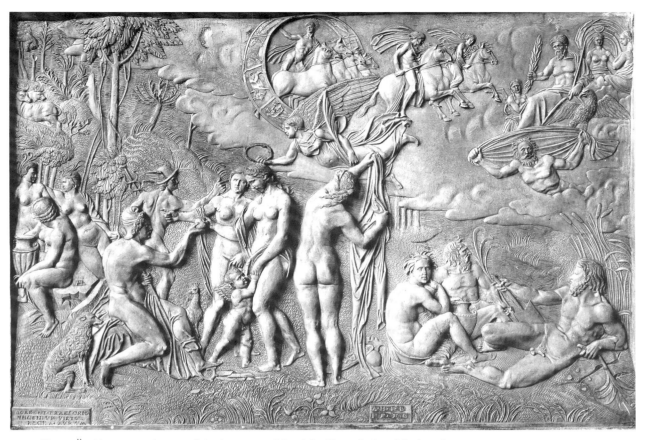

253. Hans Ässlinger, *Judgment of Paris*, 1550, Munich, Bayerisches Nationalmuseum

the relentless experimenter that his uncle, Peter the Younger, had been. His only monogrammed statue is the *Inkpot with the Figure of Vanitas*, dated 1547, in Berlin (SMBPK, Skulpturengalerie).[57] (fig. 255) It harkens back to the two inkwells by Peter in Oxford. (figs. 242 and 243) In each instance, a single female nude stands adjacent to an inkholder. Jörg's figure lacks the delicate modeling of its predecessors, as evidenced in the crude handling of the torso with its absence of anatomical definition, and the over-sized coarse hands and feet. Jörg's later *Inkpot with Orpheus and Animals* (Florence, Museo Nazionale), dated 1556 and bearing the workshop mark, is considerably rougher in execution.[58] If Pencz's *Portrait of a 27-Year-Old Man* of 1549 shows the sculptor, and unfortunately this identification is not certain, the *Pan Seducing Luna* in his hand is far more daringly composed and finely cut than any of his extant creations. (fig 241) The glory of Nu-

remberg's foremost family of sculptors and founders would never re-emerge. Pankraz and Georg Labenwolf and later Georg's nephew, Benedikt Wurzelbauer, became the city's leading casters, yet none seems to have prepared his own wax or wooden models. This specialized task fell to other sculptors. (figs. 184–187, 195 and 196, and 211)

The situation in Augsburg was not much better. The sculptors there specialized in small bronzes that served as door knockers, spigots, table fountains, and diverse statuettes. (figs. 166, 170, 172, 177) Typical is the *Venus* in Berlin (SMBPK, Skulpturengalerie) by Christoph Weiditz or an artist in his circle.[59] (fig. 256) The diminutive, bronze statue, measuring only 12.9 cm, has a precious appearance since it has been firegilt. An amalgam of powdered pure gold and mercury is mixed and brushed over the surface. The statue is then heated causing the mercury to vaporize and the gold to

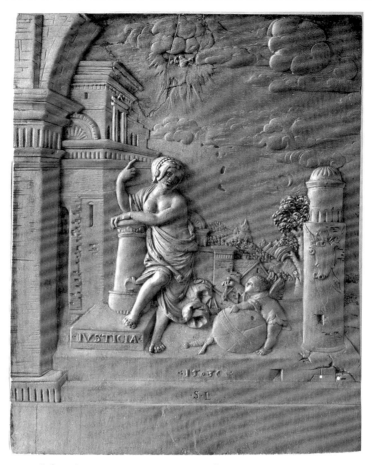

254. Sebastian Loscher, *Justice*, 1536, Berlin, SMBPK,
Skulpturengalerie

bond with the metal. The bronze now assumes the
look of gold. Having gone to this trouble and ex-
pense, *Venus* must have been made for an affluent
patron. She could have functioned as an indepen-
dent statuette or the apex figure in a small house
fountain, like the Berlin *Cleopatra*. (fig. 167) Yet in
spite of its opulence, it is really a rather simple
figure. The artist stresses the curving lines of her
body, most notably the outwards thrust of her left
hip. The modeling of the statue, which was made
sometime between 1540 and about 1550, is some-
what formulaic and far weaker than that of the
contemporary wooden *Eve* in Vienna by another
Augsburg master. (fig. 252) It pales especially
when compared with such truly magnificent bronzes
as Benvenuto Cellini's roughly contemporary Ath-

ena or Jupiter on the base of his *Perseus* in the Loggia
dei Lanzi in Florence.[60]

The quality and international importance of
German small bronzes and brasses would improve
dramatically in the 1570s and ensuing decades due
in large measure to the infusion of new talent. Jo-
hann Gregor van der Schardt, Hubert Gerhard, and
Adriaen de Vries, three Netherlandish sculptors
schooled in Italy, secured ample support from Ger-
man patricians, nobles, clerics, and even civic gov-
ernments. Their success is a central factor in the
resurgence of Central European art after 1580. Of
the trio, only van der Schardt needs to be consid-
ered here. As observed in Chapter Seven, van der
Schardt worked in North Italy before entering the
service of Emperor Maximilian II in Vienna in

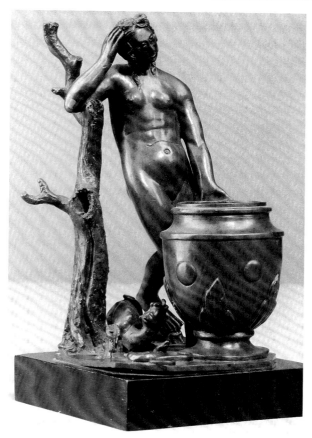

255. Jörg Vischer, Inkpot with the Figure of Vanitas, 1547, Berlin, SMBPK, Skulpturengalerie

1569. A year later he moved to Nuremberg apparently to cast the models, including the *Four Seasons* in Vienna (Kunsthistorisches Museum), for Wenzel Jamnitzer's great imperial fountain. (figs. 173–176) These are far more elegant, far more in keeping with contemporary Italian sculpture, than anything else being made in Germany.

While residing in Nuremberg off and on during the 1570s, van der Schardt produced the monogrammed *Mercury* now in Stockholm (Nationalmuseum).[61] (fig. 257) This bronze figure, measuring 114 cm, is significantly larger than most German statues other than those intended for fountains. The pose of the deity is also different. German sculptors tended to focus the viewer's attention almost exclusively upon a single frontal view. Flötner's *Adam*, for all of the beautiful carving of its backside and despite its diminutive scale that encourages examination from all angles, can only be

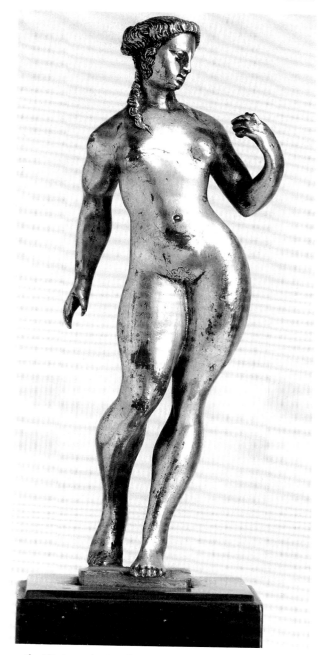

256. Christoph Weiditz or circle of, *Venus*, 1540–50, Berlin, SMBPK, Skulpturengalerie

positioned one way to make narrative and compositional sense. By contrast, van der Schardt opens up Mercury's stance so it engages the surrounding space. Adam stands still; his weight shift does not necessarily indicate motion. Mercury is depicted in mid-stride. He moves forward as he raises his left

257. Johann Gregor van der Schardt, *Mercury*, 1575–81, Stockholm,
Nationalmuseum

leg and transfers the body's weight to the right leg. We anticipate that the wide opening between the legs will soon close and then reopen with the next step. The logical movement of the rest of the body has already begun as Mercury's torso twists to his right. Next van der Schardt introduces a strong cross rhythm extending from the lowered right arm to the raised left hand. Mercury is just arriving to deliver a message to someone to his left. He turns his head and points in the same direction. His lips are slightly parted, indicating speech, a trait rarely found in German sculpture before the end of the century. Van der Schardt has devised a statue that appears to move through space. That is, to be viewed properly it must be examined from all sides. Few earlier statues have the same spatial conception, though it can be observed in the *Four Seasons*.

Van der Schardt's *Mercury* is occasionally compared with Giambologna's bronze of the same subject in Vienna (Kunsthistorisches Museum).[62] (fig. 258) While in Vienna, Van der Schardt may have studied an earlier version of Giambologna's statue that had been sent in 1565 as a wedding gift for Emperor Maximilian. Both masters' figures engage the surrounding space. Giambologna, however, prefers more dramatic gestures, as his flying Mercury seems precariously frozen in mid-stride. His right leg kicks behind him as he surges forward. The serpentine figure rests boldly on one foot. Giambologna, another Netherlandish ex-patriot, intentionally displays his artistic virtuosity. On the other hand, van der Schardt is less experimental. He prefers a greater sense of balance. His Mercury is also heavier, more muscular. These traits may reflect van der Schardt's known interest in classical art. Indeed Mercury's pose distantly echoes that of the *Apollo Belvedere* in Rome (Vatican). In spite of comments to the contrary by Leithe-Jaspar, I think van der Schardt, who spent several years in North Italy, consciously avoided the overt mannerism of Giambologna and the Florentine school. He preferred the somewhat quieter style of the late statues by Jacopo Sansovino, such as the attributed *Jupiter* in Vienna (Kunsthistorisches Museum), plus works by Danese Cattaneo and the young Alessandro Vittoria, who would strongly influence his portraiture.[63] Many of van der Schardt's sculptures were formerly attributed to these and other Italian masters. For instance, his *Diana* (*Luna*) in Vienna

(Kunsthistorisches Museum) and the *Apollo* (*Sol*) in Amsterdam (Rijksmuseum), parts of a now lost series, were earlier identified as being by Cattaneo.[64] While Giambologna's influence on van der Schardt was slight, he would have a considerable impact upon later German art through the efforts of his own pupils Hubert Gerhard and Adrian de Vries.[65]

258. Giambologna, *Mercury*, c. 1587(?), Vienna, Kunsthistorisches Museum

Van der Schardt created at least four Mercury bronzes, a vivid testimony to the popularity of his design.[66] All are very similar in appearance, though minor variations in the length of Mercury's gait, the modeling of the torso, and the expression of the face indicate that the sculptor prepared new models for each casting. Except the loss of the Mercury's caduceus in Stockholm, the sole major distinction is in their height. The Stockholm version is the same size as the example in Pommersfelden (Schloss Weissenstein). These seem slightly more developed and thus later in date than the remaining two statuettes in Stuttgart (Württembergisches Landesmuseum) and Vienna (Kunsthistorisches Museum), both of which measure only 53 cm high. All four date to the 1570s.[67] The small pair may be assigned to 1570–75 based upon the close similarity with van der Schardt's *Fall* and *Winter*. The Stuttgart statue, or another now lost Mercury, also seems to have been originally paired with the *Minerva*, now in Washington (Robert Smith Collection), whose appearance harkens back to *Spring* and *Summer*. (figs. 173–176) *Minerva* too harkens back to classical models that van der Schardt could have seen in Rome or Venice.[68] The larger Stockholm and Pommersfelden Mercurys date slightly later, perhaps between 1575 and 1581.

Who were his patrons? The Vienna statuette, long in the imperial collection, may have been commissioned by either Maximilian II, van der Schardt's employer, or, less likely, his successor Rudolf II. In later centuries, it was displayed together with Giambologna's bronze. Astronomer Tycho Brahe, whom van der Schardt met while working for the Danish court from 1577 to 1579, owned two Mercurys at Uraniborg, including one at his Stjärneborg observatory. Whether either of these statues were by van der Schardt is unclear. Honnens de Lichtenberg has tried to identify van der Schardt as the sculptor Johannes Aurifaber who died in 1591 while in Brahe's employment.[69] Can any of the existing statues be linked with the Mercury that Brahe later sent to Duke Heinrich Julius von Braunschweig, or with the sale of the astronomer's possessions in Prague between 1606 and 1610? With the Swedish sack of Prague in 1648, many works of art were looted and transported northwards. The inventory of Queen Christina's collection in 1652 lists a bronze Mercury from Prague, though no artist's name is given.[70] This may be van der Schardt's statue in Stockholm. Paulus Praun, the famed Nuremberg collector who resided in Bologna, owned dozens of statues, casts, and models by van der Schardt, including the Pommersfelden statuette. He possessed a paired Mercury and Minerva, the latter perhaps the figure in Washington, plus another smaller *Minerva*. More will be said about their relationship later.

Through these and other works, van der Schardt helped to reinvigorate the collecting of brass and bronze statues. He introduced a more modern stylistic idiom based upon a better understanding of human anatomy and movement. With patrons from Nuremberg to Bologna and from Vienna to Copenhagen, van der Schardt proved to other artists that a market existed for finely conceived statuettes. In towns such as Augsburg, Dresden, Innsbruck, and Nuremberg, there was a pool of talented founders but still a scarcity of equally talented sculptors to carve the models. The union of the two crafts in a single artist, as was customary in Italy, would occur but not until after 1580. The scarcity of names perhaps explains why the highly attractive bronze *Allegory of Fertility* in Providence (Rhode Island School of Design) has been ascribed over the years to Peter Vischer the Elder, Peter the Younger, and Jörg Vischer.[71] (fig. 259) The sleek figure, the loose handling of the hair, and the delicate face have nothing to do with any of these masters. Instead the statue dates to the 1570s, at the earliest, and loosely reveals van der Schardt's influence though not his hand.

Plaquettes and Replicable Sculpture

The ability to reproduce a composition in multiple impressions revolutionized European art in the Renaissance. In this study we have repeatedly observed the power of prints to reach a broad audience and to shape the aesthetic discourse. A single woodcut might provide one owner with a devotional aid and another with a worthy compositional model that could be copied in other media. If the paradigm over the relative merits of painting and sculpture has any validity in Germany, the ascendancy of painting around 1500 is due primarily to painters, such as Dürer or Cranach, expressing

259. Nuremberg artist, *Allegory of Fertility*, 1570s (or later), Providence, Rhode Island School of Design

themselves through prints. Sculptors, on the other hand, were limited to a single work with its inherently restricted audience. During the later 1510s two new forms of sculpture that had replicable potential—the medal and the plaquette—were introduced into German art. Multiple impressions of both could be made, though the cost of materials and labor ensured the limited size of the edition. Put simply, metal was far more expensive than paper; casting each object separately was slower and more labor intensive than printing a woodblock or plate. Metal presses were introduced in Nuremberg around 1550 but their use was limited mostly to goldsmiths stamping out repetitive decorative designs.[72] Nevertheless, Peter Flötner and a handful of South German sculptors seized the initiative by developing print-like plaquettes.

A plaquette has been succinctly defined as "a cast bronze relief, with no predetermined subject and no premeditated purpose, that is serially replicable by molds, and adaptable, integrally or through variants, to any decorative use."[73] The author here was speaking specifically of Italian examples that were normally made of bronze. In Germany, lead was used more often than bronze or brass. Models were cut in wood, stone, and even slate or formed out of wax or plaster. Casting was normally done by impressing the model into clay or fine-grained sand that was packed tightly in a frame. The molten metal was next poured into this depression and permitted to cool. Any irregularities could be carefully filed. Occasionally the metal was gilded to look more impressive, though this happened most often with seventeenth-century impressions.[74] Relatively few plaquettes exceed 15 to 20 cm in height or width, and most are less than 7 cm. The edition size was small. Seventeen extant examples of Flötner's finest plaquette, *Ate and the Litae*, are recorded by Weber.[75] (fig. 262) Maybe two or, at most, three times this amount were originally cast. Most plaquettes survive in more modest numbers. Plaquettes, like prints, were lost through repeated use or accident. Some were simply melted for their material. Plaquettes served several purposes. Many were collected as examples of *Kleinplastik* by patrons and artists alike. The distinction between a plaquette and a relief is rarely clear since impressions were made from these reliefs. Peter Vischer the Younger's lost model for the second version of his

260. Thomas Hering, *Rhea Silvia*, c. 1535–40, London,
Victoria and Albert Museum

Orpheus and Eurydice was used at least three times. (fig. 240) Schwarz or someone else cast a bronze after the central portion of his *Entombment*.[76] (fig. 245) Plaquette copies exist after carvings by Krug and Daucher, among other sculptors.[77] Some of these replicas are much later in date. Thomas Hering's exquisite *Rhea Silvia*, now in London (Victoria and Albert Museum), was made in about 1535–40.[78] (fig. 260) The solnhofen-stone relief illustrates the removal of Romulus and Remus from their mother. Nine plaquettes of *Rhea Silvia* are known, all of which date to around 1600 or later.[79] Of these, one or two may have been cast from the stone relief while the others simply copy the composition. This demonstrates both the continued popularity of earlier sculptures as collector's items and the persistent demand for plaquettes into the next century. Like prints and medals, plaquettes were stored flat in drawers and chests. Some with drilled holes were suspended from or attached to furniture, such as the *Art Chest of Rudolf II* in Vienna (Kunsthistorisches Museum).[80] Others were incorporated into objects ranging from mortars and clock cases to goldsmith cups and book covers.[81] The majority, however, were models for other artisans. Plaquette designs may be found on ceramic stoves and vessels, cut into furniture and architectural decorations, and ingeniously employed in all forms of metalwork.

Plaquettes first appeared in Rome in the mid-1450s. Inspired by ancient cameos and intaglios, it was a new art form with Filarete as its first major

practitioner. By the 1470s and 1480s plaquette makers could be found in many of the leading Italian cities. In the skilled hands of Moderno, who was active from about 1490 until 1540, the plaquette reached its creative peak. His late silver-gilt *Flagellation* and *Sacra Conversatione* in Vienna (Kunsthistorisches Museum), with their deep relief and exquisite figural modeling, rival the finest sculptures of the period.[82] Nevertheless, as Lewis and others have pointed out, the general quality of and interest in Italian plaquettes declined with the sack of Rome in 1527 and the death of Riccio five years later.[83] In Germany, the production of plaquettes started far later but persisted into the mid-seventeenth century. There exists a small group of South German religious reliefs of the second half of the fifteenth century that have many of the same characteristics.[84] These may be have been inspired by devotional images or the small metal badges sold at pilgrimage sites.[85] The first true plaquettes are those by Krug and Peter Vischer the Younger in Nuremberg. (figs. 238, 240, 247) This city and Augsburg once again cultivated this new form of art. The majority of plaquette makers in the sixteenth century resided in these two centers, with their dynamic metal industries, though with time a scattering of artists appeared in North and Southwestern Germany.

Peter Flötner and the German plaquette are almost synonymous. Between the late 1520s and his death in 1546, he created over 100 different reliefs that survive today in several hundred copies.[86] At least 17 of his solnhofen-stone models also exist. (fig. 261) None of his plaquettes are signed or dated. Fortunately, the attribution of this large corpus to Flötner is secure, based on his monogrammed *Caritas* model in Vienna (Kunsthistorisches Museum), the close stylistic similarities with his autograph prints and sculptures, and the numerous references by name to his plaquettes in sixteenth- and seventeenth-century inventories and other documents.[87] Already in 1547 his friend and collaborator Johann Neudörfer noted the delight the artist took in carving small stone reliefs that goldsmith Jakob Hoffmann and others would then cast.[88] Perhaps Hoffmann, by whom we have no known works, served as his plaquette caster. Flötner explored much of the same range of topics as the city's printmakers: Old and

New Testament stories, famous women of antiquity, planet gods and goddesses, nine muses, 12 oldest German kings, virtues and vices, and diverse classical tales. Frequently, these plaquettes formed series of 4 to 12 reliefs.

Whether using a circular or rectangular format, Flötner had two basic compositional formulas. As seen in the five models in London (Victoria and Albert Museum), a single dominant figure with its attributes sits or stands in the extreme foreground.[89] Behind the figure is a landscape of varying degrees of complexity. In this group, each offers a lush setting with detailed foliage, sweeping recession, and distant mountains. Flötner varies his poses and treatment of drapery so that each model is distinctive. The second arrangement integrates the figure or figures completely within the landscape. For instance, in his *Ate and the Litae* of 1535–40, Jupiter casts Ate, his clawfooted daughter, out of Olympus.[90] (fig. 262) As she flies, Ate spreads strife and misfortune, as evidenced by the burning castle or village at the upper left and the traveller being clubbed at the far right. The three older women in the foreground are the Litae who, travelling by foot, attempt to repair some of their sister's damage. The landscape is an integral feature. The viewer is treated to a varied setting mixing classical buildings and German thatched-roof mills. This is Flötner's largest (15.8 cm in diameter) and most complex plaquette, yet the same pictorial richness is evident in the majority of his reliefs. Although some of the simpler plaquettes were appropriate for a broad audience, *Ate and the Litae* was most likely a collector's piece. Its theme requires an educated patron. The story derives from Homer's *Iliad* (9, 502ff. and 19, 91ff.) and was popularized through the publication of Andrea Alciati's *Emblematum Libellus* in Augsburg (1531) and Paris (1534). At the bottom, Flötner includes a scrollwork cartouche in which the owner could add his or her name or coat of arms. Our example has the name "Henricus de Honthorst" faintly scratched in. The artist also could have added an explanatory text. More typical in terms of scale, design, and subject recognition is his *Sense of Touch: Venus and Amor* of 1540–46.[91] (fig. 263) Measuring only 6.9 by 9.3 cm, the edges of this rectangular relief are roughly beveled. This indicates that initially this casting was intended as a model. The story needs little explanation as Venus

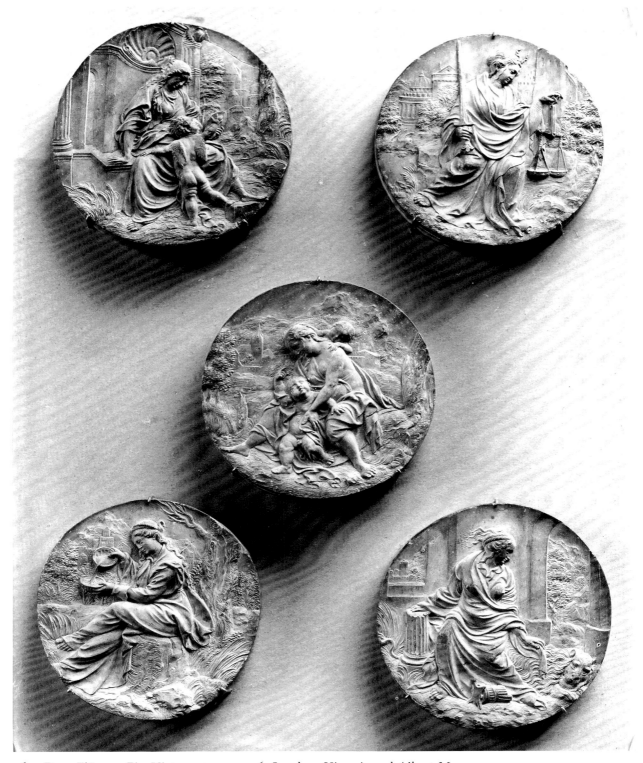

261. Peter Flötner, *Five Virtues*, c. 1540–46, London, Victoria and Albert Museum

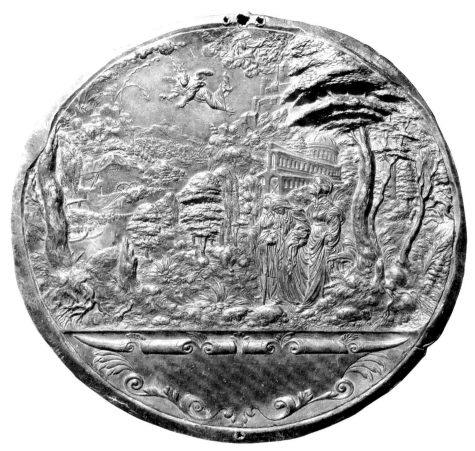

262. Peter Flötner, *Ate and the Litae*, 1535–40, plaquette, Santa Barbara, University Art Museum, University of California, Morgenroth Collection

bends to comfort Cupid who runs out of the forest. Having stolen honey, he is pursued by an angry swarm of bees. On an allegorical level, this illustrates the pain associated with love, a motif explored frequently by Cranach the Elder. Flötner's attention to the pudgy figure of Cupid and the lithe Venus is particularly impressive.

Flötner made the plaquette a valid art form in Germany. At a time when the debate over images raged throughout the land, he recognized the potential of the plaquette as a replicable mode of sculpture to reach new audiences. Collectors and artisans alike admired Flötner's inventiveness and the finesse of his carving. Because he was also a prolific printmaker, Flötner designed his plaquettes to display the same thematic and pictorial range as a good engraving by Pencz, the Behams, or

Heinrich Aldegrever. One of his models or a well-cast plaquette delights the eye and invites lengthy scrutiny. Plaquettes are a quiet type of art, without the immediate visual presence of a fountain, such as his *Apollo Fountain*, or an imposing tomb. Yet as the many copies and quotations of his work demonstrates, Flötner's impact on the course of German art surpassed any contemporary sculptor and most painters and printmakers. Each of the examples illustrated here manifests his concept of style. In work after work, whether plaquette, print, or other type of sculpture, Flötner presents a mature Renaissance vocabulary, one that draws upon both the German and Italian artistic traditions. For sophisticated clients, like Cardinal Bernardo Cles, he was the proponent of the "Welsch" style. And yet no one could mistake his creations for that of a master

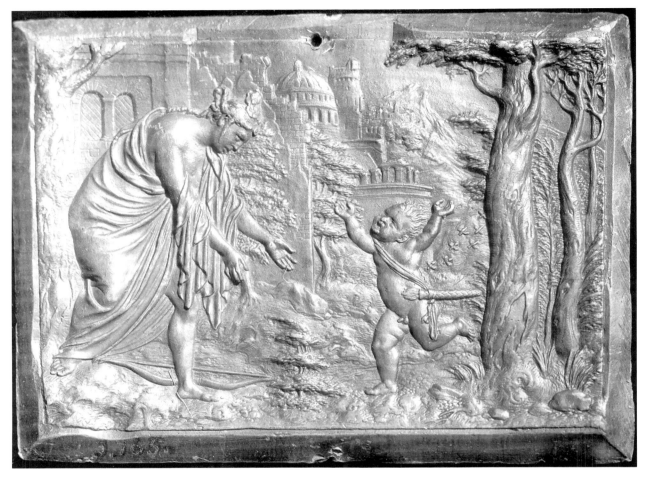

263. Peter Flötner, *Sense of Touch: Venus and Amor*, 1540–46, plaquette, Santa Barbara, University Art Museum, University of California, Morgenroth Collection

from Venice, Padua, or Florence. His sense of naturalism, his love of the minute, and his mode of composition are all firmly rooted in recent German art. This mixing of the familiar with the foreign is the key to his success.

Other Nuremberg artists were inspired to produce plaquettes. An unidentified master, working in the 1530s or early 1540s, carved the *Grieving Warrior* in Berlin (SMBPK, Kunstgewerbemuseum).[92] (fig. 264) This boxwood model depicts a seated soldier clasping his cloak. Although the specific subject is unknown, the artist's real focus was the carefully modeled nude body with its especially subtle treatment of his muscular legs. The artist has employed unusually deep relief in order to accentuate the figure, which might explain

why Wilhelm von Bode once considered it a German copy after Moderno. Unlike the five stone models by Flötner discussed above, the carving seems incomplete since the edges are truncated and there is no backing for the upper half. The latter was no problem since it would cast as a smooth background from which the tree projects. There is no evidence that the warrior was part of a larger narrative. The one extant bronze plaquette, now in Berlin (SMBPK, Skulpturengalerie), displays the same design though the tree once had short, stylized branches and the side edges were straight rather than missing two curved pieces. No other works by this artist have been identified.

Following Flötner's lead, Hans Peisser experimented with plaquettes. A series of three virtues

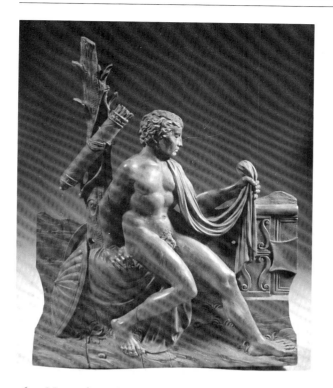

264. Nuremberg(?) artist, *Grieving Warrior*, 1530s-early 1540s, Berlin, SMBPK, Kunst-gewerbemuseum

265. Hans Peisser, *Justice*, c. 1550, Munich, Bayer-isches Nationalmuseum

(Charity, Prudence, and Justice), done around 1550, provide the basis for understanding his activities as a plaquette designer.[93] (fig. 265) He signed "HANS PEISSER FACIE" on the cartouche of Justice and "HANS PEI: F" on Prudence. In each instance, a slightly squat female personification, clad in a clinging robe, stands with her identifying attributes. A foliate wreath with fruit provides a border for each oval plaquette. The series today is incomplete. Only the wooden model for Charity, in Berlin (SMBPK, Kunstgewerbemuseum), survives. A fourth virtue, Patience, exists in a seventeenth-century bronze impression. None of these seems to be identical with the 11 round, signed and dated stone models of "emblems and virtues" once owned by Nuremberg collector Paulus Praun.[94] Unlike Flötner, Peisser's editions were quite small, and he seems to have taken only a passing interest in the medium. His talent is more evident in the exquisite wooden models of the *Forge of the Heart* and *Fortuna*, attributed to him, that are in Vienna

(Kunsthistorisches Museum).[95] The two models, plus a now lost Cleopatra, were acquired by Archduke Ferdinand of Tirol when Peisser worked for him in Prague. Later these were part of his collection at Schloss Ambras.

By mid-century most plaquettes were increasingly being created by goldsmiths not sculptors. Many offer simple figures, decorative bands, or other ornamental features that could be readily adapted by metalworkers.[96] Wenzel Jamnitzer used older plaquettes by Flötner and made his own to adorn his mortars, cups, and chests. The artistic plaquette was revived around 1570 by Master H. G., who is likely identifiable as Hans Jamnitzer (1538–1603), the second son of Wenzel.[97] The name Jamnitzer was often spelled Gamnitzer in Nuremberg records. In addition to his normal activities as a goldsmith, Hans produced figured tazze (dishes) plus at least five, and perhaps as many

301

266. Master H.G. (Hans Jamnitzer), *Fishers and Hunters under Jupiter*, 1572, Munich, Bayerisches Nationalmuseum

267. Peter Flötner, Medal Commemorating the New Castle Fortifications in Nuremberg, 1538, Nuremberg, Germanisches Nationalmuseum

as 13, plaquettes. His earliest secure work, *Minos and Scylla* of 1569, exists in 13 lead and 1 bronze examples, the greatest number by any master since Flötner.[98] Hans' finest plaquette is *Fishers and Hunters under Jupiter*, monogrammed and dated 1572, that survives in a unique silver casting in Munich (Bayerisches Nationalmuseum).[99] (fig. 266) Like all of his plaquettes, it is round. It measures 16.4 cm in diameter. The crowded landscape filled with foliages, figures, buildings, and distant mountains harkens directly back to Flötner, though Hans was less adept at integrating the different features. His perspective and scale are also slightly awkward. Nevertheless, he has composed an impressive scene. Jupiter, mounted on his eagle, flies over the world. Below are his planet children: hunters and fishers. One fisherman in the foreground is distracted by the nude water nymph holding a triton at the right. The landscape is packed with an assortment of birds, fish, turtles, lobsters, crabs, and other creatures. Hans rewards the patient viewer with a wealth of such incidental details. High-quality plaquettes were once again popular and continued to be produced primarily by Augsburg and Nuremberg goldsmiths well into the next century.

The medal is the second form of replicable sculpture. Most are portrait medals as we shall see in the next chapter. Various sculptors, including Hans Reinhart, created religious medals and even a few polemical anti-Catholic parodies.[100] (figs. 47–50) Flötner authored the first German building medal.[101] (fig. 267) In 1538 the city of Nuremberg initiated an extensive expansion of the fortifications around the outer walls of the imperial castle under the direction of Antonio Fazuni (di Vazuni). At the council's request, Flötner devised the obverse that features the imperial double-headed eagle and its two coats of arms. Behind are cannon, halberds, and other war trophies, a classicizing reference to the military function of the fortifications. The cartouche at the bottom reads: "FVNDAMENTVM / SALVTIS NOSTRAE / CHRISTVS PF" ("Christ is the foundation of our salvation. P[eter] F[lötner]"). The motto, which the city used elsewhere, seems simple enough; however, it refers both to their official Lutheran stance and to a common basis in Christ for all Christians. Since the building campaign and the medal were intended partially as in-

ducements to lure Charles V to make his inaugural visit to Nuremberg, Flötner's design was carefully crafted not to offend the emperor. The reverse of the medal displays a 17-line Latin explanatory inscription by Johann Neudörfer. The two halves of the medal were cast separately by Hans Maslitzer and then soldered together. Following an ancient Roman and papal tradition, several of the medals were set on to the foundation stone. Dr. Christoph Scheurl wrote of the Nuremberg ceremony that "the stone in question was round and hollowed out like a pestle, with a lid. Inside it they placed a silver coin."[102] Flötner's showpiece medal was cast in gold, silver, and lead. The extra copies were distributed by the council to themselves, their guests, the architects, and, one hopes, Charles V. This elegantly simple medal helped to inspire a new German tradition of commissioning commemorative medals.[103]

Sculpture and the Collector

From the mid-1510s on, German sculptors faced potentially greater opportunities than ever before. Lucrative markets for small-scale sculpture waited to be developed. In addition to the traditional forms of art, German masters could now add reliefs, statuettes, plaquettes, and medals. By the early 1520s, the first blossoming of *Kleinplastik* had already occurred. Unfortunately, the concurrent explosion of the Reformation depressed the demand for all art as we have seen. The taste for collectible sculpture though grew at a far more modest rate than would have been predicted a few years earlier. Increasingly patronage came only from the nobility, the upper clergy, and the wealthy merchant class. Medals and plaquettes alone would attract the interest of a tiny segment of the middle class. Since much of the small-scale sculpture was not as strictly utilitarian as a pre-Reformation Madonna and Child commissioned for the local church or one's tomb, success was gauged more by such aesthetic issues as the quality of the materials, the design, and the workmanship. Artistic virtuosity was increasingly prized. Indeed, it was during the period from the mid-1510s to the end of the century that a small relief or statuette was perceived from inception as a "work of art" destined for prom-

268. Peter Flötner, *Design for an Ornamental Chair*, after 1535, drawing, Berlin, SMBPK, Kupferstich-kabinett, KdZ 390

inent display in a library, a cabinet, or later a *Kunstkammer*. Its future was inextricably intertwined with the simultaneous rise of the modern art collections in the German-speaking lands.

Contemporary commentary concerning small-scale sculpture is difficult to find in sixteenth century Germany. Unlike Italy, there was no established tradition of aesthetic discourse and no theoretical literature. Issues such as beauty were important but rarely written about. The very existence of a debate is often found only in the accidental anecdote. For instance, what was the nature of the artistic dialogue that prompted Ferdinand I, then archduke of Tirol, to make a bet about a statue?[104] On 9 December 1525, he ordered founder Stefan Godl, then working on the tomb of Maximilian I in Mühlau near Innsbruck, "to cast immediately a whole naked man, standing, in a clever pose, proportioned in the nicest and most diligent manner, with the elbow raised high." He should make it "so that the casting would come out well and no one would need to help with filing it or

in any other way." He was instructed to do it "with all diligence, art, and appropriateness" so Ferdinand would not lose his wager. The resulting *Warrior*, now in Graz (Museum Joanneum), was delivered in February 1526. Alas, neither the outcome of the contest nor the name of the other bettor is known. Godl's figure, measuring 53 cm, was cast after a model probably by Leonhard Magt, his normal collaborator. If the treatment of the body hardly rivals Flötner's *Apollo* or *Adam*, the *Warrior* carefully conforms to the archduke's specifications. His patron had selected a humanistic theme: the nude male. Ferdinand was especially concerned about the statue's proportions and pose as well as the quality of the casting. The gist of the wager was the sculptor's ability to fashion a "modern" statue that was visually satisfying to the archduke and his companion.

In a similar vein, we know that Peter Flötner's carving skill and inventiveness delighted his contemporaries. Neudörfer marveled over the virtuosity of his small-scale art.[105] He mentions seeing a cow horn in which Flötner had cut 113 different male and female faces. In addition to more conventional materials, the artist also occasionally used coral, bone, and seashell. For the Bacchus reliefs on the side of the *Holzschuher Cup* in Nuremberg (Germanisches Nationalmuseum), Flötner employed a coconut shell. (fig. 163) In collaboration with Pankraz Labenwolf, he created life castings after reptiles, insects, and grasses (figs. 178 and 195). In each instance, he offered something precious, something quite extraordinary to his patrons. On 15 May 1532 Cardinal Cles ordered an "amusing chair, made of wood and covered with leather, in which to rest and sleep during the day."[106] Flötner's drawing in Berlin (SMBPK, Kupferstichkabinett) offers a general idea of the type of chair the cardinal wished. (fig. 268) The armrests are supported by nude males, perhaps signifying old age and youth. Putti riding dolphins serve as legs. Meanwhile, the rest of the chair is ornamented with grotesques faces, a garland suspended between the mouths of two putti, and a wealth of foliage motifs. Flötner's design, which would have been carried out by a carpenter, offers much to "amuse" the eye, in keeping with the request of the cardinal or another patron. Flötner's close interaction with other

artists signals his flexibility and his talent at adapting to the changing character of sculpture.

Significantly, this was a moment when some art could simply be beautiful. Its function was solely to impress viewers rather than a more utilitarian purpose. In 1549 goldsmith Wenzel Jamnitzer completed his first great masterpiece, the *Mother Earth (or Merkel) Table Decoration* (Amsterdam, Rijksmuseum), for the Nuremberg city council.[107] (fig. 269) The blank coat of arms indicates that the council intended it as a gift though the noble recipient had yet to be determine. As one of Germany's leading goldsmith centers, Nuremberg frequently showcased its artistic talent when bestowing presents upon the emperor and other princely visitors. Captivated by its appearance, the council elected instead to keep *Mother Earth* in the Rathaus for their own use. They recognized that *Mother Earth* was a unique object, the apex of a goldsmith's skill, and a monument worth adding to the city's growing art collection. Normally protected in a custom-built leather case, the table decoration was periodically exhibited at special banquets and other ceremonial occasions. The whole displays the bounty of Earth, the "Mater Omnium" or the "mother of all," as the accompanying inscription indicates. Mother Earth stands amid an abundance of cast-silver grasses and tiny animals. She supports a large basin richly covered with foliage, hanging putti, scrolls, and strapwork. Moresque designs and miniature creatures, including lobsters, frogs, and snakes, adorn the inside of the basin. Above, an enamel vase filled with more grasses and flowers rests upon three half-length nude females. Jamnitzer has created a marvelous mimicry of nature. The juxtaposition of the natural forms with man-made ones testifies to the range of the artist's skill. The table decoration offers a microcosm—the best of both the natural and man-made worlds in miniature.

This is also another example of the increasingly collaborative character of mid-century German art. The rigid divisions between media employed by many art historians are modern artifices. In this case, Jamnitzer developed the ensemble's overall design.[108] He then contracted an unknown local sculptor to cut the boxwood casting model, now in Berlin (SMBPK, Kunstgewerbemuseum).[109] (fig.

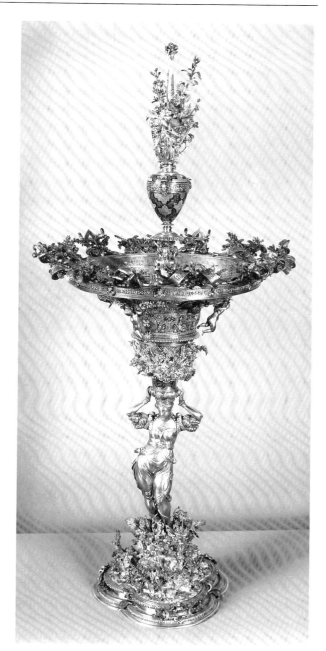

269. Wenzel Jamnitzer, *Mother Earth (or Merkel) Table Decoration*, 1549, Amsterdam, Rijksmuseum

270) Although just a model, this elegant classicizing figure with its elongated forms, clinging drapery, and distinctive contrapposto rivals any of the small-scale sculptures discussed earlier. At a height of 29 cm, the model is a mid-size statuette. Perhaps

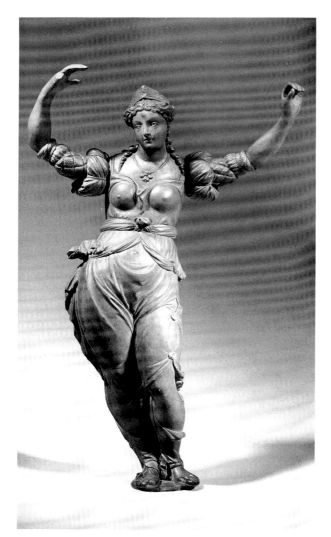

270. Nuremberg artist, *Model for Mother Earth*, by 1549, Berlin, SMBPK, Kunstgewerbemuseum

its scale and its refinement prompted its preservation. Jamnitzer followed the model closely though he altered the position of the right arm so that she seems to be steadying the weight of the dish upon her head.

A sculptor's success often depended upon his or her versatility. This would be particularly true as the century progressed. Sculptors, especially court artists, had to nurture or respond to the whims of their patrons. In 1583 Christoph II Walther showed his frequent client, August, elector of Saxony, a complex presentation drawing (Dresden, Staatliche Kunstsammlungen, Historisches Mu-

seum) for a remarkable piece of furniture—a combination writing table and organ case that is lavishly decorated with sculpted reliefs and figures.[110] (fig. 271) Based upon an entry in the 1587 inventory of the electoral *Kunstkammer* in Dresden, the project seems to have been initiated by the artist. Impressed with the unusual design, August commissioned the three-meter-tall *Positiv*, as it is called. (fig. 272) Delivered in the following year, the work remained in Dresden (Staatliche Kunstsammlungen, Historisches Museum) until its destruction in 1945. The original location of the *Positiv* is unclear. Since it houses a small organ made in 1580 by Johann Lang, perhaps it was initially intended for the palace chapel in Dresden. (fig. 67) I suspect, however, that August immediately placed the *Positiv* in his *Kunstkammer*, where it is documented, together with his huge collection of musical, artistic, and scientific instruments. This was another showpiece (a "Prunkstück") to be admired as an exemplum of artistry and functional form. To enhance its appeal, Walther employed different woods, alabaster, colored marbles, and solnhofen limestone. The lower portion's decoration reflects its musical use as Orpheus plays to the animals and King David strums his harp; eight music-playing females ornament the pilasters. The upper section contains sculptures on both the front and back sides. Its choice of religious themes and its design are reminiscent of a private altar. As befits its Lutheran patron, the scenes, which range from the Annunciation to the Resurrection, are all biblical or, in the case of the five virtues, allegorical. An elaborate blend of sculpture and furniture, the Dresden *Positiv* anticipates the ostentatious chests designed to display sumptuous works of art that became so popular in the early seventeenth century.

The history of Walther's *Positiv* illustrates the major changes that occurred in the creation and collecting of German Later Renaissance sculpture. Here the artist prominently inscribed his name on the drawing and the finished work as a record of his personal creative activity. The patron and the ultimate location of the *Positiv* are both known. This is not an isolated work but instead part of a consciously developed collection. The humanist's or noble's library, with its inkwell or occasional statuette, gradually evolved over the century into the *Kunstkammer*, a special room or set of chambers ded-

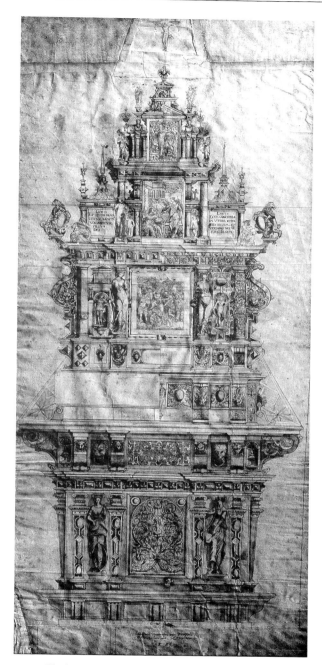

271. Christoph II Walther, *Design for the Positiv*, 1583, drawing, Dresden, Staatliche Kunstsammlungen, Historisches Museum

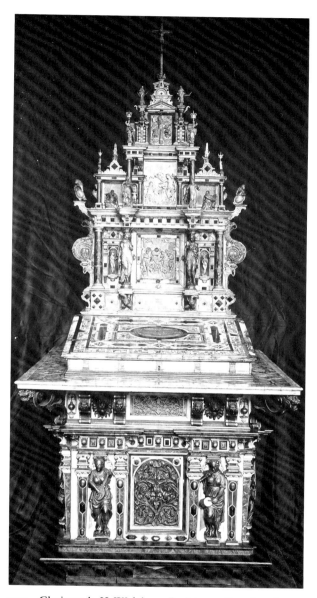

272. Christoph II Walther, *Positiv*, 1583–84, formerly Dresden, Staatliche Kunstsammlungen, Historisches Museum

icated to the display of art and other wonderous items. Such princely *Kunstkammers* in turn were the nuclei for the great museums of today. August's chamber of art, reportedly established in 1560, provided the foundation of Dresden's famous museums. Even some private citizens, such as Willibald Imhoff and later Paulus Praun of Nuremberg, considered their personal collections as permanent creations to be maintained by their heirs. The very nature and even the theoretical basis of collecting underwent dramatic transformations during the period under investigation.

An explanation of the origins of the *Kunstkammer* is far beyond the scope of this study. Nevertheless, since this development affected German sculpture, a few summary remarks are necessary.[111] Earlier in this chapter we noted that many of the first collectible sculptures, such as those by Peter Vischer the Younger, were intended for the private enjoyment of scholars and well-educated merchants. These could be kept almost anywhere in one's home though most were destined for a favored room or library where books, prints, the occasional painting, and other prized works were stored. Such small personal holdings remained fashionable, yet as the century progressed some of the patrician display spaces became ever more sumptuous. For instance, in about 1570 Hans Fugger employed Friedrich Sustris, painter Antonio Ponzano, and stuccoist Carlo Pallago to renovate the two-room library of his house at the rear of Weinmarkt 36 in Augsburg.[112] (fig. 180) Inspired by the painting in the Golden House of Nero in Rome, Sustris created the first Roman-style decorative program in Germany. Both rooms were lined with marble busts of Roman emperors set in niches. Although the library housed Hans' important collection of antiquities, he also displayed or stored his other precious art works and books there.[113]

The ideal of a special room for one's finest possessions was inspired by traditional treasuries or *Schatzkammers* established in both churches and palaces to hold precious items. A stylized view of Emperor Maximilian I's treasury at Wiener Neustadt is presented in Albrecht Altdorfer's woodcut for the *Triumphal Arch* of 1515. (fig. 160) Regalia, holy relics, small devotional statues, silver plate, a table fountain, and gold coins, all carefully separated, are displayed in a secure chamber. In this context, Maximilian's piety and his financial means are stressed, not his artistic sensibilities. A second, though initially less influential model, was the *studiolo*.[114] This was a private room or set of rooms for quiet study. Italian examples, such as those in Urbino, Mantua, or Florence, indicate that art was an integral characteristic of each. Bronze and marble statuettes occupied specially designed niches or rested on ledges. Here one could read, listen to music, and contemplate contemporary and classical art. Access to such rooms was severely limited since these often functioned as a personal retreat, a refuge

for the noble. Elector Maximilian I of Bavaria would establish a special gallery of art for only his own enjoyment in Munich palace in about 1606. Such restrictive chambers, however, were rare in sixteenth-century Germany.

In the aftermath of the Reformation, some patrons redirected capital that formerly might have been spent on an altar or church project to their homes and their art collections, as in the case of the Hirschvogel house in Nuremberg decorated by Flötner and Pencz. (fig. 212) The majority of collections remained fairly small; however, larger and more specialized holdings slowly emerged. Some patrons, like Konrad Peutinger of Augsburg, favored ancient coins and antiquities.[115] Others collected prints.[116] I know of none that exclusively focused on contemporary sculpture. Instead, the average patron gathered objects in a variety of media. Documentary information about the collecting and displaying of sculpture is scant before mid-century, so the examples cited below are skewed to the later half of our period.

Consider the activities of Nuremberg patrician Willibald Imhoff (1519–80) who owned a magnificent house at Egidienplatz 25/27 in Nuremberg.[117] As the grandson and namesake of Willibald Pirckheimer, Imhoff inherited and purchased at least ten paintings and 29 books filled with drawings and prints by Dürer as well as pictures by Altdorfer, Cranach the Elder, and Holbein the Younger. To these he added an impressive number of ancient coins, marble heads, small bronzes, and several modern copies of classical sculpture as well as plaquettes and reliefs. Interestingly, the only contemporary artist of any nationality favored by Imhoff was Johann Gregor van der Schardt who executed life-size terracotta busts of the patron (1570) and his wife, Anna (1579–80), both now in Berlin (SMBPK, Skulpturengalerie). (figs. 314 and 315) According to Hampe, at a later date these were located within their house chapel. As an original placement, this makes sense only for Anna with her pious pose and prayer book. Willibald is presented instead as the connoisseur admiring the merits of the ring in his hand. I strongly suspect that this bust was set originally within one of the rooms displaying art. Van der Schardt also sold Imhoff a terracotta *Fortuna maritima* for the high price of 32 florins in 1572. The theme of this now-

lost statue, which presumably included Fortune or Venus with a putto and dolphin, nicely fits the classical focus favored by Imhoff.

The exact display of Imhoff's collection is unknown. Portions seem to have been scattered throughout several rooms. Bust portraits of twelve Roman emperors stood on pedestals over the doors of the large rooms that he used for his commercial activities. Small marble heads appeared in other rooms. Many of his artistic treasures were kept in a single chamber with a fireproof door made of iron.[118] The overall sumptuous character of the home, its furnishing, and its art was so impressive that the city government periodically borrowed it to house important noble visitors including Duke Albrecht V of Bavaria and his wife in 1570, the archbishop-elector of Cologne in 1575, the daughter of August of Saxony in 1579, and Matthias of Austria, the future emperor, in 1582.[119] During the last years of his life Imhoff decided that his collection should remain intact. In 1588 his widow wrote Emperor Rudolf II, who would subsequently buy most of Imhoff's Dürers, that Willibald "preferred his art, and considered these pieces his most precious treasure; and in his last will he ordained that these should remain forever in the house of the Imhoff family and to their honor and never to be moved from there."[120] The idea that an art collection should form a permanent part of the family's patrimony is new. Similar decisions, though only about a few especially precious objects, occurred at the imperial and Bavarian courts in 1564 and 1565.[121] Here lies the genesis of the great family and dynastic collections. This practice would become increasingly popular in the next century.

More is known about the collecting and display of art, including sculpture, owned by Basilius Amerbach (1533–91), a doctor of law in Basel.[122] From his father Bonifacius, who was Erasmus' heir, Amerbach inherited about 100 items, most notably prized paintings and drawings by Holbein the Younger. Most of these objects were kept by Bonifacius in a single ornate wooden chest, the "Erasmus-Truhe" still in Basel (Historisches Museum), that he had made in 1539.[123] After the death of his wife in 1562, Basilius devoted himself to collecting. His 1586 inventory lists 67 paintings, 1,900 drawings, 3,900 prints, over 2,000 coins and medals (both ancient and contemporary),

770 goldsmith models, a category that includes numerous sculptures and plaquettes, a library, and a collection of musical instruments. As the collection grew so did the need for a better location to store and display the art. In 1579 he had a special vaulted chamber, the "Nüwe Cammer" or New Chamber, constructed on his house "zum Kaiserstuhl" in lower Basel. The room's designer was Daniel Heintz, a local sculptor. Paintings by Holbein, Niklaus Manuel Deutsch, and Hans Bock the Elder adorned the walls. The drawings and prints were stored in a chest with 37 drawers. Around 1578 cabinetmaker Mathis Giger made another sturdy wooden chest, today in the Historisches Museum, with 120 drawers to house the medals and coins.[124] Three niches in the front were filled with early sixteenth-century Italian bronze statues of Mercury, Venus, and Jupiter. When plague ravaged Basel between 1576 and 1578, Basilius acquired the entire workshop materials of two and perhaps three goldsmiths, including Hans Schweiger's whose father had earlier worked in Augsburg. Basilius seems to have been interested in the tools and the processes of making art, which might explain his passion for drawings and prints that served as models for painters, sculptors, and other artists. These items included plaquettes by Flötner and Hans Jamnitzer, drawings, casts including several after Hans Daucher, unfinished wooden crucifixes, and several hundred wooden and metal models. (fig. 135) When possible these items were also stored in chests with sliding shelves. Hans Wydyz' *Adam and Eve*, Hans Michel's alabaster *Jupiter* of 1582, which is a pseudo-antique figure, and a few other statuettes commissioned or collected by Basilius were set on top of the chests or on tables.[125] (fig. 246) Following his death, Amerbach's collection passed to the Iselin family. On 20 November 1661 the Basel city council acquired the collection for 9,000 thalers as university property and reinstalled it in a house near the cathedral. From this moment on, Amerbach's collection was accessible to the public as one of Europe's first municipal museums.[126] Today its contents are divided between the local museums with the sculptures and goldsmith items, other than the drawings and prints, displayed at the Historisches Museum.

Paulus Praun (1548–1616), of Nuremberg and Bologna, collected on an even greater scale.[127] He

possessed over 10,000 objects including Egyptian. Etruscan, and Roman statues, between 4,000 and 5,000 drawings, over 327 paintings, 3,797 medals, and 1,163 engraved stones, among other items. Praun had a strong interest in sculpture, both ancient and modern. He owned 9 wooden statues by Flötner and, stored in an armoire, 11 round stone models of emblems and virtues by Hans Peisser. He had numerous portraits in wax, wood, terracotta, and bronze in addition to his medals. Inventories compiled in 1616, 1719, and 1797 reveal that despite Praun's express wish that the collection remain together, many items gradually disappeared. The number of small bronzes exceeded the 131 recorded in the published inventory of 1797. These include several by Giambologna and van der Schardt. As noted above, Praun possessed at least two Mercurys and two Minervas by van der Schardt as well as brass bust portraits of *King Frederik II and Queen Sophie of Denmark*, perhaps the pair now in Copenhagen (Slot Rosenborg), and a bronze Crucifix "set upon minerals."[128] (fig. 257) By the 1570s it had become popular to combine beautiful natural forms, such as rock crystals and semi-precious stones, with man-made works. In this instance, the Crucifix was imbedded in a miniature Golgotha made of spectacular minerals. Several examples by other artists survive.[129] Honnens de Lichtenberg has recently discovered another with a finely modeled Christ in Nuremberg (Gewerbemuseum) that she attributes to van der Schardt.[130] The published 1797 inventory lists 171 terracottas as mostly being by van der Schardt; however, the 1616 inventory is less specific about their authorship. One is described as "Ein Kopf Johann Gregori Conterfect," apparently a self portrait of van der Schardt.[131] Most of the terracottas are replicas of ancient statues then displayed in Florence and Rome. Included too were numerous clay copies after Michelangelo and 50 studies of the human body.[132] Many of these have been published as clay models by Michelangelo himself. Yet the 1616 inventory, drawn up by Jakob Praun, Paulus' brother, clearly labels these as "after" Michelangelo. If there is a legitimate basis for the later attribution of these by de Murr to van der Schardt, the artist spent considerable time producing replicas either for his own use or for his patron. Somehow

Praun seems to have acquired the sculptor's workshop and its contents at a later date.[133]

The 1550s, 1560s, and 1570s witnessed the birth of princely *Kunstkammers* in Vienna, Dresden, Munich, Innsbruck (Schloss Ambras), and Prague, among other cities. Although slightly different in terms of individual design and display, each brought together diverse collections of sculptures, paintings, antiquities, and other works of art. These were then housed as an ensemble, a pictorial display of the patron's magnificence and learning. The taste for German sculpture varied from prince to prince; however, important examples were to be found in most *Kunstkammers*. Portraits, medals, small bronzes, and finely carved reliefs were prized. The original provenance of Peter Dell the Elder's *Deadly Sins* (Nuremberg, Germanisches Nationalmuseum), created in the 1540s, is unknown, but the six surviving statuettes are precisely the sort of items that would please a sophisticated German patron.[134] (figs. 273 and 274) First, the statuettes attract the eye. Dell's cutting of the pearwood is exquisite, as is demonstrated in the wonderful interplay of line, surface, and light in the Lust. Each of the personifications is fashionably clad and interestingly posed. The recent gilt on their dresses doubtlessly replicates the original decoration. Second, Dell appeals to the mind. Each statuette convincingly embodies its respective vice. The portly figure of Gluttony stares longingly at the contents of her cup. Lust entices us with her smile, inviting gestures, and sensuous form. Anger draws her dagger but it is the hateful stare that makes her so intimidating. The group offers a potent warning against sinful behavior. In sum, Dell's figures are well-crafted, visually alluring, and morally edifying. The group was designed to be displayed, most likely on a table or cabinet.

Many *Kunstkammers* intentionally included the unusual or exotic, whether a stuffed armadillo, an Aztec figurine, an Eskimo kayak, or a garment of Chinese silk. In terms of sculpture, such breadth of scope might include Hans Leinberger's horrific *Tödlein (Death)* and an artist's jointed Mannequin. (figs. 275 and 276) Leinberger's skeletal figure, perhaps originally owned by Emperor Maximilian I, is exquisite with its swaying pose and threatening demeanor.[135] A half century later when it was dis-

played in Archduke Ferdinand II's *Kunstkammer* at Schloss Ambras outside Innsbruck, it was exhibited not just as a work of art. Occupying a cupboard dedicated exclusively to wood, the *Tödlein* epitomized the heights to which an accomplished master could push the material. It functioned as an exemplum much in the same manner as a turned ivory or a statue cut from a rhinoceros horn. This demonstrates how the criteria for admiring a sculpture could change with time. The Mannequin, now in Hamburg (Museum für Kunst und Gewerbe), was made in about 1525–30 by Master I. P. or an artist in his circle.[136] Measuring 24 cm high, the fruitwood puppet is jointed to permit a variety of possible poses. Lacking a base, the Hamburg example may have been supported by a metal rod, though not necessary for seated and reclined positions. From the 1510s such figures were increasingly employed as models and teaching aids in artists' workshops. Here, however, the unusual high degree of finish, such as the careful handling of the muscles and the detailing of the head, are unnecessary were it intended for a workshop puppet. The Hamburg male and its female pendant in Leipzig were intended from inception as collector's pieces.[137]

The theoretical intent of *Kunstkammers* varied as did their arrangement and display. Some were practical and others symbolic in conception. August, elector of Saxony, founded the Dresden *Kunstkammer* in 1560.[138] It occupied seven rooms in the palace, ordered by descending importance. The first chamber contained a few natural curiosities, such as a unicorn horn and a piece of Columbian ore studded with emeralds, several goldsmith works, Italian miniature marble copies after Michelangelo's sculptures, portraits of emperors, August, and his wife, and, after 1584, bronzes by Giambologna. Altogether the seven rooms contained about 130 paintings and sculptures, including the religious reliefs that Peter Dell the Elder carved for August's father, Heinrich the Pious. (figs. 43 and 44) The items were arranged on tables, in chests and drawers, and all over the walls in order to maximize the space. August conceived of his collection as being utilitarian. Of the nearly 10,000 objects, 7,353 were tools, most specially made for the elector. August took great interest in the economic development of his lands so the tools were to aid

artist and workman alike. These ranged from medical instruments and mining implements to farm and wire-drawing machines. Craftsmen could borrow tools or use them at desks set up within the *Kunstkammer*. August reportedly was able to work many of the tools. His turned ivories were displayed along with those of more skilled masters. The Dresden *Kunstkammer*, the forerunner of the famed Green Vaults, contained both an art collection and perhaps the first science and technology museum.

Archduke Ferdinand II of Tirol sought a more comprehensive collection that symbolically recreated the world and its products in one place.[139] It offered a mixture of naturalia, artefacta (human creations), scientifica, mirabilia (miraculous objects), and exotica (African, Asian, and new world items). In 1573 he began construction on the lower castle of his newly renovated and expanded Schloss Ambras just outside Innsbruck. Three of the four rooms were dedicated to his extensive armor collection. The final chamber was the *Kunstkammer*. The objects were arranged by material in eighteen cupboards along the center of the room. Paintings hung from floor to ceiling adorned the walls. Sculptures, such as Leinberger's *Tödlein*, were set in cupboards dedicated solely to one material (crystal, animal horn, copper, bronze, silver, gold, ivory, different stones and woods, and so on). The cupboards were distinguished by their color. For instance, cupboards painted blue contained only works of gold and green ones held objects of silver, such as the inkstand by Wenzel Jamnitzer. Cellini's *Salt Cellar*, now in Vienna (Kunsthistorisches Museum), occupied a special cupboard dedicated to gifts. The inventory lists dozens of sculptures but no artists' names. Thus it is difficult to identify most of the carvings and castings, though many of the German Renaissance sculptures in Vienna (Kunsthistorisches Museum) trace their provenance back to Schloss Ambras. For instance, Ferdinand owned *Kleinplastik* by or attributed to Daucher, Master I. P., Anton Pilgram, Flötner (including his only monogrammed stone plaquette model), Loy Hering, and the Augsburg masater of the *Adam and Eve* statuettes, among others.[140] (fig. 252)

The other major *Kunstkammer* with an extensive

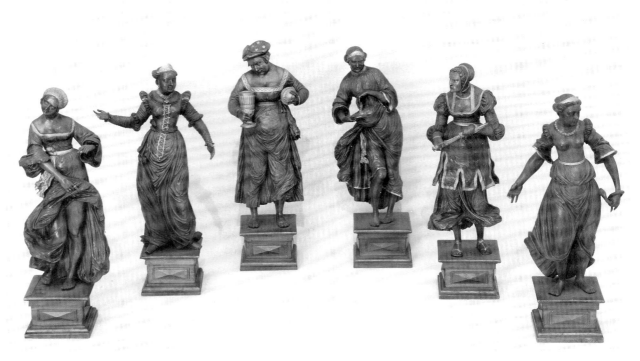

273. Peter Dell the Elder, *Deadly Sins*, 1540s, Nuremberg, Germanisches Nationalmuseum

collection of sculpture was in Munich.[141] In 1563 Duke Albrecht V of Bavaria initiated the construction of a building with a central courtyard between the Alter Hof and the Neuveste of the Residenz Palace. The arcaded groundfloor served as the horse stables while the well-lit upper story was the new *Kunstkammer*. The four wings were irregular in shape with the north or largest section measuring 35 by 6.5 meters of interior space. Using Johann Baptist Fickler's 1598 inventory, which lists about 6,000 objects excluding coins, and other old sources, Seelig's reconstruction shows how the feeling and the display of the Munich collection were far different than those in Dresden or Innsbruck. The four wings provided an open, continuous space. Entering at the northwest corner, the visitor moved in a clockwise fashion, going first down the long north wing. In the northeast corner, where the most precious objects were kept, stood a large mirror reflecting the collection. This provided a sense of the comprehensiveness of the whole. Small square tables stood by each window and large tables or chests were located in the middle of the room.

Each of the small tables had precious objects on top, such as a mountain fashioned from coral, covered with a glass lid, plus anywhere from 20 to 120 other items stored in the drawers or in chest and trunks below. In addition to the hunting trophies and paintings, the walls had two running shelves with bronze and stone sculptures as well as antique and pseudo-antique statues. Large terracotta busts stood on the floor by the windows. More elaborate objects were set on the larger tables. Fickler's inventory provides few artists' names. Albrecht owned reliefs by Ässlinger, Friedrich Hagenauer's *Portrait of Philipp, Bishop of Freising*, now in Berlin (SMBPK, Skulpturengalerie), Thomas Hering's *Portrait and Armorial Reliefs of Duchess Jakobäa of Bavaria* (c. 1535–40), and Hans Multscher's stone *Model for the Tomb of Ludwig the Bearded*, the latter pair both in Munich (Bayerisches National-museum).[142] (figs. 253 and 304) At least twenty of the roughly 90 tables displayed sculpture; another six contained plaster of Paris reliefs and models. Some attempt was made to congregate sculptures by material, but the Munich *Kunstkam-*

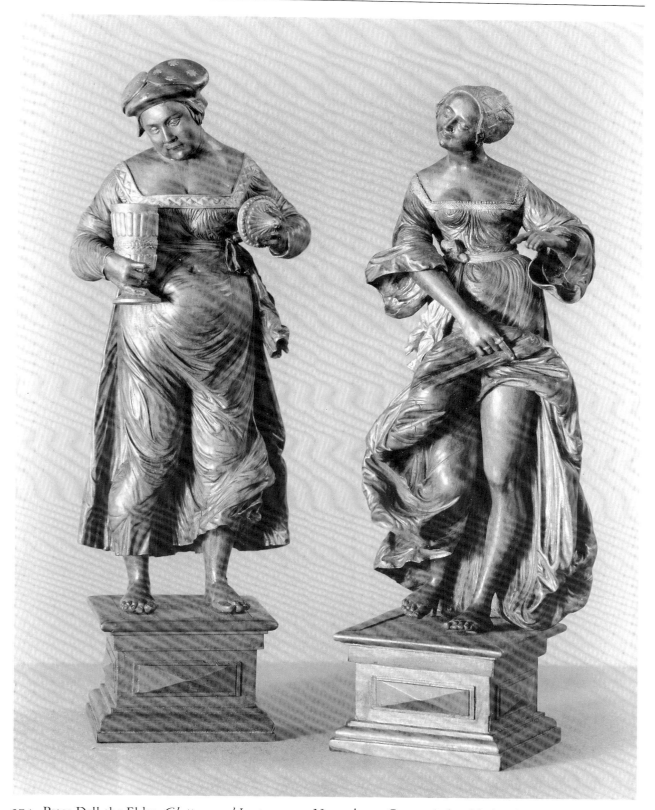

274. Peter Dell the Elder, *Gluttony and Lust*, 1540s, Nuremberg, Germanisches Nationalmuseum

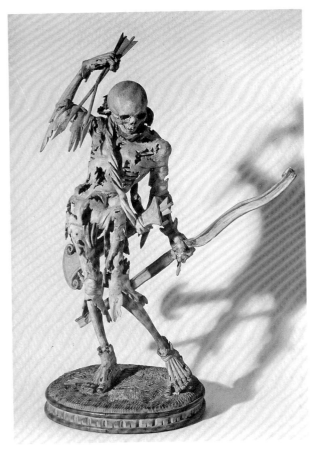

275. Hans Leinberger, *Tödlein* (*Death*), late 1510s, Vienna, Kunsthistorisches Museum—displayed Innsbruck, Schloss Ambras, Kunstkammer

mer never had the rigid separation observed at Schloss Ambras. Duke Albrecht sought an encyclopedic collection though with less emphasis placed on natural and scientific features. Coinciding with the inception of the *Kunstkammer*, Samuel Quiccheberg, the duke's Flemish artistic advisor, published the first theoretical essay on the nature of collecting, organizing, and displaying art.[143] Although not specifically about the Munich holding, Quiccheberg envisioned the ideal collection as a *Theatrum Sapientiae* or a Theater of Wisdom, a reflection of the macrocosm of the world under the prince's control. Interestingly, Albrecht had a whole section in the southwest corner dedicated to Bavaria, specifically ancient coins found within the region, models of the five largest towns made by Jacob Sandtner in 1568–74, and various other his-

torical items. The collection, which continued to expand under Wilhelm V, was accessible to visitors though not to the general public. Its decline began in 1606 when Duke Maximilian I, citing worries about security and conservation, transferred many of the finest objects to his private *Kammergalerie.* Many works were looted or destroyed by the Swedish troops during the sack of the palace in 1632.

In addition to his *Kunstkammer*, Albrecht also erected the famed *Antiquarium*, the first German

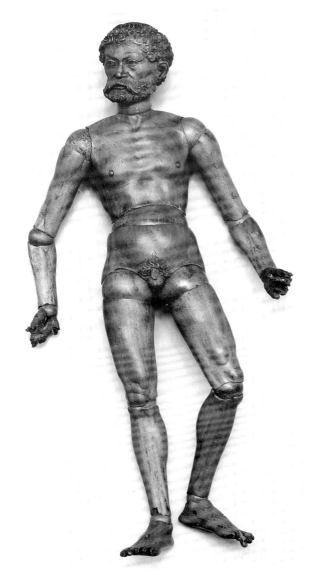

276. Master I.P. (or circle), *Mannequin*, 1525–30, Hamburg, Museum für Kunst und Gewerbe

314

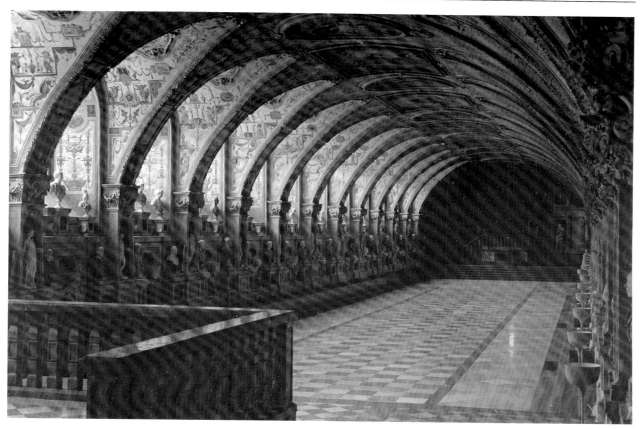

277. Jacopo Strada et al., *Antiquarium*, 1568–72 (altered 1586–87), Munich, Residenz

example of a major building being constructed specifically for the display of classical sculpture.[144] (fig. 277) The idea developed in the mid-1560s as the duke's acquisition of antiquities steadily grew. The first plans date to 1568 and construction was completed in 1572. The two-story structure contains the ducal library upstairs and a single gallery, measuring 67.75 by 11.9 meters, on the ground floor. Designed largely by Jacopo Strada, each bay of the side walls of the gallery contains niches and several ledges for pedestals. The room was altered in 1586–87 under the direction of Friedrich Sustris and a lavish program of paintings was added. Although this room was dedicated to classical not modern works, it still demonstrates the growing recognition that sculpture of all periods was to be prized and lavishly displayed.

Recalling that little sculpture other than the occasional religious statue could be found in palaces and residences at the beginning of the sixteenth century, the appreciation for sculpture and its aesthetic merits obviously had changed dramatically by the 1560s. As the number of patrician and princely collections rapidly increased, so did the demand for *Kleinplastik*. The rosy financial prospects for later artists such as Christoph Angermair, Hubert Gerhard, Georg Petel, and Adriaen de Vries, contrast greatly with the bleaker situation faced by artists in the 1530s and 1540s. Paradoxically, the desire for carvings made by Daucher, Peter Vischer the Younger, Flötner, and their peers was even stronger around 1600. Two contributing factors were the emerging historical esteem for German Renaissance art and the related mania for possessing the creations of Albrecht Dürer. Distelberger notes that Emperors Ferdinand II (1578–1637) and Ferdinand III (1608–57) kept "countless" small wooden carvings in Vienna in the belief they were

by Dürer.[145] One *Birth of Christ*, supposedly carved "by the consumate master Albrecht Dürer, who has excelled in all art," was valued at 30,000 Reichstalers. Numerous new sculptures after Dürer's drawings and prints or in his style date to the early seventeenth century.[146] Perhaps it is fitting that this later phenomenon, known as the "Dürer Renaissance," links *Kleinplastik* and Dürer. As we have seen, its earliest practitioners in the 1510s and 1520s consciously emulated the Nuremberg artist and, significantly, the form of the master print when devising this new type of collectible art. With the creation of the humanist library and, later, the *Kunstkammer*, these small precious objects were both justifiably valued.

CHAPTER TEN

The Emergence of
Sculptural Portraits

THE DESIRE to be remembered is not unusual. Most civilizations have devised means for perpetuating the memories of certain individuals. Typically, such remembrances take the form of a tomb or an epitaph as we observed in Chapters Five and Six. Located in churches and normally accessible to a broad public, these memorials celebrate the piety and the social circumstances of the person portrayed. When the term portrait is mentioned, however, we tend to think first of independent likenesses, such as those painted by Albrecht Dürer or the Holbeins, rather than of memorials. The rediscovery of portraiture would be one of the Renaissance's greatest triumphs. Inspired both by the models of Roman antiquity and by the growing wish to document self-worth or personal accomplishment, a taste for portraiture gradually emerged. In Germany, its development took far longer and a very different path than in Italy. When examining studies, such as Alfred Stange's great corpus of German painting before 1500, one quickly realizes how few independent portraits predate about 1485.[1] The majority of likenesses assume the form of kneeling donors in an altarpiece or a half-length depiction of the patron in prayer or fingering a rosary. Subsequently, increasing numbers of painted portraits of both nobles and merchants begin to appear as artists such as Holbein the Elder, Jakob Elsner, Michael Wolgemut, and, next, the masters of Dürer's generation display their skills of veristic mimicry. Concurrently, the public came to recognize certain celebrated likenesses due to the advent of mass produced, printed portraits.[2] For Protestants and Catholics alike, the faces of Luther

and, to a slightly lesser degree, Melanchthon were instantly recognizable due to the sheer volume of their painted and printed images during the Reformation.

As the acceptance of and demand for all sorts of portraiture steadily grew throughout the sixteenth century so did its range of functions. Most were intended for personal or family use. They record individual likenesses, celebrate familial memory, and commemorate important events, such as a marriage, a change in social position, a political alliance, or a death. (figs. 143 and 144) Others were gifts to friends. Upon receipt of Hans Holbein the Younger's drawing of the *Family of Sir Thomas More*, now in Basel (Öffentliche Kunstmuseum, Kupferstichkabinett), Erasmus wrote on 6 September 1528 that "if I had been among you, I would not have seen you more clearly."[3] This notion that portraits could act as surrogates, pictorial stand-ins for the distant individuals being depicted, became a humanistic topos and certainly encouraged some artists to sharpen their skills of verisimilitude. Erasmus wrote Willibald Pirckheimer in early 1525 that "I have adorned the walls of my bedroom with thee, so that wherever I turn I am seen by the eyes of Willibald."[4] The Nuremberg humanist had sent his friend two portraits of himself: a medal and Dürer's engraving (B. 106). Portrait medals and painted miniatures were occasionally attached to clothing or worn around the neck to signify one's love or political allegiance.[5] (figs. 46 and 287) Others decorated goldsmith works, game boards, fountains, and furniture. (figs. 290 and 305) Portraits also served to laud individuals, especially

those who might provide positive models for others. Sir Thomas More urged that "ymages of notable men" be erected in the marketplaces of his Utopia "for the perpetual memorie of their good actes; and also that the glory and renowne of the auncestors may sturre and prouoke their posteritie to vertue."[6] This desire to enlighten or, at least, inform others explains the increasing use of sculpted portraits, particularly those of nobles, on building facades and portals from Dresden to Heidelberg as observed in Chapter Eight. (figs. 218, 219, 221, 224)

Absent so far from our discussion is any real mention of the independent sculptural portrait. Excluding memorials, sculpture lagged far behind painting until the late 1510s. In fact, the dearth of earlier carved portraits prompts unusual skepticism about each newly discovered example. For instance, the Bayerisches Nationalmuseum in Munich has recently acquired the wooden *Bust of Hans Perckmeister*, the Nuremberg apothecary and city counselor. It bears a detailed inscription giving the figure's presumed identity and the date 1496. The lack of comparable pieces immediately raises questions about its attribution to Veit Stoss and even its authenticity. In this instance, the way the inscription is written on the front of the hat is unique. Furthermore, Hans Stafski has made an excellent case that the statue dates around 1600 and exemplifies the "Dürer Renaissance" in which works in the style of the artist and his contemporaries were manufactured for collectors, such as Paulus Praun.[7] He argues that it borrows from Dürer's *Portrait of Michael Wolgemut* and from Wolgemut's *Portrait of Hans Perck meister* of 1496, paintings both in Nuremberg (Germanisches Nationalmuseum). As we shall see, the bust is the rarest type of portrait in German sculpture. Smaller, more discrete likenesses, such as medals and reliefs, would enjoy far greater popularity.

In this chapter I wish to consider the emergence of the sculpted portrait and its diverse forms. It is a history of promising but false starts and then truly surprising successes. Consider the equestrian portrait. Among the glories of Italian Renaissance art are the imposing equestrian monuments to generals, such as Donatello's *Gattemelata* (1447–53) in Padua or Verrocchio's *Bartolomeo Colleoni* (1496) in Venice.[8] With the destruction of Leonardo's efforts,

there would not be another large scale equestrian statue until 1587 when Giambologna began work on the monument of *Cosimo I* for the Piazza della Signoria in Florence. In the German-speaking lands, comparable examples, such as Caspar Gras' statue of *Archduke Leopold V* on the fountain in Innsbruck of 1629–30, appeared only much later.[9] Perhaps the situation would have been different if Emperor Maximilian I had completed his memorial in Augsburg. On 13 July 1500 he laid the foundation stone of the new choir of the Benedictine monastery of St. Ulrich and Afra. Although his name was inscribed on the stone, Maximilian sought a more permanent artistic record. In 1508 or early 1509, the emperor finally settled upon a life-size equestrian statue. The project was overseen by Konrad Peutinger, designed by his frequent collaborator Hans Burgkmair, and carved in stone by Gregor Erhart. Burgkmair's drawing, which Falk dates between February 1508 and fall 1509, is now in Vienna (Graphische Sammlung Albertina).[10] (fig. 278) Maximilian sits upright on his powerful horse. He wears his crown and holds his symbolic sword of authority while other items of his regalia, the imperial orb and scepter, rest prominently below. The image is strikingly similar to Burgkmair's famous chiaroscuro *Maximilian on Horseback* woodcut of 1508.[11] In the latter, Maximilian sports a plumed helmet and the horse's pose is more animated. Both works celebrate Maximilian's belated coronation as emperor in Trent earlier in this year. As the Holy Roman Emperor of the German Nation, Maximilian was inspired less by Italian prototypes than by the imperial tradition of the Christian knight, the *miles christi* staunchly defending church and state. One possible model is the life-size equestian statue of *Emperor Otto the Great* that was constructed during the 1240s for the marketplace in Magdeburg.[12] Like Burgkmair's design, Otto the Great's horse stands firmly on all four legs to ensure adequate stability.

Prior to the arrival of the stone on 20 October 1509, Erhart certainly prepared a small-scale, wooden model of both the horse and the emperor. While these have not survived, there exist at least six later bronzes of a horse that display a striking similarity to Burgkmair's drawing. The finest of these, now in the Cleveland Museum of Art, was cast after a wooden model in Augsburg perhaps in

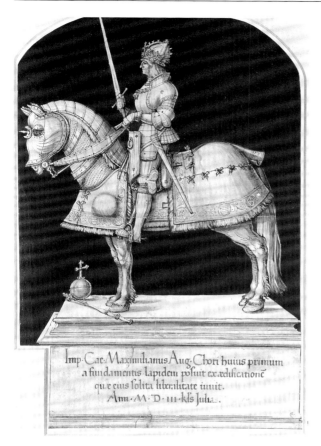

278. Hans Burgkmair, *Maximilian I on Horseback*, c. 1508–09, drawing, Vienna, Graphische Sammlung Albertina

the 1560s.[13] (fig. 279) The stance, specifically the strong balanced pose of the legs and the position of the head, is identical to Burgkmair's horse. The Cleveland bronze includes an elaborate mane, which is lacking in the Berlin version, a feature that would originally have been obscured by the horse's armor.[14] If Erhart followed Burgkmair's lead, the horse and rider stood upon a rectangular base inscribed with information about Maximilian having laid the foundation stone.

Like virtually all of Maximilian's sculptural projects, including his Innsbruck tomb and the imperial monument in Speyer, the Augsburg equestrian portrait was left incomplete. Maximilian had given an endowment of 500 gulden to the church to support its building campaign. Abbot Konrad Mörlin had used some of these funds for the equestrian statue. Upon his death in 1510, his successor, Ab-

bot Johannes Schrott found that the monastery's lavish building programs, which also included the two towers started in 1506, had left the church heavily in debt.[15] Money for the equestrian statue was diverted for other uses. Characteristically short of cash, Maximilian never provided additional funds to finish the project. Erhart completed the horse and at least a rough cut of the rider's torso. The monument was planned originally to be located inside the church, somewhere near the entrance to the choir. Whether it was ever placed there is unknown. By the early seventeenth century, and likely much earlier, the equestrian statue stood in the southwest corner of the great courtyard of the church. It is visible, albeit barely, in several prints, including Daniel Mannasser's engraved *View of St. Ulrich and Afra* of 1626. (fig. 75) With the secularization of Bavaria's churches in 1803, Erhart's sculpture plus numerous others were acquired for their materials by a stonemason. One cannot but wonder whether a completed equestrian monument might have impressed the many nobles who repeatedly passed through Augsburg for later imperial diets. If so, the history of German portraiture might have been richer. Was it coincidental that Titian painted his *Equestrian Portrait of Charles V*, now in Madrid (Prado), between April and September 1548 while both the Venetian artist and the emperor, who was Maximilian's grandson, resided in Augsburg? Titian's debt to Burgkmair's print is evident, yet perhaps too Erhart's ill-fated project inspired the emperor to commission his own equestrian portrait.

Maximilian was not the only contemporary noble with a taste for novel portraiture. Friedrich the Wise, elector of Saxony, had himself represented in innumerable paintings, prints, coins, medals, and sculptures. In Chapter Five we encountered Peter Vischer the Younger's powerful brass epitaph and the adjacent kneeling statue of the prince in the Schlosskirche in Wittenberg. (figs. 96–98) In 1498 he commissioned a life-size brass portrait bust from the Italian master Adriano Fiorentino (Adrianus de Maestri) that is now in Dresden (Staatliche Kunstsammlungen, Skulpturensammlung).[16] (fig. 280) Nothing is known about the circumstances surrounding this project beyond the information inscribed on the bust. These texts identify the sitter, the artist ("HADRIANUS FLO-

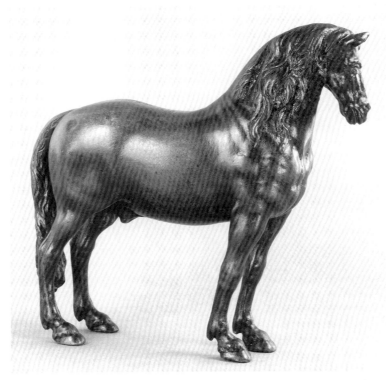

279. Gregor Erhart (copy after), *Horse*, c. 1560–70, Cleveland
Museum of Art, John L. Severance Fund, 52.108

RENTINUS ME FACIEAT"), and the date of completion. Where did the elector and the sculptor meet? Adriano spent most of his career in Naples, until the death of his patron, King Ferdinand I, in 1494, and was briefly in Urbino in 1495. In 1497 the artist prepared a portrait medal of Degenhart Pfeffinger, one of Friedrich's advisors who was an avid collector of ancient coins.[17] It was certainly Pfeffinger who brought the elector and the artist together, perhaps at the imperial diet held in Freiburg i. B. between 18 June and 11 November 1498. No other comparable busts then existed in Germany. Perhaps Friedrich had admired Italian examples as he passed through the country during his pilgrimage to the Holy Lands in 1493. Adriano offers a recognizable if idealized likeness of the prince. He emphasizes the broad head and the masses of hair and beard. With his head tilted slightly upwards, Friedrich gazes off in a detached manner. Since Adriano returned to Florence where he died on 12 June 1499, the artist may have produced only a clay model that was subsequently cast

in southern Germany or Saxony. Where Friedrich placed the bust is also uncertain, though at some later date it was displayed in the chapel at Schloss Hartenfels in Torgau.[18] Like Maximilian's horse, Friedrich's brass bust exerted little influence on German art. Sculptors, such as the Vischers, who had the technical knowledge to produce such figures, did not. Only Maximilian would commission bronze portraits, like those by Jörg Muscat, and most of these were somehow connected with the shifting plans for his tomb.[19]

German portrait sculpture was largely unaffected by these grand examples. Instead, noble and bourgeois patrons alike would respond much more enthusiastically to a range of medals and small-scale reliefs that began appearing in the later 1510s and 1520s. Particularly in an era that was becoming increasingly conscious about both the subject matter and the ostentation of art, such diminutive portraits offered an acceptable alternative. It is to these works, first medals and then reliefs and busts, that we now turn.

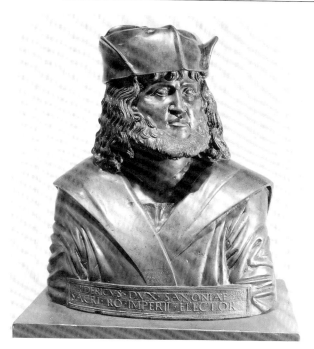

280. Adriano Fiorentino (Adrianus de Maestri), *Friedrich the Wise*, 1498, Dresden, Staatliche Kunstsammlungen

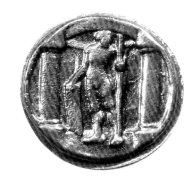

281. Peter Vischer the Younger, *Hermann Vischer*, 1507, Paris, Bibliothèque Nationale, Cabinet des Médailles

The German Medal: Portrait of Success

In 1507 and 1509, Peter Vischer the Younger created two small portrait medals of his brother, Hermann, and of himself that are today in Paris (Bibliothèque Nationale).[20] (figs. 281 and 282) What prompted these medals is unknown. Perhaps these were undertaken as study pieces and were inspired by some object in their father's reported collection of between 300 and 400 old Frankish images ("altfränkischen pild").[21] The latter may have included ancient German coins and reliefs. The obverse of Hermann's medal presents a flat, quite simplified profile portrait plus an inscription identifying the sitter and the date. The reverse contains a scarcely legible scene of a nude male (Hercules[?]) standing between two columns. Both sides of the medal are rather awkward as if the young artist was experimenting with an unfamiliar form. In fact, Peter had few if any contemporary prototypes since his portrait of *Hermann* is perhaps the first true cast German medal. He doubtlessly knew of Italian ex-

282. Peter Vischer the Younger, *Self-Portrait*, 1509, Paris, Bibliothèque Nationale, Cabinet des Médailles (same scale as Figure 281)

amples that were then circulating in trading centers such as Nuremberg and Augsburg.[22] Since 1486 Nuremberg even had a civic *Münzsammlung* or coin collection, though this consisted mainly of Roman imperial coins.[23] Two years later, and quite possibly after a trip to North Italy, Peter produced his single-sided *Self-Portrait*. Its design and execution are quite different. Here the head is large enough to dominate the composition. By contrast, the inscription threatened to overwhelm Hermann's bust. Peter's head is in higher relief, with lively handling of the tightly twisted curls of hair. For his own medal, Peter used a wax model rather than the stone or wooden one employed for Hermann's. It is with obvious pride that Peter signed his medal "EGO PETR[VS] FISCHER MEVS ALTER 22 AN[N]O 1509" ("I am Peter Vischer [and] my age [is] 22 in the year 1509"). Subsequently, Peter made another portrait of *Hermann* (Berlin, SMBPK, Münzsammlung) in 1511 and, less certainly, a *St. Trusina* (Dresden, Staatliche Kunstsammlungen, Münzsammlung) in 1512.[24] Medals, however interesting, always remained a secondary aspect of his work. He was a sculptor who happened to produce a few medals rather than the other way around. These portraits were done strictly for the family's use so they exerted scant impact upon other masters. Nevertheless, these works epitomize the growing interest in medals in the German lands.

In addition to the occasional medal, such as those by Vischer, and the influence of Italian examples, the development of the German portrait medal was also affected by the rising quality of coins bearing the likeness of Maximilian I and other princes. Foremost among these are the gold and silver coins that Friedrich the Wise was permitted to mint after Maximilian appointed him governor general of the empire in 1507.[25] In order to secure a good likeness for these, the elector ordered a stone portrait model carved by Lucas Cranach the Elder, his court artist. This proved to be too high in relief for his minters; however, Hans Krafft the Elder of Nuremberg was finally able to cut the complicated die for stamping the coins. Unfortunately, the pressure proved too great and this die broke in December 1513 after only 74 impressions. Soldering a metal blank to the surface of the die, Krafft was able to strength it sufficiently for it to last until 1517. These coins bore a crisp, clear raised portrait bust of

Friedrich that was radically different than the flat and quite generalized likenesses that characterize most other coins of the period. The attractiveness of these coins, which were issued in relatively large quantities, certainly impressed his peers and rivalled many of the Italian medals circulating in the north.

What is the difference between a coin and a medal? A coin is a commodity of trade. It has a specific face value linked to the quantity and purity of its material, which was usually gold, silver, or bronze. These coins bore the portrait and coat of arms of the issuing noble who was thereby guaranteeing the level of its quality. Medals or *Schaumünzen* (show coins) often looked somewhat similar but have far deeper relief and more accurate facial depictions. These, however, are showpieces with no commercial value beyond the redeemable metal content if melted down. Medals were produced in relatively small quantities. Nuremberg planned to make 100 copies of a special dedication medal celebrating the imperial investiture of Charles V, though the actual number proved to be far less.[26] Most medals had editions limited to five or less since these were intended typically for private enjoyment. In some cases the patrons merely commissioned a model and dispensed altogether with the cost of casting a medal. The individual first either supplied the medallist with a portrait to copy or, more commonly, sat for a sketch.[27] Only the drawings by Hans Schwarz have survived since most were merely working models to be discarded following the completion of the task. In his *Portrait of Albrecht von Brandenburg* of 1518 in Berlin (SMBPK, Kupferstichkabinett), Schwarz used chalk to record the salient features of the face and the clothing. Quick hatching and reinforced lines mark shaded areas. (fig. 284) The artist next cuts a model. Boxwood and pearwood models were favored by Swabian and Rhenish masters while stone, especially solnhofen limestone, was employed by Franconian and Saxon medallists. (figs. 288, 291, 292, 295, 296) Although Peter Vischer's *Self-Portrait* is based upon a wax model, this practice did not become common until after the 1550s. The model was then impressed into a packed sand or clay form. The latter was often baked in an oven to dry out the clay and ensure its firmness. Most early medals were single-sided so the molten metal could be poured

directly into the depression that the model had made in the form. In the case of a double-sided medal, two models or a double-sided model were needed that could be fitted and perhaps even hinged together. An opening was left between the two halves for the metal. Inscriptions could be added to the form using punches for each letter. The cooled medal would be filed to remove imperfections. Finally, varnish and, occasionally, gilt were added.

Portrait medals, much like plaquettes, entered German art rather late. Pisanello's famous medal of *John VIII Palaeologus, emperor of Constantinople* dates to 1438 or almost 70 years before Peter Vischer the Younger's experiments.[28] As knowledge of ancient Roman culture grew, artists at the courts in Mantua and Ferrara, among others, produced contemporary medals that often mimiced ancient imperial coins. Portraits were designed in profile and in moderately high relief. Some consciously emulated the appearance of a Roman bust by wearing a toga. Identifying inscriptions, personal mottos and devices, and coats of arms were added. There is no precise answer as to why German patrons, who knew about such medals, waited until the second and third decades of the sixteenth century to order their own. Their origins can, however, be traced to the humanistic circles in Augsburg and Nuremberg.

HANS SCHWARZ AND
THE DIET OF AUGSBURG IN 1518

In 1517 a couple of scholars in these two cities suddenly took an interest in commissioning portrait medals. Both protagonists, Willibald Pirckheimer and Konrad Peutinger, had long collected classical coins and, doubtlessly, possessed a few contemporary Italian medals. Pirckheimer's inventory of 1531 includes 20 silver portrait medals ("von allerlay Contrafacten angesichter und pildnus").[29] The impact of their respective medals, however, is quite different. Pirckheimer's large medal has a rather flat profile likeness, the execution of which is somewhat weak.[30] Erasmus, who received a gold impression in 1524, mentions it repeatedly in his letters. Even though he termed it a "first-rate medal," he also noted that it was too bad that Pirckheimer had not been able to find a modern Lysippos to match his Apelles. Erasmus was referring to Dürer, the author of the *Pirckheimer*

engraving that also hung on his bedroom wall. The identity of the artist or artists of the Pirckheimer medal is unknown; Hans von Kulmbach has occasionally been suggested as the author of the basic design and, less certainly, the Vischer workshop as modeller and caster. Pirckheimer's medal had no significant effect upon Nuremberg's art, and no further medals can be ascribed to the artist. Similarly, Pirckheimer's friends did not immediately follow his example.

Concurrently, Augsburg sculptor Hans Schwarz produced his revolutionary medal of *Peutinger*.[31] (fig. 283) Following Italian and Roman prototypes, Peutinger is rendered in profile. Schwarz' highly personalized image emphasizes his attentive gaze, long nose, sagging cheeks, and long straight hair cut straight just above the shoulders. Such a frank representation cannot be observed on any earlier small-scale German portrait carvings. The size of the medal, whose 8.8 cm diameter is greater than most later examples, permits Schwarz to employ a far deeper relief than found in the *Vischer* or *Pirckheimer* portraits. This heightens Peutinger's plasticity as he projects boldly into the viewer's space and his left shoulder even casts a shadow on to the surface of the medal. Simultaneously, the figure implies recession back into the picture plane. The form of the portrait, especially its use of bare shoulders, and its choice of Antiqua for the inscription style more closely resembles a Roman bust rather than any Italian medal.[32] The text encircling Peutinger identifies him, his profession as legal counselor (or secretary), and his age of 52. The portrait's basic design certainly results from the collaboration of Peutinger, Augsburg's foremost classical scholar, Schwarz, whose interest in Italianate decorative motifs and profile medallion portraits could be observed earlier in his *Entombment* of 1516, and Hans Burgkmair. (fig. 245). As early as 1506 Burgkmair employed some of Peutinger's collection of Roman imperial coins as the prototypes for his woodcut illustrations to the humanist's *Vitae Imperatorum Augustorum*.[33] Similarly, Burgkmair had already fashioned woodcuts of Conrad Celtis (1507) and himself (1514) in the guise of a coin or medal.[34] In this instance, Burgkmair may have helped plan the medal and, less certainly, Peutinger's portrait. With their assistance, Schwarz has developed a remarkable portrait that stresses his

283. Hans Schwarz, *Georg of Saxony*, 1518, and *Konrad Peutinger*, 1517, Vienna, Kunsthistorisches Museum

patron's physical characteristics, his classical learning, and, above all, his human dignity ("dignitas hominis").

In the months leading up to the opening of the imperial diet in Augsburg on 29 June 1518, Schwarz also made medals of *Burgkmair* and *Jakob Fugger*.[35] (fig. 286) Both display the same three dimensionality and clarity of features observed in Peutinger's portrait. Similarly, both highlight their distinguished achievements. Burgkmair "of Augsburg" is proudly labelled as the portraitist of his "holy imperial majesty," an allusion to his frequent work for Maximilian I. In this instance, the painter-print maker provided Schwarz with a profile self-portrait, perhaps his sketch of 1517 now in Hamburg (Kunsthalle).[36] The close association between Schwarz and Burgkmair is further evident in the bare-shouldered portrait of Fugger that derives from Burgkmair's chiaroscuro woodcut of about 1511.[37] The famed merchant required no further inscription beyond the words "Jakob Fugger of Augsburg 1518." Yet on the reverse, Schwarz includes a scene of Apollo crowning Mercury and Neptune, an allegorical allusion to Fugger's power and his world-wide business empire. In a sense, this medallic portrait functions much as a business

card might today though on a higher, more exclusive level.

Impressions of these three medals were shown to some of the delegates arriving for the imperial diet. Fugger, Peutinger, and Burgkmair all had ready access to Maximilian I and his courtiers. The medals were an instant success. Their impact can be gauged by the fact that Schwarz would produce about 25 medals in 1518. Fifteen of these represent nobles and another five Augsburg citizens attending the diet. Among the first patrons was Georg, duke of Saxony, who recorded in his expense book that he paid "Hans Schwarz the sculptor" five gulden for his portrait.[38] (fig. 283) The feeling of the portrait is slightly different since Georg wears a thick, fur-trimmed robe that fills much of the lower half of the medal. The robe, with its careful detailing, heightens his princely bearing but at the expense of an exclusive focus upon his face. Albrecht von Brandenburg was another of Schwarz' first clients. In this instance, we fortunately have the artist's preparatory drawing, now in Berlin (SMBPK, Kupferstichkabinett), and medal.[39] (figs. 284 and 285) The chalk sketch is quite close to the medal though the artist has altered the angle of the profile slightly, made the cheeks a bit puffier, and embel-

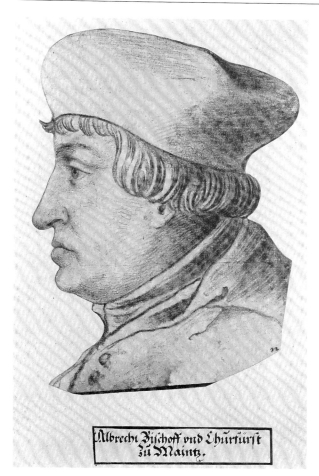

284. Hans Schwarz, *Albrecht von Brandenburg*, 1518, drawing, Berlin, SMBPK, Kupferstichkabinett, KdZ 6010

285. Hans Schwarz, *Albrecht von Brandenburg*, 1518, Vienna, Kunsthistorisches Museum

lished the sitter's ecclesiastical robes. Small personalizing features, such as the curled lock of hair in the center of the forehead, enhance the lifelike quality of the portrait. In this medal, Schwarz maintains the same highly sculpturesque feeling as if we were viewing a far more monumental object.

In contrast with the earlier medals by Vischer or the portrait of *Pirckheimer*, which were largely isolated creations, Schwarz' medals stimulated demand by an ever-growing number of patrons. Here is the true start of the German portrait medal. During the ensuing years and decades, the number of medals and medallists would increase steadily. Using Habich's corpus as his basis, Grotemeyer plausibly estimated that about 4,000 portrait medals were produced in the sixteenth century, and

that between 25,000 and 30,000 impressions were made.[40] In a land with a scant portrait tradition, the sudden explosion in the production of medals is all the more impressive. Equally interesting is the diversity of patrons. In addition to humanists and princes, merchants and other moderately well-to-do citizens shared the desire to be portrayed. For instance, in 1519 Schwarz devised a medal for *Ursula Imhoff* in which the 17 year old is prominently identified as a "Hausfrau" or housewife.[41] Medals, which might range in price from 1 to 5 gulden depending upon the quality and size, made portraiture more affordable than in the past. Furthermore, the cost also varied according to the actual number of cast medals and their material. The patron often supplied the requisite material. For instance, in 1533 Dr. Christoph Scheurl of Nuremberg provided artist Matthes Gebel with seven Joachimstalers, a very high-quality silver coin, that were melted to make the medals of Scheurl, his wife, and his brother.[42] Some patrons ordered the carved stone or wood models as independent portraits, which they never intended to have cast.

Schwarz certainly encouraged this popularization of the medal. Sometime in 1519, following the completion of the imperial diet, the artist moved to Nuremberg on the invitation of Melchior

Pfinzing, the provost of St. Sebaldus, for whom he had made a medal in 1518.[43] According to Johann Neudörfer, Schwarz resided at the provost's house.[44] His clientele was now mainly patrician as the medal, which had begun with humanists like Peutinger, appealed increasingly to the wealthy burger class. The classically inspired form of the medal also changed as Schwarz willingly experimented. For instance, in 1519 Schwarz made his medal of the *Five Pfinzing Brothers*.[45] (fig. 289) Profile portraits of the brothers, arranged in descending age from right to left, fill the entire field. Extending from edge to edge, the busts broach the normally sacrosanct zones reserved for the decorative border and inscription. Here the text is limited to the words "Fraternal Concord" ("CONCORDIAE FRATERNAE"), which defines the purpose of the medal. Perhaps inspired by the death of their mother, Barbara, two years earlier, Sigmund, Melchior, Ulrich, Seyfried, and Martin desired a monument to their brotherly ties. Schwarz took great care to vary the depth of the relief as the figures recede. The complexity of the design and the medium scale (4.75 cm) meant that Schwarz could not include the same wealth of detail observed in earlier medals. When preparing his overall design, the artist relied on separate drawings and perhaps preexisting medals rather than a joint sitting.[46] This explains the rather isolated character of each portrait.

For reasons that are not totally clear, the Nuremberg council ruled on 25 February 1520 that Schwarz must leave the city within three days. Because of his hasty departure, the artist left his collection of portrait drawings with Melchior Pfinzing. The 136 sketches date from 1518 until early 1520 but do not include all of his patrons. Medals exist for 92 of the drawings. I wonder whether the source of some citizen complaints could have been Schwarz' failure to complete portraits on time and after partial pre-payment. Was this due to the sheer quantity of the demand? Even though Schwarz did not cast his own medals, a task that Neudörfer claims Ludwig Krug did for him, the Augsburg master could hardly have found sufficient time to carve the wooden models for each of the surviving sketches. As it was, many of Schwarz' Nuremberg medals became increasingly formulaic in appear-

286. Hans Schwarz, *Hans Burgkmair*, 1518, Munich, Staatliche Münzsammlung

ance. Most of these lack the freshness and the rich sculptural qualities of his earliest efforts.

One patron who was willing to wait was Albrecht Dürer. While residing in Antwerp in September 1520, the Nuremberg master wrote in his diary that "I have sent Hans Schwarz 2 fl{orins] in gold for my picture, in a letter by the Antwerp Fuggers to Augsburg."[47] Was this payment for just the boxwood model that is now in Braunschweig (Herzog Anton Ulrich-Museum) or was it for actual copies of the medal? (figs. 287 and 288) The model is undated and without text. Dürer is presented with the same full beard and long flowing hair observed in his numerous self-portraits, though the face is now older looking. The choice of type was Dürer's but the actual drawing probably was by Schwarz due to the inherent difficulty of profile self-portraits and the sculptor's obvious skill as a portraitist. Schwarz focuses our attention on Dürer's concentrated gaze far more than in any other medal as if to distinguish the Nuremberg master's sense of sight and his mental abilities. These features are lacking in the medallist's own self-portrait done around 1520.[48]

Dürer's motivations for wanting a medallic portrait probably varied little from Albrecht von Bran-

287. Hans Schwarz, *Albrecht Dürer*, 1520, model, Braunschweig, Herzog Anton-Ulrich Museum

288. Hans Schwarz, *Albrecht Dürer*, 1520, Nuremberg, Germanisches Nationalmuseum

denburg or most of Schwarz' other patrons. All desired a degree of immortality in the form of a pictorial record that would outlive the fragile, mortal human body. Dürer's concern for the afterlife of both his ideas and his art can be judged from the pages of his travel diary and theoretical writings. Dürer too may have been impressed with Schwarz' medals of Fugger and Burgkmair, which he definitely knew since he sketched both men during his brief visit to the Augsburg diet in 1518.[49] (fig. 286) In the following year, Dürer prepared two small drawings for the reverse of his own medal, both now in London (British Museum).[50] The penned text states that here is the "image of Albrecht Dürer the German that he made with his own hand at age 48 in 1519." Unfortunately, the spot for the portrait is blank as the drawing was left unfinished. Schwarz' talents may have prompted Dürer to abandon his own project. Dürer appreciated the replicable potential of the medal. We shall never know the precise number that he personally ordered. As Mende and others have pointed out, there are at least two separate editions with different inscriptions done during Dürer's lifetime.[51] Since Schwarz had learned, perhaps from the Vischers, how to punch his text directly into the

casting form, he could easily change the wording of the inscription. The first group reads "ALBERTVS DVRER PICTOR GERMANICVS" plus Schwarz' "HS" monogram. At least one silver, three bronze, and one lead impressions are known. In the second group, Schwarz sought to expand "PICTOR" TO "PICTORIS" but the final "I" accidentally was printed as a "T" or "PICTORTS." Five bronze examples, including the Nuremberg version illustrated here, and one tin one have been identified. Dürer probably did not commission all of these though it is also possible that some of the impressions have not survived. Yet another impression that lauds Dürer as the "greatest of all painters" postdates his death in 1528.

Schwarz' hasty departure would temporarily leave a void in Nuremberg until the arrival of Matthias Gebel. He returned to Augsburg briefly before journeying on to Speyer and the diet of Worms in late 1520 and 1521.[52] After this, nothing further is known about Schwarz' career. Habich's speculation that he worked in France, the Netherlands, and Poland, among other locales, has proved baseless. Even discounting the post-1521 attributions, Schwarz still created a remarkable corpus of portrait medals in a land where virtually none had

existed before 1518. An itinerant artist without an identifiable workshop or group of pupils, Schwarz, nevertheless, established the basic design and character of the German medal. Later artists might change specific features or the manner of casting but their starting point remained the foundation established by Schwarz in 1517–18.

THE FIRST GENERATION OF MEDALLISTS

Schwarz' success at popularizing this new form of sculptural portrait inspired artists in a dozen or more cities during the 1520s and 1530s. With Protestant criticism of religious art reaching a peak at this time, medals offered an inviting alternative for numerous artists. Most medallists remain anonymous or are known today only by their initials. Other masters, such as painter Martin Schaffner of Ulm, only dabbled occasionally with medals.[53] Yet four artists—Matthes Gebel, Friedrich Hagenauer, Christoph Weiditz, and Hans Reinhart—achieved considerable renown, if not always financial reward, for their medals. As we shall see in the next section, their decisions to produce medals often angered artists in related fields, notably the goldsmiths, who felt an infringement of their proprietary domain. First, however, I wish to examine a few representative works by each of these four masters.

With the sudden departure of Schwarz in 1520, Nuremberg was without a true medallist until 1523 when Gebel acquired citizenship. He may have been the son of a die cutter active in Wiener Neustadt. During his long career, which lasted until his death in 1574, Gebel produced around 350 portrait medals, yet the vast majority of these date between 1526 and the mid-1540s.[54] In his case, little is known about his later activities. Gebel occasionally worked for the same patrons as Schwarz. For example, he made medals for four of the five surviving Pfinzing brothers in the late 1520s and early 1530s. Then in collaboration with Melchior Baier of Nuremberg, Gebel helped to develop new decorative uses for these medals. Baier incorporated impressions of each of the four medals into the *Pfinzing Dish*, one of the century's finest goldsmith works, that is still in Nuremberg (Germanisches Nationalmuseum).[55] (fig. 290) Baier created the dish in 1536 to commemorate the brothers' fraternal ties and to honor the memory of Melchior who had died in 1535. Measuring 17.5 cm high, the dish is made of gold that has been cast, chiseled, engraved, and adorned with colored enamel. Gebel's medals of Sigmund, Martin, and Seyfried decorate the exterior of the lid while that of Melchior occupies the position of honor on the inside of the lid. Classical prototypes of dishes with a portrait coin or medal on the inside inspired, at least indirectly, the design of the Pfinzing dish.[56] The dish postdates the individual medals. Either one of the brothers presented Baier with his own copies of the four medals or, more likely, Gebel cast new impressions using his original stone models. This experiment was repeated in the same year as Baier made the beautiful agate dish, now in Munich (Residenz, Schatzkammer), for Margrave Georg von Brandenburg-Kulmbach that includes six other portrait medals by Gebel ornamenting the base.[57]

Unlike Schwarz, Gebel's models are all carved from Solnhofen limestone rather than wood. This permits an even higher level of exact detail, as may be observed in his models for the printmaker *Sebald Beham and his wife Anna* of 1540, now in Berlin (SMBPK, Münzsammlung).[58] (fig. 291) These display the same characteristics as the Pfinzing

289. Hans Schwarz, *Five Pfinzing Brothers*, 1519, Santa Barbara, University Art Museum, University of California, Morgenroth Collection

290. Melchior Baier, *Pfinzing Bowl*, 1534–36,
Nuremberg, Germanisches Nationalmuseum

291. Matthes Gebel, *Sebald and Anna Beham*, 1540,
model, Berlin, SMBPK, Münzsammlung

medals. Each bust has a taut clarity, a precision of
design and execution. The small lettering of the
inscription ensures the viewer's focus exclusively
upon the portrait. The bust employs shallower re-
lief than in Schwarz' earliest medals; however,
Sebald's shoulder still casts some shadow on the
metallic surface below. Gebel's cutting style is far
more refined, if less expressive, than Schwarz'.
Each strand of hair is minutely rendered. Gebel
delights at including the intricate decorative pat-
tern of a collar, the softness of a fur trim, or the
heavy fabric of Anna's dress. The two Beham por-
traits, like many of his other models, were never
intended to be cast since these exquisite objects
were justly valued as *Kleinplastik*. By contrast, I
doubt that Schwarz ever imaged that his models,
including that of Dürer, would be judged as any-
thing more than a workpiece. Gebel, Hagenauer,
and Weiditz, however, had patrons who desired

their portraits done in stone or wood, a task each
medallist could readily accomplish. There exists
another important distinction between Gebel and
Schwarz. The former seems to have cast all of his
own medals, other than some later impressions re-
using his models. Schwarz was exclusively a sculp-
tor who relied upon metalsmiths, such as Ludwig
Krug, to cast his wooden models.

Gebel, the most prolific of all German medal-
lists, resided solely in Nuremberg. Like other art-
ists, he did venture to the imperial diets, including
those at Speyer (1529) and Augsburg (1530), in
pursuit of new patrons. Gebel also periodically
developed a medal for the general market rather
than for a specific individual, much as printmakers
hawked their "celebrity portraits" of nobles and
other illustrious persons. In 1527 Gebel depicted
Dürer at Age 56.[59] The reverse displays the artist's
coat of arms and the date. In all likelihood, this
initial version was done for Dürer. The following
year, however, Gebel reissued the medal, now with
a new textual reverse recording the death of the
famed Nuremberg master and his burial date of 8
April. The sculptor knew that a commemorative
medal of Germany's leading artist would appeal to a
diverse clientele. Over twenty copies of each medal
survive, though some are certainly of later date.
Nevertheless, we may conclude that a sizeable edi-
tion, especially of the 1528 medal, was produced.
Furthermore, other artists frequently copied Gebel's
two medals. And in at least one instance, the Dürer
medal inspired a separate commission. In an inter-
esting letter of 1530, the Tübingen scholar An-
dreas Rüttel wrote to his friend Willibald Pirck-
heimer to thank him for sending an example of one
of the medals of Dürer. Impressed by its appear-

ance, Rüttel requested Pirckheimer to have its artist, the "Statuarius Matthäus," make one in a similar style of Tübingen mathematician Johann Stöffler using an enclosed portrait.[60] Gebel's resulting stone model is today in Vienna (Kunsthistorisches Museum).[61]

Friedrich Hagenauer's career as a medallist also began in the mid-1520s. His activities somewhat parallel those of Gebel in that he was highly prolific, with upwards of 250 medals and models, including about 100 bearing his monogram. Likewise, the majority of his oeuvre dates to a relatively limited period, here between 1525 and 1532, even though he lived at least until 1545. He trained as a sculptor in Strasbourg, perhaps under the tutelage of his father(?), Nikolaus Hagenauer. Where he learned to make medals is unknown, though he resided briefly in Nuremberg before settling in Munich and, in 1527, Augsburg. Maué wonders whether Hagenauer and Gebel might have been part of the so-called Nuremberg 1525–26 workshop to which several high-quality but stylistically diverse medals have been attributed.[62] It is perhaps relevant that his first medal, done in 1525, depicts *Matthäus Zaisinger*, goldsmith and coin die cutter for the Bavaria court of Duke Wilhelm IV. Conceivably, it was Zaisinger who encouraged the young Rhenish artist to employ his portrait skills on medals. Hagenauer's earliest patrons were all associated with the court or were Munich patricians, including the former burgermeister Sebastian Liegsalz and his wife, Ursula, whose marvelous pearwood models are still in Munich (Bayerisches Nationalmuseum).[63] (fig. 292) With a diameter of 12.4 cm, each is unusually large. As indicated by the penned inscription on the reverse of Sebastian's portrait, the reliefs were showpieces—that is, finished medallions not intended for casting. Sebastian's obverse inscriptions, which identify him, his age (44), and the date (1527), are all carefully cut into the wood whereas Schwarz' extant wooden models are blank. The two models are conceived as a pair with Sebastian gazing intently at his wife. Hagenauer juxtaposes the starkly empty background with the elaborateness of the clothing and the careful handling of the facial details to achieve a convincing, if motionless, monumentality. He deftly varies the interplay of light and surface. For instance, the crinkled folds of the lower right sleeve

292. Friedrich Hagenauer, *Sebastian Liegsalz*, 1527, model, Munich, Bayerisches Nationalmuseum

contrast vividly with the smoothness of the upper sleeve and the undulations of the fur trim.

In the same year Hagenauer moved to Augsburg where he would reside until 1532. Among his first and most frequent clients was Raymund Fugger for whom he made at least nine medals including the large (7.1 cm) example of 1527.[64] (fig. 293) Hagenauer employs the same spare, uncluttered look for this profile portrait. Other than the date, the inscription and coat of arms are relegated to the edge of the composition. The sculptor focuses upon Fugger's curly hair and full beard. In this instance, it is uncertain whether Hagenauer made the original portrait sketch since there exists a remarkably similar bare-shouldered drawing of *Fugger* by Hans Burgkmair, now in Munich (Staatliche Graphische Sammlung).[65] Hagenauer's figure is better balanced since Burgkmair has the head project forward at an odd angle. The reverse displays an allegory of liberality in the form of a bearded man (Fugger?) clad in an ancient toga standing on the world globe and a sack of gold. He holds a jug and a dish with fruit that he offers to the five flying birds. Fugger indicates that he is wealthy enough to share part of his good fortune with the poor, an attitude that is reminiscent of the family's creation of the Fuggerei.

Where he learned his trade and even where he worked during these formative years are unknown. Features such as the clear half-length profile against a broad open background and the care given to the details of clothing are reminiscent of Hagenauer. But Reinhart is the superior technician. The two moderately large medals, which measure 6.1 and 6.6 cm respectively, are cast in silver. Reinhart delighted in the spatial effects achieved through his

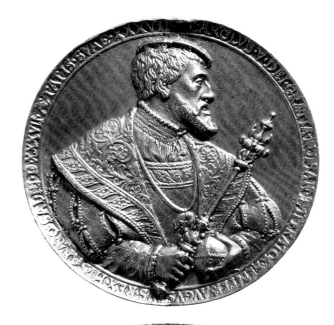

293. Friedrich Hagenauer, *Raymund Fugger*, 1527, Munich, Staatliche Münzsammlung

Although most medals were produced in Augsburg and Nuremberg, artists were also active in Saxony and along the Rhine. In Chapter Three, we discussed the religious medals that Hans Reinhart made in Leipzig in the late 1530s and early 1540s. (figs. 47–50) His earliest medals, including the portraits of *Cardinal Albrecht von Brandenburg* of 1535 and *Charles V* of 1537, exhibit an unusually high level of refinement.[66] (figs. 46 and 294)

294. Hans Reinhart, *Charles V*, 1537, Nuremberg, Germanisches Nationalmuseum

high relief. For example, the emperor's hands project outwards as they hold the mace (or scepter) and imperial orb. Both objects push forward into the viewer's space while the bottom of the mace extends over the edge of the inscription. These features anticipate the spatial complexities of his famous *Trinity* in which the holy figures were cast separately and then joined to the medal. (fig. 50) The glory of their portraits is fully matched by the impressive armorial reverses. The wings of the imperial double-headed eagle stretch out aggressively while the paired columns of Hercules define the extent of Charles' realm and pictorially match his motto "PLUS OVLTRE" ("YET FURTHER"). In Albrecht's medal, Barbara and Erasmus, two of his patron saints, support an inordinately full helm that contains 15 different coats of arms. The particular example of Albrecht's medal illustrated here is also provided with a ring so the portrait could be worn. Neither portrait medal appears to have been a direct commission as both are based upon other works of art. The ambitious young artist likely made the medals on speculation while doubtlessly sending copies to the two nobles. A similar situation occurred in 1535 when he cast a medal of *Johann Friedrich, elector of Saxony*, after a woodcut portrait by the elder Cranach.[67] A year later the prince acknowledged the present with a cash gift. If Reinhart hoped for a permanent position at one of their courts, no offer was forthcoming. Instead he settled in Leipzig where the goldsmith guild eventually forced him to undergo a new apprenticeship. Perhaps for this reason, the artist's activities as a portrait medallist were limited to primarily between 1535 and 1547, though in later years he would occasionally recast older medals or prepare new ones.

So far we have observed only profile portraits. Three-quarter and full-face poses gradually appeared during the later 1520s and 1530s especially in the oeuvre of Christoph Weiditz.[68] The impetus seems to have come from contemporary German paintings and relief carvings rather than from Italian medals where three-quarter portraits are virtually non-existent at this time.[69] The artist's first medals, done in his native Strasbourg between 1523 and 1526, copy the style of Hans Schwarz but without the rich sculptural modeling. His art would change after his move to Augsburg in 1526

and in particular during the years from 1529 until 1532 when Weiditz travelled through Spain, Italy, the Rhineland, and the Low Countries with members of Emperor Charles V's court. It was probably during the early 1530s that Weiditz encountered Charles de Solier, lord of Morette, who as the French ambassador to England in 1534–35 would be immortalized in a painting by Hans Holbein the Younger. The sculptor carved a two-sided boxwood model that is now in London (Victoria and Albert Museum).[70] (fig. 295) In contrast to Hagenauer's love of open space, Weiditz offers a crowded frontal view. De Solier, with his high shoulders, virtually fills the entire field. He stares outward to his right rather than at the viewer. The full-face format requires Weiditz to provide far more information about de Solier's physiognomy than would a profile portrait. It also necessitates a better use of relief carving so the sitter does not appear overly flat. For instance, a rich, three-dimensional effect is produced by the luxurious full beard projecting above de Solier's clothing. Similarly, the prominent nose is sufficiently high to cast a shadow on the face in certain lighting situations. The overall feeling is one of great plasticity analogous to a far larger portrait bust. (See fig. 314) This sculpturesque quality

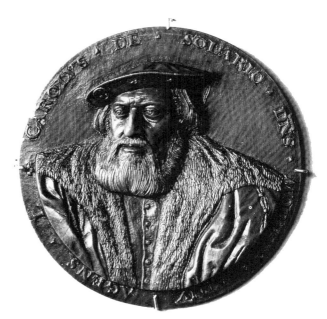

295. Christoph Weiditz, *Charles de Solier*, 1530s, model, London, Victoria and Albert Museum

explains why several independent busts have periodically but incorrectly been attributed to Weiditz.

Through the activities of these four masters, portrait medals became commonplace. Nobles and wealthy burgers alike grew accustomed to commissioning their likenesses as medals entered the mainstream of German art. As noted earlier, hundreds of new medals were produced each decade, whereas virtually none existed before 1518. The style of the portraits also diversifies as three-quarter and frontal views augment the more traditional profile form. Medals reflect the shifting artistic trends in painted portraits. For instance, Hagenauer's few late medals recall the portraits of Barthel Bruyn, the Cologne painter, for whom he made a medal in 1539.[71] This first generation of medallists consisted of both sculptors (Schwarz, Gebel, and Hagenauer) and sculptor-goldsmiths (Reinhart and Weiditz). Increasingly medals became the sole domain of goldsmiths as their guilds demanded control of the medium. For this reason, many of the major medallists later in the century, such as Valentin Maler of Nuremberg, produce technically superior medals that, however, add little new to the art of portraiture. It is interesting to note that despite the ever-growing quantity of models and medals, no preparatory drawings exist by Gebel, Hagenauer, Reinhart, and Weiditz. The same is true for most later medallists. As workshop sketches, these portraits were discarded when no longer needed. Schwarz' corpus of drawings seemingly survives only because of his sudden departure from Nuremberg and Melchior Pfinzing's interest in the artist.

Other sculptors periodically produced medals either at their own initiative or, more typically, at the request of their patrons. Dietrich Schro created a group of attractive medals for Count Friedrich Magnus von Solms and his family in the mid-1550s, and a whole series of contemporary portraits of Ottheinrich are plausible attributed to the Mainz artist.[72] Similarly, Hans Ruprecht Hoffmann represented two archbishops of Trier and a handful of other local clergy.[73] In both instances, the sculptors' contributions were limited to carving the models as the casting would have been completed by other metalsmiths.

The case of Hans Schenck is more problematic. Habich attributed to him six widely diverse groups of medals.[74] These cannot possibly all be by the

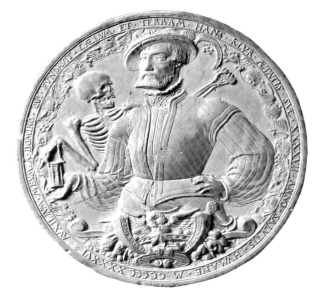

296. Hans Schenck, *Hans Klur*, 1546, model(?), Berlin, SMBPK, Skulpturengalerie

same master even if their place of origin matches Schenck's known cities of residence. Schenck did sign medals of *Luther* and *Melanchthon* with his pitcher or *krug* symbol in 1537. Other examples compare closely with the character of the artist's tombs. (See figs. 102–106) In 1546 Schenck carved the allegorical portrait of *Hans Klur*, now in Berlin (SMBPK, Skulpturengalerie).[75] (fig. 296) This is a two-sided solnhofen stone relief, measuring 9.8 cm

in diameter. It was possible intended as a model though no contemporary medals after it are known. On the obverse stands the Danzig city counsellor and burgermeister. He waits patiently for the inevitable arrival of death, the personification of which, with sickle poised, creeps up behind to place an hourglass in Klur's hand. Death's terror is here muted by Klur's faith in God. "My help [comes] from the Lord who made heaven and earth" reads part of the inscription. In a concentric ring surrounding the portrait are tiny angels while in the strapwork below appears a pelican feeding its flesh to its young, a traditional symbol of Christ's sacrifice for mankind.

Comparatively few German medals and models are so explicit about the religious attitudes of the patron as is this example. On the reverse Schenck includes a crude mockery of the papacy. The pope is depicted naked except for the glove on his right hand. His pose is consciously reminiscent of the *Laocoon* while his muscular body is an intentional slap at Roman art and its preoccupation with the classicizing nude. The pontiff sits grotesquely upon a serpent rather than the throne of St. Peter. He is the anti-Christ riding the devil to damnation. He is surrounded by a Moor who defecates into the papal tiara; a Turk, who raises his robes to urinate; and, at the far right, another wild-haired man who soils the pope's leg. These are the heathens who show their utter contempt for the pontiff. Scatalogical derision was a frequent device in Reformation polemics. Only the year before, the Cranach workshop published their *Wider das Papsttum zu Rom, vom Teufel gestiftet* (*Against the Roman Papacy Founded by the Devil*) in which the pope is repeatedly so dishonored.[76] In horror, a naked and quite muscular cardinal flees off to the right. He seems less frightened by this physical abuse than by the wrath of the tiny Christ Child above. Wielding his cross and surrounded by flames, Christ angrily condemns this clerical anti-Christ. He breathes upon the group below, a motif drawn from the accompanying inscription from 2 Thessalonians 2:8: "And then shall that wicked be revealed, whom the Lord shall consume with the spirit of his mouth, and shall destroy with the brightness of his coming." This text may also have been inspired by the Cranach workshop since the same passage was used in conjunction with the scene of the anti-Christ or pope being led

off to hell by devils in Cranach's *Passional Christi und Antichristi* (Wittenberg, 1525).[77]

The medallion reflects Klur's evangelical stance in Danzig's contemporary struggle between Catholics and Protestants. Because of his faith in Christ alone, Klur fears neither death nor the wrath of the lord. Such strident anti-Catholic representations are not so terribly unusual; however, they are typically found in satirical prints, such as those by the Cranach workshop, not in highly personal objects like this relief. In this instance, Schenck also included the words "PRO LEGE ET PRO GREGE" ("For the law and for the herd [i.e.—common good]"), on the strapwork beneath Klur. This was the motto of Duke Barnim XI of Pommeria who staunchly supported the spread of Lutheranism in his lands and generally in northeastern Germany. In 1545, just a year before carving Klur's medallion, Schenck began working for Barnim. Likely it was through the Pommerian court that the artist first met Klur.

This mixture of portrait and polemic was rare though it has a Catholic counterpart: Hans Ässlinger's portrait medal of *Albrecht V*, duke of Bavaria, of 1558.[78] (fig. 297) The medal, cast in silver and measuring a remarkable 12.4 cm in diameter, ostentatiously celebrates ducal power. The obverse offers a profile portrait of the duke clad in armor that is analogous to several medallic and life-size relief portraits made by Ässlinger during the mid-1550s. It is an image of authority rather than a subtle physiognomic exploration. The reverse is equally bold. Amid a hilly landscape two lions, symbols of Albrecht's Bavaria and Palatine, maul an ox and a lamb. Above an angel appears holding two laurel wreathes to crown the victorious lions. In the aftermath of the Treaty of Augsburg of 1555, Albrecht increasingly sought to assert his sovereign rights by declaring his lands to be Catholic. Habich has plausibly suggested that the ox and the lamb allude to Albrecht's defeat of his Protestant Bavarian nobles.[79] In September 1557 Albrecht imprisoned Ladislaus von Fraunberg who had introduced Lutheranism into the county of Haag, in 1556. Following Ladislaus' death, Albrecht permanently annexed his lands. Similarly, the duke grappled with Joachim, count of Ortenburg, who became Lutheran in 1557. Ultimately, an imperial court ruled that Joachim had the right to declare his

297. Hans Ässlinger, *Albrecht V of Bavaria*, 1558, Munich, Staatliche Münzsammlung

lands to be evangelical. In 1558 Albrecht also ordered a series of church visitations to ensure proper Catholic teachings. By 1563 the duke began using his military to re-Catholicize Bavaria. Thus the belligerent reverse reflects the confessional struggles facing the duke.

Far less aggressive than either Schenck or Ässlinger's images, yet just as poignant, are the Protestant friendship medals that Tobias Wolff, the Saxon court artist, made of *August, elector of Saxony, and Johann Georg, elector of Brandenburg*.[80] The obverse of the first, bearing the date 1577, depicts the two Lutheran electors together. On the reverse, that is dated 1574, August stands like a colossus on a cliff near Schloss Hartenfels at Torgau. He holds a giant scale with the Christ Child on one side and Satan on the other. As God approvingly looks on, various inscriptions stress the need to preserve the word of God. The medal honors the formal Lutheran concordance of 1576 and the guiding support of the two electors. In a second, quite wonderful medal of 1581, Wolff shows the two rulers as friends as Johann Georg casually puts his arm around August's shoulder.

In the capable hands of Joachim Deschler, Valentin Maler, and Tobias Wolff, among others, the art of the portrait medal prospered throughout the sixteenth century. Like ancient coins, medals were increasingly collected and large series of portraits specially ordered.[81] For example, on 9 September 1575, August of Saxony wrote Maler in Nuremberg requesting him to prepare a series of 12 silver medals of different and mostly Saxon princes. Maler was instructed to base his likenesses upon existing portraits painted mainly by the Cranachs that hung at Schloss Hartenfels at Torgau. Wolff, August's court medallist since 1574, devised series of 13 Princes, 28 Popes from Urban VI (r. 1378–89) to Gregory XIII (r. 1572–85), and 61 Kings of France. Like the fledgling portrait galleries at Schloss Ambras near Innsbruck and other palaces, August wanted comprehensive series. A completeness, an historical microcosm, was desired. This explains the seemingly surprising inclusion of the popes. Gregory XIII's medal does, however, directly mention the St. Bartholomew's day massacre of the Protestant Huguenots in Paris in 1572.

THE CREATIVE IMPULSE
AND ITS OBSTACLES

Medals posed a novel problem. As a wholly new form of art suddenly entering a conservative, tradition-bound society, under whose jurisdiction did it fall? Guilds or, in the case of Nuremberg, craft organizations were notoriously proprietary.

Vigilant guild officials jealously guarded their economic positions and hard-earned privileges. Each infringement or irregularity was vigorously protested especially in a period of growing social and financial turmoil. German sixteenth-century artists, excluding Dürer and perhaps a handful of other masters, were neither theoretically inclined nor endowed with a broader sense of their collective artistic advancement. Rather than welcoming medallists and encouraging the creative potential inherent in their art, the guilds strove to control or, at least, regulate its practitioners. In fact, Gebel, Hagenauer, Weiditz, and Reinhart all experienced professional harassment that affected their careers. Their colleagues viewed medals not as a wonderful artistic opportunity but as an economic threat that must be managed. At the root of the problem were the basic characteristics of a medal. It combines portraiture, traditionally the domain of sculptors, with metal casting, a task typically handled by goldsmiths or redsmiths ("Rothschmiedehandwerke" or brass and bronze casters) depending upon the type of medal. The debate centered over what guild, if any, medallists should be required to join.

The best documented case involves Hagenauer during his stay in Augsburg from 1526 until 1532.[82] In 1531 the guild of painters and sculptors filed a formal complaint against Hagenauer with the city council. Citing the sharp decline ("grosen abfall") in business, an allusion to the disruptions caused by the Reformation, they argued that it was unfair and against all regulations that Hagenauer should continue to practice his art outside of their guild. They noted that for five years he had operated under a special permit granted by the priests. Twice they describe themselves as the Sculptors, Carvers, and Portraitists ("Condervetten") as a means of asserting that medals, as portrait sculpture, fall under their aegis. In his written reply, Hagenauer stressed four basic points. First, that indeed he had a special permit granted by Leonhard Zinsmaister, the cathedral vicar, so he was exempt from guild regulation.[83] Second, that he had stopped being a sculptor and had become a portraitist. He claimed that he was not competing with the guild members since he had not sold any sculptures while in Augsburg. Third, the art of the "Conterfetter" or portraitist was a free art ("freie Kunst"), as was recognized in many cities, so he should not be

bound to their guild. Crafts were often divided into free arts and sworn arts, the latter bound by strict regulations due to their importance to the local economy. The free arts often included such less financially significant occupations as painting and writing. And fourth, Hagenauer attested that the quality of his work was well known to, and had been specially permitted for the past three years by, Hieronymus Imhoff, the burgermeister of Augsburg. The artist signed his letter "Fridrich Hagenawer von Strasspurg Conterfetter"; that is, he was a visiting portraitist from Strasbourg and thus outside the local guild's jurisdiction. Hagenauer's reply elicited a long response by the guild though it also encompassed detailed complaints against two additional sculptors. The counsellors were reminded that these outsiders paid no taxes. They declared, though without including any evidence, that Hagenauer's assertion that his was a free art in "all other places" was untrue. Although the council's ruling on this case is unknown, I suspect that their decision went against Hagenauer since he returned to his native Strasbourg in 1532. Furthermore, when another medallist, Christoph Weiditz, settled permanently in Augsburg in the same year, he immediately joined a guild.

Weiditz faced a different problem than Hagenauer. He had lived in Augsburg between 1526 and 1529 before traveling with the imperial court. Upon returning to Augsburg he joined the goldsmith's guild on 3 March 1532. Given the declining fortunes of sculptors and the periodic dispute over medallists' right to use silver and gold, Weiditz decided that the goldsmith's guild offered a brighter future. Guild officials strongly objected that he had trained as a sculptor not a goldsmith and that he lacked the necessary masterpiece. They demanded that he serve a four-year apprenticeship. The guild even refused to make the required quality inspections of his silver. They harassed the medallist and incited discontent among his apprentices. Weiditz, however, had a powerful ally: Charles V. On 7 November 1530, the emperor, then residing in Augsburg, had granted him an imperial "grace and freedom" privilege authorizing his status as a master goldsmith in any town. The city council backed Weiditz who later wrote that they protected him "in a fatherly manner and informed me that I could continue to do my work which redounds to

the praise and fame of the city in general. I have done and am still doing such work as that His Roman Imperial and Royal Majesty [Charles V] has himself praised it and been pleased with it, as well as other princes and lord of German and foreign ("welscher") lands."[84] He also noted that he had "made masterpieces enough, praise God." Guild officials were forced ultimately to accept Weiditz as a master goldsmith. Periodic disputes, especially during the 1550s, continued to pester Weiditz, who, however, enjoyed a prosperous career. Interestingly, no occupation is listed next to his name in the city tax records.

In Nuremberg, Matthes Gebel worked as a free artist. Here guilds had been abolished in the mid-fourteenth century. The local craft organizations were controlled and regulated by the patrician city council. More artists were described here as practicing the free arts than in most other German towns. Nuremberg was doubtlessly one of the models cited by Hagenauer. The boundry between the arts was still a matter of great concern. In 1535, the Nuremberg goldsmiths drafted a new ordinance that explicitly mentions Gebel.[85] "Matthes Gebel, sculptor, and other of his kind, thus all who cast portraits [Bilder] or who practice the same work as Free Art ("freie Kunst"), will be fined ten gulden if their work contains gold or silver, in defiance of the Goldsmith ordinance." Obviously, his exquisite silver medals vexed craft officials. There is no further evidence about whether Gebel obeyed the ordinance or even whether this proscription was supported by the city council. He remained active as a medallist until the mid-1540s. Since Gebel worked on the Pfinzing dish and the Agate cup with Melchior Baier in 1536, perhaps the agitation ultimately promoted collaboration between the artist and his goldsmith peers.

At least on the surface, Hans Reinhart suffered the most from the dispute over jurisdiction. In 1540, a year after gaining citizenship in Leipzig, he faced a formal complaint lodged by the goldsmiths' guild. They demanded that he be subject to their guild regulations since he worked in silver, which historically was their exclusive domain. Reinhart, like the others, countered that his was a free art outside their jurisdiction. After a prolonged struggle, the goldsmiths prevailed. Reinhart, who was already married and owned a house, was required to

serve a five-year apprenticeship under Georg Treutler. His apprenticeship was hardly typical since he continued making his own medals, including the *Trinity* and a portrait of *Hieronymus Lotter*, Leipzig's burgermeister, in 1544.[86] (fig. 50) Furthermore, Reinhart registered his own pupil, Treutler's son Georg, who was being instructed in "Groschen-giessen" (groschen or coin casting) as they termed medal making. Perhaps this special treatment explains why tension between artist and guild persisted. Reinhart was declared a master goldsmith in 1547 but only after the city council, not the guild, approved his three masterpieces. In later years Reinhart created relatively few new medals. He apparently was active as a goldsmith, if one can judge from the tools and workshop materials that he bequeathed to his sons; however, no specific pieces has been identified. With this pattern of friction between the early medallists and their peers, it is hardly surprising that later practitioners, excluding the occasional court sculptor, were almost always goldsmiths.

Portrait Alternatives: Reliefs and Busts

Concurrent with the rise of medals, one observes the introduction of relief portraits and busts. In contrast with the popularity of medals, there were never vast numbers of these other portraits. Perhaps only a hundred or two survive today if gamepieces with likenesses of famous nobles are excluded. Doubtlessly, many others were lost due to damage or neglect. In the discussion of *Kunstkammers*, we noted that some examples of *Kleinplastik*, including portraits, were saved only because of their mistaken attribution to Dürer or to his milieu in the seventeenth century. The reliefs and busts form a relatively homogeneous group. With a few exceptions, these portraits are small. They are often the same dimensions and by the same sculptors as the other forms of *Kleinplastik*. Most offer simple, straightforward likenesses stripped of overt ostentation. There are no imposing ruler images intended for public or semi-public display. These small portraits were for private use. This lack of pretense extends to their materials. Virtually all are fashioned from wood, stone, or terracotta. Non-funerary brass or bronze portraits, such as Adriano Fiorentino's

Friedrich the Wise, rarely reappear before the 1570s. The interest in portraiture surged in the 1520s before leveling off to lower but consistent numbers in subsequent decades. Perhaps because of this low demand, no sculptors, other than medallists, worked primarily as a portraitist.

HANS DAUCHER AND
THE POPULARIZATION OF PORTRAITURE

The success of medals may have encouraged some sculptors to experiment with other forms of portraiture. This was certainly true in Augsburg where Hans Daucher specialized in solnhofen stone reliefs of noble patrons during the early 1520s. Although I remain unconvinced that Daucher made medals, he did use their general form for his paired portraits of *Philipp* and *Ottheinrich*, now in Berchtesgaden (Schlossmuseum).[87] (figs. 298 and 299) The reliefs were commissioned in 1522 to commemorate the brothers' elevation as co-regents of the county of Palatine-Neuburg. Daucher expands the traditional medallic profile by including far more of their bodies and their arms. Ottheinrich, in particular, gestures with his right hand as if he were reciting the accompanying motto "MIT DER ZEYTT" ("With the Times"); the spelling of "ZEYTT" was incorrectly restored at a later date. Their identities and the date are provided in the surrounding inscriptions. Although occasionally referred to as models for medals, the two reliefs are far too large, as they measure 14 and 14.4 cm respectively. Touches of old gold paint can still be observed in Philipp's portrait. After this pair, Daucher abandoned the medallion format.

In the same year Daucher carved the first of a whole group of Habsburg portraits. Other than his multi-figure, allegorical *Triumph of Emperor Charles V*, now in New York (Metropolitan Museum of Art), most represent just Charles V or the deceased Maximilian I on horseback.[88] In the example now in Innsbruck (Ferdinandeum), Charles V calmly displays his consummate control as he rears up on his powerful horse.[89] (fig. 300) He has momentarily stopped while riding through a forest just beneath a castle or town on the nearby mountain. The idea for this image derives from Burgkmair's woodcuts of *Maximilian on Horseback* and *St. George*. In fact, in his undated but roughly contemporary relief in

Vienna (Kunsthistorisches Museum), the two are merged as Maximilian is represented in the guise of St. George.[90] In all cases, the likenesses are reduced to a few characteristic features, such as Charles' famous jutting jaw or Maximilian's noble nose. Daucher relied on secondary sources available in Augsburg rather than actual portrait sittings. Here Schwarz' medal of Charles V provided the necessary model.[91] Instead Daucher is creating what could be called the anecdotal portrait, in which physiognomic precision matters less than

298. Hans Daucher, *Philipp, Count Palatine*, 1522, model(?), Berchtesgaden, Schlossmuseum

299. Hans Daucher, *Ottheinrich, Count Palatine*, 1522, model(?), Berchtesgaden, Schlossmuseum

300. Hans Daucher, *Charles V on Horseback*, 1522, Innsbruck, Tiroler Landesmuseum Ferdinandeum

iconographic type, such as the dynamic and indeed heroic young emperor who halts briefly before dashing off on his steed. For whom were these portraits done? In spite of the frequent inclusion of Charles V or the occasional likeness of Ferdinand I, the issue of patronage is unresolved. Were these prepared for Charles or Ferdinand? The Innsbruck sculpture is probably identical with the "quite artistic [stone] carving of Emperor Charles riding in a landscape" listed in an early seventeenth-century Habsburg inventory.[92] Daucher also worked for other members of the court who might have commissioned the sculptures as mementos or possibly as presents for the young emperor. For instance, sometime between 1520 and 1525, Daucher carved his attractive portrait of *Cardinal Matthäus Lang* (Salzburg, Museum Carolino Augusteum), who

had been one of Maximilian's closest advisors and had officiated at his coronation.[93]

The most enigmatic of Daucher's portrait reliefs is the so-called *Allegory of Dürer's Virtues* now in Berlin (SMBPK, Skulpturengalerie).[94] (fig. 301) The carving measures 23.8 by 16.8 cm and bears Daucher's monogram and, below, the date 1522. Does the date refer to its completion or to some moment in Dürer's life? The Nuremberg master battles against an armored foe in the foreground. Daucher based his portrait of the artist upon Schwarz' medal, while the pose recalls that of Samson fighting the Philistines on the epitaph of Georg Fugger, which Dürer had designed, in St.-Anna-Kirche in Augsburg. (figs. 134 and 288) Looking on in the role of judge is Emperor Maximilian, who had died in 1519, and a counselor. Three women quietly watch just behind the combatants. Further back are three men and, within the elaborate tent, three more women. The foe's coarse face, which is not a portrait, and bat-winged armor suggest that he personifies a vice, perhaps Envy, rather than an historical adversary. If so, the three pious-looking women would be virtues (Justice, Fortitude, and Prudence[?]) linked with the artist. The key to unraveling this puzzle has yet to be found. Suggestions that Dürer is fighting Lazarus Spengler or that the allegory refers to the fate of his imperial salary are quite unconvincing. Oettinger posits that Johann Stabius, Dürer's frequent collaborator on imperial projects, including the *Triumphal Chariot* (B. 139), is the man behind Maximilian and the patron of the relief. While possible, the likeness is rather remote from medallic portraits of Stabius. What remains, at the very least, is the triumph of Dürer under Maximilian's watchful gaze. The celebration of a living artist in an independent allegorical scene is unprecedented in Germany or Italy. This fact has prompted some scholars to ask whether the reliefs might date to the early seventeenth century when the adulation of Dürer was especially strong. The sculpture, however, points to Daucher. The style of the carving, the caricature-like quality of his portraits, the form of the monogram on the tablet, and the slightly awkward spatial arrangement are all typical of his art.

Daucher's reliefs helped establish a standard for Augsburg portraits. Drawing inspiration from contemporary prints and from his own small-scale

301. Hans Daucher, *Allegory with Albrecht Dürer*, 1522, Berlin, SMBPK, Skulpturengalerie

sculptures, such as the *Judgment of Paris* of 1522, Daucher mixed portraiture with landscape settings. (fig. 236) Each carving is precisely cut and visually appealing, even if the quality of the portrait rarely approached the level of a good medal. As collectors' pieces, many subsequently entered major *Kunstkammers*, such as Archduke Ferdinand's at Schloss Ambras.

Daucher's success encouraged others, including the unknown Augsburg master of the *Friendship Temple* in Schloss Neuenstein (Hohenlohe Museum).[95] (fig. 302) This has at various times been attributed to Daucher since the projecting columns and historiated barrel vault derive from his two versions of *Mary and Child with Angels*. (fig. 235)

Yet the style, while rooted in Augsburg, is slightly different than Daucher's, and it is unlikely that Daucher would selectively repeat just the architectural motif. The relief has also been linked with Loy Hering and, more recently, Thomas (Doman) Hering. Only the latter attribution has merit, though his autograph *Judgment of Paris* and attributed *Rhea Silvia* display different treatment of such details as hair and costume. (figs. 226 and 260) An Augsburg origin, whether direct or indirect, is also suggested by the poses and costumes of the three figures that derive from Burgkmair's *Three Good Christians* woodcut (B. 64) of 1519.[96] The three rulers standing under the arch are Charlemagne, King Arthur, and Godefroy of Bouillon, as indicated by their

302. Augsburg(?) sculptor, *Friendship Temple of Ottheinrich*, c. 1534, Schloss Neuenstein

coats of arms. These three Christian members of the Nine Worthies, however, are also contemporary, if generalized, portraits. Each bears the motto of a modern prince. Charlemagne's sword is inscribed "ICH HABS IM HERZEN," a saying used by Duke Wilhelm IV of Bavaria. The other two are respectively Ottheinrich and his brother, Philipp. (See figs. 298 and 299) Such role playing does occasionally occur, as, for instance, in Ottheinrich's depiction as Paris in Thomas Hering's *Judgment of Paris* in Berlin. (fig. 226) The choice of Godefroy the crusader for Philipp was especially appropriate because this warrior-prince battled against the Turks in 1532. The artist individualized Burgk-

mair's faces only slightly for the portraits of Wilhelm IV and Ottheinrich, but no attempt was made to represent Philipp accurately. The relief celebrates the Wittelsbach family alliance, a forerunner to the Swabia League, signed in Eichstätt on 4 May 1534. Their concern with the rising strength of Protestantism is reflected in the motto above: "If God be for us, who can be against us?" (Romans 8:31). At this time, Ottheinrich was still Catholic. The Bavaria-Palatine arms held by two lions appears over their heads. These three modern princes in the guise of ancient worthies are also offered exempla of heroic and virtuous conduct in the biblical and historical stories on the vault. Several of the

individual scenes replicate known prints by the Behams, Cranach, and Heinrich Aldegrever. The latter's *Sacrifice of Marcus Curtius* (B. 68), completed only in 1532, proves that the sculpture cannot date before this year.

Which prince was the patron? A case can be made for either Wilhelm IV or Ottheinrich. The brothers stare at Wilhelm, who in the role of Emperor Charlemagne enjoys the highest rank. Perhaps Ottheinrich commissioned the carving as a present for Wilhelm, his brother-in-law. In either case, the relief ended up Munich where it was listed in the inventory of Elector Maximilian I of Bavaria, compiled in 1627–30. By this time the original white solnhofen relief had been expanded and colored with scagliola decorations. The sculpture was extended on three sides by the flanking pilasters and the architectural frame above. Passages such as the open archway behind Ottheinrich were also colored. New columns of lapis lazuli were added to enhance the sumptuous appearance of the relief.[97] The *Friendship Temple* is probably identical with a sculpture that the elector presented in 1636 to Georg Friedrich, count of Hohenlohe. And it is recorded first in the Hohenlohe *Kunstkammer* inventory of 1684.

Ottheinrich and Philipp's uncle, Philipp, bishop of Freising and count Palatine-Rhine (1480–1541), ordered several medallic and relief portraits of himself during the 1520s. These provide a cautionary tale to modern viewers who are only too willing to accept the presumed accuracy of most portraitists. In 1524 Loy Hering completed his attractive if damaged solnhofen relief of the bishop, now in Nuremberg (Germanisches Nationalmuseum).[98] (fig. 303) Inspired by Dürer's portrait engravings, most notably the *Albrecht von Brandenburg* (B. 103) of 1523, Hering borrowed the compositional motif of the half-length figure set behind an inscribed parapet and the prominent coat of arms floating in air. Similarly, Philipp is shown in profile though his body twists slightly towards the viewer. Although Hering may have met the bishop in 1518 when he visited Eichstätt, the portrait is rather idealized. Its source is an anonymous medal of 1521 that was certainly sent to the artist by the bishop.[99] Hering's likeness recalls his many memorials with their clear facial outlines and attention to the correct style of clothing. (figs. 99–101) About two

years later, Friedrich Hagenauer carved the imposing lindenwood portrait of Philipp that measures 58.4 by 41.3 cms.[100] (fig. 304) Since it is not inscribed, the sitter's identity is based upon its striking similarities with a group of three medals of Philipp attributed to Hagenauer. One of the medals is dated 1526, which conveniently corresponds with the sculptor's Munich period. Freising's diocese, of course, included nearby Munich. The relief is also listed as representing Philipp in the Fickler inventory of the Munich *Kunstkammer* of 1598. Is this even the same individual? The profile of the face is far more angular, the cheeks more pendulous, and the lines beneath the eyes more pronounced. The differences are due to the quality of the portrait, by which I mean that Hagenauer offers a careful facial study based upon his personal examination of the bishop. Hering's knowledge was second-hand, as he relied on another artist's medal. Hagenauer was a trained portraitist or a "Conterfetter" by his own definition; Hering was a stone sculptor with only an adequate proficiency as a portraitist. The open feeling of Hagenauer's relief in which the bishop seems to emerge from the spare background strongly recalls his model of *Sebastian Liegsalz*. (fig. 292) The treatment of the fur trim, the folds of the sleeve, and the finely detailed collar are also quite similar.

By the 1530s, portraits were constantly being put to new uses as evidenced by the *Pfinzing Dish*, discussed earlier, or the elaborate *Backgammon Board of King Ferdinand I* of about 1537 that is now in Vienna (Kunsthistorisches Museum).[101] (fig. 305) The front and back covers of this game board display wooden medallion portraits of Charles V and his brother Ferdinand, their ancestors, and great world leaders of the past. For instance, the front cover, illustrated here, focuses upon the emperor and his symbols. The form of the equestrian portrait once again derives from Burgkmair's woodcut of *Maximilian I* of 1508. Surrounding are profile busts of his paternal ancestors King Albrecht II (1397–1439), Emperor Friedrich III (1415–93), Maximilian I, and Philip the Fair (1478–1506), his father. In the corners as exemplars for his own reign are smaller busts of Julius Caesar, Augustus, Trajan, and Constantine, the most powerful or influential of Roman emperors. These and the corresponding nine portraits on Ferdinand's side derive from

303. Loy Hering, *Philipp, Bishop of Freising and Count Palatine*, 1524, Nuremberg, Germanisches Nationalmuseum

ancient coins, medals, or paintings, models that were doubtlessly supplied along with the overall iconographic program to the sculptor Hans Kels the Younger, who was then active in Augsburg.[102] Portraiture has thus become commonplace enough that it could serve as decoration. Although Kels' gamepieces represent historical scenes of good and bad behavior, contemporary Augsburg sculptors often adorned similar gamepieces with celebrity portraits. For instance, a set with 15 male and 15 female portraits, once listed in the Amerbach collection, survives today in Basel (Historisches Mu-

seum).[103] The gamepieces include illustrious nobles, such as Maximilian I, Charles V, Ferdinand I, and lesser princes and princesses plus a few local patricians. Each finely cut figure is based upon a medal by Schwarz or another south German master. These gamepiece portraits were produced in fairly large numbers since fragmentary sets, occasionally utilizing the same models, can be found is many museums.[104]

A similar diversification marks the growing market for elaborate portrait reliefs. These vary in size, material, and complexity as sculptors increasingly

343

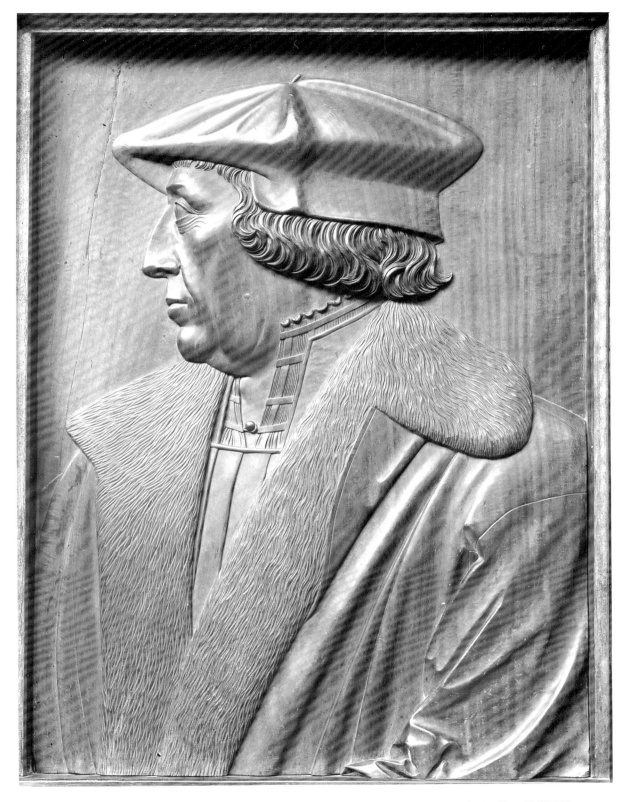

304. Friedrich Hagenauer, *Philipp, Bishop of Freising and Count Palatine*, c. 1526, Berlin, SMBPK, Skulpturengalerie

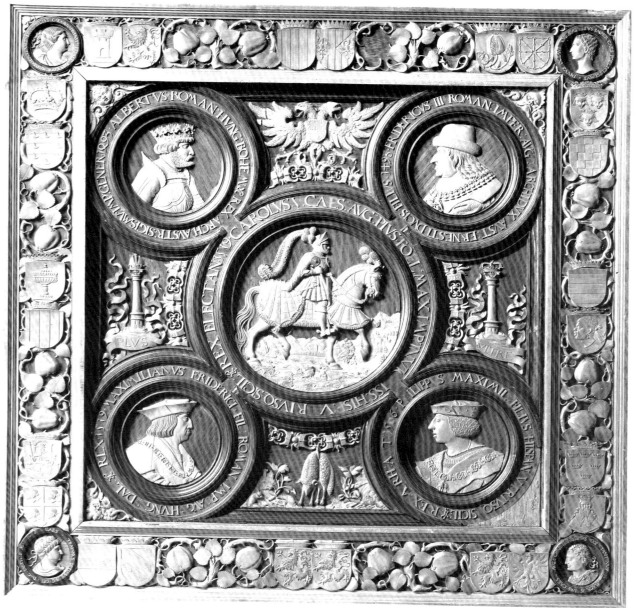

305. Hans Kels the Younger, *Game Board of Ferdinand I*, 1537, Vienna, Kunsthistorisches Museum

attempted to compete with painted portraits. For instance, Peter Dell the Elder specialized in small-scale likenesses such as that of *Georg Knauer*, now in the Cleveland Museum of Art.[105] (fig. 306) Reminiscent of his slightly earlier religious allegories, Dell fills the pearwood relief with detail. (figs. 41, 43–45) Knauer is sumptuously dressed in a rich fur-trimmed robe. He sits holding a letter that is

proportionally about the same size as this carving, which measures 14 by 10 cm. The letter is addressed to the "highly learned [K]nauer," a pictorial device concurrently utilized in paintings such as Hans Holbein's *Georg Giese* of 1532 in Berlin (SMBPK, Gemäldegalerie).[106] The 37-year-old-donor is convincingly positioned behind an ornamented window or archway, another motif found

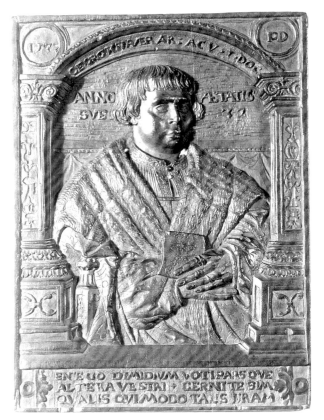

306. Peter Dell the Elder, *Georg Knauer*, 1537, Cleveland Museum of Art, Purchase from the J. H. Wade Fund, 27.427

more commonly in painting or prints.[107] The accompanying texts identify the sitter, the artist with his "PD" monogram, and the date of 1533. Dell has fashioned an elegant portrait that is sophisticated yet not overly ostentatious because of its small scale and simple material.

If Dell's sculpture was intended for private viewing, the same was not true of Hans Schenck's lindenwood portrait of *Tidemann Giese*, done between 1525 and 1530, and now in Berlin (Jagdschloss Grunewald).[108] (fig. 307) Although I think the identity of the patron as Giese, who was the bishop of Kulm from 1538, is rather shaky, the relief did hang in his residence at Schloss Löbau in West Prussia. In the early seventeenth century it was described as being located over a doorway. Its large scale, measuring 97 by 61 cm, and painted surfaces would ensure its legibility to all passersby. Tiedemann, the brother of the London-based mer-

chant Georg, rarely wore clerical attire before his election as priest in 1532 and then bishop. The later chronicler commented upon his clean-shaven face, his long nose, his lively eyes, and his German (rather than Polish) appearance. The original setting for this sculpture is unknown but its subsequent placement at Schloss Löbau was certainly selected to remind all, including Giese, of their own mortality. As encountered in Schenck's *Hans Klur* and his memorials, a *memento mori* spirit prevails. Giese holds a skull as if contemplating his own transience. Barely visible behind his left shoulder stands the skeletal apparition of death. The setting echoes the impermanence of life and of material objects. Schenck offers a gloomy view of ruined architecture. Once-grand buildings now are broken with mossy plants growing between their stones. A small bouquet of flowers over his head might refer to the beauty but brevity of life, much as they do in other works of the period. Schenck borrowed the basics of the architecture from Wolf Huber's *Adoration of the Three Kings* woodcut of about 1520–25, though he added the palaces behind and to the right.[109]

This preoccupation with the transience of human existence dominates the exquisite but worm-eaten *Portrait of a Merchant* also in Berlin (SMBPK, Skulpturengalerie).[110] (fig. 308) The artist, known only as the Master of Wolfgang Thenn after a portrait relief in London (British Museum), was active somewhere in South Germany or the Salzburg area around 1530.[111] The well-dressed man stands in the foreground surrounded by a skull, a flower, and an hourglass. Does this allegory about the fragility of life also extend to the extensive landscape behind? Various people are busily working at the right, while opposite a merchant vessel sails towards the port. By the 1520s and 1530s the great trading families, such as the Fuggers and Welsers in Augsburg, were increasingly engaged in business with the New World and the Far East. Theuerkauff has aptly suggested that long-distance trade involves both great financial rewards and tremendous risks. Good and bad fortune mirror one's life since death often comes swiftly following a sudden sickness. This is among the earliest carved portraits in which the patron is placed before a broad landscape that seems to have particular relevance for the work's overall meaning.[112]

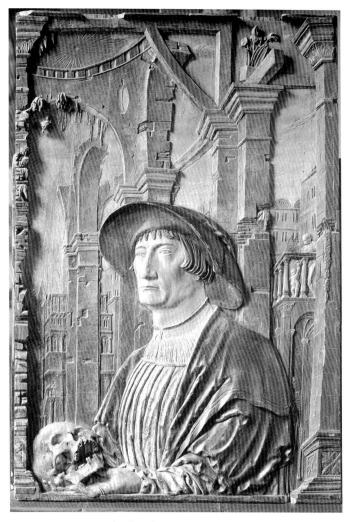

307. Hans Schenck, *Tiedemann Giese*, c. 1525–30, Berlin, Jagdschloss Grunewald

This period produced at least one notable North German portraitist, Master M.V.A., who seems, based upon the identities of his patrons, to have been active in Hamburg during the 1540s. Typical of his work is the portrait of *Werner Rolefinck* of 1548 still in Hamburg (Museum für Kunst und Gewerbe). [113] (fig. 309) Rolefinck, a local merchant, is presented in a circular format reminiscent of a medal. This has prompted Habich to suggest the master was a medallist and that this boxwood relief was a model; however, no medals by his hand are known. The bust figure is carved in very high relief. This coupled with the great attention given to the clothing and especially the beard results in an un-

usually lifelike bust that appears far more monumental than its actual diameter of 6.3 cm. The monogrammist also occasionally fashioned larger and very naturalistic relief portraits in painted terracotta. [114]

The number of high-quality reliefs dropped somewhat after mid-century as most patrons continued to prefer portrait medals. One of the most intriguing late examples is Hans van der Mul's portrait of *Julius Echter von Mespelbrunn*, now in Würzburg (Martin von Wagner-Museum der Universität). [115] (fig. 310) Dated 1576, the solnhofen stone relief by an otherwise unknown Netherlandish master presents Echter in the third year of his long

347

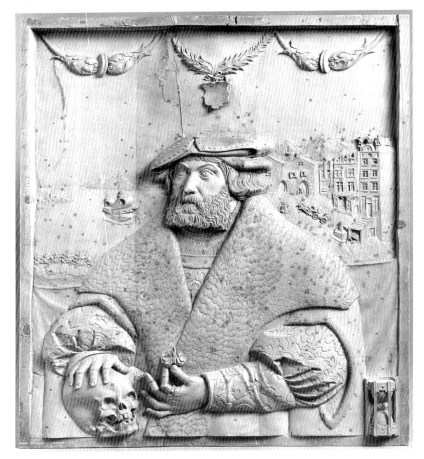

308. Master of Wolfgang Thenn, *Portrait of a Merchant*, c. 1530, Berlin, SMBPK, Skulpturengalerie

(1573–1617) and eventful reign as prince-bishop of Würzburg. The half-length figure stands before a modern building, which is certainly an allusion to his contemporary erection of the Juliusspital, among other projects. (figs. 82 and 83) Although dressed in secular clothing, he holds a small prayer book and stares outward as if asking the question inscribed above: "If God be for us, who can be against us?" This biblical quotation from Romans 8:31, whether voiced by this counter-Reformation leader or by the three princes above in the *Friendship Temple*, asserts the validity of the Roman Catholic church. With their belief that they represent the true church extending back to Christ's charge to St. Peter, they declare that God is on their side. God appears in the pediment above as if to substantiate their claim. He gestures broadly towards Sts. Kilian, on the left, and Burchard, the diocese's

founder and first bishop. Peter Osten would carve fountain statues of each for the Juliusspital three years later. God sanctions the bishop and his family coat of arms. Supporting the elaborate strapwork frame are caryatids of Faith and Hope. The abundance of fruit below may just be a decorative motif; however, given the character of the rest of the relief, their presence likely refers to the prosperity that his reign will bring. As in the case of Schenck's portrait of *Hans Klur*, the patron clearly desires a confessional statement. Yet instead of a virulent polemic, van der Mul offers a confident, divinely directed bishop striving for the betterment of his subjects. Echter's portrait signals the dynamic re-affirmation of the German Catholic Church and its leaders. It is a first step towards the triumphal imagery of the late sixteenth century.

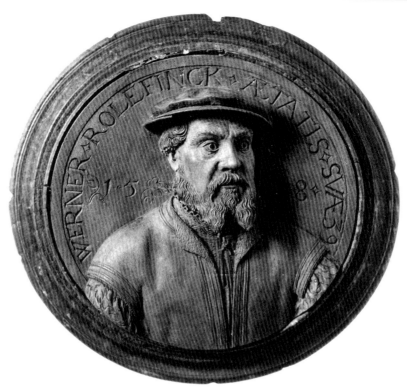

309. Master M.V.A., *Werner Rolefinck*, 1548, Hamburg, Museum für Kunst und Gewerbe

JOHANN GREGOR VAN DER SCHARDT AND BUST PORTRAITURE

Busts are the rarest of all forms of sculpted portraits in the German lands. Conrad Meit's talents as a portraitist were manifest only after he left to become a court artist in the Netherlands in the 1510s.[116] Not until the arrival of Johann Gregor van der Schardt in the 1570s would there be a capable practitioner, and even his impact was rather limited. The lack of a tradition of bust portraiture is somewhat puzzling. Obviously, Italian artists, such as Antonio Rossellino in the 1450s and 1460s, had a distinct advantage since they and their patrons were inspired by the ever-growing corpus of ancient Roman marbles. Although one might expect otherwise, Germany's humanists, its avid collectors of classical sculpture, such as Raymund or Hans Fugger, and its ambitious nobles failed to emulate their Italian peers when it came to commissioning portrait busts. Germany did have sev-

eral nascent traditions that potentially could have blossomed into a thriving demand for portrait busts. For instance, around 1370 Peter Parler and his workshop fashioned a whole series of portraits of nobles, clerics, and artists for the clerestory of the choir of St. Vitus cathedral in Prague. Similarly, bust of architects, master masons, and even sculptors occasionally can be seen in churches.[117] Religious statues were increasingly naturalistic around 1500. Reliquary busts, such as the St. Ursula type in Cologne, mimic fashion changes.[118] Sometimes these reliquary busts were portraits as in the case of the *St. Charlemagne-Charles V* and *St. Adalbert-Albrecht von Brandenburg* shrines once on the main altar in the Neue Stift at Halle, which we discussed in Chapter Three. Busts are also associated with choir stalls where half-length statues of saints, prophets, and philosophers, such as those by Jörg Syrlin in Ulm Münster or the abbey at Blaubeuren, are strikingly lifelike.[119] Rasmussen has argued that a few of the busts once above the stalls in the

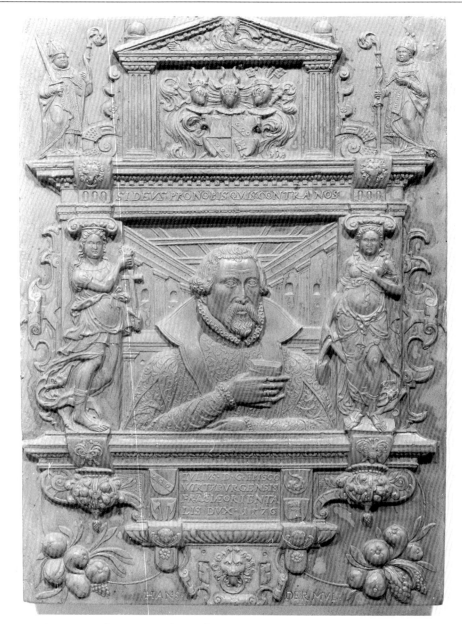

310. Hans van der Mul, *Julius Echter von Mespelbrunn, Prince-Bishop of Würzburg*, 1576, Würzburg, Martin von Wagner Museum der Universität Würzburg

Fugger chapel depicted contemporaries, including Kunz von der Rosen.[120] In addition, patrons commissioned the occasional bust for their churches. For example, in addition to Adriano Fiorentino's bronze, which may have had a church setting, Friedrich the Wise presented an alabaster portrait of himself to the Schlosskirche in Wittenberg around 1520.[121] Until its destruction in a fire in 1760, the bust was located just above a Crucifixion in an ensemble of eight Passion scenes.

Closest in appearance to these diverse ecclesiastical prototypes are two lindenwood busts of men, each about 49 cm high, in Munich (Bayerisches Nationalmuseum).[122] (fig. 311) The sculptures are straight cut at mid-chest to facilitate their placement on a table or other flat surface. Both men gaze

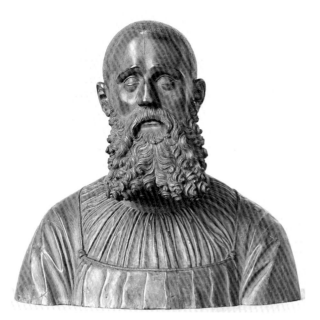

311. Matthes Gebel(?), *Bust of a Man (Friedrich II, Elector Palatine(?))*, c. 1530, Munich, Bayerisches Nationalmuseum

to be cast in brass or bronze. Despite these various problems, the directness of the busts, the wonderful carving of the collars, and especially the exuberant handling of Friedrich(?)'s beard are impressive.

Two busts attributed to Melchior Baier and Dietrich Schro are more in keeping with German taste for small, rather precious objects. The first is a boxwood *Portrait of a Man* now in Basel (Historisches Museum).[124] (fig. 312) Measuring only about 8 cm high, this diminutive bust was commissioned for a library or collector's cabinet. Was it possibly a book end? In addition to its rather flat back, the figure is designed to be viewed from the side as his head turns sharply to his right. This position also shows off the sculptor's "MP" monogram and the date 1527 that are carved prominently on the sleeve. Kohlhaussen and Hans Reinhardt have identified the monogrammist as Melchior Baier, the Nuremberg goldsmith who collaborated frequently with Peter Flötner, Matthes Gebel, and

forward with no indication of lateral movement. Thus, while the statues are carved on all sides, a limited frontal view was planned. The pair were earlier displayed in the schloss at Neuburg an der Donau but whether this was their original provenance is uncertain. Problems of identification and attribution also plague these two statues. Müller, among others, proposes that the pair represents the Palatine counts *Friedrich II* (1482–1556), shown here, and *Philipp*, Ottheinrich's brother, because of their similarities with Gebel's medals of 1531.[123] I find only the former comparison to be plausible. Yet if they are princes then why is each dressed so simply in a shirt, albeit beautifully worked, and light robe? As observed in the other portraits in this chapter, most patrons favored the inclusion of their finest fur-trimmed robes or clothes appropriate to their office. The "Philipp" statue has also been called the court fool because of its shaved head and slightly gapping mouth. Their attribution to Gebel is also problematic since no other large-scale sculptures by him or by his shop, which included his wife, Margarethe, are known. Furthermore, Gebel preferred to work in stone not wood, though an exception might be made if the busts were intended

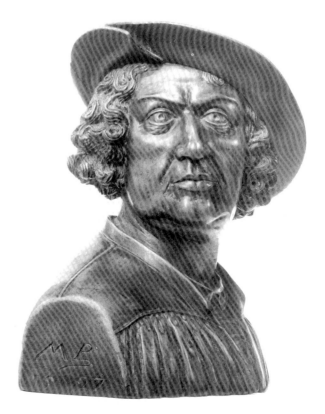

312. Master M.P. (Melchior Baier[?]), *Bust of a Man*, 1527, Basel, Historisches Museum

other artists. (figs. 24 and 290) A similar cursive "MP" appears on Baier's gold medal of *Severin Boner* (1533) that the Polish minister sent to Erasmus.[125] The letters B and P are frequently used interchangeably at this time. While plausible since Baier began as a sculptor, the attribution to him remains conjectural since little is known about his activities as a carver. The face is highly naturalistic, as the fleshiness of the cheeks and the wrinkles beneath the eyes are accentuated. The bust has a remarkably casual appearance with is tilted hat and rather simple attire. Could this be a self-portrait?

Far more formal is Dietrich Schro's bust of *Ottheinrich*, now in Paris (Musée du Louvre), that certainly dates around 1556 when the prince succeeded Friedrich II as the Palatine elector.[126] (fig. 313) The half-length alabaster portrait shows Ottheinrich seated upon a lavish chair decorated with hermes, now damaged, and his heraldic lions. He clasps a small book that rests on the lectern. Is this a bible or a humanistic text? The conscious choice of a book reminds the viewer both of his staunch Lutheranism with its stress on the word of God and of his activities as one of the century's great bibliophiles. In either case, Ottheinrich is presented as the enlightened ruler. At a height of just 15.5 cm, the bust certainly was prepared either for the prince's personal chambers or his library. The artist stresses and arguably over emphasizes Ottheinrich's rich robes and boldly puffed sleeves. Having experienced bankruptcy, the sack of his palace at Neuburg, and the contempt of Emperor Charles V, Ottheinrich celebrates both his current good fortune and his awareness of his own transience. The corpulent noble, who would die in 1559, looks in frail health. The style of the head compares closely with a series of medals of Ottheinrich, one of which is set into the base of the bust, that plausibly are ascribed to Schro who was active in nearby Mainz.[127] This was not Ottheinrich's first portrait bust since a heavily damaged clay model for a bronze example was made around 1550.[128] Unfortunately, little is known about this project.

The period's finest portraitist was Johann Gregor van der Schardt. In 1570 he moved to Nuremberg to collaborate with Wenzel Jamnitzer on Emperor Maximilian II's fountain (figs. 173–176) Among his possessions may have been a terracotta *Self-Portrait*, now in an American private collection, that he made while in Italy during the mid-1560s.[129] Half life-size, this striking polychromed bust shows the artist with bare shoulders, brown eyes, and dark hair, a likeness that is younger but otherwise matching the later painted portraits of the sculptor.[130] The naturalistic character of the self-portrait surpasses any of the busts encountered so far. Germany apparently had a tradition of terracotta portraits but remarkably little survives beyond a few reliefs by Master M. V. A. and the *Bust of Young Man* in Vienna (Kunsthistorisches Museum) perhaps by an Upper Rhenish artist.[131] Obviously, the fragility of the medium is a major factor for the losses.

During the summer of 1570 Willibald Imhoff, the Nuremberg patrician, commissioned van der Schardt to make the remarkable terracotta bust today in Berlin (SMBPK, Skulpturengalerie).[132] (fig. 314) Nothing in German sculpture prepares the viewer for the veracity of this portrait. Imhoff's half-length figure, at a height of 81 cm, is slightly over life-size. Its sense of immediacy is greatly heightened by the inclusion of arms, a comparatively rare feature in bust portraiture. Imhoff raises his left arm while his right hangs at ease. One senses that the unseen (and uncarved) right hand will appear momentarily. Without the arms, van der Schardt's bust would not be nearly as poignant since Imhoff intently gazes at the ring held in the left hand. Although the finger with the ring is not original, the positioning of the other fingers indicate that he must have supported a small object such as a ring or one of his many classical coins. The entire bust is built upon the senses of touch and sight. Imhoff tips his head and twists his wrist slightly as if trying to catch the reflected light at just the right angle. Captivated by the beauty of the object in his fingers, Imhoff's eyes and, indeed, his entire being are temporarily transfixed. Unconsciously, his mouth parts slightly. Perhaps he is poised to tell us about this treasure and how he acquired it. Few portraits utilize the surrounding pictorial space and link it with the viewer so effectively. To enhance the intimacy, van der Schardt has painted the bust in natural tones and added a wealth of details such as warts, liver spots, and wrinkles. The hair and beard, originally brown, are now black. Accurate or not, van der Schardt provides us with both a physical and a personal portrait

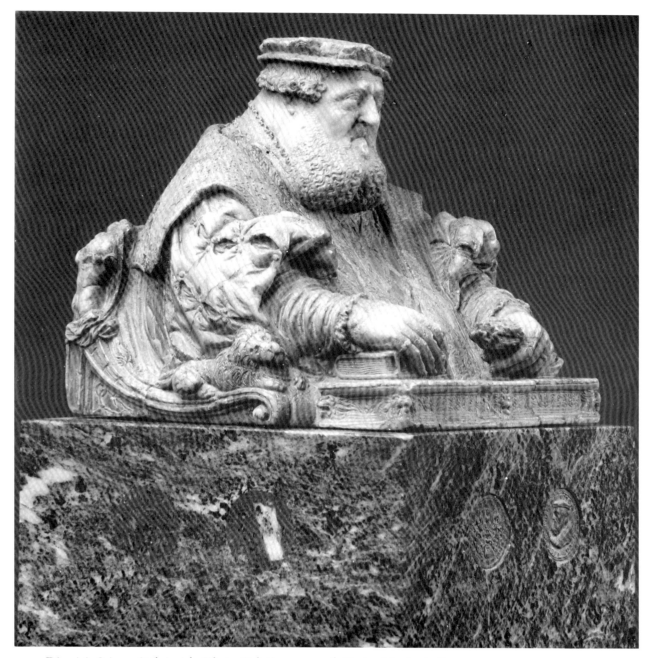

313. Dietrich Schro, *Ottheinrich, Elector Palatine*, c. 1556, Paris, Musée du Louvre

of Imhoff. He is presented as the consummate connoisseur, the cultivated merchant who constructed one of the period's finest *Kunstkammers*. Imhoff must have been pleased by the bust since he paid van der Schardt over 22 florins on 6 August and, subsequently, ordered further sculptures by the artist.

The style of the Imhoff bust is an interesting blend of different influences. The actual portrait type, notably its highly personal character, recalls the better paintings by Nicholas Neufchatel, a fellow Netherlander active in Nuremberg.[133] Since van der Schardt had only just arrived in the city, their mutual dependence upon the portrait tradi-

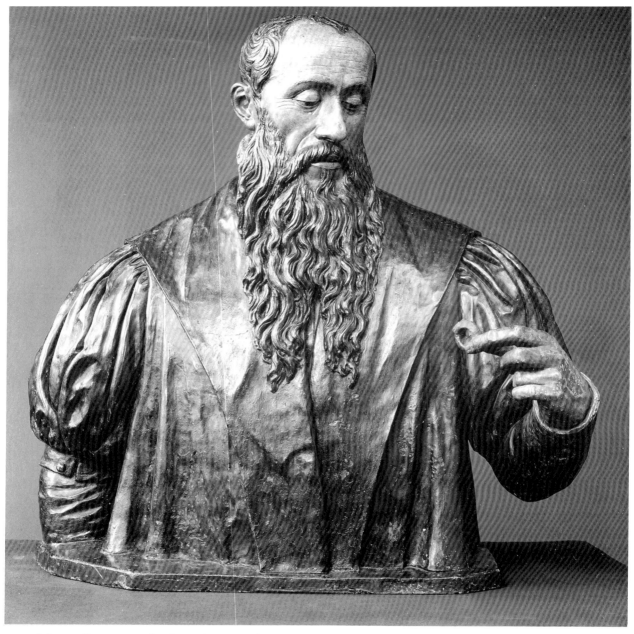

314. Johann Gregor van der Schardt, *Bust of Willibald Imhoff*, 1570, Berlin, SMBPK, Skulpturengalerie

tion of mid-century Antwerp, as represented in the works of Antonio Mor or Frans Floris, seems most likely. From his years in Venice and North Italy, van der Schardt was strongly affected by the portrait busts of Danese Cattaneo and especially Alessandro Vittoria. By the mid-1560s, Vittoria began producing a steady number of terracotta busts, as well as those in marble and bronze. A few of Vittoria's life-size terracottas, such as that of *Doge Niccolò da Ponte* (Venice, Seminario Arcivescovile) or the *Woman* in Vienna (Kunsthistorisches Museum), are embued with spirit and a spark of individuality.[134] Van der Schardt melded his Netherlandish heritage with the North Italian terracotta bust to create the

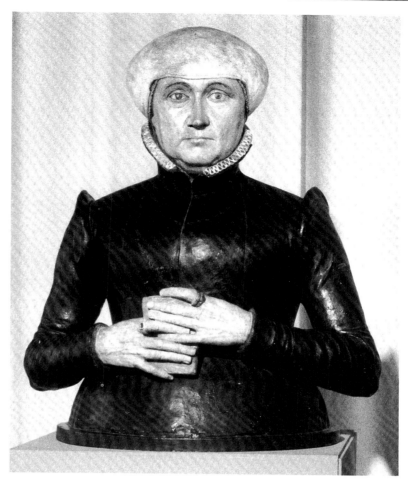

315. Johann Gregor van der Schardt, *Bust of Anna Harsdörffer*, 1579–80, Berlin, SMBPK, Skulpturengalerie

highly specific yet profoundly reflective portrait of Willibald Imhoff that surpasses all of its potential sources.

Shortly before his death on 25 January 1580, Imhoff commissioned a separate terracotta bust of his wife, *Anna Harsdörffer*, also now in Berlin (SMBPK, Skulpturengalerie).[135] (fig. 315) Its character and size (62.5 cm high) are quite different than the portrait of Willibald. Clutching a prayer book or small bible, Anna stares forward at the altar of their house chapel since this is where the bust initially was located. Her demeanor is somewhat less satisfying than Willibald's since her gaze is unfocused and the figure is not as self-contained. Nevertheless, van der Schardt has fashioned a sympathetic likeness. In addition to the face, the sculptor empha-

sizes her hands with their veins, tendons, and aging flesh. The hands stand out boldly against the black dress. Originally the dress was painted with a brighter brocade pattern that seems to have been altered shortly afterwards, presumably in response to Willibald's death. Although the two busts have long been displayed together, they were not initially conceived as a pair. Willibald's portrait stresses his passion for art while that of his wife, more conventionally, underscores her piety. His bust was displayed along with his collection of antiquities, and only at a later date was moved to the house chapel to join Anna.

During the 1570s and early 1580s van der Schardt fashioned several other terracotta portraits. For some reason, the artist switched back to the

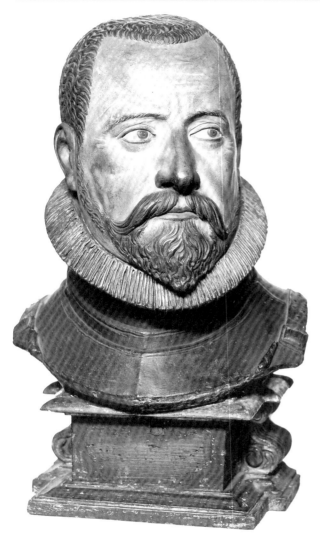

316. Johann Gregor van der Schardt, *Bust of Frederik II, King of Denmark*, 1578, Hillerød, Frederiksborg Museum

more conventional bust form without arms. Between 1 May 1577 and the fall of 1579, he worked for King Frederik II of Denmark at Slot Kronborg in Helsingør. His most important project was a pair of brass busts of the *Frederik* and *Queen Sophie* that were subsequently destroyed in the disastrous fire of 1629. A terracotta portrait of *Frederik II*, now in Hillerød (Frederiksborg Museum), may have served as the model or as a trial piece for the lost brass.[136] (fig. 316) Dressed in black armor with a white collar, the king alertly turns his head to his

left as if something has just caught his attention. Once again, sight is the energizing feature of the bust. As with the Imhoff portraits, van der Schardt dwells on the careful modeling of the cheeks, the precise cutting of the king's brown hair and beard, and especially the naturalistic detailing around the eyes. Frederik must have been pleased with van der Schardt's conception since many of the subsequent portraits of the king stem from this model.

In addition to his busts, van der Schardt occasionally produced terracotta portrait medallions. These range in size from about 10 to 28 cm in diameter. Willibald Imhoff commissioned one just before his death. His inventory lists six plaster heads, by which terracotta is probably meant, valued together at the high sum of 12 gulden.[137] Particularly attractive is van der Schardt's *Portrait of a Man*, dated 1580, that exists in two slightly different versions in Stuttgart (Württembergisches Landesmuseum) and Nuremberg (Germanisches Nationalmuseum).[138] (fig. 317) The identity of this man is uncertain. Since 1832 he has been labelled as Paulus Praun, an identification seemingly supported by the fact that both versions of the portrait belonged in Praun's famous art collection. Earlier inventory accounts provide no name. Matthäus Carl's wax and medal portraits of Praun, done in 1584, show a generally similar looking man but with a broader forehead.[139] Praun or not, this wealthy patron with his black doublet and high white collar is quite dignified. Even when limited to a profile view, van der Schardt offers an intelligent looking man with an alert expression. He enriches the portrait by contrasting textures and by the rich interplay of lines, such as the short swirling curls of the hair juxtaposed with the tight horizontal strokes of the beard.

Prior to van der Schardt's creations, such profile reliefs were extremely rare in the German lands. With his busts and medallions, as with his refined statuettes, van der Schardt contributed to the reinvigoration of German art. His is an international art with strong local roots. He skillfully blended his Netherlandish heritage, his Italian training, and his taste for the antique with the artistic traditions of southern Germany. Van der Schardt's late Renaissance style offered a comfortable mode to his Nuremberg and Danish patrons. It was at once

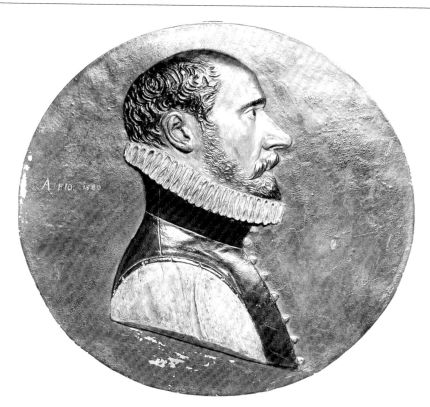

317. Johann Gregor van der Schardt, *Portrait of a Man (Paulus Praun(?))*, 1580, Nuremberg, Germanisches Nationalmuseum

sophisticated yet less threatening than the serpentine figures and mannered compositions of Giambologna and his followers. Ultimately, however, van der Schardt's influence was limited since he left no large group of pupils and his designs were not replicated in prints. Hubert Gerhard, Adriaen de Vries, Hans Krumper, Caspar Gras, and Georg Petel, among others both inside or influenced by Giambologna's circle, would dictate high fashion in northern portraiture at the turn of the century.

357

CONCLUSION

Steps towards a
New Sculptural Legacy

❧

CATHARSIS and renewal are the two funda-
mental impulses of German art and culture of
the later Renaissance. With the Reformation came
a spiritual cleansing for Protestants and Catholics
alike. Lutherans, Zwinglians, and other sects cast
aside the old church and many of its practices,
which included the visual manifesting of both the
divine and the dogmatic. Art proved to be too in-
timidating for many who came to fear the potential
power of a particular statue. For others, the elabo-
rate decoration of their churches was both morally
insidious and materially extravagant. An elaborate
Schutzmantel Madonna, which glorifies Mary's pro-
tection of the devout, or a writhing, arrow-filled
St. Sebastian rapidly metamorphosized from devo-
tional aids into decadent symbols of the errant path
offered Christians by the Roman Catholic church.
A strict reliance upon God's word, as manifest in
the bible, required, and for the purists indeed de-
manded, no art—no graven images. The Reforma-
tion also forced Catholics to defend their practices
and their traditional privileged position. A wrench-
ing process of renewal resulted from the ashes of
iconoclasm and religious pluralism. After decades
of criticism and uncertainty, the German Catholic
church slowly rebuilt itself. The Treaty of Augs-
burg assured its territorial integrity, while the
edicts of Trent codified its beliefs. Just as signifi-
cantly, the Tridentine councils and the many re-
gional ones that followed provided the basis for a
resurgent German Catholic church. By 1580 Cath-
olics were once again beginning to flex their spiri-
tual and cultural muscles.

Art was at once a pawn and a weapon of this
cultural tumult. In the early iconoclastic debates,
painting and particularly sculpture were the focus
of tremendous, often irrational criticism. Statues
were invested with lives and even personalities that
far transcended the stone or wood from which they
were carved. Paradoxically, no sooner had the Re-
formers condemned art as idolatrous then some
groups, notably the Lutherans, gingerly reem-
braced its use. A limited range of iconographic
themes were expressed, first in prints followed
gradually in paintings and sculptures. Subjects,
such as the Law and Gospel or the Last Supper, were
instructive for communicating the fundamental
tenets of the new church. In contrast with pre-
Reformation practices, however, the Lutherans re-
stricted both the content and the quantity of reli-
gious art that could appear in any church. A sculp-
ted pulpit was to teach the faithful not serve as the
focal point of their devotion.

After decades of pictorial retrenchment and the
notable failures of such enterprises as the Neue Stift
at Halle, Catholics also slowly reaffirmed their faith
in religious art. In the aftermath of the Treaty of
Augsburg, a few powerful nobles and clerics ini-
tiated new church commissions. For most sculp-
tors, the new orders arrived too late to bolster their
careers. The lack of a continuous vibrant tradition
of religious sculpture and of adequate models crip-
pled some artists. Recall Ferdinand I's difficulty in
1553 in finding a reasonably priced sculptor able to
carve the new high altar for the Hofkirche in Inns-
bruck. Perhaps Paulus Mair's *Mary Altar* in St.
Ulrich and Afra in Augsburg would have assumed a
far different appearance if more modern archetypes

had been available. Is it coincidental that two of the most successful artists after 1555 were Alexander Colin and Johann Gregor van der Schardt, Netherlandish masters who were fully trained before arriving in Germany? Similarly, Wilhelm V, duke of Bavaria, and the Jesuits turned to Netherlandish and Italian artists to supplement local ones in 1583 when they began erecting St. Michael in Munich, the first significant new church constructed in Germany since the 1520s. Outside of the Dresden school, few German artists had experience working on large-scale ecclesiastical projects.

Opportunity not talent was the primary inhibiting factor in both Protestant and Catholic regions. Artists can hardly be faulted if for over a half century the residents of towns such as Lübeck or Frankfurt failed to order a single new carved altarpiece. Between about 1520 and 1580, German sculptors were forced to adapt to their rapidly changing world. I am far less concerned by what they did not produce, though this is historically significant, than by their ability to adjust. The true sculptural legacy of this period is its innovation, not its quantity or even quality, of production. This innovation occurred quietly and, seemingly, in spite of the general conservativism of all German art during this era. In addition to devising a whole new corpus of Protestant art, these masters pioneered *Kleinplastik*. Plaquettes, small brasses, and other intricate collectors's pieces were first introduced into German art at this time. Portraiture, which had been primarily the domain of painters, suddenly burst forth as thousands of medals and a lesser but still significant number of reliefs and busts found their way into palaces and patrician houses from Basel to Berlin. This too was a great age for fountains of all descriptions. Flötner fashioned intricate grottos with cascading streams. Jamnitzer and van der Schardt produced esoteric imperial allegories in bronze. Monumental fountains were erected in Augsburg, Nuremberg, and a host of other places as civic officials beautified their towns and celebrated their particular heritages. Elaborate garden fountains became requisite features of princely residences from Stuttgart to Vienna. Sculpture also graced a growing number of buildings, notably palaces and city halls. This highly visible form of art often communicated specific conceits or iconographic messages to a public audience, much as

church carvings had done before the Reformation. Memorials, those tangible monuments to one's piety and often one's pride, were the sole type of sculpture to survive the first onslaught of the reformers' fury, though their design and message often required modification. As the century progressed, so did the complexity of German epitaphs and tombs. In some instances, Reformation themes, like Christ Triumphing over Death and the Devil, were displayed. Elaborate episcopal and princely series often stressed historical or familial continuity. Meanwhile, at Freiberg and Innsbruck sculptors constructed the largest single tombs in all of Europe. It is instructive to remember that the only comparably scaled monument, Michelangelo's *Tomb of Pope Julius II* in Rome, was never completed as originally planned.

After 1580 these newly developed forms of sculpture were suddenly supplemented by an explosion of new religious commissions. A Hubert Gerhard could fashion monumental bronzes of the amorous Mars and Venus as well as the terrible struggle of St. Michael and the Devil. In Protestant and Catholic areas, older churches were renovated and new ones were built. In most instances, sculpture was needed to define and to decorate these edifices. Among our artists, only a few younger ones like Hans Ruprecht Hoffmann, Sem Schlör, or the upcoming members of the Walther family, truly benefited. The torch was passed to their pupils and the next generation of sculptors. Although masters from other countries, notably the Netherlands and Italy, would contribute significantly to the reinvigoration of German art, strong regional schools and families of artists emerged rather quickly. For instance, sculptors Hans Krumper, Georg Petel, Hans Degler, Bartholomäus Steinle, Christoph Angermair, Philipp Dirr, and Hans Spindler, among others, all had ties to the small southern Bavarian town of Weilheim. The Gröningers in Münster and Paderborn, the Junckers in Franconia, the Wulffs in Bückeburg and Hildesheim, and the Zürns in Überlingen and later eastern Bavaria testify to the growing vitality of German art prior to the subsequent disruptions of the Thirty Years War. Civic, princely, and ecclesiastic patronage all increased. Munich and, to a lesser degree, Cologne under the Wittelsbachs emerged as vibrant centers, whereas their contributions to

German art in the mid-sixteenth century had been rather negligible. Noble courts wielded greater influence and supported better artists as the century ended. Several once-proud imperial free cities, including Nuremberg, gradually lost much of the artistic standing that they had enjoyed before 1580.

And what of the collective status of the later Renaissance sculptors? This can be gauged in two ways by studying their social standing and their relation to other artists. When examining the sculptors, excluding the Netherlander Floris, who are discussed in our Biographical Catalogue, only a few, including Colin, Dell, Loy Hering, Hans Walther, and Weiditz, seem to have enjoyed considerable financial success. Yet none amassed the sort of extra-artistic entrepreneurial fortune built by Lucas Cranach the Elder. Adequate information, normally in the form of tax records, however, is often lacking. Most owned property, a standard means of accessing material well-being. Nevertheless, one also finds artists such as Daucher who resided primarily with family or with a fellow sculptor. During the years before the presumed expulsion of his wife, the Augsburg master changed rental(?) houses with remarkable frequency. In an age with potentially fewer economic opportunities than before the Reformation, artists moved often. Less than half of the sculptors spent their careers working in their native towns. While Hagenauer's claim to have lived in Strasbourg, Speyer, Worms, Mainz, Heidelberg, Frankfurt am Main, Nuremberg, Passau, Salzburg, Munich, and Landshut before settling briefly in Augsburg was unusual, most artists expected to toil in multiple locales. Some were lured to the bigger cities or to princely courts by the prospect of more substantial commissions. Although most of our group had noble patrons, only about a third could be considered court artists, by which I mean they either held an official court appointment or they worked in a salaried position at a particular court for several consecutive years. Ässlinger, Colin, and Meit alone labored primarily for their noble patrons. Schenck and Hans Walther enjoyed the long term support of the electors of Brandenburg and Saxony respectively; however, both were permitted to devote much of their attention to other clients. In this respect, our group of sculptors seems to have commanded approximately

the same level of esteem as their peers before the Reformation. While many sculptors periodically held guild offices, only a few occupied important civic positions. Loy Hering and Hans Walther were both elected burgermeisters or mayors of their towns, Eichstätt and Dresden. Interestingly, since neither was a native, their personal and artistic talents evidently earned them the trust of the local political hierarchies. Krug was a sworn city counselor in Nuremberg, which was about as high a post as an artist could hold in the patrician-dominated government. Hoffmann served as the representative of the stonemasons' guild on Trier's city council in 1581. He subsequently held other posts including the church master of St. Gangolf in 1614. Loscher alone seems to have supplemented his artistic income by working in an appointed paid civic job, in this case Augsburg's wine drawer. In general, one may conclude that the lot of a sculptor continued much as it had earlier though there were fewer economic possibilities available. After 1580, the situation would change slightly as more princely and ecclesiastical nobles planned ambitious artistic projects that required the post of a court sculptor. Hans Krumper, for instance, had far greater creative latitude and wielded far more power than any of his predecessors.

Judging the collective artistic status of sculptors is considerably more difficult. Even before the Reformation, sculptors had largely ceded intellectual primacy to painters and printmakers.[1] Many sculptors became less self-reliant as they based their compositions and figural types upon the woodcuts and engravings of others. Without ever lifting a sculptor's hammer and chisel, Schongauer and Dürer inspired literally hundreds of statues of both large and small scale. Even a successful artist like Loy Hering borrowed their scenes and their other pictorial ideas whenever possible. For instance, the two reliefs of his *Wolfstein Altar* derive from a woodcut by Dürer and an engraving by Schongauer. (fig. 36) The Augsburg school artist's *Friendship Temple* owes its form to Burgkmair; and Hoffmann's cathedral pulpit in Trier selectively draws from a print after van Heemskerck. (figs. 81 and 302) The ideal of *inventio* or invention, so dear to Michelangelo and Italian theorists of art, mattered little to many German sculptors. Obviously, Peter Vischer the Younger and Flötner, among others, delighted in

the novelty of their art. Similarly, a hallmark of Schenck's style is its conscious pictorial originality. Yet unless one judge here too harshly, a comparable borrowing of print sources by sculptors in other lands can be observed. More critical is the creative use to which the models were put. The pose of van der Schardt's *Mercury* might have both classical and print prototypes, but this hardly diminishes its elegant grace or even the originality of the sculptor's own contributions.[2] In cases such as the *Mercury*, the skillfully borrowed source demonstrates the sculptor's learning while simultaneously enhancing the aesthetic pedigree of his or her creation. Peter Paul Rubens' oeuvre would be far less stimulating without its myriad of conscious quotations from other artists. And yet no one can criticize the great Flemish master for his lack of *inventio*. In sum, a distinction exists between the slavish and the creative use of pictorial sources. Both may be observed during this period.

Innovation occurred because artists were forced to adapt to their changing environment or lose their livelihood. This is indeed one of the great paradoxes of the mid-sixteenth century since most German artists, whether sculptors, painters, or goldsmiths, placed a greater premium upon execution than originality. Even the conservative guild system was structured to ensure the quality or craftsmanship of an artist's work rather than its uniqueness. Masterpieces encouraged homogeneity, albeit on a high level, not flights of personal expression. As observed in the case of the first generation of medallists, innovation was often threatening to others. A desire for control, for regulation, was typically the first response of other artists. This was an uncertain time, particularly prior to the Treaty of Augsburg. Caution not precocity prevailed, an attitude that is equally applicable to painters and most other artisans. No single master, whether sculptor or painter, emerged to dictate the direction of his or her generation's art. In fact, the most influential sculptor of the period proved to be Cornelis Floris of Antwerp whose ideas were disseminated through his exported carvings, his print series, and the art of his followers. Arguably among German artists, only the goldsmith Wenzel Jamnitzer truly shaped the future of his craft. Instead the remarkable changes that occurred in sculptural form and function in the later Renaissance emerged slowly, almost collectively, rather than as a sudden burst of inspiration by one master. Shaped by the dramatic cultural shifts and by the continuous introduction of new aesthetic ideas, the art of sculpture between about 1520 and 1580 underwent an astounding transformation. As I have tried to argue, German sculptors of the later Renaissance achieved much if with little fanfare. With their art bruised by the Reformation and their professional status potentially in jeopardy, these sculptors quietly revitalized their *kunst*, with its critical mix of craft and knowledge. Their legacy too is the fertile artistic foundation that they passed on to their successors. Without this heritage, without its many battles and resulting changes, the marvelous blossoming of all forms of sculpture in the decades after 1580 would have been impossible.[3]

BIOGRAPHICAL CATALOGUE
OF SELECTED SCULPTORS

THIS REFERENCE SECTION provides biographies for 44 sculptors, listed in alphabetical order. Each account includes a brief life, a list of major works divided into two groups depending upon whether the individual sculpture is signed and/or documented or merely attributed to the artist, and a short bibliography. Since these artists are discussed elsewhere in this book, I have limited my comments about style, artistic influence, and the significance of a specific work.

Hans Ässlinger

Ässlinger (Munich[?]–1567 Munich) was active as a sculptor, stone mason, and medallist in Munich and Landshut from 1535. Information about his training and early career is scanty though his father may have been Kunz Ässlinger, a Munich glazer. On 5 July 1536 he became a master sculptor in Munich, and shortly afterwards entered the service of Ludwig X, duke of Bavaria (1495–1545). Hans moved to Landshut in 1537 to participate in the construction of the Italian wing of the ducal Stadtresidenz. (fig. 213) In 1539 he travelled to Neuburg an der Donau to oversee the shipment of stone for the palace's chimneys. Hans was influenced by and may have assisted Thomas Hering, the sculptor of these chimneys. He reacquired Munich citizenship on 5 June 1555, and taught at least three pupils in the following years.

Ässlinger's activities at the Bavarian court were varied. He carved highly detailed reliefs and designed medals. In 1560 Duke Albrecht V paid him for transporting an ancient marble *Hercules* from Salzburg to Munich. The duke appreciated Ässlinger's varied talents. He paid for the education of three of the artist's sons in 1560 and had a painted portrait of Ässlinger in his art collection; a second version hung in the portrait gallery of Archduke Ferdinand of Tirol at Schloss Ambras outside Innsbruck. Between 1559 and about 1562, the sculptor also created several works for the archbishops of Salzburg.

SELECTED SIGNED AND/OR DOCUMENTED WORKS

1550 *Massacre of the Innocents* (Berlin, SMBPK, Skulpturengalerie). After Marcantonio Raimondi

1550 *Judgment of Paris* (Munich, Bayerisches Nationalmuseum; fig. 253). After Marcantonio Raimondi

1554 *Portrait of Albrecht V*, 2 medals

1554 *Portrait of Margaretha von Fraunhofen*, medal

1558 *Portrait of Albrecht V*, medal (fig. 297)

1559–61 *Resurrection* relief for the *Epitaph of Archbishop Michael von Kuenburg* (Salzburg, Franziskanerkirche)

MAJOR ATTRIBUTED WORKS

mid-1550s *Portrait of Albrecht V*, lifesize medallion bust (formerly Munich, Bayerisches Nationalmuseum)

c. 1562 *Portrait of Johann Jakob Khnen von Belasi, archbishop of Salzburg*, medal

BIBLIOGRAPHY

F. Kenner, "Die Porträtsammlung der Erzherzogs Ferdinand von Tirol," *JKSAK* 15 (1894): pp. 216–17

Vöge (1910), pp. 167–68

Bange (1928), pp. 94–5

Habich (1929–34), 2.1: pp. 457–60

Otto Hartig, "Münchner Künstler und Kunstsachen," *MJBK* 7 (1930): pp. 365, 367f, 371; 8 (1931): pp. 322–24, 327, 329, 331, 333–34, 336–37, 340, 343

Paul Grotemeyer in *NDB* 1 (1953): p. 92

Volker Liedke, "Die Meisterlisten der Münchner Maler, Bildhauer, Glaser und Seidensticker für das 16. Jahrhundert," *Ars Bavarica* 15–16 (1980): pp. 58, 60

Volker Liedke, "Die Lehrjungen der Münchner Maler und Bildhauer des 16. Jahrhunderts," *Ars Bavarica* 15–16 (1980): p. 73

Volker Liedke, "Die Landshuter Maler- und Bildhauerwerkstätten von der Mitte des 16. bis zum Ende des 18. Jahrhunderts," *Ars Bavarica* 27/28 (1982): pp. 34–5, 96–7.

Johann Brabender (Beldensnyder)

Johann (Münster c. 1500/05–1562/63 Münster) was a member of an illustrious family of sculptors. He trained with his father Heinrich (c. 1475–1535) before his wanderjahr, probably in the Low Countries. He became a master in 1539. Johann's emergence as an artist coincided with the rebuilding of Münster following the defeat of the Anabaptists in 1535. For the cathedral he carved the new choir screen, several altars, various epitaphs, and numerous other statues, including St. Paul for the Paradise Portal. Johann also worked, sometimes in collaboration with his brother Franz, in Bentlage, Burgstein, Hildesheim, and, less certainly, Osnabrück. He served as guildmaster of the stone sculptors and carvers in 1554.

SELECTED SIGNED AND / OR DOCUMENTED WORKS

1540s	*Epitaph of Bertold Bischopink* (d. 1534; Münster, Mauritzkirche)
1542– 1547/49	*Choir Screen* (Münster, cathedral). Payment documents of 1546 and 1548 list Brabender as the sculptor. The screen was removed in 1870. The few remaining fragments were transferred to the Landesmuseum in 1909. These include the seated figures of St. Matthew and St. John the Evangelist
1558	Architectural sculpture on the oriel (Burgsteinfurt, Schloss). With his brother Franz

late 1550s	*Four Standing Apostles* (Bentlage, Schloss)

MAJOR ATTRIBUTED WORKS

c. 1536– 40	*St. Paul* (Münster, cathedral, Paradise Portal; fig. 21)
1540	*St. Catherine* (Münster, cathedral)
c. 1540	*Epitaph of Theodor von Schade* (d. 1521; Münster, cathedral; fig. 22)
mid-1540s	*Epitaph of Surrogate Bishop Johann Bischopink* (d. 1543; Münster, cathedral, Marienkapelle)
mid-1540s	*Adam and Eve* (Münster, formerly in the tympanum of the outer portal of the Paradise at the cathedral, now on loan to the Westfälisches Landesmuseum). Given by Theodor von Meschede (d. 1545)
1545–50	*Crucifix* or *Prime Altar* (Münster, formerly in the cathedral but since 1875 on loan to the Westfälisches Landesmuseum)
1546	*Choir Screen* (Hildesheim, cathedral, Sankt-Antonius-Kapelle; fig. 33)

BIBLIOGRAPHY

Friedrich Born, *Hendrik und Johann Beldensnyder. Ein Beitrag zur Kenntnis der westfälischen Steinplastik im 16. Jahrhundert* (Münster, 1905)

Hans Melchers, *Die westfälische Steinskulptur von 1500–1560* (Emsdetten, 1931), esp. pp. 82–101

Geisberg (1937), pp. 66, 72, 102–12, 209–11, 256–59, 283

Max Geisberg, *Die Stadt Münster, 6. Die Kirchen und Kapellen der Stadt ausser dem Dom* [*Bau- und Kunstdenkmäler von Westfalen*, vol. 41.5] (Münster, 1941—reprinted Münster, 1977), p. 69, fig. 1822

Nora Benninghoff in *NDB* 2 (Berlin, 1955), p. 502

Neu-Kock (1977)

Jászai (1981), pp. 8–9, 12, 19, 21, 45–7

Josef Nowak, *Der Lettner des Hildesheimer Domes* (Hildesheim, 1981)

Paul Pieper, *Heinrich Brabender* (Münster, 1984).

Alexander Colin

Colin (Mechelen c. 1526–17 August 1612 Innsbruck) was among the foremost of the sculptors active at the Hapsburg courts in Innsbruck, Prague, and Vienna. His career prior to 1558 is uncertain. He likely trained with Symon Colyns, his uncle, in Mechelen around 1540. Dressler suggests that on the basis of style Colin worked at Fontainebleau in the 1540s before continuing on to Italy, perhaps Milan. His reputation was well established by 7 March 1558 when he is documented working as the master sculptor at Heidelberg castle. Colin succeeded sculptor Anthoni de Vleeschouwer (d. 1558) whose daughter Marie he would marry a year or two later in Mechelen. By late 1562 Colin moved to Innsbruck to complete the tomb of Emperor Maximilian I. Excepting periodic trips to Prague (1566, 1570, 1575, 1585, 1587, 1589) and the Low Countries (1566, 1575, 1598–99), the artist spent most of his subsequent career in Innsbruck. He purchased a house there in 1579 and acquired further property in 1605.

Colin was an extremely prolific sculptor. Of the 36 projects ascribed to him, 22 are signed, documented, or listed in a biographical letter of 1623 written by his son, Abraham (1563–1641) who was also a sculptor. These include fountains, garden decorations, tombs, epitaphs, and mythological and allegorical facade statues. His workshop was instrumental in transforming Innsbruck into a major sculptural center.

SELECTED SIGNED AND/OR DOCUMENTED WORKS

before 1558–1559	Facade and doorway sculptures (Heidelberg, castle, Ottheinrichsbau; figs. 223–225)
1562–83	*Tomb of Emperor Maximilian I* (Innsbruck, Hofkirche; figs. 146 and 151–153)
1565	*Acteon Fountain* (formerly Innsbruck, Lustgarten)
1566–89	*Tomb of Emperor Ferdinand I, Queen Anna, and Emperor Maximilian II* (Prague, St. Vitus cathedral)
1570–74	*Two Fountains* (formerly Vienna, Neugebäude; fig. 203)
1575–83	*Fountain* (formerly Vienna, Neugebäude; fragments in Vienna, Schloss Schönbrunn, Orangerie)
1580–81	*Tomb of Philippine Welser, wife of Archduke Ferdinand of Tirol* (Innsbruck, Hofkirche, Silver Chapel)
c. 1580–81	*Tomb of Katharina von Loxan* (Innsbruck, Hofkirche, Silver Chapel)
1584–87	*Tomb of Hans Fugger* with Hubert Gerhard (Kirchheim an der Mindel, Chapel)
1588–97	*Tomb of Archduke Ferdinand of Tirol* (Innsbruck, Hofkirche, Silver Chapel)
1604	*St. Francis*, terracotta (formerly, Innsbruck, Hofkirche, *High Altar*)

BIBLIOGRAPHY

David Ritter von Schönherr, "Urkunden und Regesten aus dem K. K. Statthalterei-Archiv in Innsbruck," *JKSAK* 17 (1896): esp. nr. 14982, pp. XC–XCIV

David Ritter von Schönherr, *Gesammelte Schriften*, ed. Michael Mayr, I (Innsbruck, 1900), pp. 507–90

Rott (1936–38), 3: *Quellen* I: pp. 53–4

G. F. Hartlaub, "Zur Symbolik des Skulpturenschmucks am Ottheinrichsbau," *Wallraf-Richartz-Jahrbuch* 14 (1952): pp. 165–81

Dressler (1973)

Michael Krapf, "Alexander Colins Konzeption des Grabmals Erzherzog Ferdinands II. in der Silbernen Kapelle in Innsbruck," *Wiener Jahrbuch für Kunstgeschichte* 26 (1973): pp. 199–207

Egg (1974)

Smekens (1976), pp. 191–205

Rupert Feuchtmüller, *Das Neugebäude* (Vienna, 1976), pp. 21–4

Felmayer (1986)

Lietzmann (1987), esp. pp. 142–47.

Hans Daucher

Daucher (Ulm c. 1485–1538 Stuttgart) was Augsburg's leading sculptor during the 1520s. He may

have initially trained in Augsburg with his father Adolf (by 1460–1523/24), the joiner and sculptor(?), but in October 1500 Hans began residing with Gregor Erhart, his uncle and main teacher. After travelling abroad, probably to Vienna and northern Italy, he settled in Augsburg in 1514, the year that he acquired citizenship, married Susanna Spitzmacher, and became a master sculptor. He is first mentioned in the tax records two years later, at which time he was living in his father's house. Hans and Adolf probably shared a common workshop until 1522, though Hans registered his own two pupils in 1518 and 1521. During Easter week 1528, while Hans was on a trip to Vienna, the Augsburg officials raided his house and arrested Susanna plus about 100 others during an Anabaptist celebration. Her subsequent fate is unknown though she may have been banished along with other Anabaptists, about 100 of whom settled in Strasbourg. Hans may not have shared Susanna's religious beliefs since he continued to reside in Augsburg. In 1530 he moved into the house of fellow sculptor Jakob Murmann the Elder where he lived until shortly before 21 September 1536 when he officially entered the service of Ulrich, duke of Württemberg, in Stuttgart. Towards the end of 1537, the artist fell ill and died within a year. He was survived by his daughter, Susanna, who married a Regensburg goldsmith in 1540, and son, Abraham (c. 1525–after May 1592), who was a goldsmith in Augsburg.

Since Hans was one of the few German Renaissance sculptors who frequently signed his works, a sizeable corpus of secure and attributed carvings has emerged. Most are small reliefs destined for patrician and noble collectors. Like the Augsburg painter and printmaker Hans Burgkmair, Hans frequently incorporated north Italian architectural motifs into his designs. Hans also occasionally carved tombs and epitaphs.

SELECTED SIGNED AND/OR DOCUMENTED SCULPTURES

1510–15	*Annunciation* (Vienna, Kunsthistorisches Museum)
1518	*Virgin and Child* (Vienna, Kunsthistorisches Museum)
1520	Second version of the Vienna *Virgin and Child* (Augsburg, Maximilian-museum; fig. 235)
c. 1521	*Epitaph of Melchior Funk* (d. 1521; Augsburg, Maximilian-Museum, originally in St. Margaretten-Kirche)
1522	*Judgment of Paris* (Vienna, Kunsthistorisches Museum; fig. 236)
1522	*Triumph of Emperor Charles V* (New York, Metropolitan Museum of Art)
1522	*Charles V on Horseback* (Innsbruck, Ferdinandeum; fig. 300)
1522	*Portrait of Philipp, count Palatine*, and the unsigned but related *Portrait of Ottheinrich, count Palatine* (Berchtesgaden, Schlossmuseum; figs. 298 and 299)
c. 1522	*Maximilian 1 as St. George* (Vienna, Kunsthistorisches Museum)
1520s	*Epitaph of Konrad Adelmann* (d. 1547; Holzheim, Pfarrkirche)

MAJOR ATTRIBUTED WORKS

1510–17	Fugger Chapel decoration (Augsburg, St.-Anna-Kirche; figs. 133, 135). Hans was likely part of the team of sculptors working here
1518–22	*High Altar* (Annaberg, St. Annenkirche; fig. 34). Hans certainly assisted Adolf, his father, who is documented as the head of this project
1520–23	*Lamentation* (Saverne [Zabern], parish church). A second copy by Hans and his shop is in Meissen, Georgskapelle (fig. 136)
1520–25	*Portrait of Cardinal Matthäus Lang* (Salzburg, Museum Carolino Augusteum)
1522	*Allegory with Albrecht Dürer* (Berlin, SMBPK, Skulpturengalerie; fig. 301)
1526	*Tomb of Eberhard von Hürnheim and Anna von Rechberg* (Hochaltingen, Pfarrkirche)
1527 (1530?)	*Meeting of Charles V and Ferdinand 1* (New York, Pierpont Morgan Library)
1536–37	(?) *Model for the Neptune Fountain* (Augsburg, Jakobsplatz; fig. 183)
c. 1537	(?) *Male Head* (Schloss Hohentübingen)

BIBLIOGRAPHY

Philipp M. Halm, "Hans Daucher," *JPKS* 41 (1920): pp. 283–343 (reprinted in Halm [1926], 2: pp. 189–249)

Philipp M. Halm, *Adolf Daucher und die Fuggerkapelle bei St. Anna in Augsburg* (Munich, 1921)

Bange (1928), pp. 15–26

Habich (1929–34), 1.1: pp. 13–9; 2.1: pp. LXXXV–XC

Karl Feuchtmayr, "Die Begegnung Karls V. und Ferdinands I. von Hans Daucher," *MJBK* 10 (1933): pp. IX–XIII

Gaettens (1956), esp. pp. 65–70

Karl Feuchtmayr in Lieb (1952), pp. 433–71

H. Müller (1958), pp. 131–65

Hans Reinhart, "Unscheinbare Kostbarkeiten aus dem Amerbach-Kabinett," *Jahresbericht des Historisches Museum Basel* (1958): pp. 27–35

Fleischhauer (1971), pp. 123–35

Karl Oettinger, "Hans Dauchers Relief mit dem Zweikampf Dürers," *Jahrbuch für frankische Landesforschung* 34–35 (1975): pp. 299–307

Weber (1975), pp. 115–16

Alfred Schädler in *Welt im Umbruch* (1980–81), 2: pp. 36, 160–65

Beck and Decker (1981), pp. 97–100

Eva Zimmermann in *Die Renaissance im deutschen Südwesten* (1986), pp. 549–52

Landolt and Ackermann (1991), pp. 119–21.

Peter Dell the Elder

Dell (Würzburg[?] c. 1490–1552 Würzburg) was Würzburg's foremost sculptor of the second quarter of the century. Between about 1505 and 1510, he trained with Tilmann Riemenschneider; he is listed as one of the master's twelve pupils in the membership register of the Guild of St. Luke. His style owes more to the powerful monumentality and models of Hans Leinberger with whom Dell probably apprenticed in Landshut during the mid-1510s. Before registering as a master in Würzburg on 1 March 1534, the sculptor apparently worked in Regensburg (c. 1520–21), the lower Main River area, between Hanau and Aschaffenburg (1520s), and at the court of Heinrich the Pious, duke of Saxony, in Freiberg (1528–33). Dell served as a

sworn officer of the Würzburg guild in 1539, 1542, and 1548. The artist specialized in carving stone epitaphs and tombs, armorials, and free-standing crucifixions; however, he also authored several exquisite lindenwood and pearwood religious reliefs, portraits, and small statuettes.

His first wife, Barbara Delin (d. 1550), whom he married sometime between 1520 and 1525, is listed as a "schnitzerin" or sculptress though no works by her have been identified. Their son, Peter the Younger (master 1551) ran the family workshop until his death in 1600. Over 40 tombs, including that of Bishop Melchior Zobel von Giebelstadt (1561) in Würzburg cathedral, are documented or attributed to Peter the Younger. (fig. 120)

SELECTED SIGNED AND / OR DOCUMENTED WORKS

1528	*Crucifixion* (Dresden, Staatliche Kunstsammlungen, Grünes Gewölbe)
1528	*Portrait of Wolfhart von Werensdorff* (priv. coll.)
1529	*Resurrection* (Dresden, Staatliche Kunstsammlungen, Grünes Gewölbe; fig. 43)
1529	*Portrait of Jakob Woler* (Munich, Bayerisches Nationalmuseum)
1534	*Allegory of Faith* (Nuremberg, Germanisches Nationalmuseum; fig. 45)
1534–36	*Tomb of Count Johann IV von Leuchtenberg and Margaretha von Schwarzburg* (Grünsfeld, parish church)
1537	*Portrait of Georg Knauer* (Cleveland Museum of Art; fig. 306)
c. 1540	*Tomb of Paul Fuchs von Burgpreppach* (d. 1540; Würzburg cathedral, cloister)
1548	*Allegory of the Doctrine of Redemption* (formerly in Berlin, Staatliche Museum)
1551	*Pulpit* (Ochsenfurt, S. Wolfgangskapelle)

MAJOR ATTRIBUTED WORKS

1525–30	*Crucifixion* (Berlin, SMBPK, Skulpturengalerie; fig. 41)
1529–30	*Law and Gospel* (Dresden, Staatliche

Kunstsammlungen, Grünes Gewölbe; fig. 44)

1536 *Portrait of Willibald von Redwitz*, medal (Berlin, SMBPK, Skulpturengalerie)

c. 1537 *Portrait of Pankraz Kemmerer* (Berlin, SMBPK, Skulpturengalerie)

1540s *Six Deadly Sins* (Nuremberg, Germanisches Nationalmuseum; figs. 273 and 274)

1544 *Reliefs for the Bibra oriel* (Würzburg, city hall)

c. 1544 *Epitaph of Konrad · von Bibra* (Würzburg, cathedral; fig. 119)

c. 1544 *Tomb of the Zollner von Rottenstein family* (Würzburg, St. Burkard)

BIBLIOGRAPHY

Habich (1918), pp. 135–44

Bruhns (1923), pp. 38–67

Hans Buchheit, "Beiträge zu Hans Schwarz und Peter Dell dem Älteren," *MJBK* NF 1 (1924), pp. 164–68

Paulus Weissenberger, "Die Künstlergilde St. Lukas in Würzburg," *Archiv des historischen Vereins von Unterfranken und Aschaffenburg* 70 (1935): esp. pp. 209–10, 216, 219

Georg Lill, "Aus der Frühzeit des Würzburger Bildhauers Peter Dell des Älteren," *Mainfränkisches Jahrbuch für Geschichte und Kunst* 3 (1951): pp. 139–59

Gunther Thiem, in *NDB* 3 (1957), pp. 586–87

Ewald M. Vetter, "Das allegorische Relief Peter Dells d. Ä. im Germanischen Nationalmuseum," *Festschrift für Heinz Ladendorf* (Cologne, 1970), pp. 76–88

Elmar Weiss, "Ein Werk Peter Dells d. Ä. in St. Peter und Paul in Grünsfeld (Main-Tauber-Kreis, Baden-Württemberg)," *Mainfränkisches Jahrbuch für Geschichte und Kunst* 31 (1979): pp. 81–7.

Joachim Deschler

Deschler ([?] c. 1500–1571/72 Vienna) was a medalist and portrait sculptor. Although he is recorded in Nuremberg in 1532, the year of his marriage, he did not acquire citizenship until 1537. Excepting a two-year trip to Rome and Venice, plus the occasional journey to Vienna, he resided there until the late 1550s. Writing in 1547, Johann Neudörfer compared him with Peter Flötner in accomplishment. He wrote that Deschler's "pleasure was to carve marble from which he made whole portraits of such delightful and correct proportions that it was wonderful to see." Deschler worked for the young Archduke Maximilian in 1543 and again in 1553, when he was paid 800 Talers. He moved permanently to Vienna in the late 1550s, and in 1566 Maximilian II, now emperor, appointed Deschler as a court sculptor.

Although various busts, most notably that of Ottheinrich in Paris (Musée du Louvre; fig. 313) that is probably by Dietrich Schro, and small reliefs have been attributed to Deschler, only a group of about 112 medals can today be firmly ascribed to the artist. The Vienna inventory of Archduke Leopold Wilhelm in 1659 listed a now-lost, round *Portrait of Albrecht Dürer* in boxwood and an onyx cameo *Portrait of Charles V* now in Vienna (Kunsthistorisches Museum). The attribution of the latter, while not impossible, is tenuous when compared with Deschler's medals.

SELECTED SIGNED AND/OR DOCUMENTED WORKS

1545 *Portrait of Johann Petreius*, medal

1546 *Portrait of Hans Dietz*, medal

1548 *Portrait of Anton Perrenot-Granvella*, medal

c. 1551 *Portrait of Melchior Zobel von Giebelstadt, bishop of Würzburg*, medal

1553 *Portrait of Hieronymus Baumgartner (Paumgartner)*, medal

1558 *Portrait of Hermes Schallautzer*, medal

1569 *Portrait of Sebald Kraus*, medal

BIBLIOGRAPHY

Georg Habich, "Über zwei Bildnisse des Kurfürsten Otto Heinrich von der Pfalz. I. Joachim Deschler, der Meister der Otto Heinrichbüste im Louvre," *MJBK* 9 (1914–15): pp. 67–86

Fritz Eichler and Ernst Kris, *Die Kameen im Kunsthistorischen Museum* (Vienna, 1927), p. 174, nr. 406

Habich (1929–34), 1.2: pp. 221–34, nrs. 1555–67

Metz (1966), nr. 708

Smith (1983), pp. 244–45

Wenzel Jamnitzer (1986), nrs. 631–41

Trusted (1990), pp. 28–33.

Benedikt Dreyer

Dreyer (Lübeck[?] c. 1485–1555 Lübeck) is first documented as a journeyman in Lüneburg from fall 1505 until fall 1507. Nothing further is known about his training and origins though he may have been from Lübeck. After a wanderjahr in Swabia(?), Dreyer returned to Lübeck and became a master sometime between 1510 and 1512. Due to the scant archival references to Dreyer, the reconstruction of his oeuvre is based solely upon the stylistic relationships of other sculptures to the *St. Anthony Altar* that he completed in 1522 for the Brotherhood of St. Anthony. The artist enjoyed a flourishing career during the 1510s and early 1520s when many of his carvings were done for the Marienkirche in Lübeck. Altars by Dreyer's workshop or by masters influenced by his expressive style were exported to Norway, Estonia, and other Baltic countries. Demand for his art dropped sharply as Lübeck embraced Lutheranism around 1524. Other than the powerful new pulpit and a documented wooden model for a candlestick, both made for the Marienkirche, as well as a group of four decorative armorials, Dreyer seems to have produced little sculpture during the last two decades of his life.

SELECTED SIGNED AND / OR DOCUMENTED WORKS

1522	*St. Anthony Altar* (Lübeck, St. Annen-Museum, originally in the Burgkirche; fig. 25)
1540	*Wooden model for a candlestick* (formerly Lübeck, Marienkirche)

MAJOR ATTRIBUTED WORKS

c. 1513–14	*Last Judgment Altar* (Copenhagen, Nationalmuseum, formerly in Birket, parish church)
c. 1516	*Madonna and Child*, organ (formerly Lübeck, Marienkirche)
1518–20	*Choirscreen figures*, including the Apocalyptic Woman, Annaselbdritt, Sts. John the Baptist, John the Evangelist, Roch, Michael, Anthony, and several console sculptures (formerly Lübeck, Marienkirche)
c. 1522	*Last Judgment Altar* (Landersdorf, St. Michael with portions in Providence, Rhode Island School of Design, and New York, Metropolitan Museum of Art)
c. 1525	*Man with Gold Coins* (formerly Lübeck, Marienkirche)
1527	Four shields for the house of the Merchant Company in Lübeck (3 are in Lübeck, St. Annen-Museum)
1533	*Pulpit* (formerly in Lübeck, Marienkirche; portions now in Zarrentin, parish church, and Lübeck, St. Annen-Museum; figs. 37–39)

BIBLIOGRAPHY

Hermann Deckert, "Studien zur hanseatischen Skulptur im Anfang des 16. Jahrhunderts I," *Marburger Jahrbuch für Kunstwissenschaft* 1 (1924): pp. 55–98

Gert von der Osten, "Zu Benedikt Dreyer und seinem Umkreis," *Festschrft für Peter Metz* (Berlin, 1965), pp. 305–14

Von der Osten and Vey (1969), pp. 51–2, 246

Gert von der Osten, "Drei Weltgerichtsengel von oder nach Benedikt Dreyer," *Festschrift für Heinz Ladendorf* (Cologne, 1970), pp. 69–75

Wittstock (1981), pp. 35–7 (comments by Max Hasse), nrs. 7, 126, 131, 139, 141, 174, 196.

Hasse (1982), pp. 9–58

Hasse (1983), pp. 155–60, 165, 177–82

Cornelis Floris

Floris (Antwerp 1514–20 October 1575 Antwerp) was not a German artist; however, I have chosen to include his biography here since several of his sculptures were for German patrons and since his carvings and prints exerted a tremendous influence

on the arts throughout Northern Europe. Floris, the brother of the painter Frans (1516–70), registered as a master sculptor in the Guild of St. Luke in Antwerp in 1539. He may have trained in Mechelen with Jan Mone after initially working with his father, Cornelis the Elder (d. 1538). Floris travelled to Italy though it is not clear whether the trip occurred before 1539 or between 1541/42 and 1544 when he is documented back in Antwerp. He served as second deacon of the guild in 1547 and first deacon in 1559.

Floris was active as a print designer, sculptor, and architect. His drawings of ornaments, goldsmith works, tombs and epitaphs, friezes, and grotesques were published in six booklets. Floris helped popularize the sorts of grotesques and classical motifs that he had observed in Rome. His ingenious, mannered strapwork forms, often with intertwined figures, proved to be tremendously popular with other artists. The artist ran a large workshop. According to a now-lost memoir, 26 or 27 apprentices trained with Floris after 1550. In 1562–65 alone he employed 12 sculptors and stone carvers. Most of his tombs, epitaphs, tabernacles, and choir screens were done for Netherlandish towns. He did produce commemorative monuments for churches in Cologne, Schleswig, Königsberg, and Copenhagen. Between 1560 and 1564 Floris constructed the new city hall in Antwerp, which is among the finest examples of mature Renaissance-style architecture in Northern Europe. While he contributed the design for the city hall, the execution was certainly left to others. Floris may also have authored two monogrammed drawings for the new porch on the city hall in Cologne in 1557. He designed the house of the Hanseatic League (1564–68; destroyed by fire in 1893) and the house of Frans Floris (1563–64; now destroyed) in Antwerp.

SELECTED SIGNED AND / OR DOCUMENTED WORKS

1546	Drawings in the *Liggeren* (guild register; Antwerp, Koninklijke Academie voor Schone Kunsten)
1546	*Wooden Pulpit* (formerly in Antwerp, cathedral)
1548	*Booklet of Designs for Vases, Cups, and*

	Pitchers (Antwerp: Hieronymus Cock; 19 plates engraved by Balthasar Bos)
1549–52	*Epitaph of Dorothea of Denmark* (Königsberg, cathedral; fig. 155)
1550	*Tabernacle* (Zoutleeuw, St. Leonarduskerk)
1551–55	*Tomb of King Frederik I of Denmark* (Schleswig, cathedral; fig. 139)
c. 1552–1554	*Tomb of Jan, baron of Merode and his Wife* (Geel [Gheel], St.-Dimpnakerk)
1554	*Booklet of Ornament Designs* (Antwerp: Hieronymus Cock; 6 plates engraved and etched by Jan or Lucas van Duetecum)
1556	*Booklet of Grotesque Ornament Designs* (*Veelderleij veranderinghe van grotissen ende Compertimenten . . . Libro Primo* [Antwerp: Hieronymus Cock], 12 plates engraved and etched by Jan or Lucas van Duetecum)
1557	*Booklet of Epitaph and Tomb Designs* (*Veelderley nieuwe inventien van antijcksche sepultueren . . . Libro Secundo* [Antwerp: Hieronymus Cock], 16 engraved and etched plates by Jan or Lucas van Duetecum; fig. 110)
1557	(?) *Two Drawings for the Porch of the Cologne City Hall* (Cologne, Kölnisches Stadtmuseum; see Fig. 232 for the final design)
1568	*Tomb of Herluf Trolle* (formerly in Herlufsholm [Denmark], church)
1568–70	*Tomb of Albrecht von Brandenburg-Ansbach* (Königsberg, cathedral; figs. 154 and 156)
c. 1570	*Epitaph of Anna Maria von Brandenburg-Ansbach* (Königsberg, cathedral)
1573	*Choir Screen* (Tournai, cathedral)
1575	*Tomb of King Christian III of Denmark* (Roskilde, cathedral; originally in Copenhagen)
1575	*Design for the Tomb of Hieronymus Cock*, drawing (Paris, Bibliothèque Nationale)

MAJOR ATTRIBUTED WORKS

c. 1549–55	*Five Epitaphs* (Breda, Grotekerk)

c. 1556 *Epitaphs of Adolf and Anton von Schauenburg* (Cologne, cathedral; fig. 111)

BIBLIOGRAPHY

Ehrenberg (1899), esp. pp. 43, 57–9, 63–7, 93, 111–13, 128–30

Hedicke (1913)

A. J. J. Delen, "Un dessin de Corneille Floris," *Revue Belge d'archéologie et d'histoire de l'art* 2 (1932): pp. 322–24

August Corbet, "Cornelis Floris en de Bouw van het Stadhuis van Antwerpen," *Revue Belge d'archéologie et d'histoire de l'art* 6 (1936): pp. 223–64

Josef Duverger, "Cornelis Floris II en het Stadhuis te Antwerpen," *Gentsche Bijdragen tot de Kunstgeschiedenis* 7 (1941): pp. 37–72

D. Roggen and J. Withof, "Cornelis Floris," *Gentsche Bijdragen tot de Kunstgeschiedenis* 8 (1942): pp. 79–171

Schéle (1965), esp. pp. 36, 38–62

Bialostocki (1976—I), pp. 16–19

Honnens de Lichtenberg (1981), esp. pp. 51, 53–4, 64–70

Holm Bevers, *Das Rathaus von Antwerpen (1561–1565)* (Hildesheim, 1985)

de Jong and de Groot (1988), nrs. 75–9.

Peter Flötner

Flötner ([?] c. 1485–90–23 Oct. 1546 Nuremberg) was among the most inventive and influential artists of the German Renaissance. While the appellation the "pioneer of the Renaissance" used in an early monograph might be overly simplistic, his sculptures and designs did contribute to the broad acceptance of Italianate themes and decorative motifs in Northern Europe. Details concerning his origins and early career are non-existent prior to 1 October 1522 when a motion was made to grant him citizenship in Nuremberg, an event that was formalized on 8 October 1523. The document refers to him as a foreign sculptor from Ansbach. Trips to Italy before 1512 and again in 1518–21 as well as a period working in Augsburg from 1512 to 1518 have been conjectured based upon stylistic influences seen in his later art. It is possible that his decision to move to Nuremberg was prompted by

his association with Hans Beheim the Elder, the city's leading architect and official master mason, who worked on the choir of St. Gumbert in Ansbach from 1520 until 1523. Beheim was concurrently renovating and rebuilding portions of the city hall in Nuremberg where various console carvings have been attributed to the artist by Matthias Mende. Already a master sculptor, Flötner resided in Nuremberg from 1522 until his death.

Flötner was multi-talented. In addition to his stone, wood, and metal sculptures, he produced drawings and over 70 woodcuts, many monogrammed, for altarpieces, furniture, fountains, jewelry, sword sheaths and daggers, goldsmith work, playing cards, doorways, columns and capitals, and decorative friezes, as well as numerous narrative and allegorical themes. Several including his *Triumphal Arch for Johann Eck* (G. 814), *New Passion of Christ* (G. 823–24), and *Procession of the Clergy* (G. 825–26), the latter with a satirical text by Hans Sachs, are stridently anti-Catholic. Many of the decorative prints provided models for other artisans ranging from goldsmiths to joiners and furniture makers to ceramists. Flötner also contributed one monogrammed and likely several unsigned woodcut illustrations for the first German edition of Vitruvius' treatise on architecture, which was published in Nuremberg in 1548.

Throughout his career Flötner collaborated with other masters including caster Pankraz Labenwolf, goldsmith Melchior Baier, and painter Georg Pencz of Nuremberg. In 1547 Johann Neudörfer wrote that Flötner took great pleasure in carving small figures in white stone that were then embossed or cast by goldsmiths. He also directed the decoration of several patrician houses, including those of Lorenz II Tucher in 1533–34 and Leonhard Hirschvogel in 1534.

Flötner was Germany's most prolific plaquette designer and an occasional medallist. Weber has attributed around 115 stone models and plaquettes, typically cast in lead or brass, to the artist. These range from simple single figures to complex compositions with multiple characters and elaborate landscapes.

Flötner's fame rests primarily on the breadth of his oeuvre rather than the aesthetic merits of a single work, with the exception of the *Apollo Fountain*. No grand altarpieces can be securely attributed

to him. Instead he successfully responded to the changes in art forced by the Reformation by working in a variety of different media.

SELECTED SIGNED AND/OR DOCUMENTED WORKS
(excluding prints)

c. 1525 *Adam* (Vienna, Kunsthistorisches Museum; fig. 251)

1531 *Apollo Fountain Design*, drawing (formerly archduke of Weimar Collection; fig. 197)

1531–38 *Silver Altar* (Cracow, Wawel cathedral, Sigismund Chapel; fig. 24). Collaborated with a team of artists lead by Hans Dürer

1532 *Apollo Fountain* (Nuremberg, Stadtmuseum Fembohaus; figs. 195 and 196). Cast by Pankraz Labenwolf

1534 Sculptures for the house of Leonhard Hirschvogel (Nuremberg; fragments in Stadtmuseum Fembohaus; fig. 212)

1535 *Design for an Ornamental Chair*, drawing (Berlin, SMBPK, Kupferstichkabinett; fig 268)

1538 *Medal Commemorating the Laying of the Cornerstone of the New Fortifications around Nuremberg Castle*; fig. 267). Done with Hans Maslitzer and Johann Neudörfer

c. 1540–46 *Caritas*, stone plaquette model.(Vienna, Kunsthistorisches Museum) and plaquette

MAJOR ATTRIBUTED WORKS

c. 1530 *David and Bathsheba*, drawing (Ottawa, National Gallery of Canada)

c. 1530–35 *Christ and the Samaritan Woman*, plaquette

1530–35 *Design for a Transfiguration Altar*, drawing (Erlangen, Universitätsbibliothek; fig. 29)

1535–40 *Ate and the Litae*, plaquette (fig. 262)

late 1530s *Holzschuher Cup* (Nuremberg, Germanisches Nationalmuseum; fig. 163). With Melchior Baier. Stamped with Nuremberg's civic goldsmith mark

1539 *Design for a Dagger*, drawing (Berlin, SMBPK, Kupferstichkabinett)

c. 1540 *Design for a Pitcher with a Bacchanalian Frieze*, drawing (Erlangen, Universitätsbibliothek)

c. 1540 *Design for the Foot of a Goblet*, drawing (Braunschweig, Herzog Anton Ulrich-Museum)

c. 1540 *Model for the Foot of a Goblet* (Cambridge [Mass.], Harvard University, Busch-Reisinger Museum)

c. 1540 *Design for a Wall Fountain*, drawing (Berlin, SMBPK, Kupferstichkabinett; fig. 178). The inscription refers to Master Pankraz (Labenwolf)

after 1540 *Design for a Silver Flask with a Self-Portrait*, drawing (Hamburg, Kunsthalle). The portrait reappears in a signed and dated woodcut (1533; Geisberg 839) and in a 1551 copy after another lost self-portrait drawing (Erlangen, Universitätsbibliothek)

1540–46 *Sense of Touch: Venus and Amor*, plaquette (fig. 263)

c. 1540–46 *Seated Virtues*, 7 stone models and 8 plaquettes (5 models in London, Victoria and Albert Museum, 2 in Hannover, Kestner-Museum; fig. 261)

c. 1543 *Epitaph for Josef Feyerabend* (Ansbach, St. Gumbert). Cast by Pankraz Labenwolf

BIBLIOGRAPHY

Neudörfer (1875), pp. 115–16, 125–26
Lange (1897)
Heinrich Röttinger, *Peter Flettners Holzschnitte* (Strasbourg, 1916)
Ernst Friedrich Bange, "Zur Datierung von Peter Flötners Plakettenwerk," *Archiv für Medaillen- und Plakettenkunde* 3 (1921–22): pp. 45–52
Ernst Friedrich Bange, *Peter Flötner* (Leipzig, 1926)
Jean Louis Sponsel, "Flötner Studien," *JPKS* 45 (1924): pp. 121–84 and 214–76; 46(1925), pp. 38–90
Bange (1928), pp. 77–82
Peter Flötner und die Renaissance in Deutschland, exh. cat. (Nuremberg, 1946)
Braun (1951), pp. 195–203

Pfeiffer (1955), pp. 36–44

Kohlhaussen (1968), esp. pp. 436–47, 455–58, 477–79, 484–86

Ingrid Weber, "Bemerkungen zum Plakettenwerk von Peter Flötner," *Pantheon* 28 (1970): pp. 521–25

Weber (1975), pp. 56–85

Kaiser (1978), pp. 14–22, 219–29

Mende (1979), pp. 78, 109–10

Smith (1983), esp. pp. 60–5, 224–33

Angerer (1984)

Klaus Pechstein, "Peter Flötner (um 1495–1546)," *Fränkische Lebensbilder* 11 (1984): pp. 91–100

Smith (1985), esp. pp. 88–91

Wenzel Jamnitzer (1985), nrs. 11, 25, 293, 345–53, 498, 512, 534–56, 626, 677, 696

Gothic and Renaissance Art in Nuremberg (1986), pp. 435–54

Martin Angerer, "Ein neuentdeckter Goldschmiedeentwurf Peter Flötners," *AGNM* (1986): pp. 51–4

Bräutigam (1987), pp. 205–24.

Matthes Gebel

Gebel (c. 1500–22 April 1574 Nuremberg) was a prolific medallist. He may have been the son of an identically named die cutter from Wiener Neustadt. Gebel acquired Nuremberg citizenship on 14 August 1523 and took the formal oath on 5 September. His first wife Margarethe (d. 1556) is listed as a "pildtschnitzerin" or sculptress though nothing is known about her career or her possible collaboration with Matthes. In 1534 the couple purchased a house in Oberen Wöhrd, a village just outside the northeastern walls of Nuremberg. The artist journeyed to the imperial diets in Speyer (1529) and Augsburg (1530) to make portrait medals of many of the important participants. Habich and Suhle attributed over 350 medals to Gebel with most dating between 1526 and 1543. The artist signed only 12 medals, all in 1542 and 1543. Fortunately, several other projects are documented thus providing a clear idea of his oeuvre. Gebel carved his models in fine-grain solnhofen limestone that permitted greater detail in facial and costume features. After 1550 Gebel produced few new medals and no documented sculptures.

SELECTED SIGNED AND / OR DOCUMENTED WORKS

1527 *Portrait of Albrecht Dürer*, medal. The medal was reissued with a commemorative text on the reverse in 1528, the year of Dürer's death. In 1530 Tübingen humanist Andreas Rüttel mentioned the medal as being by the "statuarius Mattheus" in a letter to Willibald Pirckheimer, who likely sent the medal as a gift

1527 *Portrait of Albrecht Scheurl*, medal. A document for the 1531 recasting survives

1529 *Portrait of Georg Hermann*, medal. Payment record exists

1530 *Portrait of Johann Stöffler*, lost model for a medal. Mentioned in a letter from Stöffler, a Tübingen mathmetician

1533 *Portraits of Dr. Christoph and Katharina Scheurl*, medal. Payment record exists

1542 *Portrait of Jörg von Embs*, medal. Monogrammed and dated

1543 *Portrait of Ulrich Stark*, medal. Monogrammed and dated

1543 *Portrait of Philipp I von Pommern-Wolgast*, medal. Monogrammed and dated

MAJOR ATTRIBUTED WORKS

1529 *Portrait of Hieronymus Holzschuher*, medal

c. 1530 (?) *Portrait Busts of Two Men* (*Friedrich II and Philipp von der Pfalz{?}*; Munich, Bayerisches Nationalmuseum; fig. 311). These lindenwood busts have been attributed to Gebel based upon their similarities to his medals of these princes (1531). Problems of portrait identification, authenticity, and association with Gebel remain to be addressed adequately.

1531 *Portraits of Heinrich Ribisch, Georg Hermann, and Konrad Maier*, medal

1540 *Portraits of Sebald and Anna Beham*, stone model (Berlin, SMBPK, Münzsammlung; fig. 291)

BIBLIOGRAPHY

Habich (1929–34), I.2: nrs. 957–1286

Vöge (1932), esp. pp 141–48

Suhle (1950), pp. 52–62

Gaettens (1956), pp. 70–3

William M. Milliken, "Four Stone Models for German Medals," *Bulletin of the Cleveland Museum of Art* 44 (1957): pp. 118–21

Müller (1959), pp. 196–97

Paul Arnold, "Die Dürermedaille von Mathes Gebel", *Dresdener Kunstblätter* 15 (1971): pp. 91–3

Mende (1983), pp. 82–93, 208–33

Smith (1983), pp. 240–43

Hermann Maué in *Gothic and Renaissance Art in Nuremberg* (1986), pp. 107, 419–23, 473

Smith (1989), pp. 52–3, 55

Trusted (1990), pp. 40–55.

Friedrich Hagenauer

Hagenauer (Strasbourg c. 1500–after 1545 [? in the Netherlands]) was among the finest medallists of the 1520s and 1530s. He trained in Strasbourg presumably with Nikolaus Hagenauer (Hagenower), the sculptor who is thought to be his father. Before settling in Augsburg in 1527, Hagenauer had an itinerant career working in Speyer, Worms, Mainz, Heidelberg, Frankfurt am Main, Nuremberg, Passau, Salzburg, Munich, and Landshut. Following a dispute over his right to produce portrait medals without joining the Painters and Sculptors' Guild in Augsburg, he returned to Strasbourg in 1532. Between 1536 and 1544 he worked in Cologne and Bonn. Nothing is known about his later whereabouts and date of death though Habich and others have speculated that he moved to the Netherlands.

Other than three Augsburg accounts, one of which describes his travels, knowledge of Hagenauer's career is based exclusively upon his medals and the localization of his patrons. Habich has attributed about 250 medals and wooden models to the artist. Nearly 100 bear his FH monogram, and the majority are dated with the greatest concentration occurring between 1526 to 1532. After 1536 very few works are signed and the quality rarely matches his earlier oeuvre. A thorough reassess-

ment of this later period, specifically the attribution of works to Hagenauer and his relationship to the art of Barthel Bruyn, is needed.

Hagenauer favored a near half-length bust form that provides a more sculptural look to his medals. Sometimes his boxwood and pearwood models were ordered as small collectible reliefs and not necessarily ever cast. The only large-scale relief credibly attributed to Hagenauer is the *Portrait of Philipp, bishop of Freising and count Palatine* (Berlin) produced while he lived in Munich.

SELECTED SIGNED AND / OR DOCUMENTED WORKS

1525	*Portrait of Matthäus Zaisinger*, medal
1527	*Portrait of Raymund I Fugger*, stone model (Augsburg, Maximilianmuseum) and medal. (fig. 293) Another smaller version of this medal is signed and dated 1527
1527	*Portraits of Sebastian and Ursula Liegsalz*, pearwood models (Munich, Bayerisches Nationalmuseum; fig. 292) and medals
1529	*Portrait of Margarete von Frundsburg*, wooden model (Nuremberg, Germanisches Nationalmuseum) and medal
1543	*Portrait of Philipp Melanchthon*, medal

MAJOR ATTRIBUTED WORKS

1526	*Portrait of Philipp, Bishop of Freising and Count Palatine*, medal
c. 1526	*Portrait of Philipp, Bishop of Freising and Count Palatine*, relief (Berlin, SMBPK, Skulpturengalerie; fig. 304)
c. 1527	*Portrait of Anna Rechlinger von Horgau*, boxwood model (Engelberg [Switzerland], Benediktinerabtei)
c. 1534	*Portrait of Christoph von Nellenberg*, wooden model (Munich, Staatliche Münzsammlung)

BIBLIOGRAPHY

Georg Habich, "Studien zur deutschen Renaissance medaille, 3: Friedrich Hagenauer," *JKPS* 28

(1907): pp. 181–98, 230–72, esp. 269–72 for the Augsburg documents of 1531.

Bange (1928), pp. 58–9

Habich (1929–34), 1.1: pp. 70–101, nrs. 439–712, and 2.1: pp. CVIII–CXV

Suhle (1950), pp. 36–40, 49–51

Zeitler (1951), esp. pp. 107–19

Müller (1959), nrs. 307–09

Müller (1963), pp. 7, 23

Metz (1966), p. 119

Baxandall (1974), pp. 70–3

Alfred Schädler, "Ingolstädter Epitaphe der Spätgotik und Renaissance," in Müller and Reismüller (1974), 2: esp. pp. 58–65

Gagel (1977), nr. 16

Welt im Umbruch (1980–81), 2: nrs. 540–41

Trusted (1990), pp. 57–62.

Loy Hering

Hering (Kaufbeuren c. 1485–after 1 June 1554 Eichstätt) was Germany's most prolific sculptor between the 1510s and 1550. Loy's father, Michael Hering, was a goldsmith in Kaufbeuren and later in Landsberg am Lech. On 15 April 1499 Loy registered as a pupil of the successful Augsburg sculptor Hans Beierlein. He is next documented in 1511 and 1512 as paying taxes in Augsburg and living in the house of Jakob Murmann the Elder, another leading sculptor. Precisely when Loy moved to Eichstätt is unknown though he was probably there in 1512 and three years later he is recorded working on an altar in the Willibald choir of the cathedral. Excepting brief trips to Augsburg, Neuburg an der Donau, and other regional towns, Hering lived in Eichstätt until his death, sometime after he made his will on 1 June 1554. In addition to his artistic fame, Loy held numerous, high civic offices. He was selected as a member of the outer city council in 1519, which indicates he must have obtained citizenship at least two years earlier. Loy was elected to the inner city council and chosen as an official of the tax office in 1522. The next year he was one of four mayors of Eichstätt, a position he also held in 1533. Loy's first wife, Anna (d. 1520), bore two sons, Martin and Thomas, both sculptors, while Magdalena, whom he married in 1521, had two sons and two daughters.

Loy was an unusually productive sculptor. Reindl has attributed 133 projects to the artist and his shop. His style and compositional ideas exerted a broad influence throughout south Germany. Most of his carvings were done for the churches in Eichstätt or its diocese; however, other works were for clients in Augsburg, Boppard am Rhein, Heilsbronn monastery, the cathedrals of Bamberg, Speyer, and Würzburg, and the Austrian cities of Schwaz and Vienna. Loy specialized in epitaphs and tombs, though early in his career he fashioned the occasional altar, sacrament niche, crucifix, and small-scale relief. Loy used the fine-grain solnhofen limestone, perhaps the best German carving stone, that is quarried in the vicinity of Eichstätt. From the mid-1520s onwards, Loy increasingly utilized the talents of his large workshop to keep pace with the growing number of commissions. His son, Martin, helped run the shop from 1543 and assumed total control in 1554.

SELECTED SIGNED AND/OR DOCUMENTED WORKS

1515–16 *Crucifix* (Schwaz am Inn, Franziskanerkirche)

1518–20 *Epitaph of Prince-Bishop Georg Schenk zu Limburg of Bamberg* (Bamberg, cathedral)

1519 *Epitaph of Margarethe von Eltz and her son Georg* (Boppard am Rhein, former Karmeliter-Kloster)

c. 1525 *Garden of Love* (Berlin, SMBPK, Skulpturengalerie; fig. 193)

1527–28 *Tombstone for Albrecht von Brandenburg* (formerly Halle, Neue Stift)

1543 *Tomb of Prince-Bishop Konrad III von Thüngen of Würzburg* (Würzburg, cathedral; fig. 118)

1552 *Tombstone for Abbot Johannes Wirsing* (Heilsbronn, former Zisterzienser-Klosterkirche)

MAJOR ATTRIBUTED WORKS

1511 *Salvator* from the former *Hörwarth Altar* (Augsburg, Augustiner-Stiftskirche St. Georg)

1512–14 *St. Willibald Monument* (Eichstätt, cathedral; fig. 11)

1514–20	*Epitaph of Bishop Gabriel von Eyb of Eichstätt* (Eichstätt, cathedral)
c. 1517	*Epitaph of Bernhard Arzt* (Eichstätt, cathedral, Mortuarium)
1519–20	*Wolfstein Altar* (Eichstätt, cathedral; fig. 36)
1521	*Monument for Georg Truchsess von Wetzhausen* (Auhausen, former Benediktiner-Klosterkirche St. Maria)
after 1521	*Sacrament Niche* (Auhausen, former Benediktiner Klosterkirche St. Maria)
1524	*Portrait Philipp, Count Palatine*, relief (Nuremberg, Germanisches Nationalmuseum; fig. 303)
1524	*Monument for Jobst Truchsess von Wetzhausen* (Vienna, former Deutschordenskirche St. Elisabeth; fig. 100)
c. 1525	*Crucifix* (Eichstätt, cathedral)
1526–28	*Epitaph for Duke Erich I von Braunschweig-Lüneburg and his wives Katharina von Sachsen and Elisabeth von Brandenburg* (Hann. Münden, St. Blasius-Kirche; fig. 99)
c. 1530	*St. Georg Altar* (Munich, Bayerisches Nationalmuseum)
c. 1536	*Epitaph for Martin Gozmann* (Eichstätt, cathedral; fig. 99)
c. 1538	*Epitaph for Margrave Georg von Brandenburg and his father Friedrich von Brandenburg-Ansbach* (Heilsbronn, former Zisterzienser-Klosterkirche)
1541	*Crucifixion Group* (Eichstätt, cathedral, Mortuarium)
c. 1541	*Epitaph for Caspar Adelmann von Adelmannsfelden* (Eichstätt, cathedral, Mortuarium)
1548	*Moritzbrunner Altar* (Munich, Bayerisches Nationalmuseum; fig. 35)
1551	*Epitaph for Bishop Moritz von Hutten of Eichstätt* (Rupertsbuch, St. Michael)
1553	*Epitaph for Albert von Hohenrechberg and Bishop Moritz von Hutten* (Eichstätt, cathedral)

BIBLIOGRAPHY

Felix Mader, *Loy Hering. Ein Beitrag zur Geschichte der deutschen Plastik des XVI. Jahrhunderts* (Munich, 1905)

Mader (1924)

Bange (1928), pp. 30–2

Peter Cannon-Brookes, "Loy Hering and the Monogrammist DH," *Apollo* 94 (1971): pp. 46–9

Peter Reindl, "Loy Herings Epitaph in Hann. Münden als Typus eines süddeutschen Renaissance-Epitaphs," *Niederdeutsche Beiträge zur Kunstgeschichte* 10 (1971): pp. 143–87

Volker Liedke, "Zwei unbekannte Werke des Eichstätter Bildhauers Loy Hering," *Ars Bavarica* 1 (1973): pp. 84–9

Alfred Schädler, "Das Eichstätter Willibalddenkmal und Gregor Erhart," *MJBK* 26 (1975): pp. 65–88

Reindl (1977)

Gagel (1977), nr. 24.

Martin Hering

Martin ([?]Eichstätt c. 1515–c. 1560 Eichstätt) trained with and frequently assisted Loy Hering, his father. Between about 1535 and 1542 he was active at the court of Ottheinrich, count Palatine, in Neuburg an der Donau. His only securely documented project, the altar for the Neuburg palace chapel, is heavily damaged and provides a weak basis for additional attributions though Reindl ascribes several tombs, epitaphs, armorials, reliefs, and carvings to Martin. He lived briefly in Munich in 1543 before returning to Eichstätt where he resided until his death. Here he collaborated with his father and in 1554 inherited the family workshop.

SELECTED SIGNED AND / OR DOCUMENTED WORKS

1540–42	*Crucifixion Altar* (Neuburg an der Donau, Schlosskapelle; fig. 58)

MAJOR ATTRIBUTED WORKS

1535–40	Building dedication plaque with *Hunting Scene* (Grünau, Jagdschloss; fig. 217)
1538	Portal with *Armorial Shield* (originally in the Rittersaal of the palace at Neu-

burg an der Donau; now Berchtesga-
den, Schlossmuseum)

after 1553 *Epitaph for Erasmus I, Schenk von Limburg*
(Grosscomburg, former Benediktiner-
Klosterkirche St. Maria and St. Nik-
olaus)

c. 1555 [?] *Epitaph and Armorial Plaque for Car-
dinal Otto Truchsess von Waldburg, bishop
of Augsburg* (Dillingen an der Donau,
Schloss, Salesiuskapelle or Bishop's
chapel)

BIBLIOGRAPHY

Horn and Meyer (1958), pp. 178–79, 210, 225–
27, 230–31, 488
Kaess and Stierhof (1977), p. 10, figs. 8, 10
Reindl (1977), pp. 443–56
Kaiser (1978), p. 545.

Thomas (Doman) Hering

Thomas (Augsburg c. 1510–1549 Munich) was
Loy Hering's eldest son. After training with his
father in Eichstätt, he moved to Munich sometime
between 1533 and 1536. Ludwig X, duke of
Bavaria-Landshut, appointed Thomas as court
sculptor in 1540 and charged him with the dec-
oration of the Italian Hall in the new wing of
the Stadtresidenz in Landshut. As the Hercules
roundels here and his other small reliefs reveal,
Thomas was far more adept than his father in his
representations of nudes and figures in action. In
addition, he also carved a few tombs and epitaphs.
Following Ludwig's death in 1545, Thomas resided
in Munich where he is listed in the civic tax records
until 1549 when his children by his two marriages
were placed in the care of other local artists.

SELECTED SIGNED AND/OR
DOCUMENTED SCULPTURES

c. 1535 *Judgment of Paris* (Berlin, SMBPK,
Skulpturengalerie; fig. 226)

c. 1542 *Monument for Bishop Philipp of Freising*
(Freising, cathedral St. Maria and St.
Korbinian)

MAJOR ATTRIBUTED WORKS

1532 *Portrait of Charles V* (Berlin, SMBPK,
Skulpturengalerie)

1535–40 *Rhea Silvia* (London, Victoria and Al-
bert Museum; fig. 260)

c. 1535–40 *Portrait of Jakobäa von Bayern* and five
armorial reliefs (Munich, Bayerisches
Nationalmuseum)

1541 *Labors of Hercules* roundels and *Plan-
etary Gods* chimney reliefs (Land-
shut, Stadtresidenz, Italian Hall; figs.
213–216). Thomas is documented
working here but the tasks are not
specified.

c. 1545 *Tomb of Ludwig X, duke of Bavaria-
Landshut* (Landshut, former Zisterzien-
serinnen-Klosterkirche Seligenthal)

BIBLIOGRAPHY

Otto Hartig, "Münchner Künstler und Kunst-
sachen II," *MJBK* 7 (1930): esp. pp. 357–
61
Metz (1966), nr. 694
Peter Cannon-Brooks, "Loy Hering and the Mono-
grammist DH," *Apollo* 94 (1971): pp. 46–9
Bulst (1975), pp. 123–76, esp. 126–42
Reindl (1977), esp. pp. 15–8, 419–42
Gagel (1977), pp. 68–72, 126–27
Die Renaissance im deutschen Südwesten (1986), pp.
550–52
Von Schweinitz (1987), esp. pp. 213–16.

Hans Ruprecht Hoffmann

Hoffmann (Worms 1543–June 1616 Trier) was the
foremost sculptor working west of the Rhine River
during the late sixteenth and early seventeenth
centuries. He apprenticed with Dietrich Schro in
Mainz from 1554 before working as a journeyman,
likely with Johann von Trarbach in Zimmern. By
1568 "Ropricht bildhawer," who was already a
master, is documented in Trier where he would
remain for the rest of his career. Under the aegis of
Jakob III von Eltz (1567–81) and his two suc-
cessors as archbishop, Hoffmann benefited from the
active patronage of the post-Tridentine Catholic

church. Over the next several decades Hoffmann, his son Heinrich (1576–1623), and their large workshop produced at least one hundred altars, religious reliefs, pulpits, epitaphs, and other stone carvings for towns primarily in the archbishopric of Trier. Most of Hoffmann's finest works are in Trier cathedral and the adjacent Liebfrauen-Basilika. His first significant project was the elaborate sandstone pulpit (1570–72) in the cathedral. The pulpit, then the most complex example since the advent of the Reformation in Germany, reveals Hoffmann's affinities for Netherlandish art. He repeatedly used Netherlandish prints for compositions and for decorative models. In addition to his religious sculpture, the artist also produced as many as eight portrait medals. Hoffmann held several important civic positions including representative of the stonemasons' guild on the city council in 1581 and church master, among other titles, of St. Gangolf in Trier in 1614.

SELECTED SIGNED AND / OR DOCUMENTED WORKS

1570–72	*Pulpit* (Trier, cathedral; figs. 79–80)
1573	*Epitaph of a Man* (Trier, cathedral—formerly in the Savigny-Kapelle)
1580	*Portrait of Jakob III von Eltz*, medal
c. 1585–90	*Trinity Altar* (*Tomb-Altar of Jakob III von Eltz*); Trier, cathedral). Set up in 1597. Following the cathedral fire in 1717, the altar was modernized in 1725–26.
c. 1590	*St. John the Baptist Altar* (Trier, cathedral). Set up in 1597. The altar was modernized in 1728.
c. 1591	*St. John the Evangelist Altar* (*Tomb-Altar of Johann von Schonenburg*; Trier, cathedral). The altar was modernized in 1728
1595	*Fountain of St. Peter* (Trier, main market)
1610	*Tomb-Altar of Bartholomäus von der Leyden* (Trier, Liebfrauen-Basilika)
1610	*Tomb-Altar of Hugo Cratz von Scharffenstein* (Trier, Liebfrauen-Basilika)
1614	*All Saints Altar* (*Tomb-Altar of Lothar von Metternich*; Trier, cathedral)

BIBLIOGRAPHY

Balke (1916)

Habich (1929–34), 1.2: pp. 245–46, nrs. 1737–45

Irsch (1931), pp. 219–34

Bunjes et al. (1938), pp. 178–81

Eberhard Zahn, "Hoffmann, Hans Ruprecht," in *NDB* 9 (Berlin, 1972), pp. 420–21

Anne-Marie Zander, "Über Geburtsort und Lehrmeister des kurtrierischen Bildhauers Hans Ruprecht Hoffmann," *Kurtrierisches Jahrbuch* 16 (1976), pp. 38–9

Ronig (1980), esp. pp. 257–73.

Victor Kayser

Virtually nothing is known about Kayser's life ([?] Augsburg c. 1502–1552/53 Augsburg). In 1516 he apprenticed with Jakob Murmann the Elder in Augsburg. Listed as a master in the local tax records for 1525, Kayser seems to have spent his entire career working in this city. He specialized in carving small and medium-size reliefs, typically of biblical subjects, using solnhofen limestone. A few of these may have once adorned local epitaphs. His distinctive style is characterized by the intensity of expression on the angular faces of his figures. Details, such as hair and drapery folds, are clearly distinguished and often quite aggitated. Occasionally, Kayser tightly frames his scenes in order to heighten the dramatic tension. He also likes to imply an extended spatial stage by showing only part of the figures at one or both sides of the composition. None of Kayser's extant sculptures is dated.

SELECTED SIGNED AND / OR DOCUMENTED WORKS

c. 1530	*Susanna and the Elders* (Berlin, SMBPK, Skulpturengalerie; fig. 194)
before 1531	*Abraham and Melchisedek* (Berlin, SMBPK, Skulpturengalerie)
1532	*Muse* (lost; Paul von Stetten saw it in 1779 in the collection of a Munich city counselor named Obel and recorded

the inscription: "Victor Kaiser hats gemacht zu Augsburg 1532")

MAJOR ATTRIBUTED WORKS

c. 1525	*Holy Family* (Paris, Musée du Louvre)
c. 1525– 30	*Arrest of Christ* (London, Victoria and Albert Museum; fig. 26)
c. 1530	*Christ Taking Leave of his Mother* (Munich, Bayerisches Nationalmuseum)
c. 1530	*Pharoah and the Flooding of the Red Sea* (Nuremberg, Kaiserburg until its destruction in 1945; according to a nineteenth century document it was originally in Augsburg, St. Katharina-Kloster)
early 1530s	*Christ and the Apostles*, two sections of a single relief (Hamburg, Museum für Kunst und Gewerbe)
early 1530s	*Christ Washing the Feet of the Apostles* (Munich, Bayerisches Nationalmuseum)
1530s	*Christ Crowned with Thorns* (Seattle Art Museum)
c. 1540	[?] *Lamentation* (Regensburg, Museen der Stadt)

BIBLIOGRAPHY

Edmund W. Braun, "Zwei Bronzeepitaphien der deutschen Frührenaissance und ihre Meister," *Kunst und Kunsthandwerk* 22 (1919): pp. 28–41

Bange (1928), pp. 32–3

Simon Meller, "Ein unbekanntes Werk Viktor Kaisers im Budapester Nationalmuseum," in E. Buchner and K. Feuchtmayr, eds., *Beiträge zur Geschichte der deutschen Kunst—Augsburger Kunst der Spätgotik und Renaissance* (Augsburg, 1928), 2: pp. 440–41

Karl Feuchtmayr in Thieme and Becker (1907–50), 20: pp. 46–7

Müller (1959), nr. 286

Metz (1966), p. 118, nr. 688

Rasmussen (1975), nr. 7

Müller (1976), pp. 77–82

Baxandall (1980), p. 304

Alfred Schädler in *Welt im Umbruch* (1980–81), 2: nrs. 542–46.

Hans Kels the Younger

"HANS KELS ZU KAUFBEIREN" reads an inscription on the game board of King and, later, Emperor Ferdinand I. This elaborate board with its intricately carved Hapsburg portraits and the accompanying narrative scenes adorning 32 game pieces was completed in 1537 and is today in Vienna (Kunsthistorisches Museum). This is the central work for attributing other medals and small sculptures to the artist. The question, however, is which artist is meant since there are two sculptors by this name. Hans the Elder ([? Kaufbeuren] c. 1480–1559 Kaufbeuren) and his son, Hans the Younger (Kaufbeuren [?]c. 1508/10–1565 Augsburg). Information about the father's career is negligible. In 1507 he received 5 gulden for a now-lost portrait sculpture of Emperor Maximilian. He produced a carving for the *St. Catherine Altar* in St. Mangen in Füssen in 1513 or 1514. In 1546 Hans the Elder is listed as a citizen in Kaufbeuren. Albrecht Miller has attributed several sculptures to him, including an altar completed in 1519 for the pilgrimage church of Maria Rain. If by Hans the Elder, their style is dissimilar to that of the game board. Hans the Elder's younger son, Veit was a master sculptor in Augsburg from 1546 until his death in 1594/95.

More is known about Hans the Younger's career. He presumably trained with his father and may have gone to Augsburg as an apprentice or a journeyman. A group of six medals and one portrait relief are monogrammed HK and dated between 1527 and 1550. Other attributed medals, such as the *Portrait of Bartholomäus Welser* of 1534, reveal his early associations with Augsburg patricians. During the late 1520s and early 1530s, Augsburg was, together with Nuremberg, the leading center for portrait medals. Friedrich Hagenauer and Christoph Weiditz were both active here. While recalling that his father produced at least one portrait, it is likelier that Hans the Younger perfected his art under the direction of an Augsburg master. After returning to Kaufbeuren, Hans the Younger

acquired Augsburg citizenship on 6 December 1541 shortly after his marriage to Barbara, daughter of Hans Flicker, an Augsburg goldsmith. His name appears for the first time in the Augsburg tax records of 1542. Between 1548 and 1564, six pupils registered Hans as their master. Hans enjoyed close relationships with several of Augsburg's leading artists. In addition to periodic collaborations, he also served as the guardian for the children of sculptor Jakob Murmann the Elder and painter Christoph Amberger in 1555 and 1562, respectively.

Hans the Younger worked later in his career for such notable patrons as the Fugger family, Ferdinand I, and the abbot of Ottobeuren. In 1546 he carved two busts for a doorway in the new portions of Anton Fugger's residence at Oberndorf. In the same year he may have carved herm figures for another Fugger house at Donauwörth. Apparently Hans was recognized for his architectural sculpture as evidenced by his activities at the Hofburg in Innsbruck between 1549 and 1551. Kels, Christoph Amberger, then Augsburg's foremost painter, and joiner Heinrich Kron, were called to Innsbruck where they made patterns and designs for two lavish ceilings, including one for a room known as the paradise chamber, and further decorations two years later for the bathing rooms. In 1553 when King Ferdinand planned a high altar for the new Hofkirche in Innsbruck, Kels was the first sculptor asked to prepare a design. Although Ferdinand decided that Hans wanted too much money to make the altarpiece, his drawing may have been the basis for the eventual altar. In the mid-1550s, Hans was busy producing choir stalls, altarpieces, doorway reliefs, and other carvings for the new abbey church at Ottobeuren. Hans is documented in 1560 in conjunction with a carnival mummery performed at the court of the duke of Bavaria in Munich. His younger brother, Veit, was also a master sculptor in Augsburg from 1546 until his death in 1594-95.

SELECTED SIGNED AND / OR DOCUMENTED WORKS

1527 [?] *Portrait of Johann the Steadfast, elector of Saxony*, wooden model (Stuttgart, Württembergisches Landesmuseum)

1537 *Game Board of Ferdinand I* (Vienna, Kunsthistorisches Museum; fig. 305). Much of the figural work can be attributed to Hans the Younger though his father and brother probably assisted

1537 *Portraits of Charles V, Isabella of Portugal, Ferdinand I, and Anna of Hungary and Bohemia* (Hamburg, Museum für Kunst und Gewerbe)

1540 *Portrait of Adam Oefner*, medal

1545 *Models for Two Series of the Virtues and the Muses* (four of the wooden models, one signed HK, in Nuremberg, Germanisches Nationalmuseum, and two in Vienna, Kunsthistorisches Museum)

1550 *Portraits of Charles V and Ferdinand I*, medal

1550 *Portrait of Matthäus Schwartz*, medal

SELECTED ATTRIBUTED WORKS

1534 *Portrait of Batholomäus Welser*, wooden model (Oldenburg, Landesmuseum) and medal

1541 *Portrait of Georg II Fugger*, wooden model (Babenhausen, Fugger-Museum) and medal

mid-1550s [?] fragments of various sculptures (Ottobeuren, Klostermuseum)

BIBLIOGRAPHY

Josephi (1910), pp. 296–97

von Schlosser (1910), pp. 7–8

Theodor Hampe, "Allgäuer Studien zur Kunst und Kultur der Renaissance," *Mitteilungen aus dem Germanischen Nationalmuseum* [*Festschrift für Gustav von Bezold zu seinem 70. Geburtstage*] (Nuremberg, 1918), pp. 42–9

Habich (1929–34), 1.1: nrs. 763–96 (not all of these medals should be attributed to Kels)

Hartig (1931), p. 325, nr. 662

Lieb (1937), pp. 50–4

Gunther Thiem, "Das Patrizierbildniss der Augsburger Renaissance," *Die Kunst und das schöne Heim* 54 (1955): pp. 50–4

Lieb (1958), pp. 83, 157, 221, 237, 404

Albrecht Miller, *Allgäuer Bildschnitzer der Spätgotik* (Kempten, 1969), pp. 29–31, nrs. 192–200

Mengden (1973)
Egg (1974), p. 73
Rasmussen (1975), nr. 12
Weber (1975), pp. 118–20
Gagel (1977), nr. 13
Welt im Umbruch (1980–81), 2: nrs. 549–56
Scheicher (1986).

Ludwig Krug

Krug (Nuremberg 1488/90–1532 Nuremberg) was among the most versatile artists active in Nuremberg during the 1510s and 1520s. Johann Neudörfer, writing in 1547, lauded him for his talents in "silver and gold work, in drawing, engraving, casting, repoussé work, painting, and cutting and making portraits." He noted that Krug's carvings in stone, shell, and iron were praised by the Italians. Neudörfer also singled out his special intellectual interest in philosophy. Ludwig trained with his father, Hans the Elder (1484 master, d. 1519 Nuremberg), one of the city's foremost goldsmiths and die cutters. Although active as an artist from the early 1510s, Ludwig only became a master goldsmith in 1522. Eight years later he served as a sworn counselor in the city government.

During the 1510s and early 1520s, Ludwig is best known as a sculptor and graphic artist rather than as a goldsmith. His monogram, L K, normally flanking a jug (Krug), appears on three small sculptures, two woodcuts, and sixteen engravings. Many of these works reveal Krug's compositional indebtedness to Albrecht Dürer. Whether there was any direct collaboration between the two artists is uncertain though Rasmussen has suggested Krug as the sculptor of the elaborate wooden frame (Nuremberg, Germanisches Nationalmuseum) for Dürer's *Landauer Altarpiece* of 1511 in Vienna (Kunsthistorisches Museum). Krug was among the first German artists to experiment with the plaquette, a relief that can be cast in multiple copies. His *Fall of Man* exists in two identical brass versions dated 1515 and 1518. Still other reliefs, such as the large, red-marble *Fall of Man* in Munich (Bayerisches Nationalmuseum), were highly refined cabinet pieces. In addition, between 1519 and 1521, Krug may have cast Hans Schwarz's

wooden models for portrait medals in bronze and silver.

The Krug family ran one of Nuremberg's largest and most productive workshops. Ludwig was adept at designing the sumptuous silver-gilt cups with tendrils and other naturalistic features that bear the workshop stamp. Several goldsmith models are ascribed to his hand. Neudörfer wrote that Ludwig embossed or cut in silver whatever figures and fountains that Hans Frey (1450–1523) first made in copper. (fig. 161) His monogram and Krug symbol adorned the now lost *Ciborium with Madonna and a Woodcutter*, whose appearance is documented in a drawing in the *Hallesches Heiltumsbuch* (Aschaffenburg, Hofbibliothek, ms. 14, fol. 157v). This was made between 1520 and 1526–27 for Cardinal Albrecht von Brandenburg. The finial figure of Mary and the Passion reliefs around the side of the cup derive from Dürer's prints. Based upon the style of this ciborium, several other items illustrated in this inventory manuscript (fols. 205v, 216v, and 367v) are tentatively attributed to Ludwig.

Most of Ludwig's goldsmith works incorporate sculptural features. For instance his *Covered Cup with the Labors of Hercules* (until 1922 in Raudnitz Castle outside Prague), stamped with the workshop's mark, has a series of shell-relief roundels illustrating Hercules' exploits. Dürer's drawings (W. 490–501) provided the specific designs for these scenes. The reliefs were carved shell cameos, a technique more commonly found in France. Two related shell carvings, possibly made for a *Hercules Cup* owned by Albrecht von Brandenburg, are in Hamburg (Museum für Kunst und Gewerbe) and St. Petersburg (Hermitage).

SELECTED SIGNED AND / OR
DOCUMENTED WORKS
(sculptures only)

1514	*Adam and Eve*, stone (Berlin, SMBPK, Skulpturengalerie); lead cast (Nuremberg, Germanisches Nationalmuseum)
1515	*Fall of Man*, brass (Brno, Moravská Galérie)
1515 (1518)	*Fall of Man*, brass (Cleveland Museum of Art; fig. 247). Dated 1518 on the reverse

MAJOR ATTRIBUTED WORKS

c. 1524 *Fall of Man*, stone (Munich, Baye-
 risches Nationalmuseum; fig. 248)

c. 1525 *Birth of Hercules*, shell (Hamburg, Mu-
 seum für Kunst und Gewerbe)

c. 1525 *Hercules and Antaeus*, shell (St. Peters-
 burg, Hermitage)

BIBLIOGRAPHY

Neudörfer (1875), pp. 124–25

Bange (1928), pp. 75–6

Otto von Falke, "Silberarbeiten von Ludwig Krug,"
 Pantheon 11 (1933): pp. 189–94

Edmund Schilling, "Zeichnungen von Ludwig
 Krug," *AGNM* (1932–33): pp. 109–18

Elfried Bock, "The Engravings of Ludwig Krug
 of Nuremberg,"*Print Collector's Quarterly* 20
 (1933): pp. 87–115

Kohlhaussen (1968), pp. 357–407 (on the gold-
 smith work)

Pechstein (1971), nrs. 44–5, 75–6, 151

Rasmussen (1975), nrs. 4–5

Theuerkauff (1975), pp. 432–39

Weber (1975), pp. 54–5, 105–06

Wixom (1975), nr. 165

Fedja Anzelewsky, "Ludwig Krug" in Hollstein,
 ed. (1954–), 19: pp. 177–94

Rasmussen (1976), esp. pp. 92–8

Gagel (1977), pp. 155–61

Claudia Diemer, "Krug, Ludwig" in *NDB* 13
 (1982): pp. 113–14

Smith (1983), pp. 49, 64, 153, 194, 214–18

Wenzel Jamnitzer (1985), pp. 151–53, nrs. 5–6,
 286–88, 290, 533

Gothic and Renaissance Art in Nuremberg (1986), pp.
 408–13.

Georg Labenwolf

Georg (Nuremberg before 1533–May 1585 Nu-
remberg) trained with and assisted his father Pan-
kraz Labenwolf. In 1559 the city council granted
him permission to work in Neuburg an der Donau
for five years. Since two of his sons were baptized in
1560 and 1562 in Nuremberg, his journey to Neu-
burg was probably brief. Georg assumed control of
the family shop and foundry in 1563. Little is
known about his career before 1570–71 when he
cast ten figures, after models by sculptor Paul
Kremer, for a large fountain, now lost, at the
Lusthaus in Aue for Wilhelm IV, Landgraf von
Hessen-Kassel. In 1576 Georg completed the cast-
ing of the *Minerva Fountain* in the courtyard of the
Hochschule (former university) in Altdorf near
Nuremberg. Later in the same year Georg travelled
to Denmark to meet with King Frederik II who
commissioned a six-meter-high *Neptune Fountain*
for Kronborg palace. Working in Nuremberg after
wooden models by Lienhard Schacht, Georg com-
pleted the fountain in late 1582 and installed it in
March 1583. In addition to such large fountains,
Georg likely collaborated with local sculptors, such
as Johann Gregor van der Schardt, in the produc-
tion of small brass statuettes. Several attributed
examples are listed in the old inventories of the
Volckamers and other Nuremberg patrician fami-
lies. Georg's assistant and nephew, Benedikt Wur-
zelbauer (1548–1620), ran the family foundry after
his death.

SELECTED SIGNED AND / OR
DOCUMENTED WORKS

1570–71 *Garden Fountain* (formerly Aue bei Ka-
 ssel, Lusthaus). With Paul Kremer.

1576 *Minerva Fountain* (Altdorf, Hoch-
 schule {former university}). With
 Lienhard Schacht(?).

1576–83 *Neptune Fountain* (formerly Kronborg,
 Slot; *Minerva*, *Juno*, and *Venus* are in
 Stockholm, Nationalmuseum; figs.
 210 and 211). With Lienhard Schacht.

n.d. *Knight on Horse* (Nuremberg, Volck-
 amer family collection {now lost} ac-
 cording to a late seventeenth–early
 eighteenth century inventory)

MAJOR ATTRIBUTED WORKS

early 1570s *Garden Fountain* (Uraniborg, Slot
 {now lost}—made for Tycho Brahe)

1570–75 (?) *Four Seasons* (Vienna, Kunsthisto-
 risches Museum; figs. 173–176). Jo-
 hann Gregor van der Schardt and
 Wenzel Jamnitzer made the fountain

from which only these four figures survive. Georg's role as caster of this project is uncertain.

BIBLIOGRAPHY

Edmund W. Braun, "Nürnberger Bronzestatuetten aus der Werkstätte von Georg Labenwolf," *Kunst und Kunsthandwerk* 23 (1920): pp. 129–34
Bange (1949), pp. 91, 99–100
Schwemmer (1949), esp. p. 128
Weihrauch (1967), pp. 324–25, 329
Larsson (1975), esp. pp. 177–86
Pechstein (1978), pp. 71–9
Josef Riederer, "Metallanalysen von Statuetten der Wurzelbauer-Werkstatt in Nürnberg," *Berliner Beiträge zur Archäometrie* 5 (1980): pp. 43–58
Honnens de Lichtenberg (1981), esp. pp. 59–60
Wenzel Jamnitzer (1986), pp. 233–35.

Pankraz Labenwolf

Pankraz (Nuremberg 1492–20 September 1563 Nuremberg) was one of Germany's leading brass casters. After training in the Nuremberg shop of Peter Vischer the Elder, Pankraz acquired citizenship on 4 June 1519 and became a master in the same year. He established his own workshop in 1523, and in 1537 the city council permitted him to build his own foundry. With the deaths of Peter Vischer the Elder in 1529, Pankraz quickly became the city's best metal founder. On five occasions (1533, 1537, 1539, 1540, and 1543) the city council granted Pankraz temporary permission to employ up to two extra journeymen over the limit prescribed by the craft ordinances in order to complete major projects. The shop continued to thrive under the direction of his son Georg (before 1533–May 1585), grandson Benedikt Wurzelbauer (1548–1620), and great grandson Johann Wurzelbauer (1595–1656).

Pankraz was a founder not a sculptor. Unlike Peter Vischer the Younger, he did not make his own models. He cast from the wooden models supplied by other masters. Peter Flötner was his most frequent collaborator during the 1530s when they worked on the *Silver Altar*, the *Apollo Fountain*, and an *Apollo and Daphne Fountain*. Evidence also sug-

gests they produced small table fountains using nature castings. (fig. 178) Sebald Hirder provided a model for a brass, bath-chamber fountain that Ottheinrich commissioned in 1535 for his palace at Neuburg an der Donau. Pankraz's monogram appears on the *Putto* or *Rathausbrunnen* (1549–57) in Nuremberg. Numerous small statuettes, epitaphs, and tombs are attributed to his workshop. In 1542 Ludwig Neufahrer carved a stone model for the *Portrait of Pankraz Labenwolf* (Cleveland Museum of Art). The medal, perhaps cast by Pankraz himself, records his age as 50 and his motto as "DI ZEIT GIBCZ" ("Time Provides").

SELECTED SIGNED AND / OR DOCUMENTED WORKS

1531–38 *Silver Altar* (Cracow, cathedral, Sigismund Chapel; fig. 24). With Hans Dürer, Peter Flötner, Melchior Baier, Georg Herten, and Georg Pencz

1531–32 *Apollo Fountain* (Nuremberg, Stadtmuseum Fembohaus; figs. 195 and 196). With Peter Flötner

1533 *Apollo and Daphne Fountain* (lost; made for Trent, Buonconsiglio Palace). Likely with Peter Flötner

1535 *Fountain* (lost; made for Neuburg an der Donau, Palace, bath chamber). With Sebald Hirder.

1549–57 *Putto* or *Rathausbrunnen* (Nuremberg, City Hall; figs. 185 and 186). With the Master of the Rathaus Putto (Hans Peisser?)

1551 *Epitaph of Graf Wernher von Zimmern* (d. 1554; Messkirch, Stadtkirche)

MAJOR ATTRIBUTED WORKS

c. 1540 *Geese Bearer Fountain* (Nuremberg, Obstmarkt—now located southeast of the city hall; fig. 184)

BIBLIOGRAPHY

Hampe (1904—I), I, nrs. 1386, 1962, 2217, 2239, 2282, 2285–86, 2362, 2438, 2452, 2525, 2794, 2812, 2975, 3309, 3458, 3504
Georg Habich, "Ein Brunnen von Pankraz Laben-

wolf in München," *MJBK* 10 (1916–18), pp. 217–22

Habich (1929–34), 1.2: nr. 1378

Bange (1949), pp. 99–102

William M. Milliken, "Four Stone Models for German Medals," *The Bulletin of the Cleveland Museum of Art* 44 (1957): pp. 118–21

Weihrauch (1967), pp. 288–90, 292, 318–19

Pechstein (1973), pp. 84–106

Pechstein (1978), pp. 71–9

Smith (1983), pp. 63, 162, 224, 248–49, 297

Wenzel Jamnitzer (1985), pp. 9–10, 123, 405

Gothic and Renaissance Art in Nuremberg (1986), pp. 59, 425–27, 438–40, 451

Bräutigam (1987), pp. 205–24

Pechstein (1990), pp. 113–19.

Sebastian Loscher

Sebastian (Augsburg 1482/83–1551 Augsburg) was the son of Augsburg Stadtwerkmeister Konrad II Loscher. On 24 June 1497 he was registered as a pupil of local sculptor Lienhart I Stromair. Little secure is known about the location and duration of his journeymanship. Trips through Swabia, the Upper Rhine, Austria, and North Italy have been suggested before returning to Augsburg where he became a master on 18 August 1510. Sebastian's early career is tied to the Burgkmair family to whom he may have been related. In 1510 he resided with Hans and from 1511 to 1514 with Thoman, Hans's father. Hans and Sebastian collaborated repeatedly. In 1513 Sebastian carved and Hans painted a St. Alexius for the Rehlinger family's chapel next to the Barfüsserkirche. Between 1520 and 1522 the pair made the *Rose Garland Altar* in the Rochuskapelle in Nuremberg for the Imhoff family.

The full significance of Loscher's career is difficult to gauge given the destruction of many early works, such as his Augsburg fountains, or the uncertainty about his precise role, if any, in the design and sculptural decoration of the Fugger Chapel in St.-Anna-Kirche. He carved the stone columns for several civic fountains including those in the Fischmarkt (1510) and Weinmarkt (1516). His association with the Fugger Chapel (fig. 133) is tied to the earliest drawing of the project (Augsburg,

Maximilianmuseum, inv. nr. G. 11994) that is signed with the initials SL. From this scholars, such as Karl Feuchtmayr, have assigned Loscher the leading role in the design and decoration of the chapel. The drawing, however, might date only to the 1530s, long after the chapel's completion, and the monogram could refer to another master. Whether he carved any of the epitaphs or the busts of the choirstalls cannot be proven based upon either documentary or stylistic evidence.

Loscher's activities as a sculptor diminished from the mid-1520s. Between 1511 and 1521 he trained four pupils; none is listed after 1521. On 15 July 1524 he was appointed city "weinzieher" or wine drawer, a job that, among other tasks, required Loscher to check wine spigots. With fewer commissions for religious art being made, the civic post offered a modicum of financial security. Loscher also switched to making small wooden reliefs, such as the *Justitia* (1536) in Berlin.

SELECTED SIGNED AND/OR DOCUMENTED WORKS

1513 *St. Alexius* (Ulm, Museum—on loan from Schloss Erbach), originally in the St.-Alexius-Kapelle next to the Barfüsserkirche in Augsburg. Inscribed "b(astian) loscher bildhauer / h(ans) burgkmaier maller / 1513".

c. 1520 *Allegory of Jakob Fugger* (Berlin, SMBPK, Skulpturengalerie). Lindenwood relief with SLB (Sebastian Loscher Bildhauer) monogram removed before 1908

1520–22 *Rose Garland Altar* (Nuremberg, Rochuskapelle). Hans Burgkmair did the painting and Augsburg joiner Thoman Hebentanz made the frame

1522 *High Altar* (formerly in Rauris [Tirol], Pfarrkirche). An eighteenth century manuscript records the inscription on the back of the altar as "Zu Augsburg gemacht von Johann Burckhmayr, Mallern, und Sebastian Löscher, Bildhauer anno 1522."

1536 *Justitia* (Berlin, SMBPK, Skulpturengalerie; fig. 254). Boxwood relief with monogram "SL".

MAJOR ATTRIBUTED WORKS

c. 1510– *Fugger Family Chapel* (Augsburg, St.-
18 Anna-Kirche). Loscher may have wor-
 ked on the marble epitaphs and, less
 certainly, on the busts of the choir stall
 (fragments in Berlin, SMBPK, Skulp-
 turengalerie)
c. 1530s *Fortuna* (Hamburg, Museum für
 Kunst und Gewerbe). Boxwood pla-
 quette model.

BIBLIOGRAPHY

Max Bernhart, "Ein Beitrag zu Sebastian Loscher,"
MJBK N.F. 10 (1933): pp. XLII–LXVI

Franz Martin, *Die Denkmale des politischen Bezirkes
Zell am See* [*Österreichische Kunsttopographie*, vol.
XXV] (Baden bei Wien, 1934), pp. 209–17

Karl Feuchtmayr in Lieb (1952), pp. 433–71

H. Müller (1954), pp. 153–211

Müller (1959), pp. 271–74

Tilman Falk, *Hans Burgkmair* (Munich, 1968), pp.
56, 74, 102, 108, 111, 116–17

Christian Theuerkauff' in Gagel (1977), pp. 72–9,
173–77

Alfred Schädler in *Welt im Umbruch* (1980–81), 2:
pp. 193–96

Jasbar and Treu (1981), pp. 212–13

Martin Angerer, "Loscher, Sebastian" in *NDB* 15
(Berlin, 1987), pp. 193–94.

Paulus II Mair

Paulus (Augsburg c. 1540–1615/19 Augsburg)
was a member of an illustrious family of sculptors.
His grandfather was Gregor Erhart and his father
was Paulus Erhart, who adopted the name Mair in
about 1550. Although he became a master in 1564,
little is known about his career before 1570–71
when he carved the monumental *Mary Altar* or
High Altar for St. Ulrich and Afra in Augsburg.
Benefiting from the resurgence of the Catholic
church, Mair made epitaphs and altars for several
local churches. For instance, in 1576 he produced
the epitaph of Bishop Egenolf von Knöringen in
Augsburg cathedral. In 1576–77 Duke Ludwig of
Württemberg lured Mair to Stuttgart to work

on the planned ancestral monument in the Stifts-
kirche. Mair's attractive model for the tomb of
Count Heinrich von Mompelgard was not used as
the nature of the project changed. Upon returning
to Augsburg, Mair continued working in the local
churches, especially in the Dominikanerkirche.

SELECTED SIGNED AND / OR
DOCUMENTED WORKS

1570–71 *Mary Altar* (Augsburg, St. Ulrich and
 Afra, former *High Altar* but moved in
 1601 to the Schneckenkapelle; fig. 76)
1576 *Epitaph of Bishop Egenolf von Knöringen*
 (Augsburg, cathedral)
1576–77 *Model for the Tomb of Heinrich von Mom-
 pelgard*, lindenwood (Urach, Schloss—
 on loan to Stuttgart, Württember-
 gisches Landesmuseum; fig. 130).
 After a design by Hans Steiner
1581 *Resurrection Altar* (Augsburg, Domi-
 nikanerkirche; sculptural portions in
 London, Victoria and Albert Museum;
 fig. 78). Mair was commissioned to
 make the now lost frame plus several
 sketches for this altar. The actual fig-
 ural work, however, is by Hubert Ger-
 hard and Carlo Pallago
1612 *Two Angels Holding the Fugger Coat of
 Arms* (formerly in Augsburg, Domi-
 nikanerkirche). This now lost group
 adorned the great organ. There is some
 question whether the sculptures were
 made by our artist or his like named
 son.

BIBLIOGRAPHY

Demmler (1910), pp. 57–78, XIII, XVI–XXXII

Hans Wiedenmann, "Die Dominikanerkirche in
Augsburg," *Zeitschrift des historischen Vereins für
Schwaben und Neuburg* 43 (1917): esp. pp. 37–9,
42

Hartig (1923), pp. 42–4

Karl Feuchtmayr, "Studien zur Augsburger Plastik
der Spätrenaissance," *Das Schwäbische Museum* 2
(1926): pp. 33–5

"Mair (Mayr), Paul (Paulus) in Thieme and Becker
(1907–50), 24: p. 493

Michael Baxandall, "A Masterpiece by Hubert Gerhard," *Victoria and Albert Museum Bulletin* 1, nr. 2. (April 1965): esp. pp. 1–5

Fleischhauer (1971), pp. 33–5

Welt im Umbruch (1980–81), 2: pp. 159–60

Rasmussen (1981), pp. 106–08

Die Renaissance im deutschen Südwesten (1986), pp. 354, 555.

Master I.P.

The monogram IP appears on three stylistically related reliefs in Leningrad, Prague, and Vienna. Each is characterized by its tight, highly detailed cutting technique and by its unusually complex compositions that borrow liberally from prints by Wolf Huber, Lucas Cranach the Elder, and other masters associated with the Danube School. This artist seems to have been active during the 1520s and 1530s in the region between Passau and Salzburg. Nothing certain is known about his identity or his career. The corpus of works given to him continued to expand dramatically until 1965 when Anton Legner and other scholars recognized that many of the attributions were by other artists in the circle of or influenced by Master I.P. One especially accomplished follower was active in Prague where he carved the elegant *St. John the Evangelist Altar* (c. 1525–30) for the Teyn Church. Complicating matters further are the few reliefs in Master I.P.'s style, such as Christoph Angermair's *St. Sebastian* (c. 1613) in Frankfurt (Liebieghaus), that date only to the "Dürer Renaissance" around 1600. Master I.P. specialized in small reliefs and statuettes made from pearwood or, less often, boxwood. In addition, several jointed puppets or mannequins, measuring about 25 cm in height, have been ascribed to the artist and his circle.

SELECTED SIGNED AND / OR DOCUMENTED WORKS

1521	*Adam and Eve* (Vienna, Österreichische Galerie)
c. 1524	*Visitation* (Prague, Národni Galérie)
c. 1525	*Lamentation* (St. Petersburg, Hermitage)

MAJOR ATTRIBUTED WORKS

early 1520s	*The Fall* and *Adam and Eve Toiling* (Frankfurt, Liebieghaus). Either by the artist or a close follower
early 1520s	*Adam and Eve* (Vienna, Kunsthistorisches Museum; fig. 27)
mid 1520s	*Adam and Eve* (Gotha, Schloss Friedenstein; fig. 250)
c. 1525	*Crucifixion* (*Christ and the Two Thieves*—Cologne, Kunstgewerbemuseum; *Mary* and *John the Evangelist*—Berlin, SMBPK, Skulpturengalerie)
1525–30	*Male Puppet* (Hamburg, Museum für Kunst und Gewerbe; fig. 276). Either by the artist or a close follower

BIBLIOGRAPHY

Theodor Müller, "Ein unvollendetes Werk des Meisters J.P.," *Form und Inhalt. Kunstgeschichtliche Studien—Otto Schmitt* (Stuttgart, 1951), pp. 225–32

Arpad Weixlgärtner, "Von der Gliederpuppe," *Göteborgs Konstmuseum. Årstryck* (1954): esp. pp. 37–55

Michael Liebmann, "Studien zur deutschen Kleinplastik—Eine Puschkin-Museum zu Moskau und die Salzburger Bildschnitzerwerkstatt um 1520–1530," *MJBK* 12 (1961): pp. 197–201

Legner (1965), pp. 278–91

Essays by Anton Legner, Jirí Kropácek, and Karel Stádnik in *Werden und Wandlung: Studien zur Kunst der Donauschule* (Linz, 1967), pp. 148–75, 201–06, 207–14

Elfriede Baum, *Österreichische Galerie—Katalog des Museums Mittelalterlicher Österreichischer Kunst* (Vienna, 1971), pp. 144–45

Michael D. Grünwald, *Christoph Angermair* (Munich, 1975), pp. 28–32

Rasmussen (1975), pp. 85–6

Spätgotik in Salzburg: Skulptur und Kunstgewerbe, 1400–1530, exh. cat. (Salzburg, 1976), pp. 160–64 (Anton Legner)

Gagel (1977), pp. 159–60, 166–71

Liebmann (1982), pp. 488–90.

Brita von Götz-Mohr, Liebieghaus-Museum. Nach-

antike Kleinplastische Bildwerke, Bd. III. Die deutschsprachingen, Länder (Melsungen, 1989). nrs. 136–37.

Daniel Mauch

Mauch (Ulm 1477–1540 Liège) was Ulm's last significant sculptor prior to the Reformation. Nothing is known about his training or early career before he opened his own workshop in 1503. He specialized in supplying altarpieces and wooden religious sculptures to local and regional churches. In 1520 Mauch and his wife, the daughter of Ulm painter Jörg Stocker, are listed as members of the St. Sebastian Brotherhood in Geislingen, north of Ulm, where he likely was engaged in carving the brotherhood's altar. Mauch's subsequent career was directly affected by the Reformation. With Ulm embracing Protestantism, the artist left Germany and moved to the Catholic stronghold of Liège in 1529. Here he continued creating religious art. Rasmussen has also attributed to him several stylish statuettes and goldsmith models. A year before his death, Mauch relinquished his Ulm citizenship.

SELECTED SIGNED AND / OR DOCUMENTED WORKS

1510 *Altar of the Holy Kinship* (Bieselbach,
(or 1501?) Kapelle St. Franz Xaver)
1510 *Altar* (lost; formerly in Ulm, Bar-füsserkirche). With painter Martin Schaffner
1530 *Madonna and Child with Angels* (Dalhem [near Liège], parish church).

MAJOR ATTRIBUTED WORKS

c. 1505 *Maggmannshofer Altar* (Kempten, Huberkapelle)
c. 1520 *Sebastian Altar* (Geislingen, Pfarrkirche)
c. 1525 *Madonna and Child* (Ulm, Museum)
1530 *Reliquary Statue of St. Catherine* by Leonard van Bommershoven (Tongern, Notre-Dame). Model by Mauch(?)

1530s *Venus* (London, Victoria and Albert Museum)

BIBLIOGRAPHY

Gertrud Otto, "Mauch, Daniel" in Thieme and Becker (1907–50), 24: pp. 240–41
Alfred Schädler, "Der Maggmannshofer Altar. Ein Werk von Daniel Mauch, dem Schnitzer des Bieselbacher Altars," *Das schöne Allgäu* 14 (1950): pp. 72–6
Jörg Rasmussen, "Eine Gruppe kleinplastischer Bildwerke aus dem Stilkreis des Conrat Meit," *Städel-Jahrbuch* n.s. 4 (1973): pp. 121–44
Baxandall (1980), p. 303
Gerald Jasbar, *Das Kunstwerk des Monats*, Ulmer Museum (Dec. 1981), 2 pp.
Jasbar and Treu (1981), pp. 202–05
Jörg Rasmussen, "Figürliche Goldschmiedearbeiten nach Modellen von Daniel Mauch," *MJBK* 36 (1985): pp. 81–94.
Laat-gotische beeldsnijkunst uit Limburg en Grensland, exh. cat. (Sint-Truiden, 1990), p. 1.9, cat. nrs. 27, 56, inv. nrs. 530, 580K.

Conrat Meit

Meit (Worms 1480s[?]–1550–51 Antwerp) was one of the century's most accomplished sculptors. Most of his career, however, was spent in Brabant and in France. Because his sculpture had little direct influence upon German art, Meit has not been discussed at length in this book. He is first mentioned in a letter by Dr. Christoph Scheurl of 1511 praising the two-sided *Madonna* that stood on a tall marble column in the Schlosskirche in Wittenberg. Done for Elector Friedrich the Wise, the wooden statue depicted the Virgin and Child on one side and Mary as Queen of Heaven on the other. Scheurl states that Meit was a member of Lucas Cranach the Elder's workshop. How long he served Cranach as a journeyman is unknown, though it must have occurred between 1505 and 1511. Other than this *Madonna*, no works can be securely attributed to this period. By 1512 or so Meit moved permanently from Germany. He worked first for Admiral Philip of Burgundy in Middleburg and, as court

sculptor, for Margaret of Austria, regentess of the Low Countries, in Mechelen from 1514 to 1530. He is documented making numerous small portraits, statuettes, and other sculptures for her. One record of 1518 lists two bronze *Hercules*, one wooden *Hercules*, and a *Self-Portrait* of the artist. Albrecht Dürer mentioned meeting Meit several times during his Netherlands trip of 1520–21. In 1534 he moved to Antwerp where two years later he joined the guild of St. Luke. Meit remained active throughout the 1540s.

SELECTED SIGNED AND / OR DOCUMENTED WORKS

c. 1507–09	*Madonna* (lost; Wittenberg, Schlosskirche)
c. 1526 ([?] 1512–14)	*Judith with the Head of Holofernes* (Munich, Bayerisches Nationalmuseum) Inscribed "CONRAT MEIT VON WORMS". I feel that this is a mature, not early, work by Meit that is tied to his activities at the court of Margaret of Austria in Mechelen.
1526–31/2	*Tombs of Margaret of Austria, Philibert of Savoy, and Margaret of Savoy* (Brou [Bourg-en-Bresse], St. Nicolas de Tolentin)
c. 1526–28	*Pietà* (unfinished; Besançon, cathedral)
1531–34	*Tomb Complex of Philibert of Chalon* (lost; Lons le Saunier, St. François)

MAJOR ATTRIBUTED WORKS

c. 1518	*Bust Portrait of Margaret of Austria* (Munich, Bayerisches Nationalmuseum). Possibly linked with a document of 1518
c. 1520	*Adam and Eve* (Gotha, Schloss Friedenstein)
1520–25	*Adam and Eve* (Vienna, Kunsthistorisches Museum)

BIBLIOGRAPHY

Bruck (1903), pp. 78–84

Friedrich Winkler, "Konrat Meits Tätigkeit in Deutschland," *JPKS* 45 (1924): pp. 43–61

Georg Troescher, *Conrat Meit von Worms: ein rheinischer Bildhauer der Renaissance* (Freiburg im Breisgau, 1927)

Josef Duverger, *Conrat Meijt (ca. 1480–1551)* (Brussels, 1934)

Müller (1955–56), pp. 11–5

Müller (1959), pp. 133–38

Lowenthal (1976)

Constance Lowenthal, "Conrat Meit's Portraits of Philibert the Fair of Savoy," in Jörg Rasmussen, ed., *Studien zum europäischen Kunsthandwerk—Festschrift Yvonne Hackenbroch* (Munich, 1983), pp. 123–28.

Peter Osten

Osten (active between 1571 and 1589) grew up and trained either in or near the Flemish town of Ypres. Sometime before 1571 he moved to Mainz with his uncles Georg and Jan Robyn, both sculptors who eventually worked as architects. From 1575 Georg held the powerful position as the chief architect or Baumeister of the archdiocese of Mainz. Osten certainly provided sculptural decorations for some of Georg's major projects, notably the now-destroyed church of St. Gangolph in Mainz and the Juliusspital in Würzburg. It was the latter that initially brought Osten to Würzburg by 1577. Prince-bishop Julius Echter von Mespelbrunn commissioned the sculptor to make the high altar and sacrament-house relief for the hospital church plus two fountains and likely additional architectural decorations for the courtyard. His finest creation is the contemporary epitaph of Julius's brother, Sebastian, in the cathedral. The size of Osten's workshop grew rapidly during the period from about 1577 to 1581 that he spent in Würzburg. In the summer of 1578 he had four assistants. On 7 March 1579 he managed one journeyman and ten assistants. And in 1581 he oversaw four journeymen. Osten designed drawings for plaster decoration for the hospital's cellars and a few other rooms. He is next recorded in Speyer in 1583 and back in Mainz in the following year when his son was baptized. The last documents about the artist refer to his work on the monumental epitaph of Count Georg of Hesse and his wife in the Stadtkirche in Darmstadt. The final payment was made on 21 July

1589. Nothing further is known about his career after this date.

<div style="text-align:center">MAJOR SIGNED AND/OR DOCUMENTED WORKS</div>

1571 *Epitaph of the Family of Heinrich and Magdalena von Wiltberg* (formerly in Alken an der Mosel and now in Bonn, Rheinisches Landesmuseum)

1577–78 *Epitaph of Sebastian Echter von Mespelbrunn* (Würzburg, cathedral; figs. 113 and 114)

1578–81 Work at the Juliusspital and church in Würzburg. *High Altar* (now lost alabaster busts of Sts. Kilian, Kolonat, and Totnan plus a relief; 1578–79). *Last Supper* (now lost relief for the door of the sacrament house). Two now lost fountains with lifesize statues of Sts. Burchard and Kilian, dating between 1579 and 1581, were designed by Osten for the hospital courtyard. He made drawings for additional sculptural decorations. See fig. 82.

1588–89 *Epitaph of Georg I and Leonore von Hessen* (Darmstadt, Stadtkirche)

<div style="text-align:center">MAJOR ATTRIBUTED WORK</div>

c. 1577 *Epitaph of the Family of Hans Zobel von Giebelstadt* (Würzburg, Franziskanerkirche)

<div style="text-align:center">BIBLIOGRAPHY</div>

Mader (1915), pp. 86, 502, 519
Bruhns (1923), esp. pp. 114–19, 120–39
Hitchcock (1981), pp. 208, 254
Wendehorst (1981), pp. 132–33, 210.
De Ren (1982), pp. 118–33

Hans Peisser

Peisser (Hassfurt am Main 1500–05–after 1571 Prague[?]) was among the most versatile of mid-century sculptors as he shifted from carving altarpieces to creating models for plaquettes and several fountains. Various engravings by Master I. B., a Nuremberg artist active in the 1520s and early 1530s, have incorrectly been attributed to Peisser. The sculptor did receive a ten-year privilege from Ferdinand I, king of Hungary and Bohemia, in 1543 to publish a book, presumably illustrated, on houses, palaces, and pleasure buildings. Unfortunately, this text was never finished. He may have apprenticed in Veit Stoss' workshop before acquiring Nuremberg citizenship on 17 November 1526. Except for a trip outside the city in part of 1553–54, Peisser resided in Nuremberg until he gave up his citizenship on 21 January 1559. He may have briefly served Barnim XI, duke of Pommeria, in Stettin before moving to Prague where he is documented on 6 November 1561 working for Archduke Ferdinand of Tirol. From 1562 until 1571 he was Ferdinand's court sculptor in Prague. There are no further records about Peisser after this date. Ludwig Neufahrer of Nuremberg made an undated portrait medal of Peisser at age 31 (Dresden, Münzkabinett) that identifies Hassfurt as his native town.

<div style="text-align:center">SELECTED SIGNED AND/OR DOCUMENTED WORKS</div>

c. 1531 *High Altar* (Kremsmünster, Stiftskirche; fragments today in Grünau [Oberösterreich]. In his *Monasteriologia* of 1551 the humanist Kaspar Brusch (Bruschius) wrote that Abbot Johannes II Habenzagel (1526–43) donated the altar in 1531 and that it was created by Johannes Peisser, the Phidias of Nuremberg ("Phidiae Norici").

1548 "Emblems and Virtues", eleven signed and dated stone plaquette models (lost; formerly Nuremberg, Paulus Praun Collection and later Paul Heinlein Collection)

c. 1550 *Virtues*, plaquettes (signed bronze copies of *Justitia* and *Prudentia* are in Munich, Bayerisches Nationalmuseum; the unsigned wooden model for *Caritas* is in Berlin, SMBPK, Kunstgewerbemuseum; figs. 265)

1562/ *Singing Fountain* (Prague, Belvedere
63–71 garden; fig. 201). Painter Francesco
 Terzio and caster Thomas Jarosch

MAJOR ATTRIBUTED WORKS

c. 1525 (?) *Welser Altar* (formerly Nuremberg,
 Frauenkirche; fragments in the Frau-
 enkirche, Jakobskirche, and Germa-
 nisches Nationalmuseum). Interesting
 though problematic attribution

1530s(?) (?) *Fountain of the Planet Deities* (Linz,
 Landhaus; figs. 188 and 189)

1530–40 *Lot and his Daughters*, plaquette

c. 1540 *Forge of the Heart*, wooden plaquette
 model (Vienna, Kunsthistorisches Mu-
 seum)

1549–57 *Putto* or *Rathaus Fountain* (Nurem-
 berg, City Hall courtyard; figs. 185
 and 186). The lindenwood model,
 now in the Germanisches National-
 museum, was cast by Pankraz Laben-
 wolf who signed the fountain. (fig.
 187)

REJECTED ATTRIBUTION

c. 1540 *Geese Bearer Fountain* (Nuremberg,
 Obstmarkt—now southeast of the
 city hall; fig. 184). Although the mo-
 del for this fountain has often been asc-
 ribed to Peisser by Pechstein, among
 others, I find the style to be unrelated
 to the artist's secure oeuvre. The lin-
 denwood model is in the Stadtmu-
 seum Fembohaus.

BIBLIOGRAPHY

Hampe (1904), I: nrs. 3381–82, 3422

Edmund W. Braun, "Hans Peissers Plaketten und
der Nürnberger Kleinmeister IB," *Archiv für
Medaillen-und Plakettenkunde* 3 (1923): pp. 104–
14

Habich (1929–34), 1.2: nrs. 1360, 1435

Hans Stafski, "Hans Peisser als Grossplastiken,"
*Jahresbericht—Germanisches Nationalmuseum Nürn-
berg* 96 (1951): pp. 11–6

Heinrich Decker, "Ein Altarwerk von Hans Peys-
ser," *Die Kunst und das schöne Heim* 52 (1954): pp.
255–58

Pechstein (1973)

Pechstein (1974)

Leonore Pühringer-Zwanowetz, "Metamorphosen
eines Kunstwerks: Der Hochaltar der Pfarrkir-
che von Grünau im Almtal und seine Vorge-
schichte im Raum der Stiftskirche von Krem-
smünster, 1511–1712," *Wiener Jahrbuch für
Kunstgeschichte* 27 (1974): pp. 83–109

Weber (1975), pp. 25, 99–103

Hans Stafski, "Zur Rezeption der Renaissance in
der Altarbaukunst Süddeutschlands," *Zeitschrift
für Kunstgeschichte* 41 (1978): pp. 134–47

Gothic and Renaissance Art in Nuremberg (1986), pp.
424–27

Smith (1989), pp. 50–3

Pechstein (1990), pp. 113–19.

Hans Reinhart the Elder

Reinhart was the finest medallist in Saxony during
the mid-sixteenth century. Little is known about
his origins or professional history before he ob-
tained citizenship in Leipzig in 1539. His earliest
signed and dated works, including the portrait
medals of Albrecht von Brandenburg and Johann
Friedrich of Saxony in 1535, demonstrate that he
was already an established artist. In 1540 the gold-
smiths' guild filed a complaint against Reinhart
charging that he should be subject to their regula-
tions since he used silver for his medals. Reinhart
countered that his was a "free art" outside their
jurisdiction. The goldsmiths prevailed since Rein-
hart subsequently spent five years as an apprentice
to Georg Treutler. He became a master goldsmith
in 1547 though only through the intervention of
the city council who approved his three master-
pieces. The majority of Reinhart's medals date be-
tween 1535 and 1547 yet a few are as late as 1574.
His subsequent activities as a goldsmith and a seal
cutter are problematic since not a single piece can
be securely attributed to him. He prepared wills in
1566 and 1579. Following Reinhart's death in
Leipzig in 1581, his son, Hans the Younger (master
1582, citizen 1584, death 1622), continued the
workshop.

SELECTED SIGNED AND / OR DOCUMENTED WORKS

1535	*Portrait of Albrecht von Brandenburg*, medal (fig. 46)
1535	*Portrait of Johann Friedrich, Elector of Saxony*, medal
1536	*Fall of Man—Crucifixion*, medal (fig. 47)
1537	*Portrait of Emperor Charles V*, medal (fig. 294)
1538	*Moses and the Burning Bush—Adoration of the Kings*, medal
1539	*Apocalypse*, medal (figs. 48 and 49)
1539	*Portrait of Friedrich Myconius*, medal
1544	*Trinity (Moritzpfennig)*, medal (fig. 50). Numerous later editions.
1544	*Portrait of Hieronymus Lotter*, medal

BIBLIOGRAPHY

Habich (1929–34), 2.1: pp. 278–87, nrs. 1925–86

Paul Grotemeyer, "Reinhart, Hans d. Ä." in Thieme and Becker (1907–50), 28: pp. 123–24

William M. Milliken, "A Medaillon of the Trinity," *Bulletin of the Cleveland Museum of Art* 43 (1956): pp. 196–97

Kunst der Reformationszeit (1983), pp. 338–40

Smith (1987—II), esp. p. 218

Trusted (1990), pp. 90–9.

Johann Gregor van der Schardt (Jan de Zar)

Van der Schardt (Nijmegen c. 1530–after 1581) was perhaps the most talented sculptor active in Germany during the 1570s. Nothing is known about his training and early career. It is possible that he studied in Antwerp or, less certainly, with Leone Leoni who was in Brussels until 1551. He is mentioned as "Giovanni di Sart di Nimega eccellente scultore" by Luigi Guiccardini in 1566, a reference repeated in the 1568 edition of Giorgio Vasari's *Lives*. The artist studied in Rome and probably also Florence in the 1560s. By 1568 at the latest, van der Schardt resided in Venice where he would be strongly influenced by the portrait sculpture of Alessandro Vittoria. In late January 1569 Veit von Dornberg, imperial ambassador to Venice, wrote to Emperor Maximilian II that he had located a new sculptor: "Johannes, a Netherlander, in Venice who had spent several years in Rome and was presently detained in Bologna." Peltzer and others had made a plausible case for claiming this "Johannes" is identical to van der Schardt, the Netherlandish ex-patriot. The ambassador also cited the authority of Daniele Barbaro, the cultivated Venetian, who had seen his "most beautiful figures and statues (done) with the greatest attention" in Rome. By June 1569 the artist, back in Venice, entered Maximilian's service and moved to Vienna where he probably began working at the Neugebäude (fig. 202). Van der Schardt accompanied the emperor to Nuremberg in June 1570. The sculptor, who remained there, was paid six months later for his labor. In all likelihood, van der Schardt was collaborating with Nuremberg's famous goldsmith, Wenzel Jamnitzer, on the modeling and casting of figures for the 3–3.5 meter-tall *Allegory of Imperial Rule Fountain* of which only the *Four Seasons* in Vienna survive. In July 1571 Maximilian granted him permission to return briefly to Italy. Van der Schardt may have left imperial service shortly afterwards.

All of van der Schardt's known works date to the years 1570–81 when he resided mainly in Nuremberg. During this decade he made terracotta portrait busts and reliefs including the exquisite life-size likeness of Willibald Imhoff, the wealthy patrician collector. In addition to reviving interest in portraits, van der Schardt created high-quality bronze statuettes, some of which were certainly cast by Georg Labenwolf. Between 1 May 1577 and fall 1579, he was employed at Slot Kronborg in Helsingør by King Frederik II of Denmark for whom he made both portraits and statuettes. He received a high monthly salary of 30 dalers at the outset plus separate payment for each work.

By late 1579 van der Schardt was back in Nuremberg where he remained until at least 1581, the date on a now-lost portrait of the sculptor by local painter Hans Hoffmann. Nothing certain is known about his subsequent career. Since Peltzer's fundamental article on the artist, it has been assumed that van der Schardt then entered the service of Paulus Praun, the era's greatest bourgeois art col-

lector. The Nuremberg patron resided in Bologna though his art holdings were divided between his native and adopted cities. Later inventories of Praun's collection indicates that he owned perhaps as many as 70 items by van der Schardt. At some date Praun must have acquired the contents of the artist's studio since the inventories list painted portraits of the artist by Hoffmann and Nicolas Neufchatel (dated 1573 and now in Trieste [Museo Storico del Castello di Miramare]), plus numerous portraits, clay models, and dozens of terracotta copies after both classical and Italian Renaissance sculptures by van der Schardt. Many are after Michelangelo. In fact those of *Day* and *Night* in London (Victoria and Albert Museum), among others, have been frequently attributed to Michelangelo himself; however, these are clearly listed in Praun's inventory of 1616 as "after Michelangelo." Some of these models are in Berlin (SMBPK, Skulpturengalerie), Houston (Museum of Fine Arts), London (Victoria and Albert Museum), and Vancouver (LeBrooy Collection). Peltzer speculated that van der Schardt may have spent the last years of his life in Bologna working for Praun.

Recently, Honnens de Lichtenberg has developed a very different theory. She believes that van der Schardt returned to Denmark where he worked for Tycho Brahe, among other patrons. She suggests that he is identical to the sculptor Johannes Aurifaber who married in 1587 and died on 30 November 1591 at Slot Uraniborg while in Brahe's service. I find this association quite tenuous, as are most of her attributions to the artist. She wonders too whether van der Schardt worked as an architect and landscape architect both in Denmark, including Slot Uraniborg, and in Vienna. I am intrigued by her suggestion that van der Schardt might have authored the attractive *Crucifixion Altar* in the church at Slot Kronborg that was completed in 1587. *Christ as the Man of Sorrows* at the apex and, to a lesser degree, the three figures on the crosses recall van der Schardt's art but the wings do not. Complicating matters further is the material. The Kronborg altar is carved in alabaster. All of van der Schardt's secure works are either in terracotta or are cast. Was he also a stone cutter? Virtually every work that Honnens de Lichtenberg ascribes to van der Schardt during the 1580s is made of stone. These are not all by the same artist but the question

remains whether any are by van der Schardt. I think that the basic premise that the sculptor returned to Denmark, at least briefly, is plausible if not yet proven. Van der Schardt could still have worked subsequently for Praun in Bologna. Honnens de Lichtenberg conjectures rather implausibly that the sculptor's estate passed to Tycho Brahe and that Praun somehow purchased it between 1606 and 1610 during the sales of Brahe's possessions at Prague.

SELECTED SIGNED AND/OR DOCUMENTED WORKS

1570 *Portrait Bust of Willibald Imhoff*, terracotta (Berlin, SMBPK, Skulpturengalerie; fig. 314)

1572 *Fortuna Maritima*, terracotta statuette (formerly in Nuremberg, Willibald Imhoff collection)

1575–81 *Mercury*, bronze statuette (Stockholm, Nationalmuseum; fig. 257). Signed "I.G.V.S.F." (Ian Gregor Van Sart Fecit[?]).

1575–81 *Mercury*, bronze statuette (Pommersfelden, Schloss Weissenstein). Identical to the statuette listed in Paulus Praun's inventories

1575–81(?) *Crucifix Imbedded in Minerals*, (lost?) Listed in Paulus Praun's inventories. Honnens de Lichtenberg believes this is identical with the bronze example in Nuremberg (Gewerbemuseum)

1579 *Portraits of King Frederik II and Queen Sophie of Denmark*, brass busts (destroyed by fire at Slot Kronborg in 1629) The brass busts of the king and queen in Slot Rosenborg in Copenhagen may be the replicas(?) listed in Paulus Praun's inventories.

MAJOR ATTRIBUTED WORKS

mid-1560s(?) *Self-Portrait*, terracotta bust (U.S.A., private collection). Possibly identical with the "Ein Kopf Johann Gregori Conterfect einer schuch hoch" listed in the 1616 inventory of Paulus Praun

1569–70 *Self-Portrait at Age 39*, medal (London,

private collection). Presumably cast after van der Schardt's own design and model

1570–75 *Four Seasons*, firegilt bronze statuettes (Vienna, Kunsthistorisches Museum; figs. 173–176). These formed the base of the *Allegory of Imperial Rule Fountain* commissioned by Maximilian II for the Neugebäude outside Vienna and completed for Rudolf II. Van der Schardt collaborated with Wenzel Jamnitzer, who was the documented artist

1570–75 *Mercury*, bronze statuette (Vienna, Kunsthistorisches Museum)

1570–75 *Mercury*, bronze statuette (Stuttgart, Württembergisches Landesmuseum)

1570–75 *Minerva*, bronze statuette (Washington, Robert Smith Collection). Possibly identical to the figure listed in Paulus Praun's inventory

1570s *Portrait Bust of a Man*, terracotta (Munich, Bayerisches Nationalmuseum)

1570s *Portrait Bust of a Man*, terracotta (The Hague, Mauritshuis)

1578 *Portrait Bust of King Frederik II of Denmark*, terracotta (Hillerød, Frederiksborg Museum; fig. 316)

1579–80 *Portrait Bust of Anna Harsdörffer*, terracotta (Berlin, SMBPK, Skulpturengalerie; fig. 315). This bust of the wife of Willibald Imhoff is undocumented but it was in the Imhoff house chapel on the Egidienhof in Nuremberg until it and the bust of Willibald were sold in 1858

1580 *Portrait Medaillon of a Man age 39* (Berlin, SMBPK, Skulpturengalerie). Formerly in Paulus Praun's collection(?)

1580 *Portrait Medaillon of Willibald Imhoff*, terracotta (Nuremberg, Germanisches Nationalmuseum

1580 *Portrait Medaillon of a Man (Paulus Praun?)*, terracotta, 2 copies (Nuremberg, Germanisches Nationalmuseum; fig. 317) and Stuttgart, Württembergisches Landesmuseum)

c. 1580(?) *Apollo (Sol)*, brass statuette (Amsterdam, Rijksmuseum)

c. 1580(?) *Diana (Luna)*, brass statuette (Vienna, Kunsthistorisches Museum). Part of the same series as the Amsterdam *Apollo*, this statue was earlier owned by Archduke Leopold Wilhelm

c. 1580 *Portrait Medaillon of a Man*, terracotta (Amsterdam, Rijksmuseum)

BIBLIOGRAPHY

Ludovico Guiccardini, *Tout le pais bas* (Antwerp, 1567), p. 136

de Murr (1797), pp. 7, 9, 230–31, 235–36, 240–43

Springer (1860)

Peltzer (1916–18), pp. 198–216

Ernst Bange, "Ein Tonrelief des Johann Gregor von der Schardt," *MJBK* N.F. 1 (1924): pp. 169–71

Christian Theuerkauff, "Johann Gregor van der Schardt," *Stiftung zur Förderung der Hamburgischen Kunstsammlungen, Erwerbungen 1963* (Hamburg, 1963), pp. 62–5

Lise Lotte Möller, "Über die florentinische Einwirkung auf die Kunst des Johann Gregor von der Schardt," in *Studien zur toskanischen Kunst: Festschrift L. Heydenreich* (Munich, 1964), pp. 191–204

Irmtraud Himmelheber, "Eine Kleinbronze von Johann Gregor van der Schardt," *Jahrbuch der Staatlichen Kunstsammlungen in Baden-Württemberg* 1 (1964): pp. 165–72

Metz (1966), nrs. 662–64

Schilderijen en beeldhouwwerken 15e en 16e eeuw—Catalogus [Koninklijk Kabinet van Schilderijen Mauritshuis] (The Hague, 1968), p. 58

Hans R. Weihrauch, "Berichte der staatlichen Kunstsammlungen. Neuerwerbungen-Bayerisches Nationalmuseum," *MJBK* 22 (1971): esp. pp. 237–38

Paul James LeBrooy, *Michelangelo Models formerly in the Paul von Praun Collection* (Vancouver, 1972)

Leeuwenberg and Halsema-Kubes (1973), nrs. 197–98

Ernst Petrasch, "Ein unbekanntes Holzmodell für eine Bronzestatuette von Johann Gregor van der Schardt," *Festschrift für Peter Wilhelm Meister* (Hamburg, 1975), pp. 103–07

Gagel (1977), pp. 47–57

Honnens de Lichtenberg (1981), esp. pp. 58–63

Weber (1983), esp. pp. 155–80

Lars O. Larsson, "Från Florens till Prag," in *Bruegels Tid—Nederländsk Konst 1540–1620*, exh. cat. Nationalmuseum (Stockholm, 1984), esp. pp. 24–8

Hanne Honnens de Lichtenberg, "Johan Gregor van der Schardt. Sculptor—and Architect," *Hafnia* 10 (1985): pp. 147–64

Anthony Radcliffe, "Schardt, Tetrode, and some possible Sculptural Sources for Goltzius," in Görel Cavalli-Björkman, ed., *Netherlandish Mannerism* (Stockholm: Nationalmuseum, 1985), esp. pp. 97–9

Smith (1985), esp. pp. 92–5

Wenzel Jamnitzer (1985), nrs. 26–30, 502, 649, 679

Filedt Kok et al. (1986), pp. 461–63

Schürer (1986)

Lars O. Larsson, "Imitation und Variation: Bemerkungen zum Verhältnis Jan Gregor van der Schardts zur Antike," in Jürg Meyer zur Capellen and Gabriele Oberreuter-Kronabel, eds., *Klassizismus—Epoche und Probleme: Festschrift für Erik Forssman* (Hildesheim, 1987), pp. 277–287

Prag um 1600 (1988), 2: pp. 46–52

Die Grafen von Schönborn, exh. cat, Germanisches Nationalmuseum (Nuremberg, 1989), nr. 116

Hermann Maué, "*Die Grafen von Schönborn—Kirchenfürsten, Sammler, Mäzene*: Ergänzungen und Korrekturen," *AGNM* (1989): esp. pp. 184–87

Willy Halsema-Kubes, "Johan Gregor van der Schardt, Sol (de Zon), c. 1580," *Bulletin van het Rijksmuseum* 37 (1989): pp. 182–84

Honnens de Lichtenberg (1991).

Hans Schenck (Scheutzlich)

Schenck (c. 1500 Schneeberg—between 1566 and 1572 Berlin) was the most successful sculptor active in North Germany during the mid-sixteenth century. He likely trained with his father, Hans the Elder, before his wanderjahr, which may have been spent in Nuremberg. Between 1526 and 1528, and perhaps as late as 1535, Schenck worked as a portraitist for Albrecht von Brandenburg-Ansbach, first duke of Prussia, in Königsberg. Albrecht apparently sent him to the court of King Sigismund I of Poland in Cracow in 1526. By 1536 Schenck moved permanently to Berlin where he became the court sculptor of Joachim II, elector of Brandenburg. Among his various duties was the carving of sandstone sculpture for the Joachimsbau of the new Berlin palace designed by Caspar Theyss (Theiss) in 1537. Schenck obtained Berlin citizenship in 1543.

Schenck was typically listed in the Prussian and Brandenburg court documents as a "Kunterfetter" ("Konterfetter") or portraitist. These portraits took the form of medals, small reliefs, and near life-size carvings, as well as detailed likenesses on numerous epitaphs and tombs. The only medals bearing the monogram "HSK" (Hans Schenck Konterfetter) date to 1524–25. In 1536 he began signing his works with a pitcher (krug), a play on his name that means water bearer. Habich has attributed over 100 medals to Schenck though some later ones are difficult to accept due to their mediocre quality. Joachim II commissioned his grandest creation—the monumental *Tomb of Friedrich III von Brandenburg, archbishop of Magdeburg* erected in 1558 in Halberstadt cathedral. Other epitaphs by him can be observed in several Berlin-area churches. Schenck's first patron, Albrecht of Prussia, continued occasionally to request new portrait medals. In 1562 he order silver medals of the electors of Brandenburg and Saxony plus the archbishops of Magdeburg. Two years later the duke gave Schenck 40 florins as a gift for the artist, his wife, and his six children. This is the last record about the sculptor until 1572 when his wife is mentioned as a widow.

SELECTED SIGNED AND/OR DOCUMENTED WORKS

1524	*Portrait of Martin Luther*, medal. Signed "HSK"
1526	*Portrait of Christoph Szydlowiecki*, medal. Recorded in a letter by Szydlowiecki, the chancellor of Poland
1526	*Portrait of Kasimir von Brandenburg-Franken*, medal. Signed with a pitcher
1533	*Portrait of Christoph and Anna Schulenburg*, medal. Signed with a pitcher
1537	8 medals signed with a pitcher. The sitters include Georg the Bearded, duke of Saxony, Johann Friedrich,

elector of Saxony, Heinrich V von Mecklenburg-Schwerin, Sigismund of Poland, Henry VIII, and a double portrait of Luther and Melanchthon

1540–50 *Portraits of Casper Theyss, the Artist, and Kunz Buntschuh* (originally Joachimsbau, Berlin-Cölln Schloss, now Berlin, Jagdschloss Grunewald) Schenck holds an oversize pitcher. The three worked together on the Joachimsbau

1558 *Tomb of Friedrich III von Brandenburg, archbishop of Magdeburg* (Halberstadt, cathedral; figs. 105 and 106). Signed "Hoc opus exculpsit Johannes Pincerna 1558". Pincerna is the Latinized form of his name

MAJOR ATTRIBUTED WORKS

c. 1525–30 *Portrait of Tiedemann Giese*, lindenwood (Berlin, Jagdschloss Grunewald; fig. 307)

c. 1543 *Epitaph of Joachim Zerer* (Berlin, Marienkirche; fig. 102)

1546 *Portrait of Hans Klur*, solnhofen stone model for a medal (Berlin, SMBPK, Skulpturengalerie; fig. 296)

1548 *Portrait of Friedrich III von Brandenburg, archbishop of Magdeburg*, medal

c. 1549 *Epitaph of Gregor Bagius* (Berlin, Marienkirche, formerly in Nicolaskirche; fig. 103)

1556 *Christus Victor* (*Epitaph of Paul Schulheiss{?} and his Wife*; Berlin, Marienkirche, formerly in Nicolaskirche; fig. 104)

BIBLIOGRAPHY

Ehrenberg (1899), pp. 32, 74, 131, 196, 198, 230

Georg Habich, "Reliefbildnis des Tiedemann Giese in Königsberg," *JPKS* 49 (1928): pp. 1–23

Habich (1929–34), 2.1: nrs. 2198–2301

Seeger (1932)

Hellmuth Bethe, *Die Kunst am Hofe der pommerschen Herzöge* (Berlin, 1937), pp. 28, 30, 36–8

Paulus Hinz, *Gegenwärtige Vergangenheit—Dom und Domschatz zu Halberstadt* (Berlin, 1963), pp. 132–40

Metz (1966), pp. 120–21

Hubert M. Mühlpfordt, *Königsberger Skulpturen und ihre Meister 1255–1945* (Würzburg, 1970), pp. 152–53

Walter Hentschel, *Denkmale sächsischer Kunst—Die Verluste des zweiten Weltkrieges* (Berlin, 1973), p. 61

Johanna Flemming, Edgar Lehmann, and Ernst Schubert, *Dom und Domschatz zu Halberstadt* (Berlin, 1976), pp. 53–4

Gagel (1977), pp. 58–63, 80–5

Trusted (1990), p. 101.

Sem (Simon) Schlör

Schlör (Lautenbach c. 1530–1597 Schwäbisch Hall) was one of the most accomplished stone sculptors working in Württemberg during the last third of the century. Nothing secure is known about his training or early career before he settled in Schwäbisch Hall in the mid-1550s. "SEM SCHLÖR V. LAUTENBACH BILDHAWER 1558" reads an inscription by a window in the Johanniskirche. Schlör carved numerous epitaphs, tombs, and crucifixes for regional churches. He is best known, however, for his long association with the ducal court in Stuttgart. In 1562–63 he made 12 reliefs depicting the articles of Protestant faith for the altar of the newly rebuilt Schlosskirche. Like many of his works, this now heavily damaged monument is signed with his mark—a left arm in a puffed sleeve holding a pointed hammer. Schlör also added a pulpit and a large Crucifix. He sculpted the huge memorial honoring the counts of Württemberg in the Stiftskirche in Stuttgart among other family monuments. Schlör contributed numerous portraits and reliefs to the sumptuous new Lusthaus or pleasure house located in the ducal garden in Stuttgart (fig. 207) Between 1564 and November 1568, Schlör also worked for Margrave Georg Friedrich in Ansbach. His sculpted palace portal there was destroyed in 1710. Most of Schlör's career was spent in Schwäbisch Hall. In 1586 he taught Erhard Barg. Interestingly, in 1588 Schlör had to complete the *Tomb of Eberhard von Stetten and his Wife* in Kocherstetten (Pfarrkirche) when the patron became dissatisfied with Barg's initial efforts.

SELECTED SIGNED AND / OR
DOCUMENTED WORKS

1556	*Epitaph of Jörg von Bemelberg and his Wife* (Stöckenburg, Pfarrkirche)
1562–63	*Altar, Crucifix, and Pulpit* (Stuttgart, Schlosskirche; only damaged fragments survive)
1565	*Tomb of Duchess Sabina von Württemberg* (Tübingen, Stiftskirche)
c. 1566–68	*Tomb of Margrave Georg Friedrich von Ansbach* (Heilsbronn, Klosterkirche)
1576–77	*Tomb of Count Albrecht von Hohenlohe* (Stuttgart, Stiftskirche)
1578–84	*Monument to the Counts of Württemberg* (Stuttgart, Stiftskirche; figs. 129 and 131)
1586–87	Sculpture for the Stuttgart Lusthaus. Although the tasks are not specified, Schlör likely carved the *Hercules* and *Samson* reliefs for the door frame of the great hall, the emperor statues of the staircase, and bust portraits including that of architect Georg Beer. The few extant fragments are in Schloss Lichtenstein and Stuttgart, Württembergisches Landesmuseum and Villa Berg. Other busts were done by Christoph Jelin

SELECTED ATTRIBUTED WORKS

| early 1560s | *Pulpit* (Kirchheim unter Teck, Stadtkirche). The reliefs were placed in a new pulpit following the fire of 1691 |
| 1580 | *Tomb of Hans Ludwig Spät and Anna von Herberstein, Heuburg, und Gutenhag* (Höpfigheim bei Ludwigsburg, Pfarrkirche) |

BIBLIOGRAPHY

Demmler (1910), esp. pp. 173–248, and appendix p. XXXIII
Bruhns (1923), pp. 184–85
Werner Fleischhauer, "Neues zum Werk des Bildhauers Sem Schlör," *Württembergisch Franken Jahrbuch*, N.F. 40 (1966), pp. 111–23
Heinrich Geissler, "Zeichner am Württembergischen Hof um 1600," *Jahrbuch der Staatlichen Kunstsammlungen in Baden-Württemberg* 6 (1969): esp. pp. 86–95, 120–21
Fleischhauer (1971), pp. 133–40
Die Renaissance im deutschen Südwesten (1986), nrs. B18, E45–7, 67, G15, I17–8 (Christoph Jelin).

Dietrich Schro

Dietrich ([Mainz c. 1510]–between 1569 and 1573 Mainz) was likely the son and pupil of Peter Schro. He is traceable in Mainz between 1546 and 1573, when his wife is described as a widow. Little is known about his personal history. In 1550–51 he registered an assistant. His son, Johann Heinrich Schro (Schrohe), is listed as a sculptor in Mainz between 1573 and 1594. Based upon a significant group of secure works, including tombs for Albrecht von Brandenburg (d. 1545) and Sebastian von Heusenstamm (d. 1555), both archbishops of Mainz, Dietrich emerges as the foremost mid-century sculptor active in the Middle Rhine region. He was primarily a tomb sculptor though his talents as a portraitist may be observed in a group of medals and perhaps the diminutive bust of Elector Ottheinrich. In addition to members of the archepiscopal court in Mainz, Schros's patrons included the counts of Solms and other regional nobles.

SELECTED SIGNED AND / OR
DOCUMENTED WORKS

c. 1542	*Portrait of Philipp, Count of Solms*, medal
1545–62	*Memorial of the Counts of Solms and their Families* (Lich, Stadtkirche)
1546–50	*Tomb of Albrecht von Brandenburg* (Mainz, cathedral; figs. 122 and 123)
c. 1549	*Tomb of Anna von Cronberg* (d. 1549; Kronberg, Pfarrkirche)
c. 1555	*Portrait of Friedrich Magnus, Count of Solms*, medal
1559	*Tomb of Sebastian von Heusenstamm* (Mainz, cathedral; figs. 125 and 126)

1564 *Tomb of Georg Göler von Ravensburg* (d. 1558; Mainz, cathedral, Memorie)

MAJOR ATTRIBUTED WORKS

c. 1540(?) *Tomb of Konrad von Liebenstein* (d. 1536; Mainz, cathedral, Memorie). This tomb has also been attributed to Mainz sculptor Nikolaus Dickhart.

1551, 1555, *Portraits of Elector Ottheinrich*, medals
1556, 1558,
1559

c. 1556 *Portrait Bust of Elector Ottheinrich* (Paris, Musée du Louvre; fig. 313)

1558 *Portrait of Friedrich III von der Pfalz*, medal

BIBLIOGRAPHY

Georg Habich, "Über zwei Bildnisse des Kurfürsten Otto Heinrich von der Pfalz," *MJBK* 9 (1914–15): pp. 67–86

Habich (1929–34), 1.2: nrs. 1689–1710

Herta Kahle, *Studien zur Mittelrheinischen Plastik des 16. Jahrhunderts* (Bonn, 1939), pp. 80–5

Gaettens (1956), esp. pp. 78–83

Jung (1975), pp. 142–43, 159

Lühmann-Schmid (1976/77), esp. pp. 84–92

Die Renaissance im deutschen Südwesten (1986), nr. I 15

Reber (1990), pp. 17–8.

Peter Schro

Schro (d. 1544/45 Mainz) was one of the leading sculptors of the Middle Rhine during the 1520s. Based upon the style of his signed early epitaph and tombs, he was strongly influenced by Hans Backoffen (d. 1519) of Mainz. Whether he served as an apprentice or journeyman in Backoffen's shop is unknown. Schro is first documented in 1522 working for Cardinal Albrecht von Brandenburg, archbishop of Mainz. In 1525 and 1526 he is described as a court servant. Was he Backoffen's successor as court sculptor? Our documentary evidence for Schro's career is limited. During the mid-1520s the archbishop engaged a follower of Backoffen to work on projects such as the dedication plaques and column statues in the Neue Stift at Halle and the Market Fountain in Mainz. Although I think that Lühmann-Schmid's attributions of these works to Schro are probably correct, her hypothesis is based mainly upon stylistic comparisons with three signed but relatively minor monuments. A solid corpus of sculptures by one artist exists, but the question remains whether this artist can be identified as Schro. He is listed in Mainz tax rolls in 1541 and 1542.

SELECTED SIGNED AND/OR DOCUMENTED WORKS

c. 1517 *Epitaph of Walter von Reiffenburg* (d. 30 Oct. 1517; Kronberg, Pfarrkirche)

1520 *Tomb of Heinrich Meyerspach* (d. 1520; Frankfurt-Höchst, Justinuskirche)

c. 1522 *Tomb of Kuno von Walbrunn* (d. 1522; Partenheim in Rheinhessen, Pfarrkirche)

MAJOR ATTRIBUTED WORKS

c. 1518 *Epitaph of Johann von Hattstein* (d. 1518; Mainz, cathedral, cloister)

1518–20 *Crucifixion* (Mainz, St. Ignace). Main figures by Schro

1522–26 *Christ, Apostles, and Saints,* column statues (Halle, Neue Stift [cathedral]; figs. 52 and 53)

1523 *Dedication Tablet* (Halle, Neue Stift [cathedral])

1526 *Market Fountain* (Mainz, Markt; fig. 182)

c. 1530 *Tomb of Konrad Hofmann* (d. 1527; Frankfurt-Höchst, Justinuskirche)

BIBLIOGRAPHY

Redlich (1900), pp. 126–35

Paul Kautzsch, *Der Mainzer Bildhauer Hans Backoffen und seine Schule* (Leipzig, 1911), esp. pp. 68–74

Gertrud Braune-Plathner, *Hans Backoffen* (Halle, 1934), esp. pp. 49–51

Lühmann-Schmid (1974), pp. 180–86

Lühmann-Schmid (1975)
Lühmann-Schmid (1976–77)
Reber (1990), pp. 16, 101–03.

Georg Schröter

Georg (Torgau c. 1535–1586 Torgau) was the oldest son of Simon Schröter the Elder with whom he trained and occasionally collaborated. He assisted his father on the portal at Schloss Grimmenstein in Gotha in 1553. Following Simon's accident in 1560, Georg likely completed the pulpit of the Schlosskirche in Schwerin, and then received his own commission for a winged altarpiece carved in stone. During the 1560s and especially the 1570s, he made numerous epitaphs and religious works for churches in Saxony and North Germany. His finest creation is the epitaph of Matthias von der Schulenburg completed in 1571 for the Stadtkirche in Wittenberg. Inspired in part by Cornelis Floris' memorial designs, this epitaph features a life-size figure of the deceased kneeling before a complex architectural frame ornamented with various relief scenes and statuettes. It anticipates the complex structures that became so popular in North German memorial art during the late sixteenth century. The success of this epitaph doubtless prompted the Wittenberg council to charge Georg with the sculpture of the new two-story porch of the city hall that he finished in 1573. During this period, Georg was among the finest and most prolific Saxon stone sculptors working outside of the electoral court in Dresden.

SELECTED SIGNED AND / OR DOCUMENTED WORKS

1562	*Altarpiece* (Schwerin, Staatliches Museum, in the Schlosskirche until its transfer in 1855). He likely finished his father's pulpit for this church sometime between 1560 and 1562
1563	*Miscellaneous Sculpture and Designs* (Torgau, city hall)
1564	*Tomb of Elisabeth von Uchtenhagen and Anna von Arnt* (Beesdau [near Luckau], Pfarrkirche)
1570	*Baptismal Font* (formerly Eilenburg, Stadtkirche)
1571	*Epitaph of Matthias von der Schulenburg* (Wittenberg, Stadtkirche)
1573	*Porch Sculptures* (Wittenberg, city hall; fig. 233)
1575	*Pulpit* (Jüterborg, Franziskanerkirche)
1581	*Altar* (Görsdorf [near Dahme], Pfarrkirche)

BIBLIOGRAPHY

Hentschel (1935), pp. 161–62, 168–78
Horst Ende, *Schloss Schwerin* (Leipzig, 1971), np, fig. 5
Findeisen and Magirius (1976), pp. 59, 221, 292, 343
Bellmann, Harksen, and Werner (1979), pp. 108–09, 184, 268.

Simon Schröter the Elder

The career of Simon the Elder (d. 10 August 1568 [Torgau]) was closely linked with that of his chief patron Johann Friedrich, elector of Saxony. When the prince erected a new chapel at Schloss Hartenfels in Torgau between 1540 and 1544, Schröter carved its portal, pulpit, and half of the altar table. Following the battle of Mühlberg in 1547, Johann Friedrich was imprisoned and stripped of his electoral title. Upon regaining his freedom but not his claim to Torgau, the prince moved to Gotha where he used his Torgau artists to rebuild Schloss Grimmenstein between 1552 and 1554. Schröter produced a variant of his Torgau pulpit plus a new portal for the chapel. He may have contributed other sculptures to the palace. During the 1550s Schröter made epitaphs for Torgau's churches, and in 1558 the city commissioned a new baptismal font for the former Alltagskirche. Two years later Schröter's career as a sculptor came to an abrupt end as he lost a hand in an accident. This incident likely occurred after he had begun work on another replica of the Torgau pulpit for Duke Johann Albrecht I of Mecklenburg's new palace church in Schwerin. His sons, Georg and Simon the Younger, helped him complete this and other projects, such as the four stone lions that the workshop placed beneath the

oven of the Ratsstube in Torgau's city hall in 1563. Hentschel has speculated that Schröter occasionally devised architectural plans and that he may have designed portions of the city hall.

SELECTED SIGNED AND / OR
DOCUMENTED WORKS

1540–44 *Pulpit, Altar Table, and Portal* (Torgau, Schloss Hartenfels; figs. 61, 62, 65)

1553 *Pulpit and Portal* (Gotha, Schloss Grimmenstein, chapel). Only parts of the portal sculpture survive at the renamed and rebuilt Schloss Friedenstein

1558 *Baptismal Font* (formerly in Torgau, former Alltagskirche).

1560–62 *Pulpit* (Schwerin, Schlosskirche)

BIBLIOGRAPHY

Hentschel (1935), pp. 153, 155–66
Thulin (1957)
Krause (1970), pp. 12–5
Findeisen and Magirius (1976), pp. 54, 59, 172, 179, 191–92, 207, 218, 221, 233, 306
Hitchcock (1981), pp. 101–04.

Hans Schwarz

Schwarz (1492 Augsburg–mid-1520s[?]) was Germany's first major medalist. He trained as a sculptor with his uncle Stephan Schwarz in Augsburg in 1506. Was he also in the workshop of painter Hans Holbein the Elder who made two portraits of the young Schwarz, now in Berlin (SMBPK, Kupferstichkabinett)? His earliest works are small lindenwood and pearwood carvings, some perhaps intended as plaquette models. In 1517 or early 1518 Schwarz made his first portrait medal of Konrad Peutinger, the Augsburg humanist. The next year he produced medals for Hans Burgkmair, Jakob Fugger, and at least fourteen patrons attending the imperial diet in Augsburg. At the invitation of Melchior Pfinzing, provost of St. Sebaldus, Schwarz moved to Nuremberg in 1519 where over the next year he created numerous portrait sketches and medals of local patricians and artists, including Al-

brecht Dürer. Ludwig Krug apparently cast some of Schwarz's medals. On 25 February 1520, the city council ordered the artist to leave Nuremberg within three days due to several citizen complaints. Schwarz likely returned to Augsburg before journeying to Speyer and to the imperial diet in Worms in 1521. His subsequent fate is unknown though he may have resided briefly in Heidelberg. There exist a group of medals of Nuremberg patricians dating 1523, which prompted scholars to conclude that Schwarz returned to Nuremberg in the mid-1520s. Maué has demonstrated that these are recastings of earlier medals that were given new borders by another medallist so it is unlikely that Schwarz came back to the city. Although Habich and others have argued that Schwarz made medals in Poland (1527), Denmark, Paris (1532), the Netherlands, and Westphalia (mid-1530s), Maué correctly questions the validity of their attributions. Schwarz likely died in the middle or late 1520s. In addition to approximately 149 medals and wooden models, at least 137 portrait drawings dating between 1518 and 1521 exist in Bamberg (Staatsbibliothek), Berlin (SMBPK, Kupferstichkabinett), New York (Metropolitan Museum of Art, Lehman Collection), and Weimar (Kunstmuseum). These sketches were formerly contained in two books owned by the Pfinzing family in Nuremberg. Schwarz may have left the sketchbooks with Melchior Pfinzing, in whose house he resided, when he was forced to leave the city so quickly.

SELECTED SIGNED AND / OR
DOCUMENTED WORKS

1516 *Entombment* (Berlin, SMBPK, Skulpturengalerie; fig. 245)

1516–20 *Apostles* (fragments of a series: *St. James Major* [Berlin, SMBPK, Skulpturengalerie] and *St. John the Evangelist* [Munich, Bayerisches Nationalmuseum])

c. 1516 *Virgin and Child with St. Anne*, (Berlin, SMBPK, Skulpturengalerie)

1518 *Portrait of Jakob Fugger*, medal. Monogrammed and dated

c. 1518 *Portrait of Kunz von der Rosen*, medal. Monogrammed

1519 *St. Margaret* (Schloss Neuenstein, Hohenlohe-Museum)

1519–20	*Portrait of Albrecht Dürer*, medal and wooden model (Braunschweig, Herzog Anton Ulrich-Museum; figs. 287 and 288). Documented
c. 1520	*Death and the Maiden* (Berlin, SMBPK, Skulpturengalerie; fig. 244)
c. 1520	*Judgment of Paris* (Berlin, SMBPK, Skulpturengalerie)
c. 1520	*Judith with the Head of Holofernes* (Berlin, SMBPK, Skulpturengalerie)
1521	*Charles V*, medal. Monogrammed and dated

MAJOR ATTRIBUTED WORKS

1517	*Portrait of Konrad Peutinger*, medal (fig. 283)
1518	*Portrait of Albrecht von Brandenburg*, medal and drawing (Berlin, SMBPK, Kupferstichkabinett; figs. 284 and 285)
1518	*Portrait of Hans Burgkmair*, medal (fig. 286)
1518	*Portrait of Georg the Bearded, duke of Saxony*, medal (fig. 283)
1519	*Portraits of the Five Pfinzing Brothers*, medal (fig. 289)

BIBLIOGRAPHY

Franz Friedrich Leitschuh, *Studien und Quellen zur deutschen Kunstgeschichte des XV.–XVI. Jahrhunderts* (Freiburg, 1912), pp. 199–212

Hans Buchheit, "Beiträge zu Hans Schwarz und Peter Dell dem Älteren," *MJBK* N.F. 1 (1924), pp. 164–68

Habich (1929–34), 1.1: nrs. 111–285 and 2.1: pp. XC–XCVIII

Bange (1928), pp. 26–9

Max Bernhart, "Die Porträtzeichnungen des Hans Schwarz," *MJBK* N.F. 11 (1934): pp. 65–95

Suhle (1950), pp. 13–28

Theodor Müller, "Hans Schwarz als Bildhauer," *Phoebus* 3.1(Basel, 1950–51), pp. 25–30

Zeitler (1951), esp. pp. 77–95

Richard Gaettens, "Der Konterfetter Hans Schwarz auf dem Reichstag zu Worms 1521," *Der Wormsgau* 3, Heft 7 (1951–58): pp. 8–17

Müller (1959), pp. 277–81

Metz (1966), nrs. 676–82

Gagel (1977), pp. 99–103, 142–47

Mende (1983), pp. 57–68, 187–200

Smith (1983), pp. 236–39

Hermann Maué in *Gothic and Renaissance Art in Nuremberg* (1986), pp. 105–06, 416–17, 474

Maué (1988), pp. 12–7

Smith (1989), pp. 46–9, 59–60

Trusted (1990), pp. 102–05.

Hans Vischer

Hans (Nuremberg c. 1489–8 September 1550 Eichstätt) was the third son and pupil of Peter the Elder. Between 1508 and 1519 he certainly contributed to the modelling and casting of the family's *Shrine of St. Sebaldus* (fig. 10) in the Sebalduskirche in Nuremberg and, from 1515 onwards, the Fugger Chapel grille. Heinrich Röttinger has speculated, incorrectly I believe, that Hans is identical with the Monogrammist H. V. who worked in Nuremberg as a painter and printmaker in the circle of Hans Springinklee. His early career seems to have been spent in the family workshop. Other than the double tomb that he executed for Johann Cicero and Johann I von Brandenburg between 1524 and 1530, little is known about his art until after he assumed control of the workshop following his father's death on 7 January 1529. Four days later Hans took possession of his father's house. The city council ordered the redsmiths (brass and bronze casters) organization to accept Hans as a master on 22 May 1532.

During the 1530s and early 1540s Hans produced numerous epitaphs, tombs, reliefs, and other brasses. In 1530 he signed and dated his *Apocalyptic Woman*, the pendant to Peter the Younger's epitaph of Albrecht von Brandenburg originally for the Neue Stift in Halle. Between 1532 and 1534 he prepared the large epitaph of Johann the Steadfast in the Schlosskirche in Wittenberg. Based upon the style of these, several other commemorative monuments are ascribed to Hans. During the early 1530s he provided a grille and candelabra for the Sigismund or Royal chapel in Wawel cathedral in Cracow. In 1536 the Nuremberg council charged

him with completing the Fugger Chapel grille that it had acquired in 1530 and now intended for the great hall of the Rathaus. These are large, showy projects. Unlike Peter the Younger or his own son Jörg, Hans made few small statuettes.

By the mid-1540s Hans's financial and personal situation had deteriorated badly. He sold the family house to Jörg in 1546. His wife, Kunigund Schweycker, died in 1547. Finally a series of council records for 18 to 24 July 1549 indicate that Hans petitioned for permission to reside in Eichstätt for five years. The Nuremberg council granted his request but only under the condition that as a "sworn handworker" he promise never to practice his trade. When he left Nuremberg shortly afterwards, control of the family workshop and foundry passed to Jörg.

SELECTED SIGNED AND/OR DOCUMENTED WORKS

1508–19 *Shrine of St. Sebaldus* (Nuremberg, St. Sebaldus; fig. 10). Hans helped his family in the final stages of this project

1524–30 *Double Tomb of Elector Johann Cicero and Johann I von Brandenburg. His Son* (Lehnin, Klosterkirche but since 1545 in Berlin, cathedral)

1530 *Apocalyptic Woman* ([*Epitaph of Albrecht von Brandenburg*] Aschaffenburg, Stiftskirche; fig. 94)

1530–32 *Grille* (Cracow, Wawel cathedral, Sigismund chapel)

1532–34 *Epitaph of Johann the Steadfast* (Wittenberg, Schlosskirche)

1534 *Two Candelabras* (Cracow, Wawel cathedral, Sigismund chapel)

1536–40 *Grille* (formerly Nuremberg, city hall; fragments in Annecy, Château de Montrottier, Musée Léon Marès; figs. 228–230). Hans likely worked on the grille during the late 1510s. Assisted by Jörg

1543 *Christ and the Canaanite Woman* (formerly above the entrance to the Schlosskapelle at Neuburg an der Donau; Munich, Bayerisches Nationalmuseum; fig. 56). Although not specifically documented or signed,

this relief is a variant of that on the *Epitaph of Margareta Tucher* of 1521 in Regensburg cathedral that bears the workshop mark. As the current head of the workshop, Hans certainly authored this revision

MAJOR ATTRIBUTED WORKS

1521 *Memorial Tablets of Henning Goden* (two copies: Erfurt, cathedral and Wittenberg, Schlosskirche)

1536 *Baldachin* (Aschaffenburg, Stiftskirche—originally intended for the Neue Stift in Halle; fig. 95)

c. 1541 *Epitaph of Hektor Pömer* (Nuremberg, St. Lorenz)

c. 1543 *Christ and the Canaanite Woman*, drawing for the Neuburg relief (London, British Museum; fig. 57)

c. 1544 *Epitaph of Sigismund von Lindenau* (Merseburg, cathedral; fig. 90)

BIBLIOGRAPHY

Hampe (1904—I), nrs. 983, 1661, 1752, 1758, 1762, 1778, 1833, 1924, 2015, 2126–27, 2240, 2399, 2547, 2790, 3179, 3182, 3184–86

Meller (1925), pp. 18, 204–14

Heinrich Röttinger, *Dürers Doppelgänger* (Strasbourg, 1926), esp. pp. 147ff.

Fritz Traugott Schulz, "Vischer, Hans," in Thieme and Becker (1907–50), 34: pp. 411–13

Bellmann, Harksen, and Werner (1979), pp. 100–02

Michal Rozek, *The Royal Cathedral at Wawel* (Warsaw, 1981), pp. 41, 84, 92

Riederer (1983)

Gothic and Renaissance Art in Nuremberg (1986), pp. 402–05, 424, 439

Rowlands (1988), pp. 140–41.

Hermann II Vischer

Named for his grandfather, who became a Nuremberg citizen in 1453 and directed the family foun-

dry until his death in 1488, Hermann II (Nuremberg c. 1486 or 1488–1 January 1517 Nuremberg) was the son of Peter the Elder. Johann Neudörfer, writing a brief biography in 1547, claimed that Hermann was the eldest son though we have no evidence to prove whether or not he was older than Peter the Younger who was born in 1487. In 1513 he married Ursula Mag. Upon her death in the following year, Hermann travelled at his own expense to Rome. Neudörfer's comments are corroborated by a collection of 20 drawings of architecture by Hermann, now in Paris, that offer views and/or plans of the Pantheon, the Colosseum, and several contemporary structures. The drawings indicate that he passed through Siena and Mantua, where he depicted the facade of S. Antonio built by Alberti. Others are apparently of his own design including an octagonal chapel and a tempietto reminiscent of Bramante's at S. Pietro in Montorio in Rome. Six of the drawings are dated 1515. Seven others are inscribed 1516. Before November 1515 Hermann was back in Nuremberg. The later drawings include new designs for the architecture of the *Shrine of St. Sebaldus* and for rebuilding the cathedral of Bamberg in a Renaissance style. On 2 January 1516 acquired a house on the Kornmarkt. The artist died suddenly less than a year later in a sleigh accident on New Year's night. In 1507 and 1511 Peter the Younger produced two portrait medals of Hermann, now in Paris (Bibliothèque Nationale; fig. 281) and Berlin (SMBPK, Münzsammlung).

Neudörfer praised Hermann as being as talented as his father in matters such as casting, sketching, architectural designs, and creating models. These laudatory comments have prompted scholars, such as Meller, to attribute numerous Vischer workshop brasses that vary slightly from Peter the Elder's style to Hermann. Unfortunately, the evidence to support these claims is negligible. The artist never signed any of his works. From 1508 onwards he was involved in the design and casting of the family's greatest project, the *Shrine of St. Sebaldus*. When Pankraz Bernhaupt (called Schwenter) wrote in November 1515 that Hermann was at the beginning of a great new work, he certainly meant the grille originally intended for the Fugger Chapel in St.-Anna-Kirche in Augsburg. Before his death Hermann had completed its design and several casting models.

SELECTED SIGNED AND/OR DOCUMENTED WORKS

1508–16 *Shrine of St. Sebaldus* (Nuremberg, St. Sebaldus; fig. 10). This family project was completed in 1519

1512–16 *Grille* (originally commissioned by Jakob Fugger for his family chapel in St.-Anna-Kirche in Augsburg; the contract was terminated in 1529 and the city of Nuremberg acquired the grille in 1530. Hans Vischer completed the revised program between 1536 and 1540 when it was installed in the great hall of the Nuremberg Rathaus. It was sold in 1806 and much of the grille was melted down. Since 1916 four fragments are in Annecy, Château de Montrottier, Musée Léon Marès; figs. 228–230)

1515–16 *Twenty Architectural Drawings* (Paris, Musée du Louvre; fig. 231)

MAJOR ATTRIBUTED WORKS

1508–12 *Tomb of Elisabeth and Hermann VIII zu Henneberg* (Römhild, Stadtkirche). Peter the Elder received this commission but Hermann seems to have done most of the figural work

1508–12 *Pilgrim* (Vienna, Kunsthistorisches Museum). Stylistically associated with the Romhild tomb

c. 1510 *Two Lions* (Nuremberg, Germanisches Nationalmuseum). Stylistically associated with the Romhild tomb

BIBLIOGRAPHY

Neudörfer (1875), pp. 21, 31–3

Hampe (1904—I), nr. 977

Meller (1925), pp. 16–7, 124–63

Habich (1929–34), 1.1: nrs. 1, 3

Demonts (1938), pp. 70–4

Bange (1949), pp. 21–6, 118

Staftski (1962, pp. 9–16, 37–8, 47–8

Wuttke (1964), pp. XIX, 106–07, 111–12, 292–93

Hitchcock (1981), pp. 34–5

Gothic and Renaissance Art in Nuremberg (1986), pp. 384–85, 387–91, 402–05
Dessins de Dürer et de la Renaissance germanique dans les collections publiques parisiennes, exh. cat. Musée du Louvre, Paris (Paris, 1991), nrs. 97–9.

Jörg (Georg) Vischer

Jörg (Nuremberg c. 1522–1592 Nuremberg) was the last member of the illustrious Vischer family of brass founders and sculptors. He trained and collaborated with his father Hans. Jörg was certainly one of the sons given "Trinkgeld" (a gratuity) by the city council in January 1540 upon the completion of the grille for the Rathaus. By 1546 the young artist purchased the family house from his father. Three years later Hans left Nuremberg and the direction of the family workshop and foundry passed to Jörg. Radcliffe has proposed that Georg Pencz's *Portrait of a 27-Year-Old-Man*, dated 1549 and now in Dublin (National Gallery of Ireland; fig. 241), depicts Jörg and was occasioned by his newly gained status. In this picture the well-dressed young man proudly holds a statuette group of *Pan Seducing Luna* that is analogous in size and design to Jörg's sole autograph sculpture—the *Inkpot with the Figure of Vanitas*, dated 1547, in Berlin. Radcliffe's thesis is appealing though not fully proven. These statuettes are typical of his production as the artist seems to have specialized almost exclusively in small brasses often with mythological or allegorical themes. Unfortunately, little is really known about his career especially after 1556. A statuette of a *Knight on Horseback* is recorded in a late seventeenth-century inventory of the Volckamer, a local patrician family. A host of small brasses of widely diverging quality and style have been grouped, often incorrectly, under his name.

SELECTED SIGNED AND/OR DOCUMENTED WORKS

1536–40 *Grille* (formerly Nuremberg, city hall; fragments in Annecy, Château de Montrottier, Musée Léon Marès; figs. 228–230). Jörg assisted his father

1547 *Inkpot with the Figure of Vanitas* (Berlin, SMBPK, Skulpturengalerie; fig. 255).

Inscribed "1547/G.F." Purchased in Nuremberg in 1890

1556 *Inkpot with the Figure of Orpheus* (Florence, Bargello). It bears the family workshop's mark

MAJOR ATTRIBUTED WORKS

1542 (?) *Boy with a Dog* (Nuremberg, Germanisches Nationalmuseum)

BIBLIOGRAPHY

Meller (1925), pp. 19, 214–15
Bange (1949), pp. 26, 30, 32–3, 121–23
Metz (1966), p. 124
Weihrauch (1967), pp. 281, 286, 312
Anthony Radcliffe, "A Portrait of Georg Vischer," *Apollo* 2 (1974): pp. 126–29
Gagel (1977), pp. 148–51
Gothic and Renaissance Art in Nuremberg (1986), pp. 405–06.

Peter Vischer the Younger

Peter the Elder (Nuremberg c. 1460–1529 Nuremberg) ran Germany's foremost metal foundry, producing fine epitaphs and other works of art. Increasingly from about 1508 he involved his five sons (Peter the Younger [Nuremberg 1487–1528 Nuremberg], Hermann II [Nuremberg c. 1486 or 1488–1517 Nuremberg], Hans [Nuremberg c. 1489–1550 Eichstätt], Jakob, and Paulus [d. 1531]) in projects such as the monumental *Shrine of St. Sebaldus* (fig. 10). Since Hermann's precise birthdate is not known, it is uncertain whether Hermann or Peter the Younger was the oldest brother. Peter the Younger was the family's most talented and innovative sculptor. In 1507 he made a portrait medal of Hermann, perhaps the earliest true German portrait medal. Far more accomplished is his *Self-Portrait* of 1509. The qualitative differences between these medals have prompted scholars to suggest that Peter journeyed to Italy in 1507. A second trip to North Italy, specifically Padua, has been proposed during the years 1512 to 1514 when there was a hiatus in work on the *Shrine of St. Sebaldus*. Peter the Younger's fascination with

Italian art, notably the small bronzes of Andrea Riccio, plus his sudden adoption of the lost-wax casting technique make an extended stay in Padua likely.

Peter the Younger only became a master in the redsmiths' (brass and bronze casters') organization in 1527. As a member of his father's workshop, he had avoided craft membership until this time. His admission, however, was imposed on the redsmiths by the city council who on 22 May accepted the artist's *Epitaph of Friedrich the Wise* as his masterpiece. Peter was a tremendously versatile sculptor who seems to have supplied designs plus wooden and wax models that were cast by other members of the family workshop. In addition to his contributions to the *Shrine of St. Sebaldus* and several epitaphs, he created brass plaquettes and statuettes, three medals, and numerous drawings. The *Allegory of the Reformation*, dated 1524 and today in Weimar, is strongly pro-Lutheran as a heroic nude labelled Luther guides a family from the ruins of the Catholic Church. Several other drawings accompany the literary texts of Peter's close friend, the humanist Pankraz Bernhaupt, called Schwenter. Johann Neudörfer, writing a brief biography of the artist in 1547, observed that Peter loved reading histories and poetry, and that in collaboration with Schwenter he made numerous colored drawings. The arrangement between artist and scholar recalls the contemporary association of Albrecht Dürer and Willibald Pirckheimer. Peter provided illustrations for Schwenter's *Apologia poetarum* (c. 1512–14) and *Histori Herculis* (c. 1515). He signed many of his works either with his monogram or with the symbol of two fish impaled on an arrow, a play on the family name.

SELECTED SIGNED AND/OR DOCUMENTED WORKS

1508–19 *Shrine of St. Sebaldus* (Nuremberg, St. Sebaldus; fig. 10). Collaborated with his father, who initiated the project in about 1488, and other members of the workshop

1509 *Self-Portrait*, medal (Paris, Bibliothèque Nationale; fig. 282). Inscribed "EGO PETR[VS] FISCHER MEVS

ALTER 22 AN[NO] 1509." ("I am Peter Vischer at the age of 22 in the year 1509.")

c. 1516 *Orpheus Losing Eurydice at the Gates of Hades*, plaquette (Washington, National Gallery of Art; fig. 238)

c. 1516 *Orpheus and Eurydice*, plaquette (copies: Hamburg, Museum für Kunst und Gewerbe—fig. 240; Berlin, SMBPK, Skulpturengalerie; Sankt Paul im Lavanttal, Benediktinerstift)

c. 1516 *Inkpot* (Oxford, Ashmolean Museum; fig. 242)

1519 *Eurydice*, drawing (Paris, Musée du Louvre)

1524 *Allegory of the Reformation*, drawing (Weimar, Goethe-Nationalmuseum)

1525 *Epitaph of Albrecht von Brandenburg* (Aschaffenburg, Stiftskirche; fig. 93)

1525 *Inkpot* (Oxford, Ashmolean Museum; fig. 243)

1527 *Epitaph of Friedrich the Wise* (Wittenberg, Schlosskirche; fig. 96)

MAJOR ATTRIBUTED WORKS

1507 *Portrait of Hermann Vischer*, medal (Paris, Bibliothèque Nationale; fig. 281)

c. 1512 18 colored drawings for Pankraz Schwenter's *Apologia poetarum* (Berlin, Staatsbibliothek Preussischer Kulturbesitz; fig. 237)

c. 1513 *Epitaph of Dr. Anton Kress* (Nuremberg, St. Lorenz; fig. 87)

1514 *Scylla* (recto) and *Orpheus and Eurydice* (verso), drawings (Nuremberg, Germanisches Nationalmuseum; fig. 239)

c. 1515 3 drawings for Pankraz Schwenter's *Histori Herculis* (Berlin, SMBPK, Kupferstichkabinett—two drawings; and Nuremberg, Stadtbibliothek)

BIBLIOGRAPHY

Neudörfer (1875), p. 33
Georg Seeger, *Peter Vischer d. Jüngere* (Leipzig, 1897)

Meller (1925), esp. pp. 17–9, 164–203

Habich (1929–34), 1.1: nrs. 1–5

Demonts (1938), pp. 74–8

Bange (1949), pp. 15–23, 115–17

Dieter Wuttke, "Die Handschriften-Zeugnisse über das Wirken der Vischer," *Zeitschrift für Kunstgeschichte* 22 (1959): pp. 324–36

Stafski (1962) [currently Stafski and Klaus Pechstein are preparing a new monograph on the artist]

Wuttke (1964), esp. pp. 105–12, 292–323

Dieter Wuttke, "Vitam non mortem recogita. Zum angeblichen Grabepitaph für Peter Vischer den Jüngeren," *Forschungen und Fortschritte* 39 (1965): pp. 144–46

Wuttke (1966), pp. 143–46

Weihrauch (1967), pp. 271–81

Dieter Wuttke, "Methodisch-Kritisches zu Forschungen über Peter Vischer den Älten und seine Söhne," *Archiv für Kulturgeschichte* 49 (1967), pp. 208–61

Rasmussen (1975), pp. 81–3

Weber (1975), pp. 55–6

Yvonne Hackenborch, "The Sleeping Hercules," *Jahrbuch der Hamburger Kunstsammlungen* 21 (1976): pp. 43–54

Gagel (1977), pp. 151–55

Hecht (1982)

Riederer (1983)

Smith (1983), pp. 26–7, 42, 45–6, 60–2, 124, 219–22, 234–35

Gothic and Renaissance Art in Nuremberg (1986), pp. 387, 393–401

Fedja Anzelewsky and Franz Josef Worstbrock, *Apologia poetarum* (Wiesbaden, 1987)

Glanz alter Buchkunst: Mittelalterliche Handschriften der Staatsbibliothek Preussischer Kulturbesitz Berlin, exh. cat. Berlin (Wiesbaden, 1988), nr. 125

Rowlands (1988), p. 141

Smith (1989), pp. 49–51

Schleif (1990), pp. 217–18, 220–21.

Christoph I Walther

Christoph (Breslau ?–1546 Dresden) was the first member of the Walther family to settle in Dresden. According to Hentschel, he trained in Breslau and perhaps Vienna before moving to Saxony where he initially appears in Annaberg in 1518 making a crucifix for the cemetery. During the next six years he carved 24 stone busts of Old Testament prophets and kings (c. 1520) and two altars, including the *Münzeraltar* (1522), for the St. Annenkirche. By 1524 Christoph had entered the service of Georg the Bearded, duke of Saxony, in Meissen where he contributed relief carvings for the great staircase of the Albrechtsburg palace. Moving to Dresden around 1530, the sculptor seems to have been the principal master of the decoration of the street and court facades of the Georgenbau of the city palace. Christoph did not work exclusively for Georg as over the next decade and a half he carved epitaphs, fountain figures, large crucifixions, and a wealth of other sculptures for patrons in Dresden, Meissen, Leipzig, and other regional towns. Upon his death the workshop in Dresden passed to his son Hans II.

SELECTED SIGNED AND / OR DOCUMENTED WORKS

1536 *St. Moritz*, fountain figure (formerly Leipzig, Paulinum)

1537 Relief Sculptures (Oschatz, city hall, steps). Only the nineteenth century copies survive

c. 1540 *Epitaph of Christoph von Beschwitz* (Niederrödern, church)

1544 *Crucifixion* (Joachimsthal [Jáchymov], Gottesacker cemetery; Mary and John are in the cemetery and the damaged figure of Christ is in the local museum)

MAJOR ATTRIBUTED WORKS

c. 1524 *Epitaph of Johannes Hennig* (Meissen, cathedral)

c. 1524 *Crucifix* (Bischofswerda, Gottesackerkirche; transferred in 1813 from Stolpen, Schlosskapelle—the residence of the bishops of Meissen)

1530–35 Sculpture for the Street and Court Facades (Dresden, Schloss, Georgenbau; figs. 218 and 219). Only a few fragments of the *Dance of Death* cycle (Dresden, Innerer Neustädter Fried-

hof) and the portal of the court facade still exist

BIBLIOGRAPHY

Kurt Bimler, *Die schlesische Renaissanceplastik, I. Die Frührenaissance* (Breslau, 1934), pp. 25–36

Walter Hentschel, *Sächsische Plastik um 1500* (Dresden, 1926), pp. 26–30

Walter Hentschel, "Epitaphe in der alten Dresdner Frauenkirche," *Jahrbuch der Staatlichen Kunstsammlungen Dresden* (1963/64): esp. pp. 101–106

Die Bezirke Dresden, Karl-Marx-Stadt, Leipzig [*Handbuch der Deutschen Kunstdenkmäler*, N.F., general editor Georg Dehio] (Munich, 1965), pp. 12, 14, 37, 48, 70, 80, 267–68, 270, 272, 274, 313, 326, 356, 367, 394

Hentschel (1966), pp. 26–37, 106–12

Hans-Joachim Krause, "Die Grabkapelle Herzog Georgs von Sachsen und seiner Gemahlin am Dom zu Meissen," in Franz Lau, ed., *Das Hochstift Meissen: Aufsätze zur sächsischen Kirchengeschichte* (Berlin, 1973), esp. p. 385.

Christoph II Walther

Christoph (Breslau 1534–1584 Dresden) was the third member of the Breslau family of sculptors to settle in Dresden, where he obtained citizenship on 11 November 1562. He was the son and pupil of Andreas I (d. c. 1560), the younger brother of Christoph I. His move to Dresden was facilitated by his cousin, Hans II, with whom he collaborated on projects such as the Wettin Family Monument in Petersburg in 1565–67. Hans may also have been instrumental in securing orders for epitaphs and other commissions for Christoph during his early years in Dresden. Christoph soon established his own reputation with the elaborate *Crucifixion Altar* (1564) in Penig and the monumental epitaph of Hugo von Schönburg-Glauchau (1567) originally in the palace chapel in Waldenburg. Elector August of Saxony sent Christoph and Hans on a trip through Saxony in August 1574 in search of high-quality marble. In 1583 Christoph undertook a similar journey to Karlstein in Bohemia. On this occasion he was likely looking for marble and other

fine-colored stones that he could use for his greatest sculpture—the "positiv" or figured organ case that he designed in 1583 and had largely completed before his death. Although originally intended for the Schlosskapelle in Dresden, August placed the organ instead in his *Kunstkammer*. Christoph had four sons who became sculptors: Andreas (c. 1560–96), Christoph IV (c. 1572–1626), Michael (c. 1574–1624), and Sebastian (1576–1645). His daughter Maria married Melchior Jobst (d. c. 1594), another Dresden sculptor. Christoph II and his son Sebastian were probably the most talented of the extended family of Walthers who were active in Dresden from about 1530 until the late seventeenth century.

SELECTED SIGNED AND/OR
DOCUMENTED WORKS

1564	*Crucifixion Altar* (Penig, Stadtkirche)
1565	*Fountain* (formerly Görlitz, lower market)
1565–67	*Wettin Family Monument* (Petersberg bei Halle, Klosterkirche; fig. 132). Signed by Christoph and Hans II
1567	*Epitaph of Hugo von Schönsburg-Glauchau* (Waldenburg, Stadtkirche—originally in the palace chapel; fig. 109)
1582	*Epitaph of Nickel Pflugk* (Zabeltitz, Dorfkirche)
1583	*Design for the "Positiv"* [organ case] (Dresden, Staatliche Kunstsammlungen, Historisches Museum; fig. 271)
1583–84	*"Positiv"* [organ case] (destroyed in 1945; formerly Dresden, Staatliche Kunstsammlungen, Historisches Museum; fig. 272)
1584	*Altar* (formerly Dresden, Frauenkirche)

BIBLIOGRAPHY

Ernst Sigismund, "Walther, Christoph II" in Thieme and Becker (1907–50), 35: pp. 112–13

Walter Hentschel, "Epitaphe in der alten Dresdener Frauenkirche," *Jahrbuch der Staatlichen Kunstsammlungen Dresden* (1963–64): esp. pp. 114–20

Die Bezirke Dresden, Karl-Marx-Stadt, Leipzig [*Handbuch der Deutschen Kunstdenkmäler*, N.F., general editor Georg Dehio] (Munich, 1965), pp. 29, 49, 81, 180, 199, 322, 410, 430

Hentschel (1966), pp. 45, 47–50, 52–60, 120, 121, 124–27, 129–33, 135

Werner Schade, *Dresdner Zeichnungen 1550–1650* (Dresden, 1969), nr. 122

Walter Hentschel, *Denkmale sächsischer Kunst—Die Verluste des zweiten Weltkrieges* (Berlin, 1973), pp. 55, 61–2.

Hans II Walther

Hans (Dresden or Meissen 1526–10 September 1586 Dresden) enjoyed a successful career as both a sculptor and as the mayor (Burgermeister) of Dresden in alternate years beginning in 1571. Tobias Wolff's portrait medal of Hans is proudly inscribed "JOHAN WALTER BVRGEMEI. V. BILTHAV. Z. DRES AET 51." Hans acquired Dresden citizenship in 1548, two years after the death of Christoph I, his father and teacher. Immediately he began working for Moritz, elector of Saxony, on the new porch of the palace in Dresden. For Moritz' brother and successor August, Hans carved the *Electoral Monument* and the portal of the palace church in Dresden plus a baptismal font for the Jakobikirche in Freiberg. The attractive mix of German and Italian artistic styles on the portal doubtlessly inspired Duke Johann Albrecht I of Mecklenburg to hire Hans as the sculptor of the portal of his new palace chapel in Schwerin in 1560. The artist was first chosen as a city counsellor in 1561. His involvement in civic government would continue to grow in subsequent years. Nevertheless, he continued receiving important commissions up until his death.

SELECTED SIGNED AND / OR DATED WORKS

1555	*Baptismal Font* (Freiberg, Jakobikirche)
1556–57	*Pulpit* (Dresden, Frauenkirche; this is probably identical with the pulpit now in Bischofswerda, Gottesacker-kirche)
1560–61	*Portal* (Schwerin, Schlosskirche)
1565–67	*Wettin Family Monument* (Petersberg bei Halle, Klosterkirche; fig. 132). Signed by Hans and his cousin Christoph II
1572–79	*Last Supper Altar* (Dresden, Kreuzkirche; now in reduced form in Schandau, Stadtkirche; figs. 68 and 69). Hans's drawing for this altar is in Leipzig, Museum der bildenden Künste
1576	*"Ritter Dutschmann" Fountain* (Bautzen, city hall). Documented as by the "alten Walter" whom Hentschel identifies as Hans
1585–85	*Epitaph of Damian von Sebottendorf* (Pirna, Stadtkirche)

MAJOR ATTRIBUTED WORKS

c. 1552	*Old Testament Battle Reliefs* (Dresden, palace, porch of the Moritzbau; fragments of the reliefs are now in the Stadtmuseum; fig. 220)
c. 1553	*Saxon Electoral Succession Monument* (Dresden, Brühl Terrace; only portions survive; figs. 143 and 144)
1555	*Portal* (Dresden, palace, chapel; only the lower parts survive; fig. 66)

BIBLIOGRAPHY

J. L. Sponsel, *Fürstenbilder aus dem Hause Wettin* (Dresden, 1906), pp. 1–2

Habich (1929–34), 2.1: nr. 2045

Löffler (1958), pp. 18–9

Walter Hentschel, "Epitaphe in der alten Dresdner Frauenkirche," *Jahrbuch der Staatlichen Kunstsammlungen Dresden* (1963–64): pp. 102, 108, 110, 112, 117

Hentschel (1966), esp. pp. 37, 40–7, 50–4, 59–60, 62, 103, 112–23, 126–29, 132, 134

Claude Keisch, "Das Dresdner Moritzmonument von 1553 und einige andere plastische Zeugnisse kursächsischer Staatsreprasentation," *Jahrbuch der Staatlichen Kunstsammlungen Dresden* (1970–71): pp. 145–65

Horst Ende, *Schloss Schwerin* (Leipzig, 1971), np, fig. 6

Karl-Heinz Mehnert, *Deutsche Zeichnungen 1600–*

1650—Museum der bildenden Künste Leipzig (Leipzig, 1976), np (Walther, Hans).

Christoph Weiditz (Weyditz)

Christoph ([Freiburg i. B.] c. 1500–1559 Augsburg) was a multitalented medallist, goldsmith, and sculptor of small figures. He likely trained with Hans Wydyz, his father(?). Based upon a group of dated medals attributed to the artist, he first worked in Strasbourg from 1523 to 1526 before moving to Augsburg. Between 1529 and 1532 Christoph travelled widely as a member of Emperor Charles V's court. In 1529 he journeyed to Spain, where he made several medals including one for Ferdinand Cortez, then continued on to Genoa and Bologna before returning to Augsburg for the imperial diet in 1530. He next accompanied the court through the Rhine valley to the Low Countries. During these years Christoph kept a *Trachtenbuch*, a book in which he sketched costumes and recorded various comments about his travels. Among the book's drawings are portraits of Cortez and the artist. In 1532 Christoph settled permanently in Augsburg where on 3 March he became a master in the goldsmith guild. His entry was hardly routine since guild officers strenuously complained that he had trained as a sculptor not a goldsmith and that he lacked a masterpiece. In fact, Charles V had granted him an imperial privilege on 7 November 1530 permitting him to be a master without the customary masterpiece. Christoph would continue to have trouble with the guild throughout his career. The artist married Regina, sister of the sculptor Joachim Forster (c. 1500–79).

Christoph worked primarily as a medallist. Over one hundred boxwood models and cast medals are attributed to him. None is signed though a few are documented. Christoph's full signature appears on a dagger and case in Dresden. Its elaborate Fortuna and other female figures provide the stylistic basis for ascribing several statuettes to the artist. Little is known about his activities after 1550. A terracotta *Bust of a Man* in London (Victoria and Albert Museum) was given to Christoph by Vöge and many other scholars; however, in 1982 a material analysis proved that the bust could not date before the late eighteenth century.

SELECTED SIGNED AND/OR DOCUMENTED WORKS

1529–32 *Trachtenbuch* (*Costume Book*; Nuremberg, Germanisches Nationalmuseum, ms. 22474.4). Includes numerous drawings by the artist

1531 *Portrait of Johann Dantiskus, bishop of Culm*, wooden model (Berlin, SMBPK, Münzsammlung) and medal. Documented in a letter as by "Christoph Pildhawer"

c. 1540 *Figured Dagger, Sheath, and Knife* (Dresden, Staatliche Kunstsammlungen, Historisches Museum). Prominently inscribed "CHRISTOF WEYDITZ/ IN AVGVSTA VIN/DELICA FACIEBAT"

MAJOR ATTRIBUTED WORKS

1523 *Portrait of Johann Huttich von Idstein*, medal

1527 *Portrait of Otmar Widenmann*, wooden model for a medal (Munich, Staatliche Münzsammlung)

1529 *Portrait of Ferdinand Cortez*, medal

1530 *Portrait of Count Wolfgang von Montfort*, medal

1530s *Portrait of Charles de Solier*, boxwood model for a medal (London, Victoria and Albert Museum; fig. 295)

1535–40(?) *Cleopatra*, ivory (Nuremberg, Germanisches Nationalmuseum). The attribution of this carving to Weiditz, who is otherwise not known to have worked in ivory, is problematic

1537 *Portrait of Georg the Bearded, duke of Saxony*, medal

c. 1540–50 *Venus*(?), firegilt bronze (Berlin, SMBPK, Skulpturengalerie; fig. 256)

BIBLIOGRAPHY

Theodor Hampe, ed., *Das Trachtenbuch des Christoph Weiditz von seinen Reisen nach Spanien (1529) und den Niederlanden (1531/32)* (Berlin, 1927)

Habich (1929–34), 1.1: nrs. 324–431

Vöge (1932), pp. 148–62
Suhle (1950), pp. 29–35
Zeitler (1951), esp. pp. 96–106
Müller (1959), pp. 294–95
Weihrauch (1967), pp. 304, 306, 308–09

Gagel (1977), pp. 127–34
Alfred Schädler in *Welt im Umbruch* (1980–81), 2: nrs. 581–86
Schädler (1987), pp. 161–84
Trusted (1990), pp. 117–20.

SUMMARY BIBLIOGRAPHY

List of Abbreviations

AGNM *Anzeiger des Germanischen Nationalmuseum*

B. (+ nr.) Adam Bartsch, *Le Peintre-Graveur*, 21 vols. (Vienna, 1803–70)

Geisberg (+ nr.) Geisberg (1974)

Habich (+ nr.) Habich (1929–34)

JKSAK *Jahrbuch der kunsthistorischen Sammlungen der allerhöchsten Kaiserhauses*

JKSW *Jahrbuch der kunsthistorischen Sammlungen in Wien*

JPKS *Jahrbuch der preussischen Kunstsammlungen*

MJBK *Münchner Jahrbuch der bildenden Kunst*

MVGN *Mitteilungen des Vereins für Geschichte der Stadt Nürnberg*

NDB *Neue Deutsche Biographie*, vol. 1– (Berlin, 1953–)

RDK *Reallexikon zur deutschen Kunstgeschichte*, vol. 1– (Stuttgart, 1937–)

SMBPK Staatliche Museen zu Berlin Preussischer Kulturbesitz

ZDVK *Zeitschrift des deutschen Vereins für Kunstwissenschaft*

Ackermann (1985) Hans Christoph Ackermann, "The Basle Cabinets of Art and Curiosities in the Sixteenth and Seventeenth Centuries," in Impey and MacGregor (1985), pp. 62–68

Angerer (1984) Martin Angerer, *Peter Flötners Entwürfe*, Ph.D. diss., Munich, 1983 (Kiel, 1984)

Balke (1916) Franz Balke, *Über die Werke des Kurtrierischen Bildhauers Hans Ruprecht Hoffmann* (Trier, 1916)

Bange (1928) Ernst F. Bange, *Die Kleinplastik der deutschen Renaissance in Holz und Stein* (Florence, 1928)

Bange (1949) Ernst F. Bange, *Die deutschen Bronzestatuetten des 16. Jahrhunderts* (Berlin, 1949)

Bauch (1976) Kurt Bauch, *Das mittelalterliche Grabbild* (Berlin, 1976)

Baxandall (1974) Michael Baxandall, *South German Sculpture 1480–1530—Victoria and Albert Museum* (London, 1974)

Baxandall (1980) Michael Baxandall, *The Limewood Sculptors of Renaissance Germany* (New Haven, 1980)

Beck and Blume (1985) Herbert Beck and Dieter Blume, eds., *Natur und Antike in der Renaissance*, exh. cat. Liebieghaus (Frankfurt, 1985)

Beck and Decker (1982) Herbert Beck and Bernhard Decker, eds., *Dürers Verwandlung in der Skulptur zwischen Renaissance und Barock*, exh. cat. Liebieghaus (Frankfurt, 1982)

Bellmann, Harksen, and Werner (1979) Fritz Bellmann, Marie-Luise Harksen, and Roland Werner, *Die Denkmale der Lutherstadt Wittenberg* (Weimar, 1979)

Bialostocki (1976-I) Jan Bialostocki, "The Baltic Area as an Artistic Region in the Sixteenth Century," *Hafnia* (1976): pp. 11–23

Bialostocki (1976–II) Jan Bialostocki, *The Art of the Renaissance in Eastern Europe* (Ithaca, 1976)

Bier (1925–78) Justus Bier, *Tilmann Riemenschneider*, 4 vols. (Würzburg, Augsburg, Vienna, 1925–78)

Bier (1982) Justus Bier, *Tilmann Riemenschneider: His Life and Work* (Lexington, 1982)

Biermann (1975) Alfons W. Biermann, "Die Miniaturenhandschriften des Kardinals Albrecht von Brandenburg (1514–1545)," *Aachener Kunstblätter* 46 (1975): pp. 15–310

Bireley (1988) Robert Bireley, "Early Modern Germany," in John W. O'Malley, ed., *Catholicism in Early Modern History: A Guide to Research* (St. Louis, 1988), pp. 11–30

Blendinger and Zorn (1976) F. Blendinger and W. Zorn, *Augsburg, Geschichte in Bilddokumenten* (Munich, 1976)

Bock (1921) Elfried Bock, *Die Zeichnungen alter Meister im Kupferstichkabinett*, I: *Die Deutschen Meister* (Berlin, 1921)

Bock (1929) Elfried Bock, *Die Zeichnungen in der Universitätsbibliothek Erlangen*, 2 vols. (Erlangen, 1929).

Boockmann (1988) Hartmut Boockmann, *Die Stadt im späten Mittelalter* (Munich, 1988)

Braun (1951) Edmund Braun, "Ein Nürnberger Bronzebrunnen von 1532/33 im Schlosse in Trient," *MJBK*, 3rd ser., 2 (1951): pp. 195–203

Braun (1988) Joseph Braun, *Tracht und Attribute der Heiligen in der deutschen Kunst* (Berlin, 1988)

Braune-Plathner (1934) Gertrud Braune-Plathner, *Hans Backoffen* (Halle, 1934)

Braunfels (1979–89) Wolfgang Braunfels, *Die Kunst im Heiligen Römischen Reich Deutscher Nation*, 6 vols. (Munich, 1979–89)

Bräutigam (1987) Günther Bräutigam, "Der Nürnberger Apollo-Brunnen von 1532," *Städel-Jahrbuch* N.S. 11 (1987): pp. 205–24

Bruck (1903) Robert Bruck, *Friedrich der Weise als Förderer der Kunst* (Strasbourg, 1903)

Brück (1972) Anton Ph. Brück, *Mainz von Verlust der Stadtfreiheit bis zum Ende des dreissigjährigen Krieges (1462–1648)* (Düsseldorf, 1972).

Bruhns (1923) Leo Bruhns, *Würzburger Bildhauer der Renaissance und der werdenden Barock. 1540–1650* (Munich, 1923)

Buczynski (1981) Bodo Buczynski, ed., *Tilman Riemenschneider: frühe Werke*, exh. cat. Mainfränkisches Museum, Würzburg (Regensburg, 1981)

Bulst (1975) Wolfger A. Bulst, "Der 'Italienische Saal' der Landshuter Stadtresidenz und sein Darstellungsprogramm," *MJBK* 26 (1975): pp. 123–76

Bunjes et al. (1938) Hermann Bunjes et al., *Die kirchlichen Denkmäler der Stadt Trier mit ausnahme des Domes* [Die Kunstdenkmäler der Rheinprovinz, vol. 13.III] (Düseldorf, 1938—reprinted Trier, 1981)

Busch (1973) Renate von Busch, *Studien zu deutschen Antikensammlungen des 16. Jahrhunderts* (Tübingen, 1973)

Campbell (1990) Lorne Campbell, *Renaissance Portraits* (New Haven, 1990)

Christensen (1965) Carl C. Christensen, "The Nuernberg City Council as a Patron of the Fine Arts," Ph.D. diss., Ohio State University, 1965

Christensen (1972) Carl C. Christensen, "The Significance of the Epitaph Monument in Early Lutheran Ecclesiastical Art (ca. 1540–1600): Some Social and Iconographical Considerations," in Lawrence P. Buck and Jonathan W. Zophy,

eds., *The Social History of the Reformation* (Columbus, 1972), pp. 297–314

Christensen (1979) Carl C. Christensen, *Art and the Reformation in Germany* (Athens [Ohio], 1979).

Cohen (1973) Kathleen Cohen, *Metamorphosis of a Death Symbol: The Transi Tomb in the Late Middle Ages and the Renaissance* (Berkeley, 1973)

Crew (1978) Phyllis Mack Crew, *Calvinist Preaching and Iconoclasm in the Netherlands 1544–1569* (Cambridge, 1978)

de Jong and de Groot (1988) Marijnke de Jong and Irene de Groot, *Ornamentprenten in het Rijksprentenkabinet, I, 15de & 16de Eeuw* (Amsterdam, 1988)

Dehio (1983) Georg Dehio, founding series ed., *Handbuch der deutschen Kunstdenkmäler: Bezirke Berlin/DDR und Potsdam* (Munich, 1983)

Demmler (1910) Theodor Demmler, *Die Grabdenkmäler des Württembergischen Fürstenhauses und ihre Meister im XVI. Jahrhundert* (Strasbourg, 1910)

Demonts (1938) Louis Demonts, *Musée du Louvre—Inventaire général des dessins des écoles du Nord: École Allemandes et Suisses. II. Fin de la première période—Maistres nés avant 1550* (Paris, 1938)

De Ren (1982) Leo De Ren, *De Familie Robijn-Osten: Ieperse Renaissance-Kunstenaars in Duitsland* (Brussels, 1982)

Diemer (1988) Dorothea Diemer, "Hubert Gerhard und Carlo Pallago als Terrakottaplastiker," *Jahrbuch des Zentralinstituts für Kunstgeschichte* 4 (1988): pp. 19–141

Distelberger (1985) Rudolf Distelberger, "The Habsburg Collections in Vienna during the Seventeenth Century," in Impey and MacGregor (1985), pp. 39–46

Domanig (1910) Karl Domanig, *Die deutsche Medaille* (Vienna, 1907)

Dressler (1973) Helga Dressler, *Alexander Colin* (Karlsruhe, 1973)

Egg (1974) Erich Egg, *Die Hofkirche in Innsbruck* (Innsbruck, 1974)

Ehrenberg (1899) Hermann Ehrenberg, *Die Kunst am Hofe der Herzöge von Preussen* (Leipzig, 1899)

Eire (1986) Carlos M. N. Eire, *War Against the Idols: The Reformation of Worship from Erasmus to Calvin* (Cambridge [Engl.], 1986)

Ellger (1966) Dietrich Ellger, *Die Kunstdenkmäler*

der Stadt Schleswig, 2. Der Dom und der ehemalige Dombezirk (Munich, 1966)

Falk (1968) Tilman Falk, *Hans Burgkmair: Studien zu Leben und Werk des Augsburger Malers* (Munich, 1968)

Falk (1979) Tilman Falk, *Katalog der Zeichnungen des 15. und 16. Jahrhunderts im Kupferstichkabinett Basel—Teil 1* (Basel, 1979)

Fehring and Ress (1977) Günther P. Fehring and Anton Ress, *Die Stadt Nürnberg* [Bayerische Kunstdenkmale, X] (Munich, 1977—2nd ed. reworked by Wilhelm Schwemmer)

Felmayer (1986) Johanna Felmayer et al., *Die Kunstdenkmäler der Stadt Innsbruck: Die Hofbauten* [Österreichische Kunsttopographie, Bd. XLVII] (Vienna, 1986)

Feulner (1926) Adolf Feulner, *Die deutsche Plastik des sechzehnten Jahrhunderts* (Florence, 1926)

Feulner and Müller (1953) Adolf Feulner and Theodor Müller, *Geschichte der deutschen Plastik* (Munich, 1953)

Filedt Kok et al. (1986) J. P. Filedt Kok, W. Halsema-Kubes, and W. Th. Kloek, *Kunst voor de Beeldenstorm: Noordnederlandse Kunst 1525–1580—Catalogus*, exh. cat. Rijksmuseum (Amsterdam, 1986)

Findeisen and Magirius (1976) Peter Findeisen and Heinrich Magirius, *Die Denkmale der Stadt Torgau* (Leipzig, 1976)

Fleischhauer (1966) Werner Fleischhauer, "Neues zum Werk des Bildhauers Sem Schlör," *Württembergisch Franken Jahrbuch* 50 [N.F. 40] (1966): pp. 111–23

Fleischhauer (1971) Werner Fleischhauer, *Renaissance im Herzogtum Württemberg* (Stuttgart, 1971)

Fleischhauer (1976) Werner Fleischhauer, *Die Geschichte der Kunstkammer der Herzöge von Württemberg in Stuttgart* (Stuttgart, 1976)

Flemming, Lehmann, and Schubert (1976) Johanna Flemming, Edgar Lehmann, and Ernst Schubert, *Dom und Domschatz zu Halberstadt* (Berlin, 1976)

Freedberg (1989) David Freedberg, *The Power of Images: Studies in the History and Theory of Response* (Chicago, 1989)

Friedel (1974) Helmut Friedel, *Bronzebildmonumente in Augsburg 1589–1606. Bild und Urbanität* (Augsburg, 1974)

Friedländer and Rosenberg (1978) Max J. Friedländer and Jakob Rosenberg, *The Paintings of Lucas Cranach* (Secaucus [New Jersey], 1978)

Gaettens (1956) Richard Gaettens, "Das Bildnis des Pfalzgrafen und Kurfürsten im Spiegel der Medaille und Grossplastik," in Poensgen, ed. (1956), pp. 62–85

Gagel (1977) Hanna Gagel, ed., *Der Mensch um 1500: Werke aus Kirchen und Kunstkammern*, exh. cat. Berlin, Skulpturengalerie der Staatlichen Museen Preussischer Kulturbesitz (Berlin, 1977)

Ganz and Major (1907) Paul Ganz and Emil Major, "Die Entstehung des Amerbach'schen Kunstkabinets und die Amerbach'schen Inventare," *Berichte, Öffentliche Sammlungen, Basel* 59 (1907): pp. 1–68

Garside (1966) Charles Garside, Jr., *Zwingli and the Arts* (New Haven, 1966; reprint New York, 1981)

Geiger (1971) Gottfried Geiger, *Die Reichsstadt Ulm vor der Reformation* (Ulm, 1971)

Geisberg (1937) Max Geisberg, *Die Stadt Münster, 5. Der Dom* [*Bau- und Kunstdenkmäler von Westfalen*, vol. 41.5] (Münster, 1937—reprinted Münster, 1977)

Geisberg (1974) Max Geisberg, *The German Single-Leaf Woodcut: 1500–1550*, revised ed. Walter L. Strauss, 4 vols. (New York, 1974)

Geissler (1978) Heinrich Geissler, "Neues zu Friedrich Sustris," *MJBK* 29 (1978): pp. 65–91

Geissler (1979) Heinrich Geissler, ed., *Zeichnung in Deutschland: Deutsche Zeichner, 1540–1640*, exh. cat. Stuttgart, Staatsgalerie (Stuttgart, 1979).

Glaser (1980) Hubert Glaser, ed., *Wittelsbach und Bayern, II. Um Glauben und Reich—Kurfürst Maximilian I.*, 2 vols. (Munich, 1980)

Goddard (1988) Stephen Goddard, ed., *The World in Miniature: Engravings by the German Little Masters, 1500–1550*, exh. cat. Spencer Museum of Art, University of Kansas (Lawrence, 1988)

Gothic and Renaissance Art in Nuremberg (1986) *Gothic and Renaissance Art in Nuremberg, 1300–1550*, exh. cat. Metropolitan Museum of Art, New York, and Germanisches Nationalmuseum, Nuremberg (Munich, 1986)

Grotemeyer (1957) Paul Grotemeyer, *"Da ich het*

die gestalt." Deutsche Bildnismedaillen des 16. Jahrhunderts (Munich, 1957)

Haas (1977) Walter Haas, "Die mittelalterliche Altarordnung in der Nürnberger Lorenzkirche," in H. Bauer, G. Hirschmann, and G. Stolz, eds., *500 Jahre Hallenchor St. Lorenz zu Nürnberg 1477–1977* (Nuremberg, 1977), pp. 63–108

Habich (1918) Georg Habich, "Porträtstücke von Peter Dell," *JPKS* 39 (1918): pp. 135–44

Habich (1928) Georg Habich, "Reliefbildnis des Tiedemann Giese in Königsberg," *JPKS* 49 (1928): pp. 1–23

Habich (1929–34) Georg Habich, *Die deutschen Schaumünzen des XVI. Jahrhunderts*, 2 vols. in 4 parts (Munich, 1929–34)

Hainhofer (1901) Philipp Hainhofer, *Des Augsburger Patriciers Philipp Hainhofer Reisen nach Innsbruck und Dresden*, ed. Oscar Doering (Vienna, 1901)

Halm (1926) Philipp M. Halm, *Studien zur süddeutschen Plastik*, 2 vols. (Augsburg, 1926)

Halm and Berliner (1931) Philipp M. Halm and Rudolf Berliner, *Das Hallesche Heiltum: Man, Aschaffenb. 14* (Berlin, 1931)

Hampe (1904-I) Theodor E. Hampe, *Nürnberger Ratsverlässe über Kunst und Künstler im Zeitalter der Spätgotik und Renaissance* (Vienna, 1904)

Hampe (1904-II) Theodor E. Hampe, "Kunstfreunde im alten Nürnberg und ihre Sammlungen," *MVGN* 16 (1904): pp. 57–124

Händler (1933) Gerhard Händler, *Fürstliche Mäzene und Sammler in Deutschland von 1500–1620* (Strasbourg, 1933)

Hans Burgkmair (1973) *Hans Burgkmair 1473–1973: Das graphische Werk*, exh. cat. Graphische Sammlung Staatsgalerie (Stuttgart, 1973)

Hartig (1923) Michael Hartig, *Das Benediktiner-Reichsstift Sankt Ulrich und Afra in Augsburg (1012–1802)* (Augsburg, 1923)

Hartig (1931) Otto Hartig, "Die Kunsttätigkeit in München unter Wilhelm IV. und Albrecht V. 1520–1579—III.," *MJBK* N.F. 8 (1931): pp. 322–84

Hartig (1933) Otto Hartig, "Die Kunsttätigkeit in München unter Wilhelm IV. und Albrecht V. 1520–1579—IV.," *MJBK* N.F. 10 (1933): pp. 226–46

Hasse (1982) Max Hasse, "Benedikt Dreyer," *Niederdeutsche Beiträge zur Kunstgeschichte* 21 (1982): pp. 9–58

Hasse (1983) Max Hasse, *Die Marienkirche zu Lübeck* (Munich, 1983)

Hayward (1976) John F. Hayward, *Virtuoso Goldsmiths and the Triumph of Mannerism, 1540–1620* (London, 1976)

Hecht (1982) Wolfgang Hecht, *Allegorie zu Ehren Luthers* (Weimar, 1982)

Heck (1989) Christian Heck, ed., *Le Retable d'Issenheim et la sculpture au nord des Alpes à la fin du Moyen Age* (Colmar, 1989)

Hedergott and Jacob (1976) Bodo Hedergott and Sabina Jacob, *Europäische Kleinplastik aus dem Herzog Anton Ulrich-Museum Braunschweig*, exh. cat. St. Annen Museum, Lübeck (Bielefeld, 1976)

Hedicke (1913) Robert Hedicke, *Cornelis Floris und die Florisdekoration*, 2 vols. (Berlin, 1913)

Hentschel (1935) Walter Hentschel, "Die Torgauer Bildhauer der Renaissance," *Sachsen und Anhalt* 11 (1935): pp. 151–92

Hentschel (1966) Walter Hentschel, *Dresdner Bildhauer des 16. und 17. Jahrhunderts* (Weimar, 1966)

Hilger (1969) Wolfgang Hilger, *Ikonographie Kaiser Ferdinands I. (1503–1564)* (Vienna, 1969)

Hill and Pollard (1967) George F. Hill and Graham Pollard, *Renaissance Medals from the Samuel H. Kress Collection at the National Gallery of Art* (London, 1967)

Hinz (1963) Paulus Hinz, *Gegenwärtige Vergangenheit: Dom und Domschatz zu Halberstadt* (Berlin, 1963)

Hitchcock (1981) Henry Russell Hitchcock, *German Renaissance Architecture* (Princeton, 1981)

Hofmann (1983) Werner Hofmann, ed., *Luther und die Folgen für die Kunst*, exh. cat. Hamburger Kunsthalle (Munich, 1983)

Hollstein (1949–) Friedrich W. H. Hollstein, ed., *Dutch and Flemish Etchings, Engravings, and Woodcuts, ca. 1400–1700*, vol. 1- (Amsterdam, 1949–)

Hollstein (1954–) Friedrich W. H. Hollstein, ed., *German Engravings, Etchings, and Woodcuts, ca. 1400–1700*, vol. 1- (Amsterdam, 1954–)

Honnens de Lichtenberg (1981) Hanne Honnens de Lichtenberg, "Some Netherlandish Artists

Employed by Frederik II," *Hafnia* 8 (1981): pp. 51–71

Honnens de Lichtenberg (1991) Hanne Honnens de Lichtenberg, *Johan Gregor van der Schardt* (Copenhagen, 1991)

Hootz (1968) Reinhardt Hootz, *Deutsche Kunstdenkmäler—Ein Bildhandbuch: Hamburg, Schleswig-Holstein* (Munich, 1968)

Horn and Meyer (1958) Adam Horn and Werner Meyer, *Stadt und Landkreis Neuburg a.d. Donau* [*Die Kunstdenkmäler von Bayern*, vol. VII.5] (Munich, 1958)

Höss (1961) Irmgard Höss, "Das religiösgeistige Leben in Nürnberg am Ende des 15. und am Ausgang des 16. Jahrhunderts," in *Miscellanea Historiae Ecclesiasticae* [Bibliothèque de la Revue d'Histoire Ecclèsiastique, fasc. 38] (Louvain, 1961), pp. 17–36

Hsia (1984) R. Po-chia Hsia, *Society and Religion in Münster, 1535–1618* (New Haven, 1984)

Hsia (1988) R. Po-chia Hsia, ed., *The German People and the Reformation* (Ithaca, 1988)

Huth (1967) Hans Kuth, *Künstler und Werkstatt der Spätgotik* (Darmstadt, 1967—2nd ed.)

Impey and MacGregor (1985) Oliver Impey and Arthur MacGregor, *The Origins of Museums: The Cabinet of Curiosities in Sixteenth- and Seventeenth-Century Europe* (Oxford, 1985)

Irsch (1931) Nikolaus Irsch, *Der Dom zu Trier* [*Die Kunstdenkmäler der Rheinprovinz*, vol. 13.I] (Düsseldorf, 1931—reprinted Trier, 1984)

The Illustrated Bartsch (1978–) Adam Bartsch, *The Illustrated Bartsch*, gen. ed. Walter L. Strauss, vols. 1- (New York, 1978–)

Jahn (1972) Johannes Jahn, *Lucas Cranach d. Ä., 1472–1553. Das gesamte graphische Werk* (Munich, 1972)

Janssen (1905–25) Johannes Janssen, *History of the German People at the Close of the Middle Ages*, tr. M. Mitchell and A. Christie, 16 vols. (London, 1905–25)

Jasbar and Treu (1981) Gerald Jasbar and Erwin Treu, *Ulmer Museum: Bildhauerei und Malerei vom 13. Jahrhundert bis 1600* (Ulm, 1981)

Jászai (1981) Géza Jászai, *Dom und Domkammer in Münster* (Königstein im Taunus, 1981)

Josephi (1910) Walter Josephi, *Die Werke plastischer Kunst* [Kataloge des Germanischen Nationalmuseum] (Nuremberg, 1910)

Jung (1975) Wilhelm Jung, ed., *1000 Jahre Mainzer Dom (975–1975): Werden und Wandel* (Mainz, 1975)

Kaess and Stierhof (1977) Friedrich Kaess and Horst Stierhof, *Die Schlosskapelle in Neuburg an der Donau* (Weissenhorn, 1977)

Kahle (1939) Hertha Kahle, *Studien zur mittelrheinischen Plastik des 16. Jahrhunderts* (Bonn, 1939)

Kähler (1955–56) E. Kähler, "Der Sinngehalt der Pfeilerfiguren und Kanzelplastik im Dom zu Halle," *Wissenschaftliche Zeitschrift der Ernst Moritz Arndt-Universität Greifswald* 5 (1955–56): pp. 231–48

Kahsnitz (1983) Rainer Kahsnitz, ed., *Veit Stoss in Nürnberg*, exh. cat. Germanisches Nationalmuseum, Nuremberg (Munich, 1983)

Kahsnitz (1985) Rainer Kahsnitz, ed., *Veit Stoss—Die Vorträge des Nürnberger Symposions* (Munich, 1985)

Kaiser (1978) Ute-Nortrud Kaiser, *Der skulptierte Altar der Frührenaissance in Deutschland*, 2 vols. (Frankfurt a. M., 1978)

Karant-Nunn (1987) Susan C. Karant-Nunn, *Zwickau in Transition, 1500–1547* (Columbus, 1987)

Katalog der Sammlung für Plastik und Kunstgewerbe (1966) *Kunsthistorisches Museum Wien—Katalog der Sammlung für Plastik und Kunstgewerbe, II. Teil—Renaissance* (Vienna, 1966)

Kaufmann (1978) Thomas DaCosta Kaufmann, *Variations on the Imperial Theme in the Age of Maximilian II and Rudolf II* (New York, 1978)

Kaufmann (1982) Thomas DaCosta Kaufmann, *Drawings from the Holy Roman Empire, 1540–1680*, exh. cat. Princeton, Art Museum (Princeton, 1982).

Kautzsch (1911) Paul Kautzsch, *Der Mainzer Bildhauer Hans Backoffen und seine Schule* (Leipzig, 1911)

Kautzsch (1925) Rudolf Kautzsch, *Der Mainzer Dom und seine Denkmäler*, 2 vols. (Frankfurt am Main, 1925)

Keisch (1970) Claude Keisch, *Zum sozialen Gehalt und zur Stilbestimmung deutscher Plastik, 1550–1650*, Ph.D. diss., Humboldt-Universität (Berlin, 1970)

Kenseth (1991) Joy Kenseth, ed., *The Age of the Marvelous*, exh. cat. Hood Museum of Art,

Dartmouth College (Hanover [New Hampshire], 1991)

Kiessling (1971) Rolk Kiessling, *Burgerliche Gesellschaft und Kirche in Augsburg im Spätmittelalter* (Augsburg, 1971)

Kiewert (1956) Walter Kiewert, *Der schöne Brunnen* (Dresden, 1956)

Kistler (1712) Romanus Kistler, *Basilika, dass ist herrliche Kirchendes Frey-Reichsklosters St. Ulrich und Afra in Augspurg* (Augsburg, 1712)

Kniffler (1978) Gisela Kniffler, *Die Grabdenkmäler der Mainzer Erbischöfe vom 13. bis zum frühen 16. Jahrhundert* (Cologne, 1978)

Koepplin and Falk (1976) Dieter Koepplin and Tilman Falk, *Lukas Cranach*, 2 vols., exh. cat. Kunstmuseum (Basel, 1976)

Kohlhaussen (1968) Heinrich Kohlhaussen, *Nürnberger Goldschmiedekunst des Mittelalters und der Dürerzeit, 1240 bis 1540* (Berlin, 1968)

Krause (1970) Hans-Joachim Krause, *Die Schlosskapellen der Renaissance in Sachsen* (Berlin, 1970)

Krause (1983) Hans-Joachim Krause, "Zur Ikonographie der protestantischen Schlosskapellen des 16. Jahrhunderts," in Ernst Ullmann, ed., *Von der Macht der Bilder* (Leipzig, 1983), pp. 395–412

Krüger and Reinecke (1906) Franz Krüger and Wilhelm Reinecke, *Die Kunstdenkmale der Stadt Lüneburg* [*Kunstdenkmälerinventare Niedersachsens*, vol. 34] (Hannover, 1906—reprinted Osnabrück, 1980)

Kunst der Reformationszeit (1983) *Kunst der Reformationszeit*, exh. cat. Altes Museum, Berlin (Berlin, 1983)

Landolt and Ackermann (1991) Elisabeth Landolt and Felix Ackermann, *Sammeln in der Renaissance—Das Amerbach-Kabinett: Die Objekte im Historischen Museum Basel* (Basel, 1991)

Landolt et al. (1991) Elisabeth Landolt et al., *Das Amerbach-Kabinett: Beiträge zu Basilius Amerbach* (Basel, 1991)

Lange (1897) Konrad Lange, *Peter Flötner, ein Bahnbrecher der deutschen Renaissance* (Berlin, 1897)

Larsson (1974) Lars Olof Larsson, *Von allen Seiten gleich schön: Studien zum Begriff der Vielansichtigkeit in der europäischen Plastik von der Renaissance bis zum Klassizismus* (Stockholm, 1974)

Larsson (1975) Lars Olof Larsson, "Bemerkungen zur Bildhauerkunst am Dänischen Hofe im 16.

und 17. Jahrhundert," *MJBK* 26 (1975): pp. 177–92

Laun (1982) Rainer Laun, *Studien zur Altarbaukunst in Süddeutschland 1560–1665* (Munich, 1982)

Leeuwenberg and Halsema-Kubes (1973) Jaap Leeuwenberg and Willy Halsema-Kubes, *Beeldhouwkunst in her Rijksmuseum* (Amsterdam, 1973)

Legner (1965) Anton Legner, "Plastik," in *Die Kunst der Donauschule 1490–1540*, exh. cat. St. Florian (St. Florian, 1965), pp. 235–92

Leithe-Jasper (1986) Manfred Leithe-Jasper, *Renaissance Master Bronzes from the Collection of the Kunsthistorisches Museum Vienna*, exh. cat. National Gallery of Art, Washington (London, 1986)

Lieb (1937) Norbert Lieb, "Ottobeurer Bildhauer- und Kunstschreiner-Arbeiten des 16. Jahrhunderts: Beiträge zu Hans Kels d. J. und Thomas Heidelberger," *MJBK* N.F. 12 (1937): 50–64

Lieb (1952) Norbert Lieb, *Die Fugger und die Kunst im Zeitalter der Spätgotik und frühen Renaissance* (Munich, 1952)

Lieb (1958) Norbert Lieb, *Die Fugger und die Kunst im Zeitalter der hohen Renaissance* (Munich, 1958)

Lieb (1980) Norbert Lieb, *Octavian Secundus Fugger (1549–1600) und die Kunst* (Tübingen, 1980)

Liebmann (1982) Michael J. Liebmann, *Die deutsche Plastik, 1350–1550*, Hans Störel (Leipzig, 1982)

Lietzmann (1987) Hilda Lietzmann, *Das Neugebäude in Wien* (Munich, 1987)

Lill (1908) Georg Lill, *Hans Fugger (1531–1598) und die Kunst* (Leipzig, 1908)

Lill (1951) Georg Lill, "Aus der Frühzeit des Würzburger Bildhauers Peter Dell des Älteren," *Mainfränkisches Jahrbuch für Geschichte und Kunst* 3 (1951): pp. 139–59

Lindner (1920) Werner Lindner, *Schöne Brunnen in Deutschland* (Berlin, 1920)

Löffler (1958) Fritz Löffler, *Das alte Dresden: Geschichte seiner Bauten* (Dresden, 1958)

Lowenthal (1976) Constance Lowenthal, "Conrat Meit," Ph.D. diss., New York University—Institute of Fine Arts 1976

Lühmann-Schmid (1974) Irnfriede Lühmann-Schmid, "Der Mainzer Marktbrunnen, seine

Denkmals- und Bildidee," *Mainzer Zeitschrift* 69 (1974): pp. 180–86

Lühmann-Schmid (1975) Irnfriede Lühmann-Schmid, "Peter Schro. Ein Mainzer Bildhauer und Backoffenschuler. 1. Teil," *Mainzer Zeitschrift* 70 (1975): pp. 1–62

Lühmann-Schmid (1976–77) Irnfriede Lühmann-Schmid, "Peter Schro. Ein Mainzer Bildhauer und Backoffenschuler. 2. Teil," *Mainzer Zeitschrift* 71–72 (1976–77): pp. 57–100

Mader (1915) Felix Mader, *Stadt Würzburg* [*Die Kunstdenkmäler von Bayern*, vol. III.12] (Munich, 1915—reprinted Munich, 1981)

Mader (1918) Felix Mader, *Stadt Aschaffenburg* [*Die Kunstdenkmäler von Bayern*, vol. III.19] (Munich, 1918—reprinted Munich, 1982)

Mader (1924) Felix Mader, *Stadt Eichstätt* [*Die Kunstdenkmäler von Bayern*, vol. IV.16] (Munich, 1927—reprinted Munich, 1980)

Mader (1933) Felix Mader, *Stadt Regensburg. I. Dom und St. Emmeram* [*Die Kunstdenkmäler von Bayern*, vol. II.22] (Munich, 1933—reprinted Munich 1981)

Magirius (1986) Heinrich Magirius, *Der Dom zu Freiberg* (Leipzig, 1986)

Martin Luther und die Reformation in Deutschland (1983) *Martin Luther und die Reformation in Deutschland*, exh. cat. Germanisches Nationalmuseum, Nuremberg (Frankfurt, 1983)

Maué (1987) Hermann Maué, "Die Dedikationsmedaille der Stadt Nürnberg für Kaiser Karl V. von 1521," *AGNM* (1987): pp. 227–44

Maué (1988) Hermann Maué, "Hans Schwarz in Nürnberg 1519–1520," *The Medal* 13 (1988): pp. 12–17

Maué (1989) Hermann Maué, "Nürnberger Medaillenkunst zur Zeit Albrecht Dürers," *Trésors Monétaires*, Supplément 2: *Médailles & Antiques—I* (Paris, 1989), pp. 23–29

Meller (1925) Simon Meller, *Peter Vischer der Ältere und seine Werkstatt* (Leipzig, 1925)

Meller (1926) Simon Meller, *Die deutschen Bronzestatuetten der Renaissance* (Florence, 1926)

Mende (1983) Matthias Mende, *Das Alte Nürnberger Rathaus*, vol. 1 (Nuremberg, 1979)

Mende (1983) Matthias Mende, *Dürer-Medaillen* (Nuremberg, 1983)

Mengden (1973) Veronika V. Mengden, *Das Ambraser Spielbrett von 1537. Hauptwerk des Hans Kels*

d. J., Ph.D. diss., Universität Munchen (Munich, 1973)

Menzhausen (1977) Joachim Menzhausen, *Dresdener Kunstkammer und Grünes Gewölbe* (Vienna, 1977)

Metz (1966) Peter Metz, *Bildwerke der christlichen Epochen* (*Aus den Beständen der Skulpturenabteilung der Staatlichen Museen, Siftung Preussischer Kulturbesitz, Berlin-Dahlem*) (Munich, 1966)

Middeldorf and Goetz (1944) Ulrich Middeldorf and Oswald Goetz, *Medals and Plaquettese from the Sigmund Morgenroth Collection* (Chicago, 1944)

Miller (1977) Naomi Miller, *French Renaissance Fountains* (New York, 1977)

Moeller (1971) Bernd Moeller, "Piety in Germany around 1500," in Steven Ozment, ed., *The Reformation in Medieval Perspective* (Chicago, 1971), pp. 50–75

Moeller (1978) Bernd Moeller, ed., *Stadt und Kirche im 16. Jahrhundert* (Gütersloh, 1978)

Montague (1963) Jennifer Montagu, *Bronzes* (London, 1963)

Mrusek (1976) Hans-Joachim Mrusek, *Drei sächsische Kathedralen: Merseburg, Naumburg, Meissen* (Dresden, 1976)

Müller, H. (1954) Hannelore Müller, "Sebastian Loscher und sein Geschlecht," *Lebensbilder aus dem Baverischen Schwaben* 3 (1954): pp. 153–211

Müller, H. (1958) Hannelore Müller, "Die Künstlerfamilie Daucher," *Lebensbilder aus dem Bayerischen Schwaben* 6 (1958): pp. 131–65

Müller (1955–56) Theodor Müller, "Conrat Meit und die Anfänge der deutschen Renaissance-Kleinplastik," *Sitzungsberichte der kunstgeschichtlichen Gesellschaft zu Berlin* N.F. 4 (1955–56): pp. 11–15

Müller (1959) Theodor Müller, *Die Bildwerke in Holz, Ton und Stein von der Mitte des XV. bis gegen Mitte des XVI. Jahrhunderts*, [*Kataloge des Bayerischen Nationalmuseums München*, vol. 13/2] (Munich, 1959)

Müller (1963) Theodor Müller, *Deutsche Plastik der Renaissance bis zum dreissigjährigen Krieg* (Königstein im Taunus, 1963)

Müller (1966) Theodor Müller, *Sculpture in the Netherlands, Germany, France, and Spain, 1400 to 1500* (Baltimore, 1966)

Müller (1976) Theodor Müller, "Zu Victor

Kayser. Nachruf für ein verschollenes Werk," *AGNM* (1976): pp. 77–82

Müller and Reissmüller (1974) Theodor Müller and Wilhelm Reissmüller, eds., *Ingolstadt. Die Herzogsstadt, die Universitätsstadt, die Festung*, 2 vols. (Ingolstadt, 1974)

de Murr (1797) Christoph Gottlieb de Murr, *Description du cabinet de Monsieur Paul de Praun à Nuremberg* (Nuremberg, 1797)

Neu-Kock (1977) Roswitha Neu-Kock, *Johann Brabender* (Münster, 1977)

Neudörfer (1875) Johann Neudörfer, *Des Johann Neudörfer Schreib- und Rechenmeisters zu Nürnberg Nachrichten von Künstlern und Werkleuten daselbst aus dem Jahre 1547 nebst der Fortsetzung des Andreas Gulden*, ed. Georg W. K. Lochner (Vienna, 1875)

von der Osten (1963) Gert von der Osten, "Über Peter Vischers Törichten Bauern und den Beginn der 'Renaissance' in Nürnberg," *AGNM* (1963): pp. 71–83

von der Osten and Vey (1969) Gert von der Osten and Horst Vey, *Painting and Sculpture in Germany and the Netherlands, 1500 to 1600* (Baltimore, 1969)

Panofsky (1964) Erwin Panofsky, *Tomb Sculpture* (New York, 1964)

Pechstein (1968) Klaus Pechstein, *Bronzen und Plaketten, Vom ausgehenden 15. Jahrhundert bis zur Mitte des 17. Jahrhunderts* [Kataloge des Kunstgewerbemuseums Berlin, vol. 3] (Berlin, 1968)

Pechstein (1971) Klaus Pechstein, *Goldschmiedewerke der Renaissance* [Kataloge des Kunstgewerbemuseums Berlin, vol. 5] (Berlin, 1971)

Pechstein (1973) Klaus Pechstein, "Der Bildschnitzer Hans Peisser," *AGNM* (1973): pp. 84–106

Pechstein (1974) Klaus Pechstein, "Zu den Altarskulpturen und Kunstkammerstücken von Hans Peisser. Studien zur süddeutschen Renaissanceplastik II," *AGNM* (1974): pp. 38–47

Pechstein (1978) Klaus Pechstein, "Die Nürnberger Erzgiesser Pankraz und Georg Labenwolf," *Fränkische Lebensbilder* 8 (1978): pp. 71–79

Pechstein (1988) Klaus Pechstein, "Kaiser Rudolf II. und die Nürnberger Goldschmiedekunst," in *Prag um 1600* (1988), 3: pp. 232–43

Pechstein (1990) Klaus Pechstein, "Hans Peisser—Modellschnitzer für Hans Vischer und Pankraz Labenwolf," *AGNM* (1990): pp. 113–19

Peltzer (1916–18) R. A. Peltzer, "Johann Gregor van der Schardt (Jan de Zar) aus Nymwegen, ein Bildhauer der Spätrenaissance," *MJBK* 10 (1916–18): pp. 198–216

Pfeiffer (1955) Wolfgang Pfeiffer, "Nürnberger Kunsthandwerk am Hofe Bernhards von Cles," *Cultura Atesina* 10 (1956): pp. 51–6

Pfeiffer and Schwemmer (1977) Gerhard Pfeiffer and Wilhelm Schwemmer, *Geschichte Nürnbergs in Bilddokumenten*, 3rd ed. (Munich, 1977)

Pfister and Ramisch (1983) Peter Pfister and Hans Ramisch, *Die Frauenkirche in München* (Munich, 1983)

Poensgen (1956) Georg Poensgen, ed., *Ottheinrich: Gedenkschrift zur vierhundertjährigen Wiederkehr seiner Kurfürstenzeit in der Pfalz (1556–1559)* (Heidelberg, 1956)

Pope-Hennessy (1966) John Pope-Hennessy, *The Portrait in the Renaissance* (Princeton, 1966)

Pope-Hennessy (1971) John Pope-Hennessy, *Italian Renaissance Sculpture* (London, 1971)

Pope-Hennessy (1985) John Pope-Hennessy, *Italian High Renaissance and Baroque Sculpture* (New York, 1985)

Poscharsky (1963) Peter Poscharsky, *Die Kanzel. Erscheinungsform im Protestantismus bis zum Ende des Barocks* (Gütersloh, 1963)

Prag um 1600 (1988) *Prag um 1600: Kunst und Kultur am Hofe Rudolfs II.*, exh. cat. Villa Hügel, Essen, and Kunsthistorisches Museum, Vienna, 3 vols. (Freren, 1988)

Pulvermacher (1931) Lotte Pulvermacher, *Das Rollwerk in der süddeutschen Skulptur und seine Entwicklung bis ca. 1620* (Strasbourg, 1931)

Rasmussen (1974) Jörg Rasmussen, *Die Nürnberg Altarbaukunst der Dürerzeit* (Hamburg, 1974)

Rasmussen (1975) Jörg Rasmussen, *Deutsche Kleinplastik der Renaissance und des Barock* [Bilderhefte des Museums für Kunst und Gerwerbe Hamburg, vol. 12] (Hamburg, 1975)

Rasmussen (1976) Jörg Rasmussen, "Untersuchungen zum Halleschen Heiltum des Kardinals Albrecht von Brandenburg, Teil I," *MJBK* 27 (1976): pp. 59–118

Rasmussen (1977) Jörg Rasmussen, "Untersuchungen zum Halleschen Heiltum des Kardinals

Albrecht von Brandenburg, Teil II," *MJBK* 28 (1977): pp. 91–132

Rasmussen (1975) Jörg Rasmussen, *Deutsche Kleinplastik der Renaissance und des Barock* [Bil-(1980–81), 3: pp. 95–114

Reber (1990) Horst Reber, *Albrecht von Brandenburg: Kurfürst, Erzkanzler, Cardinal, 1490–1545*, exh. cat. Landesmuseum Mainz (Mainz, 1990)

Redlich (1900) Paul Redlich, *Cardinal Albrecht von Brandenburg und das Neue Stift zu Halle 1520–1541* (Mainz, 1900)

Reformation in Nürnberg (1979) *Reformation in Nürnberg: Umbruch und Bewahrung*, exh. cat. Germanisches Nationalmuseum (Nuremberg, 1979)

Reindl (1977) Peter Reindl, *Loy Hering: Zur Rezeption der Renaissance in Süddeutschland* (Basel, 1977)

Die Renaissance im deutschen Südwesten (1986) *Die Renaissance im deutschen Südwesten zwischen Reformation und Dreissigjährigem Krieg*, exh. cat. Heidelberger Schloss, 2 vols. (Karlsruhe, 1986)

Riederer (1982) Josef Riederer, "Die Zusammensetzung deutscher Renissancestatuetten aus Kupferlegierungen," *ZDVK* 36 (1982): pp. 42–48

Riederer (1983) Josef Riederer, "Metallanalysen an Erzeugnissen der Vischer-Werkstatt," *Berliner Beiträge zur Archäometrie* 8 (1983): pp. 89–99

Roggen and Withof (1942) D. Roggen and J. Withof, "Cornelis Floris," *Gentsche Bijdragen tot de Kunstgeschiedenis* 8 (1942): pp. 79–171

Ronig (1980) Franz J. Ronig, "Die Ausstattung," in Franz J. Ronig, ed., *Der Trierer Dom* (Neuss, 1980), pp. 231–362

Ronig (1982) Franz J. Ronig, *Der Dom zu Trier* (Königstein im Taunus, 1982)

Roth (1901–11) Friedrich Roth, *Augsburgs Reformationsgeschichte*, 4 vols. (Munich, 1901–11)

Rott (1905) Hans Rott, "Kirchen- und Bildersturm bei der Einführung der Reformation in der Pfalz," *Neues Archiv für die Geschichte der Stadt Heidelberg und der rheinischen Pfalz* 6 (1905): pp. 229–54

Rott (1933) Hans Rott, *Quellen und Forschungen zur süddeutschen und schweizerischen Kunstgeschichte im XV. und XVI. Jahrhundert*, I. *Bodenseegebiet*, 2 vols. (Stuttgart, 1933)

Rott (1934) Hans Rott, *Quellen und Forschungen zur süddeutschen und schweizerischen Kunstgeschichte im XV. und XVI. Jahrhundert*, II. *Alt-Schwaben und die Reichsstädte* (Stuttgart, 1934)

Rott (1936–38) Hans Rott, *Quellen und Forschungen zur süddeutschen und schweizerischen Kunstgeschichte im XV. und XVI. Jahrhundert*, III. *Der Oberrhein*, 3 vols. (Stuttgart, 1936–38)

Rowlands (1988) John Rowlands, *The Age of Dürer and Holbein: German Drawings 1400–1550*, exh. cat. British Museum (London, 1988)

Rupprich (1956) Hans Rupprich, *Dürer Schriftlicher Nachlass*, vol. 1 (Berlin, 1956)

Sauerlandt (1927) Max Sauerlandt, *Kleinplastik der deutschen Renaissance* (Königstein im Taunus, 1927)

Schade (1968) Werner Schade, "Maler am Hofe Moritz' von Sachsen," *ZDVK* 22 (1968): pp. 2944

Schade (1980) Werner Schade, *Cranach: A Family of Master Painters*, tr. Helen Sebba (New York, 1980)

Schädler (1975) Alfred Schädler, "Das Eichstätter Willibalddenkmal und Gregor Erhart," *MJBK* 26 (1975): pp. 65–88

Schädler (1987) Alfred Schädler, "Zur Kleinplastik von Christoph Weiditz," *MJBK* 38 (1987): pp. 161–84

Schattenhofer (1974) Michael Schattenhofer, "Die öffentlichen Brunnen Münchens von ihren Anfängen bis zum Ende des 18. Jahrhunderts," in O. Bistritzki, *Brunnen in München* (Munich, 1974), pp. 7–32

Scheicher (1979) Elisabeth Scheicher, *Die Kunst- und Wunderkammern der Habsburger* (Vienna, 1979)

Scheicher (1985) Elisabeth Scheicher, "The Collection of Archduke Ferdinand II at Schloss Ambras: Its Purpose, Composition and Evolution," in Impey and MacGregor (1985), pp. 29–38

Scheicher (1986) Elisabeth Scheicher, *Das Grabmal Kaiser Maximilians I. in der Innsbrucker Hofkirche* (Vienna, 1986); simultaneously published in Felmayer (1986), pp. 359–425

Scheicher et al. (1977) Elisabeth Scheicher et al., *Die Kunstkammer: Kunsthistorisches Museum, Sammlungen Schloss Ambras* (Innsbruck, 1977)

Schéle (1965) Sune Schéle, *Cornelis Bos: A Study of the Origins of the Netherland Grotesque* (Stockholm, 1965)

Scher (1989) Stephen K. Scher, "Immortalitas in Nummis: The Origins of the Italian Renaissance Medal," *Trésors Monétaires*, Supplement 2: *Médailles & Antiques I* (Paris, 1989), pp. 9–19

Schiller (1966–) Gertrud Schiller, *Ikonographie der christlichen Kunst*, vol. 1- (Gütersloh, 1966–)

Schiller (1971–72) Gertrud Schiller, *Iconography of Christian Art*, tr. Janet Seligman, 2 vols. (Greenwich [Conn.], 1971–72)

Schilling (1887) A. Schilling, "Die religiösen und kirchlichen Zustände der ehemaligen Reichsstadt Biberach unmittelbar vor Einführung der Reformation," *Freiburger Diözesan-Archiv* 19 (1887): pp. 1–191

Schindler (1981) Herbert Schindler, *Der Meister HL = Hans Loy?: Werk und Wiederentdeckung* (Königstein im Taunus, 1981)

Schleif (1990) Corine Schleif, *Donatio et Memoria: Stifter, Stiftungen und Motivationen an Beispielen aus der Lorenzkirche in Nürnberg* (Munich, 1990)

von Schlosser (1910) Julius von Schlosser, *Werke der Kleinplastik in der Skulpturensammlung des allerhöchsten Kaiserhauses, I; Bildwerke in Bronze, Stein und Ton; II: Bildwerke in Holz, Wachs und Elfenbein* (Vienna, 1910)

Schmid (1985) Wolfgang Schmid, *Altäre der Hoch- und Spätgotik* (Cologne, 1985)

Schreiber (1951) Georg Schreiber, ed., *Das Weltkonzil von Trient: Sein Werden und Wirken*, 2 vols. (Freiburg, 1951)

Schürer (1986) Ralf Schürer, "Wenzel Jamnitzers Brunnen für Maximilian II. Überlegungen zu Ikonographie und Zweck," *AGNM* (1986): pp. 55–59

von Schweinitz (1987) Anna-Franziska von Schweinitz, "Die Kirchberger Kunstkammer in Schloss Neuenstein," *Württembergisch Franken* (1987): pp. 170–259

Schwemmer (1949) Wilhelm Schwemmer, "Aus der Geschichte der Kunstsammlungen der Stadt Nürnberg," *MVGN* 40 (1949): pp. 97–206

Schwemmer (1958) Wilhelm Schwemmer, *Adam Kraft* (Nuremberg, 1958)

Scribner (1981) Robert W. Scribner, *For the Sake of Simple Folk: Popular Propaganda for the German Reformation* (Cambridge, 1981)

Scribner (1987) Robert W. Scribner, *Popular Culture and Popular Movements in Reformation Germany* (London, 1987)

Scribner (1988) Robert W. Scribner, "Ritual and Reformation," in Hsia (1988), pp. 122–44

Seeger (1932) Joachim Friedrich Seeger, "Hans Schenck (genannt Scheusslich). Ein deutscher Bildhauer des 16. Jahrhunderts," *Mitteilungen des Vereins für die Geschichte Berlins* 49 (1932): pp. 33–50 and 65–86

Seelig (1985) Lorenz Seelig, "The Munich Kunstkammer, 1565–1807," in Impey and MacGregor (1985), pp. 76–89

Seelig (1989) Lorenz Seelig with Barbara Hardtwig and Peter Volk, *Modell und Ausführung in der Metallkunst*, exh. cat. Bayerisches Nationalmuseum (Munich, 1989)

Siebenmorgen (1988) Harald Siebenmorgen, ed., *Leonhard Kern (1588–1662): Meisterwerke der Bildhauerei für die Kunstkammern Europas* (Sigmaringen, 1988)

Siebert (1907) H. Siebert, *Beiträge zur vorreformatorischen Heiligen- und Reliquienverehrung* (Freiburg, 1907)

Smekens (1976) F. Smekens, "Andermaal over Alexander Colyn, Mechels beeldhouwer (tussen 1526/1530–1612)," in A. Monballieu, G. Dogaer, and R. De Smedt, eds., *Studia Mechliniensia—Bijdragen aangeboden aan Dr. Henry Joosen* (Mechelen, 1976), pp. 191–205

Smith (1983) Jeffrey Chipps Smith, *Nuremberg, A Renaissance City, 1500–1618*, exh. cat. Archer M. Hungtington Art Gallery, University of Texas (Austin, 1983)

Smith (1985-I) Jeffrey Chipps Smith, "The Transformations in Patrician Tastes in Renaissance Nuremberg," in Smith (1985—II), pp. 82–100

Smith (1985-II) Jeffrey Chipps Smith, ed., *New Perspectives on the Art of Renaissance Nuremberg: Five Essays* (Austin, 1985)

Smith (1987-I) Jeffrey Chipps Smith, "Zur Bildhauerkunst der Spätgotik und der Renaissance in den kleinen Reichsstädten in Franken," in Rainer A. Müller, ed., *Reichsstädte in Franken, Aufsätze 2: Wirtschaft, Gesellschaft und Kultur* (Munich, 1987), pp. 384–98

Smith (1987-II) Jeffrey Chipps Smith, "Verbum Domini Manet In Aeternum'—Medal Designs

by Sebald Beham and the Reformation in the Duchy of Saxony," *AGNM* (1987): pp. 205–26

Smith (1989) Jeffrey Chipps Smith, "Kleinmeisters and Kleinplastik: Observations on the Collectible Object in German Renaissance Art," *The Register of the Spencer Museum of Art* 6 (1989): pp. 44–63

Smith (1990–91) Jeffrey Chipps Smith, "Netherlandish Artists and Art in Renaissance Nuremberg," *Simiolus* 20 (1990–91): pp. 153–67

Sponsel (1925–32) Jean Louis Sponsel, *Das Grüne Gewölbe zu Dresden*, 4 vols. (Leipzig, 1925–32)

Springer (1860) Anton Springer, "Inventare der Imhoff'schen Kunstkammer zu Nürnberg," *Mitteilungen der kaiserl. königl. Central Commission* (Wien) 5 (1860): pp. 352–57

Stafski (1958) Heinz Stafski, "Die Vischer-Werkstatt und ihre Probleme," *Zeitschrift für Kunstgeschichte* 21 (1958): pp. 1–26

Stafski (1962) Heinz Stafski, *Der jüngere Peter Vischer* (Nuremberg, 1962)

Stechow (1966) Wolfgang Stechow, *Northern Renaissance Art, 1400–1600: Sources and Documents* (Englewood Cliffs, 1966)

Steinmann (1968) Ulrich Steinmann, "Der Bilderschmuck der Stiftskirche zu Halle: Cranachs Passionszyklus und Grünewalds Erasmus-Mauritius-Tafel," *Staatliche Museen zu Berlin: Forschungen und Berichte* 11 (1968): pp. 69–104

Stirm (1977) Margarete Stirm, "Die Bilderfrage in der Reformation (Gütersloh, 1977)

Suhle (1950) Arthur Suhle, *Die Deutsche Renaissance-Medaille* (Leipzig, 1950)

Talbot (1990) Charles Talbot, "Hans Schäufelein's Woodcuts and the Arts of Sculpture and Painting," in *Hans Schäufelein: Vorträge, gehalten anlässlich des Nördlinger Symposiums* [1988] (Nördlingen, 1990), pp. 273–307

Thoma, Brunner, and Herzog (1980) Hans Thoma, Herbert Brunner, and Theo Herzog, *Stadtresidenz Landshut: Amtlicher Führer* (Munich, 1980—4th printing)

Thomas (1962) Alois Thomas, "Der Künstler des Segensis-Epitaphs in Trier-Liebfrauen," *Kurtrierisches Jahrbuch* 2 (1962): pp. 26–34

Theuerkauff (1975) Christian Theuerkauff, "German Small Sculpture of the Renaissance," *Apollo* 102 (December 1975): pp. 432–39

Thieme and Becker (1907–50) Ulrich Thieme and Felix Becker, eds., *Allgemeines Lexikon der bildenden Künstler von der Antike bis zur Gegenwart*, 37 vols. (Leipzig, 1907–50)

Thulin (1957) Oskar Thulin, *Altar und Kanzel der Torgauer Schlosskirche* (Wittenberg, 1957).

Trevor-Roper (1976) Hugh Trevor-Roper, *Princes and Artists: Patronage and Ideology at Four Habsburg Courts, 1517–1633* (New York, 1976)

Trusted (1990) Marjorie Trusted, *German Renaissance Medals: A Catalogue of the Collection in the Victoria and Albert Museum* (London, 1990)

Tüchle (1977) Hermann Tüchle, "Die Münsteraltäre des Spätmittelalters. Stifter, Heilige, Patrone und Kapläne," in Hans Engen Specker and Reinhard Wortmann, eds., *600 Jahre Ulmer Münster—Festschrift* (Ulm, 1977), pp. 126–82

Ullmann (1984) Ernst Ulmann, *Deutsche Architektur und Plastik: 1470–1550* (Leipzig, 1984)

Viebig (1971) Johannes Viebig et al., *Die Lorenzkirche in Nürnberg* (Königstein im Taunus, 1971).

Vöge (1910) Wilhelm Vöge, *Beschreibung der Bildwerke der Christlichen Epochen, IV. Die deutschen Bildwerke und die der anderen cisalpinen Länder* (Berlin, 1910)

Vöge (1932) Wilhelm Vöge, "Bildwerke deutscher Medailleure," *JPKS* 53 (1932): pp. 138–62

Vogts (1930) Hans Vogts, *Die Kunstdenkmäler der Stadt Köln*, vol. II.4 *Die profanen Denkmäler* (Cologne, 1930)

Wandel (1989) Lee Palmer Wandel, "The Reform of the Images: New Visualizations of the Christian Community at Zürich," *Archiv für Reformationsgeschichte* 80 (1989): pp. 105–24

Warncke (1979) Carsten-Peter Warncke, *Die ornamentale Groteske in Deutschland, 1500–1650*, 2 vols. (Berlin, 1979)

Warnke (1973) Martin Warnke, "Durchbrochene Geschichte? Die Bilderstürme der Wiedertäufer in Münster 1534/1535," in Martin Warnke, ed., *Bildersturm: Die Zerstörung des Kunstwerks* (Munich, 1973), pp. 65–98, 159–67

Weber (1975) Ingrid Weber, *Deutsche, niederländische und französische Renaissanceplaketten, 1500–1650*, 2 vols. (Munich, 1975)

Weber (1983) Gerhard Weber, "Das Praun'sche Kunstkabinett," *MVGN* 70 (1983): pp. 125–95

Weihrauch (1956) Hans R. Weihrauch, *Die Bildwerke in Bronze in anderen Metallen* [Kataloge des Bayerischen Nationalmuseums, München, vol. 13/5] (Munich, 1956)

Weihrauch (1967) Hans R. Weihrauch, *Europäische Bronzestatuetten 15.–18. Jahrhundert* (Braunschweig, 1967)

Welt im Umbruch (1980–81) *Welt im Umbruch: Augsburg zwischen Renaissance und Barock*, exh. cat. Stadt Augsburg, 3 vols. (Augsburg, 1980–81)

Wendehorst (1981) Alfred Wendehorst, ed., *Würzburg: Geschichte in Bilddokumenten* (Munich, 1981)

Wenzel Jamnitzer (1985) *Wenzel Jamnitzer und die Nürnberger Goldschmiedekunst 1500–1700*, exh. cat. Germanisches Nationalmuseum, Nuremberg (Munich, 1985)

Wiedertäufer in Münster (1982) *Die Wiedertäufer in Münster*, exh. cat. Stadtmuseum (Münster, 1982)

Wiles (1933) Bertha H. Wiles, *The Fountains of Florentine Sculptors and their Followers from Donatello to Bernini* (Cambridge [Mass.], 1933)

Wittstock (1981) Jürgen Wittstock, *Kirchliche Kunst des Mittelalters und der Reformationszeit: Die Sammlung im St.-Annen-Museum* [Lübecker Museumskataloge 1] (Lübeck, 1981)

Wixom (1975) William D. Wixom, *Renaissance Bronzes from Ohio Collections*, exh. cat. Cleveland Museum of Art (Cleveland, 1975)

Wood (1988) Christopher S. Wood, "In Defense of Images: Two Local Rejoinders to the Zwinglian Iconoclasm," *Sixteenth Century Journal* 19 (1988): pp. 25–44

Wuttke (1964) Dieter Wuttke, *DIE HISTORI HERCULIS des Nürnberger Humanisten und Freundes der Gebrüder Vischer, Pangratz Bernhaubt gen. Schwenter* (Cologne, 1964)

Wuttke (1966) Dieter Wuttke, "Theodoricus Ulsenius als Quelle für das Epigramm auf den Orpheus-Eurydike-Plaketten Peter Vischers des Jüngeren," *ZDVK* 20 (1966): pp. 143–46

Zeeden (1973) Ernst Walter Zeeden, ed., *Gegenreformation* (Darmstadt, 1973)

Zeitler (1951) Rudolf Zeitler, "Frühe deutsche Medaillen 1518–1527. Studien zur Entstehung des Stiles der Medaillenmeister Hans Schwarz, Christoph Weiditz und Friedrich Hagenauer," *Figura* 1 (1951): pp. 77–119

Zink (1968) Fritz Zink, *Die Handzeichnungen bis zur Mitte des 16. Jahrhunderts* [Kataloge des Germanischen Nationalmuseums, Die deutschen Handzeichnungen, vol. 1] (Nuremberg, 1968)

Zweite (1980) Armin Zweite, *Marten de Vos als Maler* (Berlin, 1980)

NOTES

Introduction

1. *Eygentliche Beschreibung Aller Stände auff Erden* (Frankfurt: Sigmund Feyerabend, 1568), p. H iv. The translation is mine with some suggestions by Sigrid Knudsen. See also Benjamin A. Rifkin, intro., *The Book of Trades {Ständebuch}—Jost Amman & Hans Sachs* (New York, 1973), p. 36.

2. "Die Krisis der Deutschen Kunst im Sechzehnten Jahrhundert," *Archiv für Kulturgeschichte* 12 (1914): pp. 1–16.

3. Lewis Spitz, *Conrad Celtis: The German Arch-Humanist* (Cambridge [Mass.], 1957), pp. 66–67, 93–106; and Smith (1983), pp. 40–1, 103.

4. Fedja Anzelewsky, *Albrecht Dürer—Das malerische Werk* (Berlin, 1991 revised ed.), nrs. 66, 93, 105.

5. Braunfels (1979–86), 1: pp. 11–9; and Kaufmann (1982), pp. 3–4.

6. "**Die Reformation beginnt**" exclaims the bold text in Günter Naumann, *Sächsische Geschichte in Daten* (Leipzig, 1991), p. 90.

7. See Reindl (1977), pp. 129–43 on what he terms the "Pseudo-Renaissance"; and Heinz Stafski, "Zur Rezeption der Renaissance in der Altarbaukunst Süddeutschlands," *Zeitschrift für Kunstgeschichte* 41 (1978): pp. 134–47.

8. Peter Strieder, "'Schri. kunst. schri. vnd. klag. dich. ser'—Kunst und Künstler an der Wende vom Mittelalter zur Renaissance," *AGNM* (1983): pp. 19–26, esp. 19.

9. Smith (1983), pp. 45–52.

10. While Baxandall (1980) inexplicably labels artists from Hans Multscher and Nicolas Gerhaerts to the Ottobeuren Master and Leinberger as "Renaissance," Bernhard Decker was far more sensitive when he titled his excellent book *Das Ende des mittelalterlichen Kultbildes und die Plastik Hans Leinbergers* (Bamberg, 1985).

11. Baxandall (1980), pp. 135–42 offers a good assessment of these two styles. He cites a woodcut, incorrectly attributed to Peter Flötner, that depicts a halberdier who had turned to soldiering when he could no longer survive as a sculptor. The complete accompanying dialogue reads: "Fine figures did I carve galore, / In Southern and in German style, / But now this art nobody wants / Unless I carve my figures fine / As nudes and make them come to life—/ Such could I sell in ev'ry town. / But since I cannot do this trick / I'll have to choose some other job / And with my halberd I will serve / A potentate of great renown." The translation is from Stechow (1966), p. 133.

12. See the summmary comments in Jan Bialostocki, "Two Types of International Mannerism: Italian and Northern," *Umení* 18 (1970): pp. 105–9.

13. Baxandall (1980); and Schleif (1990).

14. On these subjects, see the extensive published documentation in Rott (1933; 1934; 1936–38); Huth (1967); Johannes Taubert, *Farbige Skulpturen: Bedeutung, Fassung, Restaurierung* (Munich, 1978); Baxandall (1980), pp. 27–48, 95–122; Arnulf von Ulmann, *Bildhauertechnik des Spätmittelalters und der Frührenaissance* (Darmstadt, 1984); and Rainer Brandl, "Art or Craft? Art and the Artist in Medieval Nuremberg," in *Gothic and Renaissance Art in Nuremberg* (1986), pp. 51–60. As in the previous period, guild ordinances, such as the articles of Augsburg's sculptors, written in 1564, tend to be practical documents explicating basic issues such as the training of apprentices and the use of journeymen. See Karl Feuchtmayr, "Studien zur Augsburger Plastik der Spätrenaissance," *Das Schwäbische Museum* 2 (1926): esp. pp. 48–49.

15. For example, see Pomponius Gauricus, *De Sculptura (1504)*, ed. and tr. André Chastel and Robert Klein (Geneva, 1969); Giorgio Vasari, *Vasari on Technique Being the Introduction to the Three Arts of Design, Architecture, Sculpture and Painting*, intro. G. Baldwin Brown, tr. Louisa S. Maclehose (New York, 1907—reprinted 1960), esp. pp. 141–202; and *The Treatises of Benvenuto Cellini on Goldsmithing and Sculpture*, tr. C. R. Ashbee (New York, 1888—reprinted 1967), esp. pp. 111–45.

16. *Paragone: A Comparison of the Arts by Leonardo da Vinci*, intro. and tr. Irma A. Richter (London,

1949), esp. pp. 81–109; and David Summers, *Michelangelo and the Language of Art* (Princeton, 1981), pp. 269–78.

Chapter One

1. Sixten Ringbom, *From Icon to Narrative* (Abo, 1965), p. 29; and Smith (1983), p. 23. Joachim von Pflummern, writing in the 1530s about pre-Reformation religious practices, noted that such *heilige Briefe*, or single-sheet woodcuts with holy images and prayers, could be found commonly "in houses, rooms, chambers, on fences, on trunks, on doors and on walls and everywhere. There was also much trade in them, and many used to buy them gladly, for the sake of piety." Woods (1988), p. 39.

2. For example, between 1506 and 1508 Adam Kraft of Nuremberg erected large reliefs depicting the stations of the cross. These were set on pedestals along the road from the Tiergärtnertor to the Johannisfriedhof or cemetery. At the cemetery the cycle culminated in the over life-size Crucifixion group and an Entombment. Schwemmer (1958), pp. 34–37, pls. 56–67; Smith (1983), pp. 24–25.

3. Johan Huizinga, *The Waning of the Middle Ages* (Garden City, New York, 1954 ed.), ch. XII; Hoss (1961); Jacques Toussaert, *Le sentiment religieux en Flandre à la fin du Moyen-Age* (Paris, 1963); Moeller (1971); and Eire (1986), pp. 10–11. Antonio de Beatis, an Italian cleric who traveled in the company of Cardinal Luigi of Aragon through Germany in 1517–18, praised the high level of piety there. He wrote that in Germany one could find many newly built churches, a fact that prompted him to lament the decay of the Italian churches and his country's low esteem for religion. Boockmann (1988), p. 11.

4. Smith (1983), p. 165.

5. For an excellent broad discussion of this phenomenon see Freedberg (1989).

6. Smith (1983), p. 160.

7. Eire (1986), pp. 14–15.

8. Achim Hubel, "Die Schöne Maria von Regensburg. Wallfahrten, Gnadenbilder, Ikonographie," in P. Mai, ed., *850 Jahre Kollegiatstift zu den Heiligen Johannes Baptist und Johannes Evangelista in Regensburg, 1127–1977* (Munich, 1988), pp. 199–237; Gerhard B. Winkler, "Die Regensburger Wallfahrt zur Schönen Maria (1519) als reformatorisches Problem," in Dieter Henrich, ed., *Albrecht Altdorfer und seine Zeit* (Regensburg, 1981), pp. 103–21; Christiane Andersson and Charles Talbot, *From a Mighty Fortress: Prints, Drawings, and Books in the Age of Luther, 1483–1546*, exh. cat. (Detroit, 1983), pp. 323–25; and Christopher Wood, "Ritual and the Virgin on the Column: The Cult of the Schöne Maria in Regensburg," *Journal of Ritual Studies* 6 (Winter 1992): pp. 87–107.

9. Wolfgang Pfeiffer, "und lobt die schöne Maria—Ein Votivrelief der Regensburger Wallfahrt von 1520," *AGNM* (1983): pp. 27–31. The relief is in the Museen der Stadt in Regensburg.

10. On the rise of individual meditations, see Klara Erdei, *Auf dem Wege zu sich selbst: Die Meditation im 16. Jahrhundert. Eine funktionsanalytische Gattungsbeschreibung* (Wiesbaden, 1990).

11. Smith (1985—I), pp. 84–86; and Schwemmer (1958), pp. 16–19.

12. Thomas à Kempis, *The Imitation of Christ*, tr. L. Sherley-Price (Harmondsworth, 1972), p. 85 (ch. 12).

13. During the late fifteenth and early sixteenth centuries the cult of St. Anne grew the most rapidly. See Ernst Schaumkell, *Der Kultus der Heiligen Anna am Ausgange des Mittelalters* (Leipzig, 1893); Beda Kleinschmidt, *Die Heilige Anna, ihre Verehrung in Geschichte, Kunst und Volkstum* (Düsseldorf, 1930), p. 139; and Garside (1966), pp. 85–86; and Kathleen Ashley and Pamela Sheingorn, eds., *Interpreting Cultural Symbols: Saint Anne in Late Medieval Society* (Athens [Georgia], 1990).

14. Geiger (1971), p. 158.

15. Moeller (1971), p. 53.

16. In the 1530s Joachim von Pflummeran of Biberach described the various saints' feast days, the celebrations performed, and the specific intercessor functions of each saint. See Schilling (1887), esp. pp. 98–110 (St. Sebastian's to St. Thomas' days).

17. Garside (1966), p. 90; also Siebert (1907), pp. 42–61.

18. For the Augsburg example of 1491, see Rasmussen (1981), pp. 100–101 and fig. 1 that is attributed to Ulrich Apt; for the version in Strasbourg until its destruction in 1525, see Christensen (1979), p. 89.

19. For a good introduction to relics and their

veneration, see Anton Legner, ed., *Reliquien: Verehrung und Verklärung*, exh. cat. Schnütgen-Museum (Cologne, 1989).

20. Garside (1966), p. 84. For a discussion of the sort of prayers recited at pilgrimage sites, see Siebert (1907), pp. 55–61.

21. Franz Rudolf Reichert, "Trier Heiltumsschriften," in Franz J. Ronig, ed., *Schatzkunst Trier: Forschungen und Ergebnisse* (Trier, 1991), pp. 167–86.

22. Hofbibliothek, ms. Man. 14. The art at Halle will be discussed in Chapter Three. On the history and form of the collection, see Halm and Berliner (1931); and Rasmussen (1976 and 1977). Rasmussen provides the best discussion of the reliquaries as works of art attributable to specific masters or towns.

23. Halm and Berliner (1931), nr. 174b and folio 227v. It dates c. 1520.

24. Halm and Berliner (1931), nr. 274 and folio 353v. This bust was designed either by Lucas Cranach the Elder or another master in his circle.

25. This point plus other expressions of faith, including a strong affirmation in the belief of saintly intercession, can be found in the many letters of endowments to the church. For examples from Augsburg and Ulm, see Kiessling (1971), p. 236 and Geiger (1971), pp. 167–68. One of the clearest statements of the exchange of goods occurs in the foundation charter of the Hôtel Dieu in Beaune (Côte d'Or) in 1443 in which Nicolas Rolin, the Burgundian chancellor, wrote "disregarding all human concerns and in the interest of my salvation, desiring by a favorable trade to exchange for celestial goods temporal ones, that I might from divine goodness render those goods which are perishable for ones which are eternal . . . in gratitude for the goods which the Lord, source of all wealth, has heaped upon me, from now on and for always, I found . . . a hospital." Shirley N. Blum, *Early Netherlandish Triptychs* (Berkeley, 1969), pp. 46–47.

26. Moeller (1971), p. 55. Albrecht's concern for indulgences was widely shared by his contemporaries, though not to the same extremes. In 1498 Stefan Baumgartner of Nuremberg travelled to Jerusalem with Heinrich the Pious, duke of Saxony, and a group of other Germans. Baumgartner's diary offers a fascinating account of the religious sites of

the city. Yet for every one of his descriptions of specific churches, he carefully lists the value of the indulgence that he has received. Typically each stop amounted to another seven years and seven quadregenes (one quadregene equals 40 days) of indulgence. See Stefan Baumgartner, *Reise zum Heiligen Grab 1498 mit Herzog Heinrich dem Frommen von Sachsen*, ed. Thomas Kraus and Lotte Kraus (Göppingen, 1986), esp. pp. 31–58.

27. Lukas Cranach, *Wittenberger Heiltumsbuch—Faksimile-Neudruck der Ausgabe Wittenberg 1509* (Unterschneidheim, 1969); Bruck (1903), esp. pp. 207–23; Jahn (1972), pp. 456–544.

28. Not thoroughly paginated. St. Catherine appears on the equivalent of folio 9 recto.

29. Bruck (1903), p. 208. By 1520 the collection had grown to 19,013 pieces. On the history of the collection and its contents, see Bellmann et al. (1979), pp. 257–67.

30. Folio 3 verso (a iii verso).

31. Jahn (1972), pp. 456–57.

32. Hoss (1961), p. 19.

33. Julia Schnelbögl, "Die Reichskleinodien in Nürnberg, 1424–1523," *MVGN* 51 (1962): pp. 78–159; Smith (1983), pp. 28–30.

34. I picked these four examples because of the elaborateness of the resulting shrines and because of their geographic proximity. Several other nearby towns chose to honor their patron saints by commissioning new altarpieces.

35. Kiessling (1971), p. 291.

36. Blendinger and Zorn (1976), p. 68, pl. 149. On the saint and his artistic representations, see Peter Rummel, ed., *St. Simpert, Bischof von Augsburg 778–807* (Augsburg, 1978), esp. pp. 61–95.

37. Müller (1959), nr. 94; Anja Broschek, *Michel Erhart* (Berlin, 1973), pp. 14, 189–90. For a seventeenth-century engraved view of the tomb in situ following its renovation in 1579, see Kister (1712), pl. opp. p. 38.

38. H. Müller (1958), pp. 134–35. The altar was also destroyed in 1537.

39. Kiessling (1971), p. 292. In the engraved view of the chapel, later votives of body parts hang above the tomb as testimony to the saint's healing powers. See Kister (1712), pl. opp. p. 38.

40. Justus Bier, "Riemenschneider's Tomb of Emperor Henry and Empress Cunegund," *Art Bulletin* 29 (1947): pp. 95–117; Bier (1925–78), 3:

pp. 1–48, 166–77; Buczynski (1981), pp. 351–56; and Bier (1982), pp. 106–7, pls. 40A–G.

41. Bier (1982), pp. 86–87, pls. 22A–E.

42. Braunfels (1979–89), 2: pp. 229–30, fig. 210.

43. The literature on the shrine is extensive. See especially Stafski (1958); Stafski (1962), pp. 9–37; Kurt Pilz, *Das Sebaldusgrabmal im Ostchor der St.-Sebaldus-Kirche* (Nuremberg, 1970).

44. Christensen (1979), pp. 16–17.

45. The exact motivating factors behind the commission are impossible to reconstruct though the contemporary completion of Riemenschneider's tomb at Bamberg might have provided the impetus. A large section of Eichstätt's original diocesan lands had been transferred at Heinrich's request in 1007 to form the new bishopric of Bamberg. See Reindl (1977), pp. 49–56 and 267–72 for what follows. Schädler (1975) has tried to reattribute the Willibald-Monument to Gregor Erhart based upon a stylistic argument that while interesting fails to understand the Augsburg roots of Hering's own art, as well as Hering's subsequent documented career in Eichstätt.

46. In 1515 Hering is documented being paid for "zway stainen pylde" for this altar. As Reindl (1977, pp. 236 and esp. 272) correctly observes, the record is sufficiently vague that these two stone images could have been reliefs illustrating the saint's life or simply two angels for the altar.

47. Emanuel Braun, *Eichstätt—Dom und Domschatz* (Königstein im Taunus, 1986), pp. 74 and 80 (rationale of Bishop Johann von Eych [r. 1445–64]); and Reindl (1977), pp. 274–75 (Hering's Epitaph of Gabriel von Eyb, 1514–20, in Eichstätt Cathedral).

48. The altar was dismantled in 1701 and the predella figures were destroyed in 1945. See Bier (1925–78), 2: pp. 104–15, 179–85; Bier (1982), pp. 103–4; and *Kilian: Mönch aus Irland—aller Franken Patron, 689–1989*, exh. cat. Festung Marienberg (Würzburg, 1989).

49. Hans Peter Hilger, *Der Dom zu Xanten* (Königstein im Taunus, 1984), pp. 16–17, 62–65, 69, 73, 76.

50. The Halle altar will be discussed in Chapter Three. Nikolaus Hagenauer's service altar of 1501 in Strasbourg was recorded in an engraving of 1617 by Isaac Brunn. The eight saintly busts presumably housed relics. See Heck (1989), p. 106, fig. 8. Two portions of the reliquary high altar made in 1499 for the Kreuzherrnkloster at Bentlage are now in the Falkenhof-Museum in Rheine. See Leonie von Wilckens, "Zur Restaurierung der Reliquienschreine aus Kloster Bentlage," *Kunstchronik* 45 (1992): pp. 184–85, figs. 2–3.

51. Moeller (1971), p. 53; and see the comments below on the altars in Ulm Münster.

52. Smith (1987—I), pp. 388 and 393.

53. The *Deichsler Chronicle* in *Chroniken* (Nuremberg, 1874), 5: p. 549; cited by Rainer Kahsnitz in *Gothic and Renaissance Art in Nuremberg* (1986), p. 63.

54. Stechow (1966), pp. 78–81.

55. Tüchle (1977), p. 127 and passim.

56. Geiger (1971), p. 158.

57. Tüchle (1977), pp. 142–43.

58. Tüchle (1977), p. 130.

59. Tüchle (1977), pp. 173–74; and Hermann Baumhauer, *Das Ulmer Münster und seine Kunstwerke* (Stuttgart, 1977), pp. 76–81.

60. For the population figures, see Wood (1988), p. 28; and Norbert Lieb, "Augsburger Baukunst der Renaissancezeit," in *Augusta 955–1955* (Augsburg, 1955), p. 233. Around 1500–20 Augsburg had over 20,000 inhabitants, Nuremberg c. 40,000, Frankfurt 10,000, Munich 13,500, and Cologne probably around 40,000.

61. Schilling edited and published Heinrich's text in 1875 and Joachim's in 1887. He did not know of the identity of the author of the second text though he believed the writer to be a cleric. The identification of the latter author as Joachim plus additional biographic information on the brothers is given in Albert Angele, *Altbiberach um die Jahre der Reformation* (Biberach, 1962), esp. pp. 9–12 and 125–29. A good recent introduction to the two texts, though without knowledge of Angele's work, is Wood (1988), pp. 25–44.

62. Schilling (1887), p. 7; Wood (1988), pp. 26–27.

63. Schilling (1887), pp. 22–32.

64. Schilling (1887), pp. 26–27.

65. Schilling (1887), p. 29.

66. See Erhard Schön's *The Great Rosary* of 1515 for a comparative image of souls in purgatory; Geisberg (1974), nr. 1133; and Smith (1983), pp. 162–63. The power of earthly prayers for the deceased is

illustrated in the scene on the wing of the *Tegernsee Altar* (1476), now in Munich (Bayerisches Nationalmuseum), in which St. Ottilie's prayers are shown helping her father; see Boockmann (1988), p. 22, fig. 28.

67. Schilling (1887), p. 34.

68. Garside (1966), pp. 82–83, and 83–93 for what follows.

69. Harald Siebenmorgen, *St. Martinikirche in Braunschweig* (Munich, 1984), p. 4; Karant-Nunn (1987), p. 17; Adalbert Ehrenfried, *Die Liebfrauenkirche in Frankfurt am Main* (Munich, 1987), pp. 7–10; Haas (1977), p. 89; and Pfister and Ramisch (1983), pp. 16–19.

70. Hasse (1983), pp. 76, 167–73.

71. Boockmann (1988), p. 34, note 14 citing *Barthel Steins Beschreibung von Schlesien und seiner Hauptstadt Breslau 1512/13 in deutscher Übersetzung*, ed. Hermann Markgraf (Breslau, 1902), pp. 64ff..

72. Bellmann, Harksen, and Werner (1979), p. 246; also see 90–98 and 242–53 on the church, which was begun in 1489, and its former decoration.

73. Christensen (1979), p. 171.

74. Lothar Altmann, *Der Heilige Berg Andechs—Geschichte und Kunst* (Munich, 1986 ed.), pp. 8–11.

75. Christensen (1979), p. 171. For an excellent study of documented and extant sculpture in Constance and the Bodensee area, see Wolfgang Deutsch, "Die Konstanzer Bildschnitzer der Spätgotik und ihr Verhältnis zu Nikolaus Gerhaert," *Schriften des Vereins für Geschichte des Bodensees und seiner Umgebung* 81 (1963): pp. 11–129, and 82 (1964), pp. 1–113.

76. Redlich (1900), p. 177 on Magdeburg; and Mrusek (1976), p. 374 on Meissen.

77. Schmid (1985), pp. 14, 28–30.

78. For what follows, see especially Haas (1977) who has made an excellent study on the history of the different altars; Viebig (1971)—with photographs of the various monuments mentioned below; Fehring and Ress (1977), pp. 64–110; and Schleif (1990). The latter offers a superb discussion of selected monuments within the church and the motives of their patrons.

79. Haas (1977), p. 89.

80. Schwemmer (1958), pp. 19–23, pls. 6–27; *Der Englische Gruss des Veit Stoss zu St. Lorenz in Nürnberg* (Arbeitsheft 16—Bayerisches Landesamt für Denkmalpflege; Munich, 1983); and Schleif (1990), pp. 16–75 (on the sacrament house).

81. The commission document repeatedly mentions how the carvings closest to the ground are to be worked especially carefully since these are the most visible. For the text, see Schleif (1990), pp. 242–44. A partial English translation is given in Stechow (1966), pp. 81–82.

82. Gabriel and Mary both measure about 2.18 meters in height. The whole ensemble, in its present form, measures over 5 meters high and 3 meters wide.

83. It is represented in Michael Herr's body color drawing of 1646, now in a private collection. See *Der Englische Gruss des Veit Stoss zu St. Lorenz in Nürnberg* (Arbeitsheft 16—Bayerisches Landesamt für Denkmalpflege; Munich, 1983), p. 3 and fig. 1. Two of the angels surrounding Mary and Gabriel have also been lost.

84. Karl Joseph Klinkhammer, "Frömmigkeitsgeschichtliche Voraussetzungen zum Englischen Gruss," in Kahsnitz (1985), pp. 183–191, esp. 188ff.

85. These epitaphs are discussed in Chapter Five.

86. Haas (1977), p. 20.

87. At the Neue Stift in Halle, such processions were common because of the large number of saints whose relics were housed and venerated there. In the *Missale Hallense* (or *Great Halle Missal*) of 1524, Nikolaus Glockendon of Nuremberg depicted Cardinal Albrecht von Brandenburg participating in the Corpus Christi procession in Halle. He walks holding a monstrance. Above him is a canopy marked with his three episcopal titles of Magdeburg, Mainz, and Halberstadt plus painted busts of Sts. Moritz and Mary Magdalene, the patrons of the Neue Stift. See Aschaffenburg (Hofbibliothek, ms. 10, fol. 193v; and Biermann (1975), pp. 160–61, fig. 210.

88. Moeller (1971), pp. 66–67.

89. Schilling (1887), pp. 114–15, 133. Pieter Bruegel's *Battle Between Carnival and Lent* (1559) in Vienna (Kunsthistorisches Museum) depicts the covering of statues; see Fritz Grossmann, *Pieter Bruegel: Complete Edition of the Paintings* (London, 1966 ed.), pls. 6–7.

90. Schilling (1887), pp. 117–18.

91. Garside (1966), p. 92.

92. Jasbar and Treu (1981), nrs. 35–36. On the latter, see Geiger (1971), p. 159. Also see E. Wiepen, *Palmsonntagsprozession und Palmesel* (Bonn, 1909).

93. Schilling (1887), pp. 124ff..

94. Schilling (1887), p. 35.

95. Geiger (1971), p. 159; Jasbar and Treu (1981), nrs. 117–18 (attributed to Michel Erhart); and Scribner (1988), p. 131.

96. Viebig (1971), p. 17 (the original is in the Germanisches Nationalmuseum); and Garside (1966), p. 92.

97. See Schilling (1887), pp. 35 and 126–36 for what follows; also Wood (1988), pp. 34–35. In the Grossmünster in Zürich, the Holy or Easter Grave was a pilgrimage site set within the Chapel of the Twelve Apostles. The statue of Christ was also removed on Easter day. See Garside (1966), pp. 88–89. One of the most famous, though earlier (thirteenth-century), Holy Graves that was used in liturgical and dramatic ceremonies is still in Constance cathedral; see Rudolf Busch, "Das Heilige Grab zu Konstanz," *Oberrheinische Kunst* 1 (1925–26): pp. 106–25.

98. This is the concluding scene in Adam Kraft's great passion cycle completed in 1508. See Schwemmer (1958), pl. 63.

99. On statues designed specifically for this occasion see Ulla Haastrup, "Medieval Props in the Liturgical Drama," *Hafnia* 11 (1987): pp. 133–70; and esp. Hans-Joachim Krause, " 'Imago ascensionis' und 'Himmelloch'. Zum 'Bild'-Gebrauch in der spätmittelalterlichen Liturgie," in Friedrich Möbius and Ernst Schubert, eds., *Skulptur des Mittelalters. Funktion und Gestalt* (Weimar, 1987), pp. 280–353. An Augsburg example will be discussed in Chapter Two.

Chapter Two

1. Page 19 as cited by Christensen (1979), p. 25.

2. This subject, like the wealth of scholarly literature, is vast. Our intention is to summarize several of the basic practices and ideas in order to understand the impact that the Reformation had upon the broader history of German Renaissance art. I have relied often on the excellent studies of Garside (1966), Stirm (1977), Christensen (1979),

Scribner (1981) and Eire (1986), plus the exhibition catalogues *Martin Luther und die Reformation in Deutschland* (1983), *Kunst der Reformationszeit* (1983), and Hofmann (1983). Linda B. Parshall and Peter W. Parshall, *Art and the Reformation: An Annotated Bibliography* (Boston, 1986) provides an intelligently organized guide to the subject. Also see Steven Ozment, ed., *Reformation Europe: A Guide to Research* (St. Louis, 1982).

3. Christensen (1979), p. 22.

4. Garside (1966), p. 92.

5. Garside (1966), p. 91.

6. Garside (1966), p. 91 citing an Augsburg religious manual of the fifteenth century.

7. For an excellent discussion, see Wandel (1989), esp. pp. 106–9.

8. Eire (1986), p. 33 citing chapter I, part 5.

9. For a good overview of Erasmus's views on piety, see Eire (1986), pp. 28–53.

10. Eire (1986), pp. 39–40 citing *The Praise of Folly (1509)*, ed. and tr. H. H. Hudson (Princeton, 1974), p. 66.

11. Hofmann (1983), pp. 130–31. Myconius, a teacher in Lucerne, was a friend of Erasmus.

12. Eire (1986), p. 50 citing J. P. Dolan, ed. and tr., *The Essential Erasmus* (New York, 1964), p. 380.

13. The best discussions of Karlstadt's criticism of images are in Stirm (1977), pp. 24 and 38ff.; Christensen (1979), pp. 23–35; and Eire (1986), pp. 55–65. Karlstadt's text has recently been translated into English. See *A Reformation Debate: Karlstadt, Emser, and Eck on Sacred Images*, tr. and ed. Bryan Mangrum and Giuseppe Scavizzi (Toronto, 1991), pp. 19–39.

14. Stirm (1977), p. 24—"Item die bild vnd altarien in der kirchen sollen auch abgethon werden, damit die abgotterey zu vermeyden, dann drey altaria on bild genug seind."

15. Christensen (1979), p. 28.

16. Christensen (1979), pp. 40–41.

17. Christensen (1979), p. 43 (WA 10[I.1]:39).

18. Eire (1986), pp. 65–73.

19. "A good work is good for the reason that it is useful and benefits and helps the one for whom it is done; why else should it be called good? . . . Whom does it help if you put silver and gold on the walls, wood and stone in the churches? . . . Who is better for it, if every church had more silver,

pictures, and jewelry than the churches of Halle and Wittenberg? That is altogether vain fool's work and production." *Advent Postils* of 1522. Christensen (1979), p. 44 (WA 10[I.2]:39–40) and, on the same page, see Luther's *Long Sermon on Usury* (1520). Luther here was referring to the great collections of relics in Halle and Wittenberg discussed above in Chapter One.

20. Christensen (1979), pp. 51–52 (WA 18: 83).

21. Stirm (1977), pp. 69–89, esp. 81ff.; Christensen (1979), pp. 59–65.

22. His position recalls that of Erasmus who in 1514 published a poem entitled *The Complaint of Jesus* in which Christ complains that the people turn only to the saints and not to him in their prayers because of the Catholic church's teachings. Garside (1966), p. 93.

23. Garside (1966), pp. 93–103 and the subsequent chapters; Stirm (1977), pp. 130–60, esp. 138–53 on Zwingli; and Eire (1986), pp. 73–94.

24. Garside (1966), pp. 129–51; also see Wandel (1989), pp. 109–13.

25. Garside (1966), p. 147.

26. Garside (1966), p. 143.

27. Garside (1966), pp. 148–49.

28. Garside (1966), 150.

29. Wandel (1989), pp. 110–14.

30. His sentiments were shared by the majority including Balthasar Hubmaier of Waldshut who in 1519 had been the first chaplain appointed to the chapel dedicated to the Virgin Mary in Regensburg. (fig. 3) His attitude had changed dramatically in the interim. Shortly after the disputation he wrote that "Images are good for nothing: wherefore such expense should be no longer wasted on images of wood and stone, but bestowed upon the living, needy images of God." Garside (1966), p. 144.

31. Garside (1966), pp. 146–60 for a full accounting of local actions.

32. Eire (1986), p. 69.

33. On Calvin, see Stirm (1977), pp. 161–223; and Eire (1986), pp. 195–233. On his effect on art in the Low Countries, see Crew (1978).

34. Eire (1986), p. 208.

35. Eire (1986), p. 226.

36. Eire (1986), p. 211 (CR 6.409).

37. Eire (1986), pp. 221–24.

38. "In brief, if all the pieces [of the true cross] which could be found were collected into a heap, they would form a good ship-load, though the gospel testifies that a single man was able to carry it." *Inventory of Relics* (CR 6.420) cited by Eire (1986), p. 229.

39. *A Treatise on Relics by John Calvin* (Edinburgh, 1854), p. 271.

40. The literature is extensive. In addition to Crew (1978), see especially David Freedberg, "Art and Iconoclasm, 1525–1580: The Case of the Northern Netherlands," in Filedt Kok et al. (1986), pp. 69–84; and Peter W. Parshall, "Kunst en reformatie in de Noordelijke Nederlanden—enkele gezichtspunten," *Bulletin van het Rijksmuseum* 35 (1987): pp. 164–75.

41. Among other recent studies, in addition to those given below, see Gerhard Jaritz, "Von der Objektkritik bis zur Objektzerstörung. Methoden und Handlungsspielräume im Spätmittelalter," and Sergiusz Michalski, "Die protestantischen Bilderstürme. Versuch einer Übersicht," in Bob Scribner, ed., *Bilder und Bildersturm im Spätmittelalter und in der frühen Neuzeit* (Wiesbaden, 1990), pp. 37–50 and 69–124.

42. On this general subject, see Michael P. Carroll, *Madonnas that Maim: Popular Catholicism in Italy since the Fifteenth Century* (Baltimore, 1992).

43. Scribner (1988), pp. 130–41 provides several examples.

44. Eire (1986), p. 28.

45. Scribner (1988), pp. 132–33.

46. Geisberg (1974), nr. 1145 (with text); *Reformation in Nürnberg* (1979), nr. 137; Baxandall (1980), pp. 78–81 (with a partial translation of the text); *Martin Luther und die Reformation in Deutschland* (1983), nr. 515; and Hofmann (1983), nr. 1.

47. Later Calvin wrote in his *Institutes*, "Formerly I was the trunk of a wild fig tree, a useless log; when the artificer, after hesitating whether he would make me a stool or a deity, at length determined that I should be a god." Cited by Crew (1978), p. 29.

48. Christensen (1979), pp. 35–41.

49. Scribner (1988), p. 132.

50. Karant-Nunn (1987), pp. 17, 45–47, 134, 200. Zwickau's officials did remove a few altars and the Chapel of St. Jakob was transformed into a tavern for the city councillors, yet the major church

decorations, including Michael Wolgemut and Veit Stoss's High Altar in the Marienkirche, survive. On the possible attribution of this altar to the young Stoss, see Michael Stuhr, "Der Bildwerkschmuck des Zwickauer Schreins. Ein Frühwerk des Veits Stoss?" in Kahsnitz (1985), pp. 79–87.

51. Klaus Kratzsch, *Bergstädte des Erzgebirges: Städtebau und Kunst zur Zeit der Reformation* (Munich, 1972), pp. 26 and 32. For a political map of this period, see K. Blaschke, *Sachsen im Zeitalter der Reformation* (Gütersloh, 1970), pp. 24–25.

52. Scribner (1988), pp. 126–27.

53. Garside (1966), pp. 159–60.

54. Garside (1966), p. 160.

55. Eire (1986), pp. 108–12. Interestingly, their destruction of the cathedral's art was not complete. They left largely untouched the great choir stalls that Jacob Ruess and Heinrich Seewagen had finished only in 1524 apparently after the design of Niklaus Manuel Deutsch, one of the leaders of the Reformation in Bern. See Hans Bloesch and Marga Steinmann, *Das Berner Münster* (Bern, 1938), pp. 57–62 with numerous illustrations; and *Niklaus Manuel Deutsch: Maler, Dicter, Staatsmann*, exh. cat. Kunstmuseum (Bern, 1979), esp. pp. 488–91 on the choir stalls and 100–13 and 513–25 on his Reformation activities.

56. Eire (1986), pp. 111–12 (ZW 6/1.497–8).

57. For what follows, see Janssen (1905–25), 5: pp. 135–47; Stirm (1977), pp. 156–59; Christensen (1979), pp. 79–102; Eire (1986), pp. 105–19.

58. Constance cathedral lost 63 altars, including Nikolaus Gerhaert's famous high altar. All of the altars and paintings in nearby Petershausen were destroyed on 23 May. See Konrad Gröber, "Die Reformation in Konstanz von ihrem Anfang bis zum Tode Hugos von Hohenlandenberg (1517–1532)," *Freiburger Diözesan-Archiv* 46 (1919): pp. 120–322, esp. 282–301.

59. Janssen (1905–25), 11: p. 31.

60. Here the cleansing was not as thorough as in the Swiss towns. See Heinrich Weizsäcker, *Die Kunstschätze des ehemaligen Dominikanerklosters in Frankfurt a. M.* (Munich, 1923), pp. 30–31.

61. On these towns see our comments in Chapter One; Martin Scharfe, *Evangelische Andachtsbilder* (Stuttgart, 1968), pp. 7–15; and Wood (1988).

62. The preacher Elias Frick wrote the following about the destruction of art in the Münster: "die beyde Orglen wurden abgehoben und hinaus geschafft als es aber schwer hergehen wolte die grosse Orgel mit allem herunter zu bringen bunde man Sailer und Ketten darum spannete sodann Pferdte an diese und risse vermittelst derselben mit groester Gewalt alles herunter: alle Heiligen-Bilder an Saeulen und Waenden dem Cantzel-Deckel und der Cantzel selbsten um den Tauff-Stein und zwey vom Sacrament-Haesslein und die Oberste im chor wurden ebenfalls von ihnen hinweg und zur Kirche hinaus gethan." Cited by Hermann Baumhauer, *Das Ulmer Münster und seine Kunstwerke* (Stuttgart, 1977), p. 10.

63. Rott (1934), 2: p. 76; and Scribner (1988), p. 131.

64. Robert W. Scribner, "Why was there no Reformation in Cologne?," in Scribner (1987), pp. 217–42; and Brück (1972), pp. 17–30.

65. On the art and history of the German episcopal cities, see Braunfels (1979–89), 2. Also see Heide Stratenwerth, *Die Reformation in der Stadt Osnabrück* (Wiesbaden, 1974); and Robert W. Scribner, "Civic Unity and the Reformation in Erfurt," in Scribner (1987), pp. 185–216.

66. Gottfried Seebass, "Stadt und Kirche in Nürnberg im Zeitalter der Reformation," in Bernd Moeller, ed., *Stadt und Kirche im 16. Jahrhundert* (Gütersloh, 1978), pp. 66–86; Christensen (1979), pp. 66–78; *Reformation in Nürnberg* (1979); Günther Vogler, *Nürnberg 1524–25: Studien zur Geschichte der reformatorischen und sozialen Bewegund in der Reichsstadt* (Berlin, 1982); and Smith (1983), pp. 30–36.

67. Christensen (1979), p. 73.

68. For Caritas Pirckheimer's opposition to the Reformation and the reactions within the convent of St. Klara, see Christoph von Imhoff and Georg Deichstetter, *Caritas Pirckheimer und die Reformation in Nürnberg* (Nuremberg, 1982), esp. pp. 34–48; and Lotte Kurras and Franz Machilek, *Caritas Pirckheimer 1467–1532* (Munich, 1982), pp. 19–25 and 143–44. The last nun of St. Klara died in 1596.

69. Eberhard Lutze, *Veit Stoss* (Munich, 1968–3rd ed.), pp. 57–62; Günther Bräutigam, "Ehem. Hochaltar aus der Karmeliterkirche zu Nürnberg,

1520–1523," in Kahsnitz (1983), pp. 333–50; and Rainer Kahsnitz in *Gothic and Renaissance Art in Nuremberg* (1986), pp. 252–54.

70. For the debate over whether the program of the altarpiece was intentionally anti-Lutheran or simply a reiteration of fundamental Catholic ideals, see Reiner Haussherr, "Der Bamberger Altar," in Kahsnitz (1985), pp. 207–28, esp. 222–28; and Robert Suckale, "Das ehemalige Hochaltarretabel der Nürnberger Karmelitenkirche und sein altkirchliches Programm," in Kahsnitz (1985), pp. 229–44.

71. Muzeum Historyczne Uniwersytetu Jagiellonskiego. Rainer Kahsnitz in *Gothic and Renaissance Art in Nuremberg* (1986), pp. 252–54.

72. Haas (1977), p. 87 lists the removed altars and 93–107 discusses the individual histories of each altar.

73. The Imhoffs paid for minor repairs in 1501, 1571, 1605, 1654, and 1670. See Schwemmer (1958), p. 23.

74. Christensen (1979), pp. 76–77.

75. Hans-Christoph Rublack, *Eine bürgerliche Reformation: Nördlingen* (Gütersloh, 1982), pp. 181–85; Ulrich Kopf, "Reichsstadt und Kirche," in Rainer A. Müller, ed., *Reichsstadt in Franken, Aufsätze 2—Wirtschaft, Gesellschaft und Kultur* (Munich, 1987), pp. 244–60, esp 254ff.; and Smith (1987—I). Some removal of art occurred in each of these towns.

76. Roth (1901–11), 2 (1531–37); and esp. Rasmussen (1981).

77. Rasmussen (1981), p. 95.

78. Scribner (1988), pp. 128–30 for what follows.

79. Rasmussen (1981), pp. 102–3.

80. Rasmussen (1981), p. 103. After the restitution of Catholicism in 1548 a replica of the epitaph was made and set back in the cathedral cloister.

81. Rasmussen (1981), pp. 101–2 for what follows.

82. Rasmussen (1981), pp. 99–100 for the text.

83. This fountain, which dates to about 1537, will be discussed in Chapter Seven. See *Welt im Umbruch* (1980–81), 2: nr. 502.

84. Rasmussen (1981), pp. 104–5.

85. Rasmussen (1981), p. 105.

86. At the 1550–51 Reichstag a Catholic servant of an Italian official ripped apart a great cloth inscribed with the ten commandments and other biblical texts that was used in the Protestant preacher's house of St. Ulrich and Afra. Another pair of Catholics destroyed the pulpit and altar table. Rasmussen (1981), p. 104.

87. Rasmussen (1981), p. 106. Rasmussen notes, however, that the cardinal wisely chose to erect his own votive relief in the Salesiuskapelle in the bishop's palace at Dillingen. The carving, attributed to Martin Hering, contains a crucifixion combined with the imperial eagle and the cardinal's pelican symbol. In 1552 Charles V had spoken in Augsburg about the power of the imperial eagle and, specifically, about the concept of the "Holy Roman (ie. Catholic) Empire." The allusion to Rome as the center of the Christian faith would have offended Protestants.

88. Some of these are discussed in Chapter Four.

89. For what follows, I have relied primarily on the following: Geisberg (1937), pp. 22–28; Warnke (1973); Jászai (1981); and *Die Wiedertäufer in Münster*, exh. cat. Stadtmuseum (Münster, 1982) with its survey article by Gerd Dethlefs on pp. 19–36. On the city's history, see Hsia (1984); and his "Münster and the Anabaptists" in Hsia (1988), pp. 51–69.

90. Warnke (1973), pp. 80–98 provides a detailed account.

91. Geisberg (1937), pp. 22–23 publishes an excerpt of the Anabaptist ordinance of 1535 in which specific destructive actions are described.

92. The Anabaptists defaced the clerical epitaphs of the Herrenfriedhof though some survive in fragmentary form. Geisberg (1937), figs. 1555–1557.

93. The only exceptions seem to have been the statues of the two saints, dating around 1350, on the walls of the choir; see Geisberg (1937), p. 102, figs. 1404–1405.

94. Jászai (1981), p. 7 notes that the outer building of the Paradise forehall was demolished as were the evangelist symbols that surrounded the figure of Christ in Judgment above the statue of Paul. The wooden doors adjacent to St. Paul were burned. See Geisberg (1937), p. 66.

95. *Die Wiedertäufer in Münster* (1982), nrs. 81–

89. These nine fragments, which range from a head of Christ of the late thirteenth century to an early fifteenth-century angel to a crucifixion fragment of c. 1500, were found by the Hörstertor and likely came from the Martinikirche. Also Warnke (1973), p. 79. Janssen (1905–25) 11: p. 36 mentioned that fragments of statues of saints still with their gilding and painting, though minus their heads, were found as filler in the walls of the Rathaus in Zerbst, southeast of Magdeburg.

96. Geisberg (1974), nrs. 1256–1257; Smith (1983), p. 171.

97. Jászai (1981), pp. 14–15, 19. Franz von Waldeck, bishop of Münster, was also concurrently bishop of Osnabrück. The city of Osnabrück's long flirtation with and, in 1542, official adoption of Lutheranism further hindered his ability to direct significant capital to the redecoration of the Münster Dom. Heide Stratenwerth, *Die Reformation in der Stadt Osnabrück* (Wiesbaden, 1971), pp. 98ff. for the city's relationship with its bishop.

98. Geisberg (1937), pp. 116, figs. 1424–1425 for the 13.3 meter-tall sandstone sacrament house; and p. 66, fig. 1387 on St. Paul.

99. In the 1540s, at the request of Canon Theodor von Meschede (d. 1545), Brabender carved the *Fall of Man* relief for the tympanum of the outer Paradise portal. The statues were removed in 1863 and are today in the Westfälisches Landesmuseum. See Geisberg (1937), p. 72, fig. 1401; and Neu-Kock (1977), pp. 26–27, figs. 11–13.

100. The screen was dismantled in 1870 and some of the remaining sculptural fragments were transferred to the Westfälisches Landesmuseum in 1909. See Geisberg (1937), pp. 102–12; fig. 1407, a general view of the screen photographed in 1858; and Neu-Kock (1977), pp. 22–24, figs. 2–5.

101. The altar dates between 1545 and 1550; since 1875 it has been on loan to the Westfälisches Landesmuseum. See Geisberg (1937), pp. 209–10, fig. 1494.; and Neu-Kock (1977), pp. 24–25, figs. 6–9.

102. The 1.58 meter-tall figure of Christ, which is also tentatively attributed by Geisberg to Brabender, was moved in 1870 to a passageway between the Maximin and Ludgerus chapels. See Geisberg (1937), p. 112, fig. 1413.

103. The design of this epitaph is also discussed in Chapter Five. See Geisberg (1937), pp. 256–58.

104. He wrote "auch alle gedechtnus auff der Herren greber in sonderheit seliger Herr Dietrichs Schadens Thumbtechants mit seinem laygenstain ist gar mitainander verderbt worden." Geisberg (1937), p. 258.

105. On the Gröningers, see Geisberg (1937), passim; Géza Jászai, *Das Werk des Bildhauers Gerhard Gröninger, 1582–1652* (Münster, 1989); and Christoph Stiegemann, *Heinrich Gröninger um 1578–1631* (Paderborn, 1989).

106. Geisberg (1937), pp. 290–92, figs. 1541–1543.

107. Rott (1905) for what follows.

108. Rott (1905), pp. 239–41.

109. Rott (1905), p. 252.

Chapter Three

1. Rott (1936–38), Quellen II: pp. 131–32 for the full text of their letter; and Christensen (1979), p. 166.

2. Rott (1936–38), Quellen I: pp. 304–5.

3. Geisberg (1974), nr. 222; Herbert Zschelletzschky, *Die "Drei gottlosen Maler" von Nürnberg— Sebald Beham, Barthel Beham und Georg Pencz* (Leipzig, 1975), pp. 230–34; Scribner (1981), pp. 30–32; and Hofmann (1983), nr. 3.

4. Christensen (1979), pp. 166–67; and Hofmann (1983), p. 130 for the German text. The booklet was published in 1537, 1538, 1545 and in several later editions. A facsimile was printed in Zwickau in 1919.

5. Kohlhaussen (1968), pp. 455–58; Michal Rozek, *The Royal Cathedral at Wawel* (Warsaw, 1981), pp. 64–67, 92.

6. Brotherhood membership was limited to Lübeck citizens who did not belong to any handcraft guilds. See Wittstock (1981), nr. 141; Hasse (1982), pp. 23–24.

7. Measuring 50.5 cm square, Kayser's limestone relief might also have originally been part of an epitaph. See Müller (1976), p. 78 (c. 1530); *Welt im Umbruch* (1980–81), 2: nr. 542. On Master I.P., see Legner (1965), nr. 679.

8. On the Fugger Chapel, see Baxandall (1980), pp. 132–35, 296–98; and our brief comments in Chapter Six.

9. Hans Wiedenmann, "Die Dominikanerkir-

che in Augsburg," *Zeitschrift des historischen Vereins für Schwaben und Neuburg*, 43 (1917): pp. 1–56, esp. 27; "Daniel Hopfer I" in Thieme and Becker, eds. (1907–50), 17: p. 475; Hollstein (1954–), 15: "Daniel Hopfer" nr. 28; and Kaiser (1978), pp. 572–74. An Augsburg artist, the Monogrammist ZS, sketched this altar in about 1531. His drawing follows Hopfer's etching though the figures of the Holy Kinship and the pair flanking Christ are missing. See Zink (1968), nr. 134.

10. For a survey of church building from the late fifteenth and sixteenth centuries, see Hitchcock (1981). Several other churches completed previously initiated construction. Similarly a few churches of modest importance, such as the Lutheran Marienkirche in Marienberg in Saxony begun in 1558, were also erected.

11. Hitchcock (1981), pp. 25–30, 39.

12. Hitchcock (1981), p. 36; and Sibylle Harksen, *Die Marktkirche St. Marien zu Halle an der Saale* (Berlin, 1984—2nd ed.), pp. 14–22.

13. Rasmussen (1974), pp. 92–96; and Martin Angerer in *Gothic and Renaissance Art in Nuremberg* (1986), pp. 436–37.

14. For the masters not discussed in the Biographical Catalogue, see Friedrich Gorissen, *Ludwig Jupan von Marburg* (Düsseldorf, 1969); Gerd de Werd, "De Kalkarse beeldhouwer Arnt van Tricht," *Bulletin van het Rijksmuseum* 21 (1973): pp. 63–90; and Jürgen Soenke, *Jörg Unkair* (Minden, 1958). Most of the works of the 1530s and early 1540s formerly attributed to Hendrik Douvermann are now ascribed to van Tricht.

15. Gisela Matthes, *Der Lettner von St. Maria im Capitol zu Köln von 1523*, Ph.D. diss., Bonn, 1967 (Bonn, 1967).

16. On Master H.L.'s figure, see Schindler (1981), pp. 52–56.

17. Victor Elbern, *Dom und Domschatz in Hildesheim* (Königstein im Taunus, 1979), pp. 17–18, 24.

18. Schiller (1971–72), 2: pp. 124–26; Christensen (1979), pp. 124–30.

19. Josef Nowak, *Der Lettner des Hildesheimer Domes* (Hildesheim, 1981), esp. p. 7 and the accompanying unnumbered illustrations; and Adolf Zeller, *Die Kunstdenkmale der Stadt Hildesheim—Kirchliche Bauten* (Hannover, 1911 [reprint Osnabrück, 1979]), pp. 78–80, pl. VIII. The cathedral was severely damaged in the bombings of 1943 after which it was decided not to reinstall the screen in the choir of the church. The pulpit portion is now set off to the side of the screen.

20. Smith (1983), pp. 35–36. Indeed there were few gifts prior to the early seventeenth century.

21. For an excellent monograph on the artist, see Reindl (1977).

22. On Gabriel von Eyb and his humanistic outlook, see Monika Fink-Lang, "Eichstätter Geistesleben im Zeitalter des Humanismus," *Sammelblatt Historischer Verein Eichstätt* 77–78 (1984–85): pp. 30–45.

23. Compare the many Hausmadonnas or saintly statues carved by Veit Stoss. See Kahsnitz (1983), nrs. 2, 3, 6, 8, 10, 11, 15, 21, and 24.

24. Schwemmer (1958); and Kautzsch (1911).

25. H. Müller (1958), pp. 141–43, 147–48.

26. Reindl (1977), nrs. A3, A16 , A51, and A121 (*Moritzbrunneraltar*, now in Munich (Bayerisches Nationalmuseum); it measures 2.42 x 1.75 m.

27. Reindl (1977), pp. 81–82, nrs. A20, A32, A59, A66.

28. Reindl (1977), nr. A132.

29. Reindl (1977), nr. A16. It measures 3.35 x 1.67 m.

30. Dürer's *Trinity* woodcut (B. 122) of 1511 and his *Coronation* woodcut (B.94) dated 1510 from the *Life of the Virgin* series.

31. This scene derives from Martin Schongauer's engraving (B. 55) of the 1470s.

32. The best study is Hasse (1982). Also see Hermann Deckert, "Studien zur hanseatischen Skulptur im Anfang des 16. Jahrhunderts," *Marburger Jahrbuch für Kunstwissenschaft* 1 (1924): pp. 55–98.

33. Hermann Deckert, "Die lübisch-baltische Skulptur im Anfang des 16. Jahrhunderts," *Marburger Jahrbuch für Kunstwissenschaft* 3 (1927): pp. 1–75. The literature on Notke is vast but see esp. Walter Paatz, *Bernt Notke und sein Kreis* 2 vols. (Berlin, 1939); Max Hasse, "Bernt Notke," *ZDVK* 24 (1970): pp. 19–60; and Gerhard Eimer, *Bernt Notke* (Bonn, 1985).

34. Gert von der Osten, "Drei Weltgerichtsengel von oder nach Benedikt Dreyer," *Festschrift für Heinz Ladendorf* (Cologne, 1970), pp. 69–75; and Hasse (1982), pp. 23–27.

35. Wolf-Dieter Hauschild, *Kirchengeschichte Lübecks* (Lubeck, 1981), pp. 165–232, esp. 186–203.

36. Hasse (1982), pp. 29–35; and Hasse (1983), pp. 177–80.

37. The Annunciation is today in the St.-Annen-Museum in Lübeck. See Wittstock (1981), nr. 7.

38. Hasse (1982), p. 30 for what follows. Also see Heimo Reinitzer, *Biblia deutsch—Luthers Bibelübersetzung und ihre Tradition*, exh. cat. Herzog August Bibliothek (Wolfenbüttel, 1983), pp. 166–69.

39. The texts at the bottom of the two reliefs read, "Dorch dat gesette kuemt erkenntnisse der sunde—Dorch eine minsken ist die sunde gekame i de werlt und dorch de sunde de doeth" ("Therefore as through one man sin entered into the world and through sin death, and thus death has passed unto all men because all have sinned"—Romans 5:12) and "Doeth bote [Busse] wente dat himmelrike is nar bi kamen" ("Repent ye: for the kingdom of heaven is at hand"—Matthew 3:2).

40. Christensen (1979), pp. 126–27.

41. B. 60; Hofmann (1983), nr. 104.

42. The text beneath Christ reads, "Ik bin ein gudt heirde, ein gudt heirde leth sin levent vor sine scape" ("I am the good shepherd; the good shepherd giveth his life for the sheep"—John 10:11). Dreyer may have adopted the image of the crucified Christ with his flock of sheep gathered around the base of the cross from either of two roughly contemporary (1530s) anonymous woodcuts, both of which include Luther standing nearby. See Scribner (1981), p. 27, figs. 19–20; and Hofmann (1983), nr. 108.

43. Hasse (1982), p. 30 cites Luther's *Eine Predigt vom verlorenen Schaf* (Wittenberg: Hans Lufft, 1533).

44. The texts read, "Gaeth hen in de gantze werlth unde p[re]diket dat evangelium allen creatur" ("Go ye into all the world, and preach the gospel to every creature"—Mark 16:15) and "Seht ju vor de falsken propheten dede in scapes klederen to ju kame inwendich awerst sin see ritenden wuelwe" ("Beware of false prophets, which come to you in sheep's clothing, but inwardly they are ravening wolves"—Matthew 7:15).

45. Now in the Museen der Stadt Regensburg; see *Martin Luther und die Reformation in Deutschland* (1983), nr. 539.

46. More will be said about pulpits below in the discussion of the Schlosskapelle at Torgau.

47. The back of Dell's relief has been cut out at some later(?) date. See Bange (1928), pl. 89; Metz (1966), nr. 696a. Metz dated it c. 1550; however, his late works, which are mainly tombs and epitaphs, are heavier in feeling. The style is much closer to the Dresden and Nuremberg reliefs discussed below. On Leinberger's carving, see Müller (1958), nr. 209. On the association of these two artists, see Lill (1951), pp. 142ff..

48. On Heinrich, his patronage, and his religious beliefs, see Smith (1987—II), esp. pp. 214ff.

49. The *Crucifixion, Resurrection, Law and Gospel*, and the *"ejectio draconis"* (*Fall of Rebel Angels*?) appeared in the 1587 inventory of the Dresden Schloss. Except for the last relief, which disappeared around 1732, the carvings are in the Staatliche Kunstsammlungen, Grünes Gewölbe. See Sponsel (1925–32), 4: p. 120. On the *Crucifixion*, see Bruhns (1923), pp. 41–42, pl. 4; *Kunst der Reformationszeit* (1983), nr. E 54.1. Sponsel states the reliefs are of pearwood; however, Menzhausen (1977), p. 60 and later writers identify the wood as linden.

50. It measures 58.5 x 69 cm. Heinrich's coat of arms and the inscription "DEM.D.H. FVRSTEN. VND H.H.HEINRICH H.ZV.SACHSEN L.G. IN.DORINGEN VND.M.G.ZV.M.VNSEREN. G.H. 1529" appear on the lefthand pillar. See Bruhns (1923), pp. 42, pl. 5; Sponsel (1925–32), 4: p. 120; and *Kunst der Reformationszeit* (1983), nr. E 54.2.

51. Psalm 23:7 in the Latin Vulgate edition.

52. Christensen (1979), p. 157.

53. Luther's ideas are expressed in article 9 of the *Book of the Concord*; cited by Schiller (1966–) 3: p. 63. The Descent into Limbo and the Resurrection were paired in Daniel Hopfer's *Confession of Lutheran Beliefs* etching (B. 33) of the mid-1520s that is based upon Luther's writings; see Wolfgang Wegner, "Beiträge zum graphischen Werk Daniel Hopfers," *Zeitschrift für Kunstgeschichte* 20 (1957): pp. 239–40, fig. 1. Was a prototype of this theme by Cranach also available by the late 1520s? A workshop painting of 1537–40 in Aschaffenburg depicts the Resurrection and Descent into Limbo though the composition lacks Dell's clarity and his use of inscriptions. See Schiller, fig. 164.

54. In paintings such as *The Law and Gospel*, dated 1529, in Gotha (Schlossmuseum), Cranach relegated the texts to the panels at the bottom of composition. See Christensen (1979), fig. 2, and compare figs. 3 and 4.

55. The carving is neither signed nor dated but it is iconographically and stylistically related to the previous two reliefs. Bruhns (1927), p. 43.

56. Christensen (1979), pp. 124–30; Scribner (1981), pp. 216–19.

57. Smith (1987—II), p. 212, fig. 16.

58. Christensen (1979), p. 129.

59. Several later Lutheran Bibles use variations of this Law and Gospel program. See Scribner (1981), pp. 218–19, figs. 172–73.

60. 1) *Allegory of Holy Teaching*, Kirchberg, Schloss Neuenstein; 1530s with PD monogram though possibly shopwork; this is similar to the *Law and Gospel* relief in Dresden but reversed and with a few additional scenes. Hans Buchheit, "Beiträge zu Hans Schwarz und Peter Dell dem Älteren," *MJBK* NF 1 (1924): esp. pp. 166–68; and von Schweinitz (1987), pp. 212–13. 2) *Allegory of Faith*, Nuremberg, Germanisches Nationalmuseum, 1534 with PD monogram. See our discussion below. 3) Fragments of an *Allegory of the Sacraments*, Munich, Bayerisches Nationalmuseum, c. 1540, unsigned. The lindenwood reliefs include Old Testament typologies for communion. Müller (1959), nr. 163. 4) *Allegory of the Doctrine of Redemption*, 1548 and PD monogram, destroyed, formerly Berlin, Staatliche Museum. Vöge (1910), pp. 128–30 with a listing of all inscriptions; Bruhns (1927), pp. 44–45; and Schiller (1971–72), 2: pp. 163–64, fig. 539 who provides a brief description of its iconographic program.

61. This lindenwood relief with an old oak frame measures 51 × 72 cm. See Josephi (1910), pp. 311–12; Bruhns (1927), pp. 43–44; Ewald M. Vetter, "Das allegorische Relief Peter Dells d. Ä. im Germanischen Nationalmuseum," *Festschrift für Heinz Ladendorf* (Cologne, 1970), pp. 76–88; and Hofmann (1983), nr. 76.

62. On the meaning of the ship, also see Scribner (1981), pp. 106–15; Smith (1983), p. 272 (Matthias Zündt's *The Apostle Ship* etching of 1570); and Hofmann (1983), nrs. 77–78.

63. Ewald M. Vetter, "Das allegorische Relief Peter Dells d. Ä. im Germanischen Nationalmu-

seum," *Festschrift für Heinz Ladendorf* (Cologne, 1970), esp. pp. 80–84, fig. 3.

64. Josephi (1910), p. 312. The relief is presently on loan from the city to the Germanisches Nationalmuseum.

65. On Reinhart's career, see our Biographical Catalogue.

66. Habich (1929–34), 2.1: p. 278 (with Johann Friedrich's 1536 payment document), nrs. 1935 and 1941.

67. Habich (1929–34), 2.1: nr. 1968, pl. CCXI, 1, 3 and 4. The medal measures about 7 cm in diameter. Various copies and later versions of this medal exist; see nrs. 1969–1970.

68. Smith (1987—II), esp. pp. 214 and 216 for this meeting and the surrounding political events.

69. Habich (1929–34), 2.1: nrs. 1947 and 1973 respectively. The *Apocalypse* measures 7 cm.

70. Jahn (1972), pp. 720–21; and Heimo Reinitzer, *Biblia deutsch—Luthers Bibelübersetzung und ihre Tradition*, exh. cat. Herzog August Bibliothek (Wolfenbüttel, 1983), pp. 130–34. There are several minor compositional changes in the medal. I wonder whether the inclusion of Christ holding the keys serves as a reminder that he, and not St. Peter whose symbol is the key, is the judge of mankind and the means to eternal salvation.

71. For a detailed discussion of Luther's writings on the Apocalypse, his involvment in this project, and the later versions of these illustrations, see Hans-Ulrich Hofmann, *Luther und die Johannes-Apokalypse* (Tübingen, 1982); Peter Martin, *Martin Luther und die Bilder zur Apokalypse* (Hamburg, 1983); and Schiller (1966–), 5: pp. 343–83.

72. Scribner (1981), ch. 6 on the antichrist, and pp. 213–14.

73. Smith (1987—II) for the history of this project. Beham's drawings are in the Nelson-Atkins Museum of Art, Kansas City. In 1540 Reinhart also created the portrait medal of Johann Cellarius (Kellner), the superintendent of the Lutheran church in Dresden from 1539 until his death in 1542, and his wife; Habich (1929–34), 2.1: nr. 1948.

74. Habich (1929–34), 2.1: nr. 1962. Other copies and variants of the medal are dated 1556, 1561, 1569, and 1574. Numerous later impressions were also cast; see Habich, nrs. 1963–1967. Also see William M. Milliken, "A Medaillon of the

Trinity," *Bulletin of the Cleveland Museum of Art* 43 (1956): pp. 196–97.

75. Karlheinz Blaschke, *Moritz von Sachsen— Ein Reformationsfürst der zweiten Generation* (Göttingen, 1983), esp. pp. 25–51.

76. "We unanimously hold and teach, in accordance with the decree of the Council of Nicaea, that there is one divine essence, which is called and which is truly God, and that there are three persons in this one divine essence, equal in power and alike eternal: God the Father, God the Son, God the Holy Spirit. All three are one divine essence, eternal, without division, without end, of infinite power, wisdom, and goodness, one creator and preserver of all things visible and invisible." *The Augsburg Confession*, tr. and ed. Theodore G. Tappert (Philadelphia, 1980), p. 9. Also see Wilhelm Maurer, *Historical Commentary on the Augsburg Confession*, tr. H. George Anderson (Philadelphia, 1986), pp. 239ff. for Luther's ideas on the Trinity.

77. "HAEC EST FIDES CATHOLICA, VT VNVM DEVM IN TRINITATE, ET TRINITATEM, IN VNITATE VENEREMVR. ALIA EST PERSONA PATRIS, ALIA FILII, ALIA SPIRITVS SANCTI, SED PATRIS ET FILII ET SPIRITVS SANCTI, VNA EST DIVINITAS, AEQVA LIS GLORIA, COETERNA MAIESTAS O VENERADA VNITAS, O ADORANDA TRINITAS, PER TE SVMVS CREATI, VERA AETERNITAS, PER TE SVMVS REDEMPTI SVMMA TV CHARITAS, TE ADORAMVS OMNIPOTENS TIBI CANIMVS, TIBI LAVS ET GLORIA."

78. The complexity of the iconographic programs plus the expense of using silver, I think, precludes that these religious medals were done on speculation as was often the case with the increasing trade in portraits of celebrated nobles and clerics.

79. More will be said in about the use of medals in Chapter Ten. Lucas Cranach the Elder's painted *Portrait of a Man (Gregor Brück?)* of 1533 shows the sitter wearing a medal of Johann Friedrich. See Grotemeyer (1957), pl. IV; Friedländer and Rosenberg (1978), nr. 341 (various copies); Lore Börner, *Deutsche Medaillenkleinode des 16. und 17. Jahrhunderts* (Leipzig, 1981), pp. 8–20.

80. See Hugo Schnell, *Martin Luther und die Reformation auf Münzen und Medaillen* (Munich, 1983); and Margildis Schlüter, *Münzen und Medaillen zur*

Reformation 16. bis 20. Jahrhundert—Aus dem Besitz des Kestner-Museums Hannover (Hannover, 1983).

81. Habich (1929–34), 2.1: nr. 1954.

82. In 1579, two years before his death, Reinhart bequeathed his goldsmith models and lead patterns ("alles Werkzeug mit Belin und Modellen") to his two sons. Hayward (1976), p. 61. His actual activities as a goldsmith are unclear. Marc Rosenberg finds Reinhart's monogram or mark only on medals; see his *Der goldschmiede Merkzeichen* (Frankfurt, 1922–28) 2: nr. 3030.

83. Given by Christoph von Reineck, deacon of Trier Cathedral. Fragments of this sandstone group, which measured 3.19 m wide and was originally set in an architectural frame, are today in the Rheinisches Landesmuseum in Trier. See Bunjes et al. (1938), pp. 191–93; and Kaiser (1978), pp. 541–42 with further literature. The Regensburg altar was originally made for the Obermünster. See Felix Mader, *Stadt Regensburg, II. Die Kirchen der Stadt (mit Ausnahme von Dom und St. Emmeram)* [Die Kunstdenkmäler der Oberpfalz, vol. II.22] (Munich 1933—reprinted Munich, 1981), p. 260, pls. XXIV–XXV; and Joseph Braun, "Altarretabel in der katholischen Kirche," *RDK* (1937–), 1: col. 557, fig. 27.

84. His simultaneous possession of two metropolitan sees was unprecedented and was approved by Pope Leo X only after a payment of 10,000 ducets. Albrecht and the pope devised the Mainz-Magdeburg indulgence to raise the necessary revenues. On the history of this indulgence, see Reinhold Kiermayr, "How Much Money was actually in the Indulgence Chest?" *The Sixteenth Century Journal* 17 (1986), pp. 303–18, esp. 306–9.

85. The basic study on the church is Redlich (1900). Also see Ludwig Grote, *Kardinal Albrecht und die Renaissance in Halle* (Halle, 1930). A good recent overview of Albrecht's life and artistic interests is Reber (1990). There are several sculptural programs, such as the new portal decorations, about which little is known.

86. The plan is derived from my reading of the 1525 inventory of the church plus the excellent comments of Redlich (1900), ch. 3 and Beilage pp. 42–55 (inventory text); Edgar Wind, "Studies in Allegorical Portraiture," *Journal of the Warburg and Courtauld Institutes* 1 (1937–38): pp. 138–62, esp.

154–55; and Steinmann (1968). Wind inadvertantly reversed the positions of all of the altars by misunderstanding the orientation comments given in the inventory. Steinmann offers the best reading though his comments are limited only to the paintings. Also see Andreas Tacke, *Der Katholische Cranach* (Mainz, 1992), pp. 16–169, with its general comments on the church and exhaustive analysis of its former paintings. I learned of this excellent study only after the completion of my text.

87. Steinmann (1968), pp. 71–92.

88. Steinmann (1968), p. 74; Biermann (1975), pp. 215–16; and Reber (1990), nr. 86.

89. Steinmann (1968), p. 76.

90. Halm and Berliner (1931) remains the basic study of this manuscript. Rasmussen (1976 and 1977) offers an insightful examination of the style and provenance of select reliquaries. Also see Reber (1990), pp. 152–72.

91. Halm and Berliner (1931), p. 58, nr. 274 (fol. 353v).

92. Redlich (1900), pp. 162–69 on the choir.

93. Halm and Berliner (1931), p. 46, nr. 174b (fol. 227v). Also see Redlich (1900), pp. 165–66. The artist of this imposing work is unknown.

94. Steinmann (1968), pp. 98–104. The author discusses the association between Charles V and several works of art in the church, the most significant of which is Grünewald's *The Meeting of Sts. Erasmus and Moritz* (Munich, Alte Pinakothek) then decorating the Moritz altar in the south aisle.

95. Redlich (1900), pp. 162–65 examines the configuration of the high altar.

96. Wolfgang Braunfels, ed., *Lexikon der christlichen Ikonographie* (Rome, 1968–76), 5: cols. 25–28.

97. Redlich (1900), pp. 141–42. Sts. Augustine, Mary Magdalene, John the Evangelist, Christopher, and Martin are represented.

98. These statues are attributed to Schro based upon their style; see the discussion in Lühmann-Schmid (1975), pp. 55–62. Only one statue, presumably of either St. Barbara or St. Ursula, has disappeared. Also see Redlich (1900), pp. 132–35; and Kähler (1955–56), pp. 231–48, esp. 233–44.

99. Lühmann-Schmid (1975), pp. 1–62, esp. 8–9, 48–62; and Kautzsch (1911), pp. 68–71.

100. This dedication tablet, carved from the same Mainz limestone used for the apostles, consists of Albrecht's arms flanked by the church patrons Moritz and Mary Magdalene. Hans Volkmann, "Die Weihetafeln des Kardinals Albrecht von Brandenburg in der Stiftskirche zu Halle," *Wissenschaftliche Zeitschrift der Martin-Luther-Universität Halle-Wittenberg* 12 (1963): pp. 757–63, esp. 760–62; Lühmann-Schmid (1975), pp. 52–55. A second, smaller dedication tablet was made perhaps by a follower of Loy Hering; see Volkmann, pp. 757–60, fig. 2; and Reindl (1977), nr. B11.

101. The total height is approximately 5 meters.

102. For instance, another impressive cycle, dating around 1505, ornaments the nave of Freiberg cathedral. See Magirius (1986), p. 222, figs. 58, 70–75. These cycles become very popular in the late sixteenth and seventeenth centuries. For a discussion of examples in the Southern Netherlands, see Cynthia Miller Lawrence, *Flemish Baroque Commemorative Monuments, 1566–1725* (New York, 1981), pp. 76–98. On the iconographic tradition, which stems in part from Paul's statements in Galatians 2:9, see Adolf Katzellenbogen, "Apostel," *RDK* (1937–), 1: cols. 811–29, esp. 816 and 821; and Schiller (1966–), 4.1 [1988 revised ed.]: pp. 30–1. The association of church columns with the apostles is addressed in Richard Krautheimer, "Introduction to an Iconography of Medieval Architecture," *Journal of the Warburg and Courtauld Institutes* 5 (1942): esp. pp. 10–11; I wish to thank Joan Holladay for this reference. Also see Schleif (1990), pp. 197–202 for a discussion of the cycle in St. Lorenz in Nuremberg that dates to about 1380 but was augmented by Dr. Anton Kress shortly before his death in 1513.

103. Steinmann (1968), pp. 70–71.

104. Ursula Weirauch, *Der Engelbertschrein von 1633 im Kölner Domschatz und das Werk des Bildhauers Jeremias Geisselbrunn* (Düsseldorf, 1973), pp. 27–28.

105. Redlich (1900), pp. 135–36; Kähler (1955–56), esp. pp. 244–48.

106. Brück (1972), p. 20. I wish to thank Thomas DaCosta Kaufmann for his comments about the association of Mercury and eloquence. Hans Burgkmair's emblem of the collegium poetarum or college of poets in Vienna included Mer-

cury, as did the famed decorative program of the library of Sebald Schreyer in Nuremberg. Both reflect the influence of Conrad Celtis (d. 1508), the imperial poet laureate. See Sonja Brink, *Mercurius Mediceus: Studien zur panegyrischen Verwendung der Merkurgestalt im Florenz des 16. Jahrhunderts* (Worms, 1987), pp. 120–21.

107. The Mainz-Magdeburg indulgence (see note 84 above) was presented in Germany as a fundraising campaign for the construction of St. Peter's.

108. On Albrecht's problems and the demise of the Neue Stift, see Redlich (1900), pp. 317–61.

109. Redlich (1900), p. 337.

110. Redlich (1900), p. 344, Beilage, pp. 159–80.

111. The tomb is discussed in Chapter Six.

112. Redlich (1900), p. 337.

113. Redlich (1900), pp. 355–56.

114. Kaess and Stierhof (1977), pp. 7–20 for most of what follows.

115. The relief is today in the Bayerisches Nationalmuseum in Munich; a replica appears at Neuburg. Meller (1925), p. 212 attributed it to Paulus Vischer about whom very little is known; and Weihrauch (1956), nr. 25 who defends the attribution to Hans. A photograph with the relief in its position above the chapel door is reproduced on the title page of Kaess and Stierhof (1977).

116. Jaroslav Pelikan and Helmut T. Lehmann, gen. eds., *Luther's Works* (St. Louis—Philadelphia, 1955–), 6: *Lecture on Genesis Chapters 31–37*, tr. and ed. Jaroslav Pelikan, pp. IX (re: date), and 139–40. Here the story is cited as a New Testament parallel to Jacob wrestling with the angel (Genesis 32:28).

117. Gerhard Müller and Gottfried Seebass, eds., *Andreas Osiander d. Ä.—Gesamtausgabe* (Gütersloh, 1975–), 7: pp. 486–91. It was published in 1542 by Valentin Otmar of Augsburg.

118. Gerhard Müller and Gottfried Seebass, eds., *Andreas Osiander d. Ä.—Gesamtausgabe* (Gütersloh, 1975–), 7: pp. 569–878. Johann Petreius published it in Nuremberg in 1543.

119. Christensen (1965), p. 101; Hitchcock (1981), p. 8.

120. Neudörfer (1875), p. 36.

121. Rott (1905), esp. pp. 229–41.

122. Mader (1933), pp. 124–25, fig. 68. The epitaph bears the mark of Peter Vischer the Elder,

Hans' father. Prior to Peter's death in 1529, brasses from the family's foundry often had his mark regardless of his personal involvement. Occasionally after 1529 Hans employed the family mark so this date cannot be understood as a strict *terminus ante quem.*

123. Rupprich (1956), p. 264. On Martin, also see Ludwig Grote, *Die Tucher* (Munich, 1961), pp. 77–78.

124. Rupprich (1956), p. 260.

125. Habich (1929–34), I.1: nr. 161.

126. Rupprich (1956), p. 243.

127. Ee.1–29. Unsigned and undated; 41.1 × 29 cm. Rowlands (1988), nr. 110.

128. Reindl (1977), nr. D14 with illustration; Kaess and Stierhof (1977), pls. 8, 10. The present figures of Christ and the bad thief were added later in the mid-sixteenth century with the good thief dating to c. 1600.

129. Reindl (1977), p. 443, nrs. D10 (the deer-hunting scene ornamenting the building plaque at Ottheinrich's lodge at Grünau) and D15 (the marble doorway from the Rittersaal).

130. Kaess and Stierhof (1977), p. 15. The prominent inclusion of the Ten Commandments may, once again, have been Osiander's suggestion. Their importance to Osiander is evidenced by the series of lengthy sermons on them that he delivered in Nuremberg during Lent, 22 February and 1 April 1542. See Gerhard Müller and Gottfried Seebass, eds., *Andreas Osiander d. Ä.—Gesamtausgabe* (Gütersloh, 1975–), 7: pp. 343–438.

131. Bocksberger was paid 250 florins when the cycle was completed on 6 July 1543. Kaess and Stierhof, (1977), pp. 12–20, pls. 13–50.

132. Findeisens and Magirius (1976), pp. 105–219, figs. 64–189 is the best study. Also Hentschel (1935), esp. pp. 155–67; Thulin (1957); Hitchcock (1981), esp. pp. 101–4 on the chapel; and generally Krause (1983), pp. 395–412.

133. Jaroslav Pelikan and Helmut T. Lehmann, gen. eds., *Luther's Works* (St. Louis—Philadelphia, 1955–), 51: *Sermons I*, ed. and tr. John W. Doberstein (Philadelphia, 1959), pp. 333–54, here 333. The German text (WA 49, 588–615) is given in Thulin (1957), p. 6 who also quotes one of Luther's best known definitions of the house of God being wherever the word is spoken. "Wo Gott redet, da wohnt er. Wo das Wort klingt, da ist Gott,

da ist sein Haus, und wenn er aufhort zu reden, so is auch immer sein Haus da. Wenn es auch Klange auf dem Dach oder unter dem Dach und gleich auf der Elbbrucke, so ist's gewiss, das e da wohne" (W 14, 386—1523–254).

134. The Cranachs collaborated on most of the elector's religious projects and at least two of their paintings hung in the Torgau chapel. In Lucas Cranach the Younger's *Protestant Communion and the Catholic Way to Hell* woodcut of 1547, Luther is shown preaching in a pulpit shaped like Schröter's. The angels again supporrt the pulpit though the four evangelist symbols ornament the basket. See Hofmann (1983), nr. 69.

135. This was the subject of a sermon that Luther delivered in Wittenberg in 1531. The elder Cranach and his workshop depicted this theme on several occasions. See Christensen (1979), pp. 130–134, esp. 131 for the quotation; and Christiane D. Andersson, "Religiöse Bilder Cranachs im Dienste der Reformation," in Lewis W. Spitz, ed., *Humanismus und Reformation als kulturelle Kräfte in der deutschen Geschichte* (Berlin, 1981), pp. 43–79, esp. 50–53.

136. Jahn (1972), pp. 580–81.

137. Jaroslav Pelikan and Helmut T. Lehmann, gen. eds., *Luther's Works* (St. Louis—Philadelphia, 1955–), 51: *Sermons I*, ed. and tr. John W. Doberstein, pp. 333–47, esp. 334–37, 345–46.

138. Hentschel (1935), pp. 159–62, fig. 3 (Schwerin). For a useful typological discussion of Lutheran pulpits, see Poscharsky (1963), pp. 64–71, 102–45.

139. Helmuth Eggert, "Altar in der protestantischen Kirche," *RDK* (137–), 1: cols. 430–39, esp. 430; Christensen (1979), p. 137. Thulin (1957), p. 2 claimed that the Torgau altar type is a conscious revival of early Christian practice.

140. The Wulffs carved the altar in 1603–6 for Count Ernst von Schaumburg, a staunch Lutheran. Johannes Habich, *Die künstlerische Gestaltung der Residenz Bückeburg durch Fürst Ernst 1601–1622* (Bückeburg, 1969), pp. 96–98, 124–25, and figs. 22–24. Another Lutheran variation on the Torgau model was made for the Schlosskirche in Schmalkalden in 1585–86. Here the four evangelist symbols rather than angels support the altar stone. Helmuth Eggert, "Altar in der protestantischen Kirche," *RDK* (1937–), 1: col. 438, fig. 12.

141. Findeisen and Magirius (1976), p. 191. They speculate the painting was by the Cranach workshop. Krause (1983), p. 396 claims, without proof, that the Cranach workshop painted this altarpiece and placed it in the summer of 1545 so that the idea of an empty altar table was never part of the chapel's program.

142. Findeisen and Magirius (1976), pp. 194–95.

143. This will be discussed in Chapter Four.

144. 2.37 × 1.72 m. The plaque now stands on the east wall. Findeisen and Magirius (1976), pp. 193–94, figs. 181–83. The inscribed text is given here. Payments for gilding the panel were made in 1544 before its completion. This tablet offers an interesting comparison with Albrecht von Brandenburg's bronze tomb plate now in Berlin (Kunstgewerbemuseum). It presents a similar combination of a long inscription set beneath a portrait of Albrecht in the form of a medal. Here artist Conrad Göbel of Frankfurt modelled his likeness directly on Ludwig Krug's 1526 medal of the cardinal. See Reber (1990), pp. 148–50.

145. Habich (1929–34), 2.1: nrs. 1935–1936.

146. The tradition of figured portals and doorways was well established in Saxony and adjacent territories. For instance in Annaberg, see the Anna Selbdritt door in Annenkirche and Hans Witten's *Schöne Tür* (1512) originally in the Franciscan church and since 1577 also in the St. Annenkirche; see Ullmann (1984), figs. 54–55.

147. Findeisens and Magirius (1976), p. 218.

148. Jahn (1972), p. 319; and Ulrich Linkner, *Die Reformation in Torgau* (Torgau, 1983), pp. 76, 79–80.

149. Schiller (1966–), 2: p. 84.

150. See the discussion of Adam Kraft's *Schreyer-Landauer Epitaph* (fig. 4) in Chapter One.

151. A century later, the pulpit and the altar, the two principal pieces of Lutheran church furniture, would be combined occasionally into a single object that fulfilled both functions. On pulpit altars, see Hartmut Mai, *Der evangelische Kanzelaltar—Geschichte und Bedeutung* (Halle, 1969).

152. Krause (1970), pp. 12–15. The palace was destroyed in 1567 and rebuilt in the early seventeenth century. Schröter's portal was incorporated into the new Schlosskirche. At Gotha, the angels surrounding the portal hold Johann Friedrich's coat

of arms rather than the instruments of the passion. The difference is tied to Johann Friedrich's campaign to be reinstated as elector, a title that Emperor Charles V had stripped him of following the battle of Mühlberg in 1547. The angels support his electoral coat of arms while the accompanying inscription reminds the viewer that he was the "senior duke of Saxony and the born elector."

153. See for instance the polemical responses to Karlstadt's *Von abtuhung der Bylder* by Hieronymus Emser (1522) and Johannes Eck (1522–23); *A Reformation Debate: Karlstadt, Emser, and Eck on Sacred Images*, tr. and ed. Bryan Mangrum and Giuseppe Scavizzi (Toronto, 1991), pp. 41–115.

154. In the mid-1530s Albrecht von Brandenburg's nephew Joachim II commissioned a painted passion cycle for the Stiftskirche and later cathedral in Berlin. The pictures were inspired by those at the Neue Stift. See Steinmann (1968), pp. 88–90.

Chapter Four

1. The papacy suspected Maximilian II of being a Lutheran sympathizer since he would neither confess nor receive communion as a Catholic. See Trevor-Roper (1976), p. 89.

2. On Ferdinand's erection of the Hofkirche in Innsbruck, see our discussion below. More will be said Maximilian II's patronage in Chapter Seven.

3. Hellmuth Rössler, "August, Kurfürst von Sachsen," *NDB* 1 (Berlin, 1953): pp. 448–50.

4. On the Dresden palace and its chapel, see Löffler (1958), pp. 17–19; Hentschel (1966), pp. 42–44, 115–17; Hitchcock (1981), pp. 75–77, esp. 103; Krause (1983), pp. 397–98; and our comments in Chapter Eight.

5. These projects are discussed in Chapter Six.

6. Schade (1968), pp. 42–44. His activities at court are unclear though he probably designed the tomb plate of August's brother, Severin (d. 1533), that was placed in the Klosterkirche at Stams by 1556.

7. Pope-Hennessy (1985), fig. 101. The correctness of the chapel portral's adoption of Italian architectural forms may also be contrasted with the attractive yet hybrid borrowings seen the Georg's gate, dated 1534, at the Dresden palace; see Löffler (1958), pl. 34.

8. On the monuments below, see Chapter Eight. On Moritz, see Schade (1968), pp. 29–30. I wish to thank Larry Silver for his helpful suggestions.

9. The best study of Hans Walther and indeed Dresden's sculptors is Hentschel (1966). On the portal see pp. 43–44 and 115–17.

10. The statue of John the Evangelist dates about 1738 and is attributed to Johann Benjamin Thomä; see Hentschel (1966), p. 116.

11. For a discussion of this motto, see F. J. Stopp, "Verbum Domini Manet in Aeternum: The Dissemination of a Reformation Slogan, 1522–1904," in Siegbert S. Prawer et al., eds., *Essays in German Language, Culture and Society* (London, 1969), pp. 123–35; and Smith (1987—II), esp. p. 212 with additional references.

12. The analogy between the importance of the word of God and a Christian's access into heaven was clearly stated on an inscription tablet that hung from the later 1560s until the mid-eighteenth century by the door of the Protestant Schlosskapelle in Celle. The text read:

> Was von Godt ist, der horet sein Wordt,
> auff das ihme wol gehe hier und dort.
> Wer Gottes Wordt nicht horen will,
> des achtet Gott wieder nicht vill.
> Was nur fur die Thur bleibt stehen,
> mus hintern Himmel hingehen.

Cited in Zweite (1980), p. 105.

13. This subject figured earlier on Schröter's Torgau pulpit discussed in Chapter Three. See Christensen (1979), pp. 130–34.

14. Christensen (1979), p. 133 (LW, 23: ix–xi, pp. 318–19).

15. Hainhofer, an Augsburg patrician and art dealer, visited Johann Georg I's court in Dresden and left a detailed travel account. On the Schlosskapelle, see Hainhofer (1901), pp. 202–3. Conrad's print, which is the title page of a song book of 1676, is illustrated in Löffler (1958), fig. 45. Much of the essential decorative features recorded by Hainhofer and Conrad date to August's reign, though a few items, such as the choir loft, were added in the seventeenth century. The chapel was torn down in 1757.

16. For instance, extensive inscriptions may be observed in the Schlosskapelles in Celle, which will

be discussed below, and in Schmalkaden that dates to 1586–90; see Hitchcock (1981), pls. 207, 267, and 269.

17. Krause (1982), pp. 15–20 mentions the restoration campaigns. Hainhofer (1901), p. 203 described the ceiling as being covered with stone snakes and spirits *ex apocalypsi* being driven down by Archangel Michael and other angels holding the instruments of the passion. Christ is represented as triumphing over sin, death, the devil, and hell. Hainhofer specifies these figures were stone ("in stain gehauenen"), yet some of the lower angels appear to be painted on the ceiling in Conrad's print. I suspect the impression was reminiscent of the *Last Judgment* ceiling in the Albertine chapel in Freiberg cathedral commissioned by August but completed between 1589 and 1595 under the direction of court artist Giovanni Maria Nosseni. Here the carved figures are surrounded by an illusionistically painted sky and more angels. See Magirius (1986), figs. 193–94, 198.

18. Only a few fragments survived the bombing of Torgau in 1945. See Hentschel (1966), pp. 117–19; Walter Hentschel, *Denkmale sächsischer Kunst—Die Verluste des zweiten Weltkrieges* (Berlin, 1973), pp. 76–77; and Findeisen and Magirius (1976), pp. 191–92.

19. Leeuwenberg and Halsema-Kubes (1973), esp. nrs. 176–77 for two small altars with several similar decorative features; and Michael K. Wustrack, *Die Mechelner Alabaster-Manufaktur des 16. und frühen 17. Jahrhunderts* (Frankfurt, 1982).

20. Hedicke (1913), pls. XII–XIV, XVII.

21. The practice of creating stone altarpieces was much more common in the southern Netherlands than in Germany. Perhaps secondary knowledge of examples, albeit Catholic, such as Jan Mone's alabaster altar (1533) in Notre-Dame at Hal or, more likely, Jacques Du Broeucq's *Magdalene Altar* (c. 1550) in Sainte-Wandru at Mons influenced August's decision to commission a Netherlandish artist to make a stone altar for Dresden. See von der Osten and Vey (1969), fig. 220; and *Jacques Du Broeucq, sculpteur et architecte de la Renaissance* (Mons, 1985), pp. 86–89.

22. Cited by Helmuth Eggert, "Altarretabel in der protestantischen Kirche," *RDK* (1937), 1: col. 574; and Christensen (1979), p. 150.

23. The Penig altar was given by Wolf von Schönburg auf Glauchau und Waldenburg and his wife; see Hentschel (1966), pls. 31–32. On the Kreuzkirche altar, see below.

24. The altar, completed in 1577–78, is now in the Stadt- und Bergbaumuseum in Freiberg. Hentschel (1966), pp. 130–31, pl. 47. Between 1567 and 1573 the elector erected a new hunting lodge at Augustusburg. The chapel's decoration, specifically the altar and the wooden pulpit, consisted primarily of paintings by Lucas Cranach the Younger. See Schade (1980), pp. 95–97, 443 (fig. b), 448–49; and Hitchcock (1981), figs. 200–202.

25. Hentschel (1966), p. 120, pl. 23. The form of the font, which is inscribed with the sculptor's HW monogram, and especially the angels on the base harken back to older Saxon fonts, especially that Hans Witten made in about 1515 for the St. Annenkirche in Annaberg. See Walter Hentschel, *Sächsische Plastik um 1500* (Dresden, 1926), pl. 76.

26. See the discussion in Chapter Six.

27. Hentschel (1966), pp. 123–24, pls. 28–29. The program is once again the contrast of the Fall and Expulsion of Adam and Eve with the Crucifixion and Resurrection of Christ.

28. After fire destroyed much of the Kreuzkirche in 1760, the altar was moved to the Annenkirche in Dresden where it remained until 1927. Hentschel (1966), pp. 124, 127–28, text fig. 3 opposite p. 49, pls. 31, 39–41.

29. Hans Walther's epitaph for the young prince, also commissioned in 1570, has not survived.

30. Karl-Heinz Mehnert, *Deutsche Zeichnungen 1600–1650—Museum der bildenden Künste Leipzig* (Leipzig, 1976), np (Walther, Hans). Inv. nr. Nl. 8487.

31. The drawing lists the texts as Acts 3, John 3 (twice), I Peter 2, Ephesians 2, and Colossians 2.

32. For instance, see Danese Cattaneo's *Fregoso Altar* of c. 1565 in S. Anastasia in Verona; Pope-Hennessy (1985), pp. 411–13, fig. 106, pl. 121.

33. Hentschel (1966), pp. 128, 138–39, 143–45, pls. 70 and 82; and Heinrich Magirius, "Die Werke der Freiberger Bildhauerfamilie Ditterich und die lutherische Altarkunst in Obersachsen zwischen 1550 und 1650," in Hans-Herbert Möller, ed., *Die Hauptkirche Beatae Mariae Virginis in Wolfenbüttel* (Hannover, 1987), pp. 174–75, figs. 152, 155, 158. Hentschel (p. 128) also lists the

altars in Reinsberg (now in the museum in Freiberg) and Taubenheim as deriving from the Kreuzkirche altar.

34. On Dittrich and the relations with Dresden, see Hilda Lietzmann, "Der Altar der Marienkirche zu Wolfenbüttel," *Niederdeutsche Beiträge zur Kunstgeschichte* 13 (1974): pp. 199–222 with documentation; and Magirius, "Die Werke der Freiberger Bildhauerfamilie Ditterich und die lutherische Altarkunst in Obersachsen zwischen 1550 und 1650," in Hans-Herbert Möller, ed., *Die Hauptkirche Beatae Mariae Virginis in Wolfenbüttel* (Hannover, 1987), pp. 169–78.

35. On the building, see Hitchcock (1981), pp. 126–27. On the carvings by Walther that date to 1560–61, see Hentschel (1966), p. 123, pl. 30.

36. The reliefs illustrate Moses and the Brazen Serpent, the Resurrection, the Last Judgment, and the Fall of Adam and Eve. See Jozef Duverger and M. J. Onghena, "Beeldhouwer Willem van den Broecke alias Guilielmus Paludanus," *Gentsche Bijdragen tot de Kunstgeschiedenis* 5 (1938): esp. pp. 103–4 with reproductions on 107, 109, 111, 113.

37. On Celle, see Zweite (1980), chs. 4 (the chapel's program) and 5 (the paintings); and Hitchcock (1981), p. 82.

38. Zweite (1980), pp. 110–11.

39. Hootz (1968), pp. 315 and 389 on Schloss Gottorf; Habich (1969), pp. 80–135, figs. 17–42; and Hitchcock (1981), pl. 359.

40. Poscharsky (1963), esp. p. 103.

41. The events of 1555 strongly affected August of Saxony as discussed earlier. It is useful to recall that between 1555 and 1557 he commissioned new pulpits for the Dresden Schlosskapelle, the Frauenkirche in Dresden, and the Jakobikirche in Freiberg; see Hentschel (1966), pp. 123–24. With the erection of the Augustusburg palace between 1567 and 1573 he ordered a new pulpit with paintings by Lucas Cranach the Younger; see Schade (1980), pp. 95–97, 448–49.

42. Ellger (1966), pp. 348–56.

43. Ellger (1966), p. 350 for the Latin text and 352 for the second inscription that runs along the top of the pulpit basket. The latter reads: "And the servant of the Lord must not strive; but be gentle unto all men, apt to teach, patient, In meekness instructing those that oppose themselves" (2 Timothy 2:24–5).

44. Ellger (1966), p. 354–55. Ellger compares the oak pulpit of 1550 in Grote Kerk in The Hague. It is useful to remember that Eminga was Netherlandish, originally a native of Groningen. Schleswig cathedral's ties with the Low Countries were further strengthened between 1551 and 1556 when Cornelis Floris of Antwerp carved the church's most significant artistic project, the tomb of Frederik I, king of Denmark.

45. Poscharsky (1963), pp. 102ff..

46. Funds were donated in 1568 by Lübeck cathedral pastor Dionysius Schünemann. Hans Fleminck (Flemming) carved the attractive pulpit reliefs in sandstone imported from Gotland. See Wolfgang Grusnick and Friedrich Zimmermann, *Der Dom zu Lübeck* (Königstein im Taunus, nd), pp. 12–14 with illustrations.

47. Heinz-Dietrich Gross, *Dom und Domhof Ratzeburg* (Königstein im Taunus, 1978—3rd ed.), pp. 8, 40–41.

48. See Hentschel (1966), esp. pp. 74–87, 139–41, 143–55.

49. Bireley (1988), p. 13.

50. Hugo Schnell, *Ottobeuren: Kloster und Kirche* (Munich, 1979—7th ed.), esp. pp. 3–5. On the later history of the monastery, see Braunfels (1979–89), 3: pp. 355–57, 385–92; and Norbert Lieb, *Barockkirchen zwischen Donau und Alpen* (Munich, 1984—5th revised ed.), pp. 82–92.

51. Lieb (1937), esp. pp. 50–54. On Kels, see our Biographical Catalogue.

52. Lieb (1937), pp. 51–53 for the attribution and suggested origins. Among the more attractive of these scenes are the Christ before Caiphas and Christ before Herod. The expressive figures and carefully defined rooms reveal Kels's familiarity both with earlier prints and with the reliefs of the slightly older Augsburg sculptor Victor Kayser (e.g., fig. 26).

53. For what follows, see Egg (1974), pp. 64–94; Felmayer (1986), pp. 237–43, fig. 305; and Peter Fidler, "Die Hofkirche in Innsbruck: Das Kunstwerk als Ergebnis eines politischen Kampfes," *Österreichische Zeitschrift für Kunst und Denkmalpflege* 41 (1987): pp. 77–88. Fidler (p. 77) gives the 1543 document, which Egg had misdated

to 1547. Fidler provides interesting observations about the building costs and about the Hofkirche as a pivotal transitional monument between the late Gothic and Renaissance styles.

54. Egg (1974), pp. 73–78 for what follows.

55. Von Mengden (1973), pp. 7–8; and Egg (1974), p. 73.

56. Little is known about his career. According to Thieme and Becker, eds. (1907–50), 29: p. 323, he was active from 1550 in Ulm and carved several epitaphs, including that of Elisabeth von Gundelfingen, geb. Grafin von Montfort in the Pfarrkirche in Neufra a. Donau.

57. The 1553 plan also called for four side altars dedicated to the Assumption of the Virgin, John the Baptist, St. George, and St. Sebastian. Each was to have a carving in the center and painted wings depicting six episodes from their respective lives. Only two of the altars seem to have been made. Domenico Pozzo of Milan painted the Assumption Altar. Information about the appearance of these altars and whether sculpture was included is lacking. Egg (1974), p. 73. The non-figural choir stalls were carved by Hans Waldner in 1562–63; (Egg, p. 77, pl. 128).

58. H. J. Schroeder, *Canons and Decrees of the Council of Trent* (St. Louis, 1950), pp. 215–17. All quotations cited below derive from Schroeder's translation.

59. For analyses of the meaning of these decrees for the visual arts, also see Hubert Jedin, "Das Tridentinum und die Bildenden Künste," *Zeitschrift für Kirchengeschichte* 74 (1963): pp. 321–39; and, more generally, Benno Ulm, "Das Konzil von Trient und die Kunst," in *Die Bildhauerfamilie Zürn, 1585–1724*, exh. cat. (Braunau am Inn, 1979), pp. 33–40.

60. Hubert Jedin, "Das Tridentinum und die Bildenden Künste," *Zeitschrift für Kirchengeschichte* 74 (1963): p. 326.

61. For instance, see the reform decrees of the 21st, 22nd, and 24th sessions; see H. J. Schroeder, *Canons and Decrees of the Council of Trent* (St. Louis, 1950), pp. 135ff., 152ff., and 190ff.

62. Ernst (1554–1612), the son of Albrecht V, Duke of Bavaria and the strongest of the German princes, held numerous titles simultaneously. In addition to being named the archbishop of Cologne

in 1583, Ernst was also the bishop of Freising (1566), Hildesheim (1573), Liège (1581), and Münster (1585). See Max Braubach, "Ernst, Herzog von Bayern," *NDB* 4 (Berlin, 1959): pp. 614–15.

63. On what follows see Ernst Walter Zeeden, *Deutsche Kultur in der frühen Neuzeit* (Frankfurt, 1968), pp. 391–96; Josef Krasenbrink, *Die Congregatio Germanica und die katholische Reform in Deutschland nach dem Tridentinum* (Münster, 1972), esp. chs. III–IV; and Bireley (1988), pp. 13–17.

64. Ernst Schubert, "Gegenreformationen in Franken," in Zeeden (1973), pp. 222–69. More will be said about Würzburg below.

65. James Brodrick, *Saint Peter Canisius, S.J., 1521–1597* (London, 1935), p. 253. Schools were founded in other German towns, such as Mainz, but without the direct role of Canisius; Brück (1972), pp. 32ff. On the Jesuits, see Bernhard Duhr, *Geschichte der Jesuiten in den Ländern deutscher Zunge*, 4 vols. (Freiburg i. B., 1907–28); and *Die Jesuiten in Bayern, 1549–1773* (Weissenhorn, 1991).

66. Although the Jesuits entered Münster only in 1588, the struggle they faced against the local population, which included many Protestants, and the Catholic clerical community typifies their dogged resolve. See the excellent discussion in Hsia (1984), pp. 59–92.

67. For example, between 1580 and 1640, Jesuit churches were built in over 40 towns, including Aachen, Bamberg, Cologne, Koblenz, Munich, Münster, Osnabruck, Paderborn, Strasbourg, and Würzburg. See Joseph Braun, *Die Kirchbauten der deutschen Jesuiten*, 2 vols. (Freiburg im Breisgan, 1908–1910).

68. On what follows, see Friedrich Zoepfl, *Geschichte des Bistums Augsburg und seiner Bischöfe* (Munich, 1969), 2: pp. 173–463; Blendinger and Zorn (1976), pp. 62–63, 174–80; Rasmussen (1981), esp. pp. 104–6.

69. Roth (1901–11), 4: pp. 170ff.. Roth (passim) is the best source for Augsburg's complicated history during the later 1540s and 1550s.

70. *Hans Holbein der Ältere und die Kunst der Spätgotik*, exh. cat. Rathaus (Augsburg, 1965), p. 20, nrs. 77, 156, and 191; and Bruno Bushart, "Die Barockisierung des Augsburger Domes," *Jahrbuch*

des Vereins für Augsburger Bistumgeschichte 3 (1969): pp. 109–29, here 109–12.

71. The re-emergence of art was discussed in the episcopal synod that Otto conducted in Augsburg in 1567. As at Trent, the clerics were instructed that no unusual paintings and sculptures be tolerated without the permission of the bishop or his general vicar. Friedrich Zoepl, "Die Durchführung des Tridentinums im Bistum Augsburg," in Schreiber (1951), 2: p. 149.

72. An interesting example of the balance between faiths is provided by the arrival of the Jesuits in Augsburg in 1580. They announced their decision to erect a Gymnasium, which was formally opened in 1582. The Lutherans, seeking parity, announced in 1581 that their school at St. Anna's would also be elevated to a Gymnasium. Blendinger and Zorn (1976), p. 180; and Wolfram Baer and Hans Joachim Hecker, eds., *Die Jesuiten und ihre Schule St. Salvator in Augsburg 1582*, exh. cat. Dom (Augsburg, 1982).

73. He was criticized for residing in Rome in 1559–63 and, more critically, 1568–73. Peter Canisius wrote to the cardinal about his bad example. The Jesuit preacher even went so far as to wonder how Otto could peacefully sleep while many thousand souls were perishing. See Friedrich Zoepl, "Die Durchführung des Tridentinums im Bistum Augsburg," in Schreiber (1951), 2: pp. 135–69, esp. 150–51.

74. Köplin would also provide new church vestments for the sacristy, restore the tomb of St. Simpertus in 1576, and donate 15,000 gulden in 1594 to erect the new north tower. Hartig (1923), p. 44.

75. Kistler (1712), pp. 41–42 (with illustration between pp. 40 and 41); and Hartig (1923), pp. 42–44.

76. Baxandall (1980), pl. 19; Hildebrand Dussler, *Jörg Lederer* (Kempten, 1963), nr. A19. For a useful study of the various forms of these late Gothic altarpieces, see Herbert Schindler, *Der Schnitzaltar—Meisterwerke und Meister in Süddeutschland, Österreich und Südtirol* (Regensburg, 1978) with illustrations of numerous other examples. Alfred Schädler in *Welt im Umbruch* (1980–81), 2: pp. 159–60 offers the comparison with Lederer. Rasmussen (1981), p. 108 noted the similarity between Mair's Virgin and those of Michel

and Gregor Erhart. Our artist was the grandson, not son as given by Rasmussen, of Gregor Erhart.

77. Rasmussen (1981), p. 108.

78. On this phenomenon, see Theodor Müller, *Frühe Beispiele der Retrospektive in der deutschen Plastik* [Bayerische Akademie der Wissenschaften: Philosophische-Historische Klasse, Sitzungsberichte] (Munich, 1961); Herbert Beck, "Mittelalterliche Skulpturen in Barockaltaren," *Mitteilungen der Gesellschaft für Salzburger Landeskunde* 108 (1968): pp. 209–93; and Beck, "Barocke Nachbildungen mittelalterlicher Skulpturen," *Städel-Jahrbuch* NF 3 (1971): pp. 133–60.

79. Kistler (1712), p. 41 provides the date of the altar's rededication in its new setting; see also Hartig (1923), pp. 44–46 with additional major commissions by Merk.

80. At the abbot's request, Degler next made the flanking altars dedicated to St. Ulrich and St. Afra that were dedicated in 1607. See Wilhelm Zöhner, "Hans Degler (1564–1634/35)," *Lech-Isar-Land* (1977), pp. 76–89. Although Degler's altar forms recall older examples, his use of modern architectural motifs, carefully conceived compositional designs, and superbly carved figures clearly reveal how far Catholic sculpture would progress in the intervening three decades after the completion of Mair's altar.

81. Kistler (1712), p. 42 recounts how the blind are made to see, the lame to walk, and the sick are cured.

82. See our comments on the monument in Chapter One; also see Müller (1959), p. 108.

83. Hartig (1923), p. 42 mentions that Georg Fugger took over the Dionyskapelle in 1563; Marx Fugger the Andreaskapelle in 1578; Jakob Fugger the Michaelskapelle in 1580; Octavian Secundus Fugger the Benediktuskapelle in 1583; and Christoph Fugger another chapel, perhaps the Stephanuskapelle, in 1604.

84. Today these are in the Maximilianmuseum in Augsburg. See Thomas Muchall-Viebrook, "Alabasterreliefs von Wilhelm van den Broeck im Maximiliansmuseum in Augsburg," *Monatshefte für Kunstwissenschaft* 12 (1919): pp. 57–65; Jozef Duverger and M. J. Onghena, "Beeldhouwer Willem van den Broecke alias Guilielmus Paludanus," *Gentsche Bijdragen tot de Kunstgeschiedenis* 5 (1938): pp. 75–140, esp. 96–103; and Alfred Schädler in: *Welt*

im Umbruch (1980–81), 2: nr. 572 (Crucifixion of 1562).

85. Hans Wiedenmann, "Die Dominikaner-kirche in Augsburg," *Zeitschrift des historischen Vereins für Schwaben und Neuburg* 43 (1917): pp. 1–55, here 37–39; and Michael Baxandall, "A Masterpiece by Hubert Gerhard," *Victoria and Albert Museum Bulletin* 1, nr. 2 (April 1965): pp. 1–17, esp. 1–5.

86. Josef Krasenbrink, *Die Congregatio Germanica und die katholische Reform in Deutschland nach dem Tridentinum* (Münster, 1972), pp. 136–37; and Hansgeorg Molitor, "Die Generalvisitation von 1569/70 als Quelle für die Geschichte der katholischen Reform im Erzbistum Trier," in Zeeden (1973), pp. 155–74, esp. 158–64 and 174 for what follows.

87. Balke (1916), pp. 11–24 is the best study of the pulpit and of Hoffmann's oeuvre. None of the examples offered as possible models seems to be a convincing prototype for the Trier pulpit. Also see Ronig (1980), pp. 257–60; and Franz Ronig, *Der Dom zu Trier* (Königstein im Taunus, 1982), pp. 17 and 59–61.

88. Ronig (1980), p. 259.

89. Hollstein (1949–), 8: nrs. 160–66. Balke (1916), pp. 11–24 was the first to point out Hoffmann's dependency upon Heemskerck.

90. Hollstein (1949–), 8: nr. 562; and Ilja M. Veldman, *Leerrijke reeksen van Maarten van Heemskerck*, exh. cat. Haarlem, Frans Hals Museum (The Hague, 1986), pp. 47, 56–57.

91. Hedicke (1913), pp. 31–35, pl. XII; Hollstein (1949–), 4: nrs. 309–36; and de Jong and de Groot (1988), pp. 65–66, nr. 76. The prints were engraved by Lucas or Jan van Duetecum after Floris' drawings of c. 1548. On Floris' tombs and designs, see Chapters Five and Six.

92. Hedicke (1913), pl. XII,2 as well as in Floris' carvings such as XIII,2, XXIV, and XLII,2. For a study of strapwork in German sculpture, see Pulvermacher (1931).

93. Hedicke (1913), pl. XII,6, and cf. XII, 5, 7, and 8.

94. Hanna Mayer, *Deutsche Barockkanzeln* (Strasbourg, 1932), esp. pp. 16ff.. This book provides a useful listing of pulpits around Germany, but the author offers very little critical commentary.

95. Balke (1916), pp. 24–26.

96. This altar and its pendant, the *John the Baptist Altar*, were severely damaged in the fire that ravaged the cathedral on 17–18 August 1717. Both were given lavish new frames designed by Joseph Walter in 1725 and 1728 respectively. See Balke (1916), pp. 64–71; Ronig (1980), pp. 260–63.

97. On Würzburg's history, see Hans Eugen Specker, "Nachtridentinische Visitationen im Bistum Würzburg als Quelle für die katholische Reform," in Zeeden (1973), pp. 175–89; Hans-Christoph Rublack, "Reformatorische Bewegungen in Würzburg und Bamberg," in Moeller (1978), pp. 109–24, esp. 109–18 ; and Wendehorst (1981), esp. pp. 67–76, 209–11.

98. On Riemenschneider's role in Würzburg's upheavals, see Bier (1982), pp. 18–22.

99. A contemporary woodcut of the murder is illustrated in Wendehorst (1981), fig. 171.

100. Hans-Christoph Rublack, "Reformatorische Bewegungen in Würzburg und Bamberg," in Moeller (1978), p. 113.

101. The term is given in Wendehorst (1981), p. 211. Hans van der Mul's portrait of Echter (1576) will be discussed in Chapter Ten.

102. Janssen (1905–25), 11: p. 120. The best study is Max H. von Freeden and W. Engel, *Fürstbischof Julius Echter als Bauherr* (Würzburg, 1951).

103. Janssen (1905–25), 11: p. 120.

104. Hans Dünninger, *Maria siegt in Franken: Die Wallfahrt nach Dettelbach als Bekenntnis* (Würzburg, 1979), esp. pp. 39–58; Hitchcock (1981), pp. 207–9, 351–52, pls. 330–31, 447–48; and Wendehorst (1981), pp. 77–78, 153–54, figs. 179, 181, 213; Richard Helm, *Die Würzburger Universitätskirche 1583–1973* (Neustadt an der Arsch, 1976). Interestingly, the Universitätskirche, also known as the Neubaukirche, is still strongly Gothic in its window tracery patterns, vaults, and other features. I think that this new Gothic style, as it is sometimes called, is another manifestation of the Catholic conservativeness or conscious association with the past that we witnessed in Mair's *Mary Altar* in St. Ulrich and Afra in Augsburg. Barbara Schock-Werner, "Stil als Legitimation 'Historismus' in den Bauten des Würzburger Fürstbischofs Julins Echter von Mespelbrunn," *Pirckheimer Jahrbuch* 6 (1991): pp. 51–82.

105. Wendehorst (1981), pp. 36–37, 132–33, figs. 64–65.

106. On the sculptures, see Bruhns (1923), pp. 114–22 and on Rodlein's career see 194–202. Rodlein, briefly a pupil of Peter Dell in 1557, worked primarily on epitaphs and tombs. In 1585–87 Johann von Beundum created the much more attractive relief over the portal of the university. Echter kneels before a scene of the Descent of the Holy Spirit. Unlike Rodlein, von Beundum had the benefit of a clear model, an engraving by Hans Sadeler after Marten de Vos. See Bruhns, pp. 166–67, figs. 43–44; and Wendehorst (1981), p. 153, fig. 179.

107. The foundation document states that the hospital was "für allerhand Sorten arme, kranke, unvermugliche, auch schadhafte Leut, die Wund- und anderer Arznei notturftig sein, desgleichen verlassene Waysen und dann füruberziehende Pilgram und dörftige Personen." Wendehorst (1981), p. 37.

108. The epitaph will be discussed in Chapter Five.

109. On the saints, see Braun (1974), cols. 158–59, 422–23.

110. Bruhns (1923), p. 121.

111. Bruhns (1923), p. 120; and De Ren (1982), pp. 125–127.

112. Destroyed in 1945. See Bier (1925–78), 2: pp. 104–15, 179–85, pls. 118–22.

113. Bruhns (1923), pp. 120–39.

114. See the general comments in Irnfriede Lühmann-Schmid, "Das Brendelsche Chorgestühl in der Nikolauskapelle des Mainzer Domes und das Problem der Meisterfrage," *Mainzer Zeitschrift* 73–74 (1978–79): pp. 1–19, esp. 1–2 where the author disputes the hypothesis that these choir stalls were originally in St. Gangolph.

115. Bruhns (1923), pp. 226–353, 384–426.

116. F. W. Fischer, "Die Stadtpfarrkirche zur Schönen Unserer Lieben Frau" and Theodor Müller, "Die Wittelsbachische Grablege" in Müller and Reissmüller (1974), 1: pp. 295–355 and 357–72. In the fifteenth and early sixteenth centuries several of the dukes were buried or had at least portions of their bodies buried here.

117. On Albrecht V's religious activities, see Glaser (1980), 2.2: pp. 32–49.

118. Albrecht V commissioned the altarpiece, new choir stalls, and a new bell in 1560. While the stalls were finished in 1561 and the bell in 1562, the altarpiece does not seem to have been started until the mid-1560s. The latter is prominently dated 1572. See Heinrich Geissler, "Der Hochaltar im Münster zu Ingolstadt und Hans Mielichs Entwürfe," in Müller and Reissmüller (1974), 2: pp. 145–78; Siegfried Hofmann, "Der Hochaltar im Münster zur Schönen Unserer Lieben Frau in Ingolstadt," *Ars Bavarica* 10 (1978): pp. 1–18; Siegfried Hofmann and Johannes Meyer, *Das Münster zur Schönen Unserer Lieben Frau in Ingolstadt* (Ingolstadt, 1980), esp. pp. 18–24; and Laun (1982), pp. 37–46.

119. Relatively little is known about Wörner. He is documented working in the Bavarian court from 1567 to 1571. In 1569 he received payment of 175 florins for his carvings for the altar in Ingolstadt. Wörner is recorded in Landshut, another ducal residence city, in 1578 and he may be identical with the sculptor Hans Werner who died here in 1581 or 1582. See Hartig (1931), esp. pp. 345, 350, 352–53; Hartig (1933), pp. 238–39, nrs. 880–81; and Volker Liedke, "Die Landshuter Maler- und Bildhauerwerkstätten von der Mitte des 16. bis zum Ende des 18. Jahrhunderts," *Ars Bavarica* 27–8 (1982): pp. 1–112, here 35–37, 39, and 98–99.

120. This use of golden grounds was common throughout Europe and became a particular characteristic of the Cologne school; see Rainer Budde, *Köln und seine Maler 1300–1500* (Cologne, 1986). Among the many examples in painted and carved retables, see Friedrich Herlin's High Altar (after 1466) in St. Jakob in Rothenburg and the Erhart's Blaubeuren altar; see Müller (1966), pl. 117B; and Hans Hermann and Willy Baur, *Kloster Blaubeuren* (Tübingen, nd), esp. pp. 6, 13, and 19.

121. Egg (1974), pp. 88–94; Johanna Felmayer, "Der Hofgoldschmied Anton Ort und sein Hauptwerk in der Silbernen Kapelle," *Veröffentlichungen des Museum Ferdinandeum, Innsbruck* (1974): pp. 101–40; and Felmayer (1986), pp. 427–48, esp. 441–43.

122. Egg (1974), p. 91.

123. C. H. Bagley, "Litany of Loreto," *New Catholic Encyclopedia* 8 (New York, 1967), pp. 790–91. The listing of prayers is given in Gaspar

Lefebvre, *Saint Andrew Daily Missal* (St. Paul, 1956), pp. 1116–117.

124. Occasional evangelical artistic projects were erected in southern Germany. For instance, Duke Christoph of Württemberg built an imposing new palace in Stuttgart. Work on the palace chapel, which is not to be confused with the nearby Stiftskirche, began in 1558. Sem Schlör carved a stone pulpit and altarpiece for the chapel in 1562–63, which included a large crucified Christ and twelve reliefs illustrating specific Protestant beliefs. Little survives; however, Fleischhauer has identified five reliefs in the pulpit of the Stadtkirche in Kirchheim unter Teck as formerly belowing to the Stuttgart pulpit. See Fleischhauer (1966), pp. 111–13; and Klaus Merten, *Das alte Schloss in Stuttgart* (Munich, 1975) pp. 3–4, 8–9.

125. Small altars were added in many episcopal centers throughout this period. A typical example is the red-marble altar with solnhofen limestone reliefs that Prince-Bishop Urban von Trenbach erected in his burial chapel in Passau cathedral in 1572. Equally characteristic is the drastic rearrangment of this altar, including the loss of the original crowning crucifixion, at a later date. See Felix Mader, *Stadt Passau* [*Die Kunstdenkmäler von Bayern*, vol. IV.3] (Munich, 1919—reprinted Munich, 1981), pp. 172–74, fig. 136.

Chapter Five

1. Alwin Schultz, ed., "Der Weisskunig," *JKSAK* 6 (1888): p. 66, lines 33–36. These autobiographical comments were collected around 1512 by imperial secretary Marx Treitzsauerwein von Ehrentreitz. I quote the translation given in Stanley Appelbaum, ed., *The Triumph of Maximilian I* (New York, 1964), p. v.

2. Surprisingly there exists no comprehensive study of German Renaissance funerary art. A general background of pre-1500 European tombs is given in Kurt Bauch, *Das mittelaltarliche Grabbild* (Berlin, 1976). Some of the regional studies and individual monographs will be cited below.

3. Sebastian Brant, *The Ship of Fools*, tr. Edwin H. Zeydel (New York, 1944), pp. 282–83, chapter 85; also Keisch (1970), p. 40.

4. For example, in the Würzburg region, see

Bruhns (1923), figs. 1–3, 7–11, 13–24, etc.; in Württemberg, see Demmler (1910), pls. 17–18, 21–23, etc.; or in Landshut, see Mader (1927), pls. VII, IX, XXIV and figs. 49–52.

5. This epitaph will be examined in our discussion of the episcopal cycle in Würzburg at the beginning of Chapter Six.

6. For instance, in 1518 the Nuremberg city council decreed that all non-ecclesiastical burials must occur outside the town walls. Pfeiffer and Schwemmer (1977), p. 42. In 1520 and 1522 the laws were further tightened to restrict the type and expense of tombs erected in the two city cemeteries. In many towns, such as Würzburg, important clerics and nobles continued to be permitted burial in local churches.

7. First painted and later carved epitaphs appeared in the fourteenth century in Germany. Around 1500 sculpted epitaphs had gained widespread popularity and were increasingly replacing tombs as the primary type of artistic memorial. See Paul Schoenen, "Epitaph," in: *RDK* 5 (1967), cols. 872–921, esp. 896–906 for the basic definition used below. For a general study of the origins of epitaphs, see Alfred Weckwerth, "Der Ursprung des Bildepitaphs," *Zeitschrift für Kunstgeschichte* 20 (1957): pp. 147–85; and for an excellent look at the evolution of its use in a single town, see Rainer and Trudl Wohlfeil, "Nürnberger Bildepitaphien," *Zeitschrift für historische Forschung* 12 (1985): pp. 129–80.

8. These are my calculations derived from Reindl (1977), pp. 260–407.

9. See Bruhns (1923), pp. 38–57, and my comments in Chapter Three on his Saxon works.

10. Bruhns (1923), pp. 58–67, figs. 10–13.

11. Meller (1925), pp. 169–71; Stafski (1962), pp. 40–41, figs. 78–79; Fehring and Ress (1977), p. 89; and, above all, Schleif (1990), pp. 188–227 on Kress and his patronage and esp. 217–22 on the epitaph.

12. Riederer (1983), pp. 89–99. Unlike most German metalworkers, the Vischer workshop favored brass over bronze. From the early 1490s Peter the Elder and his assistants employed a fairly consistent chemical mix, a recipe that was low in the levels of tin and lead. Riederer has analyzed eighty works by the Vischers, including the epitaph of Dr. Anton Kress. These form a homogeneous group

that differ from the brasses of such later Nuremberg metalcasters as the Labenwolfs and Wurzelbauers.

13. See Viebig (1971), pp. 21 and 45; Fehring and Ress (1977), p. 81; and especially Schleif (1990), pp. 76–129 on Horn and 76–89 on the epitaph.

14. Halm (1926), pp. 199–202; and Schleif (1990), p. 77.

15. The painting is today in the Bayerisches Nationalmuseum in Munich. See Schleif (1990), figs. 98–100; and see figs. 105–6, 112, 117, 122–24 for examples of kneeling donors represented in small scale.

16. Nuremberg, Germanisches Nationalmuseum, Hs. 113264; see *Gothic and Renaissance Art in Nuremberg* (1986), pp. 192–97, fig. 54.

17. *Vita Reuerendi patris Domini Anthonii Kressen. I.V.D. & praepositi sancti Laurentii Nurenbergii* (Nuremberg: Friedrich Peypus, 1515). Schleif (1990), pp. 256–67 publishes the German translation of the text. The epitaph is mentioned on folio 20 (page 265). Scheurl, like Kress, was a doctor of canon and civil law. He returned to his native Nuremberg in 1512 and served as the legal advisor to the city council.

18. Schleif (1990), pp. 195–202, figs. 160–62, 165–66.

19. Schleif (1990), p. 260.

20. Best known is the fragment of a window, formerly in the Michaelskirche in Fürth and now in the Germanisches Nationalmuseum in Nuremberg, designed by Michael Wolgemut and dated 1487. See *Gothic and Renaissance Art in Nuremberg* (1986), pp. 174–76; and Schleif (1990), fig. 145 and compare figs. 138, 140, and 144 (Tucher in a seventeenth-century window in St. Lorenz).

21. Dürer's drawing, dated in 1511, is today in the Kupferstichkabinett in Berlin; see Fedja Anzelewsky and Hans Mielke, *Albrecht Dürer— Kritischer Katalog der Zeichnungen* (Berlin, 1984), nr. 65. On the painting, see *Meister um Albrecht Dürer*, exh. cat. Germanisches Nationalmuseum (Nuremberg, 1961), nr. 162.

22. See Meller (1925), p. 212; Fehring and Ress (1977), p. 89; and Schleif (1990), pp. 225–27, fig. 184.

23. Meller (1925), p. 212. Its setting in the narthex is illustrated in Mrusek (1976), pl. 23. The Vischer family had made other funerary monuments in the 1470s and 1510s for the cathedral; see Mrusek, pls. 42–44.

24. Alfred Schädler, "Ingolstädter Epitaphe der Spätgotik und Renaissance," in Müller and Reissmüller (1974), 2: pp. 37–79, esp. 58–65; and Reindl (1977), pp. 470–71.

25. Alfred Schädler, "Ingolstädter Epitaphe der Spätgotik und Renaissance," in Müller and Reissmüller (1974), 2: esp. pp. 63–65.

26. Mader (1933), pp. 124–25, fig. 68. For the use of such motifs in Augsburg, see our figs. 235 and 245.

27. The Tucher epitaph, minus the spandrel roundels, provided the model for Hans Vischer's relief of *Christ and the Canaanite Woman* of 1543 formerly at Neuburg an der Donau, that was discussed in Chapter Three (fig. 56).

28. Meller (1925), p. 196; and Hasse (1983), pp. 163–64.

29. Wigerinck, a Lübeck citizen who had travelled to Augsburg and Nuremberg, left funding for several artistic project in the Marienkirche. He helped pay for new stalls in the Sangerkapelle in 1521. His will also provided for the renovations of the choir screen that included major carvings by Benedikt Dreyer between 1518 and 1520 and paintings attributed to Hans von Köln. See Hasse (1983), pp. 144 and 155–63.

30. Redlich (1900), p. 149.

31. Meller (1925), pp. 44–52, figs. 10, 14–28. It was commissioned in 1494 and completed in 1495. Between 1524 and 1530 the Vischers also created the elaborate double tomb of Johann Cicero (d. 1499) and Joachim I (d. 1533), Electors of Brandenburg and, respectively, Albrecht's father and brother, now in Berlin cathedral. See Meller, p. 208, figs. 133–34; Dehio (1983), p. 27; and esp. Karl-Heinz Klingenburg, *Der Berliner Dom* (Berlin, 1977), p. 22, figs. 204–6. This double tomb was originally in Kloster Lehnin until it was transferred to Berlin in the mid-1550s.

32. On the three brasses that the Vischers made for the Neue Stift, see Redlich (1900), pp. 147–62 with accompanying documentation; Mader (1918), pp. 76–77, pls. x–xi; Meller (1925), pp. 200, 208, and 210; and Stafski (1962), p. 42. Redlich provides the most thorough discussion of these

monuments and their relation to the Neue Stift. The epitaph of the cardinal is inscribed "OP' M PETRI FISCHERS NORMBERGE: 1525." It measures 2.65 by 1.40 m. Recently, Andreas Tacke has argued that Albrecht initially transferred the epitaph to the Heiliggrabkirche not Stiftskirche in Aschaffenburg, but it was moved to its current location in the fall of 1545. See his "Die Aschaffenburger Heiliggrabkirche der Beginen," *AGNM* (1992): pp. 195–239, esp. 208–210, 224.

33. While Vischer probably did not invent this formula, his epitaph for the Cardinal likely provided the model for two stone tombplates attributed to Master Wendel of Aschaffenburg. See Irnfriede Lühmann-Schmid, "Meister Wendel—Ein Aschaffenburger Bildner der Reformationszeit," *Mainzer Zeitschrift* 63–64 (1968–69): esp. p. 45, pl. 10b (Konrad Hoffmann {d. 1527}, who worked for Cardinal Albrecht, in Justinuskirche in Frankfurt-Höchst) and 10c (Canon Heinrich zum Rhein {d. 1527} in Frankfurt cathedral; note that the photographs for 10a and 10c are switched).

34. It measures 2.7 by 1.44 m.

35. Reindl (1977), p. 319, nr. A48.

36. The baldachin measures 1.95 m long and 1.43 m wide. It is inscribed: "ABSORPTA EST MORES IN VICTORIA IDEO / LAETATVS SVM HIS QVAE DICTA SVNT MIHI / IN DOMVM DOMINI IBIM9 / HEC EST HEREDITAS D(=domini) CV(=cum) DEDE(=dederit) DILEC(=dilectis) SVIS SONV(=somnum)." Cited in Mader (1918), p. 76.

37. The gold chest or *Sarg* was documented there in the mid-1520s, but it is unclear where the reliquary remained after the addition of the two epitaphs. Redlich (1900), p. 167. The analogy between Albrecht and the saints that I suggest would still hold since anyone looking at the baldachin and epitaphs would have seen these surrounded by the many other reliquaries that filled the choir.

38. Bruck (1903), pp. 92–94; Meller (1925), pp. 200–201; Stafski (1962), pp. 42–43; and esp. Bellmann, Harksen, and Werner (1979), pp. 100–101 and 243–44. The epitaph measures about 4.0 by 2.12 meters. Although Peter the Younger had been active for two decades, he had never become an independent master in the bronzesmiths' craft association in Nuremberg. Under pressure from the

city council, the bronzesmiths accepted the *Epitaph of Friedrich the Wise* as his masterpiece and he was permitted to join on 23 May 1527. See Meller (1925), pp. 200–201.

39. Bellmann, Harksen, and Werner (1979), p. 26.

40. Bellmann, Harksen, and Werner (1979), p. 100. Their suggestion is likely even though no specific evidence is given. Cranach's drawing has not survived. In the late 1520s Cranach made another drawing of a couple's epitaph, now in Braunschweig (Herzog Anton Ulrich-Museum), that demonstrates that this was hardly an unusual task for the prolific master. See Jahn (1972), p. 86.

41. Mrusek (1976), figs. 289–91.

42. Bruck (1903), p. 87; and Meller (1925), pp. 71–72, fig. 34. Friedrich was also familiar with the *Epitaph of Henning Goden*, his provost, that the Vischers made for the Schlosskirche in 1521; see Bellmann, Harksen, and Werner (1979), p. 100, fig. 94. Its *Coronation of the Virgin* derives from Dürer's woodcut (B. 94).

43. Bellmann, Harksen, and Werner (1979), pp. 101 and 250.

44. Bruck (1903), pp. 76–78; and Bellmann, Harksen, and Werner (1979), pp. 98–99. The statue is about 1.5 m high.

45. Bellmann, Harksen, and Werner (1979), pp. 101–2 and 243–44 for what follows. Also see Meller (1925), p. 210, fig. 140 for Johann's epitaph. The epitaph, measuring about 4.0 by 1.98 m, is slightly narrower than Friedrich's.

46. On the Rottalers who were active in Munich, Landshut, Freising, and Ingolstadt, as well as other towns in between, see Volker Liedke, "Die Baumeister- und Bildhauerfamilie Rottaler (1480–1533)," *Ars Bavarica* 5/6 (1976): pp. 1–435. On the Brabenders, see Chapters Two and Three, plus our Biographical Catalogue.

47. I have discussed Hering's non-funerary religious sculpture in Chapter Three; also see Reindl (1977).

48. Mader (1924), p. 114; and Reindl (1977), pp. 343–44, nr. A74a. Originally the epitaph was accompanied by Hering's tomb slab of Gozmann (p. 345 and nr. A74b) that today is located elsewhere in the cathedral.

49. Compare Hering's epitaph with Flötner's

design for an altar, discussed in Chapter Three. (fig. 29) Although there are many affinities between the two, Flötner possessed a much better grasp of architectural forms.

50. Reindl (1977), pp. 303–5, nr. A32. One of Jobst's brothers, Erhard, who was a canon of Eichstätt cathedral and had commissioned an epitaph (nr. A20) in 1519, probably introduced him to Hering.

51. Reindl (1977), pp. 293–95, nr. A20. Georg was one of Hering's most frequent patrons.

52. See Chapter Three for this work; and Reindl (1977), pp. 393–95, nr. A121.

53. Reindl (1977), pp. 326–27, nr. A59. The monument was later transferred to St. Jakob where it was destroyed in 1945.

54. Reindl (1977), pp. 315–16 (nr. A44).

55. Reindl (1977), pp. 86–87 and 194–95. Hering used it for the first time in Duke Erich's epitaph.

56. Reindl (1977), pp. 260–407. For the purposes of these statistics, I include only those objects that Reindl firmly attributes to Hering. I have excluded the sizeable group of Heringesque sculptures that may or may not be associated with his workshop, as well as the unknown number of now lost and undocumented carvings.

57. On Martin, see our comments in Chapter Three; and Reindl (1977), pp. 443–56, esp. nr. D4 in Dillingen.

58. Reindl (1977), pp. 419–42, esp. nr. C3.

59. Geisberg (1937), pp. 23 and 256–58; and see our comments in Chapter Two.

60. Geisberg (1937), pp. 258–59, fig. 1515.

61. Seeger (1932), p. 37; and Marianne Tosetti, *St. Marien zu Berlin* (Berlin, 1973), p. 20, fig. 32 and see fig. 33 for Schenck's *Epitaph of Jakob Flaccus and his Wife*.

62. Panofsky (1964), figs. 91–94, 281 (Hans Burgkmair's printed *Epitaph of Conrad Celtis*), 283 (*Epitaph of Johannes Cuspinianus* in St. Stephan in Vienna), and 288. Also Bauch (1976), pp. 206–7, fig. 322 (*Epitaph of Dr. Adolf Occo* in Augsburg cathedral).

63. Seeger (1932), pp. 65–67. Most of the epitaphs and tombs, including Bagius's, originally in St. Nicolas have been moved to the Marienkirche.

64. Bildarchiv Foto Marburg no. Z.28.112; and Seeger (1932), pp. 67–69 and fig. 15. The donors,

probably Paul Schulheiss and his wife, kneel behind next to Christ's open tomb. See also Seeger's fig. 16–the *Cenotaph of Chancellor Thomas Matthias and his Wife*. Both of these are presumably today in the Marienkirche.

65. Schéle (1965), nrs. 123 (dated 1546), 125, and esp. 177–95. Seeger (1932), p. 68 cites Hedicke (1913), plates IV.2 and L.10 as possible models.

66. Habich (1928), esp. pp. 14–15; Seeger (1932), pp. 40–48 with a complete listing of the inscriptions and their positions on p. 48; Hinz (1963), pp. 132–40; and Flemming, Lehmann, and Schubert (1976), pp. 54, 152–53, pls. 85–87.

67. Friedrich's brother, Sigismund, succeeded him and did convert to Protestantism in 1561.

68. Habich (1929–34), 2.1: nr. 2251.

69. The frieze is not visible in our photograph. See the illustrations of the reliefs in Hinz (1963), pp. 132 and 137–40.

70. For instance, see Hedicke (1913), pls. VI, IX, XII.3; and Schéle (1965), figs. 126–27. Schenck has again used their strapwork designs for much of the upper portions of this tomb.

71. Most examples of his influence can be found in the memorials in Brandenburg and Pomerania. Further west, however, in Lüneburg, the sculptor Albert von Soest's sandstone tomb monuments of mayors Hartwich Stöterogges (d. 1539) and Nikolaus Stöterogges (d. 1561) in the Johanniskirche recall Schenck's art. The first of these, finished in 1552, offers a crowded composition with Christ standing on Death and the Devil in the center surrounded by innumerable angels and, below, Hartwich and his wife. Albert von Soest's design is more balanced, more controlled and his figures lack the mannered proportions and poses that characterize Schenck's epitaphs, but the spirit of the whole and the flat carving style suggest his familiarity with the Berlin master's oeuvre. Albert von Soest also incorporates the Antwerp strapwork though only for framing inscription tablets. This type of epitaph that wraps around a column revives a popular form used in the fifteenth century. See Krüger and Reinecke (1906), pp. 107–10, figs. 29–30.

72. See Siegfried Fliedner, *Welt im Zwielicht: Das Werk des Bildhauers Ludwig Münstermann* (Oldenburg, 1962); Liselotte Stauch, *Christoph Dehne, ein Magdeburger Bildhauer um 1600* (Berlin, 1936).

73. Bunjes et al. (1938), p. 186; and esp. Alois Thomas, "Der Künstler des Segensis-Epitaphs in Trier-Liebfrauen," *Kurtrierisches Jahrbuch* 2 (1962): pp. 26–34. Thomas (pp. 27–28) provides the payment documents for this work. This artist signed himself Hans Bildhauer (Hans the sculptor). The use of Bildhauer as a family name extended also to Hieronymus Bildhauer, who was probably his father, and to Peter, Hans's brother.

74. Compare Hedicke (1913), pls. VII.3, X.12–16, and XI.1–12.

75. Alois Thomas, "Der Künstler des Segensis-Epitaphs in Trier-Liebfrauen," *Kurtrierisches Jahrbuch* 2 (1962): esp. pp. 28–30 and pls. III (the tomb of Nikolaus Lant [d. 1566] now in the Rheinisches Landesmuseum in Trier) and IV (epitaph of Johannes von Neuerburg [d. 1576] in the Hospitalkapelle in Bernkastel-Kues).

76. Bunjes et al. (1938), pp. 186–87, fig. 145.

77. Hentschel (1966), pp. 47, 125–26, pls. 34–36. It measures 6.58 by 2.95 meters.

78. In addition to the direct source in Dresden, Walther or another artist at the electoral court was familiar with Baldassare Peruzzi's *Monument of Pope Adrian VI* in S. Maria dell'Anima and Jacopo Sansovino's *Monument of the Cardinal of Sant' Angelo* in S. Marcello in Rome. See Pope-Hennessy (1985), pp. 55–56, figs. 61–62.

79. Hentschel (1966), pp. 120–21, pl. 24.

80. Hentschel (1966), p. 124, pl. 31.

81. Christoph II used it again on several occasions. See Hentschel (1966), pls. 48, 49, 51, and 63.

82. On Floris' tombs and epitaphs, see Hedicke, pp. 24–63 and 220–28; Roggen and Withof (1942), pp. 100–121. The Königsberg monuments will be discussed in Chapter Six.

83. More will be said about his pupils and followers in Chapter Six. On the subject, also see Hedicke (1913), pp. 154–69.

84. The engraved and etched plates after Floris' designs, which may have been completed by 1548, are attributed to Lucas or Jan von Duetecum. See Hedicke (1913), pp. 31–35, pls. VI.1 (title page), VII.1–8, XVII.1 for the memorial designs; and de Jong and de Groot (1988), pp. 65–66, nr. 76.

85. Hedicke (1913), pp. 47–49, pl. XVI.2 (Anton); and Paul Clemen, Heinrich Neu, and Fritz Witte, *Der Dom zu Köln [Die Kunstdenkmäler*

der Rheinprovinz, vol. 6, III.] (Düsseldorf, 1938), pp. 277–80. Anton ordered his brother's epitaph between 1556 and 1558; however, it was his successor Archbishop Gebhard I von Mansfeld (1558–62) who commissioned the second epitaph and had them placed in 1561. In 1863 these epitaphs were moved to the St. Stephanus and St. Engelbertus chapels thus preventing them from being seen together. The epitaphs are undocumented but stylistically linked with Floris and his shop. It is relevant to note that in 1557 Floris was involved in another project in Cologne. Two monogrammed and dated drawings of the planned portico for the Rathaus were made for the city council. These served as the basic models for the portico that Willem Vernukken erected between 1569 and 1573. See our discussion in Chapter Eight.

86. The Netherlandish and German artistic community in Rome was centered in the vicinity of this church. Hedicke (1913), p. 48; and Pope-Hennessy (1985), pp. 54–55, 346–47, figs. 57–58. Roggen and Withof (1942), pp. 85 and 146 publish the document of 1544 in which the sculptor's Roman trip six years earlier is mentioned. The "demi-gisant" type, to borrow Erwin Panofsky's felicitous term, has a complex history that has not been adequately explored. Although ancient Roman monuments provide the model for Sansovino, late Gothic examples in Spain may have a wholly independent origin. Contemporary with Floris' epitaphs are a few French tombs in which the half-seated, half-recumbent figure is shown reading or staring outwards. The spirit of Floris' epitaphs is much closer to Sansovino than to these other examples. Also see Panofsky (1964), pp. 81–82, figs. 364–66, 370–71; and Jean Adhémar, "Les tombeaux de la collection Gaignières, tome II," *Gazette des Beaux-Arts* 88 (July–Sept. 1976): nrs. 1598–99, 1720, 1731.

87. Mader (1915), p. 86; esp. Bruhns (1923), pp. 125–31; De Ren (1982), pp. 124–25.

88. Hedicke (1913), pls. XII, XIII.1 and 2, XIV, XVI.1 and 2, XVII–XIX. Bruyns (1923), p. 129 says that Osten was never in Floris' shop though he was acquainted with the Antwerp master's work through the published designs and a probable trip north sometime between 1571 and 1577.

89. Hedicke (1913), pls. XII.1, 7, and 8; XIII.1 and 2; XXI.3; XXII; XXV.3 and 4; etc..

90. Bruhns (1923), p. 129; and Heinz Peters's comments in Günter Aders et al., *Die Stifts- und Pfarrkirche St. Lambertus zu Düsseldorf* (Ratingen bei Düsseldorf, 1956), pp. 116–24; and Inge Zacher, *Düsseldorfer Friedhöfe und Grabmäler* (Düsseldorf, 1982), pp. 20–24, 233, color pl. II. Jeremias Geisselbrunn, Cologne's leading sculptor of the seventeenth century, recalled Floris' epitaphs when he designed the reclining figure of St. Engelbert on the top of his reliquary shrine in the cathedral. The saint props his body up with his left arm, though the motif of the supported head has been eliminated. On this shrine, which was completed by goldsmith Conradt Duisbergh between 1630 and 1633, see Ursula Weirauch, *Der Engelbertschrein vom 1633 im Kölner Domschatz und das Werk des Bildhauers Jeremias Geisselbrunn* (Düsseldorf, 1973).

91. In the Gemmingen epitaph, which is attributed to Hans Krumper, the deceased lies contemplating the crucifix held in his left hand; see Mader (1924), pp. 102–3, fig. 67, and pl. XII. This work directly inspired the *Epitaph of Schenk von Castell* of 1729–31 that is located on the opposite wall of the choir. See Mader, p. 106 and fig. 68; and Braun (1986), pp. 62 (with a good view of the two epitaphs) and 68. On the Trier monument, see Bunjes et al. (1938), pp. 176–78, fig. 139.

92. Helmut Ricke, *Hans Morinck* (Sigmaringen, 1973), p. 125, fig. 110.

93. The Kassel tomb was carved between 1567 and 1572 by Elias Godefroy of Cambrai and Adam Liquir Beaumont, his assistant. Commissioned by Landgrave Wilhelm IV, the 12 meter-tall monument originally dominated the eastern end of the choir. After the destruction of much of the church in 1943 it was moved to the north aisle. Godefroy designed its triumphal arch form and carved at least the two standing figures of Philipp and Christine, who flank the central bier, before his death in 1568. Beaumont completed the rest including the slightly overbearing armorial display and crowning figure of Death. "Godefroy (Gottfro), Elias," in Thieme and Becker (1907–50), 14: p. 290; Gerhard Bott et al., *Hessen-Kunstdenkmäler* [Reclams Kunstführer—Deutschland, vol. 4] (Stuttgart, 1967), pp. 295–97; and Hitchcock (1981), p. 166, pl. 206.

94. For instance, see Panofsky (1964), figs. 352–53, 378–81. These secondary tombs did exist, however, in Germany. For instance, the bishops of Würzburg traditionally had their hearts buried with simple memorials in the abbey church at Ebrach. In 1588–1589, sculptor Jan Robyn carved an elaborate alabaster tomb for Bishop Julius Echter von Mespelbrunn that was prominently located in the nave of his newly constructed Universitätskirche in Würzburg. See Reinhard Helm, *Die Würzburg Universitätskirche 1583–1973* (Neustadt an der Arsch, 1976), pp. 47–50.

95. Two of the finest late examples, dating between 1509 and 1518, are the *Epitaphs of Ulrich and Georg Fugger* in their chapel in St.-Anna-Kirche in Augsburg. (fig. 134) See Cohen (1973), pp. 117–18, figs. 64–67; and see our comments in Chapter Six. Loy Hering also included a small skeleton of the deceased in his *Epitaph of Bernhard von Waldkirch* of 1523–24 in the cloister of Eichstätt cathedral; see Cohen, p. 118, fig. 71; and Reindl (1977), pp. 76–77, 301–2, nr. A30.

96. Cohen (1973), pp. 120–25, figs. 72–77; and Lowenthal (1976), pp. 35–61.

97. Panofsky (1964), figs. 324, 331, 354, 356, 362; Pope-Hennessy (1985), fig. 64, pl. 107.

98. The relatively elaborate *Epitaph of Matthias von der Schulenburg (d. 1569)* that Torgau sculptor Georg Schröter completed in 1571 for the Stadtkirche in Wittenberg is one of the first of what, a decade later, would be a growing number of memorials with a kneeling statue of the deceased. See Bellmann, Harksen, and Werner (1979), p. 184, fig. 192. During the late 1570s, Hans Friedmann the Elder produced the first of his many complex epitaphs for the churches of Erfurt. Several include kneeling donors set both within and to the side of the main relief. Since these are characteristic of a new epitaph style that became popular after 1580, I have chosen not to discuss it in this chapter. See Alfred Overmann, *Die älteren Kunstdenkmäler der Plastik, der Malerei und des Kunstgewerbe der Stadt Erfurt* (Erfurt, 1911), esp. pp. XLV–XLVIII, 171–82.

99. Rupert Feuchtmüller, *Der Wiener Stephansdom* (Vienna, 1978), pp. 221–36.

100. In Nuremberg this became law in 1522 though other restrictions had been applied earlier. See Pfeiffer and Schwemmer (1977), p. 42, fig. 166 (illustrating the tombs of Albrecht Dürer and his immediate neighbors).

101. Alfred Schröder, "Die Monumente des Augsburger Domkreuzganges," *Jahrbuch des historischen Vereins Dillingen* 10 (1897): pp. 33–91, and 11 (1898): pp. 31–114 offers a thorough description of the memorials though little comment about any of the artists; and Rasmussen (1981), pp. 102–3. Many of these memorials, which were located both within the church and in the cloister are no longer extant. Some disappeared during the extensive rebuilding of the north aisle of the church.

102. See Chapter One, note 12.

103. Cited by Christensen (1972), p. 300.

104. Reindl (1977), pp. 323–24 (nr. A54) and 356–58 (nr. A86a).

105. Christensen (1972), esp. pp. 300–305 offers a good overview of painted examples.

106. For a few examples, see Hentschel (1966), nrs. 22, 24, 26, 33, 41b–51–64a, and 48.

107. Christensen (1972), pp. 302–3 for what follows.

108. Christensen (1972), p. 303 (LW 36:69; WA 6:535).

109. In Hans Walther's *Epitaph of Georg von Schleinitz (d. 1554)* in Meissen (St. Afra), shows an infant resting on a skull. Nearby are an hour glass and the words "Hodie michi cras tibi." Hentschel (1966), nr. 24.

110. Only the central relief remains of this epitaph originally in the Frauenkirche. Hentschel (1966), nr. 33.

111. Kurt Pilz, "Epitaphaltar," in *RDK* 5 (1967), cols. 921–32; and Dagmar Alexandra Thauer, *Der Epitaphaltar* (Munich, 1984), esp. pp. 8–28.

Chapter Six

1. The painting is the predella of the *St. Bartholomew Altar* commissioned by Georg von Wiesenthal, cathedral deacon. It originally hung in the cathedral and is today in the Martin von Wagner-Museum in Würzburg. Wendehorst (1981), p. 149, fig. 156; Volker Hoffmann and Konrad Koppe, *Gemäldekatalog—Martin von Wagner Museum der Universität Würzburg* (Würzburg, 1986), nr. 55. I do not think that the tombs were moved at this time since most continued to occupy their original locations. Since the stone memorials were situated by and worked in concert with the tombplates, I am referring to these as tombs rather than epitaphs.

2. Following the devastation of the cathedral in the Second World War, the original locations of several of the memorials were altered in the mid-1960s. The correct settings are listed in Mader (1915), pp. 64–80; the current placements are given in Rudolf Kuhn, *Grosser Führer durch Würzburgs Dom und Neumünster* (Würzburg, 1968), pp. 29–41, 65, 70, 72, 136. I have borrowed the term "via triumphalis" from Kuhn.

3. The busts of St. Kilian and his two companions, carved by Riemenschneider between 1508 and 1510, burned in 1945. See Bier (1925–78), 2: pp. 104–15, 179–85, pls. 118–22.

4. Mader (1915), pp. 71–72, pl. VIII; and Bier (1925–78), 3: pp. 97–117, 177–78, pls. 190–200. It was probably started in 1518, during Bibra's lifetime, and set on 8 February 1522.

5. For instance, see the *Kilian Banner*, formerly in the cathedral treasury and now in the Mainfränkisches Museum, of the first half of the thirteenth century. Wendehorst (1981), pp. 16–18, 122, fig. 7, also compare figs. 8 and 9; Braun (1988), cols. 422–23; and esp. *Kilian: Mönch aus Irland—aller Franken Patron, 689–1989*, exh. cat. Festung Marienberg (Würzburg, 1989), nrs. 3, 9, 245–46, 249–50, 253, 261, 393 (the banner).

6. Mader (1915), figs. 43 (Mangold von Neuenburg {d. 1303}) to 54 and 56–57.

7. Mader (1915), p. 72, fig. 49; and Reindl (1977), pp. 374–76, nr. A100.

8. Reindl (1977), pp. 273–75 and 284–87, nrs. A7 and 14.

9. Mader (1915), p. 79, fig. 57.

10. Mader (1915), p. 72; and Bruhns (1923), pp. 52–54, fig. 2. Although only two or three years separate these two tombs, Dell may have been better paid than Hering. According to Würzburg chronicler Lorenz Fries, Hering received about 250 gulden and Dell 300 gulden. See Bruhns, p. 53; and Reindl (1977), p. 255, doc. 88.

11. Mader (1915), p. 72, fig. 51; and Bruhns (1923), pp. 59–60, fig. 13.

12. The bishop's murder was mentioned in Chapter Four. He is accompanied by Karl von Wenkheim and Jakob Fuchs von Wonfurt, both dressed in armor, who died defending the bishop.

13. Mader (1915), p. 72, fig. 52; and Bruhns (1923), pp. 111–13, fig. 14.

14. Mader (1915), pp. 72, 74, fig. 53; and Bruhns (1923), pp. 370–72, fig. 117.

15. Kniffler (1978) has written the most comprehensive study on the tombs up to 1514. Although this author provides good descriptions of each tomb, she totally ignores any larger issues or conclusions. Questions about placement, meaning, or even the concept of a series are never addressed. A thorough study of this genre needs to be done. Kautzsch (1925) published good illustrations of the tombs; Jung (1975) offers a useful description of the church's decorations. Also see Braunfels (1979–89), 2: pp. 44–47.

16. Backoffen made the tombs of *Berthold von Henneberg (d. 1504), Jakob von Liebenstein (d. 1508)*, and *Uriel von Gemmingen (1514)*. See Braune-Plathner (1934), pp. 2, 9–16, 23–28, and 40–46; and Kniffler (1978), pp. 121–35.

17. In 1482 Adalbert von Sachsen (d. 1484) was only 15 years old, too young to be consecrated bishop. Therefore he served as the administrator of Mainz until his premature death. As a result, he is represented without the miter and crozier. Ulrich von Gemmingen's tomb, commissioned by the young Albrecht von Brandenburg, has the archbishop kneeling before the crucified Christ and accompanied by his patron saints. See Kniffler (1978), p. 118 and fig. 11. The tombs of *Siegfried III von Eppstein (d. 1249)* and *Peter von Aspelt (d. 1320)* depict the archbishops crowning secular lords; however, this formula was not continued by their successors. See Kniffler, pp. 1–6, 11–27, figs. 1 and 4.

18. Jung (1975), pp. 142–43, nrs. 21–22. In both cases, the figures are carved from Solnhofen limestone but Eiffel tufa is used for the rest. The attribution of the first tomb to Schro is based upon stylistic comparison with his signed or documented sculptures including the monogrammed Heusenstamm tomb. Figures 123 and 126 permit a close examination of Schro's angels from the two Mainz tombs.

19. This is visible on the pier at the left of fig. 122. This low-relief armorial plate, dated 1540, is attributed to the Schro family workshop. Following the death of Peter Schro, the court sculptor, in

1542–43, Dietrich assumed control of the workshop. Lühmann-Schmid (1976–77), p. 92 thinks a task of this sort would have been assigned to the son.

20. This fountain is discussed in Chapter Seven.

21. For instance, see Panofsky (1964), figs. 301–2 and 318. None of these, however, is freestanding. Albrecht's memorial likely inspired the inclusion of an angel holding a laurel wreath in the *Tomb of Julius Echter von Mespelbrunn* in Würzburg. (fig. 121)

22. Many of these drawings were owned by Basel goldsmiths Jörg and Hans Schweiger. These later entered the Amerbach Cabinet in Basel. More will be said about the Amerbachs as collectors in Chapter Nine; however, here it is sufficient to note that they systematically sought working models, whether drawings, prints, or plaquettes. In this way, the Schweiger collection has been preserved. See Falk (1979), pp. 116–18, 159–60 and nr. 693 (Inv. U. XIII.101) for the drawing discussed below.

23. Compare Floris' cross-armed terms; see Hedicke (1913), pl. VII.2.

24. Schro was involved with another series of three large epitaphs located in the Memorie, a large chapel and passageway adjacent to the south transept and aisle, forming part of the cloister at Mainz cathedral. Schro's monogram and the date 1564 appear on the *Epitaph of Georg Göler von Ravensburg (d. 1558)*, the cathedral canter. The three epitaphs offer sequential narrative scenes: the Crucifixion (*Epitaph of Martin von Heusenstamm {d. 1550}*, archepiscopal counsel and brother of Sebastian), Resurrection (*Epitaph of Konrad von Liebenstein {d. 1536}*, a member of the cathedral chapter), and Ascension (*Epitaph of Göler von Ravensburg*). The three were all designed by Schro(?) in a common style in the early 1550s. Schro signed only the one epitaph, but he may also have carved von Heusenstamm's. Nikolaus Dickhart produced the third. See Dietmar Hoth, "Die Epitaphien in der Memorie des Mainzer Doms," in *Mainz und der Mittelrhein in der Europäischen Kunstgeschichte—Studien für Wolfgang Fritz Volbach zu seinem 70. Geburtstag* (Mainz-Wiesbaden, 1966), pp. 425–36; and Jung (1975), p. 159.

25. Irsch (1931), pp. 214–19, pl. XII, figs.

145–47; Ronig (1980), 252–53, figs. 91–92. The tomb was likely carved by a Trier master (Jakob Kerre?) and is based closely upon Hans Backoffen's *Tomb of Archbishop Uriel von Gemmingen (d. 1514)* in Mainz cathedral. See Kautzsch (1911), figs. 26–27.

26. Irsch (1931), p. 1.

27. Irsch (1931), pp. 272–75, pl. XIV, figs. 179–80; Kahle (1939), pp. 98ff.; Thomas (1962), p. 28; and Ronig (1980), pp. 253–55.

28. Irsch (1931), p. 274.

29. Irsch (1931), p. 274; Pope-Hennessy (1985), figs. 57–58. The artist of the Trier tomb does not develop the triumphal arch motif that is central to Sansovino's designs. Even the normal wreath-bearing angels are replaced with warriors brandishing their swords and shields.

30. Many of these features were already used by Augsburg artists of the 1510s and 1520s. For example, Sebastian Loscher and Hans Burgkmair's *Rosary Altar* (1521–22) in St. Rochus in Nuremberg includes similar architectural motifs, flanking, though smaller-arched niches, and five statuettes positioned like those in the upper zone of the Metzenhausen tomb. See Lieb (1952), fig. 156. Related forms can be observed in several of the Basel sculpture and goldsmith designs after Augsburg models; see Falk (1979), esp. pp. 158–60, nrs. 688, 690 (large, central shell niche with smaller flanking niches), and 692.

31. On the latter, see Irsch (1931), pp. 284–86, fig. 187.

32. Irsch (1931), pp. 275–76, fig. 16. An eighteenth-century painting of the cathedral's interior places the tomb and establishes its scale as being similar to the Metzenhausen tomb; however, little can be determined about its design or its subject. A better color reproduction is given in Ronig (1982), p. 49.

33. Eberhard Leppin, *Die Elisabethkirche in Marburg an der Lahn* (Königstein im Taunus, 1980), pp. 7, 14–15, 71–75. On Ludwig Juppe, the sculptor of the last of these tombs, see Friedrich Gorissen, *Ludwig Jupan von Marburg* (Düsseldorf, 1969).

34. Mrusek (1976), pp. 374–75, figs. 229 (general view), 288–91, and 295–96.

35. Hans-Joachim Krause, "Die Grabkapelle Herzog Georgs von Sachsen und seiner Gemahlin am Dom zu Meissen," *Das Hochstift Meissen: Aufsätze zur sächsischen Kirchengeschichte,* ed. Franz Lau (Berlin, 1973), pp. 375–402; and Mrusek (1976), figs. 297–98.

36. See our discussion later in this chapter.

37. On the Tübingen cycle, see Demmler (1910), esp. pp. 1–40, plus plates and documents; and Fleischhauer (1971), pp. 109, 127–30, figs. 51, 62, 64, 66, 75, 80–81.

38. A good study of this period is Martin Brecht and Hermann Ehmer, *Südwestdeutsche Reformationsgeschichte: Zur Einführung der Reformation im Herzogtum Württemberg 1534* (Stuttgart, 1984).

39. Demmler (1910), pp. 20–28, pl. 2 (Jakob Woller's 1556 sketch of the choir with the positions of four tombs indicated); Manfred Tripps, *Hans Multscher* (Weissenhorn, 1969), pp. 66 and 263, fig. 87; and Fleischhauer (1971), pp. 109 and 128, fig. 64.

40. Demmler (1910), esp. pp. 41–56 and 226–39; Fleischhauer (1971), pp. 110, 137–39; and Theo Sorg, *Die Stiftskirche in Stuttgart* (Königstein im Taunus, 1984), pp. 2–3, 9–10, 26–29.

41. Nine drawings attributed to Steiner are in the Print Cabinet of Szépmüvészeti Muzeum in Budapest. See Heinrich Geissler, "Zeichner am Württembergischen Hof um 1600," *Jahrbuch der Staatlichen Kunstsammlungen in Baden-Württemberg* 6 (1969): esp. pp. 91–94, figs. 8 (Heinrich von Mempelgard)–11. Since the architectural frames and figure positions are especially close to the final program of the choir, I think that Steiner's first sketches, including that used by Mair, are lost. The Budapest drawings illustrate the second stage of the project immediately before the decision to bring the eleven works together in a single monument.

42. Mair delivered his trial piece to the duke in Stuttgart in December 1577. This model in presently on loan from Schloss Urach to the Württembergisches Landesmuseum in Stuttgart. See Demmler (1910), esp. pp. 67–76; and Volker Himmelein's comments in *Die Renaissance im deutschen Südwesten* (1986), p. 555, nr. I 17.

43. Schlör worked frequently for the ducal court. In 1562–63 he made the altar and pulpit of the Schlosskirche in Stuttgart. He carved the *Tomb of Duchess Sabina (d. 1564)* for the family mausoleum in Tübingen. In 1576–77, just prior to be-

ginning the monument of the eleven counts, Schlör completed the free-standing *Tomb of Count Albrecht von Hohenlohe* who had died accidentally in 1575 during the tournaments celebrating Duke Ludwig's marriage. This tomb is also in the Stiftskirche in Stuttgart. See Werner Fleischhauer, "Neues zum Werk des Bildhauers Sem Schlör," *Württembergisch Franken Jahrbuch* 50 [n.f. 40] (1966): pp. 111–23; Fleischhauer (1971), pp. 109, 134, 136–37, fig. 75 (Sabina); Theo Sorg, *Die Stiftskirche in Stuttgart* (Königstein im Taunus, 1984), p. 34.

44. Compare these with Schlör's busts of Georg Beer, building master of the Lusthaus, of 1586 now in the Württembergisches Landesmuseum in Stuttgart or of Duke Ludwig (now lost). See Fleischhauer (1971), fig. 36; and Ulrike Weber-Karge, '. . . einem irdischen Paradeiss zu vergleichen . . .': *Das Neue Lusthaus in Stuttgart* (Sigmaringen, 1989), pp. 26–27, fig. 1.

45. On 11 February 1514 the emperor wrote to Bishop Georg of Speyer and the cathedral chapter that he wished to erect a large shrine honoring his Salian and Hohenstaufen ancestors, some of whom were buried there. Six days earlier he had entered into an agreement with Salzburg sculptor Hans Valkenauer. The project called for 12 statues carved in red marble that would be placed on 12 columns that in turn supported a giant stone imperial crown. The Salian figures were Emperors Konrad II (1024–39), Heinrich II, Heinrich III, and Heinrich IV, as well as Empresses Gisela and Berta; the Hohenstaufen were Philipp von Schwaben, Emperors Rudolf von Habsburg (1273–91, Adolf von Nassau, and Albrecht von Österreich plus Beatrix, the wife of Friedrich Barbarosa and her daughter, Agnes. A court artist, most likely Maximilian's favorite project designer, Jörg Kölderer, produced the working sketches. According to Halm, the monument would have measured about six meters in diameter with a slightly lesser height. Between 1514 and 1519 Valkenauer worked on the twelve statues. With Maximilian's death the project was abandoned. Fragments of six of these statues, which measure from 1.35 to 1.5 meters in height, are in the Museum Carolino-Augusteum in Salzburg. This project, like the Innsbruck tomb (see below), was intended to celebrate Maximilian's distinguished ancestry and his role as the family's torchbearer. See Halm (1926), 1: pp. 176–82 and

222–24. His fig. 205 on p. 224 offers a rather fanciful reconstruction of the monument. Also see Reindl (1977), pp. 54–55.

46. Wolfgang Lotz, "Historismus in der Sepulkralplastik um 1600: Bemerkungen zu einigen Grabmalen des Bamberger Domes," *Anzeiger des Germanischen National-Museums* (1940–53 [1954]): pp. 61–86, esp. 75–78 on Petersberg and Stuttgart; and esp. Hentschel (1966), pp. 53–54, 126–27, fig. 37. The group extends from Konrad the Great (d. 1157) to Heinrich III (d. 1217). The sculptors' monograms appear on the monument.

47. Claude Keisch, "Zu einigen Stilkopien in der deutschen Plastik des 16. und 17. Jahrhunderts," *Staatliche Museen zu Berlin: Forschungen und Berichte* 15 (1973): pp. 71–78, esp. 72–73.

48. Emperor Maximilian II performed the ceremony at Augsburg. For a contemporary woodcut illustrating this event, see Blendinger and Zorn (1976), p. 75 and fig. 183.

49. Jakob's nephews, Raymund (d. 1535) and Hieronymus (d. 1538) are also buried here. Only a fraction of the original chapel decoration survives; the remaining busts of worthies and prophetesses are in the Bode Museum in Berlin. The Lamentation group temporarily was transferred in 1581 to the new St. Markus-Kirche in the Fuggerei in Augsburg. It is missing in Johann Weidner's drawing of the interior done about 1660, which provides the best idea of the chapel's original appearance. See Lieb (1952), pp. 135–249, 373–402, 433–71 (Karl Feuchtmayr's discussion of the sculptors), fig. 70 (Weidner's sketch); this remains the best study of the chapel and its works of art. Also see Philipp Maria Halm, *Adolf Daucher und die Fuggerkapelle bei St. Anna in Augsburg* (Munich, 1921); Lieb (1958), 268–74 and 448–54; Henry-Russell Hitchcock, "The Beginnings of the Renaissance in Germany, 1505–1515," *Architectura* 1 (1971): pp. 123–47, esp. 137–47; Baxandall (1980), pp. 132–35 and 296–98; and Jörg Rasmussen, "Kunz von der Rosen in der Fuggerkapelle," *ZDVK* 38 (1984): pp. 47–53.

50. Several drawings linked with these two reliefs survive. The closest is his *Samson and the Philistines* in the Kupferstichkabinett in Berlin that dates to about 1510. See the literature in the previous note plus Strauss (1974), nos. 1506/40–41, 1510/19–23; and Fedja Anzelewsky and Hans

Mielke, *Albrecht Dürer—Kritischer Katalog der Zeichnungen, Staatliche Museen Preussischer Kulturbesitz* (Berlin, 1984), nrs. 61–62.

51. The Basel relief measures 34.9 by 23 cm. As will be discussed in Chapters Nine and Ten, many of Daucher's small carvings functioned as forms for making copies, whether plaquettes in metal or, as here, in white plaster. See Hans Reinhardt, "Unscheinbare Kostbarkeiten aus dem Amerbach-Kabinett," *Jahresbericht des Historisches Museum Basel* (1958): pp. 27–35; and Landolt and Ackermann (1991), pp. 50, 119, 121.

52. Perhaps he owned Daucher's original stone models. Raymund also had inherited a now lost alabaster *Portrait of Jakob the Rich*. Lieb (1958), p. 42.

53. Lieb (1952), p. 380.

54. The portal relief was carved either by Daucher or a member of his shop. It replicates Daucher's *Lamentation* that Duke Georg sent in 1523 as a present to Wilhelm von Honstein, bishop of Strasbourg, who also had attended the 1518 diet in Augsburg. In the nineteenth century, the latter relief was discovered in the sacristy of Notre Dame de la Nativité in Saverne (Zabern). It measures 1.06 by 1.13 meters. See Karl Feuchtmayr in Lieb (1952), pp. 439–40; Hans-Joachim Krause, "Die Grabkapelle Herzog Georgs von Sachsen und seiner Gemahlin am Dom zu Meissen," *Das Hochstift Meissen: Aufsätze zur sächsischen Kirchengeschichte*, ed. Franz Lau (Berlin, 1973), esp. pp. 380–82 and 387–89; *Inventaire général des monuments et des richesses artistiques de la France. Bas-Rhin: Canton Saverne* (Paris, 1978), p. 312, fig. 362; and Schädler in *Welt im Umbruch* (1980–81), 2: p. 36.

55. By far the best discussion of the church and its artistic monuments is Magirius (1986), esp. pp. 41–57, figs. 154–63 (Moritz's tomb) and 174–98 (choir). Much of what follows is adapted from a talk that I presented at the American Historical Association meeting in San Francisco. The revised text "From Catholic Dukes to Protestant Electors: Albertine Ideological Imagery and the Cathedral of Freiberg in Saxony" appeared in the *Proceedings of the American Historical Association* (Ann Arbor: UMI, 1989). I wish to thank Carl Christensen, Susan Karant-Nunn, and Jonathan Zophy for their helpful comments.

56. On Moritz and his career, see Karlheinz Blaschke, *Moritz von Sachsen: Ein Reformationsfürst der zweiten Generation* (Göttingen, 1984), esp. pp. 51–84.

57. Fleischhauer (1971), p. 109 citing Chr. Axel Jensen, *Danske Adelige Gravsten fra sengotikens og renaissancens tid*, (Copenhagen, 1953), 2: pp. 11 and 138.

58. Rolf Hunicken, *Halle in der mitteldeutschen Plastik und Architektur der Spätgotik und Frührenaissance 1450–1550* (Halle, 1936), pp. 41–50 on Schlegel and 47ff. on this tomb; and Irene Roch, "Zur Renaissanceplastik in Schloss Mansfeld und Eisleben," *Wissenschaftliche Zeitschrift der Martin-Luther-Universität Halle-Wittenberg* 12 (1963): pp. 765–84, esp. 774–76.

59. Hedicke (1913), pp. 38–42; and Ellger (1966), pp. 533–42.

60. Charles de Tolnay, *Michelangelo. IV. The Tomb of Julius II* (Princeton, 1954); and Panofsky (1964), pp. 88–90, figs. 417–19.

61. Schiller (1971–72), 2: pp. 136–37.

62. Louis Charbonneau-Lassay, *Le Bestiaire du Christ*, (Milan, 1974—2nd ed.), pp. 364–77; and Magirius (1986), p. 44. Griffins were guardians of tombs who conducted souls to heaven. Often they were equated with Christ and Apollo.

63. Panofsky (1964), pp. 87–96.

64. Magirius (1986), p. 42. The advisors included Christoph von Carlowitz, Dr. Ulrich Mordeisen, Dr. Franz Kramer, Dr. Johannes Lindemann, Joachim Camerarius, and Georg Fabricius.

65. I have not had an opportunity to read Monika Meine, *Die Grablege der Wettiner im Dom zu Freiberg: Die Umgestalt und des Chores durch Giovanni Maria Nosseni 1585–1594*, Ph.D. diss., Göttingen, Georg-August-Universität, 1989 (Munich, 1992). The core of the dissertation, however, has appeared; see Monika Meine-Schawe, "Giovanni Maria Nosseni. Ein Hofkünstler in Sachsen," *Jahrbuch des Zentralinstituts für Kunstgeschichte* 5–6 (1989–90): pp. 283–325, esp. 290–307.

66. Colin worked on the project, which also included the effigy of Queen Anna, from 1566 until 1589. Dressler (1973), pp. 64–74, figs. 138–53.

67. Hentschel (1966), pp. 113–15; and Claude Keisch, "Das Dresdner Moritzmonument von 1553 und einige andere plastische Zeugnisse kursächsischer Staatsrepräsentation," *Jahrbuch der Staatlichen Kunstsammlungen Dresden* (1970–71): pp.

145–65, esp. 148ff.. Both authors attempt, rather unsuccessfully, to identify artistic precedents for this work. Keisch (p. 150, figs. 7–8) relates it to a monument on the Brenner pass and to an emblem by Andrea Alciati.

68. The drawing (dated 1591) was in the Sächsische Landesbibliothek in Dresden until its disappearance in World War II. Hentschel (1966), text fig. 2 opp. p. 48.

69. The literature on this tomb is vast and many of the problems concerning its design and execution cannot be addressed here. My intention is simply to introduce the tomb and relate it to the general development of German funerary monuments. The best recent study of the tomb is Scheicher (1986), pp. 359–425; also see V. Oberhammer, *Die Bronzestandbilder des Maximilian-Grabmales in der Hofkirche zu Innsbruck* (Innsbruck, 1935); Karl Oettinger, "Die Grabmalkonzeptionen Kaiser Maximilians," *ZDVK* 19 (1965): pp. 170–84; Karl Oettinger, *Die Bildhauer Maximilians am Innsbrucker Kaisergrabmal* (Erlangen, 1966); and Egg (1974), esp. pp. 10–63.

70. The Innsbruck monument is technically a cenotaph or empty tomb since Maximilian's physical remains are buried in Wiener Neustadt. For a good summary of the identities, dates, attributions of these statues, see Scheicher (1986), esp. pp. 368–401. The Arthur and Theodoric figures mentioned below are nrs. 9 and 12, pp. 377 and 380.

71. These are the tombs of *Anne of Bedford*, formerly in the Celestine church in Paris; *Louis of Mâle*, formerly in St. Pierre in Lille; and *Jeanne of Brabant*, formerly in the Carmelite convent in Brussels. See my "The Artistic Patronage of Philip the Good, Duke of Burgundy (1419–1467)," Ph.D. diss., Columbia University, 1979, pp. 65–74 and 86–89; and "The Tomb of Anne of Burgundy, Duchess of Bedford, in the Musée du Louvre," *Gesta* 23 (1984): pp. 39–50, esp. 46–7.

72. The effigy is today in Antwerp cathedral and the family statuettes are in Amsterdam (Rijksmuseum). See Leeuwenberg and Halsema-Kubes (1973), pp. 40–45 for its history and bibliography.

73. Scheicher (1986), pp. 413–18. These range from 63 to 79 cm in height.

74. Rupert Feuchtmüller, *Der Wiener Stephansdom* (Vienna, 1978), pp. 221–36, esp. fig. 225.

Nicolaus Gerhaerts' effigy of Friedrich dates between 1467 and 1473.

75. Scheicher (1986), pp. 419–22. Also see Hans Weihrauch, "Studien zur Süddeutschen Bronzeplastik," *MJBK* 3–4 (1952–53): pp. 199–219, esp. 203–11; and Scheicher et al. (1977), pp. 178–85.

76. For a useful introduction to these projects, see Larry Silver, "Prints for a Prince: Maximilian, Nuremberg, and the Woodcut," in Smith (1985—II), pp. 7–21.

77. Egg (1974), pp. 54–62; and Scheicher (1986), pp. 402–11.

78. Egg (1974), fig. 14. It is inv. nr. Arch. 9685 in the Graphische Sammlung Albertina in Vienna.

79. Egg (1974), figs. 15–16. It is inv. nr. A 2418 at the Kunsthistorisches Museum in Vienna and now housed at Schloss Ambras.

80. On Colin's reliefs and decorative carvings, see Dressler (1973), pp. 46–56 and 174–79; and Smekens (1976), esp. pp. 198–203.

81. Dressler (1973), p. 51 attributes this scene to the Abel brothers, while Egg (1974), p. 116 and Smekens (1976), p. 201 ascribe it to Colin or his shop.

82. Alwin Schultz, ed., "Der Weisskunig," *JKSAK* 6 (1988): p. 134, fol. 223b.

83. Was the original design more centrally focused? In the Bibliothèque Royale in Brussels is an anonymous pen drawing, dating around 1570 and measuring 53 by 78 cm. The sketch presumably reflects Florian Abel's now-lost design rather than the completed carving. The composition omits the four women and the archway on the right and everything left of the corner of the lefthand gallery. See *Vijf Jaar Aanwinsten 1969–1973*, exh. cat. Bibliothèque Royale Albert Ier (Brussels, 1975), nr. 191, pp. 408–12.

84. Hans Christoff Löffler cast the frieze. See Dressler (1973), pp. 56–60; and Egg (1974), pp. 57 and 60 for what follows on the cenotaph. In 1564 Archduke Ferdinand II ordered the elaborate grille that surrounds the cenotaph. It was made by Jörg Schmidhamer of Prague, who shipped it to Innsbruck in 1573 where it was painted by Paul Trabel. See Egg (1974), p. 63.

85. Germain Pilon's *Tomb of King Henri II and Catherine de' Medici* of about 1563 in the abbey of St. Denis outside Paris has kneeling figures, though at

formal prayer benches, and large statues of virtues. See Panofsky (1964), fig. 331. Dressler (1973), p. 60 also points to Freiberg as a model for the Innsbruck tomb.

86. Egg (1974), p. 57 notes that 9,200 gulden were spent just for the years from 1561 to 1564.

87. For what follows, see especially Ehrenberg (1899); and the essays in *Albrecht von Brandenburg-Ansbach und die Kultur seiner Zeit*, exh. cat. Rheinisches Landesmuseum Bonn (Düsseldorf, 1968). Albrecht grew up in Ansbach. As the third son of Margrave Friedrich von Brandenburg-Ansbach, a church career was planned for him beginning with his appointment as a *Domherr* in Cologne in 1507. Between February 1511 and April 1525 Albrecht was the high master of the Teutonic Knights. In the aftermath of the peace of Cracow of 1525 that ended the Prussian-Polish war, the new duchy was created with Albrecht as duke. He married Dorothea in the following year.

88. On the two epitaphs, see Ehrenberg (1899), pp. 59–60 plus the relevant documents on 176ff.; Hedicke (1913), pp. 24–31, pl. XIII.1–4; and Roggen and Withof (1942), pp. 102–6 and 114. I know the Königsberg works only from photographs. I have been unable to determine whether any of these is still extant since much of the city, including the cathedral, was destroyed in the aftermath of bombings of 29 and 30 August 1944. Even a post-war catalogue of sculptures in Königsberg avoids any attempt to distinguish which works still survive. See Hubert Meinhard Mühlpfordt, *Königsberger Skulpturen und ihre Meister 1255–1945* (Würzburg, 1970).

89. The epitaph left Lübeck for Königsberg on 1 July 1552. See Thomas Riis, "Jacob Binck in Lübeck," *Hafnia* (1970): pp. 35–49, esp. 43–44 and 46. Binck also arranged for Floris to carve Frederik I's tomb in Schleswig. On his activities, also see Bialostocki (1976—I), pp. 16–18.

90. See for example Panofsky (1964), figs. 91–94, 285 (*Epitaph of Andrea Bregno* in S. Maria sopra Minerva in Rome), and 288.

91. Ehrenberg (1899), pp. 60–67; Hedicke (1913), pp. 53–55; and Roggen-Withof (1942), pp. 114–15.

92. See Hedicke (1913), pls. XLIII.1 and XLVII.1.

93. Floris here seems to recall once again Andrea

Sansovino's Sforza and Basso monuments in S. Maria del Popolo in Rome with their use of an arch above the central bier. (fig. 112) Other features, such as the medallion behind the deceased, reappear in Königsberg.

94. Carl van de Velde, *Frans Floris (1519/20–1570): Leven en Werken* (Brussels, 1975), pp. 314ff., fig. 91.

95. Hedicke (1913), esp. pl. XII. 1, 4, and 6.

96. Ehrenberg (1899), pp. 109–12. The original shipment of stone sank at sea on its way to Königsberg. Van den Blocke used limestone rather than the costlier alabaster employed by Floris.

97. See Lech Krzyzanowski, "Plastyka Nagrobna Wilhelma van den Blocke," *Biuletyn historii sztuki* 20 (1958): pp. 270–98 (with French summary).

98. Hessel Miedema, "De Bijbelse ikonografie van twee monumenten: De 'kraak' to Oosterend (Fr.), en het grafmonument van Edo Wiemken te Jever," *Bulletin van de Koninklijke Nederlandse Oudheidkundige Bond* 77 (1978): pp. 61–88; and Bernhard Schönbohm, *Die Neue Stadtkirche zu Jever* (Munich, 1979), pp. 4, 6–8. Schönbohm (p. 6) and others identify the artist as Heinrich Hagart; however, Miedema (pp. 66–67) rightly argues that there is no firm basis for the attribution. Miedema's article is primarily an iconographic study of the two New Testament relief friezes beneath the effigy. As models for these friezes, the sculptor has relied exclusively upon prints published in Antwerp bibles.

99. De Jong and de Groot (1988), p. 66, nr. 76.14 with illustration. The caryatids represent Justice, Wisdom, Hope, Love, War, and Peace.

100. Around the lower zone stand Rhetoric, David, Dialectic, Solomon, Music, Uzziah, Maria, and Saul. Above are Mercury, Venus, Jupiter, Sol, Saturn, Fortitude, Mars, and Luna.

Chapter Seven

1. There exists no serious treatment of German Renaissance fountains excepting the occasional article on a single work or artist. Useful picture books include Lindner (1920) and Kiewert (1956) though there are several factual errors in their captions. Although I do not discuss it below, there is a fascinating manuscript, later owned by the dukes of

Bavaria, that Christoph Sesselschreiber wrote in 1524 detailing, among other things, how to construct a working fountain. He penned several fountain designs, including a drawing of a two-basin example then in Freising. Its title, *Von Glocken—Stuckgiesserei, Büchsenmacherei, Pulverbereitung, Feuerwerk, Heb- und Brechzeug, Wasser- und Brunnwerken* (Munich, Bayerische Staatsbibliothek, Cod. Germ. 973), provides an idea of the wide range of topics, other than fountains, discussed by the author, who was the son of the painter-founder Gilg Sesselschreiber who worked on the tomb of Maximilian in Innsbruck. See Schattenhofer (1974), pp. 19–20, figs. 4, 14–16.

2. *Gothic and Renaissance Art in Nuremberg* (1986), pp. 132–36 (with further literature); and on Lüneburg, see Bange (1949), pp. 73–74, fig. 131.

3. This fountain was first mentioned in Johann Neudörfer's biography of Nuremberg artists of 1547. Collaborating with Vischer was Hieronymus Gärtner who specialized in devising water pumps. See Neudörfer (1875), p. 117; and Redlich (1900), p. 149. On the history of the castle, see Burkard von Roda, *Schloss Aschaffenburg und Pompejanum* (Munich, 1982). For Veit Hirschvogel's drawing of this building before its destruction, see Reber (1990), p. 100.

4. H. Müller (1954), pp. 180–81 on this work and 173–77, 179–83 on his other fountains.

5. Friedel (1974), pp. 72–87.

6. Franz Winzinger, *Albrecht Altdorfer—Graphik* (Munich, 1963), pl. 74. This is a generic fountain rather than a depiction of a specific object owned by the emperor.

7. A fragment of a mid-fourteenth-century one is in the Cleveland Museum of Art; see, among other sources, Miller (1977), pp. 10–14, fig. 8; and *Les Fastes du Gothique—Le siècle de Charles V*, exh. cat. Galeries nationales du Grand Palais (Paris, 1981), nr. 191.

8. Neudörfer (1875), p. 124.

9. Nr. B 147. See Kohlhaussen (1968), pp. 255–65 on this drawing and the subject of Nuremberg table fountains.

10. On Krug, see Kohlhaussen (1968), pp. 357–407; and Smith (1983), pp. 214–17.

11. 56 × 35.8 cm. Kohlhaussen (1968), pp. 258–60; and Rowlands (1988), nr. 47.

12. Neudörfer (1875), p. 115; and translation given in *Gothic and Renaissance Art in Nuremberg* (1986), p. 452.

13. Kohlhaussen (1968), pp. 477–79; *Wenzel Jamnitzer* (1985), nr. 11; and *Gothic and Renaissance Art in Nuremberg* (1986), pp. 451–54.

14. *Wenzel Jamnitzer* (1985), nr. 382 and also see nrs. 370–81; and Smith (1983), pp. 270–72.

15. Hayward (1976), pp. 46–47.

16. Inv. nr. Z 2860—K IV. The actual height of the fountain proper is 135 cm and the largest basin has a width of 61 cm. A copy of the drawing, minus the inscriptions and a few details, is in the Kupferstichkabinett in Basel. Heino Maedebach, ed., *Kunstsammlungen der Veste Coburg* (Coburg, 1978—2nd revised ed.), nr. 120 with texts of the inscriptions; and *Wenzel Jamnitzer* (1985), nr. 303.

17. Heino Maedebach, ed., *Kunstsammlungen der Veste Coburg* (Coburg, 1978—2nd revised ed.), nr. 120.

18. Weihrauch (1967), p. 311, fig. 375; *Welt im Umbruch* (1980), 2: nr. 508.

19. Franz Winzinger, *Albrecht Altdorfer—Graphik* (Munich, 1963), p. 133 (Anhang 20) illustrates a *Fountain of Love* engraving (Pass. V. 188, 99) by the Tarocchi Master, active around 1470, as a possible model for Altdorfer. Although both the prints have certain features in common, the massing and scale are radically different. I think that Altdorfer is making up a fountain that emulates a type then being made in Augsburg and perhaps in other German-speaking towns. The persistence of this form may have also been observed in the *Venus and Amor Fountain* in Vienna (Kunsthistorisches Museum) that the shop of Benedikt Wurzelbauer made late in the sixteenth century; Weihrauch (1967), fig. 396.

20. Bange (1949), pp. 40–42, fig. 92 (with front and back views of *Cleopatra*); Edmund W. Braun, "Der Kleopatrabrunnen des Berliner Museums, seine Nürnberger Herkunft und sein Besteller," *Festschrift für Erich Meyer zum 60. Geburtstag* (Hamburg, 1957), pp. 172–75; and *Kunst der Reformationszeit* (1983), nr. E 20. The author of the latter entry makes several mistakes, most notably the identification of the main statue as Prudentia rather than Cleopatra. In sixteenth-century German prints, such as those by Burgkmair (B. 54) or Sebald Beham (B. 130), Prudentia typically holds a

mirror, a compass, and an eel. The nude Berlin statue, like *Cleopatra*, carries only a snake that bites her on the breast. She stares heavenwards in anguish just as she does in prints of Cleopatra; see Beham's standing and seated Cleopatra engravings (B. 76–7). This gesture is nonsensical for Prudentia.

21. It dates around 1506. Bock (1921), p. 4, nr. 85; Hans Mielke, *Albrecht Altdorfer*, exh. cat. Kupferstichkabinett (Berlin, 1988), nr. 176.

22. Bock (1929), nr. 310.

23. On Beham's interaction with sculptors, see Smith (1989), esp. pp. 53–56.

24. On the subject of lifecasting, see Ernst Kris, "Der Stil 'Rustique,' die Verwandlung des Naturabgusses bei Wenzel Jamnitzer und Bernard Palissy, " *JKSW* 1 (1926): pp. 137–208; Klaus Pechstein, "Wenzel Jamnitzers Silberglocken mit Naturabgüssen," *AGNM* (1967): pp. 36–43; *Wenzel Jamnitzer* (1985), nrs. 15, 18, 21, 517–21; and Norberto Gramaccini, "Das genaue Abbild der Natur—Riccios Tiere und die Theorie des Naturabgusses seit Cennini," in Beck and Blume (1985), pp. 198–225.

25. Neudörfer (1875), p. 126; and Hayward (1976), p. 208 (with translation).

26. Montague (1963), pp. 59 and 63; Weihrauch (1967), p. 264.

27. Bange (1949), nr. 136 and cf. 137–38, two figures in Stift Klosterneuburg formerly part of a fountain; Wixom (1975), nr. 178 (with an excellent discussion of the Cleveland statue and a photograph of its rear view); *Welt im Umbruch* (1980), 2: nr. 500. The Cleveland statue measures 28.2 cm while the Budapest version is .8 cm taller.

28. Bock (1929), p. 119, nr. 437; Weihrauch (1967), p. 286, fig. 342; Gagel (1977), fig. 84.

29. Weihrauch (1967), pp. 305–6, fig. 366; and Gagel (1977), pp. 115–18. For an example of a similar, if artistically inferior, contemporary fountain figure, see the bronze or brass *Venus Standing on a Ball*, now in Florence (Museo Nazionale); Weihrauch, fig. 338.

30. The literature on this project is extensive. See especially *Wenzel Jamnitzer* (1985), nrs. 26–30; Schürer (1986), pp. 55–59; Lietzmann (1987), pp. 70–73; *Prag um 1600*, (1988), 2: nr. 520; Pechstein (1988), pp. 232–35; Honnens de Lichtenberg (1991), pp. 97–104.

31. The crown recalls Maximilian I's equally ambitious plan to have an imperial shrine, shaped in the form of a crown, erected in Speyer cathedral. See Chapter Six, note 45 for a brief discussion.

32. Pechstein (1988), p. 233, fig. 3 offers a very rough reconstruction drawing. A detailed account, written around 1640, provides the basis for our knowledge of the different stages of the fountain. See *Wenzel Jamnitzer* (1985), nr. 26.

33. Lietzmann (1987), p. 173 and note 91.

34. Schürer (1986), p. 56; and Thomas DaCosta Kaufmann, "Arcimboldo's Imperial Allegories. G.B. Fonteo and the Interpretation of Arcimboldo's Paintings," *Zeitschrift für Kunstgeschichte* 39 (1976): pp. 275–96.

35. Rupert Feuchtmüller, *Das Neugebäude* (Vienna, 1976), pp. 33–36; Schürer (1986), p. 56; and esp. Lietzmann (1987), pp. 9–23.

36. *Wien 1529—Die erste Türkenbelagerung*, exh. cat. Historisches Museum (Vienna, 1979).

37. Schürer (1986), p. 58. On Strada's architectural contributions at the Neugebäude, see esp. Lietzmann (1987), pp. 110–30. He did design the Antiquarium for the ducal palace in Munich, a room we shall return to in Chapter Nine. (fig. 277

38. On his time in Nuremberg, see Hayward (1976), pp. 47–48.

39. "Sonst hatt der Jamitzer von Nurnberg den prunnen, so er gemacht herbracht sambt ainem grossen wäxen bildt, das haben mir Ir. Mt. gezaigt. Ist ain solch werkh, dergleichen ich mein lebenlang keines gesehen hab, kunstlich vnnd schön, vnnd alles ist von sylber. Ist souil sach durchainandt, das ichs nit describieren kan, will aber sehen obs muglich wär, das ich ain abris dauon kandt zuwegen bringen." Cited by Lietzmann (1987), p. 171, note 79.

40. Peltzer (1916/18), esp. pp. 199–200 and 206. On the entry, see Smith (1983), p. 279. Jamnitzer's imperial goblet (Berlin, Kunstgewerbemuseum), with statuettes of Maximilian II and the seven electors, was probably presented to the emperor by city officials on this occasion. See *Wenzel Jamnitzer* (1985), nr. 25.

41. For a brief summary of the history of the attribution, see *Prag um 1600* (1988), 2: nrs. 518–20.

42. Some, however, are quite appealing. See the

mask of a youth, dating around 1400, in the Germanisches Nationalmuseum in Nuremberg; *Gothic and Renaissance Art in Nuremberg* (1986), nr. 17.

43. The unsightly alteration of the nipples, which were opened up to permit the flow of water, occurred at a later date. Bange (1949), nr. 140 (photographed with a dolphin-adorned conduit valve) and cf. 141-42, both in Munich (Bayerisches Nationalmuseum); Weihrauch (1967), p. 309; and *Welt im Umbruch* (1980), 2: nr. 503. Weihrauch suggests that this and one of the Munich examples were cast in the shop of one of the Augsburg members of the Labenwolf family. The Berlin figure may have originally been placed within a small wall niche, such as the Salzburg marble example located under the small loggia at Ludwigstrasse 15 in Augsburg with its pilasters, pediment, niche ornamented with a shell, and catch basin. See Robert Pfaud, *Das Bürgerhaus in Augsburg* (Tübingen, 1976), pl. 102b.

44. Inv. nr. 1263. Martin Angerer offers an excellent brief discussion of this work; see *Gothic and Renaissance Art in Nuremberg* (1986), nr. 262.

45. For instance, see Sebald Beham's *Fountain of Youth* (B. 165) of 1531-36; Smith (1983), pp. 188-89; and especially Alison Stewart, "Sebald Beham's Fountain of Youth—Bathhouse Woodcut," *The Register of the Spencer Museum of Art* 6 (1989): pp. 64-88.

46. The text reads, "Die fissirung Ist nit die Recht gross Sunder Ein mainung dor Von man muss dem prunenn und Berckwerk nach machenn Bei maiser pangratz find / man wol aller ley gaittung dor nach fein zwsamen richt Und ordennir." The transcription is given in *Gothic and Renaissance Art in Nuremberg* (1986), nr. 262.

47. Precious mountain scenes, but without flowing water, were later popular in princely *Kunstkammers*. One more sculptural example was mentioned in the Dresden court inventory of 1591. Two mountain peaks were adorned with bronze statues of a unicorn and a lying deer, both of which had been cast in the 1570s by Hans Reisinger of Augsburg. These two statuettes, measuring 37.8 and 20.5 cm respectively and still in Dresden (Grünes Gewölbe), may have been placed within small caves or grottos in the mountain side. Bange (1949), p. 94, figs. 157-58.

48. Graphische Sammlung, inv. nr. 123; it measures 17.8 by 39.1 cm. Geissler (1978), pp. 66-69; and Geissler (1979), D 5.

49. There exists no adequate modern monograph on Sustris. See the brief biography in Kaufmann (1982), p. 118; and the numerous references to his work in Glaser (1980), passim.

50. Lill (1908), pp. 44 and 46ff..

51. Geissler has proposed that another drawing in Dresden (Kupferstichkabinett, inv. nr. 1975-197) represents the next stage of this project. I find this impossible to accept since this sketch, which shows the lefthand portion of a fountain with a reclining river god on the lower basin and a group of animals above, is for a much larger, much more complex fountain that could not possibly fit into the Fuggerhaus site. See Geissler (1978), pp. 68-69, fig. 3.

52. Lill (1908), pp. 53-75; and Hitchcock (1981), pp. 172-73, pls. 215-16. These rooms were destroyed in the World War II.

53. Mader (1927), pp. 341-48; and Hitchcock (1981), pl. 214.

54. Giorgio Vasari, *Vasari on Technique*, tr. Louisa S. Maclehose (London, 1907), pp. 87-90; *Le Opere di Giorgio Vasari*, ed. Gaetano Milanesi (Florence, 1973), I: pp. 140-43. On this subject, see especially Wiles (1933), pp. 73-76; and Naomi Miller, *Heavenly Caves: Reflections on the Garden Grotto* (New York, 1982).

55. Wiles (1933), pp. 74-75, figs. 143-45.

56. Wiles (1933), pp. 75-76, figs. 146-48. She attributes the design and one of the sculpted goats to Baccio Bandinelli.

57. The statue, dating around 1560, is today in the Bargello in Florence. See Wiles (1933), pp. 42-44, fig. 80.

58. See Miller (1977).

59. Wiles, (1933), figs. 88, 92, 96, 132; and Pope-Hennessy (1985), pp. 74-81.

60. Friedel (1974), pp. 27-87.

61. Kiewert (1956), pls. 12-13.

62. This was created by Lienhart Rännacher and Peter Mülich. The latter had earlier worked in the Vischer foundry in Nuremberg, a fact that Oberhaidacher thinks is critical for the design and decorative details of this fountain. Jörg Oberhaidacher, "Der Pilgerbrunnen von St. Wolfgang," *Österreichische Zeitschrift für Kunst und Denkmalpflege* 43 (1989): pp. 6-25.

63. Balke (1916), pp. 42–45.

64. Kiewert (1956), pl. 10; and Jasbar and Treu (1981), pp. 83–85. Two hold Ulm's arms and the third that of the Teutonic Knights. Copies of these statues were placed on the fountain in 1910.

65. It dismantled in the mid-eighteenth century. When Zwerchfeld worked on three fountains in Augsburg between 1512 and 1515 he is listed as a stone mason. Thus it is likely that another stone sculptor actually carved the knight. The appearance of this fountain is given in generalized form in several later prints. See Schattenhofer (1974), pp. 16–17, figs. 3, 9–11.

66. Kiewert (1956), pl. 18.

67. Kiewert (1956), pls. 21, 48, 62, and 66; and Lindner (1920), fig. 313. On Ansbach, see Weihrauch (1967), p. 299, fig. 359.

68. On Lüneburg, see note 2 above. On Altdorf, see Lindner (1920), fig. 164; Larsson (1975), p. 183, figs. 9–10. *Minerva*, who measures 58 centimeters high, was probably cast after a model carved by Lienhard Schacht with whom Labenwolf worked on the great *Neptune Fountain* made for the king of Denmark. The latter fountain is discussed at the very end of this chapter. (fig. 211) Other connections were less specific. For instance, the tailors' guild in Colmar had an attractive *Venus Fountain* in their courtyard. The figure, dating 1526, is now in the Musée d'Unterlinden; see Lindner, fig. 33.

69. Kiewert (1956), pl. 38.

70. Lindner (1920), figs. 106, 141, and 154.

71. On Frankfurt, see Kiewert (1956), pl. 63.

72. Lühmann-Schmid (1974) and (1976–77), pp. 65–68; and Reber (1990), pp. 17 and 101–3.

73. The Latin texts are transcribed in Reber (1990), p. 102. The translation is mine.

74. My comments below are based upon Brück (1972), pp. 20–22; and especially Tom Scott and Bob Scribner, *The German Peasants' War—A History in Documents* (London, 1991), pp. 32–33 and 281–82 (doc. 134).

75. Lühmann-Schmid (1976–77), esp. pp. 66–68.

76. Lühmann-Schmid (1974), esp. 182–83; and Jung (1975), pp. 14–15.

77. Lühmann-Schmid (1974), p. 183 mentions Ulrich without explicating the reasons for the appropriateness of his inclusion here. See Blendinger and Zorn (1976), pp. 36–37 and 134. In 1520

Hans Burgkmair produced his dramatic *St. Ulrich during the Hungarian Battle* woodcut; see Geisberg (1974), nr. 1505.

78. Hans-Ernst Mittig, *Dürers Bauernsäule: ein Monument des Widerspruchs* (Frankfurt a. Main, 1984), pp. 44–45, fig. 2 where the author mentions the parallel between these two works. He also notes that Dürer designed a monument in the form of an upturned cannon that alludes to the battle of Pavia. Both prints were published in his *Underweysung der Messung* (*Art of Measurement*).

79. The text is given in Jürgen Zimmer, "Die Veränderungen im Augsburger Stadtbild zwischen 1530 and 1630," *Welt im Umbruch* (1980–81), 3: p. 57, note 16.

80. *Welt im Umbruch* (1980–81), 2: nr. 502; and Bushart (1981), pp. 82 and 84–85. For a view of it in about 1720 when it was located at the corner of Karolinen and Karl streets, see Blendinger and Zorn (1976), fig. 130.

81. Fleischhauer (1971), pp. 123–25. He has attributed the fountain to Daucher based on a comparison with a wooden head of a bearded man on a doorway of 1537 in Schloss Hohentübingen that he holds to be by the artist. See also Alfred Schädler's comments in *Welt im Umbruch* (1980–81), 2: nr. 518.

82. H. Müller (1954), pp. 181–82. This fountain, with its ten-sided basin, was renovated in this year but the figural decoration, known only through prints, is undated. By 1551 Catholic control of the city had been temporarily reinstated; however, it is probably too speculative given the paucity of the evidence to suggest this second fountain represented an artistic compromise between the two sides.

83. Bange (1949), pp. 101–2, fig. 171; Pechstein (1973), pp. 89–92; *Gothic and Renaissance Art in Nuremberg* (1986), pp. 425–26.

84. See Hans-Joachim Raupp, *Bauernsatiren* (Niederzier, 1986), passim, figs. 94 (a table-fountain design with a disheveled peasant holding a goose and a bag of money, now in Erlangen [Universitätsbibliothek], attributed to Hans Frey), 95, and 107 for three images of peasants carrying geese; and Keith Moxey, *Peasants, Warriors, and Wives—Popular Imagery in the Reformation* (Chicago, 1989), esp. ch. 3.

85. K. ter Laan, *Nederlandse spreekwoorden, spreu-*

ken en zegswijzen (Amsterdam, 1984), p. 41 ("boer", nr. 9). I am grateful to Cynthia Lawrence who brought this reference to my attention.

86. B. 58 and 59; A. Schmitt, *Hanns Lautensack* (Nuremberg, 1957), nrs. 50–51; Smith (1983), nrs. 163–64.

87. Bange (1949), p. 101 with illustration.

88. Pechstein (1973), pp. 90–91; and esp. Pechstein (1990), pp. 116. Weihrauch (1967), pp. 319–20 suggested that the sculptor was Netherlandish, but he offered no support beyond observing the farmer looked somewhat like the market figures of Pieter Aertsen of Amsterdam. Such figures can also be found in the prints of Sebald Beham and Erhard Schön.

89. Bange (1949), p. 100, fig. 167; Weihrauch (1967), p. 319; and Pechstein (1973), pp. 84–89. Coincidentally, Andrea del Verrocchio's *Putto with Fish* was moved to the courtyard of the Palazzo Vecchio in Florence sometime between 1550 and 1568. Pope-Hennessy (1971), pp. 295–96, pl. 78.

90. Although Flötner and Sebald Beham, among others, created numerous prints of designs for columns, capitals, and other architectural elements, local interest was especially strong during the mid-1540s as Flötner and others produced illustrations for the *Vitruvius Teutsch*, the first German edition of Vitruvius treatise. This was published in Nuremberg in 1548 by Johann Petreius. See Erik Forssman (foreword), *Zehen Bücher von der Architectur und künstlicher Bauen Marcus Vitrivius Pollio: Erstmals verteutscht durch Gualther Hermenius Rivius* (Hildesheim, 1973); and Smith (1983), p. 233.

91. Josephi (1910), pp. 294–95.

92. Pechstein (1973), p. 86; Pechstein (1990), p. 116. Peisser's plaquettes will be discussed in Chapter Nine.

93. Pechstein (1973), pp. 92–97.

94. Pechstein (1973), p. 96 notes that a second, virtually identical set of planetary deities are in the Museo Nazionale in Naples; here Jupiter is the same scale as the other statuettes. These probably once adorned yet another fountain.

95. Bange (1949), pp. 108–9, figs. 189–201; Weihrauch (1967), pp. 327 and 329; Hans R. Weihrauch, "Príspevky k dílu Benedikta Wurzelbauera a Adriaena de Vriese," *Umeni* 18 (1970): pp. 70–71; Hubert Herkommer, "Heilsgeschichtliches Programm und Tugendlehre—Ein Beitrag zur Kultur- und Geistesgeschichte der Stadt Nürnberg am Beispiel des Schönen Brunnens und des Tugendbrunnens," *MVGN* 63 (1976): esp. pp. 212–16; and Smith (1983), pp. 78–79.

96. The title page of the 1498 edition of the code displays a copy of Michael Wolgemut's famed 1493 view of Nuremberg. In Dürer's woodcut of 1521 for the 1522 edition, Holy Justice and Liberality reign while two angels support the city's arms. Master M.S. combines these ideas by presenting a view of the castle and northwest portion of the city. Seated before the view is Respublica, the personification of the community, with her handmaidens Justice, Peace, and Liberality. The city's concord is compared to honey bees working together for the collective good, here presented as gold coins falling from an inverted purse for the betterment of Nuremberg and its needy subjects. Above, God approves of this allegory, specifically the patrician council's running of the city. Nuremberg is the sacred community united by law and faith, peace and concord. Valentin Maler's medals of 1585, 1589, and 1593 are equally specific. In the first two, a model of the city is literally resting on the shoulders of a Ratsherr, who is aided by an angel and a craftsman. He is also represented as the good shepherd guarding and nurturing his flock. Biblical inscriptions are used to equate the council with God's vicar who preserves the city and its faith. These and a host of other flattering civic images will be discussed in a separate article. For illustrations, see Smith (1983), nr. 24; Wenzel Jamnitzer (1985), nrs. 674–76; and Kristin E. S. Zapalac, *"In His Image and Likeness": Political Iconography and Religious Change in Regensburg, 1500–1600* (Ithaca, 1990), pp. 87–89, fig. 37.

97. Compare for instance the fountain with Jamnitzer's *Emperor's Cup* (c. 1565; Berlin, SMBPK, Kunstgewerbemuseum) with its finial figures of the emperor, at the apex, and four contemporary princes standing around the central column. Ornamenting the tall stem of the cup are four virtues. See Pechstein (1971), nr. 100.

98. Kiewert (1956), pl. 63 (Frankfurt). The Frankfurt fountain reveals the iconographic influence of the Nuremberg fountain. Hoffmann, on the other hand, created a candelabrum-style fountain with statues of putti and female virtues surrounding the central column. He also continued to use

many of the mannerist devises observed in Wurzel-bauer's fountain.

99. For the most comprehensive study of German gardens, see Dieter Hennebo, *Geschichte der deutschen Gartenkunst*, I. *Gärten des Mittelalters* (Hamburg, 1962), esp. pp. 50–109 (literary references), 154–56 (water in gardens), and 158–78 (burger gardens); and Hennebo and Alfred Hoffmann, *Geschichte der deutschen Gartenkunst*, II. *Der architektonische Garten. Renaissance und Barock* (Hamburg, 1965), esp. pp. 15–84.

100. Franz Winzinger, *Albrecht Altdorfer—Die Gemälde* (Munich, 1975), p. 75, nr. 7; and Staatliche Museen Preussischer Kulturbesitz, Berlin, *Picture Gallery—Catalogue of Paintings. 13th–18th Century*, tr. Linda B. Parshall (Berlin, 1978–2nd ed.), p. 19.

101. Gagel (1977), nr. 24; Reindl (1977), nr. A38.

102. Schade (1980), fig. 182. On the woodcut (c. 1535) by Schön, who as we shall see below did design actual fountains, see *The Illustrated Bartsch*, 13 *Commentary*, ed. Robert Koch, pp. 358–59.

103. For instance, see the woodcuts by Albrecht Altdorfer, *Dream of Paris* (1511; B. 60); Hans Burgkmair, *David and Bathsheba* (1519; Geisberg [1974], nr. 498); Sebald Beham, *Story of the Prodigal Son* (c. 1535; Geisberg [1974], nrs. 219–20); and Jörg Breu, *Rich Man and Lazarus* (1545; Geisberg [1974], nrs. 398–99). The fountain in the latter, which sits in a courtyard before a garden, has an interestingly different design. Breu dispensed with the central column. Instead, four nude female statues stand on the rim of the basin and water from their breasts pour into the fountain. In Niklaus Manuel Deutsch's *Bathsheba at her Bath* (1517; Basel, Öffentliche Kunstsammlung), it is the fountain with its energetic putti statuettes rather than Bathsheba that dominates the drawing; see Paul H. Boerlin, *Das Amerbach-Kabinett—Die Gemälde* (Basel, 1991), nr. 6.

104. Franz Winzinger, *Albrecht Altdorfer—Die Gemälde* (Munich, 1975), nr. 49.

105. Baxandall (1980), p. 304; *Welt im Umbruch* (1980–81), 2: nr. 546. Measuring 44.9 by 29.7 cm, this solnhofen stone relief is unusually large for this type of cabinet carving as will be seen in Chapter Nine. A compact garden fountain is included in Jost Amman's drawing of this theme, dated 1572,

in Berlin (SMBPK, Kupferstichkabinett); see Bock (1921), p. 6, nr. 210, pl. 8.

106. The literature is extensive. See Bange (1949), pp. 27–29, 118–19, fig. 61; Weihrauch (1967), pp. 288–89; Smith (1983), pp. 62, 224; *Natur und Antike in der Renaissance* (1985), nr. 318; *Gothic and Renaissance Art in Nuremberg* (1986), nr. 248; Bräutigam (1987), pp. 205–24.

107. Wilhelm Schwemmer, *Das Bürgerhaus in Nürnberg* (Tübingen, 1972), pls. 51b, 96b.

108. Helmut Pfadenhauer, *Prospekt der Reichsstadt Nürnberg des Hieronymus Braun 1608* (Nuremberg, 1985), section 10; and esp. Bräutigam (1987), pp. 216–18, figs. 6–7.

109. The drawing has disappeared. On the history of its ownership, see Bräutigam (1987), pp. 209, 211.

110. Jay A. Levenson, Konrad Oberhuber, and Jacquelyn L. Sheehan, *Early Italian Engravings from the National Gallery of Art* (Washington, 1973), nr. 141.

111. Braun (1951), esp. pp. 195–200; Pfeiffer (1955), pp. 36–44 with the fullest transcriptions of the documents; and Bräutigam (1987), esp. pp. 206–7, 220.

112. See comments in Chapter Nine.

113. Apparently Scheurl also solicited fountain drawings by other artists. On 27 Sept. 1532 Nuremberg printmaker and painter Erhard Schön was paid 1 florin, 4 hellers, and 6 schillings plus another 24 schillings Trinkgeld for one of these "Prunnenvisierung." Braun (1951), p. 195. This sketch has not survived though two others of the same theme, *Apollo and Daphne*, done by Schön in 1540, are in Erlangen (Universitätsbibliothek) and Seattle (Art Museum); see Bock (1929), nr. 259, pl. 105; and Smith (1983), p. 174.

114. *Il magno Palazzo del Cardinal di Trento* (Venice, 1539—reprinted Trient, 1858), p. 20; Braun (1951), p. 201; Pfeiffer (1955), p. 37. On the palace and the patronage of Cardinal Cles, see *Bernardo Cles e l'Arte del Rinascimento nel Trentino*, exh. cat. Museo Provinciale d'Arte (Trent, 1985), pp. 155–56, esp. figs. 63–64 of the courtyard.

115. Braun (1951), p. 202.

116. Kunsthistorisches Museum, inv. nr. 5350. This manuscript of fountain drawings originally in the possession of Archduke Ferdinand II of Tirol in the 1570s; see our comments on the Innsbruck Ac-

teon Fountain below. Braun (1951), p. 203, figs. 4–6 for this and two further *Acteon* drawings in this volume.

117. Pfeiffer (1955), p. 37, figs. 3 and 4.

118. Pfeiffer (1955), p. 39, fig. 6 (a 1794 view of the courtyard). This *Neptune Fountain* seems to have been carved in stone. Where it was made and its subsequent fate are unknown.

119. Georg Habich, "Ein Brunnen von Pankraz Labenwolf in München," *MJBK* 10 (1916–18): pp. 217–22. I have been unable to find any trace of this fountain that may have been destroyed during the bombings of World War II when the Residenz was severely damaged. From the three photographs published in this article it is difficult to arrive at a sure attribution. On p. 220 he says that the fountain came from Neuburg to Munich along with other works, including Hans Vischer's *Christ and the Canaanite Woman* (our fig. 56).

120. Done in pen and gray ink with a gray wash, the drawing (KdZ 5515) measures 34.3 × 20.2 cm. Bock (1921), p. 96; and *Dürer et son temps, chefs-d'oeuvre du dessin allemand de la collection du Kupferstichkabinett, Musée de l'Etat, Stiftung Preussischer Kulturbesitz à Berlin—XVe et XVIe siècles*, exh. cat. (Brussels, 1964), nr. 123. In both studies, the drawing is dated c. 1530 without any explanation. Based upon the style of the figures and the fountain design, the sketch was more likely made around 1550.

121. *Katalog der Sammlung für Plastik und Kunstgewerbe* (1966), nr. 276 (inv. nr. 9895). The inscription is rather puzzling since Maximilian is referred to as the king of Bohemia, a title for which he only received homage beginning on 20 September 1562, two years after the date given in the relief. The same text also appears on the complete, later sixteenth- or seventeenth-century replica of this carving (inv. nr. 7244) in Vienna. Thomas Kaufmann has suggested to me that Maximilian's use of the title might have been prompted by political considerations. Maximilian had been recognized as the heir to the kingdom on 14 February 1549. This move would also strengthen his future chances to become emperor since the king of Bohemia was one of the seven imperial electors. With the abdication and later death of Emperor Charles V, plus the divison of the Habsburg lands between Ferdinand I and Philip II, Maximilian II may have

used the title in anticipation of the next imperial election. On Brachmann, who was also a medallist, see Habich (1929–34), 2.2: pp. 475–83.

122. Maximilian hosted a grand tournament honoring Albrecht V, duke of Bavaria, in Vienna in June 1560. See Kaufmann (1978), pp. 24–26.

123. Information about Maximilian's gardens is given in Leitzmann (1987), pp. 29–31, figs. 4 (plan of Hirschbrunnen) and 5 (Schloss Ebersdorf).

124. Pechstein (1973), pp. 99–103; Ferdinand Seibt, ed., *Renaissance in Böhmen* (Munich, 1985), pp. 52, 216, pl. XVIII, fig. 8.

125. An early drawing by Terzio is preserved in Archduke Ferdinand's fountain manuscript in Vienna (Kunsthistorisches Museum, inv. nr. 5350), the same volume as the *Acteon* drawing discussed above. (fig. 198) See the reproduction after Terzio in Albert Ilg, "Francesco Terzio, der Hofmaler Erzherzogs Ferdinand von Tirol," *JKSAK* 9 (1889): esp. pp. 241–44.

126. Dressler (1973), pp. 60–62, 173–74; and Felmayer (1986), p. 639.

127. Felmayer (1986), pg. 631 (Plan II, 5d), figs. 14–15.

128. Felmayer (1986), pp. 630 and 638.

129. Lietzmann (1987), pp. 59–104 and, for a discussion of Italian examples, such as the Villa d'Este at Tivoli, 183–95.

130. The drawing bears a nineteenth-century inscription: "Wien 1570. Plan zu einem Marmorbrunnen für den neuen Hofgarten in Wien den A. Collin ausführen soll v(on) Tirol(ischem) Marmor." Lietzmann (1987), p. 145.

131. Wiles (1975), figs. 40, 42–44, and 50 (Montorsoli's *Fountain of Orion* in Messina with its use of supporting figures).

132. Lietzmann (1987), p. 147 mentions plans to reconstruct this fountain.

133. Cosimo's role is noted by Pope-Hennessy (1985), p. 71.

134. Weihrauch (1967), p. 312; and esp. Schattenhofer (1974), p. 20. Marx Labenwolf also delivered two fountain pedestals decorated with children and salmon to Vienna in 1568; see Bange (1949), p. 92.

135. Schattenhofer (1974), p. 20. On the garden, see Kurt Hentzen, *Der Hofgarten zu München* (Munich, 1959), esp. pp. 11–24.

136. Mader (1927), p. 396; Dorothea Diemer in *Wittelsbach und Bayern* (1980), 2.2: nr. 116.

137. Geissler (1978), p. 70, fig. 4.

138. Today in the Residenz. See Dorothea Diemer in *Wittelsbach und Bayern* (19809), 2.2: nrs. 116 and 892a.

139. Weihrauch (1967), pp. 312-13.

140. Georg Labenwolf of Nuremberg made another fountain consisting of ten figures cast after models by sculptor Paul Kremer. This fountain was situated in the Lusthaus at Aue. Pechstein (1978), p. 77.

141. Bange (1949), pp. 92-94 and figs. 149-55; Weihrauch (1967), pp. 314-15; Leeuwenberg and Halsema-Kubes (1973), nr. 822; *Europäische Kleinplastik aus dem Herzog Anton Ulrich-Museum Braunschweig*, exh. cat. (Braunschweig, 1976), nrs. 2-3; *Welt im Umbruch* (1980-81) 2: nrs. 560-67.

142. The print is in J. Royer, *Beschreibung des gantzen Fürstlichen Gartens zu Hessen* (Halberstadt: Andreas Kolwald, 1648), pp. 3ff. Matthäus Merian published an engraving of the Schloss with its gardens. In the text he notes the existence of this and three other fountains. He writes "In diesem Lustgarten sind unter anderem drei schöne Kunstbrunnen mit Spritz-künsten zugerichtet, und der eine Kunstbrunnen ist von Kaufleuten aus Augsburg und Regensburg um 8000 gute Gulden eingehandelt worden." Matthaeus Merian, *Die schönsten Schlosser, Burgen und Garten*, intro. Elisabeth Höpker-Herberg (Hamburg, 1965), nr. 61. This information about the fountain being sold by Augsburg merchants conforms with the style of the figures.

143. On the Stuttgart fountains discussed below, see Fleischhauer (1971), p. 71. Two of the garden fountains were decorated with a fencing school, presumably a group of young men wielding swords, and bronze figures of little children and satyrs. Fleischhauer (p. 72) mentions that by 1566, prior to the major expansion of the garden, there was a small, wooden garden house on stilts with another fountain. The pleasure house, constructed by Georg Beer between 1580 and 1593, included at least one more fountain. See Ulrike Weber-Karge, "*. . . einem irdischen Paradeiss zu vergleichen . . . "—Das Neue Lusthaus in Stuttgart* (Sigmaringen,

1989), pp. 44-45, figs. 5, 56, 587; also see pp. 93-118 for a useful survey of the growing popularity of pleasure houses at German princely residences.

144. Bange (1949), p. 91, fig. 156; Weihrauch (1967), p. 313; *Welt im Umbruch* (19890-81), 2: n. 558.

145. Bange (1949), p. 91, fig. 163; Weihrauch (1967), p. 313, fig. 380; *Welt im Umbruch* (1980-81), 2: nr. 559. For both this and the previous fountain, the names of sculptors are unknown.

146. Larsson (1975), pp. 177-80; Pechstein (1978), pp. 75-79; Honnens de Lichtenberg (1981), p. 59; and Larsson in *Bruegels Tid—Nederländsk Konst 1540-1620*, exh. cat. Nationalmuseum (Stockholm, 1984), pp. 28-30. Georg Labenwolf may have been suggested to the king by his astronomer, Tycho Brahe, who had recently purchased another fountain cast by this artist for Slot Uraniborg.

147. Steven Ozment, *Magdalena and Balthasar—An Intimate Portrait of Life in 16th-Century Europe Revealed in the Letters of a Nuremberg Husband and Wife* (New York, 1986), p. 41.

148. A song in praise of the project was also composed. See Martin Kirnbauer, "'Die Kronborg-Motetten'—Ein Beitrag zur Musikgeschichte Nürnbergs?" *MVGN* 78 (1991): pp. 103-122. Bange (1949), pp. 103-5 illustrates an engraving after Stromer that was published in Johann Gabriel Doppelmayer's *Nachrichten* of 1730. On Stromer, see Wolfgang von Stromer, "Ein Lehrwerk der Urbanistik der Spätrenaissance. Die Baumeisterbücher des Wolf-Jacob Stromer, 1561-1614, Ratsbaumeister 34 Nürnberg," in August Buck and Bodo Guthmüller, ed., *La città italiana del Rinascimento fra utopia e realtà* (Venice, 1984), pp. 71-115. I wish to thank Wolfgang Frhr. von Stromer for these references.

149. The figure wearing a turban on the left recalls the earlier brass *Turk* fountain statue (Munich, Bayerisches Nationalmuseum) that Bange and Weihrauch have attributed to the sculptor who carved the model for the *Geese Bearer* (fig. 184); it was presumably cast by Pankraz Labenwolf. Figures of shooters became increasingly popular in German fountains after 1550. Bange (1949), fig. 172; Weihrauch (1967), p. 320, fig. 391.

Chapter Eight

1. Margarete Baur-Heinhold, *Süddeutsche Fassadenmalerei vom Mittelalter bis zur Gegenwart* (Munich, 1952).

2. Rowlands (1985), pp. 53–55 and L4.

3. Carl Wolf, A. von Behr, and U. Hölscher, *Die Kunstdenkmale der Stadt Goslar* [*Kunstdenkmälerinventare Niedersachsens*, vol. 23] (Hannover, 1901—reprinted Osnabrück, 1979), esp. pp. 271–84 (sibyls, prophets, evangelists, biblical images); and Krüger and Reinecke (1906), esp. pp. 226–35 (rulers).

4. Ten of the original 16 figures survive and are today in the Stadtmuseum in Munich. Liebmann (1982), pp. 241–44, figs. 122–25; and esp. Johanna Müller-Meiningen *Die Moriskentänzer und andere Arbeiten des Erasmus Grasser für das Alte Rathaus in München* (Munich, 1984), pp. 18.

5. Schwemmer (1958), p. 26, figs. 33–35.

6. Lange (1897), pp. 64–73; Smith (1985-I), pp. 90–91, figs. 6–8.

7. Mader (1927), pp. 405–42, esp. 405–12 and 428–32; Bulst (1975); Thoma, Brunner, and Herzog (1980); and Hitchcock (1981), pp. 94–98.

8. Bulst (1975), p. 123. On the palace with its great hall painted in 1532 by Dosso and Battista Dossi, see *Bernardo Cles e l'Arte del Rinascimento nel Trentino*, exh. cat. Museo Provinciale d'Arte (Trent, 1985), esp. pp. 83–196.

9. "Der gleichen glaube ich dass kain sollicher gesehen worden." Thoma, Brunner, and Herzog (1980), p. 6; Hitchcock (1981), p. 95 (with partial translation). On the Palazzo del Te, see *Giulio Romano*, exh. cat. Mantua (Milan, 1989), esp. pp. 317–83 and 512–15 (with an architectural comparison with Landshut by Kurt Forster).

10. He worked on the room's sculpture between 1540 and 1542–43. Bulst (1975), pp. 127–30; Reindl (1977), nr. C6n.

11. Jean Seznec, *The Survival of the Pagan Gods* (Princeton, 1970 ed.), esp. pp. 69–77.

12. Geisberg (1974), nr. 990; Smith (1983), pp. 204–5.

13. Bulst (1975), esp. pp. 130–42 and fig. 6 (reconstruction schema); Reindl (1977), nr. C6a–m.

14. The order is as follows: Hercules and the Serpent; Hercules Killing the Nemean Lion; Hercules and the Lernean Hydra; Hercules Battling the Centaurs; Hercules and Cacus; Hercules Carrying the Columns of Gibraltar and Ceuta; Hercules and Atlas; Hercules Carrying Cerberus; Hercules and Antaeus; Hercules and Achelous; Hercules, Deianira, and the Centaur Nessus; Death and Apotheosis of Hercules.

15. Oskar Lenz, "Über den Ikonographischen Zusammenhang und die Literarische Grundlage einiger Herkuleszyklen des 16. Jahrhunderts und zur Deutung des Dürerstiches B. 73," *MJBK* N.F. 1 (1924): pp. 80–103, esp. 86–87 and fig. 5.

16. Reindl (1977), nr. C7.

17. *Giulio Romano*, exh. cat. Mantua (Milan, 1989), pp. 340–42.

18. Erwin Panofsky, *Hercules am Scheidewege und andere antike Bildstoffe in der neueren Kunst* (Leipzig, 1930); Erwin Panofsky, *The Life and Art of Albrecht Dürer* (Princeton, 1955-4th ed.) pp. 73–76; Edgar Wind, *Pagan Mysteries in the Renaissance* (New York, 1968 ed.), esp. pp. 82, 205–6.

19. "For a mortal to aid mortal—this is God, and this is the road to eternal glory." Pliny as cited by Jean Seznec, *The Survival of the Pagan Gods* (Princeton, 1970 ed.), p. 11. For what follows also see the comments of Bulst (1975), esp. pp. 155–57.

20. Illustrated in Walter Strauss, *The Book of Hours of Emperor Maximilian the First* (New York, 1974), p. 336. For an example of the princely use of this conceit, see Corrado Vivanti, "Henry IV, the Gallic Hercules," *Journal of the Warburg and Courtauld Institutes* 30 (1967): pp. 176–97.

21. Bulst (1975), pp. 156–57.

22. Hitchcock (1981), pls. 284, 348–51. On Hans Fugger's palace at Kirchheim with its great hall (1583–86) decorated with lifesize terracotta statues by Carlo Pallago and Hubert Gerhard plus its intricate wooden ceiling by Wendel Dietrich, see Lill (1908), pp. 86–127; Diemer (1988), esp. pp. 36–53.

23. Horn and Meyer (1958), pp. 170–83, 209–27; Hitchcock (1981), pp. 64–71, pls. 73, 105, 123.

24. One red-marble doorway with Ottheinrich's coat of arms is attributed to Martin Hering. See Reindl (1977), nr. D15 (now in the palace at Berchtesgaden).

25. Horn and Meyer (1958), pp. 477–94; Reindl (1977), nr. D10 on Hering's relief.

26. Löffler (1958), pls. 28–29, 31, 34; Hentschel (1966), pp. 27–31, 106–7; and Hitchcock (1981), pp. 76–78, pls. 83–84.

27. Today only the heavily damaged *Adam and Eve* portal and fragments of the *Dance of Death* survive. The Georgenbau was damaged by fire on 25 March 1701. The *Dance of Death* was moved several times; today the remains are in the Innerer Neustädter Friedhof in Dresden.

28. Löffler (1958), pls. 36 (*Altan*) and 37 (the staircase tower of 1549 with its reliefs and portrait medaillons); Hentschel (1966), pp. 42 and 115; Schade (1968), esp. pp. 36–38; and Hitchcock (1981), pp. 103–5, pls. 131–33. Damaged fragments of battle reliefs mentioned below are today in the Stadtmuseum in Dresden.

29. On Berlin (Joachimsbau, begun 1538) and Wismar (Fürstenhof, 1553–54), see Hitchcock (1981), pp. 83–85, 113–14, pls. 100–101, 146–48 respectively; also Werner Burmeister, *Seestadt Wismar* (Berlin, 1938—2nd ed.), pp. 26–27 and pls. 7, 36–39. Statius von Düren, a Netherlandish brickmaker and sculptor living in Lübeck, provided the extensive terracotta friezes and portal decorations for Wismar.

30. Findeisen and Magirius (1976), pp. 138–88, pls. 109–10, 119–52, 156–60 provides the most thorough examination of the architectural and sculptural programs. Also see Hitchcock (1981), pp. 72–75, pls. 78–80, 126.

31. Schade (1980), pp. 437–38. Cranach made paintings for the great hall, among other works.

32. Findeisen and Magirius (1976), pp. 172, 178–79. In July 1544 he was paid 102 florins for "Bildenwerk und Laubwerk." Compare Friedländer and Rosenberg (1978), figs. 230–40.

33. The shallow relief carving with portrait heads and foliate patterns predates Schloss Hartenfels. The use of busts in architecture entered German art first in prints and small sculptures of the 1510s, such as Hans Schwarz's *Entombment* relief of 1516 in Berlin (SMBPK, Skulpturengalerie). (fig. 245) Medallions figure prominently in the decoration of the portal of the Armory in Wiener Neustadt of 1524. Similar portraits also adorn both the inner portal of the Georgenbau (1535) and both staircases at the side of the Moritzbau (c. 1545–50) at Dresden. Further examples appear on the Kanzlei (1544–46) in Amberg, the Boeck von Boecken-stein house (1544–46) in Augsburg, the Fürstenhof (1553–54) in Wismar, and Freyenstein palace (1556), among others. See Hitchcock (1981), pls. 22, 87, 133, 146–49, 161, 166.

34. Kurt Rossmann, "Der Ottheinrichsbau," in Poensgen (1956), pp. 261–73; Dressler (1973), pp. 20–45, 166–72, figs. 4–83 (including Colin's interior doorways); Hitchcock (1981), pp. 132–38, pls. 139, 177–79.

35. For an excellent discussion of his library, see Elmar Mittler, ed., *Bibliotheca Palatina*, 2 vols., exh. cat. Heiliggeistkirche (Heidelberg, 1986), esp. 1: pp. 12–13, 202–20.

36. Dressler (1973), p. 32 argues that only Justitia and Spes are completely by Colin; I think Caritas is also autograph. She also attributes the bodies of Mercury, Diana, and Zeus; the heads of Caritas, Samson, and Hercules; most of the hands; and the children accompanying Caritas, Saturn, and (?) Venus. She cites artists such as Benvenuto Cellini and Conrad Meit (at Brou) who did only heads and hands. Interestingly, the portrait of Ottheinrich on the portal seems to be by an assistant. Note that the original facade statues were removed and replaced with copies in 1898. The originals are displayed on the ground floor.

37. A thorough analysis of the facade's iconography needs to be done. Dressler (1973) only describes the individual statues. G. F. Hartlaub, "Die Kunst und das magische Weltbild," in Poensgen (1956), pp. 274–95 offers numerous interesting insights into Ottheinrich's fascination with astronomy and astology, and how these may have influenced the facade program. His overall reading of the facade is, however, incomplete.

38. This relief was once in the collection at Schloss Ambras in Innsbruck and is today in Berlin (Skulpturengalerie). See Reindl (1977), nr. C1; Gagel (1977), pp. 126–27.

39. These busts are based upon illustrations in Johann Huttich's *Imperatorum & Caesarvm Vitae, cvm Imaginibus ad viuam effigiem expressis* (Lugdvni, 1550) that was in Ottheinrich's library. See Elmar Mittler, ed., *Bibliotheca Palatina*, 2 vols., exh. cat. Heiliggeistkirche (Heidelberg, 1986), 2: E 3.6.

40. Habich (1929–34), 1.2: nr. 1703. The robes differ slightly.

41. Kurt Rossmann, "Der Ottheinrichsbau," in Poensgen (1956), p. 272 cites the poem. In the

same volume Hartlaub challenges Rossmann's reading and suggests (p. 289) the left hand represents the contemplative side of man (melancholy and phlegmatic) and the right the active side (choleric and sanguinity). He argues that Ottheinrich offers a harmony of the four temperments. On Schro's bust, see our comments in Chapter Ten.

42. Hitchcock (1981), pl. 366.

43. Hitchcock (1981), pp. 120–21, 131–32, pls. 163 and 175; Holm Bevers, *Das Rathaus von Antwerpen (1561–1565): Architektur und Figurenprogramm* (Hildesheim, 1985), esp. 41–92 (on its sculpture); and Lutz Unbehaun, *Hieronymus Lotter* (Leipzig, 1989), pp. 78–105.

44. Hitchcock (1981), pp. 184–85, pl. 234.

45. Floris' personal role in incorporating sculpture is all the more evident when the city halls of Antwerp and Emden are compared. The latter was constructed between 1574 and 1576 by Antwerp architect Laurens van Steenwinckel. It is inspired by the building in Antwerp but now the sculptural decoration of the central gable is minimal. See Hitchcock (1981), pp. 196–97, fig. 39.

46. Deborah Howard, *Jacopo Sansovino: Architecture and Patronage in Renaissance Venice* (New Haven, 1987 ed.), pp. 28–35.

47. Klaus Goettert, *Das Kölnische Rathaus* (M. Gladbach, 1959), pp. 20–23, 30–31.

48. The statues adorned the exteriors of the windows of the great hall. See Jasbar and Treu (1981), pp. 40–55.

49. O. Stiehl, *Das deutsche Rathaus im Mittelalter* (Leipzig, 1905), figs. 14, 45, 75; Erich Stephany, *Aachen* (Munich, 1983), p. 14, pls. 6 (Dürer's drawing of 1520, now in Chantilly [Musée Condé], shows its original appearance) and 7.

50. For instance, the original programs of the city halls in Bruges, Brussels, Ghent, Louvain, and Middleburg; see Yvan Christ, *Pierres Flamandes* (Paris, 1953), pls. 30, 48, 68–69, 74, and 119.

51. Ernst Murbach, *Altstadt Basel* (Basel, 1979), pp. 20–21; Rowlands (1985), pp. 55–56 and L6 (1520–21 and c. 1530; only copies and drawings of Holbein's contribution survive); and Christian Müller, *Hans Holbein d. J.—Zeichnungen aus dem Kupferstichkabinett der Öffentlichen Kunstsammlung Basel* (Basel, 1988), pp. 117–23. Minor sculptures were included. For instance, Martin Hoffmann

made busts of prophets in 1521 for the counsel chamber. See Sophie Guillot de Suduiraut, ed., *Sculptures allemandes de la fin du Moyen Age*, exh. cat. Musée du Louvre (Paris, 1991), figs. 27a–b.

52. Mende (1979), pp. 38–88, 192–409 (interior program), 410–40 (exterior program); Smith (1983), pp. 9, 11–12, 55–56.

53. Johann the Younger created the facade design of 1564. These and other paintings were carried out by Melchior in 1573. As at Nuremberg, the cycles allude to historical models of justice and other virtues. Mader (1933), p. 86; Kristin E. S. Zapalac, *"In His Image and Likeness": Political Iconography and Religious Change in Regensburg, 1500–1600* (Ithaca, 1990), pp. 85–89, 131, 134, figs. 39, 62.

54. Hitchcock (1981), pls. 55, 70, 162, 230–31, 243–44. This use of elaborate architectural design for the facades was already well established by the fifteenth century, especially in northern Germany, as can be observed at Stargard, Tangermünde, Lübeck, Stralsund, Neustadt an der Orla, and Brandenburg, among others. See O. Stiehl, *Das deutsche Rathaus im Mittelalter* (Leipzig, 1905), figs. 19, 21, 50, 87–88, 91, 104, 106, 126–28.

55. Hitchcock (1981), pls. 376–78.

56. For what follows, see Meller (1925), pp. 156–63; Lieb (1952), pp. 135–36, 138–40; Stafski (1962), pp. 47–48; Christensen (1965), pp. 99–108; and William Wixom's comments in *Gothic and Renaissance Art in Nuremberg* (1986), pp. 402–5; and William Wixom, "Some Italian Sources for the Decoration of the Rathaus Screen in Nuremburg," *Festschrift für Gerhard Bott zum 60. Geburtstag* (Darmstadt, 1987), pp. 53–69. Mende (1979), pp. 38–88 offers a general history of the great hall (1332–40). His planned second volume, with a specific discussion of the grille, has never appeared.

57. Mende (1979), figs. 5, 45, 50, 64, 165.

58. Mende (1979), pp. 192–211, 314–19.

59. Juvenel's small picture is the only view predating the radical rebuilding of the west wall in 1619. Meller (1925), figs. 93–94; Mende (1979), cat. nrs. 110–12; and Smith (1983), pp. 301–2.

60. As William Wixom has noted, the battle scenes may have been a conscious revival of the ancient ritual practice of combat to honor the death

of a great man, in this instance the three Fugger brothers. *Gothic and Renaissance Art in Nuremberg* (1986), p. 404.

61. Meller ascribed all of the Annecy sections to Hermann; Stafski attributed these to Peter the Younger, Hermann's brother. In the comments below I concur with Wixom's more sensible accessment of the brothers' respective contributions. Meller (1925), pp. 160–63, figs. 70–83 (Römhild); Stafski (1962), pp. 47–48; and William Wixon in *Gothic and Renaissance Art in Nuremberg* (1986), pp. 402–5.

62. Meller (1925), p. 160, fig. 95; Demonts (1938), p. 71, nr. 334.

63. The sandstone laube or gallery was built in 1570–71 by masons Hans Fleminck (Flemming) and Herkules Midow. Hitchcock (1981), pp. 182, 189–90, pl. 238. The combination of caryatids and coats of arms reappears in the ornate staircase added in 1594; see Hitchcock, pl. 340.

64. Vogts (1930), pp. 190–94, 201–3; Roggen and Withof (1943), pp. 133, 135; Klaus Goettert, *Das Kölnische Rathaus* (M. Gladbach, 1959), pp. 13–15; Hitchcock (1981), pp. 187–89, pls. 235–37; and Michael Kiene, "Zur Planungsgeschichte der Kölner Rathausvorhalle," *Wallraf-Richartz-Jahrbuch* 52 (1991): pp. 127–50. See Kiene's discussion of the several other design drawings, including those by Henrick van Hasselt (c. 1560), Lambert Sudermann (1562), and two made c. 1571.

65. Hans Vogts, "Vernukken, Wilhelm" in Thieme and Becker (1907–50), 34: pp. 288–89.

66. Much of the relief carving of the porch was "renewed" in the nineteenth century, and other portions were restored following the bombings of World War II. The third story with its large statues dates to the seventeenth century.

67. Bellmann, Harksen, and Werner (1979), pp. 107–14. The authors do an excellent job in describing the individual features of the porch. No attempt, however, is made to understand the program and its intended purpose.

68. Hentschel (1935), pp. 171–72; Bellmann, Harksen, and Werner (1979), pp. 108–9. On Schröter, who also worked in Torgau and at the palace chapel at Schwerin, see Hentschel, pp. 168–78. His finest and best preserved sculpture is the

epitaph of Matthias von der Schulenburg completed in 1571 for the Stadtkirche in Wittenberg. It was probably upon the merits of this project that he received the porch commission.

69. Transcriptions of the texts are given in Bellmann, Harksen, and Werner (1979), pp. 112–13.

70. Leonhard Weidmann devised the plan for the addition to the Rothenburg Rathaus in 1568 though he only oversaw the construction from 1575 until its completion in 1578. Weidmann seems also to have carved some of the new sculptural decoration, such as the portal with its eagle and armorials, the large knight on the south gable, and other works for the court portal and interior. In Bamberg Bishop Veit II von Würtzburg (1561–77) rebuilt portions of the Alte Hofhaltung between 1568 and 1572. Although not strictly a public structure, it did serve a similar purpose since it was the administrative center for the diocese of Bamberg. Pankraz Wagner's sculpted portal celebrates the origins and continuity of episcopal rule. Heinrich Mayer, *Bamberger Residenzen* (Munich, 1951), esp. pp. 34–35, 142–43; "Weidmann, Leonhard," in Thieme and Becker (1907–50), 35: p. 273; Hitchcock (1981), pl. 243 (Rothenburg), 251–52 (Bamberg).

71. After 1567 von Soest replaced Suttmeier. Wilhelm Behncke, *Albert von Soest* (Strasbourg, 1901), pp. 5–43; Krüger and Reinecke (1906), pp. 263–73.

72. Hitchcock (1981), pp. 294–95, pl. 377.

73. Hitchcock (1981), pl. 399; Thomas Paul Bruhn, "Hans Reichle (1565/70–1642): A Reassessment of His Sculpture," Ph.D. diss., University of Pennsylvania 1981, pp. 55–65.

74. Joachim Toppmann carved the central portal in 1616 but was succeeded by Leonhard Kern who made the statues of the north and south portals in 1617–18. The originals were replaced by copies and removed to the Germanisches Nationalmuseum in 1889–91. Today the heavily damaged statues are in the city Bauhof. Ernst Mummenhoff, *Das Rathaus in Nürnberg* (Nuremberg, 1891), pp. 134–35; Hitchcock (1981), pl. 421; Siebenmorgen (1988), pp. 17, 90–91. I shall discuss this project in a separate article on Nuremberg and its civic imaging.

75. Hitchcock (1981), pl. 420; Sergiusz Mi-

chalski, "Das Ausstattungsprogramm des Augs-
burger Rathauses," in Wolfram Baer et al., eds.,
Elias Holl und das Augsburger Rathaus (Regensburg,
1985), pp. 77-90, and see pls. XI-XIII and cat.
nrs. 2, 64.

76. Maria Bogucka, *Das alte Danzig* (Munich,
1980), pp. 59-60, 93-102, 226, 229, pls. VIII,
59-64, 68-69, 87-88, 90.

Chapter Nine

1. There exists no thorough study of German
Kleinplastik. Sauerlandt (1927) and Bange (1928)
offered the first introduction to the topic, though
their texts were very brief. Bange (1949) addressed
small bronzes, which were excluded from his first
book. Most of the best literature on the subject is
contained in the individual museum catalogues,
especially those for the collections in Berlin, Ham-
burg, Munich, and Vienna; see Vöge (1910)
and Metz (1966); Rasmussen (1975); Weihrauch
(1956) and Müller (1959); and von Schlosser
(1910). The only serious analytical assessment is
the marvelous exhibition catalogue, *Der Mensch um
1500*, by the staff of the Skulpturengalerie in Ber-
lin; see Gagel (1977). Theuerkauff (1975) is also
quite useful.

2. Halm (1927), pp. 190-91, 220-21, 223-
24; Bange (1928), pls. 5-6; *Katalog der Sammlung
für Plastik und Kunstgewerbe* (1966), nr. 251; Han-
nelore Müller, *Städtische Kunstsammlungen Augsburg:
Das Maximilianmuseum* (Munich, 1982), nr. 11.

3. Bruno Bushart, *Hans Holbein der Ältere* (Augs-
burg, 1987), pp. 130-34.

4. Compare Thomas Hering's later use of the
same print model. See fig. 226. On the print and
the theme, see Koepplin and Falk (1976), 2: pp.
613-22, nr. 528; Gagel (1977), pp. 122-27.

5. For an interesting discussion of the shift in
spatial and conceptual aesthetics in early sixteenth-
century German art, see Talbot (1990) and his fig.
165 for the Blaubeuren altar.

6. Perhaps the same patron also owned Dau-
cher's first attempt at this theme. Two years earlier
he carved a slightly less elaborate *Madonna and
Child with Angels*, now in Vienna (Kunsthisto-
risches Museum), that lacks a few of the angels
and the Old Testament scenes in the vault, among

other details. See von Schlosser (1910), p. 19, pl.
XLVIII.

7. Smith (1983), pp. 39-40; and Béatrice Her-
nad, *Die Graphiksammlung des Humanisten Hart-
mann Schedel*, exh. cat. Bayerische Staatsbibliothek
(Munich, 1990), esp. pp. 13-37, 103-6.

8. Franz Xaver Pröll, *Willibald Pirckheimer
1470-1970: Eine Dokumentation in der Stadtbiblio-
thek Nürnberg* (Nuremberg, 1970), esp. nrs. 9, 60,
73-81.

9. These words are in a letter that Celtis sent to
Sixtus Tucher of Nuremberg on 18 April 1487.
Lewis Spitz, "The Course of German Humanism,"
in Heiko Oberman and Thomas Brady, Jr., eds.,
Itinerarium Italicum (Leiden, 1975), pp. 371-436,
here 372.

10. Falk (1968), pp. 81-86; and *Hans Burgk-
mair* (1973), nr. 77.

11. Neudörfer (1875), p. 33.

12. On Vischer's relationship with Schwenter,
which also included drawings for his *Histori Hercules*
of about 1515 in Berlin (SMBPK, Kupferstich-
kabinett) and Nuremberg (Stadtbibliothek), see
Dieter Wuttke, "Die Handschriften-Zeugnisse
über das Wirken der Vischer nebst kristischen
Bemerkungen zu ihrer Auswertung," *Zeitschrift für
Kunstgeschichte* 22 (1959): pp. 324-36; Wuttke
(1964), esp. 105-12, 292-323; Fedja Anzelewsky
and Franz Josef Worstbrock, *Apologia poetarum*, 2
vols. (Wiesbaden, 1987); and *Glanz alter Buch-
kunst: Mittelalterliche Handschriften der Staatsbiblio-
thek Preussischer Kulturbesitz Berlin*, exh. cat. Berlin
(Wiesbaden, 1988), nr. 125.

13. Meller (1925), pp. 189-90; Stafski (1962),
p. 38; John Pope-Hennessy, *Renaissance Bronzes from
the Samuel H. Kress Collection* (London, 1965), nr.
435; and William Wixom in *Gothic and Renaissance
Art in Nuremberg* (1986), nr. 193.

14. Stafski (1962), p. 75; Zink (1968), nr. 103;
and Rainer Schoch in *Gothic and Renaissance Art in
Nuremberg* (1986), nr. 102.

15. The Hamburg relief measures 16.3 by 11.3
cm. The copies in Berlin (SMBPK, Skulpturen-
galerie) and Sankt Paul im Laventtal (Benedik-
tinerstift) have casting flaws. The Berlin example is
virtually identical in size and appearance to the
Hamburg version, while the Austrian plaquette
lacks the text and artist's mark. It may have been an
aftercast. See Stafski (1962), p. 38; Rasmussen

(1975), nr. 3; Christian Theuerkauff in Gagel (1977), nr. 27; and William Wixom in *Gothic and Renaissance Art in Nuremberg* (1986), nr. 194.

16. Wuttke (1966). In translation the text reads: "It is told in Greece that Orpheus, who (with his playing and songs) has moved the forests, rivers, and rocks, came to the river Lethe; he would have called back to life Eurydice if he would have kept his contract (not to look back) with the Stygian Jupiter." The translation is from *Gothic and Renaissance Art in Nuremberg* (1986), p. 396.

17. Dublin, National Gallery of Ireland. Hans Georg Gmelin, "Georg Pencz als Maler," *MJBK*, 3rd ser. 17 (1966): nr. 37; Anthony Radcliffe, "A Portrait of Georg Vischer," *Apollo* 2 (1974): pp. 126–29; and *Gothic and Renaissance Art in Nuremberg* (1986), nr. 203.

18. Weihrauch (1967), pp. 38–62, 75–135 provides a useful overview of Italian small bronzes.

19. Montague (1963), fig. 8; and detail in Weihrauch (1967), fig. 546.

20. Friedländer and Rosenberg (1978), nrs. 185–86.

21. These measure 16.7 by 11.4 cm and 19.3 by 11.5 cms respectively. Meller (1925), pp. 189, 191, 193; Stafski (1962), pp. 53–54; William Wixom in *Gothic and Renaissance Art in Nuremberg* (1986), nrs. 195–96. There are other possibly earlier bronzes and brasses; however, many of these are undated or problematic in other ways. For instance, many scholars attributed the *Hercules and Antaeus* in Munich (Bayerisches Nationalmuseum) to Peter the Elder and date it between 1500 and 1510; others claim it is Italian and a century later. While not dismissing the former suggestion, since it is somewhat crude in execution, there is no compelling stylistic reason for ascribing it to Vischer. See Weihrauch (1956), pp. 16–18; Stafski (1962), p. 65; Beck and Blume (1985), nr. 308.

22. Schwemmer (1949), p. 128.

23. On the use of religious prints, see Chapters One and Two. Schedel owned over 230 prints that he kept in a special album that he personally annotated and decorated. See Béatrice Hernad, *Die Graphiksammlung des Humanisten Hartmann Schedel*, exh. cat. Bayerische Staatsbibliothek (Munich, 1990), esp. pp. 39, 43–65, 107–14.

24. See Dürer's diary; and Robert Grigg, "Studies on Dürer's Diary of his Journey to the Netherlands," *Zeitschrift für Kunstgeschichte* 49 (1986): pp. 398–409.

25. *Hans Burgkmair* (1973), nr. 22.

26. William Martin Conway, tr. and ed., *The Writings of Albrecht Dürer* (New York, 1958 ed.), p. 70.

27. Falk (1968), pp. 56, 74, 111 (note 545), 116–17.

28. The relief has a diameter of 10.5 cm and a thickness of about 1 cm. See Metz (1966), nr. 679; Gagel (1977), pp. 142–47.

29. Marrow and Shestack (1981), figs. 5–6, 35–36.

30. See the Biographical Catalogue for examples.

31. Bange (1928), p. 26; Metz (1966), nr. 676; Gagel (1977), pp. 113–14.

32. *Hans Burgkmair* (1973), nrs. 59–65 (*Seven Vices*, *Seven Virtues*, and *Seven Planets* series), 75 (*St. Sebastian*, dated 1512).

33. Kaiser (1978), pp. 568–69 claimed that it was a modello though no proof was offered. Contemporary sculptors made presentation drawings, like Veit Stoss' sketch in Cracow for the *Mary Altar* now in Bamberg cathedral (fig. 19), not small carved modelli for altarpieces. And second, Schwarz, who was primarily a portraitist, cannot be linked conclusively with the production of a single altar.

34. Hans Buchheit, "Beiträge zu Hans Schwarz und Peter Dell dem Älteren," *MJBK* N.F. 1 (1924): pp. 164–65; and Legner (1965), nr. 673.

35. See the respective lists of works in our Biographical Catalogue.

36. *Spätgotik am Oberrhein: Meisterwerke der Plastik und des Kunsthandwerks 1430–1530,* exh. cat. Badisches Landesmuseum (Karlsruhe, 1970), nr. 142; Baxandall (1980), p. 282; Gert von der Osten, "Zur Kleinplastik von Hans Wydyz dem Älteren und seiner Werkstatt," *AGNM* (1981): pp. 44–55; and Landolt and Ackermann (1991), nr. 39. Eve now holds an apple in her right hand that does not appear in our photograph.

37. Kenseth (1991), nr. 44.

38. Hollstein (1954–), 19: pp. 178–79, nrs. 1 and 2; Gagel (1977), pp. 155–61; Smith (1983), p. 216; and *Gothic and Renaissance Art in Nuremberg* (1966), nr. 204.

39. Wixom (1975), nr. 165; Smith (1983), p. 217; and *Gothic and Renaissance Art in Nuremberg*

(1986), nr. 205. Measuring 12.2 by 10.8 cm, the Cleveland relief is dated 1515 on the front and 1518 on the reverse. The first impression, now in Brno (Moravská Galérie), has only the 1515 date.

40. Müller (1959), nr. 193.

41. Innis H. Shoemaker and Elizabeth Broun, *The Engravings of Marcantonio Raimondi*, exh. cat. Spencer Museum of Art, University of Kansas (Lawrence, 1981), nr. 22.

42. Legner (1965), nr. 682 and compare nrs. 678–81, 683–85; *Deutsche Kunst der Dürer-Zeit*, exh. cat. Staatliche Kunstsammlungen (Dresden, 1971), nr. 20; pp. 159–60. The Gotha version is also by far the largest.

43. Michael J. Liebmann, "Die Jünglingsstatue vom Helenenberge und die Kunst der Donauschule (Antike Motive in der Kunst der deutschen Renaissance)," *Actes du XXIIe congrès international d'histoire de l'art* (Budapest, 1972), I: pp. 739–43.

44. Theodor Müller, "Ein unvollendetes Werk des Meisters I.P.," in *Form und Inhalt. Kunstgeschichtliche Studien—Otto Schmitt zum 60. Geburtstag am 13. Dezember 1950* (Stuttgart, 1951), pp. 225–32.

45. Walter L. Strauss, *The Intaglio Prints of Albrecht Dürer* (New York, 1976), pp. 128–32.

46. Bange (1928), pl. 43.

47. The artist carved his initials, PF, and his mark, a knife, on the base between Adam's legs. The four fingers on the left hand are later restorations. Von Schlosser (1910), p. 9, pl. XIX; Bange (1928), p. 77; Bange (1949), p. 39; *Katalog der Sammlung für Plastik und Kunstgewerbe* (1966), nr. 285; William Wixom in *Gothic and Renaissance Art in Nuremberg* (1986), nr. 246.

48. Vöge (1932), esp. pp. 157–62; *Katalog der Sammlung für Plastik und Kunstgewerbe* (1966), nr. 317; Müller (1963), pp. 13, 68; *Welt im Umbruch*, II: nrs. 583–84; and Schädler (1987), esp. pp. 174–81. The attribution to Weiditz, first made by Vöge, has been challenged on stylistic grounds by Schädler. Weiditz was primarily a medallist. His only signed example of *Kleinplastik* is the dagger and case in Dresden (Historisches Museum) made around 1540. Vöge and Schädler both use this work with its female head and Fortuna to reach their opposing conclusions. I am more inclined to ascribe the Vienna statues to an Augsburg master

who was familiar with Weiditz' art. Schädler's argument, while raising several valid questions, is weakened by a series of bizarre attributions of works in different media to Weiditz.

49. For instance, Baldung's painted *Adam and Eve* (c. 1525) in Budapest (Szépmüvészeti Múzeum) and, for Eve's pose but not her head, woodcut (B. 2) of 1519. See Marrow and Shestack (1981), fig. 50, nr. 75.

50. Other examples were made by Conrat Meit and Tilmann Riemenschneider, both in Vienna (Kunsthistorisches Museum), Loy Hering in London (Victoria and Albert Museum), Leonhard Magt formerly in Vienna (private collection); Master H.L. in Freiburg i. B. (Augustinermuseum), and a Franconian artist in Munich (Bayerisches Nationalmuseum). See Julius von Schlosser, "Aus der Bildnerwerkstatt der Renaissance," *JKSAK* 31 (1913–14): esp. pp. 67–73, fig. 4; Bange (1949), nr. 121; Müller (1963), p. 5; *Katalog der Sammlung für Plastik und Kunstgewerbe* (1966), nr. 295; Reindl (1977), nr. A69; and Schindler (1981), pp. 86–88.

51. Recall the lament of the sculptor-halberdier quoted in the Introduction (note 11) that if he could carve fine, life-like nudes he would not have been forced to take up arms for a living. For a brief introduction to both the use of nudes and their sensual allure, see Meinrad Maria Grewenig, *Der Akt in der deutschen Renaissance: Die Einheit von Nacktheit und Leib in der bildenden Kunst* (Freren, 1987); and Janey L. Levy, "The Erotic Engravings of Sebald and Barthel Beham: A German Interpretation of a Renaissance Subject," in Goddard (1988), pp. 40–53.

52. Gagel (1977), pp. 138–42, figs. 105–7.

53. See Chapter Seven.

54. Both have the initials of the duke and the artist. The *Massacre of the Innocents* in Berlin (SMBPK, Skulpturengalerie) is made of terracotta that is painted blue and white with bits of gold color. See Vöge (1910), nr. 355; Bange (1928), pp. 94–95; and Innis H. Shoemaker and Elizabeth Broun, *The Engravings of Marcantonio Raimondi*, exh. cat. Spencer Museum of Art, University of Kansas (Lawrence, 1981), nrs. 26 and 43.

55. Max Bernhart, "Ein Beitrag zu Sebastian Loscher," *MJBK* NF 10 (1933), pp. xlii–xlvi; Gagel (1977), nr. 31; and Smith (1989), esp. pp. 45–46.

56. Goddard (1988), esp. pp. 13–18 and the entries.

57. Bange (1949), nr. 70; Weihrauch (1967), p. 286; Anthony Radcliffe, "A Portrait of Georg Vischer," *Apollo* 2 (1974): pp. 126–29; Gagel (1977), 148–51; and William Wixom in *Gothic and Renaissance Art in Nuremberg* (1986), nr. 200.

58. Bange (1949), nr. 73.

59. Since all attributes are lacking, the figure's identification as Venus is conjectural. Bange (1949), p. 88, nr. 143; Gagel (1977), nr. 22; *Welt im Umbruch* (1980–81), nr. 581; Schädler (1987), pp. 172–73.

60. Commissioned upon Cellini's return from France in 1545. Pope-Hennessy (1985), p. 371, figs. 47–48.

61. Peltzer (1916–18), pp. 210–11; Lars Olof Larsson, "Från Florens till Prag," in *Bruegels Tid— Nederländsk Konst 1540–1620*, exh. cat. National-almuseum (Stockholm, 1984), 25–7; *Prag um 1600* (1988), 1: nr. 75. Leithe-Jasper (1986), nr. 49 is, I think, incorrect when he speculated that the Vienna version of this statue was intended only for frontal viewing.

62. Leithe-Jasper (1986), nr. 51; *Prag um 1600* (1988), 1: nr. 48. This version, perhaps the latest, dates to about 1587. Giambologna began experimenting with this composition before 1565.

63. Pope-Hennessy (1985), p. 410, pl. 118; Leithe-Jasper (1986), nr. 42.

64. Weihrauch (1967), p. 143, fig. 163; Willy Halsema-Kubes, "Johan Gregor van der Schardt, Sol (de Zon), c. 1580," *Bulletin van het Rijksmuseum* 37 (1989), pp. 182–84; Honnens de Lichtenberg (1991), pp. 104–9.

65. Lars Olof Larsson, "Die niederländischen und deutschen Schüler Giambolognas," in *Giambologna 1529–1608: Ein Wendepunkt der europäischen Plastik*, exh. cat. Kunsthistorisches Museum (Vienna, 1978), pp. 57–62.

66. All four Mercury statues and Minerva (see below) are illustrated together in Hermann Maué, "*Die Grafen von Schönborn—Kirchenfürsten, Sammler, Mäzene*: Ergänzungen und Korrekturen," *AGNM* (1989): esp. pp. 184–87 (comments by Katharina Bott), figs. 8–12. Also see Peltzer (1916–18), pp. 210–11; Filedt Kok et al. (1986), pp. 461–63; Leithe-Jasper (1986), nr. 49; *Prag um 1600* (1988), 2: nr. 518; *Die Grafen von Schönborn*, exh. cat. Ger-

manisches Nationalmuseum (Nuremberg, 1989), nr. 116; Honnens de Lichtenberg (1991), pp. 75–96.

67. None of the statues is dated. Corroborating evidence to support a specific chronology does not exist since the fragmentary data can be interpreted to fit various conflicting theories. The suggestions offered here are based solely upon my sense of the statuettes' relation to the *Four Seasons*, which were begun in 1570. Honnens de Lichtenberg (1991), pp. 80–88 offers an excellent discussion of the four statues. She argues, incorrectly I think, that all four date 1569–70. In her scenario, the Stockholm *Mercury* was brought from Venice to Vienna as a presentation gift from the artist to Maximilian II. The others were then made soon afterwards but all or most remained in the artist's possession until he took them to Denmark in 1576 or 1577. This allows for no real stylistic development. Furthermore, van der Schardt's itinerant schedule, which included his move to Vienna in June 1569 and subsequent transfer to Nuremberg a year later, allowed him little time to produce four or more Mercurys, a Minerva, and the bust of Willibald Imhoff (dated 1570; fig. 314) plus additional sculpture commissioned by his patron, Maximilian II. His first six months in Nuremberg were certainly spent working with Wenzel Jamnitzer on the emperor's fountain.

68. Honnens de Lichtenberg (1991), pp. 93–96.

69. Honnens de Lichtenberg (1991), pp. 23–24.

70. Honnens de Lichtenberg (1991), p. 77.

71. 50 cm. high. Bange (1948), nr. 71; and Weihrauch (1967), p. 281.

72. Weber (1975), p. 11.

73. Francesco Rossi as cited in Douglas Lewis, "Introduction: The Past and Future of the Italian Plaquette," in Alison Luchs, ed., *Italian Plaquettes* [*Studies in the History of Art*, v. 22] (Washington, 1989), p. 11. The best introduction to German plaquettes in Weber (1975), pp. 9–16. Weber's superb study is the basic corpus on Northern European plaquettes.

74. Smith (1983), nrs. 125–27.

75. Weber (1975), nr. 42.

76. Weber (1975), nr. 124.

77. Weber (1975), nrs. 27 (Krug), 126–27 (Daucher).

78. This relief, which is based on an engraving (B. 66) by Aldegrever, has traditionally been attributed to Loy Hering. Although certain features, such as the hair strands that end with a deep spiral, recall Loy, I find the developed treatment of the bodies and the detailing of the landscape to be more in keeping with the sculptures of his son, Thomas (Doman). This change in authorship was first suggested by Peter Cannon-Brooks, "Loy Hering and the Monogrammist DH," *Apollo* 94 (1971): pp. 46–49. Also see Reindl (1977), nr. A63.

79. Weber (1975), nr. 758.

80. The 18 plaquettes ornamenting this chest date as early as 1546 while the chest may date around 1560. Weber (1975), nr. 378, pl. 104.

81. Lange (1897), pp. 141–51 offers a long list of the subsequent uses of Flötner's plaquettes. Also see Pechstein (1968), nr. 8; Weber (1975), passim; and Smith (1983), nr. 198.

82. Leithe-Jasper (1986), nrs. 25–26. These date to about 1538–39.

83. Douglas Lewis, "Introduction: The Past and Future of the Italian Plaquette," in Alison Luchs, ed., *Italian Plaquettes* [*Studies in the History of Art*, v. 22] (Washington, 1989), esp. pp. 12–13.

84. Weber (1975), p. 16, nrs. 1–19. She hesitates over whether these reliefs should even be considered plaquettes.

85. Kurt Köster, "Mittelalterliche Pilgerzeichen," in Lenz Kriss-Rettenbeck and Gerda Möhler, eds., *Wallfahrt kennt keine Grenzen* (Munich, 1984), pp. 203–24.

86. The literature on his plaquettes is vast though entries on individual works are usually quite brief. The best assessment of his work is Lange (1897), esp. pp. 118–40; and Weber (1975), pp. 56–85, nrs. 32–63.

87. *Caritas* is Weber (1975), nr. M63.3. Most of the "little leads of Flötner" ("blÿin des Fletners") mentioned in the 1585–87 inventory of Basilius Amerbach in Basel are still there today in the Historisches Museum. See Landolt and Ackermann (1991), pp. 96–100. Typical of the many references is the commentary of Philipp Hainhofer who sought to sell three objects to the Elector of Bavaria during his visit to Munich between 21 and 27 April 1611. One was "ein kunstst in stein geschnitten vom Alten Fletner, dessen künsten sonsten in bley abgossen, aber man nit waisst das disess nach gos-

sen oder abgeformet worden." This included a "beautiful" landscape of "great understanding." Oscar Doering, *Des Augsburger Patriciers Philipp Hainhofer: Beziehungen zum Herzog Philipp II. von Pommern-Stettin* (Vienna, 1894), pp. 129–30.

88. Neudörfer (1875), pp. 115.

89. These belong to a series of eight seated virtues, each measuring about 7.1–7.3 cm. In addition to the five London models (Prudence, Justice, Charity, Temperance, and Fortitude), two others (Faith and Hope) are in Hannover (Kestner Museum). The Patience model is lost. Weber (1975), nr. 62 lists the numerous impressions of each virtue. For instance, 19 copies of Prudence are known though a few are later casts. Replicas of Faith, Hope, and Fortitude were incorporated into the *Salt Cellar of Queen Elizabeth I* made in 1572–73 and now in the Tower of London. Also see Lange (1897), nrs. 73–80; Bange (1928), pp. 80–81, pls. 83–84.

90. Lange (1897), nr. 38; Middeldorf and Goetz (1944), nr. 361; Rasmussen (1975), nr. 10; Weber (1975), nr. 42; Smith (1983), nr. 128; and Wixom in *Gothic and Renaissance Art in Nuremberg* (1986), nr. 254.

91. Lange (1897), nr. 111; Weber (1975), nr. 53; and Smith (1983), nr. 134. Wenzel Jamnitzer copied this plaquette on his Mortar of the 1550s in Berlin (SMBPK, Kunstgewerbemuseum). See Pechstein (1968), nr. 8.

92. Kohlhaussen (1968), nr. 423; Pechstein (1971), nr. 151; Weber (1975), nr. 102 (with a citation of Wilhelm von Bode). 14.2 × 10.8 cm. The tentative attribution of the model to Ludwig Krug seems quite unlikely.

93. Pechstein (1973), 86–87; Pechstein (1974), pp. 45–47; Weber (1975), nr. 93. Justice measures 19.9 by 13 cm.

94. De Murr (1797), p. 244; Pechstein (1974), p. 43.

95. Pechstein (1974), pp. 46–47; Weber (1975), nrs. 91–92; Smith (1989), pp. 50, 52–53 where I trace the history of the *Forge of the Heart* from a drawing by Dürer to a print to a medal to Peisser's model.

96. See Weber (1975), nrs. 160–229, 240–70.

97. See Ingrid Weber "Fragen zum Oeuvre des Meister H. G.," *MJBK* 22 (1971): pp. 133–45; Weber (1975), pp. 159–66; Hayward (1976), p.

216; and Klaus Pechstein, "Beiträge zur Jamnitzer-forschung," *AGNM* (1984): esp. pp. 73–75 over the debate linking Master H. G. with Hans Jamnitzer.

98. Weber (1975), nr. 271. Such large editions can be found for several of his plaquettes. Twenty-seven copies of the *Judgment of Solomon* are cited by Weber (nr. 282).

99. Weber (1975), nr. 275; *Wenzel Jamnitzer* (1985), nr. 561.

100. Several satirical and religious medals are attributed to Flötner. These include satires against the pope and monks. Habich (1929–34), 1.2: nrs. 1822, 1826–1830, 1833–1834. On Reinhart's *Pope-Devil, Cardinal-Fool*, see *Reformation in Nürnberg* (1979), nr. 158.

101. Neudörfer (1875), p. 160; Habich (1929–34), 1.2: nr. 1831; Kohlhaussen (1968), nr. 457; *Wenzel Jamnitzer* (1985), nr. 626; *Gothic and Renaissance Art in Nuremberg* (1986), nr. 258.

102. The translation is cited by Hermann Maué in *Gothic and Renaissance Art in Nuremberg* (1986), nr. 258.

103. For later Nuremberg examples, see *Wenzel Jamnitzer* (1985), nrs. 696, 709, 721–24.

104. Bange (1948), pp. 51–53, nr. 120; Montague (1963), pp. 67–69; Weihrauch (1967), pp. 301–2. The translated text is given by Montague.

105. Neudörfer (1875), p. 115.

106. Braun (1951), p. 198; Angerer (1984), nr. 24; and Martin Angerer in *Gothic and Renaissance Art in Nuremberg* (1986), nr. 253.

107. Klaus Pechstein, "Der Merkelsche Tafel-aufsatz von Wenzel Jamnitzer," *MVGN* 61 (1974): pp. 90–121; Hayward (1976), p. 377, pls. 416–20; Smith (1983), pp. 80–81; *Wenzel Jamnitzer* (1985), nr. 15.

108. The presentation drawing, with its variant Mother Earth, is by Jamnitzer and is now in Nuremberg (Germanisches Nationalmuseum). *Wenzel Jamnitzer* (1985), nr. 299, color pl. 9.

109. Pechstein (1971), nr. 155; *Wenzel Jamnitzer* (1985), nr. 502; Schädler (1987), pp. 180–81. Schädler has revived the attribution of this figure to Christoph Weiditz that Hans Weihrauch initially suggested in 1965. There is no evidence for Weiditz' association with Jamnitzer. Other than the outwards-thrusted hip motif, I find little similarities between the model and Weiditz's oeuvre,

such as the attributed *Venus* in Berlin (SMBPK, Skulpturengalerie). (fig. 256) The dress and particularly the hair style are characteristic of mid-century Nuremberg and Augsburg art rather than the defining traits of a single master.

110. The drawing measures 112.5 by 50 cm and is done in pen and black ink with blue wash. Portions of both the front and back sides are represented. The marble writing surface also serves as the cover for the instrument's keyboard. Both the drawing and the *Positiv* are signed and dated. Hentschel notes that because of Christoph II's ill health, he must have been assisted by his son, Andreas III. Hentschel (1966), pp. 56–59, 132–33, fig. 4, pls. 52–60, 62; Werner Schade, *Dresdener Zeichnungen 1550–1650* (Dresden, 1969), p. 103, nr. 122.

111. For the basic history and references to additional literature, see Julius von Schlosser, *Die Kunst- und Wunderkammern der Spätrenaissance. Ein Beitrag zur Geschichte des Sammelwesens* (Leipzig, 1908—reprinted Braunschweig, 1978); Händler (1933); Gagel (1977), pp. 37–46; Beck and Blume (1985), pp. 282–304; Impey and MacGregor (1985); and Kenseth (1991), esp. pp. 25–59, 81–101.

112. Lill (1908), pp. 47–75.

113. On his antique and coin collections, see Lill (1908), pp. 162–74. On p. 170 Lill mentions that Innsbruck sculptor Alexander Colin sold Fugger two ancient busts of *Hercules* and *Faustina* in 1574.

114. Heike Frosien-Leinz, "Das Studiolo und seine Ausstattung," in Beck and Blume (1985), pp. 258–81.

115. Von Busch (1973), pp. 11–16.

116. Goddard (1988), pp. 18–23. Melchior Ayrer (1520–70), a Nuremberg physician, purchased mainly prints and drawings. Although the precise size of his collection is unknown, his son Julius possessed about 20,000 sheets.

117. Springer (1860); Hampe (1904—II), pp. 67–82, 108–20; Peltzer (1916–18), esp. pp. 198–99; von Busch (1973), pp. 99–102; Gagel (1977), pp. 47–57; Smith (1985), pp. 92–94; and Honnens de Lichtenberg (1991), pp. 70–72, 138–42 for what follows.

118. Honnens de Lichtenberg (1991), p. 56.

119. Hampe (1904—II), p. 74.

120. Fritz Koreny, *Albrecht Dürer and the Animal and Plant Studies of the Renaissance* (Boston, 1988) p. 261. Also see p. 263 for a similar reference to Imhoff's wishes.

121. Seelig (1985), p. 76; but also see Distelberger (1985), pp. 39–40 who explains that the Habsburg's did not institutionalize the practice until 1621 and 1635.

122. Ganz and Major (1907); Falk (1979), pp. 116–62; Ackermann (1985), pp. 62–64; esp. Landolt and Ackermann (1991); Landolt et al. (1991) with a discussion of provenance and transcriptions of the inventories and other important documents; and Paul Tanner, *Das Amerbach-Kabinett: Die Basler Goldschmiederisse* (Basel, 1991).

123. Landolt and Ackermann (1991), nr. 14.

124. It measures 45.7 (h) by 73.3 (w) by 55.8 (b) cm. Landolt and Ackermann (1991), nr. 66.

125. Landolt and Ackermann (1991), nrs. 39–41, 44, 47.

126. During the seventeenth century Nuremberg's city council also acquired various sculptures and models that are today in the Germanisches Nationalmuseum and the Stadtmuseum Fembohaus. The city's painting collection dates back to Dürer's lifetime. Schwemmer (1949), p. 109; Smith (1990–91), pp. 161–63.

127. De Murr (1797), esp. pp. 230–45 with a listing of the sculpture; Hampe (1904—II), pp. 82–87; Schwemmer (1949), pp. 124–25; Weber (1983), esp. pp. 155–80; Smith (1985), pp. 94–95; Smith (1990–91), pp. 164–67; Honnens de Lichtenberg (1991), esp. pp. 54–66.

128. On the busts and their provenance, see Honnens de Lichtenberg (1991), pp. 145–50.

129. See the Bohemian example once owned by Ferdinand II, archduke of Tirol, at Schloss Ambras. Scheicher et al. (1977), nr. 43, color pl. II. Another especially splendid example made by Nuremberg goldsmith Elias Lencker is in Dresden (Grünes Gewölbe); see Joachim Menzhausen, *The Green Vault: An Introduction*, tr. Hartmut Angermüller (Dresden, 1983), fig. on p. 29.

130. Honnens de Lichtenberg (1991), pp. 179–83. I was unaware of this work until recently. Since I know it only from photographs, I am still uncertain about the attribution.

131. Honnens de Lichtenberg (1991), pp. 58, 136–38 who suggests this is identical with the painted terracotta bust *Portrait of a Man* in an American private collection. The facial features of the man, who is shown bare shouldered, only loosely conform with Nicolas Neufchatel's *Portrait of Johann Gregor van der Schardt* of 1573, now in Trieste (Museo Storico del Castello di Miramare), which also was owned by Praun, or the artist's undated *Self-Portrait* medal. See Honnens de Lichtenberg, figs. 1 and 115.

132. Honnens de Lichtenberg (1991), pp. 58–68. The items mentioned below are in Berlin (SMBPK, Skulpturengalerie), Houston (Museum of Fine Arts), London (Victoria and Albert Museum), and Vancouver (LeBrooy Collection), among others. The best-known examples are linked with Michelangelo's sculptures for the Medici Chapel in Florence.

133. See our Biographical Catalogue for a discussion of van der Schardt's possible career after 1580–81.

134. Their heights, without the later bases, range from 21.5 to 23 cm. In fig. 273, the order is Lust, Pride, Gluttony, Avarice, Anger, and Envy. Sloth is lost. Unlike Flötner's plaquettes and Pencz' engravings (B. 98–104) of the same subject, all done around 1540, Dell has chosen contemporary not classical dress for his figures. This makes the immediacy of their message more poignant. Josephi (1910), pp. 298–300; Bange (1928), pls. 93–94; Lill (1951), p. 158. On Flötner's figures, see Weber (1975), nr. 56.

135. C. Theodor Müller, "Ein Problem deutscher Kleinplastik des 16. Jahrhunderts," *ZDVK* 10 (1943): pp. 255–64, esp. 259–61; Scheicher et al. (1977), nr. 309; Hans Thoma, *Hans Leinberger* (Regensburg, 1979), nr. 33; Scheicher (1985), p. 37.

136. Arpad Weixlgärtner, "Von der Gliederpuppe," *Göteborgs Konstmuseum. Årstryck* (1954): pp. 37–71; Legner (1965), nr. 688 and see 686–87, 689; Rasmussen (1975), nr. 6; and Gagel (1977), nr. 30 (on Berlin's *Female Mannequin*).

137. *Kunsthandwerk und Plastik aus Deutschland im Museum des Kunsthandwerks Leipzig* (Leipzig, 1961), pp. 47–48. Both works are listed in the city's art collection in 1725. The Munich *Kunstkammer* contained a mother-of-pearl chest with male and female jointed dolls plus three additional jointed figures. From the wording I am not positive

if these are mannequins or just dolls. The collection included a doll's house though I do not know where it was exhibited. See Seelig (1985), p. 78, fig. 32 (nrs. 14 and 16).

138. Menzhausen (1977); Joachim Menzhausen, "Elector Augustus's Kunstkammer: An Analysis of the Inventory of 1587," in Impey and MacGregor (1985), pp. 69–75.

139. The inventory compiled in 1596 is published in *JKSAK* 7 (1988): pp. CCLXXIX–CCCXIII. Scheicher et al. (1977); Elisabeth Scheicher, *Die Kunst- und Wunderkammern der Habsburger* (Vienna, 1979) with comments about the origins of the family's different collections in Innsbruck, Graz, Prague, and Vienna; Scheicher (1985).

140. *Katalog der Sammlung für Plastik und Kunstgewerbe* (1966), nrs. 251, 256–57, 262–63, 270, 272, 281, 286, 289–90, 293, 308, 310, and 317.

141. Seelig (1985).

142. Manfred Tripps, *Hans Multscher* (Weissenhorn, 1969), p. 260, fig. 40; and Reindl (1977), nr. C8. On the bishop's portrait, see Chapter Ten.

143. *Inscriptiones vel tituli theatri amplissimi* (Munich, 1565). Rudolf Berliner, "Zur älteren Geschichte der allgemeinen Museumslehre in Deutschland," *MJBK* N. F. 5 (1928): esp. pp. 328–31; Elizabeth M. Hajós, "The Concept of an Engravings Collection in the Year 1565: Quicchelberg, INSCRIPTIONES VEL TITULI THEATRI AMPLISSIMI," *Art Bulletin* 40 (1958): 151–56; Seelig (1985), pp. 86–87.

144. Von Busch (1973), pp. 105–89; Hitchcock (1981), pp. 221–24; Ellen Weski and Heike Frosien-Leinz, *Das Antiquarium der Münchner Residenz. Katalog der Skulpturen*, 2 vols. (Munich, 1987), esp. 1: pp. 13–84.

145. Distelberger (1965), pp. 40–41.

146. The subject is discussed in Beck and Decker (1982), pp. 386–96, nrs. 73–122.

Chapter Ten

1. Alfred Stange, *Deutsche Malerei der Gotik*, 11 vols. (Berlin, 1934–61). Covering the period from roughly 1250 until 1500–15, Stange discusses and illustrates thousands of paintings. Up until volume 8, there are remarkably few portraits and all of these were designed for a devotional context. Independent portraits only gradually appear especially in Swabian, Bavarian, and Franconian towns from the late 1470s and most postdate 1490. Also see Ernst Buchner, *Das deutsche Bildnis der Spätgotik und der frühen Dürerzeit* (Berlin, 1953).

2. Werner Hofmann, ed., *Köpfe der Dürerzeit*, exh. cat. Kunsthalle (Hamburg, 1983).

3. Campbell (1990), p. 143.

4. Trusted (1990), pp. 10 and 35 includes all four letters about Pirckheimer's portraits. The medal is discussed below.

5. For examples of this practice, see Grotemeyer (1957), pls. IV–V; Gagel (1977), fig. 54; Smith (1983), nr. 166.

6. Campbell (1990), p. 194 citing More's *Utopia*; E. Surtz and J. H. Hexter, eds., *The Complete Works of St. Thomas More* (New Haven, 1965), pp. 192–93.

7. Hans Stafski, "Die lange verschollene Büste des Hans Perckmeister: eine alte Zuschreibung an Veit Stoss," *Zeitschrift für Kunstgeschichte* 47 (1984): pp. 49–57.

8. Pope-Hennessy (1971), pp. 52–60, figs. 88–89; and for what follows, Pope-Hennessy (1985), p. 103.

9. Erich Egg, "Caspar Gras und der Tiroler Bronzeguss des 17. Jahrhunderts," *Veröffentlichungen des Museum Ferdinandeum* 40 (1960): esp. pp. 42–48; and Ebba Koch, "Das barocke Reitermonument in Österreich," *Mitteilungen der Österreichischen Galerie* 19–20 (1975–76): pp. 32–80, esp. pp. 38–42. An equestrian portrait of Ferdinand I of Bavaria was also once planned but never carried out for the *Wittelsbach Fountain* at the Residenz in Munich.

10. Falk (1968), esp. pp. 71–73. On this project and what follows, also see Kistler (1712), pp. 24–26; Georg Habich, "Das Reiterdenkmal Kaiser Maximilians in Augsburg," *MJBK* 8 (1913): pp. 255–62; Hartig (1923), pp. 40–41; Gertrud Otto, *Gregor Erhart* (Berlin, 1943), pp. 53–56; Fedja Anzelewsky, "Ein unbekannter Entwurf Hans Burgkmairs für das Reiterdenkmal Kaiser Maximilians," *Festschrift für Peter Metz* (Berlin, 1965), pp. 295–304; and especially Larry Silver, "Shining Armor: Maximilian I as Holy Roman Emperor," *Art Institute of Chicago Museum Studies* 12 (fall 1985): pp. 9–29.

11. *Hans Burgkmair* (1973), nrs. 21–22.

12. Larry Silver, "Shining Armor: Maximilian I as Holy Roman Emperor," *Art Institute of Chicago Museum Studies* 12 (fall 1985): pp. 9–29.

13. Weihrauch (1967), pp. 293–94, 303; Wixom (1976), nr. 192 who lists the other versions. The Cleveland example measures 15.2 by 15.9 cm.

14. Ernst F. Bange, "Das Reiterdenkmal Kaiser Maximilians und die Statuette eines Pferdes im Kaiser-Friedrich-Museum," *JPKS* 45 (1924): pp. 212–13; and Müller (1963), pp. 8, 10, who, incorrectly I believe, dates the Berlin horse to c. 1508–9.

15. Hartig (1923), pp. 40–41.

16. Bruck (1903), pp. 99–100; Cornelisz de Fabriczy, "Adriano Fiorentino," *JPKS* 24 (1903): pp. 71–98, esp. 72, 83–88. This bust is periodically included in catalogues but there has been no substantive discussion of it. For instance, see *Kunst der Reformationszeit* (1983), nr. C 17; or *Barock in Dresden*, exh. cat. Essen, Villa Hügel (Leipzig, 1986), nr. 227.

17. Paul Arnold, "Kurfürst Friedrich der Weise von Sachsen als Förderer der Medaillenkunst," *The Medal* 17 (1990): esp. pp. 4–6.

18. Findeisen and Magirius (1976), p. 159, fig. 135 use this bust to illustrate how a much later bust of Elector Johann Friedrich might have been placed over the main entry portal of the great staircase. They mention that the bust was earlier in Moritzburg. With the change in the electoral title from the Ernestines to the Albertines under Moritz, residences such as Torgau became Albertine possessions. It is quite possible that the bust, like other works of art, was at Torgau only to be shifted gradually to other residences before entering the electoral art collections in Dresden.

19. Between 1510 and 1514 several busts, including some by Muscat, for Maximilian are documented in the Augsburg Baumeisterbuch. These include the bust of *Philip the Good, duke of Burgundy* (1510) in Stuttgart (Württembergisches Landesmuseum). The busts of *Maximilian* and his mother, *Eleonore*, both in Vienna (Kunsthistorisches Museum), are attributed to Muscat. Karl Feuchtmayr, "Der Augsburger Bildhauer Jörg Muscat," *MJBK* 12 (1922): esp. pp. 99–101, figs. 2, 5, 7.

20. A second impression of Hermann's medal is in Basel (Historisches Museum). Habich (1929–

34), 1.1: nrs. 1 and 2; Grotemeyer (1957), p. 48; Stafski (1962), pp. 37–38; Maué in *Gothic and Renaissance Art in Nuremberg* (1986), nrs. 187–88. They measure 3.1 and 4.3 cm respectively. Northern European and Italian medals tend to be studied separately. To correct this, Stephen Scher and the Frick Collection are preparing a detailed exhibition of Renaissance portrait medals.

21. Gert von der Osten, "Über Peter Vischers Törichten Bauern und den Beginn der 'Renaissance' in Nürnberg," *AGNM* (1963): esp. pp. 80 and 83.

22. For instance, on 30 November 1459 Ulrich Gossembrot sent three medals of his university teachers in Verona and Padua to his father Sigismund, the burgermeister of Augsburg. Such incidents were not uncommon. Grotemeyer (1957), p. 5.

23. Hermann Maué and Ludwig Veit, eds., *Münzen in Brauch und Aberglauben*, exh. cat. Nuremberg, Germanisches Nationalmuseum (Mainz, 1982), pp. 198, 214, 216. Stephan Fridolin's *Etlicher Keysser Angesicht* of 1487 is the unpublished inventory of the collection; see Nuremberg, Stadtbibliothek, Inv. Nr. Amb. 1357. Albrecht Dürer the Elder was hired to gilt 32 copper imperial coins given in 1486 by Hans Tucher.

24. Stafski (1962), figs. 75 c and d.

25. Paul Grotemeyer, "Die Statthaltermedaillen des Kurfürsten Friedrich des Weisen von Sachsen," *MJBK* 21 (1970): pp. 143–66; Hermann Maué, "Die Dedikationsmedaille der Stadt Nürnberg für Kaiser Karl V. von 1521," *AGNM* (1987): esp. pp. 223–24; and Paul Arnold, "Kurfürst Friedrich der Weise von Sachsen als Förderer der Medaillenkunst," *The Medal* 17 (1990): pp. 4–9.

26. Hermann Maué, "Die Dedikationsmedaille der Stadt Nürnberg für Kaiser Karl V. von 1521," *AGNM* (1987): pp. 227–44.

27. General comments on technique are given in Habich (1929–34), 1.1: pp. XIII–XXXV; Grotemeyer (1957), pp. 9–12; Smith (1983), p. 234; Maué in *Gothic and Renaissance Art in Nuremberg* (1986), pp. 105–7; and Trusted (1990), pp. 1–10, esp. 5–8.

28. George Hill and Graham Pollard, *Renaissance Medals from the Samuel H. Kress Collection at the National Gallery of Art* (London, 1969), nr. 1.

29. Hermann Maué and Ludwig Veit, eds., *Münzen in Brauch und Aberglauben*, exh. cat. Nu-

remberg, Germanisches Nationalmuseum (Mainz, 1982), p. 216. He also owned hundreds of old and new coins including a golden schilling with the likeness of Friedrich the Wise.

30. It measures 7.4 cm in height; however, the area devoted to the head is relatively small since the artist has included so much of Pirckheimer's torso. Habich (1929–34), 1.1: nr. 17; Zeitler (1951), p. 95; Mende (1983), nr. 5, and see nrs. 6–9 for early seventeenth-century copies; Smith (1983), nr. 137; esp. Maué (1989), pp. 24–25; and Trusted (1990), p. 10 (with the correspondence about the medal).

31. Habich (1929–34), 1.1: nr. 111; Zeitler (1951), pp. 80–83; Grotemeyer (1957), p. 48; Gagel (1977), nr. 15; Werner Hofmann, ed., *Köpfe der Dürerzeit*, exh. cat. Kunsthalle (Hamburg, 1983), nr. 113; Trusted (1990), nr. 155. The medal states that Peutinger, who was born in 1465, was then 52. This means that the date could be either 1517 or early 1518. While medal historians, especially Zeitler, can quibble over this or over whether the 1518 medal of Jakob Fugger somehow is the "first" of Schwarz' portraits, it does not diminish the ultimate significant of this work.

32. This medal in particular, which Dürer could have seen in 1518 at the imperial diet, influenced the design of his *Portrait of Hans Kleberger* of 1526, Pirckheimer's son-in-law, that is now in Vienna (Kunsthistorisches Museum). Fedja Anzelewsky, *Albrect Dürer: Das malerische Werk*, 2 vols. (Berlin, 1991—2nd ed.), nr. A 182.

33. Falk (1968), pp. 46–47; Gagel (1977), fig. 65 (*Titus*). On Peutinger's collection of antiquities, see von Busch (1973), pp. 11–16. She notes that his interest in the antique started in 1482–88 when he studied in Padua and Bologna.

34. Falk (1968), p. 52, figs. 23 and 25.

35. Habich (1929–34), 1.1: nrs. 116 and 127; Zeitler (1951), pp. 81–85; Christian Theuerkauff in Gagel (1977), pp. 74, 77, 111–15, figs. 43–44.

36. Gagel (1977), fig. 79.

37. Hollstein (1954–), 5: nr. 315.

38. Grotemeyer (1957), p. 6, doc. nr. 6. Also see Habich (1929–34), 1.1: nr. 112; Zeitler (1951), pp. 81–83. Georg is normally referred to as "the bearded." Obviously beardless here, Georg grew a long one only following the death of his wife, Barbara of Poland, in 1534.

39. Habich (1929–34), 1.1: nr. 113; Max Bernhart, "Die Porträtzeichnungen des Hans Schwarz," *MJBK* N.F. 11 (1934): pp. 65–95, esp. nr. 4.

40. Grotemeyer (1957), pp. 13–14. Habich (1929–34) listed around 3,700 entries though some of these are not strictly medals. Grotemeyer's estimate also reflects the number of medals discovered in the years after 1934.

41. Habich (1929–34), 1.1: nr. 184.

42. Maué (1989), p. 29.

43. Habich (1929–34), 1.1: nr. 133.

44. Neudörfer (1875), pp. 124–25.

45. Habich (1929–34), 1.1: nr. 177; Middeldorf and Goetz (1944), nr. 155; Smith (1983), nr. 141; Maué in *Gothic and Renaissance Art in Nuremberg* (1986), nr. 217. The wooden model is in Stuttgart (Württembergisches Landesmuseum); see Habich, pl. XXIX,4.

46. Schwarz' drawings and separate medals of Melchior and Martin survive. See Habich 1.1: nrs. 174–76 (Melchior) and 185 (Martin); Max Bernhart, "Die Porträtzeichnungen des Hans Schwarz," *MJBK* N.F. 11 (1934): pp. 65–95, esp. nrs. 50 and 60; and Smith (1983), nr. 140.

47. Rupprich (1956), p. 157; and William M. Conway, *The Writings of Albrecht Dürer* (New York, 1958), p. 104. Habich (1929–34), 1.1: nr. 201; Karl Oettinger, "Hans Dauchers Relief mit dem Zweikampf Dürers," *Jahrbuch für frankische Landesforschung* 34–5 (1975): esp. pp. 305–7; Hedergott and Jacob (1976), nr. 31; Beck and Decker (1981), nr. 44; Mende (1983), pp. 57–68, 187–93; Smith (1983), nr. 141; Maué in *Gothic and Renaissance Art in Nuremberg* (1986), nr. 216. Oettinger argues that Dürer made a self-portrait that Schwarz then copied.

48. Habich (1929–34), 1.1: nr. 171; Mende (1983), fig. 24.

49. Gagel (1977), fig. 78; Walter L. Strauss, *The Complete Drawings of Albrecht Dürer*, 6 vols. (New York, 1974), nrs. 1518/21 and 1525/15; and Fedja Anzelewsky and Hans Mielke, *Albrecht Dürer: Kritischer Katalog des Zeichnungen [Die Zeichnungen alter Meister im Berliner Kupferstichkabinett]* (Berlin, 1984), nr. 90. I do not accept Strauss' later date of 1525 for Dürer's drawing of *Jakob Fugger*.

50. Walter L. Strauss, *The Complete Drawings of Albrecht Dürer*, 6 vols. (New York, 1974), nr. 1519/17; and Rowlands (1988), nr. 79a.

51. Mende (1983), esp. nrs. 15–16 and his 17ff. for later versions and copies.

52. Richard Gaettens, "Der Konterfetter Hans Schwarz auf dem Reichstag zu Worms 1521," *Der Wormsgau* 3, Heft 7 (1951–58), pp. 8–17; and especially Maué (1988); and Maué (1989), pp. 25–26.

53. There is some question about whether the artist of a small group of medals, including a self-portrait, is Schaffner. See Habich (1929–34), 1.1: nrs. 822–35.

54. On Gebel, see our Biographical Catalogue.

55. The dish was presented to the museum by the Seyfried Pfinzing Stiftung. Habich (1929–34), 1.2: nrs. 970, 1070, 1084, and 1140; Kohlhaussen (1968), pp. 440–42, nr. 465; Smith (1983), p. 65; *Wenzel Jamnitzer* (1985), nr. 10; and Klaus Pechstein in *Gothic and Renaissance Art in Nuremberg* (1986), nr. 212.

56. For instance, see the 4th century B.C. South Italian cup with a dekadrachme of Syracuse in the center in Hermann Maué and Ludwig Veit, eds., *Münzen in Brauch und Aberglauben*, exh. cat. Nuremberg, Germanisches Nationalmuseum (Mainz, 1982), nr. 255.

57. Kohlhaussen (1968), nr. 467.

58. Habich (1929–34), 1.2: nrs. 1180–1181; *Martin Luther und die Reformation in Deutschland* (1983), nrs. C 49.4 and .5; Smith (1989), pp. 52–53, 55.

59. Habich (1929–34), 1.2: nrs. 959, 968; Mende (1983), nrs. 31–32, 34, and see nrs. 35–46 for subsequent copies after Gebel's medals; *Gothic and Renaissance Art in Nuremberg* (1986), nrs. 225–26.

60. Hans Rupprich, ed., *Dürer. Schriftlicher Nachlass* (Berlin, 1969), 3: pp. 458–59; cited by Maué (1989), p. 28.

61. Habich (1929–34), 1.2: nr. 1042. No medals cast from this model are known.

62. Maué (1989), pp. 27–28; and Trusted (1990), p. 84.

63. Habich (1929–34), 1.1: nrs. 465–66; Suhle (1950), p. 37; Zeitler (1951), pp. 107–18; Müller (1959), nrs. 307–8. On Hagenauer's career, also see our Biographical Catalogue.

64. Habich (1929–34), 1.1: nr. 471, and cf. 470, 472–74, 477–78, 490; Lieb (1958), pp. 56–57 (nr. 10); *Welt im Umbruch* (1980–81), 2: nr.

540. In 1530 Gebel would use Hagenauer's medal as the basis for his own of Fugger; see Habich, 1.2: nr. 1014.

65. Lieb (1958), p. 58, fig. 84.

66. On Albrecht, see Habich (1929–34), 2.1: nr. 1941; and Reber (1990), nr. 48. The face is patterned after a medal made in 1526 by an unknown Nuremberg artist, see Habich, 1.2: nr. 923. On Charles V, see Max Bernhart, *Die Bildnismedaillen Karls des Fünften* (Munich, 1919), nr. 93, pl. VIII; Habich, 2.1: nr. 1926; and Trusted (1990), nr. 143.

67. Habich (1929–34), 2.1: nr. 1935; Trusted (1990), nr. 139 (with a ring for hanging the medal).

68. Weiditz experimented with both three-quarters and full-face poses as early as 1526; see Habich (1929–34), 1.1: nrs. 343–44, 348, 371, 374–76. Hagenauer also made the occasional non-profile medal; see Habich, 1.1: nrs. 487, 491, 565 (Melchior Boss, Augsburg Münzmeister, dated 1531), 569, 571, 573. Schwarz's *Kunz von der Rosen* medal of c. 1518 is his only non-profile example; Habich, 1.1: nr. 120.

69. Of the roughly 1300 Italian medals listed in Hill's great corpus, Andrea Guacialoti's *Alfonso, duke of Calabria* (1481), which exists in two versions, is the only non-profile example. See Georg F. Hill, *A Corpus of Italian Medals of the Renaissance before Cellini*, 2 vols. (London, 1930), nrs. 745 and 752.

70. Habich (1929–34), 1.1: nr. 398; Suhle (1950), pp. 34–35; Zeitler (1951), pp. 96–106; Trusted (1990), nr. 183. The reverse displays an allegorical scene and the motto "Fortune schools men, and virtue adorns them." On the artist's career, see our Biographical Catalogue. If the early 1530s dating is correct, I wonder whether Weiditz' sculpted portrait influenced the design of Holbein's full-face painting of the noble, much as medals would affect Holbein's development of the English portrait miniature. See John Rowlands, *The Paintings of Hans Holbein the Younger* (Oxford, 1985), nr. 53.

71. Habich (1929–34), 1.1: nr. 630.

72. Habich (1929–34), 1.2: nrs. 1689–1710.

73. Habich (1929–34), 1.2: nrs. 1737–1745.

74. Habich (1929–34), 2.1: nrs. 2198–2295. For the medals of Luther and Melanchthon cited below, see nrs. 2231–2232.

75. Habich (1929–34), 2.1: nr. 2246; Seeger (1932), pp. 34ff.; Christian Theuerkauff in Gagel (1977), nr. 11; *Martin Luther und die Reformation in Deutschland* (1983), nr. 638.

76. Scribner (1981), pp. 79–86; also Hofmann (1983), nrs. 37–42 for other forms of mockery including medals.

77. Hildegard Schnabel, ed., *Lucas Cranach d. Ä.—Passional Christi und Antichristi* (Berlin, 1972), pp. 26 and 39.

78. Habich (1929–34), 2.1: nr. 3176. Also see his other portraits of the duke, nrs. 3170–3171, 3174–3175, 3178–3179.

79. Habich (1929–34), 2.1: nr. 3176 though no proof is provided. For what follows, see Glaser (1980), 2.2: pp. 27–28, 38, nrs. 54 and 59.

80. Habich (1929–34), 2.1: nrs. 2050 and 2083.

81. For instance, Otteinrich had a gallery filled with princely portraits painted primarily by Peter Gertner. See Susanne Wagini, *Ottheinrichs Porträtgalerie Neuburg an der Donau* (Munich, 1987). Also Archduke Ferdinand II of Tirol began a collection of portraits copied in an identical small-scale format in 1576. Today these are displayed in Vienna (Kunsthistorisches Museum, Münzsammlung). See Günther Heinz and Karl Schütz, *Kunsthistorisches Museum, Wien: Porträtgalerie zur Geschichte Österreich von 1400 bis 1800* [Katalog der Gemäldegalerie] (Vienna, 1976), esp. pp. 9–10. For what follows, see Habich (1929–34), 2.1: nrs. 2630–2641 (Maler), 2167–2179 and pp. 310–11 (Wolff).

82. The documents and a brief commentary are given in Georg Habich, "Studien zur deutschen Renaissancemedaille, III. Friedrich Hagenauer," *JPKS* 28 (1907): esp. pp. 181–83, 269–72.

83. For his signed medal of Zinsmeister, see Habich (1929–34), 1.1: nr. 550.

84. For Weiditz' dispute with the goldsmiths and his comments, see Theodor Hampe, *Das Trachtenbuch des Christoph Weiditz* (Berlin, 1927), pp. 66–67 (with translation). The original text is given in Habich (1929–34), 2.1: p. CIII.

85. Habich (1929–34), 1.2: p. 140; and Maué (1989), p. 27. The rough translation of the following quotation is mine.

86. On the general dispute and on Lotter's medal, see Habich (1929–34), 2.1: p. 278, nr.

1953. He made other medals during these years.

87. Georg Habich, "Über zwei Bildnisse Ottheinrichs von der Pfalz. II. Steinmedaillon von Hans Daucher," *MJBK* 9 (1914–15): pp. 212–23; Halm (1926), 2: pp. 205–8; Bange (1928), pls. 11–12; Habich (1929–34), 1.1: nrs. 48–49, and generally 45–82 for the attributed medals, none of which is signed or stylistically identical with Daucher's secure oeuvre.

88. Halm (1926), 2: pp. 209–18, figs. 184–87, 189, 191; Sauerlandt (1927), pp. 70, 72; Bange (1928), pls. 7–10, 13; Karl Feuchtmayr, "Die Begegnung Karls V. und Ferdinands I. von Hans Daucher," *MJBK* 10 (1933): pp. IX–XIII; Müller (1963), p. 26.

89. Portraits of Charles and his brother, Ferdinand I, are often so stylized as to be interchangeable. Since a coat of arms is lacking here, it is possible, though less likely, that the rider is Ferdinand rather than Charles. Halm (1926), 2: pp. 209, 211; Bange (1928), pl. 8.

90. Halm (1926), 2: p. 209; Bange (1928), pl. 10. Maximilian founded the chivalric Order of St. George in 1508, which partially explains his association with the holy knight. On Burgkmair's prints, see our comments at the beginning of this chapter.

91. Habich (1929–34), 1.1: nrs. 223–25, 228–34, which date between 1520 and 1522.

92. Cited by Bange (1928), pl. 8. He notes that the 1522 variant of this carving with Charles riding before a town, now in Vienna (Kunsthistorisches Museum and then in Paris [private collection], was recorded in the imperial inventories of 1735 and 1861. See Bange, pl. 9.

93. *Welt im Umbruch* (1980–81), II: nr. 514; *Martin Luther und die Reformation* (1983), nr. 151.

94. Halm (1926), 2: pp. 218–20; Bange (1928), p. 21; Karl Oettinger, "Hans Dauchers Relief mit dem Zweikampf Dürers," *Jahrbuch für fränkische Landesforschung* 34–5 (1975): pp. 299–307; Beck and Decker (1981), nr. 47; and Mende (1983), pp. 66–67.

95. Halm (1926), 2: pp. 197–204; Bange (1928), pl. 14; Alfred Schädler in *Bayern, Kunst und Kultur*, exh. cat. Munich Residenz (Munich, 1972), nr. 586; Reindl (1977), nr. F43; Monika Bachtler in Glaser (1980), 2.2: nr. 295; Eva Zim-

mermann in *Die Renaissance im deutschen Südwesten* (1986), 2: 113; and von Schweinitz (1987), esp. pp. 213–16 (with the various inventory references cited below).

96. Hollstein (1954–), 5: nr. 247.

97. A plaster replica of the relief, now in Braunschweig (Herzog Anton Ulrich-Museum), records its general appearance before the early seventeenth-century enhancements. See Halm (1926), p. 202, fig. 177.

98. Josephi (1910), nr. 62; Bange (1928), pl. 21; and Reindl (1977), nr. A31.

99. Habich (1929–34), 1.1: nr. 91. His attribution to Hering is incorrect.

100. Georg Habich, "Studien zur deutschen Reniassancemedaille, III. Friedrich Hagenauer," *JPKS* 28 (1907): esp. pp. 196–97; Vöge (1910), nr. 142; Habich (1929–34), 1.1: nrs. 446–48 (medals of Philipp), fig. 89; Vöge (1932), pp. 139–40; Müller (1963), pp. 7, 23; Metz (1966), nr. 697.

101. Mengden (1973), passim and esp. pp. 15–25 on the portraits; and Scheicher (1986) with excellent illustrations of all parts. In the Biographical Catalogue, I briefly discuss the debate over whether Hans Kels the Elder or the Younger should be identified as the "Hans. Kels. zv. Kavfbeiren" who signed the portrait of Ferdinand I and one of the game pieces. Although I argue for the latter, the project certainly involved the entire family workshop. This included Veit, his brother, who created monogrammed medals of Charles, Ferdinand, and their wives in 1536. The interior of the board is equally elaborate as are the 32 surviving boxwood game pieces that illustrate historical or mythological tales of good and bad behavior, such as Samson and Delilah, the abduction of Helen, or the cyclop and Galatea. The program draws heavily from Ovid's *Metamorphosis* as well as his other writings, Virgil's *Aeneid*, Suetonius's *Lives of the Caesars*, and a host of other texts. Prints by Burgkmair, Pencz, Sebald Beham, and Raimondi provide some of the pictorial models used by Kels. On medals by Hans the Younger and Veit, see Habich (1929–34), 1.1: nrs. 763–96 and 797–800 respectively.

102. Ferdinand is surrounded by medallions of Ferdinand of Aragon, Duke Charles the Bold of Burgundy, Vladislaw, king of Poland who was Ferdinand's father-in-law, and Ludwig, his predecessor as king of Hungary. The corner roundels depict Ninus, Cyrus, Alexander the Great, and Romulus, signifying the four great world empires.

103. Landolt and Ackermann (1991), nr. 56.

104. For instance, see the examples in London (Victoria and Albert Museum) and Munich. Müller (1959), nrs. 303–6; Trusted (1990), nrs. 189–204. *Christine of Saxony*, Trusted's nr. 199, is based upon the same source as the *Christine* gamepiece in Basel, which is by a different artist. See Elisabeth Landolt, *Kabinettstücke der Amerbach im Historischen Museum Basel* (Basel, 1984), pp. 84–85 with detail. The dress has been modified somewhat.

105. Habich (1918), pp. 138–40; Bruhns (1923), p. 45; and Bange (1928), pl. 92.

106. Gagel (1977), fig. 29; and John Rowlands, *The Complete Paintings of Hans Holbein the Younger* (Oxford, 1985), nr. 38.

107. For instance, see Cranach the Elder's *King Christian II of Denmark* woodcut of 1523; Hollstein (1954–), 6: nr. 124. The form remains somewhat unusual until the 1540s and 1550s.

108. Bange (1928), pl. 41; Seeger (1932), p. 37; Muller (1963), pp. 12, 55; Legner (1965), nr. 699; and esp. Christian Theuerkauff in Gagel (1977), nr. 7.

109. Gagel (1977), fig. 30. The rounded gables of the palace are reminiscent of contemporary buildings in North Germany, such as the renovated Neue Stift at Halle.

110. Bange (1928), nr. 47; Metz (1966), nr. 699; and Christian Theuerkauff in Gagel (1977), nr. 8.

111. Bange (1928), nr. 46; Metz (1966), nr. 698 (a terracotta copy in Berlin [SMBPK, Skulpturengalerie]); Hugh Tait, *The Waddesdon Bequest—the Legacy of Baron Ferdinand Rothschild to the British Museum* (London, 1981), p. 93, fig. 69. The pose of this work is fascinating since Wolfgang Thenn sits on a ledge with his foreshortened legs dangling over the edge. Did the artist, like Thenn, live in Salzburg?

112. The motif was used earlier and more often in Italian and Netherlandish painting. Cranach the Elder was the first German artist to adopt this form, as in his portraits of *Johannes and Anna Cuspinian* (Winterthur [Oscar Reinhart Collection]) or *Stephan Reuss and his Wife* (1503; Nuremberg [Germanisches Nationalmuseum] and Berlin [SMBPK, Gemäldegalerie]); see Ernst Buchner, *Das deutsche*

Bildnis der Spätgotik und der frühen Dürerzeit (Berlin, 1953), nrs. 188–91. Most artists employed instead a simple window with a landscape at the rear of the composition.

113. Habich (1929–34), 1.1: nr. 747; Rasmussen (1977), nr. 17.

114. Rasmussen (1977), nr. 18 (*Portrait of a 26-Year-Old Man*).

115. Van der Mul's portrait and inscription derive from Valentin Maler's medal of the previous year. This explains the rather cool, detached expression on the bishop's face. The exact purpose of the relief, which measures 23.5 by 17 cm, is uncertain. Kieser correctly compares it with the small portrait relief of *Daniel Brendel, archbishop of Mainz*, made by Master H.K.V.B. in 1568 and now in New York (Metropolitan Museum of Art). He also asks whether this was a trial piece to test van der Mul's talents since the bishop was soon to commission his brother's tomb and a host of projects for the new hospital. (figs. 82 and 83, 113 and 114) Echter likely kept the portrait in his personal *Kunstkammer*. At a later date, it was set into the north wall of the *Ahnensaale* (ancestral hall) at Schloss Mespelbrunn, Echter's family seat and birth place, where it remained until its transfer to Würzburg in 1932. Habich (1929–34), 2.1: nr. 2500 (on Maler); Emil Kieser, "Zum Reliefbildnis Julius Echters," in Max Buchner, ed., *Aus der Vergangenheit der Universität Würzburg* (Berlin, 1932), pp. 1–8; H. Rageller, *Martin-von-Wagner-Museum: Verzeichnis der Gemälde und Skulpturen* (Würzburg, 1969), p. 67, fig. 60; Wendehorst (1981), fig. 175.

116. On Meit's career and his busts, see our Biographical Catalogue. There exists no adequate study of German bust portraits of this period. See the brief remarks in Harald Keller, "Büste," *RDK* 3 (1954): esp. cols. 264–71.

117. On this subject, which includes two of the Prague busts, see Kurt Gerstenberg, *Die deutschen Baumeisterbildnisse des Mittelalters* (Berlin, 1966), esp. pp. 44–45, 78–127, 204–8.

118. Joseph Braun, "Büstenreliquiar," *RDK* 3 (1954): esp. cols. 274–85.

119. Wilhelm Vöge, *Jörg Syrlin der Ältere und sein Bildwerke* (Berlin, 1950), passim.

120. Jörg Rasmussen, "Kunz von der Rosen in der Fuggerkapelle," *ZDVK* 38 (1984): pp. 47–53.

121. Bellmann, Harksen, and Werner (1979), p. 251.

122. Vöge (1932), pp. 141–48 (who first argued for an attribution to Gebel instead of Hagenauer); Müller (1959), nrs. 191–92; Müller (1963), p. 45.

123. Habich (1929–34), 1.2: nr. 1052–1053. Gebel's *Philipp* has a pointed beard that is altogether lacking in the Munich bust. In conversation, Peter Volk of the Bayerisches Nationalmuseum questioned the identifications and raised the possibility that the pair might be nineteenth-century in date. The busts entered the museum in 1854 after a stay of undetermined length in Neuburg. From my brief examination of the pair, I do not think they are forgeries but I have not seen any of the technical data. The most celebrated recent "unmasking" is the terracotta *Bust of a Man* in London (Victoria and Albert Museum) long attributed to Christoph Weiditz that through laboratory examination proved to be made in the nineteenth century. See Vöge (1932), pp. 148–57; and Trusted (1990), p. 117.

124. Kohlhaussen (1968), p. 433 (where he cites the research of Hans Reinhardt).

125. *Erasmus von Rotterdam: Vorkämpfer für Frieden und Toleranz*, exh. cat. Historisches Museum (Basel, 1986), nr. A 2.9. Boner had extensive ties with Nuremberg's artists.

126. Georg Habich, "Über zwei Bildnisse des Kurfürsten Otto Heinrich von der Pfalz," *MJBK* 9 (1914–15): pp. 67–86; Gaettens (1956), pp. 78–82; Müller (1963), p. 47; *Die Renaissance im deutschen Südwesten* (1986), 2: nr. I 15.

127. Habich (1929–34), 1.2: nrs. 1696–1707, esp. 1706 (dated 1558), and cf. 1689–1692. In his earlier article, cited in the previous note, Habich attributed the bust to Joachim Deschler, the Nuremberg sculptor and medallist. With the subsequent discovery of Schro's monogrammed medals of Count Friedrich Magnus von Solms (1555) and members of his family, Habich picked Schro as the artist. I think that the style of the von Solms and Ottheinrich medals indicate one artist. Also see Gaettens (1956), pp. 81–82; and *Die Renaissance im deutschen Südwesten* (1986), 2: nr. K 12.

128. The fragmentary head is lifesize (30 cm) is in the Schlossmuseum in Neuburg an der Donau. See Gaettens (1956), pp. 73–75; and *Die Renaissance im deutschen Südwesten* (1986), 2: nr. I 14.

129. Honnens de Lichtenberg (1991), pp. 136–38, pls. VII–X, figs. 86–87. In 1616 it was listed in Paulus Praun's inventory (folio 36).

130. Compare Nicolas Neufchatel's portrait of 1573 in Trieste (Museo Storico del Castello di Miramare); see Honnens de Lichtenberg (1991), fig. 1.

131. The 48 cm-high painted bust dates around 1540–45. *Kunsthistorisches Museum Wien: Führer durch die Sammlungen* (Vienna, 1988), p. 179.

132. Peltzer (1916–18), pp. 198–99; Christian Theuerkauff in Gagel (1977), nr. 5; Smith (1983), pp. 77–78; Smith (1990–91), p. 158; and Honnens de Lichtenberg (1991), pp. 138–41, pls. XI and XIII, figs. 88–90.

133. Given Neufchatel's success in Nuremberg, van der Schardt may have used his paintings as a general model. For instance, Neufchatel's *Johann Neudörfer and his Son* of 1561 (Munich, Alte Pinakothek; on loan to Nuremberg, Germanisches Nationalmuseum) shows the famed calligrapher-biographer concentrating fully on the dodecahedron held in his hand, a motif that anticipates that of Imhoff. Compare too the stylistic and facial similarities of Neufchatel's *Wenzel Jamnitzer* of c. 1562, now in Geneva (Musée d'art et d'histoire), and the bust. See R. A. Peltzer, "Nicholas Neufchatel und seine Nürnberger Bildnisse," *MJBK*, N.F. 3 (1926): pp. 187–231, esp. 192–221, figs. 3, 7, 14; Smith (1990–91), pp. 153, 155–56, figs. 6–8.

134. See Francesco Cessi, *Alessandro Vittoria: Scultore, I Parte* (Trent, 1961), passim but esp. pls. 14, 37, 41; and Pope-Hennessy (1985), p. 98, fig. 117.

135. Peltzer (1916–19), pp. 198–99; Christian Theuerkauff in Gagel (1977), nr. 6; Honnens de Lichtenberg (1991), pp. 141–42, pls. XII and XIV, figs. 91–92.

136. Peltzer (1916–18), pp. 207–9; Honnens de Lichtenberg (1981), pp. 58, 63; and Honnens de Lichtenberg (1991), pp. 142–45, pl. XV, figs. 93–95.

137. The medallion is in Nuremberg (Germanisches Nationalmuseum). On it and the inventory reference, see Smith (1985), p. 92, fig. 12; *Wenzel Jamnitzer* (1985), nr. 649; Smith (1990–91), pp. 159, 161, fig. 14; Honnens de Lichtenberg (1991), pp. 159–60. The portrait seems to have inspired Valentin Maler's posthumous(?) medal; see Habich (1929–34), 2.1; nr. 2526.

138. Ernst Bange, "Ein Tonrelief des Johann Gregor von der Schardt," *MJBK* N.F. 1 (1924): pp. 169–71; Smith (1985), p. 95, fig. 13; Smith (1990–91), pp. 161, 164; Honnens de Lichtenberg (1991), pp. 161–63, figs. 112–13.

139. Habich (1929–34), 2.1: n. 2659; *Wenzel Jamnitzer* (1985), nr. 679.

Conclusion

1. Charles Talbot has presented the interesting argument that a stylistic shift from a dominant sculptural mode to a pictorial one also affected sculpture, painting, and prints around 1500. See Talbot (1990).

2. Lars Olof Larsson, "Imitation and Variation: Bemerkungen zum Verhältruis Jan Gregor van der Schardts zur Antike," in Jürg Meyer zur Capellen and Gabriele Oberreuter-Kronabel, eds., *Klassizimus-Epoche und Probleme: Festschrift für Erik Forssman* (Hildesheim, 1987), pp. 277–87.

3. The character of German sculpture, in particular Protestant and Catholic religious art in the face of the Counter Reformation and the Thirty Years War, or roughly from 1580 to 1630–48, will be the subject of my next book.

PHOTOGRAPHIC ACKNOWLEDGMENTS

Munich, Staatliche Münzsammlung: 48, 49, 286, 293, 297

Munich, Wittelsbacher Ausgleichsfonds: 298, 299

Munich, Zentralinstitut für Kunstgeschichte: 112

Münster, Westfälisches Amt für Denkmalpflege: 21, 22

New York, Art Resource/Bildarchiv Foto Marburg: 9, 12, 19, 55, 73, 83, 92, 95, 101, 155, 218–220, 232

Nuremberg, Bayerisches Staatsarchiv: 7

Nuremberg, Bildstelle und Denkmalsarchiv, Hochbauamt Stadt Nürnberg: 4, 10, 15, 88, 184, 186, 190, 195, 212

Nuremberg, Germanisches Nationalmuseum: 13, 18, 23, 32, 45, 46, 89, 163, 164, 187, 197, 227, 239, 249, 267, 273, 274, 288, 290, 294, 303, 317

Oxford, Ashmolean Museum: 242, 243

Paris, Musée du Louvre (Service photographique de la Réunion des musées nationaux): 231, 313

Paris, Bibliothèque Nationale: 281, 282

Rhode Island School of Design: 259

Santa Barbara, University of California, University Art Museum: 262, 263, 289

Smith, Jeffrey: 14, 36, 47, 70, 87, 98, 132, 134, 153, 186, 191, 196, 201, 277

Stockholm, Nationalmuseum: 211, 257

Stuttgart, Landesdenkmalamt Baden-Württemberg: 128, 129, 131, 207

Stuttgart, Staatsgalerie: 179

Stuttgart, Württebergisches Landesmuseum: 130, 208, 209

Ulmer Museum: 16, 17

Vienna, Bundesdenkmalamt: 74, 86, 100, 145, 146, 147, 149, 151, 152, 188, 189

Vienna, Graphische Sammlung Albertina: 278

Vienna, Kunsthistorisches Museum: 27, 50, 173–176, 198, 200, 236, 251, 252, 258, 275, 283, 285, 305

Washington, National Gallery of Art: 2, 238

Wittenberg, Lutherhalle (Photo Wilfried Kirsch); 97

Wolfenbüttel, Herzog August Bibliothek: 1, 40, 202, 204

Würzburg, Mainfränkisches Museum: 82

Würzburg, Martin von Wagner-Museum der Universität Würzburg: 116 (Verlag Gundermann); 310

INDEX

ICONOGRAPHIC INDEX

Biblical Texts

OLD TESTAMENT

NEW TESTAMENT